£30·20

Pietro da Cortona at the Pitti Palace

PRINCETON MONOGRAPHS IN ART AND ARCHAEOLOGY
XLI / PUBLISHED FOR THE DEPARTMENT OF
ART AND ARCHAEOLOGY, PRINCETON UNIVERSITY

Pietro da

MALCOLM CAMPBELL

Cortona at the Pitti Palace

A Study of the Planetary Rooms and Related Projects

PRINCETON UNIVERSITY PRESS, PRINCETON, NEW JERSEY

Library of Congress Cataloging in Publication Data

Campbell, Malcolm, 1934-
 Pietro da Cortona at the Pitti Palace.

 (Princeton monographs in art and archaeology; 41)
 Bibliography: p.
 Includes index.
 1. Pietro da Cortona, 1596-1669. 2. Florence.
Palazzo Pitti. I. Title. II. Series.
ND623.P56C35 759.5 76-3247
ISBN 0-691-03891-0

COPYRIGHT © 1977 BY PRINCETON UNIVERSITY PRESS
PUBLISHED BY PRINCETON UNIVERSITY PRESS, PRINCETON, NEW JERSEY
IN THE UNITED KINGDOM: PRINCETON UNIVERSITY PRESS, GUILDFORD, SURREY

ALL RIGHTS RESERVED

PUBLICATION OF THIS BOOK HAS BEEN AIDED BY A SUBSIDY
FROM THE PAUL MELLON FUND OF PRINCETON UNIVERSITY PRESS.

THIS BOOK HAS BEEN COMPOSED IN LINOTYPE JANSON

BLACK AND WHITE ILLUSTRATIONS BY MERIDEN GRAVURE
COMPANY, MERIDEN, CONNECTICUT

COLOR PLATES BY VILLAGE CRAFTSMEN, ROSEMONT, NEW JERSEY

DESIGNED BY BRUCE D. CAMPBELL

PRINTED IN THE UNITED STATES OF AMERICA
BY PRINCETON UNIVERSITY PRESS, PRINCETON, NEW JERSEY

To Myron Gilmore, Mason Hammond, and the late Millard Meiss, who, as Director and Acting Directors, respectively, together with their wives, the Fellows and Staff, made the Villa I Tatti a *locus amoenus* during the academic years 1966-1967 and 1971-1972.

Preface

Over a decade ago I wrote a doctoral dissertation entitled "The Frescoes of Pietro da Cortona in the Palazzo Pitti and Related Problems." This thesis was the starting point for the present volume, which deals more broadly and more fully with the work completed by Pietro da Cortona for Grand Duke Ferdinand II. The rooms in the Pitti Palace dedicated to five planetary deities and used as royal presence chambers by the Grand Duke, together with the closely related Sala della Stufa, are the focal point of this study. These rooms, which were decorated by Cortona or his student, Ciro Ferri, have been frequently noted in the literature of art. Contemporary guidebooks, biographies, and diaries indicate that the Planetary Rooms were of interest to travelers and connoisseurs in the seventeenth century. Modern scholarship supports the judgment of the past. Recent major surveys of Italian and European art of the seventeenth century have singled out the Planetary Rooms for illustration and comment.

This study brings together for the first time all available resources for the evaluation and interpretation of the decorations of these rooms. A document catalogue and a drawing catalogue have been assembled, and in an appendix an attempt is made to ascertain the chronology of Cortona's work at the Pitti Palace on the basis of current information. The text includes a consideration of the circumstances of these commissions and the function of the rooms in question. Iconographic interpretations of the decorations are attempted, but it must be stated that these are made without benefit of the actual written programs. Problems of style and content are considered. It is a presupposition of this study that we can learn much about the finished work of art from the evolution of its form and content; therefore, documents and preparatory studies are discussed in the text when they shed light on these aspects of the work. In the closing sections of the text, Cortona's commissions in the Pitti Palace are considered with respect to their impact on art in Florence and on European art in general.

Given the intended readership of this study, it should not be necessary to do more than admit that it does not presume to achieve definitive treatment of its subject. New documents will be discovered, additional preparatory drawings will be identified. Even were this not the case, the continued enrichment of our knowledge of seventeenth-century art and culture may offer bases for fuller or even new interpretations of these decorations and their history. In this context it is most encouraging to note the publication of a series of frescoes and grotto decorations by Cortona that were discovered recently in the mezzanine rooms in the eastern wing of the Pitti Palace by Marco

Chiarini. Drawings in private collections (Drawing Cat. Nos. 126-132) have come to my attention in just the past weeks which illuminate the evolution of the Sala di Marte. These events, as noted in the text and footnotes of the present study, enhance our knowledge of Cortona's work and of his influential role in the development of the Baroque style.

Many friends and colleagues have aided and advised me in the research that is the basis of this work. Here I shall attempt to acknowledge those individuals to whom I am indebted for specific counsel or information incorporated in the present study. I would like to thank John Rupert Martin, who guided this study through its early stage as a dissertation and who later read the manuscript of the present study, sharing his wide-ranging knowledge of Baroque art and purging the text of inconsistencies of grammar and content. In the initial stages of this project, I benefited from the expertise of the art historians James Holderbaum, Ulrich Middeldorf, Michelangelo Muraro, and the late Walter Vitzthum. In my archival investigations I was helped by Roberto Abbondanza, Francesca Morandini, Allen Ceen, and Wolfram Prinz. As indicated in the notes, I am particularly indebted to my good friend Gino Corti, who worked in my behalf, discovering important documents, transcribing others that I found, and checking practically every document published here against the original.

In 1964, drawings in the possession of the Uffizi Drawing Cabinet were exhibited and a catalogue published. I greatly benefited from the opportunity to make the selection and prepare the catalogue, for which I am beholden to Giulia Sinibaldi and Anna Forlani Tempesti. I am especially grateful to Maria Fossi Todorow, who as translator of my catalogue and as a friend greatly contributed to the realization of this project.

When I first sought to explore the Pitti Palace, Anna Maria Ciranfi was helpful and enthusiastic, as have been Kirsten Aschengreen Piacenti and Marco Chiarini.

Creation of an adequate photographic record of the room decorations and of their preparatory drawings was an important aspect of this project. When I commenced this study of the Planetary Rooms, few published sources illustrated their decorations. A group of photographs was provided by James Holderbaum, and A. Richard Turner gave me an extensive collection of photographs of the paintings, architecture, and decorative projects of Pietro da Cortona. Giuliano Briganti permitted my acquisition of photographs commissioned by him for his monographic study of Pietro da Cortona. He also kindly allowed me to read the manuscript version of the monograph prior to its publication in 1962. Evelina Borea and the staff of the Gabinetto Fotografico of the Soprintendenza delle Belle Arte are to be thanked for their great helpfulness as is the photographer of the Uffizi Drawing Cabinet. A portion of the cost of photographic work, including the construction of scaffolding, was defrayed by a grant-in-aid from the Spears Fund of the Department of Art and Archaeology, Princeton University.

Concerning iconographic problems, I have been encouraged in my belief that the Planetary Rooms are not a horoscope or cosmology for a specific individual by Otto

Neugebauer, who kindly took time to examine the cycle. Jennifer Montagu, on the basis of her work in the Barberini Salone, suggested that frescoes in the Sala della Stufa might contain the theme of the "Return of the Golden Age," a thesis that proved correct when the frescoes and their preparatory drawings were studied in detail.

Requests for information about drawings, securement of photographs and related matters received careful attention from many individuals, several of whom have been particularly helpful, and I therefore mention: Alexandre Ananoff, Keith Andrews, Jacob Bean, Anthony Clark, Pierre Rosenberg, and Helen Seiferheld.

The present study has been an important, though not the exclusive focus of my scholarly activity during two lengthy stays in Italy for the academic years 1966-1967 and 1971-1972. I am grateful to the University of Pennsylvania for sabbatical leaves for these periods of time. During 1966-1967, I was generously aided by a fellowship from the Simon H. Guggenheim Foundation and a U.S. Government Junior Research Fellowship. In 1971-1972, I received a fellowship from the Leopold S. Schepp Foundation. During these two years of full-time research, I was designated a Fellow of the Harvard Center for Italian Renaissance Studies at the Villa I Tatti, for which my thanks are attested in the dedication of this book.

The manuscript of this study was improved by the suggestions of Howard Hibbard, who read the work in its entirety. It is a pleasure to acknowledge my thanks to Mary Laing and Gail Filion, who as fine arts editor and copy editor, respectively, for Princeton University Press provided sound advice, friendly criticism, and encouragement.

A portion of this manuscript was typed by Jean Ingram and Christine Pappa. Ellen Ravin with patience and care checked footnote references and bibliographic citations. Most of the manuscript was typed and retyped by my wife, Joan, through its varied stages. Of my debt and gratitude to her, however, that for efforts clerical and stenographic is the least part.

M.C.

December 1973

PHOTOGRAPHIC CREDITS

Author: Figs. 155, 157, 171, 173.

Berlin, Kunstbibliothek: Fig. 120.

Berlin, Walter Steinkopf (Kupferstichkabinett, Staatliche Museen): Fig. 134.

Budapest, Museum of Fine Arts: Figs. 30, 31.

Darmstadt, Hessisches Landesmuseum: Figs. 87, 133.

Düsseldorf, Landesbildstelle Rhineland: Fig. 76, 168.

Edinburgh, Tom Scott: Fig. 82.

Florence, Alinari: Figs. 2, 3, 10, 12, 20 (Brogi), 21, 24 (Brogi), 42, 43 (Brogi), 89, 94 (Brogi), 95, 96, 97, 99, 116, 117, 121, 140, 143, 145-148, 149-151 (Brogi), 153, 154, 160, 161, 165, 169, 170, 172, 174, 175, 176, 180, 182, 188, 190, 192.

Florence, Scala: Color Plates I-IV.

Florence, Artini: Fig. 144.

Florence, Soprintendenza: Figs. 1, 4, 5, 9, 11, 14, 22, 23, 25-28, 32-41, 44-60, 62-71, 73-75, 88, 90, 92, 93, 98, 100-106, 108-115, 122-124, 128-132, 141, 152, 156, 158, 159, 162, 183-187, 189, 191.

Hamburg, Kunsthalle: Fig. 118.

London, British Museum: Figs. 91, 195.

London, A.C. Cooper Ltd.: Fig. 107.

London, Royal Institute of British Architects: Fig. 164.

Munich, Staatliche Graphische Sammlung: Figs. 8, 15, 15A.

New York, Cooper-Hewitt Museum of Decorative Arts and Design: Fig. 84.

New York, Metropolitan Museum of Art: Figs. 7, 17, 18, 79.

New York, Seiferheld: Figs. 13, 29, 77, 81, 83, 86, 125.

Paris, Alexandre Ananoff: Fig. 194.

Paris, Jean Dubot: Fig. 202.

Paris, Louvre: Fig. 85.

Paris, Musées Nationaux: Figs. 196-201.

Prague, National Gallery: Fig. 16.

Princeton University, The Art Museum: Fig. 19.

Rome, Bibliotheca Hertziana: Fig. 177.

Rome, Gabinetto Fotografico Nazionale: Figs. 135-139, 142, 163, 166, 167, 181.

Rome, Oscar Savio: Figs. 6, 61, 72, 78, 80, 126, 127, 178.

Toronto, Art Gallery of Ontario: Fig. 193.

Windsor Castle, Royal Library: Fig. 119. By gracious permission of Her Majesty the Queen.

Contents

Contents

Illustrations

List of Illustrations

Pietro da Cortona at the Pitti Palace

"O Curradi, o Curradi quanto noi altri siamo piccini,
che dite, che dite non siamo noi ben piccinini?"

*(Oh, Curradi, oh Curradi how small the rest of us are!
What do you say? What do you say? Aren't we very tiny?)*

The artist Matteo Rosselli to his elder colleague
Francesco Curradi upon viewing the Planetary Rooms for
the first time (F. Baldinucci, *Notizie dei Professori del
Disegno* . . . , Florence, 1702, v, 410f.).

I. The Sala della Stufa

INTRODUCTION

In the spring of 1637 Pietro Berrettini da Cortona began to fresco the walls of a small room known as the Sala della Stufa in the Pitti Palace apartments of Grand Duke Ferdinand II de' Medici. It was the artist's first Medici commission, but his place in the triumvirate of artists—Bernini, Berrettini, and Borromini—which shaped the style of the Roman High Baroque was virtually assured. Although his emergence as a significant creative force had not been as precocious as that of Gian Lorenzo Bernini or Francesco Borromini, Cortona at forty-one years of age had made a series of major artistic statements in both painting and architecture.[1] His stature in Rome is reflected in his clientele, which consisted in the main of two of the most eminent and powerful families in the city—the Sacchetti and the Barberini, both of whom, like the artist, were Tuscan in origin.[2]

The early Cortona-Sacchetti-Barberini connection, which has bearing on the circumstances of the Pitti Palace commissions, can be briefly summarized. Pietro da Cortona's first important patron was the Marchese Marcello Sacchetti, whom his chief biographer, Passeri, has credited with having discovered him.[3] Thereafter he worked also for Marcello's brother Giulio, who became a cardinal in 1626. Of the two brothers, Marcello seems to have played the dominant role in supporting and promoting the young Tuscan artist. In all probability it was he who introduced Cortona into the court of Pope Urban VIII Barberini. Urban, with his characteristic perspicacity in matters of art patronage, commissioned the artist to fresco a wall of the nave in the church of S. Bibiana, which his earlier discovery, Gian Lorenzo Bernini, was in charge of renovating and enlarging. The S. Bibiana frescoes [Fig. 135], executed between 1624 and 1626, mark a pivotal point in Cortona's career, for they constitute his first truly public commission.[4]

[1] The career of Pietro da Cortona as an architect and painter has been admirably presented in R. Wittkower's *Art and Architecture in Italy: 1600-1750*, 2nd ed., Harmondsworth, 1965, 152ff. Also essential to the study of Cortona is the excellent monograph of G. Briganti, *Pietro da Cortona o della pittura barocca*, Florence, 1962. Among early biographies the most informative are G. B. Passeri's *Vite dei pittore, scultore, e architetti . . .*, Rome, 1772 (edited by J. Hess as *Die Kunstlerbiographien von Giovanni Battista Passeri*, Leipzig, 1934) and

a manuscript "Vita" by F. S. Baldinucci published by S. Samek Ludovici, "Le 'Vite' di Francesco Saverio Baldinucci . . . ," *Archivi*, XVII, 1950, 8; ff.

[2] For the Sacchetti and Barberini families, see G. Ceccarelli, *I Sacchetti*, Rome, 1946, and P. Pecchiai, *I Barberini*, Rome, 1959.

[3] Passeri, *Vite*, 374.

[4] After the Sta. Bibiana frescoes, Cortona received a series of altarpiece commissions, of which the most important were a *Madonna and Saints*, 1626-1628, for S. Agostino in Cortona; an *Adora-*

It is conceivable that Grand Duke Ferdinand II saw these frescoes less than two years after their completion. In 1628, while he was heir apparent to the Grand Duchy of Tuscany, Ferdinand visited Rome for fifteen days as part of a grand tour which included major cities in central and northern Italy and also Innsbruck, Munich, and Prague. An early connection between the Grand Duke and the young Tuscan painter in the service of the Barberini, is, however, pure speculation, for although the Grand Duke himself writes of having "tante e tali preoccupazioni . . . per vedere le anticaglie, e le cose moderne . . ." during his stay in Rome, the commemorative account of his trip written by the poet Margarita Costa does not mention churches and collections in which Cortona's work was prominently displayed.[5]

If Grand Duke Ferdinand had visited S. Bibiana, he would have seen a remarkable adumbration of the stylistic crisis that arose in his capital city when Cortona commenced the frescoes in the Sala della Stufa. At S. Bibiana, Cortona's frescoes in the as yet unnamed Baroque style face across the nave those by the Tuscan master Agostino Ciampelli, aged pupil of Matteo Rosselli, who practiced a pleasing but uninventive post-Mannerist style. The frescoes of Ciampelli epitomize the limited but competent painting then indigenous to Tuscany, a type of painting which would have been familiar to the Prince. Thus the confrontation parallels that which would occur when Cortona brought his style to Florence. The success of Cortona's style over that of Ciampelli in Barberini patronage signals the future defeat of the Tuscan style on home ground.[6]

The frescoes in the church of S. Bibiana are devoted to the life of the titular saint.[7] These frescoes, which occupy the windowless walls above the nave arcading, are divided into two groups. On the right wall, Agostino Ciampelli produced a series of vignettes illustrating events from the life of the martyred saint, but enacted in contemporary costume.[8] The scenes are curiously unemotional. There is no real brutality, no horror in the scene in which the body of the martyred saint is thrown to dogs in the Forum Boarium; the nocturnal interment of the corpse of the saint is without tragedy or mystery, and the building of a church in honor of St. Bibiana and her martyred sister [Fig. 136] is neither monumental nor memorable.[9]

Turning from Ciampelli's frescoes to those of the left wall, the spectator encounters a vastly different experience, for here the frescoed scenes [Fig. 135] are filled with

tion of the Shepherds, 1628-1630, for S. Salvatore in Lauro in Rome; and a monumental *Trinity*, 1628-1631, for the high altar of the Cappella del Sacramento in St. Peter's (secured with heavy Sacchetti-Barberini intervention), which introduced his art to a wider public. For these commissions see Briganti, *Pietro*, *passim*.

[5] M. Costa, *Istoria del viaggio d'Alemagna del serenissimo gran duca di Toscana Ferdinando Secondo*, Venice, n.d. For further mention of the trip see G. Gigli, *Diario Romano, 1608-1670*, ed. by G. Ricciotti, Rome, 1958, 101, and G. Pierac-

cini, *La Stirpe de' Medici di Cafaggiolo*, Florence, 1947, II, Pt. 2, who cites the grand-ducal letter here quoted (170).

[6] After the S. Bibiana decorations, Ciampelli received no major public commissions from the Barberini.

[7] D. Fedini, *La vita di Santa Bibiana vergine e martire*, Rome, 1627.

[8] Briganti, *Pietro*, 72ff.

[9] For illustrations of the latter two scenes, *ibid.*, Figs. 34, 35.

people of an ancient age and heroic order who portray earlier events in the life of the saint.[10] Dressed in antique Roman costume, monumental in scale, they possess the *gravitas* and grandeur that characterized the Roman style of the High Renaissance. Although both of Cortona's teachers, Baccio Ciarpi and Andrea Commodi, practiced a style not dissimilar from that of his competitor on the opposite wall in the nave of S. Bibiana, the three frescoes by Cortona have little relation to this Tuscan vernacular and draw inspiration from the stylistic idiom of the Bolognese artists affiliated with Annibale Carracci in Rome.

Pietro da Cortona's stylistic relation to the Bolognese School is complex, as is amply attested when one compares his *St. Bibiana Refuses to Worship an Idol* [Fig. 135] with a fresco by Domenichino, one of the most severely classicizing artists of the Bolognese group. *St. Cecilia before the Judge* [Fig. 137], dating between 1615 and 1617, was probably studied by Cortona when he worked on the S. Bibiana cycle; yet it is the differences between the two works of art rather than their more obvious similarities that are most striking.[11]

In Cortona's fresco, human relationships triumph over the purely formal aspects of the composition. Whereas the self-conscious, static pose of Domenichino's St. Cecilia was a learned—and accurate—quotation from the antique, that of St. Bibiana is a freer translation of the same classical source, the pose of the well-known Callipygian Venus. In Cortona's scene, the intellectualized order established by the relief-like composition of Domenichino's fresco is suppressed in favor of dramatic impact achieved by placing figures in deeper space, and by bringing them forward to the very edge of the picture space. St. Cecilia is isolated but within a frieze-like composition; St. Bibiana and her imploring companion, Rufina, are positioned so that together with the votive statue of Jupiter they form a strong diagonal recession. We read the composition along this critical diagonal—not from left to right in a single plane as in Domenichino's fresco—and thus encounter with immediacy the saint and Rufina, who tugs at her cloak and gestures toward the object of her antipathy, a statue of Jupiter. This diagonal is reinforced by the architectural setting. The other figures, the priestess and her acolytes, act as a foil to St. Bibiana's dramatic rejection of the pagan idol.

If Cortona's artistic development had been arrested at the point it had reached in

[10] For illustrations of the other frescoes, as well as details of the wall decorations, *ibid.*, Figs. 36, 39a and b, and 40.

[11] For confirmation of this relation see Wittkower, *Art and Architecture*, 163. For illustrations of the entire cycle see E. Borea, *Domenichino*, Milan, 1965, Pls. 28, 29, 31, and 36. The connection between the two frescoes is especially clear if the intermediary role of a preparatory drawing now at Rennes is considered (Briganti, *Pietro*, 170 and Pl. 37). In the drawing, the distribution of principal elements in the scene is the same as in

Domenichino's fresco; the saint occupies a central foreground position with her accuser to the right. Behind her, there is a flaming brazier, and behind the brazier appears a votive statue. Even the poses of the two saints are strikingly similar; Cortona has simply rotated the figure to a frontal position and slightly altered her gestures. For additional connections between Cortona and Domenichino see G. Panofsky-Soergel, "Zur Geschichte des Palazzo Mattei di Giove," *Römisches Jahrbuch für Kunstgeschichte*, XI, 1967/68, 142ff.

5

the S. Bibiana frescoes, and if the style thus obtained had been introduced into the decorations of the Pitti Palace, the contrast with local Florentine procedure would nonetheless have been as sharp as that between the two nave walls of S. Bibiana. What is extraordinary, however, is that his style underwent a profound metamorphosis in the decade separating the S. Bibiana frescoes and those of the Sala della Stufa, his first Florentine commission. The painting that most appropriately documents this development is the *Rape of the Sabine Women* [Fig. 138], probably painted shortly before 1630.

Commissioned by the Sacchetti as a pendant to Cortona's earlier (before 1624) *Sacrifice of Polyxena* [Fig. 139], the *Rape of the Sabine Women* also elucidates the theme of heroic womanhood.[12] Here the High Baroque style of Cortona is spelled out, and yet there are motifs that clearly reveal its creator to be one and the same with that of the richly chiaroscuro painting of the *Sacrifice of Polyxena*.[13] The stage-like space on which the participants move is now light-filled, and the landscape and architecture, incorporated to define space and to echo the movement of the figures, are more clearly visible. The architecture serves to define the positions and relations of these figures but does not restrain their interaction. Although the figures are actually held to a bas-relief composition, or more accurately two such compositions superimposed one upon the other, Cortona's figures do not seem "fitted" to the scene. Even more than in the S. Bibiana frescoes, the human figure in action—palpably alive and vividly reacting to its emotional circumstances—commands the attention of the spectator. Architectural elements define the scene and also accent its centerpoint, which is marked by an obelisk placed directly behind the central protagonists. These figures, like Polyxena and her immediate group in the earlier work, set the mood of the painting. At first inspection the figures in the *Rape of the Sabine Women* convey a sense of swirling motion and hectic confusion. The disorder is only apparent, however, and in fact the movement and gesture of every figure have been carefully studied.[14] The three principal sets of figures in the foreground produce a sequence of right to left movements that are so closely integrated that they could be a series of movie stills of the same couple crossing a stage in a choreographic maneuver in which the female principals register varying emotional reactions from violent protest from the woman in the right-hand group to fearful pleading in the center, and, on the far left, pained resignation. In each of these

[12] The scene is described by Livy I. 9 and Plutarch *Lives* (Life of Romulus, xiv). Cortona appears to have followed Plutarch, for it is he who mentions a detail, included in the painting, of Romulus rising and throwing his purple cloak about himself as a signal for his followers to seize the Sabine women. Consus, the god for whom the festival that brought the Sabines into Rome had ostensibly been prepared, appears behind Romulus. Cortona has taken liberties with this deity, for the text describes him as an equestrian Neptune.

[13] Admittedly, the association of the paintings as pendants accounts in part for their strong similarities. For the story of the sacrifice, see Ovid *Metamorphoses*, XIII, 446-481.

[14] This is especially true of the central group whose pose, still a stock ensemble on the operatic stage, would surely have been known to Cortona from theatrical productions. (See also Wittkower, *Art and Architecture*, 164.)

6

groups and in the background as well (where the right-to-left movement of figures in the foreground is reversed) Cortona is passionately concerned with recording the physical reaction of different ages and sexes to an emotion-charged event. It would seem, in fact, to have been his intention to prove that it was possible to combine a loosely handled brush with highly literate history painting in the Grand Manner—to fuse, more completely even than his older contemporaries such as Giovanni Lanfranco had succeeded in doing, Venetian color and illusionism with the *gravitas* and *disegno* of the Roman and Florentine traditions.[15]

The style enunciated in the *Rape of the Sabine Women* was to inform Cortona's commissions of the late 1620's and the 1630's with rich color and movement. This is true not only of the great oil paintings of this period—*The Trinity* in the Cappella del Sacramento in St. Peter's; *Allegiance of Jacob and Laban*, now in the Louvre; *Laban Searching for the Idols* in the Bristol Art Gallery; and the *Victory of Alexander over Darius* in the Capitoline Museum—but also of Cortona's tapestry cartoons commissioned by the Barberini to complete the Constantine tapestry series by Rubens that Louis XIII had given Cardinal Francesco Barberini in 1625.[16]

Even if the future Grand Duke of Tuscany did not view Cortona's work during his visit to Rome in 1628, he would certainly have heard that a native of his principality had emerged in Rome as an architect and painter of the highest promise before Cortona's visit to Florence in 1637. By that date Cortona had designed an exquisite casino called the Villa Pigneto for the Sacchetti, participated in the design of the Palazzo Barberini, executed the spectacular festival decorations for the 1633 Quarantore in the Roman church of S. Lorenzo in Damaso, and most important had been commissioned to transform the modest church of SS. Luca e Martina [Fig. 140] into one of the masterpieces of the Roman Baroque.[17]

As a painter and particularly as a decorative painter, Cortona had won a reputation which most certainly extended to the Florentine Court. For the Sacchetti family, Cortona had executed numerous easel paintings and had also frescoed or at least fully planned the decorations for the central gallery of the Villa del Pigneto, for which he had also served as architect. The gallery, together with the villa, are now destroyed, but from engravings [Fig. 141] we can document the design of the decorations, which closely resembles the gallery that Annibale Carracci had decorated in the Farnese Palace about two decades earlier.[18] Under the auspices of the Barberini, Cortona was given

[15] These observations closely parallel those made by Wittkower (*ibid.*), who points out that the group to the right derives from Bernini's *Rape of Proserpina*.

[16] See Briganti, *Pietro*, 185ff., and D. Dubon, *Tapestries from the Samuel H. Kress Collection at the Philadelphia Museum of Art. The History of Constantine the Great Designed by Peter Paul Rubens and Pietro da Cortona*, London, 1964.

[17] See the monographic study of K. Noehles, *La chiesa dei SS. Luca e Martina nell'opera di Pietro da Cortona*, Rome, 1969, *passim*.

[18] For illustrations of the Farnese Gallery see J. R. Martin, *Farnese Gallery*, Princeton, 1965, *passim*. The decorations of the Farnese Gallery were carried out between 1597 and 1609. The Villa del Pigneto has not been precisely dated. Its decorations are an outgrowth principally of the Farnese

the opportunity to paint on a truly monumental scale. It was the papal family who in 1632 invited him to fresco the vault of the immense Salone in their family palace, on which, it should be added, he worked earlier as an architect along with Bernini and Borromini under Carlo Maderno.[19] The ceiling frescoes [Figs. 142, 143] of the Salone will be discussed later, for although Cortona had the commission as early as 1632, it is very possible that the final version of the decorations was determined only after the artist's trip through central and northern Italy in 1637. A stopover in Florence during this trip was the occasion of the commission to fresco the walls of a relatively small room in the Palazzo Pitti known as the Sala della Stufa. We now turn our attention to the circumstances of this commission.

THE COMMISSION

The Sala della Stufa commission [Fig. 1] evolved from a constellation of events that has been described in some detail by Cortona's contemporary and near-contemporary biographers.[20] These accounts are in general accord. On a trip to the major cities of northern Italy, Cortona, in the company of Cardinal Giulio Sacchetti, who was on his way to assume the office of Papal Legate in Bologna, stopped at Florence.[21] While he was there, Grand Duke Ferdinand II persuaded him to undertake the frescoing of a room identified variously as the Gabinetto, Camera, or Sala della Stufa with the Four Ages of Man, a subject chosen, according to F. S. Baldinucci, Cortona's most accurate early biographer, by the poet Michelangelo Buonarroti the Younger.[22]

The chief negotiator of Cortona's commission has been identified through the discovery of an important document in the Buonarroti archive. In the draft of a letter

Gallery decorations but also profit from Cortona's experience as an assistant to Pietro Paolo Bonzi in the decorating of the Gallery of the Palazzo Mattei di Giove. The Gallery of the Palazzo Mattei was executed between 1621 and 1623 (cf. Panofsky-Soergel, "Palazzo Mattei," 142ff., Figs. 106, 110, 111).

[19] Most recently treated in H. Hibbard, *Carlo Maderno and Roman Architecture, 1580-1630*, London, 1971, 8off. and 222ff.

[20] These sources are a biography of Cortona contained in a letter that his nephew Luca Berrettini wrote to Ciro Ferri at the latter's request (published by G. Campori, *Lettere artistiche inedite*, Modena, 1866, 505ff.); an incomplete *vita* in Passeri, *Vite*, 373ff.; L. Pascoli, *Vite de' pittori, scultori, ed architetti . . .* , Rome, 1730, 1, 6ff.; and a manuscript *vita* written by F. S. Baldinucci (Samek Ludovici, "Vite," 82ff.).

[21] For Cortona's trip see Luca Berrettini (Campori, *Lettere*, 508); Pascoli (*Vite*, 1, 6); and Baldi-

nucci (Samek Ludovici, "Vite," 82), who claims, certainly inaccurately, that Cortona went to Lombardy first, then to Florence, where he was tendered the commission. The fact that he was traveling with Cardinal Sacchetti is noted in Luca Berrettini's letter.

[22] Passeri (*Vite*, 383) claims that Cortona was called to Florence by the Grand Duke, but all other sources agree that he was already in Florence when offered the commission. Passeri makes no mention of the northern Italy trip. The subject of the Stufa frescoes is given by Passeri (*Vite*, 383ff.) and F. S. Baldinucci (Ludovici, "Vite," 82ff.), who identifies Buonarroti as the author of the program. Buonarroti's authorship is also noted in the eighteenth-century compendium, *Serie degli uomini i più illustri nella pittura, scultura, e architettura con i loro elogi, e ritratti*, x, Florence, 1774, 54, but omitted by L. Rossi in *Dizionario Biografico degli italiani*, Rome, 1972, xv, 178ff.

dated August 24, 1641, and addressed to Luigi Arrigucci, *architetto camerale* to Urban VIII, Michelangelo the Younger describes the initiation of the commission: "Four years ago when Sig. Pietro [da Cortona] was passing by here with the Most Eminent Signor Cardinal Sacchetti it was proposed by me to these Highnesses, by way of an intermediary, that it would not be right to let him leave here without doing some work for them. My idea passed. I invited him to my house." The invitation, Buonarroti explains, was accepted despite the availability of rooms in the Pitti, the considerable distance between the palace and the Casa Buonarroti, and the summer heat because Cortona was "persuaded by the Cardinal" to accept Buonarroti's hospitality.[23] Thus Buonarroti emerges as the prime instigator and negotiator of the commission, a situation that lends further credibility to Baldinucci's assertion that he was the author of the program for these decorations.[24]

Michelangelo Buonarroti the Younger (1568-1647), grand nephew of his namesake, the immortal Michelangelo, though rather neglected in the history of Italian literature, is nevertheless of interest to us in the present context.[25] His career as a writer began early; at the age of sixteen he was already a member of the Accademia Fiorentina. Later he became a member of the Accademia della Crusca and played a major role in the first edition of their *Vocabolario* (1612) and was also involved in the second edition (1623). In 1612, one of the two comedies which established his literary fame was published. This play, entitled *La Tancia*, was followed by *La Fiera* in 1618. The latter play was presented during the carnival of 1618 in the Medici theatre located in the Uffizi. This connection with the Medici theatre is scarcely surprising for, during the reigns of Ferdinand II's father and grandfather, Buonarroti wrote official descriptions of court weddings and provided plays for such occasions.[26] After the death of Grand Duke

[23] Doc. Cat. No. 22. Luigi Arrigucci has been little studied. Florentine in origin, he was a minor architect whose chief employment was the renovation of churches. For biographical information see G. Baglione, *Le vite de' pittori, scultori, et architetti . . .*, Rome, 1642, 179f. and R. Battaglia, "Luigi Arrigucci architetto camerale d'Urbano VIII," *Palladio*, IV, 1942, 174ff.

[24] Although Buonarroti's description of his role may be a trifle exaggerated, it must substantially match the facts because we know that he and his correspondent Arrigucci were in communication about Cortona just prior to the departure of the artist for Florence in 1637, which suggests that Arrigucci would have had some knowledge of the circumstances in question. (See Doc. Cat. No. 1.) For a good summary of Buonarroti's career and additional bibliography see U. Limentani, *La satira nel seicento*, Milan and Naples, 1961, 66ff. Unfortunately, no copy of the *libretto* for the decorations has been located.

[25] Michelangelo the Younger was one of the six children of Leonardo Buonarroti and Cassandra Ridolfi. He is often referred to as a *nipote* of his namesake, rather than the more correct *nipote ex fratre*. For the Buonarroti genealogy see P. Litta, *Famiglie celebri italiane*, Milan, n.d., I, under "Buonarroti da Firenze." At the time of this writing, the volume containing his *vita* in the excellent *Dizionario biografico degli Italiani* (Istituto della Enciclopedia Italiana) has not appeared. Buonarroti is treated by G. M. Mazzuchelli, *Gli scrittori d'Italia*, Brescia, 1753, IV, Pt. 2, 2352, and by A. Belloni in the *Enciclopedia italiana di scienze, lettere ed arti*, VIII, 1930, 116.

[26] The following examples may be cited: *Discrizione delle nozze della crist. maestà di Mad. Maria Medici, Regina di Francia e di Navarra*, Florence, 1600; *Il natale d'Ercole. Favola rappresentata al Ser. D. Alfonso d'Este . . . e all'ecc. sig. d. Luigi suo fratello, nella venuta loro a Firenze, da madama sereniss. di Toscana nel palazzo dell'Eccellentiss. d. Antonio Medici*, Florence, 1605; *Il giudizio di Paride. Favola rappresentata nelle nozze*

Cosimo II, however, Buonarroti's star seems to have faded at the Medici court; with a panegyric recitation for the funeral of that grand duke, his productive career virtually closed.[27] Advanced in years when Cortona arrived in the city, he was completing a gallery of decorated rooms in the Casa Buonarroti that was to glorify the Buonarroti family in general and his namesake in particular.[28] In all probability it was this project that first awakened Buonarroti's interest in Cortona.[29]

Letters written by Arrigucci to Buonarroti attest that the Florentine playwright had actively sought an example of Cortona's work just prior to his arrival in Florence and also that the two had not as yet met. The first letter, dated May 16, 1637, explains that although Cortona was very busy he had promised to complete, albeit in haste, a drawing requested by Buonarroti.[30] It would be interesting to know the subject of this drawing. The second letter, dated June 20, 1637, states that the artist's given name was Pietro Berrettini, a point of information which makes it unlikely that the two had ever been introduced.[31]

Luigi Arrigucci was, as we have noted, a confidant of the Barberini and house architect for Urban VIII. Buonarroti, too, was on cordial terms with the Barberini, especially his coeval Urban VIII, for whom he performed services and from whom he received gifts.[32] When the Barberini placed a memorial and coat of arms [Fig. 144] in

del ser. Cosimo Medici principe di Toscana, e della ser. principessa Maria Maddalena archiduchessa d'Austria, Florence, 1607 and 1608; Rome, 1609; and *La Fiera. Commedia recitata in Firenze nel Carnevale del 1618 nel teatro della gran sala degli Uffizi e la Tancia. Commedia con le annotazioni di Antonio M. Salvini*, Florence, 1726. In addition Buonarroti produced numerous manuscript works for the Medici (see D. Moreni, *Bibliografia storico-ragionata della Toscana . . .*, Florence, 1805, 187f.).

[27] M. Buonarroti, *Delle lodi del g. duca di Toscana Cosimo II. Orazione recitata nell'accademia fiorentina il dì 21 di dicembre 1621*, Florence, 1622. For concurrence in this evaluation of Buonarroti's career see Limentani, *Satira*, 79, n. 14, who cites sources in which Buonarroti alludes to his lack of adaptability to court life and further indicates that the poet was caught in the middle of the gathering Medici-Barberini feud.

[28] For full discussion see the appropriate sections of U. Procacci's *La casa Buonarroti a Firenze*, Milan, 1965.

[29] It has even been suggested that Cortona designed the gallery, which, as discussed by Procacci (*Casa Buonarroti, passim*), is entirely unlikely.

[30] Doc. Cat. No. 1.

[31] Florence, Biblioteca Medicea Laurenziana, Archivio Buonarroti, 41, c. 159: ". . . io serrai, o per meglio dire feci fare la soprascritta alla lettera che ella mi aveva inviata per il Sig.r Pietro Berret-

tini, che tale è il cognome del Sig.r Pietro da Cortona, e gl[i]e ne feci pervenire; e pochi giorni dopo egli venne da me e mi disse che avrebbe risposto a V.S." The letter, written in Rome by Luigi Arrigucci, was sent to Buonarroti on June 20, 1637. This letter was found and transcribed by Gino Corti.

[32] Letters in his archive show that Buonarroti maintained a lively correspondence, especially with friends in Rome, many of whom were in the Barberini entourage. Buonarroti's friendship with Urban VIII was close and of long standing. While the Pope was still Cardinal Maffeo, Buonarroti published the sonnets of his namesake and dedicated the work to the future Pope (*Rime di Michelagnolo Buonarroti, raccolte da Michelagnolo suo nipote*, Florence, 1623). Significantly, Buonarroti prepared an epistolary eulogy of eighty-two stanzas entitled *Nella creazione di Papa Urbano Ottavo* for the election of Urban VIII (Florence, Biblioteca Marucelliana, A, XXXVII, 11, cc. 278ff.). The title appears among the *bozze* at c. 305. For further comment concerning his relation to Urban VIII see C. Guasti, *Le carte strozziane del r. archivio di stato in Firenze*, Florence, 1884, I, 61. It should also be remembered that a critique of Roman palaces that may have had a formative influence on the conception of the Barberini Palace has been attributed to Michelangelo the Younger. See O. Pollak ("Italienische Künst-

the wall of the Convent of Sta. Maddalena dei Pazzi at the corner of the Borgo Pinti and the via Colonna, they asked Buonarroti to prepare an inscription and, in consultation with Cortona, add finishing touches to the design prepared by Arrigucci.[33] In fact, it was probably Buonarroti's closeness to the Barberini and their circle that emboldened him to encourage the Grand Duke to offer Cortona a commission, since he could count on cordial personal relations with the Barberini to facilitate negotiations, a matter of no small consequence inasmuch as the Barberini were not liberal lenders of their principal artists.[34]

Buonarroti's close connections with the Barberini circle may also have given him access to the knowledge that, notwithstanding the work in progress on the ceiling of the Salone Barberini, Cortona's relations with his chief Roman patrons were rather strained. The source of strain does not seem to have been due, strictly speaking, to aesthetic considerations but rather to the fact that the Barberini were inclined to favor Bernini, not only as an executant of commissions but also as a source of advice. Bernini's relations with Cortona had been poor since the young Tuscan had worked under him in the S. Bibiana renovations of 1624-1626, and thereafter Bernini did not hesitate to promote other artists in painting commissions. According to Narciso Fabbrini, in 1637 Cortona attempted to secure several commissions in St. Peter's and the Vatican Palace, owing in large part to the intervention of Bernini, he was passed over by the Barberini, who selected Cortona's former pupil and assistant, Giovanni Francesco Romanelli (1610-1662) instead, a choice which must have been especially galling to Cortona. Fabbrini and other scholars who subsequently depended on him for this information failed to identify the "lost" commission, which can only have been the extensive Vatican Palace fresco cycle in the Sala della Contessa Matilde, which was tendered the younger painter in 1637 and on which he worked until 1642.[35]

lerbriefe aus der Barockzeit," *Jahrbuch der Königlich Preussischen Kunstsammlungen*, XXXIV, 1913, 63ff.), who provides considerable material concerning the relations between the Barberini and Buonarroti. A. Blunt ("The Palazzo Barberini: the Contributions of Maderno, Bernini and Pietro da Cortona," *Journal of the Warburg and Courtauld Institutes*, XXI, 1958, 261) accepts the importance of the critique but doubts Buonarroti's connection with it. Buonarroti's Barberini connections extended to Florence, where he was a close friend of the two sisters of Cardinal Francesco Barberini who were Carmelite nuns in the Convent of Sta. Maria degli Angeli, which had moved into the conventual quarters of Sta. Maddalena dei Pazzi. That he enjoyed the confidence of one of the Barberini sisters, Innocenzia, is attested by a letter she wrote to him in July 1637 (Florence, Biblioteca Medicea Laurenziana, Archivio Buonarroti, 42, No. 251), and from inventories of his house it is evident that he was favored with gifts from the other, Sister Costanza (Procacci, *Casa Buonarroti*, 228).

[33] Florence, Biblioteca Medicea Laurenziana, Archivio Buonarroti, 40, c. 111 *recto*. For the design, which had been prepared by Luigi Arrigucci, see Battaglia, "Arrigucci," 175.

[34] See F. Haskell, *Patrons and Painters*, London, 1963, especially 24ff., for a discussion of the degree of control exercised by the Barberini over their stable of artists.

[35] N. Fabbrini, *Vita del Cav. Pietro Berrettini da Cortona pittore ed architetto*, Cortona, 1896, 66; F. Noak, U. Thieme and F. Becker, *Allgemeines Lexikon der Bildenden Künstler*, Leipzig, 1934, XXVIII, 545. For discussion and illustrations of Romanelli's frescoes see J. Hess, "Die Fresken der sala della contessa Matilde im Vatikan," *Kunstgeschichtliche Studien zu Renaissance und Barock*, Rome, 1967, I, 105ff.; II, Pls. 43-47 (Figs. 1-8).

Buonarroti could have had several motives for promoting Cortona at the grand-ducal court. First, he was anxious that the artist remain in Florence long enough to contribute to his own gallery. Second, he must have been aware that the Grand Duke was searching for an artist whose talents were commensurate with the enormous decorative program already commenced in the Pitti Palace. For him, this situation, if Cortona were accepted, offered the opportunity of ingratiating himself with the Grand Duke and, more specifically, the possibility of entry into the preparation of the iconography of the fresco program not only in the Sala della Stufa but in other palace rooms as well. In any event his presentation of Cortona was successful, and, if F. S. Baldinucci is correct, he did succeed in proposing the *concetto* for the Sala della Stufa.[36]

One other personality is linked in early accounts with Cortona's commission, Cardinal Giulio Sacchetti. As proved by the researches of Hans Geisenheimer, Cardinal Sacchetti arrived in Florence on June 28, 1637.[37] Although Sacchetti was ostensibly in transit, his arrival in Florence just a few days before the public festivities scheduled to accompany the consummation of the marriage of Grand Duke Ferdinand II and Princess Vittoria della Rovere was surely prompted by political considerations, for this marriage was of the greatest concern to the Papacy.[38] Vittoria della Rovere was the only surviving direct heir of Duke Francesco II della Rovere, and through her union with Grand Duke Ferdinand the Medici hoped to acquire the Duchy of Urbino.[39] On the other hand, the Rovere held the duchy in fealty to the papacy, a situation which provided Urban VIII with an excuse to intervene in the succession. Urban's concern about the succession of the duchy was twofold; first, he wanted it for his own land- and title-hungry family, and second he emphatically did not want it acquired by the Medici. In their control, it would constitute a geographical wedge under foreign domination, which would split apart the papal states of Umbria and the Romagna. So possessive was Urban about the dukedom that even before the death of Vittoria's father in 1631 papal soldiers had illegally occupied Urbino. Although the dowry of Vittoria included much movable property of the Duke of Urbino, thus adding works of art of extraordinary quality and immense value to the already rich Medici holdings, the loss of the

[36] For the attribution of the program to Buonarroti, see footnote 22 above. If Buonarroti had aspirations to receive commissions for future programs, they were not realized, and his personal involvement was limited to the Sala della Stufa. In the later rooms by Cortona, and by others as well, the themes of the decorations were placed in the trust of the writer with whom Ferdinand had commenced his decorative program, Francesco Rondinelli, one of a younger generation of *letterati* who had superseded Buonarroti at the Medici court in the early 1630's.

[37] H. Geisenheimer, *Pietro da Cortona e gli affreschi nel Palazzo Pitti*, Florence, 1909, 30, No. 9.

[38] For a review of the rather complicated history of this marriage see Pieraccini, *Stirpe*, II, Pt. 2, *passim*, and also R. Galluzzi, *Istoria del granducato di Toscana*, new ed., Florence, 1823, 47ff.

[39] Vittoria was the daughter of the deceased Federigo Ubaldo della Rovere and Claudia de' Medici. Through the latter, the Medici House acquired a peripheral claim to the dukedom. Actually Ferdinand had a prior claim to the dukedom. His grandmother, Cristina of Lorrain, had received the rights of Catherine de' Medici to the duchy as part of her dowry. This claim, which predated the reinstatement of the Rovere by Pope Adrian VI, had never been annulled.

duchy was naturally a bitter disappointment to the territorial aspirations of the Medici.[40] In view of this volatile situation the Barberini had good reason to wish an emissary present at the Rovere-Medici wedding both as a minimal gesture of diplomatic courtesy and as an observer.[41]

The political aspects of Sacchetti's appearance in Florence are clear, but why Cortona was with him needs explanation. There is little reason to believe that the Barberini sent the artist for the express purpose of having him enter the service of the Medici.[42] On the contrary, the idea of a north Italian trip was the artist's. He had wanted to see the work of north Italian painters at first hand and for this purpose had solicited Marchese Marcello Sacchetti for the requisite funds for the journey.[43] It is therefore more likely that the Barberini permitted him to make the trip because it was under Sacchetti auspices, and thus the artist would be within, as it were, the Barberini orbit while he was in Florence. Undoubtedly, the Barberini were sufficiently perspicacious to foresee the possibility of Cortona's being requested to perform while in Florence and diplomatic enough to realize that a flat refusal to a grand-ducal request would be untimely.[44] With Sacchetti on hand they knew that their interests would be strongly represented at the attendant negotiations.[45] They would have had good cause to take such precautions in view of Cortona's involvement in major Barberini projects in Rome, including, as we

[40] For an impassioned discussion of the papal seizure of Urbino from the Medici point of view see R. Galluzzi, *Istoria del gran ducato di Toscana . . .* , Florence, 1781, II, 455ff.

[41] Cardinal Sacchetti was sufficiently in evidence at the celebration to be noted by Ferdinando Bardi, an official chronicler of the event, who, in his description of the parade that accompanied the festivities, states: "Il sereniss. di Parma passegiando in carrozza e gl'eminentiss. Capponi, e Sacchetti stando a una finestra del palazzetto de Giacomini sulla piaza degl' Antinori goderono di veder passare la celebrità della po[m]pa." (F. Bardi, *Descrizione delle feste fatte in Firenze per le reali nozze de Serenissimi Sposi Ferdinando II gran duca di Toscana e Vittoria della Rovere Principessa d'Urbino*, Florence, 1637, 14. See also p. 11.)

[42] Such an interpretation is discounted by the manner in which Cortona breaks the news of the Sala della Stufa frescoes to Cardinal Francesco Barberini (see Doc. Cat. No. 2).

[43] Samek Ludovici, "Vite," 82. It is probable in fact that Marcello Sacchetti was in the entourage of Cardinal Sacchetti. Although he is not identified as involved in the negotiations attendant to the Sala della Stufa commission, Pietro does state in his letter of September 13, 1637, to Cardinal Francesco Barberini that ". . . il Sig. Cardinal Sacchetti

quale me disse che se non mi fussi piaciuto che fussi andato dai Sig. Sacchetti . . ." (Doc. Cat. No. 3). The phrase "dai Sig. Sacchetti" should mean that both Sacchettis were in Florence.

[44] The Barberini, and especially Cardinal Francesco, knew well what a solace a gift of art provided in the face of a galling political defeat. It had been Francesco who in 1625 received the magnificent set of Rubens tapestries illustrating the Life of Constantine from Louis XIII at the termination of political negotiations that had ended ignominiously for papal interests (see Dubon, *Tapestries*, 11ff.). By the same token, presenting Ferdinand with the best Tuscan painter in the Barberini entourage, albeit only briefly, made good political sense, especially on the eve of the marriage that the Medici had hoped would include the Duchy of Urbino in its dowry.

[45] From a letter to Cardinal Francesco Barberini, written on the eve of his north Italian trip, we know that Cortona intended to return to Rome from Venice via the "Loreto road," thus circumventing Tuscan territory (Doc. Cat. No. 3). This itinerary, which seems to have been prearranged in consultation with the Barberini, tends to support the thesis that Cortona was under Barberini protection while in Tuscany.

13

have already noted, the decorations for the Salone of their new palace (c. 1632-1639) and the construction of the church of SS. Martina e Luca (1635-1650).

Evidence of Barberini control over the artist in the Sala della Stufa commission is the fact that when Cardinal Mazarin wanted to arrange for Cortona to come to France in 1641, he wrote to Cardinal Sacchetti for information about the arrangements that had been made for the commission, as well as to the Grand Duke and to Gondi, the Tuscan ambassador in Rome, even though the artist was working in Florence, not Rome, when the letter was posted. Sacchetti turned the letter over to Cardinal Antonio Barberini, in whose archive the letter is preserved.[46] Furthermore, the correspondence of Cortona with Cardinal Francesco Barberini abounds with indications of the strictness of their control. In his progress report on the first two frescoes in the Sala della Stufa, he describes himself as "under the protection" of Cardinal Barberini and begs permission to continue his trip to Venice. He adds that the Grand Duke wants him to return to Florence and complete the two remaining frescoes; ". . . His Highness is well informed of the obligations that I have to Your Eminence . . . and he indicates that it is his opinion that Your Eminence would have me under his protection. Nevertheless, I have not pledged to anything. . . . I will not do anything unless Your Eminence orders me to do it."[47] These phrases reflect a continuing *servitù particolare* rather than mere flattery.

Cortona's description of the conditions under which he remained in Florence and his living arrangements there, recorded in a letter to Cardinal Francesco, are interesting in this connection. Cardinal Sacchetti, he states, told him that if he was not pleased with his circumstances in Florence he could rejoin the Bologna-bound Sacchetti entourage. He adds that, with the approval of Sacchetti, he has taken up residence at the home of Michelangelo Buonarroti the Younger. He underscores carefully that not only is he living with Buonarroti but he is at the grand-ducal palace only during the day and returns to the Casa Buonarroti every evening.[48] Cortona, it would seem, was at pains not to give the public appearance of having been absorbed into the grand-ducal household while he walked a delicate tightrope between Barberini will and Medici wishes.

The control exercised by the Barberini is further emphasized by the contrasting lack of control of the Medici revealed in a letter sent to Michelangelo the Younger on behalf of the Grand Duke on the eve of Cortona's departure. "His Highness is in doubt," wrote Jacopo Soldani, "as to whether Pietro da Cortona will come to a stop Saturday evening on the work in his cabinet, or if he will continue with the remaining compartments, and the decision depends on the painter, because His Highness intends not only not to force him to stay, but not even to beg him [to do so]. If he stops work but does not leave immediately and remains here for three or four days, he will not be

[46] Doc. Cat. No. 27. [47] Doc. Cat. No. 3.
[48] This arrangement is confirmed by a letter of Buonarroti's (Doc. Cat. No. 22) from which it is apparent that when Cortona worked at the Pitti Palace in the morning his lunch was brought to him from the Casa Buonarroti!

14

expected to render service for us before he leaves your hospitality."[49] Hints of grand-ducal exasperation gleam forth from the last phrase, which covertly threatens Buonar-roti's guest with more work if he lingers in Florence for more than three or four days.

The aspects of the Sala della Stufa commission thus far considered pertain to politics and patronage. The artistic situation in Florence was another facet of the commission. The frescoes of Pietro da Cortona are related in both time and function to a general renovation of the Florentine capital. This program of embellishment had as its focal point the Pitti Palace and the Boboli Gardens. It encompassed all the major arts and was intended, not surprisingly, to glorify the Medici dynasty. Many aspects of this renovation had been initiated by Grand Duke Cosimo II and were continued during the joint regency (1621-1628) of his mother, Cristina of Lorrain, and his widow, Maria Maddalena of Austria.[50] Then in the mid-1630's two events sparked new activity. The first was the official ratification of the marriage of Grand Duke Ferdinand to Vittoria della Rovere on August 2, 1634, and the second was the death of Cristina in December 1636, which gave Ferdinand and his brothers full control over Medici patronage. The marriage in 1634 was not consummated—Vittoria was then twelve years of age—and was in fact enacted as a private celebration at the request of the Dowager Grand Duchess, who feared she would not live to witness the actual marriage scheduled for consummation and public celebration on April 6, 1637.[51] The new projects of Ferdinand were initiated after the 1634 private marriage, and their projected completion date, not always realized, appears to have been the public marriage in 1637.

In comparison with the work undertaken by the Barberini in Rome during the late 1620's and 1630's, one can scarcely call the Medici activities a program; yet something of the sort was clearly their intention. The unity of Ferdinand's projects suffered from two serious defects. First, he was attempting to complete work whose character had already been determined. Second, he was committed to local artists and could not arbitrarily remove them from projects that had been given to them before he came into power. A prime example of this situation was the enlargement of the facade of the Pitti Palace [Fig. 145]. This vast undertaking was actually the creation of Ferdinand's father, Cosimo II, who in 1618 had ordered the Florentine architect Giulio Parigi (1571-1635) to start construction of two new wings.[52] Parigi's scheme, which called for simple repetition of the original seven-bay structure to create one of twenty-seven bays, was largely

[49] Doc. Cat. No. 4.

[50] See Pieraccini, *Stirpe*, II, 383f.

[51] *Ibid.*, 490 and 507. The marriage was consummated on the scheduled date; the couple honeymooned at Poggio a Caiano, but because the court was in mourning for the German Emperor Ferdinand II, the public festivities were delayed until July of that year.

[52] For the most detailed account of these enlargements see R. Linnenkamp, "Giulio Parigi archi-

tetto," *Rivista d'Arte*, XXXIII, 1958, 51ff. Linnenkamp bases his observations on documentary sources. Cf. F. Morandini, *Mostra documentaria e iconografica di Palazzo Pitti e Giardino di Boboli*, Cataloghi di Mostra Documentarie No. 4, Archivio di Stato di Firenze, Florence, 1960, and F. Morandini, "Palazzo Pitti, la sua costruzione e i successivi ingrandimenti," *Commentari*, XVI, Jan.-June 1965, 35ff., who was apparently unaware of Linnenkamp's article.

completed by the time he died in 1635.[53] Most of the remaining work involved completion of the interior of the palace. The only later, important, exterior change was the demolition of the habitations that crowded in on the edges of the main facade.[54] Their removal provided the palace with a generous piazza flanked to the left by the long outer wall of a large warehouse called the Stanzone di Legno and to the right by a series of stalls or sheds set against a wall, thus creating a primitive *cour d'honneur*, even before the addition of side pavilions (often referred to as the *rondos*) in the eighteenth century.[55] Even this piazza, however, has its origins in the scheme submitted to Cosimo II in 1618.

The same situation beset Ferdinand's activity in the Boboli Gardens behind the palace. In 1637, he set up the *Oceanus* fountain of Giovanni Bologna at the center of the Isolotto at the westerly end of the garden. But it was his father who had removed it from the Prato Grande, as the grassy lawn immediately behind the main courtyard of the palace was called, and who had intended, before his death, to place it in the Isolotto.[56]

Even in the sculpture projects not directly connected with his father's intentions, Ferdinand was often reduced to simply relocating a monument or converting it to suit his needs. One of the Boboli sculptures falls into this category, the reconstitution of a colossal statue by Giovanni Bologna which initially had been planned as a portrait of Grand Duke Francesco I's first wife, Giovanna d'Austria, as a figure of *Dovizia* [Fig. 147]. The statue was completed by Bartolomeo Salvini, an assistant of Pietro Tacca, and set up in the garden at a point where it forms a terminus to the main garden axis running from the Prato Grande toward the Fortezza Belvedere. The *Dovizia*, as its

[53] When Giulio Parigi died, his son Alfonso Parigi, 1606-1656, continued the work on the palace. I follow Linnenkamp's ("Parigi," 51ff.) chronology of the Pitti enlargement and therefore do not give any major portion of it to Alfonso as has been argued (see Morandini, *Mostra, passim*; "Palazzo Pitti," *passim*; and U. Procacci, *La reggia di palazzo Pitti*, Florence, 1966, *passim*). Alfonso, as described by Baldinucci, was primarily a contractor and a skillful engineer rather than a real architect (F. Baldinucci, *Notizie de' professori del disegno da Cimabue in qua . . .* , Florence, 1728, VI, 333f.).

[54] Payments for work at the palace continue into the 1640's and are recorded in the account books of the Fabbriche Medicee in the State Archives, Florence, but these pertain to interior work and to the demolition of houses in front of the palace facade in order to create the piazza di Pitti.

[55] See Linnenkamp, "Parigi," Fig. 5; Morandini, *Mostra*, 29, Cat. No. 113, and Morandini, "Palazzo Pitti," Fig. 6.

[56] The fountain was removed from the Prato Grande in 1618. The date appears on an inscription on its base, which has misled scholars into dating the arrival of the fountain at the Isolotto on that date. (Cf. B. Wiles, *The Fountains of Florentine Sculptors and Their Followers From Donatello to Bernini*, Cambridge, Mass., 1933, 61, and J. Pope-Hennessy, *Italian High Renaissance and Baroque Sculpture*, London, 1963, Catalogue Volume, 82.) The fountain can be seen in its dismembered state in a drawing dated September 1632 [Fig. 156]. Payments for the translocation of the fountain indicate that it was moved to its present location between December 1636 and December 1637. During the same period, the huge granite basin at the foot of the fountain was shipped from Elba and installed on the Isolotto. These activities are recorded in the grand-ducal accounts. Florence, A.S.F., Fabbriche Medicee, F. 75 bis, cc. 17, 19-22, 51, 54, 55, 57-62, 65-69. An accounting dated 20 July 1637 is provided by A.S.F., Fabbriche Medicee, F. 140, c. 40, which has been cited by Morandini, *Mostra*, 22, Cat. No. 66.

inscription dated 1636 makes clear, celebrates the plenitude and abundance of Ferdinand's reign.[57] Unfortunately, the *Dovizia*, in spite of her monumental proportions, is impossible to distinguish clearly from the palace [Fig. 146]. To make the figure more visible, the wall behind the statue was originally painted green.[58]

At the opposite end of the axis on which the *Dovizia* was placed, a substitution of fountains occurred in which a fountain by Bartolommeo Ammannati on the terrace overlooking the courtyard of the Pitti Palace was removed in 1635 and replaced with a candelabrum-type fountain [Figs. 146 and 148] executed by Francesco Susini (1639-1641) and known as the Fountain of the Artichoke (Fontana del Carciofo).[59] Although this fountain bears a dedicatory inscription to Ferdinand II, the visual elements make no clear allusion to him. For a more direct association of commissioner and monument we must turn to the decorations and sculpture ensemble that Ferdinand installed in the grotto [Figs. 146 and 149] of the courtyard beneath the terrace on which the Fountain of the Artichoke stood. This grotto, designed by Ammannati (1511-1592), was structurally complete and already contained some of its decorations when Ferdinand decided to add elements that would allude specifically to his reign.[60]

The renovation of the grotto was initiated by Ferdinand in 1635 and dragged on until the early 1640's.[61] When completed, it included a vault decorated with the figure of Fame executed in mosaic and two bizarre wall fountains, one of which is topped by an oak tree, symbol of the Rovere [Fig. 150], and the other by a laurel tree that bears the six *pomi d'oro* of the Medici coat of arms. The most important additions to the grotto were the five large statues representing *Legislation* by Antonio Novelli, *Zeal* by Giovanni Battista Pieratti, *Clemency* and *Authority*, both by Domenico Pieratti, and, as a centerpiece of this sculpture ensemble, a large porphyry statue of *Moses* constructed from an antique torso with additions by Raffaello Curradi and Cosimo

[57] See Baldinucci, *Notizie*, 1846, IV, 83f. For the completion date and attribution see also Florence, A.S.F., Fabbriche Medicee, F. 35, c. 34f. Payments for work on the base for the statue were made to Bastiano Pettirossi, identified as a sculptor, and Lorenzo Fantini (Florence, Fabbriche Medicee, F. 75 bis, cc. 1 and 2 [28 June and 5 July 1636]).

[58] For a full discussion of this figure the dissertation of Katherine Watson ("Pietro Tacca, Successor to Giovanni Bologna. The First Twenty-five Years in the Borgo Pinti Studio, 1592-1617," University of Pennsylvania, 1973) must be consulted. I am indebted to Dr. Watson for the information that the wall behind the *Dovizia* was once painted.

[59] For the history of the first fountain see F. Kriegbaum, "Ein verschollenes Brunnenwerk des Bartolomeo Ammanati," *Mitteilungen des Kunsthistorischen Institutes in Florenz*, III, 1919-1932, 71ff., and Wiles, *Fountains*, 42f. Wiles, presumably following F. M. Soldani (*Il reale Giardino di Boboli*, Florence, 1789, 14f.) dates the Fontana del Carciofo as 1639-1641, p. 31. Plans for it were under way in 1635 (see Morandini, *Mostra*, 22, Cat. No. 69).

[60] For the early history of the grotto see S. Lo Vullo-Bianchi, "Note e documenti su Pietro e Ferdinando Tacca," *Rivista d'arte*, XIII, 1931, *passim*, and Wiles, *Fountains*, *passim*. Payments for work on the grotto are published by Morandini, *Mostra*, 20, Cat. Nos. 56 and 58. Work is recorded on the mosaic decorations and small *puttini* swimming in the basin inside the grotto. For a reference to the work initiated by Ferdinand, see *ibid.*, 22, Cat. No. 67. The commencement date for the work in the grotto initiated by Ferdinand is given in Florence, A.S.F., Fabbriche Medicee, F. 140 (ordini e rescritti), fol. 31. Dated 31 August 1635, this document signals the release of funds from the Fabbriche de' Pitti.

[61] See for example Morandini, *Mostra*, 22, Cat. No. 67.

Salvestrini.[62] Thus, Moses is presented as the ideal ruler of his people, and the other statues reflect aspects of his rulership. When one reads the inscription on the pedestal, the significance of Ferdinand's additions to the grotto become clear: the water brought forth here from the rock is that of the Acqua Ferdinanda, and furthermore we are informed that, just as Moses brought forth water from the rock by divine intervention, so too the attributes of rulership, represented in the surrounding figures, are bestowed upon the ruler, and by inference upon Ferdinand, Grand Duke of Tuscany.[63]

As was the case with so many of Ferdinand's projects, the aqueduct that fed the grotto fountain was an inheritance. Belatedly christened the "Acqua Ferdinanda," this aqueduct had been started by Cosimo I and markedly developed under succeeding grand dukes. To Ferdinand II had fallen the task of completion, which involved bringing the aqueduct to the upper reaches of the Boboli Gardens, from whence it activated garden fountains, emerging at last at the feet of *Moses*.[64] From the grotto the water passed into the city, where it provided water to the populace by means of fountains that the Grand Duke had put up at key points: the piazza Sta. Croce, the Mercato Nuovo, and the piazza SS. Annunziata.[65] The fountain in the piazza Sta. Croce is a simple candelabrum in form, of unattributed design. The Mercato Nuovo fountain is of course the well-known *Bronze Boar* cast by Pietro Tacca from an antique marble now in the Uffizi Gallery. The piazza SS. Annunziata received the two fancifully grotesque fountains that Pietro Tacca had made in 1627 for what is now the piazza Micheli in Leghorn.[66] Thus a hydraulic system embellished by fountains took form in which water passed through the grand-ducal gardens, was collected physically and symbolically at the Moses Fountain in the grotto of the courtyard, and then was dispensed to major watering places in the city. It is significant, however, that the fountains which celebrate Ferdinand's accomplishments are linked together neither by theme nor by style.

In sculpture and architecture, Ferdinand continued what had been started or reused what had already been executed. Only rarely did he initiate work, and when he

[62] For the distribution of these contracts see Florence, A.S.F., Fabbriche Medicee, F. 140 (ordini e rescritti), fol. 32 (October 11, 1635). See also Morandini, *Mostra*, 22, Cat. No. 67.

[63] EN ISRAELIS DVX E CAVTE / FERDINANDAM AQVAM EDVCENS. / INTVERE HOSPES. / HINC LEGES CAELESTIA DONA / ET VINDEX IVSTITIAE STVDIVM / HINC PRINCIPATVS / OCVLATO SCEPTRO INSIGNIS / ET CHARITATE MATERNA / SVBIECTORVM IMBECILLITATI / PARCENS TOLERANTIA / HEROEM COMITANTVR / VNDE DISCAS, VT AVRIBVS / QVI PARET, OCVLIS VTI / DEBERE QVI IMPERAT / ET REGNAM SINE LEGIBVS / LEGES SINE VLTIONE / AC SAEPIVS CLEMENTIA / NON CONSISTERE.

[64] Work on the aqueduct is recorded in Florence, A.S.F., Fabbriche Medicee, F. 151 (debitori e creditori del condotto di Monte Reggi, 1636-

1639). A final, itemized reckoning of these considerable expenses is found in Florence, A.S.F., Fabbriche Medicee, F. 140 (ordini e rescritti), fol. 106 (July 20, 1640). For a general history of this enterprise see Soldani, *Giardino*, 15.

[65] First mention of the Sta. Croce fountain in the Fabbriche Medicee *registri* is dated July 1, 1639 (Florence, A.S.F., Fabbriche Medicee, F. 75 bis, c. 151). For the first mention of the work on the installation of the Mercato Nuovo Fountain, see *ibid.* The Annunciata fountains are recorded in the Fabbriche *registri* on December 17, 1639 (Florence, A.S.F., Fabbriche Medicee, F. 75 bis, c. 175).

[66] Ferdinand also added a dedicatory plaque to the equestrian statue of his uncle Ferdinand I in the piazza. The plaque, dated 1640, alludes to both grand dukes. The twin fountains were unveiled on June 14, 1641 (see Guasti, *Carte strozziane*, 60).

did so he turned to local artists who perpetuated established conventions so totally that their work was indistinguishable in style from that of the preceding generation. In contrast, new ground was broken in the decorations of the Pitti Palace and at some cost, as we shall see, to local artists and the indigenous Tuscan style they practiced.

During the 1630's, practically every major and minor Florentine painter was employed on the interior of the Pitti Palace.[67] By far the most extensive and lucrative fresco commission went to Giovanni Mannozzi (1592-1636), better known as Giovanni da San Giovanni. It is indicative of his position among the local Tuscan painters that he was selected to decorate the four ground floor rooms that served as the grand-ducal reception rooms during the summer.[68] These decorations were initiated in May 1635, shortly after the private Medici-Rovere wedding. The artist started work in the largest room in the series, the Salone Terreno, now generally known as the Sala degli Argenti [Fig. 151], and there is little reason to doubt that at least the Salone was to be finished in time for the public wedding and festivities scheduled for April 1637. This commission deserves special consideration because, from a *post festum* vantage point, the critical reception accorded these decorations was to call into question the future of the indigenous Florentine seventeenth-century style as a form of public art.

According to Filippo Baldinucci, the program for Giovanni da San Giovanni's decorations was to have been provided by the Grand Duke's librarian, Francesco Rondinelli, author of the commemorative inscriptions attached to the Boboli sculpture installed by Ferdinand II during 1634-c. 1640, but the artist objected and insisted on drawing up his own scheme, which won the acceptance of Rondinelli.[69] Recently a letter in the hand of the artist and addressed to the Maestro di Casa of Cardinal Benti-voglio has been published that describes the original program of the Salone as he had planned it.[70] This description coincides with those portions of the room completed by the artist prior to his death in December 1636.[71] It is with these portions of the room that we will commence our consideration of the decorations.

The Salone, a large barrel-vaulted room, was treated as if it were a freestanding

[67] These included not only Giovanni da San Giovanni, Francesco Montelatici (called Cecco Bravo), Baldassarre Franceschini (called Volter-rano), Francesco Furini and Ottavio Vannini, but also lesser and unknown artists whose activities are recorded in the entries of the Fabbriche Medicee. This group included Filippo Tarchiani, Fabrizio Boschi, Giovanni Battista Rosati, Giovanni Battista Incontri, and Pier Antonio Michi. Although many entries designate these men as *pittori*, they also received payments for gilding and the like.

[68] For the details of this commission see my article, "Medici Patronage and the Baroque: A Reappraisal," *Art Bulletin*, XLVIII, June 1966, 133ff. Documentary support for the dating of the frescoes is published in this article. For the function of these ground floor rooms see the descriptions provided in the seventeenth century inventories of the palace in the Florentine State Archives (Fabbriche Medicee, Guardaroba Medicea, F. 525, 535, 725 and 932).

[69] Baldinucci, *Notizie*, 1846, IV, 252ff.

[70] A. Fortuna, "Giovanni da S. Giovanni nel salone degli argenti di Palazzo Pitti," *Firme Nostre*, Nos. 30-31, June 1966, 3 and 10. This letter has been republished by Fortuna in *Giornale di bordo*, III, April-May 1970, 365ff.

[71] The principal source for the iconography of the Salone Terreno as executed is Baldinucci, *Notizie*, 1728, VI, 38ff. See also O. H. Giglioli, *Giovanni da San Giovanni (Giovanni Mannozzi: 1592-1636)*, Florence, 1949, 122ff.

pavilion. This pavilion, a rather spindly, unorthodox structure executed in a freewheeling *quadratura* style that seems to mock serious, monumental exercises in this illusionistic technique, provides a setting for the aerial events in the vault and a series of scenes arranged in clockwise succession, starting with the long southerly wall, around the walls of the room.

In the center of the vault [Fig. 152], Giovanni da San Giovanni painted an allegory in honor of the Medici-Rovere nuptials in the form of a charming *concetto* in which *amorini* carry a few verdant twigs from an atrophying oak branch, symbolizing the nearly extinct Rovere family, whose *impresa* was an oak, to a Medici coat of arms to which the twigs are being affixed. The Medici *stemma* is flanked by Juno, patroness of marriage, and Venus, goddess of sensual love. Their counterparts around the oak branch are the three Fates, who are engrossed in their grim task of winding, measuring, and cutting the thread of life, which, to make the allegory absolutely clear, is wrapped around the leafless oak branch.

The ceiling also contains two small vignettes that flank the center fresco. In one, a lion, the Marzocco of Florence, bows to Mars, who may be interpreted allegorically as the Grand Duke. In the other, smaller scene, Pan, representing the uncultured world, exclaims in wonder over Flora, who of course symbolizes Florence.

Below, starting on the southern wall, the inhabitants of Mount Parnassus, routed from their ancient habitat by harpies and satyrs [Fig. 153] in the central section of the decorations, and in the far left section by Mohammed, immigrate to Tuscany, where on the adjacent western wall they are welcomed by Lorenzo the Magnificent. These are the frescoes that Giovanni da San Giovanni completed or at least started. He died before completing the western wall. According to the program he described in his letter, the northern wall was to celebrate the victories of the galleys of the Knights of Santo Stefano over the Turkish corsairs.[72] This triumph, in which Neptune and his retinue of sea deities were to have participated, would have been understood as a reference to the activities of the Knights in general and, in particular, to their role in the Battle of Lepanto, where in 1572 the western thrust of Mohammedan conquest and expansion was effectively checked by the naval forces of the Catholic world. This scene would have provided an appropriate pendant to the destruction of Mount Parnassus on the opposite wall in which Mohammed was prominently featured because, Baldinucci informs us, the latter scene is an allegory of the Turkish conquest of Constantinople in 1453.

For the eastern wall, there was to have been an allegorical scene in which the waters of the Arno River were depicted splashing forth from an overturned urn while the nymphs excavate a beautiful, youthful female who, the artist informs us, symbolizes the Age of Gold. In the final scene on the eastern wall, the figure representing the

[72] Baldinucci (*Notizie*, 1846, IV, 163) indicates that the destroyed frescoes of Giovanni da San Giovanni on the western wall, like those of Cecco Bravo that replaced them, depicted the "fatti del Magnifico Lorenzo." For full transcription of Giovanni's letter see Fortuna, "Giovanni," 3 and 10.

Golden Age was to have been brought before the Arno River, to which she pays homage.

The actual decorations of the Salone Terreno reveal that the program described in Giovanni da San Giovanni's letter was carried out only on the ceiling and the southern and western walls of the room. A visitor to the room now views scenes by other Florentine artists illustrating the activities of Lorenzo the Magnificent as a patron of the arts on the northern wall. On the eastern wall the founding of Lorenzo's Platonic Academy and his death [Fig. 154] are recorded.

The implications of the program Giovanni da San Giovanni planned to execute are quite different from those of the executed cycle. Whereas the final version stresses Lorenzo the Magnificent as a culture hero who creates a second Athens on the banks of the Arno, the original intention was to make him an incident in a series of events stretching beyond the limits of his life. The founding of the Knights of Santo Stefano did not occur until long after Lorenzo's death, during the reign of Cosimo I, first Grand Duke of Tuscany; and the closing scene, in which a figure symbolizing the rediscovery of the Golden Age of Tuscan soil, obviously signaling its rebirth or return, was to have been interpreted as concomitant with the grand-ducal marriage which, as already noted, was more specifically celebrated in the frescoes of the ceiling.

How the iconography of the Salone Terreno would have related to the decorations in the three adjacent rooms included in the original commission is not known. By late November 1636 Giovanni da San Giovanni was too ill to continue working, and by December 6th of that year the artist was dead. At the moment of the artist's death, the *quadratura* setting, the ceiling, and the long southern wall of the room were completed.

In view of the fact that the Salone Terreno was started shortly after the contractual Medici-Rovere marriage and that its ceiling alluded to that union, it is surprising that the room was not the scene of an intense campaign in which artists labored to complete the decorations in time for the actual consummation and public celebration of that marriage. But this was not the case; instead the incomplete Salone Terreno became the subject of debate in which the destruction of the existing frescoes was seriously considered. No immediate steps appear to have been taken to secure artists for the three rooms remaining in the commission. It should be noted that Giovanni da San Giovanni's death coincided with that of Ferdinand's domineering grandmother, which brought an end to her interference in matters of artist patronage. For the first time, Ferdinand and his brothers were in full control of family commissions, a situation that suggests that the abeyance of work in the Salone Terreno was partly caused by a reconsideration of this project and perhaps also of the many projects that were planned or actually in progress.[73]

When Cortona arrived in Florence, the decorations on the ground floor of the

[73] This agrees with the assessment of E. K. Waterhouse, *Italian Baroque Painting*, London, 1962, 158, that Cristina exercised an inhibitive control over Medici patronage until her death.

palace were still in abeyance, and the fate of the remaining rooms on the ground floor was undecided. In view of these circumstances it is not surprising that the Grand Duke reacted favorably to Buonarroti's suggestion that a commission be offered to Cortona. The moment was opportune for Ferdinand to turn from the parochial masters of Florence and to secure a major Roman painter. Whether Buonarroti anticipated a commission in fresco as extensive as the Four Ages cycle we do not know.[74] When we consider the dilemma over the incomplete state of the ground floor rooms in the palace, it seems likely that the Grand Duke wanted a work in fresco to serve as a test piece for more extensive work.[75] In all probability he hoped to obtain Cortona for the completion of these rooms, an undertaking clearly out of the question at that moment for the artist.

Thus, it would seem almost inevitable that Buonarroti's suggestion was well received. On July 20, 1637, Cortona reported to Cardinal Francesco Barberini that "it is necessary for me to remain here in Florence in order to make two paintings in fresco for His Highness, one of which is the Age of Gold and the other [the Age] of Silver"[76] The frescoes in the Sala della Stufa were under way. A new phase in Florentine art and Medicean patronage had begun.

THE EXECUTION OF THE FRESCOES

The first frescoes Pietro da Cortona painted in the Pitti Palace depicted the Four Ages of Man on the walls of a room situated at the southeastern corner on the *piano nobile* (floor plan, p. 69). The room is known as the Sala della Stufa [Fig. 1].[77] Square in plan and measuring 6.6 meters on a side, it is capped by a vault, 7.3 meters high, which terminates in pendentives located at the corners and midpoints of each wall. Natural illumination is provided by two large windows in the southern wall. Access is now pro-

[74] It is of interest to note that a composition study now in Munich (Drawing Cat. No. 2) for the Sala della Stufa indicates that markedly oblong scenes were considered at an early stage. Furthermore the drawing in question contains mutually exclusive iconographic motifs essential to the portrayal of the Age of Gold and that of Silver, a situation that strongly suggests that at one point consideration was given to incorporation of the two Ages in a single scene. Perhaps Buonarroti's first idea called for pendants in fresco, or possibly in oil, in which the Ages of Gold and Silver were combined in one and those of Bronze and Iron in the other.

[75] Fabbrini (*Vita*, 47) suggested that the Sala della Stufa was a test piece for the later rooms Cortona decorated. In view of the circumstances we have reviewed, these frescoes may in fact have been initially intended as a test piece for the completion of the ground floor left unfinished by Giovanni da San Giovanni.

[76] Doc. Cat. No. 2.

[77] Contemporary documents describe the room variously as the Camera, Camerino, Gabinetto, Stanza, or Sala della Stufa. Apparently the various appellations reflect individual reactions to the size of the room. Several scholars have favored Camera della Stufa in recent publications (Wittkower, *Art and Architecture*, 166, and Waterhouse, *Painting*, 161). The term "Sala," actually used on an official museum label in the room, has also received general acceptance (D. Coffin, "A Drawing by Pietro da Cortona for His Fresco of the 'Age of Iron,'" *Record of the Art Museum, Princeton University*, XIII, No. 2, 1956, 33ff.; R. Chiarelli, *La Galleria Palatina a Firenze*, Rome, 1954, 30; A. Ciaranfi, *The Pitti Gallery*, Eng. trans., Florence, 1957, 139; G. Briganti, "Pietro da Cortona dalla volta Barberini alla Sala della Stufa," *Paragone*, XII, Nov. 1961, 3ff. Although the room is admittedly of *camerino* proportions, I have chosen to accept the label posted in the room.

vided by two doors, one of which opens on to the nineteenth-century public stairway of the Galleria Palatina at the easternmost end of the palace.[78] The other door is located in the western wall and opens on to a slightly larger adjacent room with which the Sala della Stufa forms part of a series of four rooms arranged *enfilade* along the southern side of the eastern wing of the palace.

Even a cursory inspection of the Sala della Stufa reveals that it has undergone alterations, some of which postdate the Cortona frescoes. The door leading to the public stairway was obviously installed when the stairway was constructed. It is equally evident that the wall containing the two windows has been subjected to changes. This wall is actually of two thicknesses; at its corners and at midpoint it is a true bearing wall and of a thickness commensurate with its function. The windows, however, pierce a thin wall that is no more than a partition. The disparity in the width of these two wall sections is filled on either side of the windows by niches set into the thickness of the actual bearing wall [Fig. 155].[79] The much-restored majolica floor tiles, designed by Benedetto Bocchi, fail to conform to the irregularities of this wall, and the floor space between the bearing wall and the nonbearing wall is filled with slabs of *pietra serena*, the characteristic gray Tuscan stone. Like those along the other sides of the room, the tile border along this side of the room forms a straight line. Presumably it conformed to the configuration of the room at the time of its installation.[80]

A drawing [Fig. 156] by the engraver Remigio Cantagallina, signed and dated September 1632, provides a visual description, though by no means an unproblematic one, of the exterior of the Sala della Stufa before the intervention of Pietro da Cortona.[81] This drawing, which should be compared to a contemporary photographic view [Fig. 157], appears to indicate that the wall overlooking the Boboli Gardens was once pierced by a single large rectangular aperture. Such an arrangement would, of course, eliminate the pilaster that is now placed at the midpoint of that wall, thus disrupting the sequence of pilasters in the room. More important—for it is possible, though doubtful, that the pilasters postdate 1632—this large opening would have eliminated as well the section of bearing wall associated with the pilaster. It is therefore more likely that either the mullions visible in the Cantagallina sketch were placed in front of this section of wall or that Cantagallina misunderstood the architecture. (It is possible, for example, that the two little fan shapes within the subdivisions of the aperture are the result of an awkward rendering of a foreshortened view of two of the niches that flank the present windows.) As depicted in the Cantagallina drawing, the fenestration—if such it may be called—possessed little architectural character and may well have been a temporary

[78] The stairway, designed by Luigi del Moro, was completed in 1896 (Morandini, *Mostra*, 37, Cat. No. 167).

[79] The antique statues now occupying the niches are a much later addition. See C. Huelson, *Das Skizzenbuch des Giovannantonio Dosio*, Berlin, 1933, 34, No. 167.

[80] The tile floor has been dated 1640 by Ciaranfi (*Pitti Gallery*, 140) but without citation of documents. An earlier date seems more likely.

[81] The drawing is in the collection of Federico Nomi (see Morandini, *Mostra*, 22, Cat. No. 70, and Morandini, "Palazzo Pitti," 40, Fig. 5).

arrangement pending the completion of a projected range of rooms that would have extended the palace toward the Boboli Gardens.[82]

When conventional fenestration replaced the 1632 arrangement is not known. As late as March 2, 1638, an inventory describes the room as "loggetta dipinta d[ett]a della Stufa, dell'appart[ament]o nuovo verso [Fortezza] bel'veder'," a phrase attesting to the loggia-like aspect imparted to the room by the large aperture toward the Boboli Gardens and furthermore suggesting that the wall toward the Boboli retained its open character.[83] If the large opening still existed at the time of this inventory, it was most certainly fully glazed, for the furnishings recorded would have been unsuitable to a loggia.[84] The term *loggetta* does not occur in subsequent inventories. We may conclude that the Sala della Stufa possessed a loggia-like character shortly before and possibly even at the time Cortona commenced his frescoes. This aspect of the room would have been enhanced by the Rosselli ceiling decorations [Figs. 158 and 159] and the tile floor, if it was already installed. Florentines often frescoed the ceilings of loggias open to the elements [Fig. 160], and a ceramic floor is an entirely sensible installation in such a situation.[85] Even the pilasters which decorate the side walls of the Sala della Stufa would have accentuated the loggia-like aspects of this small room. Cortona must have reacted favorably to this quality, for his frescoes, as we shall see, enhance, rather than negate, it.

The loggia aspect of the Sala della Stufa is important to us because Cortona was interested in preserving this quality in his decorations. It may also explain the name of the room. According to the *Vocabolario della Crusca, stufa* means a hot room and generally one heated by a fire located beneath the floor or in the walls.[86] Neither seventeenth-century inventories and plans nor the present condition of the room give evidence of an artificial heating system. However, the solar heat in this room is exceptional and in its original condition must have been even more strikingly intense. This fact alone could easily account for the name.

It is possible that the Sala della Stufa was actually used as a *stufa* from time to time by augmenting the solar heat with braziers. A contemporary account (1625) often attributed to Michelangelo Buonarroti the Younger speaks glowingly of the delights of good health attributed to the use of a *stufa*, which is described as an ancient Roman invention.[87] In this account a distinction is made between *bagni* and *stufe*, and the con-

[82] The point of entry into this new wing on the *piano nobile* would have been the southern wall of the Sala della Stufa.

[83] Florence, A.S.F., Guardaroba Medicea, F. 525, c. 39r.

[84] The description of the furnishings given below is taken from A.S.F., Guardaroba Medicea, F. 535, c. 52f. This inventory is a duplicate of A.S.F., Guardaroba Medicea, F. 525 mentioned above, except that it omits the term *loggetta* and refers to the room simply as "Stufa dell'Appartamento Nuovo."

[85] This fact leads us to suggest that a date earlier

than 1640, the date generally assigned to the floor, is highly possible.

[86] *Vocabolario degli Accademici della Crusca*, Venice, 1612, 860.

[87] Pollak, "Italienische Künstlerbriefe," 68: ". . . sì che essendo tanta l'utilità degl'Hipocausti, et potendosene far uno con poca spesa, loderei che V. S. Ill.ma facesse praticare simil curiosità; la quale sarà di non poca comodità specialmente à gl'infermi in tempo d'inverno, poichè se bene si possono le camere riscaldare con foconi, et bracieri quanto si vuole"

struction of the latter, following ancient practice, is described as involving a hot-air heating system in the floor or walls. To this the account adds, however, that a room can be converted into a modest *stufa* by the simple introduction of braziers, an arrangement suited to the room under consideration.[88] It is more likely, however, that the name Sala della Stufa derived from the association of this room with one on the ground floor that functioned as a *stufa*. In the inventories of the palace the room directly beneath the Sala della Stufa is designated a *bagno*, and, in a description of a model of the palace made by Piero Falconieri in 1681, Filippo Baldinucci notes the presence of a *bagno* and *stufa* at this ground floor location.[89] A nearby stairway would have made the Sala della Stufa easily accessible from these rooms. Baldinucci's description, although not easily interpreted, indicates that these ground floor facilities were used by the duke and the nobles who played tennis in the "pallacorda segreta" and in the unfinished courtyard behind the eastern wing of the palace.

Ten years before Cantagallina sketched the garden facade of the palace, the surfaces of the lunettes and vaults of the Sala della Stufa had been frescoed by Matteo Rosselli and decorated with stuccoes by Antonio Novelli.[90] Rosselli visually opened the center of the vault by means of a frescoed polygonal oculus [Fig. 158] which frames, against a cloudless blue sky, the figure of winged Fame with a long-stemmed trumpet and crown. The rest of the mural surface is treated as a closed surface enriched by a small-scale trellis pattern executed in gold and white. At the four springing points of the vault appear the four cardinal virtues—Justice, Prudence, Temperance, and Fortitude—portrayed as isolated figures enclosed in stucco cartouches surmounted by gilded stucco peacocks. Between the cardinal virtues, stuccoed figures of decidedly adolescent *putti* clamber along the cornice of the vault. In the spandrels of the vault are low relief medallion portraits of eight rulers: Ninus the Assyrian; Arbace, King of the Medes; Cyrus, King of the Persians; Alexander of Macedonia; Julius Caesar; Jacob Almanson, King of the Saracens; Solyman, Emperor of the Turks; and Charles V, Emperor of Austria [Fig. 159].[91] Each ruler is in turn provided with a lunette in which he is allegorically represented by an appropriately armed female figure set against a background illustrating a military exploit of his reign. In the four corners of the room and at the same level as these lunettes are four fictive stucco pots from which sprout polychromed flowers.

The Rosselli-Novelli decorations are a curious hotchpotch of elements. The polygonal aperture, the trellis work, the peacocks, the precariously perched *putti*, and

[88] At no time do the inventories describe furniture in the adjacent room appropriate to a *bagno* (both rooms contained chamber pots in 1638, but these were much in use throughout the palace); however, the room directly below the Sala della Stufa was a bath, and via the nearby stairs this room and the Stufa may have served in conjunction as *bagno* and *stufa*.

[89] Baldinucci, *Notizie*, 1688, III, 49.

[90] *Ibid.*, 1702, V, 405: "Del 1622 [Matteo Rosselli] colorì a fresco la Volta della Stanza detta la Stufa nel Palazzo Sereniss. le cui Pareti furono poi arricchite dal celebre penello del Cortona." For the stucco attribution see *ibid.*, 1728, VI, 340.

[91] See N. Cipriani, *La Galleria Palatina nel Palazzo Pitti a Firenze*, Florence, 1966, 252, for further illustrations.

the ridiculous flower pots all suggest an amusing evocation of a garden pavilion or villa loggia, and this to be sure is in keeping with their setting. In contrast, the overtly iconographical elements of the scene—Fame, the cardinal virtues, the cameo portraits of eight famous rulers, their dedicatory inscriptions, and the lunette allegories—are more didactic in character.[92] The result is a mixture of frivolity and high seriousness. These decorations are indicative of the felicitous, if conventional, effects of which Rosselli was capable and as such were to provide a foil for Cortona's later work.

In all probability the grotesques painted in gold on the pilasters [Figs. 1 and 161] date from the time of Rosselli's decorations. Not only are the grotesques of a similar spirit but in fact they repeat certain motifs that occur in the ceiling. Thus, for example, the winged female at the top of the recessed panel of each pilaster also ornaments the frames of the ruler portraits in the spandrels of the lunettes. Like the ceiling frescoes, these decorations pertain to a long-standing tradition.[93] They in no way partake of the spirit of Cortona's later decorations, and they have no predecessors or antecedents in his art. Moreover, their effect on the pilasters is to negate their structural relevance to the architecture of the room, precisely the opposite of what we expect from Cortona, who, in fact, sought to strengthen the role of the pilasters by adding illusionistically painted ones to each group.

In contrast to the grotesque decorations on the pilasters, those on the wall surfaces immediately adjacent to the windows mix geometric and curvilinear forms in a way that suggests, though they seek to imitate the pilaster decorations, a late eighteenth- or early nineteenth-century date. The wainscoting decorations, the painted coffers in the ceiling panels above the windows, and the dreary allegories over the doorways are certainly later in date than the period with which we are concerned.

The First Campaign

Although no payment records for the Cortona decorations in the Sala della Stufa have come to light, it is possible to reconstruct the two periods in which the artist worked in the room. Court records note the arrival of Cardinal Giulio Sacchetti and his entourage in Florence on June 28, 1637.[94] We know that he remained in Florence for the marriage festivities of the first week in July. A letter of Michelangelo Buonarroti the Younger makes it clear that arrangements were made for Cortona to execute a set of frescoes in the Sala della Stufa and for the artist to stay as a guest in the Casa Buonarroti prior to the departure of the Cardinal.[95] Although Buonarroti does not mention the

[92] The inscriptions strongly suggest that these subjects were culled from a contemporary anthology of great warrior rulers.

[93] See for example the frescoed pilasters in the *Chiostro Verde* of Andrea del Sarto (E. Borsook, *The Mural Painters of Tuscany*, London, 1960, Pls. 89 and 90). See also the grotesques on the illusionistically painted pilasters in Mantegna's Camera degli Sposi in the Palazzo Ducale, Mantua, the much restored complex of decorated ceiling lunettes and decorated pilasters in the main loggia of the Belvedere of the Vatican by Pintoricchio and his circle, and most important Peruzzi's Sala di Galatea in the Farnesina, Rome.

[94] Geisenheimer, *Pietro*, 30, No. 9.

[95] Doc. Cat. No. 22.

fact, the theme of these frescoes, the Four Ages, chosen by him, must have also been decided upon at this time. This sequence is confirmed by Cortona's first report to Cardinal Francesco Barberini on July 20.[96] In this letter Cortona informs Cardinal Barberini that Sacchetti has departed Florence for Bologna and that he is remaining in Florence for some time in order to execute two frescoes for the Grand Duke, one of which is the *Age of Gold* and the other the *Age of Silver* [Figs. 2 and 3]. Cortona also states that he will surely have finished the two *Ages* by the end of August, and then, if the Barberini approve, he will continue his trip.

Cortona anticipated a swift conclusion to the two frescoes. This hope proved to be optimistic. When he next wrote to Cardinal Barberini, on September 13, the job was still not finished.[97] "Here I find myself at the completion of the two stories for the fresco. I need only to retouch them. One is that of [the Age of] Gold and the other of Silver." For the first time in his correspondence Cortona noted that, "In this room there is lacking that of Bronze and of Iron." He then describes his projected northern trip and his intention of returning to Rome by way of Loreto, thus by-passing Florence. Cortona clearly wants it understood that he will not return to Florence unless the Barberini order him to do so. He also reports that two months would be needed to execute the other two Ages. Thus in a somewhat *sotto voce* manner Cortona had let the Cardinal know the true dimensions of the grand-ducal commission. That his work on the first two Ages was very nearly complete is supported by a letter Jacopo Soldani sent to Buonarroti three days later.[98] Cortona probably left Florence in late September or, at the latest, early October. When next we hear from him it is in the form of an undated letter written to Buonarroti from Venice in November.[99] The letter indicates that he has been traveling extensively and rapidly since he left Florence and therefore has had no time in which to write. "I have been constantly on the road," he informs Buonarroti, "and have not stopped in one place for a longer stay than here in Venice where I will be for ten days." He explains that his trip has been successful, for the seasonal rains have not yet broken the roads and he has been able to see "queste opere così belle." If he can be of service in Venice to Buonarroti, he would be honored to receive instructions from the poet. No mention is made of a return to Florence.

Indeed, Cortona's next letter to Buonarroti, dated December 19, was sent from Rome.[100] In it he announced his arrival in that city and sent him best wishes for Christmas. Shortly thereafter, on December 26, Buonarroti received a communication from Luigi Arrigucci in which the writer, who, it should be recalled, had served the poet in establishing first contacts with the painter, reported that he had seen Cortona several times.[101] Although he is vague as to just what was discussed with the artist, Arrigucci

[96] Doc. Cat. No. 2. [97] Doc. Cat. No. 3.

[98] Doc. Cat. No. 4. [99] Doc. Cat. No. 5.

[100] Doc. Cat. No. 6.

[101] Florence, Biblioteca Laurenziana, Archivio Buonarroti, 21 (Lettere di vari a Michelangelo il Giovane), No. 160: "Molto Ill.re Sig.re P.ron Oss.mo. Il nostro Sig.r Pietro arrivò qua più giorni sono, e con ottima salute. Più volte in questo poco di tempo sono stato con lui e aviamo discorso delle cose di costà, e particolarmente aviamo fatto commemoratione di V. S., a cui egli professa obbligo infinito per le infinite di cortesie che ha da lei

does note that he and Cortona "talked about things where you are," but no specific mention is made of the unfinished Sala della Stufa. This letter closes our documentation of the artist's activities from May to December 1637. We may now direct our attention to the works of art completed in this period.

The two frescoes executed by Pietro da Cortona during his first campaign in the Sala della Stufa—the *Age of Gold* and the *Age of Silver*—illustrate the first two Ages of Man. The story of the Ages of Man was first related by Hesiod, who described five ages.[102] In his retelling, Ovid reduced the Ages to the four metallic ones: the Ages of Gold, Silver, Bronze, and Iron.[103] That Cortona's frescoes are based on the Ovidian version is clear from his references to four frescoes in his letters to Cardinal Barberini.[104]

The frescoes admirably capture the mood of Ovid—the Arcadian tranquillity of his Age of Gold [Pl. I, Fig. 2], the agrarian activity of his Age of Silver [Fig. 3]: "Golden was that first age, which, with no one to compel, without a law, of its own will, kept faith and did the right. There was no fear of punishment, no threatening words were to be read on brazen tablets; no suppliant throng gazed fearfully upon its judge's face; but without judges lived secure. Not yet had the pine-tree, felled on its native mountains, descended thence into the watery plain to visit other lands; men knew no shores except their own. Not yet were cities begirt with steep moats; there were no trumpets of straight, no horns of curving brass, no swords or helmets. There was no need at all of armed men, for nations, secure from war's alarms, passed the years in gentle ease. The earth herself, without compulsion, untouched by hoe or plowshare, of herself gave all things needful. And men, content with food which came with no one's seeking, gathered the arbute fruit, strawberries from the mountain-sides, cornel-cherries, berries hanging thick upon the prickly bramble, and acorns fallen from the spreading tree of Jove. Then spring was everlasting, and gentle zephyrs with warm breath played with the flowers that sprang unplanted. Anon the earth, untilled, brought forth her stores of grain, and the field, though unfallowed, grew white with the heavy, bearded wheat. Streams of milk and streams of sweet nectar flowed, and yellow honey was distilled from the verdant oak.

"After Saturn had been banished to the dark world of death, and the world was under the sway of Jove, the silver race came in, lower in the scale than gold, but of greater worth than yellow brass. Jove now shortened the bounds of the old-time spring, and through winter, summer, variable autumn, and brief spring extended the year in four seasons. Then first the parched air glared white with burning heat, and icicles hung down congealed by freezing winds. In that age men first sought the shelter of houses.

ricevute, et in effecto gli vive servitore non meno di quello che faccio io Roma li 26 di Dicembre 1637. Dev.mo Ser.re Luigi Arrigucci" This previously unpublished letter was found and transcribed by Gino Corti.

[102] See A. Lovejoy and G. Boas, *Primitivism and Related Ideas in Antiquity*, Baltimore, 1935, *passim*, for a complete discussion of the problems and variations on the theme of the Ages (or Races) of Man. See also the more recent study, H. Levin, *The Myth of the Golden Age in the Renaissance*, London, 1969. Levin cites Cortona's frescoes as illustrating the Four Ages of Man (197f.).

[103] Ovid *Metamorphoses*, trans. F. J. Miller, Loeb Classical Library, New York, 1926, I. 89 sqq.

[104] See Doc. Cat. Nos. 2 and 3.

Their homes had heretofore been caves, dense thickets, and branches bound together with bark. Then first the seeds of grain were planted in long furrows, and bullocks groaned beneath the heavy yoke."[105]

Upon first appraisal, Cortona seems to have been more concerned with establishing the related, yet different, moods of the two Ages than in rendering a precise visualization of their text. In order to present essence rather than detail, he has selected motifs from the observations of Ovid. For the *Age of Gold*, he therefore stresses the carefree and ageless nature of its inhabitants, the peaceful simplicity of their existence in a world of perpetual spring. They are shown laughing and playing among some of the fiercest and timidest creatures in the animal kingdom. Innocent are their pleasures—laughter, shepherds' pipes, the dance—and minimal are their labors, for they draw sustenance from the untended bounty of nature; their only task is to gather, as the artist has depicted, the food readily at hand such as edible acorns.

In the *Age of Silver* we observe an era in which man's activities follow the passage of the seasons. It is autumn; the harvest is underway. Nature, though still bountiful, demands man's labor. The ox, as Ovid noted, is now harnessed to the plow. The means of sustaining life have become more complex and the sources of pleasure, more sophisticated. Now the shepherd's crude pipes, held by a youth in the left foreground of the *Age of Gold*, have been superseded by a more advanced, reeded horn, whose operation is being taught to a child by two young girls in the right middle ground of the *Age of Silver*.

Although Cortona's Gold and Silver Ages represent a distillation of Ovid's text, it is apparent that several particular motifs of the text are emphatically stressed, and furthermore that several details have been incorporated that are extraneous to the text or not even justified by it. For example, two sailing ships appear in the background of the *Age of Silver* [Fig. 4], although ships with sails are not mentioned until the Age of Iron in Ovid's account. This anachronism might be an oversight on the part of the artist. It is more difficult, however, to account for the appearance of man-made metallic objects such as the fluted urn of bronze in the *Age of Silver* and the gold *patera* lying disused and perhaps unnoticed among the weeds in the lower right corner of the *Age of Gold*. A full explanation of Buonarroti's lost or destroyed program does not seem justified or required until we can consider the cycle in its entirety. Still, enough of the work was completed in the fall of 1637 for the Grand Duke and his advisers to assay, on a preliminary basis, the iconographic as well as the stylistic merits of the cycle.[106] Thus, we may make some tentative comments on the program of the Four Ages.

It is evident that the program prepared by Buonarroti was more than merely an

[105] Ovid *Metamorphoses* I. 113 sqq.

[106] This is true provided these metallic objects pertain, as I believe, to Cortona's first campaign in the Sala della Stufa and are not later additions. The *patera* in the *Age of Gold* could conceivably have been added to the fresco *al secco* at a later date; however, close examination of the fresco provides no supporting evidence for such a thesis. In the case of the urn in the *Age of Silver* there is also no evidence of an *al secco* addition, and in this case the object is so essential to the activity of the figures in the scene that a later introduction is ruled out.

illustration of the Ovidian cycle. Not surprisingly, he appears to have enriched the text with allegorical allusions. The two metallic objects just noted provide a clue to the nature of this enrichment. Clearly both the *patera*, decorated with a raised sunburst, and the fluted urn are products of more sophisticated civilizations than the ones depicted here. Thus we may infer that they are the products of an earlier, but more technologically advanced age, similar, we may also infer, to the later ages as described by Ovid, to which metal objects such as these are specifically assigned. In its broadest terms, such a *concetto* implies a cyclical as well as a periodic history in which definable epochs not only pass in linear succession but recur as well. The idea of the return of a past era is of course not new; it is, in fact, as old if not older than civilization itself.[107] Its application to Ovid's Age of Gold seems especially appropriate since it provides in a developed canonical form an archetypal concept of the earliest condition of man as a period of plenitude, innocence, and pleasure. In its Ovidian context, the return is more than a nostalgic *in illo tempore, ab origine* (in that time, at the beginning); it is the Return of the Golden Age.[108] To look again at the *Age of Gold* with the theme of the return established, if not fully developed, is to realize that the motifs of the first Ovidian Age which Cortona has stressed in his rendering—the oak tree and gathering of acorns and the choice of a lion among the more harmless animals as a symbol of peacefulness—may be interpreted as celebrating a Return of the Golden Age in terms of a contemporary event, namely the public marriage of Ferdinand de' Medici and Vittoria della Rovere. In this context the emphasis on the oak tree and the gathering up of bundles of its branches—rather than merely the acorns as described by Ovid—is significant, for the oak is the symbol of Vittoria's family, the Rovere.[109] The collecting of the oak branches reflects the gathering up of the hereditary possessions of the Rovere by the marriage, an intention implicit in that event though in fact not achieved owing to the intervention of the Papacy. The union of the two houses was alluded to in similar, though not identical, conceits in the opera *Le nozze degli dei* written by Giovanni Carlo Coppola expressly for the public wedding celebrations.[110]

[107] For the classic study, see M. Eliade, *The Myth of the Eternal Return*, trans. W. Trask, Bollingen Series XLVI, New York, 1954, which contains an excellent bibliography.

[108] *Ibid.*, 112, and also A. B. Giamatti, *The Earthly Paradise and the Renaissance Epic*, Princeton, 1966, 15ff. The presence of this theme of the Return of the Golden Age in Cortona's *Four Ages* in the Sala della Stufa was first published by W. Vitzthum ("Correspondence: 'Pietro da Cortona's Camera della Stufa,'" *Burlington Magazine*, CIV, No. 708, March 1962, 120f.) and criticized by me in the same issue of the journal (121ff.). The issues set forth in the dialogue depend in the main upon an earlier article by M. Laskin, Jr., and myself ("A New Drawing for Pietro da Cortona's 'Age

of Bronze,'" *Burlington Magazine*, CII, No. 703, Oct. 1961, 423ff.), which deals primarily with the later Ages. I therefore prefer to take up in detail the issues presented in this literature on the frescoes following our consideration of Cortona's second campaign in the Sala della Stufa when the entire program can be considered.

[109] For a detailed explication of the oak as a Rovere symbol see F. Hartt, "'Lignum Vitae in Medio Paradisi': The Stanza d'Eliodoro and the Sistine Ceiling," *Art Bulletin*, XXXII, No. 3, Sept. 1950, *passim*.

[110] G. C. Coppola, *Le nozze degli dei*, Florence, 1637. The score of the opera was prepared by three unidentified composers (F. Rondinelli, *Relazione delle nozze degli dei, favola dell'Abate Gio: Carlo*

Although in the Coppola opera, the allusion to the Medici-Rovere union differs considerably from that of the frescoes, it provides a clue to the *concetto* of the Stufa frescoes and, therefore, deserves a brief description.[111] In act two, scene one, Coppola treated the spectators to a view of a stormy cavern on the island of Lemnos, where, in the midst of arms and armor in various stages of completeness, appear Vulcan and his Cyclopes. Jupiter's eagle is also present. As the scene opens, the Cyclopes beat time on their anvils on which they are forging arrows for Jupiter. As soon as an arrow is finished, it is snatched up by the eagle who carries it to Olympus. Finally this early prototype for Verdi's Anvil Chorus is interrupted by Vulcan, who commands his Cyclopes to produce a shield to be given by him to a great hero. He explains that it is to be decorated with a heraldic device consisting of an aged, almost moribund oak (Rovere) from whose newly sprouting branches hang six golden apples (the six *palle* of the Medici coat of arms).[112]

The imagery of the Coppola conceit and the closeness of its theme to that of the collecting of oak branches in Cortona's *Age of Gold* and to the allegory of the Medici-Rovere nuptials frescoed on the ceiling of the Salone Terreno by Giovanni da San Giovanni [Fig. 152] are perfectly clear, but even more important is the fact that a seventeenth-century *letterato* such as Buonarroti would have recognized the source of this scene both in setting and content to be the eighteenth book of Virgil's *Aeneid*, in which Vulcan also orders his one-eyed cohorts to fashion "arms for a brave warrior," that is, for Aeneas.[113] What is of special significance, however, is that, in an earlier passage of the same book, King Evander describes the early history of these people of whom Aeneas the Trojan is to be the new leader. "In these woodlands the native Fauns and Nymphs once dwelt," the old king explains, "and a race of men sprung from trunks of trees and hardy oak, who had no rule nor art of life and knew not how to yoke the ox or to lay up stores, or to husband their grains; but tree-branches nurtured them and the huntsman's savage fare. First from the heavenly Olympus came Saturn, fleeing from the weapons of Jove and exiled from his lost realm. He gathered together the unruly race, scattered over mountain heights, and gave them laws, and chose that the land be

Coppola . . . , Florence, 1637, 7). The settings were created by Alfonso Parigi, and Angiolo Ricci prepared the choreography. For a description and detailed summary of the opera see A. M. Nagler, *Theatre Festivals of the Medici, 1539-1637*, New Haven, 1964, 162ff.

[111] Not surprisingly, the opera was constructed to celebrate the marriage of Ferdinand and Vittoria, and this theme is interwoven with a rather trite tale of four celestial marriages decreed by Jupiter. Needless to say, the matchmaking of Jupiter is an utter disaster, and a dreadful scramble ensues. Of course all is at last put to rights, and after a series of extravagantly costumed scenes four

marriages—though with several quite different partners than those initially selected by Jupiter—are performed.

[112] Coppola, *Nozze*, 20f. and Rondinelli, *Nozze*, 15: ". . . Vulcan comandò che si desse perfezione à uno scudo destinato da lui dono per un grand'Eroe, nel quale disegnava intagliare una Rovere, che quasi secca germogliasse, e da rami di quella Vermena, voleva, che pendessero sei Pomi d'oro."

[113] Virgil *Aeneid*, trans. H. R. Fairclough, Loeb Classical Library, New York, 1916, VIII, 439 sqq. For all purposes the scene is identical. Vulcan's forge is located in a cavern, and, until interrupted, the Cyclopes are forging thunderbolts for Jupiter.

31

called Latinium since in these borders he had found a safe hiding place. Under his reign were the *golden ages men tell of*: in such perfect peace he ruled the nations; till little by little there crept in a race of worse sort and duller hue, the frenzy war, and the passion for gain."[114] Thus, by means of a Virgilian thread, we can thematically link a scene in Coppola's opera and Cortona's frescoes. It is possible that Buonarroti could have drawn the kernel of his *concetto* from the opera, but such is scarcely necessary, for a man of his erudition knew his Virgil well enough to choose his imagery without a guide. Furthermore, in selecting Virgilian themes related to the Return of the Golden Age as a panegyric device for honoring a ruler, Buonarroti was following a precedent initiated by Virgil himself, who applied the conceit to Augustus Caesar in the sixth book of the Aeneid: "This, this is he . . . who shall again set up the Golden Age amid the fields where Saturn once reigned. . . ."

Evander's description of "the Golden Age ruled by Saturn" and its gradual passing provides an imagery admirably suited to the Medici-Rovere marriage, for Virgil embroiders Ovid by having the oak not only sustain man but bear him as well. The symbolic use of the oak in a female role as the begetter and nurturer of man is so atypical as to make this passage especially relevant, for normally the oak, the tree of Jupiter, is a virile rather than a feminine symbol of fertility and hence scarcely an appropriate allusion to the female member of a marriage.

In contrast, the Virgilian image of the oak is ideal for a *concetto* that celebrates the consummation of the Medici-Rovere marriage.[115] Striking proof of the relevancy of the latter interpretation of the oak is provided by a panegyric poem by Margarita Costa entitled *Flora Fecunda*, published in 1640.[116] Dedicated to Ferdinand, the poem celebrates the pregnancy of Vittoria and anticipates the arrival of a male heir to the throne. The poem is a paean to the fecundity of the Grand Duchess, which is likened to that of the nut-bearing oak. To reinforce the analogy, she is even referred to as "Altezza della Quercia." Finally in the ninth canto (one for each month of pregnancy) the oaken mast of the vessel in which Venus and her entourage are sailing to the New Athens, i.e. Tuscany, germinates, producing golden acorns during a spectacle put on by aquatic creatures. The ship is dismantled on the beach, the mast is planted, and with Flora as a midwife it brings forth a child.[117] Alas, even before the poem had gone to press the Grand Duchess suffered a premature birth and the infant died within twenty-four hours (December 22, 1639). In order to account for this infelicitous event a tenth canto was

[114] *Ibid.*, 314 sqq. Italics added.

[115] In epithalamic poems it was customary for the bride to be compared to the flower or fruit; the groom, to the tree. See A. L. Wheeler, "Tradition in the Epithalamium," *American Journal of Philology*, LI, 1930, 213.

[116] M. Costa, *Flora Fecunda*, Florence, 1640.

[117] *Ibid.*, Canto Nono, Argomento: "Venere, ed Amore incontrano la pompa degli Dei marini, e Flora, e Zeffiro; e dopo molti scherzi, e giochi marini si vede l'Albero di Quercia della Nave germogliare e partorire ghiande d'oro; ed intanto scorto l'oracolo adempirsi, s'montano su l'Lido, e dentro nobil Tempio d'Arte, e dalla virtù fabricato ripongono Nave e l'albero della Quercia d'oro. Finita sì grand'opera Flora à pie' della Quercia espone bellisimo fanciullo; accorrono tutte le Deità, e con doni cantano all' Infante eternità d'honori."

added to the text in which the newborn is described as so perfect and beautiful that like Ganymede of old he was called to heaven by Jupiter! The last canto closes with prognostications of another, successful pregnancy: "E fertil de la Rovere il rampollo/ Più d'un Marte produce d'un Apollo."

A closely related conceit occurs in a long epithalamic poem written by Pier Francesco Minozzi in honor of the grand-ducal marriage, which utilized the same imagery and in a closing stanza rhapsodized about Ferdinand: "Un sol, che sia di mille soli il sole, Per fecundar de' la tua QUERCIA i rami, A cui FERDINANDO i pomi d'oro innesta...."[118]

The foregoing examples from the literary and visual arts are sufficient evidence that the allegorical presentations of the Medici-Rovere marriage drew upon a body of similar conceits and, further, that these conceits enjoyed currency around 1637, the moment of the wedding and Cortona's commission. These programs share the themes celebrating the union of the two houses through the fusion of their coats of arms, an event which is demonstrated either by the actual transfer of a branch of the Rovere golden oak to the Medici *stemma* as in the Salone Terreno or via the germination of the oak which then bears golden acorns or *pomi aurati*. Both these themes are manifest in Cortona's *Age of Gold*, although less overtly stated.

In the *Age of Gold* [Fig. 2], the theme of transference is enacted by a young child who carries a bundle of acorn-laden oak branches across the center foreground of the fresco. Although it is not emphatically stressed, the acorns are in fact being transported to the youthful couple in the far left of the scene [Fig. 5]. The female member of this group is in the act of crowning her consort with a wreath of laurel, a traditional Medici emblem. In keeping with the character of the cycle, both members of this couple are idealized, and therefore should not be interpreted as personifying Ferdinand and Vittoria.[119] I propose instead that the handsome youth in this group symbolizes the anticipated birth of a male heir. Seated beneath an oak—we should recall that Costa was to describe him as born from the trunk of an oak—he is crowned with a circlet of laurel by a female who can be identified, on the basis of a preparatory study in which she is depicted with wings [Fig. 6],[120] as a figure of Victory, that is to say Vittoria, a natural allusion to his mother's given name and in conjunction with an oak tree to her motto, *A Robore Victoria*. Apparently Cortona decided that a winged Victory figure would be too overt an allusion in his arcadian scene, and her wings were shed in the scene as executed, as documented in a preparatory study for both figures in question [Fig. 7], and another victory symbol, the palm branches once held by the youth being crowned, was later replaced with a shepherd's pipes.[121] Interestingly enough, the final

[118] P. F. Minozzi, *La musa vezzegiante nelle nozze del serenissimo gran duca di Toscana Ferdinando II e della Serenissima Vittoria della Rovere. Epitalmio*, Pisa, 1636, Stanza XXXIX.

[119] Contrary to what I once suggested; Campbell, "Correspondence," 122.

[120] Drawing Cat. No. 25.

[121] Drawing Cat. No. 21. It appears that Cortona considered a crown of oak leaves for the youth, perhaps an allusion to Virgil's description of the race of the new Golden Age: "What youth! What mighty strength, lo! they display, and bear brows

metamorphosis of this group may have been achieved during the execution of the fresco. Such a conclusion is justified by the fact that the edges around the *giornate* these two figures occupy consistently overlie the surrounding fresco surfaces on *all* sides, an indication that their surface is really a patch, the original surface having been cut away after the surrounding areas were finished. In all probability Cortona initially painted figures in this area that alluded clearly to the marriage. These figures were replaced by the present group, which, as suggested above, alludes indirectly to the birth of an heir.

If the athletic, blond, and well-formed youth can be identified as the personification of the future progeny of the Medici-Rovere nuptials, we need have no doubt about the source of Buonarroti's commentary on the Four Ages; it is Virgil's Fourth Eclogue: "Now is come the last age . . . the great line of the centuries begins anew Now the Virgin returns, the reign of Saturn returns, now a new generation descends from heaven on high. Only do thou, pure Lucina, smile on the birth of the child, under whom the iron brood shall first cease, and a golden race spring up throughout the world! Thine own Apollo now is king!"[122] We need only substitute Vittoria for Lucina to apply these Virgilian lines to Cortona's frescoes. (And Costa, it should be recalled, predicted that Vittoria's first-born would be "more than a Mars, an Apollo.")[123] Virgil's panegyric continues: "But for thee, child, shall the earth untilled pour forth, as her first pretty gifts, straggling ivy with fox glove everywhere, and the Egyptian bean blended with the smiling acanthus. Uncalled, the goats shall bring home their udders swollen with milk, and the herds shall fear not huge lions"[124]

Cortona's choice of flora and fauna is especially appropriate to the grand-ducal marriage. The lion may be understood as the Marzocco, the lion of Florence; the hare is a traditional symbol of Venus and of fecundity too; and the abundance of flowers alludes to the city of Florence (Fiorenza). Several other animals in the fresco seem to have been selected with this theme in mind; the dog in the left foreground and the doves in the upper right corner of the fresco may be interpreted as symbols of fidelity.[125] The inclusion of the hare and the doves in the *Age of Gold* may have been influenced by another Ovidian description of the first Age: "But that pristine age, which we have named the golden age, was blessed with the fruit of the trees and the herbs which the ground sends forth . . . Then birds plied their wings in safety through the heaven, and hare loitered unafraid"[126]

shaded with the civic oak!" (Virgil, *Aeneid* vi. 711 sqq.). A later fresco (1652) in the palace, Volterrano's ceiling on the *piano nobile*, displays these elements, the Rovere oak, the same motto, and a winged Victory who grasps palm branches and a laurel crown, suggesting that the pun of Vittoria and the Rovere oak were common knowledge (Fig. 190). The date of Volterrano's ceiling has not been precisely determined (see M. Gregori, *70 pitture e sculture del '600 e '700 Fiorentino*, Florence, 1965, 26). The date here given is from Wittkower, *Art and Architecture*, 225. For a de-

scription of the iconography of the ceiling see Baldinucci, *Notizie*, 1846, v, 168.

[122] Virgil *Eclogue*, trans. H. R. Fairclough, Loeb Classical Library, New York, 1916, IV. 4 sqq.

[123] Costa, *Flora*, Canto X, 38.

[124] Virgil *Eclogue* IV. 18.

[125] The dog as a symbol of faithfulness needs no explication. The birds are probably intended to represent turtledoves who were thought to mate for life (G. P. Valeriano, *Hieroglyphica sive De Sacris Aegyptiorum*, Lyons, 1610, 16).

[126] Ovid *Metamorphoses* xv. 96 sqq.

Even without the two concluding Ages, Cortona's first campaign in the Sala della Stufa elucidates the essentials of Buonarroti's *concetto*. The gathering of acorns, oak twigs, and flowers signals the union of the Medici and Rovere houses; the locus of the event proclaims, in its allusions to Virgil's Fourth Eclogue, the Return of the Age of Gold, which we are assured will commence with the first-born of this felicitous union. We have, in short, a representation of the classic panegyric sung through the centuries for royal marriages and royal births. It should be noted that Buonarroti has, perhaps by accident but more probably by plan, repeated the theme of the union of Rovere oak and Medici *palle* that Giovanni da San Giovanni had frescoed on the vault of the Salone Terreno and, furthermore, combined it with the Return of the Golden Age, which was originally planned for the eastern wall of the same room. The similarity of themes could be consciously intended to challenge both the style and the program of the unfinished Salone Terreno. Consideration of the style and composition of Cortona's first two Sala della Stufa frescoes supports such a thesis.

The two *Ages* [Fig. 1] occupy the two wall surfaces between the decorated *pietra serena* pilasters and, when viewed together, form an ensemble. They function, in point of fact, as pendants that are so integrated that the compositional unity of each depends in no small degree upon the adjacent fresco. Thus the right-hand group of figures in the *Age of Gold* forms a pyramid in conjunction with the left-hand group in the *Age of Silver* and strongly suggests that, behind the beaded frames and pilasters, space is continuous, permitting the potential movement of figures from one fresco to the other. This illusionistic flow of space has a liberating effect on the rather compactly grouped figures in both scenes, and counteracts the constricted enframements through which we view them. In order to control and contain this interplay of scenes, Cortona deployed the figures and the oak tree to the far left in the *Age of Gold* and the figures and fall of drapery to the far right of the *Age of Silver* so as to bracket and define the total composition. To the same end he eschewed any suggestion of spatial interaction between his figures in the scenes and the *quadratura* of their enframement, a matter to which we will return at a later point.

The degree to which the Ages of Gold and Silver evolved as an integral composition is shown by one of the earliest composition studies—in fact, probably the earliest found to date—which is now in Munich [Fig. 8].[127] This drawing seems to have served as a *primo pensiero* for both of the frescoes inasmuch as it contains figural motifs ultimately used in both Ages. Thus, one can identify the seated group that appears in the left foreground of the *Age of Gold*, along with the youth in the tree gathering nuts. In the center foreground, however, there is a recumbent female figure who passes, virtually unchanged in general posture, into the same location in the *Age of Silver*. In the far right foreground of the drawing, a sturdy rustic carries a small animal over his shoulder, and a child reaches up imploringly. Considerably altered in pose, the figure with the animal slung over his shoulder can be found in the left middleground of the

[127] Drawing Cat. No. 2.

Age of Silver, and his juvenile companion in the sketch, with only slight changes in gesture, is transformed into the child carrying a blunch of oak branches in the center foreground of the *Age of Gold*. What makes this blend of figural motifs from the two Ages especially intriguing is the fact that they encompass activities that apply exclusively to one Age or the other; thus the gathering of acorns by the youth in the tree would be included only in the *Age of Gold*, and the carrying of an animal, whether for domestication or slaughter, would apply only to the *Age of Silver*. This conjunction of motifs from the two Ages in a drawing whose format varies considerably from that of the areas ultimately frescoed opens a Pandora's box of speculation. Was the original scheme to present aspects of the Ages of Gold and Silver in one painting? If this is the case, there may have been planned two pendant scenes, one portraying the first two Ages, the second the two later Ages. If so, did Cortona at first conceive of two pendants in a location other than the Sala della Stufa? In any event we may be certain that the two frescoes were executed within an extremely short period of time—a scant two months—and that key figural motifs were conceived for the two frescoes simultaneously, even, in fact, in the same composition sketch.

As we have stressed, the Munich composition study figures in the evolution of both Ages. The next major composition study, now in the Uffizi, in contrast pertains entirely to the *Age of Gold* and carries us to a stage in its development that is very close to the final version [Fig. 9].[128] Indeed, Cortona must have considered this version practically definitive, for not only has it been squared for transfer, presumably on a large scale, but also there exists a number of individual figure studies that clarify poses of figures that do not recur in the executed fresco.[129] The figures pertaining to the *Age of Gold* in the Munich composition are all present in the Uffizi composition study. Most of the figures in this study will be retained in the fresco, with one minor and one major change. A minor change is the elimination of the child who catches the acorn-laden branches being broken off the tree. A major change is the replacement of the two garland-entwined females standing in the left middleground by a seated male and female couple. The latter group would appear to have evolved from the seated male youth in the lower left corner of the composition sketch who watches the activity of the other figures; this figure is so tentatively sketched that neither its sex nor its pose can be precisely determined. In the frescoed version, the pose of the couple is radically transformed. The indeterminate figure in the group no longer holds hands with the lounging youth, but instead crowns him with a laurel wreath, which as we have already seen is of great importance to the iconography of the *Age of Gold*.[130]

We have no similarly advanced composition study for the *Age of Silver*. The Munich drawing discussed above is the only known preparatory study related to the

[128] Drawing Cat. No. 1.
[129] Drawing Cat. Nos. 5, 17, and 19.
[130] The final pose of the male youth in this group may have been derived from Sebastiano del Piombo's *Polyphemus* who stares longingly at Raphael's *Galatea* from the adjacent wall compartment in the Farnesina (P. d'Ancona, *Gli affreschi della Farnesina*, Milan, 1955, Fig. 20).

entire composition, although others were certainly made. In this drawing, Cortona considered an asymmetrical format of low pyramidal group played off against taller vertical massing; in the fresco he repeated in reverse the general grouping in the *Age of Gold*.[131] As already noted, the recumbent nymph in the drawing passed almost unaltered into the fresco.[132] From her first appearance she displayed a marked similarity to a conventional antique type and also a close connection with the female repoussoir figure in the lower right corner of the Bacchus and Ariadne panel in the Farnese Gallery.[133] Such a "Bacchic" prototype is by no means out of place in this depiction of the *vendemmia*, or grape harvest, and Cortona has underscored the Bacchic associations by quoting also from his own *Triumph of Bacchus*, from which comes the motif of the *putto* eating grapes.[134] The other figure in the *Age of Silver* who can be found in the Munich sketch undergoes, in contrast, a drastic revision of position and posture. In the fresco the figure carrying an animal over his shoulder is moved to the left middleground and adjusted so that he turns into the scene, in which position his pose suggests a rather striking connection with the antique statue of Laocoön.

Surely one of the most striking features of these pendant Ages is the rapidity with which they were conceived and executed. The large *giornate*, the demarcations of each day's labor, are clearly visible in the frescoes and easily detected in photographs.[135] Each fresco contains about fourteen *giornate*, indications of the relatively short time Cortona required for actual execution. The sutures along the edges of the *giornate* reveal that Cortona worked from top right to left and down instead of the customary top left to right and down. This sequence would be less surprising were Cortona left-handed, but the shading lines on the frescoes and in the preparatory drawings provide convincing evidence that he was right-handed.

The *giornate* are also a reminder that we are concerned with a major fresco painter, one whose technique deserves some comment.[136] The presence of clearly defined *giornate* and the fact that the color value of a particular object or surface will often vary considerably on either side of a suture in Cortona's frescoes are clear evidence that he

[131] The Munich composition drawing is very nearly a mirror reversal of Cortona's slightly earlier painting of *Jacob and Laban* now at the Louvre (Briganti, *Pietro*, 209f., Fig. 158). A number of motifs in the two Ages can be found in Cortona's *Xenophon Sacrificing to Diana*, now dated 1631 (I. Lavin, "Pietro da Cortona Documents from the Barberini Archive," *Burlington Magazine*, CXII, No. 808, July 1970, 450 and Fig. 26).

[132] This evolution, devoid of any major changes, may be traced in Drawing Cat. Nos. 28, 31, 33, and 34.

[133] For confirmation see Martin, *Farnese Gallery*, 153, n. 22.

[134] Cf. Briganti, *Pietro*, Pl. 28.

[135] For the following observations I am greatly indebted to Leonetto Tintori, who took time to discuss the frescoes with me and generously shared his unparalleled knowledge of fresco technique.

[136] To the best of my knowledge a serious investigation of baroque fresco techniques has never been undertaken. For the best discussion to date of fresco technique see L. Tintori and M. Meiss, *The Painting of the Life of Saint Francis in Assisi*, New York, 1962, which also provides a selective listing of technical studies on fresco problems (187f.). Further material is presented by L. Tintori and M. Meiss, "Additional Observations on Italian Mural Technique," *Art Bulletin*, XLVI, No. 3, Sept. 1964, 377ff. A lucid account of traditional fresco methods is to be found in Borsook, *Mural Painters, passim*.

37

worked in *buon fresco*. Like most *buon frescanti*, however, he was not a purist about his medium and occasionally applied *al secco* passages to the fresco surface, a technique that has been recently defined as *secco su fresco*.[137] This combination of media helps explain the brilliance of Cortona's color, his success with highlights and bold coloristic effects including the depiction of *changeant* fabrics. From close examination of the frescoes, it can be determined that the middle ranges of color are certainly applied in *buon fresco*, that is, directly to the fresh *intonaco*. In a few cases, darker tones and highlights have been added later. In a few instances in which these colors have been slightly chipped, the middle range color is revealed underneath. Yet even these added passages appear very much a part of the mural surface, revealing the granular surface of the plaster.[138]

We would not have expected Cortona to transfer his designs to the wall by any method other than by means of cartoons (whose design would be pressed into the fresh soft *intonaco* by means of a stylus), and their use can be confirmed even though they are now lost or destroyed. F. S. Baldinucci mentions that the cartoons for the Sala della Stufa were presented to Buonarroti, his host and the programmer of the decorations.[139] The existence of these cartoons is further confirmed by Buonarroti's letter to Arrigucci of August 24, 1641, in which he mentions Cortona's gifts of "some sheets of drawings and cartoons," and in a late-seventeenth-century inventory of the Casa Buonarroti, the *Descrizione Buonarrotiana*, an entry reads, ". . . in the armoire at the end of the library room, where are the four cartoons of the Stufa of the Grand Duke"[140] Although visible only in a raking light, the incised marks of the stylus can be detected in the surfaces of the frescoes.

Consideration of the techniques leads to the question of Cortona's use of assistants. To study these frescoes at first hand is to realize that Cortona must have produced them virtually unaided. There is no indication of a second significant artistic personality involved in their execution;[141] they are all of a piece. Yet Cortona did have an artist to assist him. In his second letter to Cardinal Francesco Barberini, Cortona mentions a certain "Rafaello" who, from the context of the letter, is clearly an artist.[142] Bottari, who

[137] Tintori and Meiss, "Mural Technique," 377ff. For confirmation of Cortona's use of mixed media we can turn to the correspondence of the artist himself, for in his letter of September 13, 1637, Cortona informed Cardinal Barberini that, "I have nearly finished the two stories in fresco (i.e. the Ages of Gold and Silver), it only remains for me to retouch them." (Doc. Cat. No. 3.)

[138] There is one striking exception to this observation: the highlights on the beaded frames around the scenes. The beads appear to have been added after the scenes were frescoed (note for example the beads near the left toe of the recumbent girl in the *Age of Silver*, which vary in size to accommodate her foot). The highlights are set upon the surface, forming raised areas in the mural topography. These deductions are tentative and have been made on the basis of what is discernible to the naked eye and a magnifying glass, aided by a raking light.

[139] Samek Ludovici, "Vite," 82.

[140] Doc. Cat. No. 22 for the letter in question, and for the inventory see Procacci, *Casa Buonarroti*, 229. For references to other drawings Cortona gave to Buonarroti see p. 227f.

[141] The question of hands presents no interesting problem though it is possible that an assistant put in foliage and minor background passages.

[142] Doc. Cat. No. 3.

first published this letter, was uncertain about the identity of this person whom I would tentatively identify as Raffaellino Mandossi, an obscure student of Cortona whose name and career are briefly noted in Giuseppe Ghezzi's history of paintings exhibited in the cloister of San Salvatore in Lauro between 1682 and 1716.[143] In 1713 a figure of St. Bassianius by Mandossi was exhibited, and Ghezzi provides a short profile of the artist. He is described as Genoese, the son of a certain Matteo Mandossi, who was a servant in the Genoese embassy at Rome. He became a pupil of Cortona under the auspices of the Sacchetti. According to Ghezzi, he was making great progress as a painter until his death from a venereal disease at the age of twenty-three.[144] Possibly he is also the *giovane di rispetto* described by Buonarroti as Cortona's companion at the Casa Buonarroti when he returned to Florence in 1641.[145]

While the Sala della Stufa frescoes were nearing completion, the Grand Duke and his advisers must have appraised them and made the inevitable comparison with the incomplete decorations of Giovanni da San Giovanni in the Salone Terreno [Figs. 151, 152, 153]. It is instructive to repeat the comparison.

Cortona's compositions are clear examples of the Roman Grand Manner of the as yet unnamed style of the Baroque. Full-bodied figures are interlocked in simple, monumental groupings. Movement and gesture are readily comprehensible, and amplitude of form is enhanced by the rich abundance of color. The frescoes of Giovanni da San Giovanni are quite different. He seems deliberately to have eschewed conventional, geometrical composition devices in favor of broken curvilinear groupings. His scrawny and sinewy figure style is diametrically opposed to that of Cortona. The differences between the two sets of frescoes is heightened by their color; the delicate and subtle hues of the Salone Terreno seem rarefied and precious compared to the opulent colors of the Sala della Stufa.

There are, however, similarities in the frescoes of the two artists that seem to be as consciously selected and as deliberate as the glaring differences. These similarities have to do with the settings of the scenes portrayed. The scenes in the Salone Terreno are an integral part of a *quadratura* system whose illusionistic architecture is designed to suggest a large pavilion through whose arcaded sides and open ceiling a series of dramatic events are viewed. Cortona, in the Sala della Stufa, created an analogous setting, a fact that is especially striking if we think of the Rosselli ceiling decorations as no more than an elegant canopy. Capitalizing on the loggia aspects of the room, he utilized the pre-existing groups of pilasters in such a way as to suggest a free-standing pavilion supported at the corners and midpoints of each wall. To heighten this effect he even added illusionistically frescoed pilasters to each cluster of real pilasters and reinforced the lintel-like quality of the stone moldings that form a cornice just below the lunette frescoes. At the midpoints of the illusionistically painted lintels, Cortona frescoed suspended cartouches on which are mounted grimacing faces. He also frescoed garlands that hang

[143] See Briganti, *Pietro*, 284ff.
[144] *Ibid.*, p. 285.
[145] See Doc. Cat. No. 22.

in swags between these cartouches and the frescoed capitals at the corners of each scene. Just as Giovanni da San Giovanni had done in the Salone Terreno, Cortona retained a decorated wainscoting,[146] and he also strengthened the area directly beneath his frescoes by adding heavy, illusionistically painted moldings above a stone chair rail that formed the top of the original area demarcated as a wainscot.

These similarities, limited to illusionistic setting, suggest that Cortona sought to enhance the loggia or pavilion effect of the small room and thereby to draw attention to the fact that his Ages presented an alternative style to that used by Giovanni da San Giovanni in his "pavilion" on the ground floor of the palace. The future course of events indicates that the intended comparison was made and that Cortona's frescoes were highly favored and, in point of fact, swung the balance in favor of the incorporation of other foreign artists in the decorative program of the Pitti Palace.

We do not know whether or not the Florentine court hoped that Cortona would stay in Florence, finish the Sala della Stufa, and then continue with the decorations in the three remaining rooms in Giovanni da San Giovanni's commission. We do know, however, that when Cortona quitted Florence in the early autumn of 1637, the Grand Duke was anxious to commission non-Florentine artists to finish the ground floor rooms and that, through the intercession of Cardinal Sacchetti, he had secured Angelo Michele Colonna, the Bolognese quadraturist, by November of that year.[147] Colonna started the decorations in the first room in the remaining series of three, that is, the room immediately adjacent to the Salone Terreno.[148] He was later joined by Agostino Mitelli, who collaborated with him in the execution of the decorations of the other rooms. While Mitelli and Colonna were at work, but not until one month short of a year after they started, three Florentine artists, Francesco Montelatici (Cecco Bravo), Ottavio Vannini, and Francesco Furini, were commissioned to complete Giovanni da San Giovanni's Salone in accordance with a revised program. The parceling out of the three undecorated walls of the Salone, in contrast to the large commission tendered the Bolognese

[146] This area has since been repainted in a neoclassic style.

[147] For further details see Campbell, "Medici Patronage," 135f.

[148] It has been incorrectly assumed that Colonna started with the third room in the series, i.e., the room nearest to the nineteenth-century stairway that now provides public access to the Museo degli Argenti and the Galleria Palatina (cf. R. Battaglia, "Note su Angelo Michele Colonna," *L'Arte*, XXXI, Jan.-Feb. 1928, 17f.; E. Feinblatt, *Agostino Mitelli Drawings: Loan Exhibition from the Kunstbibliothek, Berlin*, Los Angeles, 1965, *passim*; I. Svensson, "Disegni inediti di Angelo Michele Colonna," *Arte Antica e Moderna*, Nos. 31-32, July-Dec. 1965, 368f., all of whom state or imply either that the *first* room to be painted was the one nearest to the modern entrance to the Museo degli Argenti or that the *last* room in the series was the one nearest to Giovanni da San Giovanni's Salone Terreno). That the first room to be decorated by Colonna was adjacent to the Salone Terreno can be proven from an examination of an inventory of this range of rooms made on February 26, 1638, in which this room is described as "Camera . . . di Audienza" and is described, like the incomplete Salone Terreno, as being empty. In contrast the two rooms to the east are described as richly furnished; six paintings are recorded in the middle room and four in the third room, i.e., the room previously identified as the first in the series to be painted. The Colonna-Mitelli frescoes make the installation of paintings quite impossible (Florence, A.S.F., Guardaroba Medicea, F. 525, cc. 3v-5r; see also A.S.F., Guardaroba Medicea, F. 535, cc. 1-6).

quadraturists, indicates the shift in Medici taste caused by Cortona's frescoes. Further evidence of Medici re-evaluation of local talent is the fact that Filippo Baldinucci reports that, prior to turning over the unfinished Salone Terreno to a consortium of Florentine artists, consideration was actually given to destroying those portions Giovanni da San Giovanni had completed and that only the good offices of Jacapo da Empoli, elder statesman among the Florentine painters, saved them.[149]

The Ages of Gold and of Silver in the Sala della Stufa initiated a new stylistic trend in Florence. In matters of art the Medici were now in accord with, and even willing to imitate, the patronage of their political rivals, the Barberini.

The Second Campaign

Throughout the closing months of 1637 Cortona maintained a steady exchange of letters with his Florentine host, Michelangelo Buonarroti the Younger.[150] On January 9, 1638, Cortona wrote a general letter of greeting to Buonarroti, saluting him with best wishes for the new year and acknowledging his obligations to the Medici.[151] Seven days later he wrote again.[152] This letter was an acknowledgment of the receipt of some poems by Buonarroti, but no mention of the grand-ducal commission was made. Then on December 25, Cortona wrote again to Buonarroti offering him season's greetings.[153] Finally the silence was broken with regard to the Sala della Stufa commission. On June 11, 1639, Michelangelo Buonarroti the Younger wrote to Luigi Arrigucci in Rome announcing that the artist was expected in Florence.[154] He added, somewhat ruefully, "I know that he has things to do, serving there [in Rome] with great works the Padroni [meaning, of course, the Barberini], but his valor makes him desired by all"

There followed a lengthy period without communication until September 24, 1639, when Cortona wrote a long letter to Buonarroti.[155] In it he stated, "now I am at the end of the work of the room of the Cardinals Barberini [i.e. the Salone Barberini] which I am finishing, and already I have started to raise part of the scaffoldings that have carried me a longer time than I believed possible. Thus, in order for it to be a great work I must continue to stay at Rome, where it is necessary to finish things well so that it [will] be a work of a greatness that one does not do every day. I have not wished to make it less than the diligence of which I am capable. However, I hope to be finished in a month and a half, for now the large cornice which goes around [the ceiling] is being gilded. Since the season is well along I plan to be there [in Florence] in March if at that time it will please His Highness that the room underway be finished." That the Salone Barberini was completed close to the projected schedule is supported by an *avviso* dated December tenth, 1639, which records the inspection of the decorations

[149] Baldinucci, *Notizie*, 1728, VI, 45.
[150] Doc. Cat. Nos. 5 and 6.
[151] Doc. Cat. No. 7.
[152] Doc. Cat. No. 8.
[153] Doc. Cat. No. 9.
[154] Doc. Cat. No. 10.
[155] Doc. Cat. No. 11.

by Urban VIII.[156] Eleven days later, in another letter to Buonarroti,[157] the artist reaffirmed his intention to arrive in Florence by March.

It has been generally assumed, on the basis of the foregoing letters, that Cortona returned to Florence around March 1640 to complete the Sala della Stufa. The traditional commencement date for his work in the room has been adduced from the letter of the then-Monsignor Jules Mazarin supposedly sent to Cardinal Antonio Barberini (actually addressed to Cardinal Giulio Sacchetti and filed with the Barberini papers) in which the procurement of Cortona's services at the French court in Paris is discussed: "Sig. de Chantelù [Paul-Fréart, Sieur de Chantelou] has stated that Sig. Pietro [da Cortona] was satisfied with the commitment [*impegno*] which he had with the Grand Duke in the summer just passed."[158] Hans Posse, who found the letter, and Hans Geisenheimer, who published it, both identified the *impegno* as the arrangements for the remaining work in the Sala della Stufa. Geisenheimer dated the letter simply 1641 and assumed that the summer "just passed" must be that of 1640, a dating which won general acceptance. In point of fact, this important letter is dated September 26, 1641, and thus the summer "just passed" must refer to that of 1641.[159] When another documentary source, the *bozza* of a letter to Michelangelo Buonarroti the Younger, is introduced, all possibility of a 1640 sojourn is eliminated, and we are permitted to establish *in fine* the period of Cortona's second campaign in the Sala della Stufa, not to mention a number of other interesting aspects of the situation in Florence.[160] The letter, dated August 24, 1641, and addressed to Luigi Arrigucci in Rome, opens with a brief eulogy to Pietro da Cortona describing him as one of the "finest men in the world," but cautions Arrigucci that the contents of the letter are to remain in confidence. Buonarroti then explains how Cortona arrived in Florence four years earlier in the company of Cardinal Sacchetti and how, with the writer as an intercessor, it was arranged that the artist should execute a commission for the Grand Duke before he continued his travels. With the approval of Cardinal Sacchetti, it was also agreed that the artist would live in the Casa Buonarroti. Cortona, the letter continues, was Buonarroti's guest for four months, notwithstanding the summer heat and the considerable distance between the Casa Buonarroti and the Pitti Palace.[161] Buonarroti confesses to considerable inconveniences in view of the limitations of his guest quarters and then adds that Cortona, who decided to leave the work unfinished in order to make a trip through Lombardy, had informed him that

[156] "Di Roma x dec. 1639. Quel giorno [Monday] dopo pranzo . . . Sua Santità . . . si compiacque di vedere le belle figure fatte dal famoso Pittore Pietro da Cortona nella sua sala del Palazzo del detto Sign. Card. Antonio Barberini." (O. Pollak, *Die Kunsttätigkeit unter Urban VIII*, Vienna, 1928, 1, 328, No. 922.)

[157] Doc. Cat. No. 12.

[158] Geisenheimer, *Pietro*, 5, n. 1: "Sig. de Chantelù ha riferito che il Sig. Pietro havrebbe sodi-sfatto all'impegno, in che era con il Gran Duca nell'estate già passata." (See Doc. Cat. No. 27.)

[159] First noted in M. Campbell, *Mostra di disegni di Pietro Berrettini da Cortona per gli affreschi di Palazzo Pitti*, Florence, 1965, 17, n. 2.

[160] Doc. Cat. No. 22.

[161] A slight exaggeration since Cortona, according to our deductions, was probably in Florence only from the latter part of June to mid-September.

when he returned to complete his work he would in fact seek lodging in the vicinity of the Pitti.

During the three and a half years that followed the first campaign in the Sala della Stufa, Buonarroti informs Arrigucci, he was called many times to appear *in camera* by the Grand Duke to answer demands as to when Cortona would return. To this purpose, Buonarroti continues, he wrote many times to Cortona, but the response of the artist was always the same; namely, that he was involved in work for the Barberini. Finally, an exchange of letters occurred in January 1641, the upshot of which was that Cortona arrived in Florence on May second of that year and, much to the consternation of Buonarroti, reinstalled himself as a guest in the Casa Buonarroti with grand-ducal approval until the following September. Buonarroti, it would seem, was beside himself. His house, he informs Arrigucci, was ill-designed to house comfortably Cortona and a young companion, without severely inconveniencing himself, particularly since his health had seriously declined of late.[162]

Now Buonarroti writes in exasperation that Cortona has undertaken "months and months of new work," which he plans to interrupt with a trip to Rome at Christmas after which he will return to continue his labors in the Pitti Palace. Buonarroti ends with a plea to Arrigucci to intervene on his behalf and assist in the removal of Cortona from his house with discretion, but also with the maximum alacrity.

The letter we have remarked in such detail sheds light on several aspects of Cortona's Florentine period; it yields information about his negotiations, his living conditions, and the chronology of his work in Florence. It also tells us much about his personal relations in Florence, much, indeed, that he himself can scarcely have known or in any event have learned only later. The information in this remarkable document meshes with and enhances the other primary source materials available for establishing the chronology of the second campaign in the Sala della Stufa. Beyond all doubt, Cortona left Florence in late September or early October 1637 and did not return until May 2, 1641, when he arrived to finish the two remaining frescoes in the Sala della Stufa, a work which, we should note, he had estimated would take two months of work.[163] Thus it is not surprising that when Cortona wrote to Cassiano dal Pozzo on June 11, 1641, he stated that "I am disposing of the task so speedily that already with regard to the fresco the work is coming to a fine conclusion."[164]

From the Medici building records we may ascertain with considerable precision the *terminus ante quem* of the last campaign in the Sala della Stufa. This information is provided by an estimate of the expenses anticipated in the first room in the series Cor-

[162] These complaints are a more serious reverberation of Buonarroti's distress caused by Cortona's extended stay at the Casa Buonarroti in 1637, of which we saw signs in the letter of Jacopo Soldani, written on the eve of the painter's departure. (Doc. Cat. No. 4.)

[163] Doc. Cat. No. 3.

[164] Doc. Cat. No. 13. It has been previously assumed that this referred to work in the Sala di Venere. See, for example, Geisenheimer, *Pietro*, 31, No. 21.

tona decorated after he completed the Sala della Stufa. This estimate is dated August 3, 1641, and is described as for the room that "Pietro da Cortona has to paint," implying that he was about to start work on this room.[165]

The two frescoes executed in the Sala della Stufa between May 2, 1641, and August 3 of the same year admirably complete and complement the first two scenes in the cycle and continue, when read in clockwise sequence, the Ovidian theme of the Four Ages of Man. On the northwestern wall is the *Age of Bronze* [Fig. 10], the successor in the Ovidian sequence of the *Age of Silver*: "Next after this and third in order came the brazen race, of sterner disposition, and more ready to fly to arms savage, but not yet impious."[166] Cortona amplified Ovid's brief description and evoked a scene of Roman conquest in which prisoners and captured arms are gathered in the foreground, and immediately behind them a general or emperor distributes crowns to loyal legionnaires who, with much gesticulation, exhibit their battle wounds. Cortona stressed the aggressive instincts of this age as described by Ovid, but the phrase "yet not impious" had not been overlooked, for in the background of the left section of the fresco a woman kneels before a statue of Christ who is housed in a small round temple [Fig. 11].

Before exploring the *Age of Bronze* and the related preparatory studies, let us turn to the last of the Four Ages [Fig. 12], for which Ovid saved his most pessimistic description: "The age of hard iron came last. Straightaway all evil burst forth into this age of baser vein: modesty and truth and faith fled the earth, and in their place came tricks and plots and snares, violence and cursed love of gain. Men now spread sails to the winds, though the sailor as yet scarce knew them; and keels of pine which long had stood upon high mountain-sides, now leaped insolently over unknown waves. And the ground, which had hitherto been a common possession like the sunlight and the air, the careful surveyor now marked out with long-drawn boundary-line. Not only did men demand of the bounteous fields the crops and sustenance they owed, but they delved as well into the very bowels of the earth; and the wealth which the creator had hidden away and buried deep amidst the very Stygian shades, was brought to light, wealth that pricks men on to crime. And now baneful iron had appeared, and gold more baneful still; war came, which fights with both, and brandished in its bloody hands the clashing arms. Men lived on plunder. Guest was not safe from host, nor father-in-law from son-in-law; even among brothers 'twas rare to find affection. The husband longed for the death of his wife, she of her husband; murderous step-mothers brewed deadly poisons, and sons inquired into their fathers' years before the time. Piety lay vanquished, and the maiden Astraea, last of the immortals, abandoned the blood-soaked earth."[167] Greed, violence, plunder are given a special place in the frescoed scene in which a pagan house of worship is sacked by fierce soldiers who respect neither age nor sex in their looting. Stressed also are the Ovidian leitmotifs of the Age: the flinty iron of the soldiers' weapons and the gleaming gold that is the object of their desires.

[165] Doc. Cat. No. 16.

[166] Ovid *Metamorphoses* I. 125 sqq.

[167] *Ibid.*, 127 sqq.

According to our calculations, it would have been possible for Grand Duke Ferdinand to enjoy the completed fresco cycle of the Four Ages of Man as a splendid decorative ensemble toward the latter part of July 1641. By then he could have also indulged in the activity dear to the heart of seventeenth-century connoisseurs, that of reading the scenes. To the Grand Duke and his circle no assessment of the frescoes would have been complete without consideration of the relation of the frescoes to their literary source, and, beyond that, the more subtle nuances of the interpretation of that source, the *concetto*, which constituted the very kernel of the work of art to which the qualities of style and form contributed.

From what we have adduced from the first two Ages, it is obvious that an essential aspect of the *concetto* is the theme of the Return of the Golden Age, which Buonarroti introduced into the cycle in order to celebrate the Medici-Rovere union and the anticipated birth of an heir. In order to imbue the Ovidian cycle with this double meaning, Buonarroti turned, as noted in our consideration of the first two Ages, to several Virgilian sources including the Fourth Eclogue, which predicted the coming of a new golden age to supplant that of the present, the Age of Iron.[168] "Now is come the last age of the song of Cumae; the great line of centuries begins anew Only do thou, pure Lucina, smile on the Birth of the child, under whom the iron brood shall first cease, and a golden race spring up throughout the world!" Cortona's problem was to produce a cycle that would keep intact the conventional, Ovidian sequence but to freight it with motifs that would permit the cycle to be read as celebrating the Virgilian Return. Two possibilities were open to the artist. One was to simply suggest the continuation of a clockwise narrative *from* the *Age of Iron to* the *Age of Gold*. The other possibility, considerably more complex and subtle, was to interweave motifs implying a counterclockwise reading with those illustrating the Ovidian Four Ages.

Focusing on key passages in the Fourth Eclogue, Cortona, following the advice of Michelangelo the Younger, chose the latter solution. The verses in question describe the coming of the new Golden Age as a gradual change rather than a sudden transformation, one in which peace and plenty are commingled with motifs from the later Ovidian Ages: "But soon as thou [the new-born hero] canst read of the glories of heroes and thy father's deeds, and canst know what valour is, slowly shall the plain yellow with the waving corn, on wild brambles shall hang the purple grape, and the

[168] Virgil in turn based his concetto upon the Sibylline Oracles (*Oracula Sibyllina* iii. 743-759, 787-795), which supposedly records the utterances of the famous sibyl of Cumae who prophesied a new circuit of ages after the Age of Iron had passed. To this prediction Virgil added two important elements: first, the vision of a new golden age under Augustus Caesar, and second, the time of this event to be determined by the birth of a certain child. The same themes occur in the *Aeneid* vi. 777 sqq. For a discussion of the relation of Virgil's text to that of the Cumaean Sibyl, see Lovejoy and Boas, *Primitivism*, 85ff. It should be stressed that the interpretation of the Age of Iron as extending to present time cannot be adduced from Ovid in whose account the iron race is destroyed by flood, but *only* when the Virgilian text is applied to the cycle. Cf. Vitzthum, "Correspondence," 121, who assumed that Ovid's last age extends to present time. The lines in question are found in Virgil *Eclogue* iv. 4.

stubborn oak shall distil dewy honey. Yet shall some few traces of olden sin lurk behind, to call man to essay the sea in ships, to gird towns with walls and to cleave the earth with furrows"[169]

For the gradual return of the Age of Silver [Fig. 3], this passage is very useful. The references to grapes and cultivation fit well with Cortona's conception of that age. More striking, however, is that in the background of his fresco, on a patch of sea near the horizon, Cortona included the ships of sail mentioned by Virgil, but which, as we earlier noted, are not mentioned until the Age of Iron by Ovid.

In the Virgilian passage that follows, the transfer from the Age of Silver to that of Gold is completed: "Next, when now the strength of years has made thee man, even the trader shall quit the sea nor shall the ship of pine exchange wares; every land shall bear all fruits. The earth shall not feel the harrow, nor the vine the pruning-hook; the sturdy ploughman, too, shall now loose his oxen from the yoke."[170]

When we turn to the two Ages frescoed in Cortona's second campaign, Virgil's account is less useful, for it supplies little more that is applicable than the mention of walled towns and continued strife. Therefore either Buonarroti or Cortona, or perhaps both, decided to exploit Ovid's mention of the Bronze Age as free from impiety and to use this motif to reverse the sequence of the last two Ages; thus the Age of Iron is a pagan, Roman setting and that of Bronze is depicted as a scene in the period of Christianized Rome. This arrangement not only reversed the sequence of the two Ages, it also placed both of these Ages in historic time. Thus the Four Ages are split into two groups; the Ages of Iron and Bronze are conceived as within historic time in their Ovidian sense and, more significant in the context of the fresco cycle, as extending into future time as an allegory of the Virgilian predictions that depend on the birth of an as yet unconceived child. This elaboration of the Four Ages does considerable violence to the Ovidian text and raises the important question of whether or not it is valid even to refer to the cycle as the Four Ages of Man, or if as has been suggested it is more correctly entitled the Return of the Golden Age.[171]

The title given the cycle depends very much on the role one assigns its *concetto*, that is, to the introduction of the theme of the Return of the Golden Age under Medicean rule into a cycle illustrating the Four Ages of Man. It should be noted that we are dealing with a four-part cycle whose periodical denominations of Gold, Silver, Bronze, and Iron do not collectively belong to the literary tradition of the Return of the Golden Age in which only two Ages are mentioned by name: Iron and Gold. The sequence of four Ages as represented by Cortona is provided in its canonical form by Ovid. Thus the Four Ages of Man constitute the fundamental structure of the cycle, the first, immediate layer of significance in its interpretation. To this theme Buonarroti added a second; this is the *concetto* of the Virgilian Return, which was so interwoven as to become intrinsic to the cycle, but which was to be accessible only to those who

[169] *Ibid.*, 26 sqq. [170] *Ibid.*, 37 sqq. dence," 120f. See also my comments in the same
[171] As proposed by Vitzthum, "Correspon- issue of the magazine, 121ff.

46

possessed the "key" or who were sufficiently erudite and observant to decipher it. We therefore argue that the primary theme of the cycle is the Four Ages of Man as recounted by Ovid and that the Return of the Golden Age as described by Virgil is the secondary theme of the cycle.

Considerable evidence supports this thesis. It should be noted that the *concetto* of the Return of the Golden Age did not even enter the seventeenth-century descriptions of the Stufa frescoes in which they are consistently entitled the Four Ages.[172] Although the *Age of Bronze* is the scene most readily apprehended by the spectator as he walks through the doorway into the room, it is with the *Age of Gold* that the spectator is in most immediate contact once the threshold has been crossed. In contrast, the *Age of Iron* can be seen only when the spectator has moved in a clockwise arc in which he embraces the Ages in their Ovidian sense or by a less natural counterclockwise movement in which the *Age of Gold* would still almost certainly be seen before that of Iron. We tend to view a series of objects in a left to right direction. In general this essentially literary convention is followed in the presentation of scenes in series.[173] Another important consideration is that only in the *Age of Gold* are motifs implying a reverse reading given a prominent compositional role. In the *Age of Bronze*, the scene of Christian devotion occurs in the left background of the fresco. In the *Age of Silver* the sailing ships are all but invisible on the horizon, and, although it is in the foreground, the bronze urn is obscured by foliage. Thus the theme of the Return can be ascertained only when the frescoes are closely examined. Finally, the preparatory drawings provide evidence that the cycle was conceived as the Ovidian Four Ages of Man with the theme of the Return confined to the first two Ages. Although the Return via the other Ages may have been determined before Cortona left Florence in 1637, its application to the last two Ages was not resolved until later, in fact probably not until he returned to Florence in 1641. With these observations in mind, we can direct our attention to the important

[172] See especially the detailed description of the frescoes provided by Giovanni Cinelli: "Segue dipoi la Stufa del Padron Ser.mo quale è tutta da Pietro da Cortona vagamente a fresco dipinta; in ogn'una delle facciate è una delle 4 Età dipinta; Vedesi in questa l'età dell'oro ove molti fanciulli domesticamente col Lione scherzando si stanno mentre altri a'lor passatempi intenti di sollazzar si studiano. Quivi è la dilicatezza del mondo, e la gioia, e l'allegrezza tutta racchiusa, ed ognuno a quelli spassi che più gli aggradano se ne sta applicato. Segue l'Età dell'Argento, nella quale a varie opere boscherecce, e di campagna stanno le genti intente, scherzano molti con l'uve, altri le pecore mugnendo il latte raccolgono. Età del Rame ove molti soldati le cicatric' per le ferite ricevute nelle battaglie al Dittatore mostrando son da esso con larghi premi rimunerati, e le fatiche loro ricompensate. Nell'altra è l'Età del Ferro nella quale alcuni soldati mentre in un tempio si sacrifica furiosamente in quello entrando non solo de' vasi o paramenti al sagrifizio destinati lo spogliano, ma tratti da furor militare anche da' capelli delle caste donzelle con mano armata per saziar lor avide brave le gioie imbolano; son tutte queste molto vaghe e di stima, e del luogo ov' elle sono d'esser collocate ben degne" (Florence, Biblioteca Nazionale Centrale, MS Magliabechiano, XIII, 34, cc. 139r-139v). See also Samek Ludovici, "Vite," 82ff.; Passeri, *Vite*, 383; and the Medici inventories of the Pitti Palace which refer to the decorations as the Four Ages of Man (see especially the 1663 inventory, A.S.F., Guardaroba Medicea, F. 725, c. 57v).

[173] A notable exception is Andrea del Sarto's Baptist cycle in the Chiostro dello Scalzo, which reads counterclockwise.

composition studies for the Ages and consider them both as stages in the genesis of the compositions of the Ages and as documents of the growth of its iconography.

From the preparatory studies we have already considered, it can be ascertained that either the *concetto* of the Return of the Golden Age and its allusions to the contemporary Medicean celebrations took shape in the mind of Buonarroti gradually or that Cortona did not fully grasp the *concetto* in the initial stages of his work on the cycle. As evidence we have the Munich preparatory study [Fig. 8] in which elements of both the Ages of Gold and Silver appear.[174] The theme of the gathering of oak leaves and branches is presented in this sketch, a motif essential for the Medici-Rovere connection with the first Age, but the numerous motifs that relate the frescoed scene to Virgil's Return of the Golden Age are missing. The Uffizi preparatory study [Fig. 9] presents most of the essentials used by Cortona in the final *Age of Gold* fresco except for the prominent display of the youth being crowned at the far left of the fresco and the discarded gold patera in the lower right corner of the scene. In this context, we should recall that the youthful couple seated beneath the oak in the *Age of Gold*, which closes a counterclockwise reading of the frescoes, was not introduced into the scene until the moment of its execution, for the *intonaco* on which they are executed is actually a patch replacing an area chiseled away. By the time the first two Ages were complete, however, the theme of the Return through the Ages was established. This is made clear by the aforementioned motifs of patera, urn, and ships, none of which appears to have been added *al secco* when Cortona returned to Florence in 1641. It follows that the theme of the Return was not explicitly stated in the initial formulation of the first two Ages, but it was definitely established before they were executed in fresco. With this fact in mind let us turn to the last two Ages.

The last two Ages in the cycle presented special problems to both Cortona and Buonarroti. Ovid's brief description of the Age of Bronze provided few motifs for visual presentation. Ovid merely informs us that the inhabitants of this age were more warlike than those of the preceding age, but not yet impious. Since the Age of Iron was also bellicose, this aspect of the Age of Bronze provided no contrast with the last one in the cycle. It was the religious tolerance of the Age of Bronze, then, which set it apart from the Age of Iron, where "piety lay vanquished, and the maiden Astraea [Justice], last of the immortals, abandoned the blood-soaked earth."[175] This contrast provided the theme of the Cortona-Buonarroti interpretation of the last two Ages. How it was developed and finally used to provide a reverse reading from the *Age of Iron* to the *Age of Bronze* can be ascertained from extant preparatory studies.

To date, six such studies have been assigned to the *Age of Bronze* [Fig. 10], and recently a sequential ordering encompassing them all has been proposed by Felice Stampfle and Jacob Bean, according to whom the drawings are to be arranged as follows: a pen sketch from a private collection [Fig. 13], a drawing in the Uffizi [Fig. 14],

[174] Drawing Cat. No. 2. [175] Ovid *Metamorphoses* I. 149 sqq.

one in Munich [Fig. 15], a drawing in Prague [Fig. 16], a sketch in the Metropolitan Museum of Art [Fig. 17], and a drawing of presentation quality in the collection of Walter C. Baker [Fig. 18].[176] Except for questions raised by the first drawing in this ordering, I find this sequence entirely convincing.

The first sheet [Fig. 13] in the Stampfle-Bean series presents a violent but somewhat indeterminate scene in which a group of bound prisoners is harassed by soldiers dressed in antique armor. The prisoners huddled in the lower right corner of the scene stare at the soldiers, two of whom point in the general direction of a blazing altar. Next to the foremost soldier a pagan priest kneels, holding a sacrificial patera. To the right of the priest a roughly sketched figure appears to threaten one of the prisoners with a knife. In the center foreground another patera is prominently displayed. The content of this drawing is far from clear. Are the soldiers forcing their prisoners—who are presumably barbarians or Christians—to worship a Roman deity, or are the prisoners about to be sacrificed to some god? In either case, the subject does not seem ideally suited to the Age of Bronze, for although the warlike aspect of the Age is represented, the element of religious tolerance described by Ovid seems subverted. Notwithstanding the similarity of the group of prisoners in the right foreground of this drawing to those that appear in later studies for the *Age of Bronze*, it is possible that this sketch was actually a very early study for the *Age of Iron*, with which its cruelty is more attuned. One point that argues for its connection with the *Age of Iron* is the fact that the light source in this drawing comes from the left and is consistent with the natural illumination of the Sala della Stufa only if the scene was intended for the wall occupied by the fresco of the *Age of Iron*. The drawing does not provide sufficient internal evidence on which to reach an absolute decision about its intended subject, a situation not unlike the one presented by the Munich drawing associated with the first two Ages [Fig. 8], which also ambiguously combined motifs appropriate to both earlier Ages. The interweaving of motifs germane to the Ages of Gold and Silver in the Munich drawing and the possibility of a similar stage in the evolution of the last two Ages, as attested by the drawing here under discussion, re-opens the possibility that two pendant scenes incorporating the Ages of Gold and Silver and the Ages of Bronze and Iron were contemplated at the initiation of the commission. It should be noted, however, that the two drawings in question vary markedly in proportion and format.

With the next drawing for the *Age of Bronze* we are on firmer ground [Fig. 14]. This drawing, the verso of a sketch [Fig. 162] of SS. Luca e Martina under construction [Fig. 140], is, owing to its recto, a datable document. According to K. Noehles, who first published it, the recto of this drawing records the condition of the church at the time Cortona left Rome for his north Italian sojourn with Sacchetti in June 1637, and thus argued Noehles, the recto provides us with a 1637 version of the *Age of*

[176] This ordering is presented in F. Stampfle and J. Bean, *Drawings from New York Collections*, *Vol. II: The Seventeenth Century in Italy*, N.Y., 1967, 49f., Cat. No. 62. Drawing Cat. Nos. 42-47.

Bronze.[177] Obviously, the correctness of this dating hinges on the condition of the church in June 1637, and it is difficult to agree with Noehles on the basis of what is known about its construction. Cortona was given permission to rebuild, according to his own plans and at his own expense, the crypt of the church of the Academy of St. Luke in July 1634.[178] Late in October of that year, in the course of excavating the crypt, the bodies of St. Martina and two companions were discovered. On July 7, 1635, Cardinal Francesco Barberini ordered that the church be rebuilt "from its foundations." Although a small amount of work was done on the sacristy of the church during 1635, most of the year appears to have been devoted to fund-raising for the edifice.[179] Toward the end of the year, marble was being stockpiled for the church, and houses on the site were bought up for demolition, a process that continued through 1636.[180] On January 4, 1639, Cortona was paid for columns to be used in the fabric of the church.[181] Columns, it should be noted, are used, with only two exceptions, on the ground story of the church, which leads us to a crucial question. In June 1637 could the church possibly have resembled the Uffizi sketch, which shows the facade slightly above the first story and parts of the vaulting and dome completed? Furthermore, if the church had been at this advanced stage in 1637, it is unlikely that Passeri's efforts to have Domenichino's funeral held there in April 1641 would have been thwarted by the incompleteness of the structure and consequently held at the Palazzo Cancelleria.[182] It therefore seems much more likely that the state of the church recorded in Cortona's sketch dates from the time of his departure for the second Florentine campaign. Such a date fits much better with Wittkower's assertion that the church was vaulted "by about 1644."[183] Of course an objection can be made on the grounds that we have no certain way of knowing if the recto or verso was drawn first, or even at the same time. It could be argued that Cortona drew the church on the verso of a 1637 drawing for the *Age of Bronze*, but this is unlikely. The sketch of the church is the more finished drawing; the *Age of Bronze* is no more than a *pensiero*, and therefore it is more probable that Cortona first documented the 1641 state of SS. Luca e Martina on this sheet; then, either on the eve of his departure for Florence or immediately after his arrival there, produced the sketch for the *Age of Bronze* which is now—and quite correctly—catalogued as the verso.

The 1641 date for this sheet is important to the genesis of both the Roman church and the Sala della Stufa frescoes. In the case of the latter commission, it points up the rather surprising fact that Cortona's conception of both the formal and iconographical aspects of the last two Ages in his cycle was still in an embryonic state when he left

[177] K. Noehles, "Review of G. Briganti, *Pietro da Cortona* . . . ," *Kunstchronik*, XVI, No. 4, April 1963, 105 and now also, K. Noehles, *La chiesa dei SS. Luca e Martina* Rome, 1972, 99ff.

[178] Cortona, who was *Principe* of the Academy at the time, intended to use the crypt as his tomb. For documents see Pollak, *Kunsttätigkeit*, I, 185ff.

[179] *Ibid.*, 188, Doc. No. 651. The year 1635 was also one of important changes in the design of the church (see especially Wittkower, *Art and Architecture*, 155, n. 18a).

[180] *Ibid.*, 190f., Doc. Nos. 657, 658.

[181] *Ibid.*, 191, Doc. No. 662.

[182] Passeri, *Vite*, 69.

[183] Wittkower, *Art and Architecture*, 155.

Florence in the fall of 1637; so embryonic in fact that what we know of the schema of the Four Ages and their *concetto* at that date must rest on the motifs in the frescoed versions of the first two Ages.[184]

With the Uffizi drawing, produced just prior to or at the moment of Cortona's arrival in Florence in 1641, we can commence a secure documentation of the evolution of the *Age of Bronze* [Fig. 10]. The drawing [Fig. 14], executed in a swift, brittle pen line whose angled calligraphy speaks for the speed with which Cortona recorded his conception, presents a composition dominated by two almost equally important groups that form opposing right triangles. The right-hand group has been given special emphasis. Set forward in space, it slightly overlaps its counterpart in the left side of the scene and is furthermore reinforced by a small triangular group in the lower right corner which echoes its configuration.[185] It is with this group in the lower right corner that the spectator makes first contact in viewing the drawing. The supine pose of the principal figure in this group leaves no doubt that Cortona here intended a prisoner—or prisoners—with an overseer. A captured battle standard lying foreshortened on the ground completes the triangulation of this group. Immediately adjacent to this sketchy image of subjugation two figures step onto a low podium to pay homage to a standing figure. The standing figure, who may be female, appears to place a wreath on the head of the first supplicant with one hand and to hold in the other a crown. A battle standard rises behind this group, and a temple appears further back in space. The left-hand triangular group is dominated by a bearded man who appears to be bestowing something or receiving something from two figures in obeisant poses. Their gestures suggest the enactment of a pagan religious ceremony. Behind this group there is a round temple. In this drawing, Cortona produced two almost equally balanced groups, one engaged in a religious ceremony and the other, slightly more emphasized, involved in a military ceremony.

The Uffizi drawing is very closely related to a study now in Munich [Fig. 15], in which the scene is much more clearly defined. In the latter drawing there appears once more the huddle of prisoners, and behind them a figure in Roman military dress—clearly a general or emperor—is seated on a faldstool placed on top of a suggestum and he is depicted in the act of crowning a soldier who, spear in one hand, steps upon the base of the podium and bows to receive the proffered crown. Immediately behind him another soldier bares his chest at which he points as he calls out toward the figure seated on the suggestum. Next to the seated figure can be discerned a table with other crowns. One, possibly two, figures assist him. Behind this group several Roman standards, one

[184] This constitutes a revision of earlier opinions. Writing in 1961 when only the Munich and Prague drawings were known, M. Laskin, Jr., and I argued that the former was produced in 1637 and the latter when Cortona returned to Florence ("New Drawing," 424), and more recently Stampfle and Bean have suggested on the basis of style that all of the Age of Bronze studies date from 1637 (*Drawings*, 49f., Cat. No. 62).

[185] I surmise from the position of the right-hand group in space that it is set slightly in front of its opposite in the left section of the fresco despite the fact that the latter group is drawn to a slightly larger scale.

51

carrying a vexillum, rise above the crowd. In the left section of this drawing a pagan sacrifice takes place. This scene has clearly been evolved from the left-hand group in the Uffizi drawing. Now, however, the action is more comprehensible. A priest dominates the group. He is assisted by acolytes and a muscular, bare-torsoed figure who is apparently preparing a sacrifice. The round temple, roughly sketched in the Uffizi drawing, is here given a more precise, if somewhat unusual, form. A curious structure, it appears to be a round temple with peristyle to which have been added two short projections.[186] A statue is placed at its center. The architectural background behind the right-hand group underwent two major changes. At first Cortona considered a variation on the peristyle temple in the Uffizi drawing [Fig. 15A]; then he produced an alternative, a Roman triumphal arch and in the background a coliseum which he drew on a movable flap of paper glued to the original sheet [Fig. 15].

In the Munich drawing two major actions are taking place. The first, and now the emphatically stressed one, is the crowning of loyal soldiers as kings of captured provinces, and the second is the performance of a religious celebration. Thus a warlike people, who rule by force but who are as yet free from impiety, are depicted, and the essentials of Ovid's Age of Bronze have been established. The juxtaposition of the round temple containing a pagan deity on the left and a Roman triumphal arch on the appended flap on the right serves to reinforce this content. The principal scene portrayed in this drawing is probably derived from an important act of the Roman emperors, the *Rex Datus*, in which a barbarian king friendly to the Romans was appointed by imperial investiture. The ceremony is depicted on Roman coinage.[187] Cortona merely changed the barbarian king to a Roman soldier and converted the Roman soldiery, who were normally witnesses to such investitures, into contestants for the same honor. The scene also calls to mind the ceremony of *Liberalitas*.[188]

Scenes of *Allocutio* may also have helped Cortona formulate his composition. In this connection it should be recalled that Cortona made drawings of the Column of Trajan, on which numerous presentation scenes occur.[189] Attention should be called as well to an important Renaissance source for the *Age of Bronze*. When Cortona produced cartoons for the completion of the Constantine Tapestries series that had been started by Peter Paul Rubens, he closely followed Giulio Romano's version of the

[186] The similarity of this temple to the portico Cortona designed for S. Maria della Pace (begun 1656) is striking (Fig. 180). The same side projections occur on the church portico at the point where it joins the facade, and just as the spaces between the columns of the temple have been adjusted to provide major axial views, so too have the columns of the church portico been grouped to provide easy access to the portal at principal points of entry.

[187] See for example H. Mattingly, *Coins of the Roman Empire in The British Museum*, London,

1936, III, Cat. No. 1043. The pose of the soldier receiving the crown may have been derived from a related scene in which a barbarian king swears fealty to the emperor (*ibid.*, Cat. No. 1014).

[188] R. Brilliant, *Gesture and Rank in Roman Art*, New Haven, 1963, 170ff.

[189] One such drawing has been located in the Fondo Corsini at the Farnesina. See A. Marabottini and L. Bianchi, *Mostra di Pietro da Cortona*, Rome, 1956, 57, Cat. No. 47, Pl. LI and for further comment and bibliography for Cortona's drawings of the column, 2 and n. 6.

Vision of Constantine in the Vatican Palace in designing the same scene for the tapestries.[190] In the *Age of Bronze*, Cortona again turned to Giulio Romano's fresco, especially for the soldiers gathered at the base of the podium. The soldier standing to the far right, however, is an almost exact repetition in reverse of the soldier who stands with his right hand to his hip in the tapestry version of the *Vision of Constantine*.

The next drawing in this evolving series is in all probability that now in Prague [Fig. 16], although certain variations of figural action could be adduced to place the Metropolitan Museum drawing next in order [Fig. 17]. This situation serves to underscore the fact that these drawings, each experimental in character, could in fact have been produced virtually contemporaneously as Cortona tried variations of theme and gesture which contributed to the ultimate design. The Prague drawing is a tentative sketch in which form and action are blurred by linear repetitions and in which *pentimenti* abound—qualities which make it highly informative.

In the Prague drawing, the investiture ceremony has been moved into a more prominent foreground position. The figure seated on the suggestum now wears an imperial diadem, and the posture of the soldier receiving the crown is more agitated; the formality and control exhibited in his pose in the Munich drawing has been deliberately suppressed. The fact that other soldiers now emphatically crowd up to the suggestum demanding their rewards serves to characterize the soldiery as a jostling, undisciplined crowd. The use of steps at the base of the podium has been restudied several times, and a series of parallel lines suggests their cancellation in favor of a series of steps across the width of the picture plane. In the left section of this drawing, the religious ceremony has undergone important alterations. The round peristyle temple remains, but the protagonists have changed, and for the iconography of the cycle a major alteration has been effected. A bearded man, bareheaded and dressed in a flowing robe, exhibits a tablet to several figures, the foremost of whom kneels in an attitude of Christian prayer.[191]

The Prague drawing has a corollary in a sheet now in the Metropolitan Museum [Fig. 17], a study focused exclusively on the investiture scene. This drawing offers both a clarification and some variations on the earlier studies.[192]

Of the known drawings for the third Age, a highly finished sketch from the Walter C. Baker collection [Fig. 18] is closest to the frescoed version of the scene, although in fact the placement of the soldiers before the suggestum in the Metropolitan

[190] For the history and illustrations of the tapestries see Dubon, *Tapestries*, *passim*; for illustrations of the tapestry version of the Vision of Constantine see Pl. 38 and Fig. 19. For Giulio Romano's fresco (which was perhaps executed from his cartoons by Raffaellino dal Colle) see F. Hartt, *Giulio Romano*, New Haven, 1958, II, Fig. 57.

[191] Although the gesture of this figure is different, the pose derives from that of the figure kneeling before a priest in the Munich drawing.

[192] The general pose of the soldier baring his chest is firmly established. A new figure, a soldier holding a standard, has been introduced between the chest-baring soldier and the one receiving a crown. Another soldier, left arm akimbo, has been introduced at the far right, and the position of the figure on the suggestum has been changed to a standing pose.

study is closer to that finally used, as is the pose of the soldier standing to the far right in that drawing. In the Baker drawing, the emperor wears a diadem of laurel and is once more in a seated pose. The bound figure who has formed a leitmotif in all the preparatories survived to at least this stage, but was dropped in the fresco, and a group in the lower left corner consisting of a captured barbarian couple bound and seated amongst captured arms is present for the first time. In this drawing the Christian religious theme is more fully developed. The bearded figure who demonstrates a tablet has been retained, and two men whose costumes suggest that they may well be barbarian converts make obeisance before him. Behind this group looms the round temple once more. Figures can be glimpsed through its intercolumniations, and at the far left a statue of Christ, haloed and in the act of blessing, can be discerned. From this drawing it is but a short step to the frescoed scene.

When the fresco of the *Age of Bronze* and the preparatory drawings related to it are reviewed, several themes emerge as Cortona's prime interest. The major theme, obviously, is the representation of the two contrasting aspects of the Age: militarism and religiosity. Thus at the onset Cortona had divided the composition almost equally between these two motifs (Uffizi drawing). Then he stressed the militarism more emphatically, giving more space and sharper focus to the ceremony of investiture and adding prisoners to reinforce this aspect of the Age (Munich drawing). At this stage the religious ceremony was a pagan sacrifice. In the succeeding stages (starting with the Prague drawing) the religious service was altered from a pagan ritual to a Christian service and the soldiers depicted as increasingly vocal and demanding. The more brutal details of the subjected people were gradually suppressed. In the fresco the conquered nation is represented by two dejected but not overtly maltreated prisoners. The soldiers scramble for their rewards, especially the figure being crowned who now no longer bows his head in keeping with the ceremony of the *Rex Datus* but instead reaches for the crown with outstretched hands. The religious service has been relegated to a secondary plane where it takes the form of Christian worship [Fig. 11] and is so stated as to imply that this creed has here supplanted a pagan one. The tablet discussed by the elderly man on which the letters, though illegible, suggest Hebrew script now rests on a disused pagan altar, and as in one of the preparatory drawings (Baker collection) a statue of Christ appears to have been placed in a pagan round temple now converted to Christian use.

The introduction of the Christian theme, essential to the counterclockwise reading of the cycle, into the *Age of Bronze* was of course arrived at in conjunction with the genesis of the pendant fresco. Not surprisingly, this transformation of theme in the *Age of Bronze* involved a reciprocal alteration in the *Age of Iron*, presumed to be in Rome. A drawing now in Princeton [Fig. 19] documents the introduction of Christianity into the *Age of Iron*.[193] In this drawing, the age of violence and impiety is rep-

[193] Drawing Cat. No. 49.

resented by the sacking of a Christian place of worship. On the left side of this drawing between two candlesticks can be discerned a rude crucifix. Immediately in front of this simple altar an elderly figure—presumably a priest—awaits death from an armed assailant with hands clasped in a prayerful attitude. In the actual fresco, the site of looting and massacre was transferred to a pagan temple and appropriate iconographic changes introduced. In reconstructing the evolution of the cycle, it is clearly imperative to determine the chronological position of this drawing.

If the Princeton drawing can be dated in the 1641 campaign it is possible that the sequence proposed by Walter Vitzthum is correct, that is, a three-stage evolution in which the last two Ages were first both placed in pagan antiquity, then in the Christian era, and finally one in antiquity and the other in the Christian era.[194] Vitzthum connected the Munich drawing [Fig. 15] for the *Age of Bronze* with the first stage and hypothesized an as yet unlocated pendant drawing for the *Age of Iron*.[195] Next he linked the Prague and Princeton drawings [Figs. 16 and 19] as documenting an all-Christian stage followed by the frescoes as the final stage. Such a reconstruction presents several problems. First it is based upon an arbitrary pairing of the preparatories (the Princeton-Prague set is unconvincing), and second it supposes the use of all alternatives, when in fact the necessity of a stage in which both Ages were simultaneously Christian is neither necessary nor likely.

The Uffizi and Munich drawings [Figs. 14 and 15], together with the Metropolitan drawing [Fig. 17], form a group that is technically and stylistically coherent, and on the basis of our conclusions about the execution date of the Uffizi drawing they can be dated 1641. In terms of chronological development of iconographic themes, the Prague drawing and the Baker drawing [Fig. 18] must be closely associated with this group. Now we can turn to the Princeton drawing [Fig. 19]. In Vitzthum's three-stage evolution this drawing is to be paired with the Prague drawing [Fig. 16]. To be sure, they share like media, but in other respects they are quite different. The Prague drawing is a much redrawn red chalk drawing to which pen and ink have been applied only to specific areas for clarification. In contrast, the Princeton drawing is a vigorous sketch in which red chalk established a cryptic, minimal *primo pensiero* which was then reaffirmed but not meticulously detailed in pen and ink. This drawing is comparable in style and technique to the Uffizi study [Fig. 9] for the *Age of Gold*. The drawing has several times been dated in the 1637 period, and I would still so place it.[196] In that chronological position its interpretation as a document of a stage in which both of the last two Ages were Christian must be discarded, and we can only make somewhat more limited deductions. We can hypothesize a first stage in 1637 during the execution of the *Age of Gold* in which the entire cycle was presented as prehistorical or at least pagan, followed—also in 1637—by a variation in which the *Age of Iron* was

[194] Vitzthum, "Correspondence," 121.

[195] Perhaps the drawing presumed to be in Rome is a candidate (Drawing Cat. No. 47, Fig. 13).

[196] Coffin, "Drawing," 36f.; Campbell and Laskin, Jr., "New Drawing," 423ff.; and, by inference, Stampfle and Bean, *Drawings*, 49f., Cat. No. 62.

changed to the Christian era, thus connecting it more emphatically with present time, i.e. 1637.[197] At this moment, prior to the execution of the *Age of Silver*, we have no evidence that an evolutionary reading from the *Age of Iron* to the *Age of Gold* through the intervening Ages had been introduced into the cycle. The theme of the Return was certainly a part of the original scheme for the *Age of Gold*; however, the Return may have been understood as a continuing clockwise reading from the *Age of Iron* to the *Age of Gold*. This, as we noted earlier, would have been the easiest method of resolving the problem of implementing the theme of the Return and would have conformed as well to Virgil's description, which mentions specifically only the gold and iron races. Before leaving Florence in 1637, Cortona established the reverse reading of the Four Ages by including the bronze urn and sailing ships in the *Age of Silver*. Apparently the scheme presenting the *Age of Iron* as Christian prevailed until 1641, when Cortona moved the Christian theme to the *Age of Bronze* (Prague drawing) and with a few changes—as yet undocumented by a drawing—converted the *Age of Iron* as depicted in the Princeton drawing into the sacking of a pagan temple. At this late stage, and only at this late stage, the complex themes of Cortona's Sala della Stufa cycle were completed and fully stated.

As already noted, the composition of the *Age of Bronze* was derived in part from Cortona's tapestry cartoon depicting the *Vision of Constantine* and Giulio Romano's version of the same scene (which in turn derives from the well known ancient relief of *Marcus Aurelius Addressing His Troops* on the Arch of Constantine). The *Age of Bronze* is thus linked to the iconography of Constantine through its several prototypes, a situation that suggests that Cortona wanted the observer to connect this age with the period of his rule, especially in the reverse reading of the cycle when the detail of the statue of Christ appearing in a pagan temple assumes special importance.[198]

The Sala della Stufa decorations are more, however, than an iconographic riddle, and an assessment of Cortona's contribution to the Sala della Stufa must include a consideration of the frescoes as a decorative ensemble, for they are an interdependent series, and, unlike individual oil paintings, their true merit cannot be determined by examining them individually. As we have already noted, Cortona took pains to keep the four

[197] Our only evidence of an early stage in which the Iron Age is depicted as pagan depends upon the by no means certain association of the drawing presumed to be in Rome with the last Ovidian age. It is therefore entirely possible that the Princeton drawing is the *primo pensiero* for the *Age of Iron* and that Cortona's first idea of this Age was to represent it as Christian.

[198] In this connection it will be useful to review the various borrowings involved in the formulation of the frescoed version of the *Age of Bronze*. (For illustrations of the following monuments see footnote 190 above.) Giulio Romano's fresco of the *Vision of Constantine* in the Sala di Constantino in the Vatican Palace was a source for the soldiers grouped at the foot of the podium and for the crown and dress of the figure distributing crowns. From his own tapestries Cortona borrowed several motifs. These include, from his Vision of Constantine, a soldier who stands with hand on hip (who in turn derives from a soldier in Giulio Romano's fresco) and a round temple in the background which in the tapestry is much more exotic in shape. It should also be noted that the statue of Christ in the temple in the *Age of Bronze* is identical in pose to the one featured prominently in the tapestry of *Constantine Destroying the Idols* (see Dubon, *Tapestries*, Pl. 39, Fig. 22).

frescoes stylistically and coloristically homogeneous, and, in the case of each fresco, the transition from a composition sketch to the executed work marked, as we have demonstrated, a process of clarification and organization into a more structural system of parallel planes. This consistent attitude toward pictorial space in each fresco—the horizon line is a constant in all the Ages—is one of the means by which Cortona strengthens the observer's realization that the Four Ages form a unity that is visual as well as narrative. Another unifying device is the light source, which in each fresco conforms with the location of the frescoes to the actual source of illumination in the room, the two windows that open onto the Boboli Gardens. The coherent illumination thus obtained, though necessarily less overtly apparent in the *Age of Gold* and the *Age of Silver*, is particularly striking in those of the *Age of Bronze* and the *Age of Iron*, which are placed at right angles to the windows.

Cortona has illuminated each fresco in conformity with its relative position to the physical illumination of the Sala della Stufa for two purposes: to make the spectator aware that the frescoes exist within a real architectural setting and to intensify the impression that these frescoes constitute a consciously arranged series of scenes. Another element serving to reinforce the fact that the Four Ages are an ensemble is the fictive head set in a cartouche at the midpoint of the frescoed architrave above each Age. Essentially repetitive, ornamental motifs, these heads nevertheless serve a dramatic function, for they run the gamut of emotions from blissful tranquility to outright terror in response to the particular Age over which they preside. The heads provide at one and the same time elements of continuity and of distinction among the Ages that are reflected not only in the gestures and actions of the figures in the Ages but in their compositions as well. So strong is the effect of content on composition that one cannot avoid the conclusion that Cortona, in composing his Four Ages as an ensemble, closely adhered to a theory of modes not unlike that propounded by the arch-classicist of the Baroque, Nicolas Poussin, according to whom each subject elicited a mode or manner of stylistic expression particularly suited to its representation.[199] Indeed, Poussin's description of Virgil's ability to match content to mode of expression could describe Cortona's representation of the Arcadian joys of the Age of Gold and the grim horror of the Age of Iron: "So, when he [Virgil] is speaking of love, he has cleverly chosen certain words that are sweet, pleasing, and very grateful to the ear. Where he sings of a feat of arms or describes a naval battle or accident at sea, he has chosen words that are hard, sharp, and unpleasing, so that on hearing them or pronouncing them they arouse fear."[200]

The *Age of Gold* [Fig. 2] is essentially a narrative composition. By means of a right to left movement the spectator is directed across the foreground area by a series

[199] See A. Blunt, "Poussin's Notes on Painting," *Journal of the Warburg and Courtauld Institutes*, I, 1936-1937, 344ff. Blunt identifies the Venetian writer on music, Zarlino, as the source for Poussin's theory of the modes (349).

[200] From his letter to Chantelou, November 24, 1647. Translation taken from A. Blunt, *Nicolas Poussin*, New York, 1967, I, 226. More recently, see also A. de Mirimonde, "Poussin et la Musique," *Gazette des Beaux-Arts*, LXXIX, March 1972, 129ff.

of interlinked figures. The composition consists of a low pyramidal group on the far right and a taller, more angular figure group on the far left. The two opposing groups are connected by a curving band of figures occupying the center foreground. All movement is regular, assured and interlocking. There are no harsh, angular forms. The underlying geometry of the figure groups has been suppressed, and the dominant element of the composition is the swaglike disposition of the figures. The figures in the *Age of Iron* [Fig. 12], in contrast, create compactly structured groupings within the scene and would be highly dramatic images, even if seen in isolation. Here space is constricted and figures are composed in compressed geometric groupings disposed in a series of planes parallel to the picture surface. Whereas the *Age of Gold* is in a sense open-centered, a void enframed by a low-slung figure group, the *Age of Iron* is dominated by a central pyramidal group composed of a soldier seen almost frontally and a young woman who lies parallel to the picture plane. These two figures form a triangular composition that functions as a self-sustaining unit, a vigorous symbol of violence and tragedy whose effect is heightened by the massive column immediately behind them that visually intensifies the force with which the soldier presses the old man to the ground. The central protagonists relate to the other figures in the scene by means of a series of sharply angled diagonals that are parallel one to another and rigidly parallel to the picture plane. The effect of these compositional devices is forced and harsh and totally different from the repetitive curves of the *Age of Gold*.

The compositional differences of these two Ages reflect the steadily rising emotional pitch of the scenes represented, in which action and gesture become increasingly vigorous as we move from the *Age of Silver* to *Bronze* and finally to that of *Iron* with its crescendo of violence. Thus the intrinsic nature of the scene portrayed and its location are of far more importance in explaining these differences than dates of execution. If a date of 1637 for the Princeton preparatory study for the *Age of Iron* is correct, then we have clear proof for these observations, because Cortona reused this composition in the final version of the *Age of Iron* by merely introducing necessary changes in iconography. The other changes introduced are essentially examples of the kind of discipline and clarification that Cortona brought to his art and are not evidence of a stylistic reorientation.[201]

The composition of the *Age of Iron* is an outgrowth of Cortona's earlier work with similarly violent subject matter. The *Age of Iron* bears a marked resemblance to a painting of a similar subject, the *Rape of the Sabine Women* [Fig. 138], which we have already considered. Although the physical proportions of the two scenes are much changed, in both a central set of protagonists acts as an emotional hub for the scene.

[201] Location does, of course, remain a factor. The *Age of Gold* shares a wall with the *Age of Silver*; therefore, Cortona produced a composition that is open at its center in keeping with the tranquility of the arcadian scene and which could also be attractively echoed in its pendant. The *Ages of Bronze* and *Iron* are on separate walls, and hence the visual continuities of the earlier set were simply not relevant.

In both instances, other action is subsidiary to this compact, central dramatic group. The principal group in the *Age of Iron* forms a harsher, more angular composition, but this is in keeping with its greater violence and brutality. And even these more strident qualities of form have antecedents in Cortona's *oeuvre*, for, as noted by Wittkower, the panel representing the *Death of Joab* in the Gallery of the Palazzo Mattei (1622-1623) anticipates the last Age in the Sala della Stufa.[202] In achieving a more violent effect, Cortona probably turned to depictions of the Massacre of the Innocents such as that by Altobello Melone in the Cremona cathedral as sources for his central protagonists.[203]

THE FRESCOES OF THE SALA DELLA STUFA AND RELATED MEDICI PROGRAMS

It has already been noted that the Cortona-Buonarroti Four Ages can be related chronologically and thematically to other projects at the Pitti Palace. Even within the decorations of the Sala della Stufa, the Four Ages frescoes establish thematic relations with the early work of Rosselli. Fabbrini's statement that Cortona was "hired to finish at the Pitti the room of the Stufa, colored above by Matteo Rosselli, but [which] remained incomplete in the walls" is not, strictly speaking, correct.[204] As we have already noted, the Sala della Stufa was initially either a bona fide *loggetta* or at the very least a room that had been deliberately endowed with the character of the loggia. The Rosselli decorations, located entirely within the vault and lunettes, pertain to the tradition of the decorated loggia and were therefore certainly planned as a self-sufficient entity. Also, no iconographic relationship can be established between the specific rulers portrayed in the spandrels of the lunettes and the Ages immediately beneath them. In fact, only four of the eight lunettes have wall decorations beneath them; the other wall compartments are either blank or pierced by a door or by windows. In a more general sense, however, the theme of the vault decorations does relate to the *concetto* of Buonarroti's Four Ages. Although the Rosselli decorations form a program complete in itself, Buonarroti's Four Ages do exploit the presence of the great ruler theme and the cardinal virtues, for, after all, these great rulers are in a sense *exempla* for the new Medici prince whose arrival is so auspiciously announced in Cortona's frescoes.

The parallel allusions in the iconography of the Salone Terreno and that of the Four Ages also suggest an interrelation, and this is borne out by an appraisal of the

[202] Wittkower, *Art and Architecture*, 163. For an illustration see Briganti, *Pietro*, Fig. 17.

[203] For an illustration of Melone's *Massacre of the Innocents*, 1517, see S. J. Freeberg, *Painting in Italy 1500 to 1600*, Harmondsworth, 1970, Pl. 159. Significantly, the Princeton drawing was once mistakenly catalogued as a *Massacre of the Innocents* (F. J. Mather, Jr., "The Platt Collection of Drawings," *Bulletin of the Department of Art and Archaeology, Princeton University*, June 1944, 4).

[204] Fabbrini, *Vita*, 47: "... incaricarlo d'ultimare in Pitti la stanza della Stufa, colorita in alto da Matteo Roselli, ma rimasta incompleta nelle pareti." See also the statement that follows: "Chiamato quindi il Berrettini, lo pregarono a finir detta stanza."

changes in the program of the former room following the death of Giovanni da San Giovanni. As we have noted earlier, he lived long enough to complete the ceiling, the extensive southern wall, and a portion of the western wall of the Salone. On the western wall he had started to narrate the rehabilitation of the arts in Tuscany under Lorenzo the Magnificent. He had intended to follow this scene with a representation of a Triumph of the Knights of Santo Stefano and to conclude the cycle with a scene representing the rediscovery of the Golden Age in Tuscany. Following his death in 1636, however, the Return of the Golden Age theme was absorbed into the Ovidian Four Ages by Buonarroti in the Sala della Stufa, and the program in the Salone Terreno was revised, presumably by Francesco Rondinelli, who had been responsible for the programs and dedications initiated earlier by Ferdinand II and to whom the Salone program had been given before Giovanni da San Giovanni had elected to write his own. In the revised program (executed between 1638 and 1642) the Salone Terreno cycle was altered so as to celebrate events in the life of Lorenzo the Magnificent. Important for our considerations is the fact that the revised program closed with a scene by Francesco Furini, *Allegory on the Death of Lorenzo the Magnificent* [Fig. 154], in which the Three Fates appear, cutting a thread symbolizing the life of Lorenzo while a white swan holds a medal inscribed with Lorenzo's name and bearing his likeness over the river Lethe. Overhead, Mars is depicted descending to earth while Astrea, who removes her laurel wreath, and Peace, who stoops to water the civic oak, accompanied by Fame depart heavenward on a cloud. As the inscription beneath the fresco elucidates, this scene also signals the close of a Golden Age: MUORE, ED AL SUO MORIR LA PACE E ASTREA TORNAN DOLENTI AL CIEL It was Astrea, we should recall, who regretfully "abandoned the blood-soaked earth" for heaven in the Iron Age, whose advent is adumbrated in the descending, armed figure of Mars. Far from ending with a Return of the Golden Age, the Salone frescoes now memorialize the close of just such an epoch. Still, when viewed in sequence, the decorations of the Salone conclude on a festive note, for we are to interpret the ceiling last in which the Three Fates reappear as participants in a celebration of the Medici-Rovere nuptials, the marriage that of course links the Salone decorations with the Four Ages in the Sala della Stufa from which a counter-reading yields the promise of a Virgilian Return of the Golden Age to be ushered in by the birth of an heir to the grand-ducal throne.

It was probably Buonarroti's intention that the Four Ages should stand as an independent unit in the Pitti decorations, and if, as may have been the case, he knew of Giovanni da San Giovanni's intentions in the Salone Terreno, as a challenging thematic duplication of the scene planned as the closure of the wall decorations in the Salone. It is to Rondinelli's credit that he succeeded in adjusting the Salone program and thus integrated the Four Ages with the program he was ultimately to realize in the other rooms of the palace.[205]

[205] Cortona's later commission, the Planetary Rooms, for which Rondinelli provided the libretto, will be considered below. In all probability, the three rooms *enfilade* with the Salone and deco-

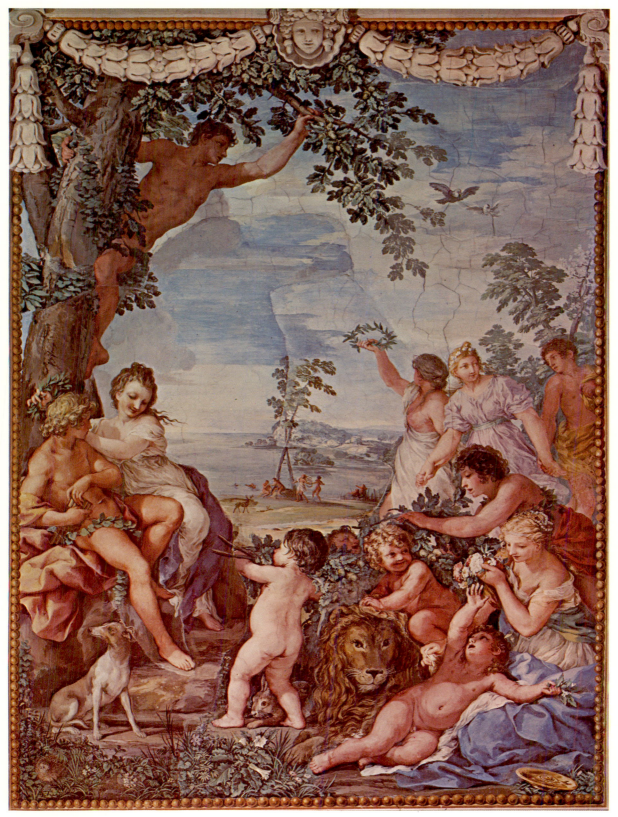

1. *Age of Gold*, Sala della Stufa

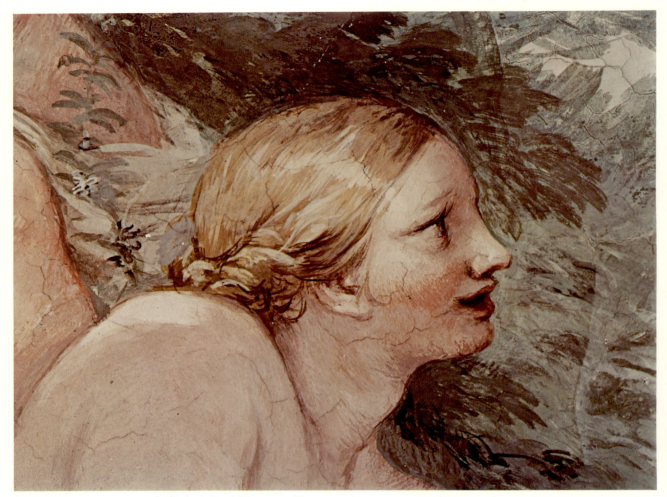

II. Head of a nymph: detail of the Sala di Venere ceiling

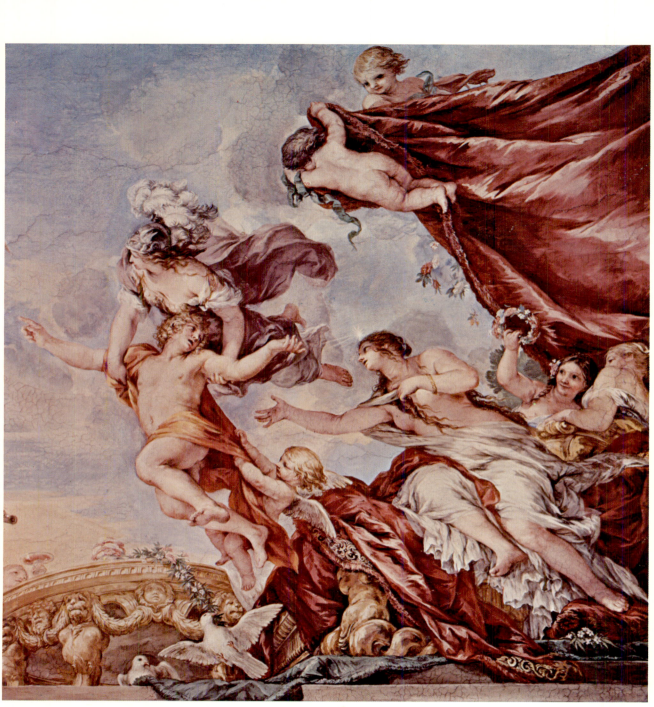

III. Venus and the prince: detail of the Sala di Venere ceiling

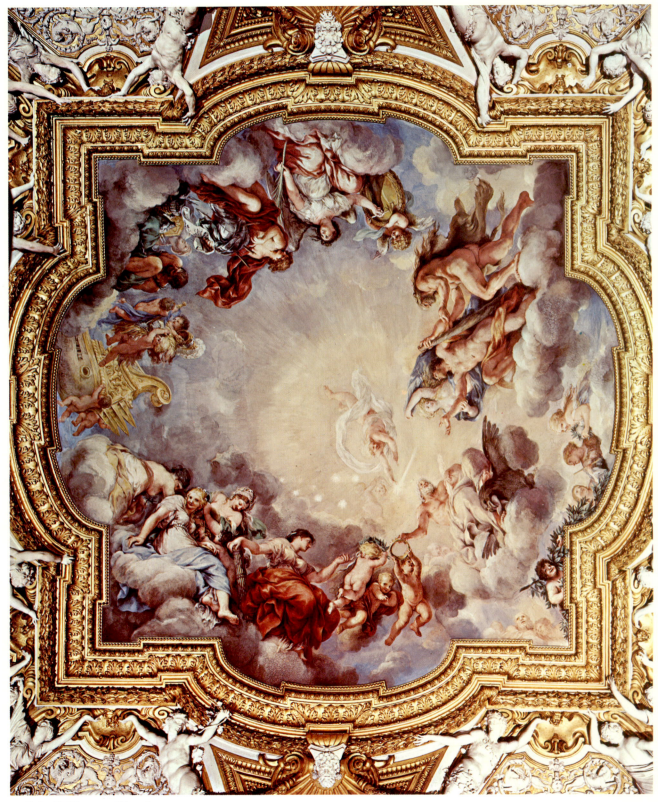

IV. Sala di Giove, ceiling fresco

If the iconographical adjustments were successful, the attempts on the part of the executors of the unfinished decorations in the Salone Terreno to adapt to the stylistic criteria of the Buonarroti-Cortona Four Ages were less so. Cecco Bravo's frescoes constitute a brilliant but capricious variation on Giovanni da San Giovanni's, and Ottavio Vannini's northern wall is uninspired. In Furini's frescoes, however, we have strong evidence that he at least saw a need to relate his work stylistically as well as iconographically to the challenge of the Four Ages. As Ellis Waterhouse has observed in speaking of this artist's *Allegory on the Death of Lorenzo the Magnificent* [Fig. 154], "[Furini] had clearly studied Raphael's *Stanze* with attention and the mourning River God owes a great deal to Andrea del Sarto, while the whole composition is based on an exciting spiral which makes it one of the few near-Baroque designs by a Florentine painter."[206] Why Furini, who had collaborated with Giovanni da San Giovanni in Rome in the 1620's, should have here made a stylistic departure that evokes Raphael and Andrea del Sarto—two great practitioners of the Grand Manner—should be clear, for in his fresco we are presented with an attempt to answer the frescoes of Cortona, which constitute a Baroque exercise in the tradition of the Grand Manner.

Furini's far from inadequate response was, however, too late. By the time he finished his share of the Salone in May 1642, the vast cycle of the Planetary Rooms was in the hands of Cortona; an heir to the Medici had been born; and to many observers it must have seemed that the Return of the Golden Age prophesied in the Four Ages was dawning.[207]

The themes of the frescoes in the Sala della Stufa and the Salone Terreno are part of a general Medici tradition in which similar themes of revival, renewal, and reawakening were repeatedly used to celebrate grand-ducal reigns[208] and can be traced back to Lorenzo the Magnificent and also to Cosimo Pater Patriae.[209] As E. H. Gombrich,

rated by Colonna and Mitelli also owe their programs to Rondinelli. These rooms pick up related themes of rulership in the Apotheosis of Alexander the Great (as an *exemplum* of the virtuous ruler), the Triumph of Truth (with the aid of Time) over Infamy, and, lastly, a series of scenes devoted to the Grand Dukes Cosimo I, Francesco I, Ferdinand I, and Cosimo II capped by a vault in which the major cities of Tuscany pay homage to a Grand Duke (Ferdinand II?) who is crowned by Jupiter.

[206] Waterhouse, *Painting*, 158. For comment and recent bibliography on Furini, see G. Cantelli, *Disegni di Francesco Furini e del suo ambiente*, Gabinetto Disegni e Stampe degli Uffizi, XXXVI, Florence, 1972.

[207] Campbell, "Medici Patronage," 137.

[208] The theme of the Return of the Golden Age was also utilized in Medici festivals, especially those connected with weddings. See the wedding of Cosimo I and Eleonora of Toledo and that of Cosimo II and Maria Magdalena (cf. Nagler, *Festivals*, *passim*).

[209] E. H. Gombrich, "Renaissance and Golden Age," first published in the *Journal of the Warburg and Courtauld Institutes* in 1961, 306ff., and here cited from the anthology *Norm and Form*, London, 1966, 29ff. The image of Lorenzo the Magnificent as the preserver and restorer of the classical culture evoked in connection with the theme of the Return of the Golden Age is especially interesting in view of the literary tradition of the Age of Gold as a postprimitive period ruled by an enlightened Saturn who, in the words of Lovejoy and Boas, is a culture-hero (*Primitivism*, 57f.). See also A. Brown, "The Humanist Portrait of Cosimo de' Medici, Pater Patriae," *Journal of the Warburg and Courtauld Institutes*, XXIV, 1961, 186ff.

who was aware that the Salone Terreno frescoes are connected to this tradition, has demonstrated, aspects of the theme of the Golden Age are repeated in Vasari's frescoes in the Palazzo Vecchio commissioned by Grand Duke Cosimo I.[210] Furthermore, the decorations in what has been identified as the Seconda Stanza of the Casino Mediceo executed between 1621 and 1623 provide evidence that the use of the theme of the Return of the Golden Age in terms of the restoration and revival of culture continued to be exploited during the interim between Vasari's decorations and the Salone Terreno commission.[211] These decorations, the work of Giovanni da San Giovanni, Fabrizio Boschi, Francesco Furini, the Fontebuoni, and assistants, include a ceiling fresco depicting the apotheosis of Grand Duke Cosimo II and a series of lunettes in which scenes usually described as *gesti* or *fatti*, that is scenes of a biographical nature, alternate with allegorical ones in which Cosimo II is depicting paying homage to Music, reviving Science, and awakening Painting.

The completion of Cortona's frescoes had little or no effect on the furnishings or function of the Sala della Stufa. When the cycle of the Four Ages was completed, the room was so filled with furniture that some of it must have obscured parts of the frescoes.[212] The nature of these furnishings—small tables, a buffet, a small armoire, and a few low chairs—point to the use of the Sala della Stufa as a private grand-ducal chamber used in conjunction with the three other rooms with which it forms an ensemble looking south toward the Boboli Gardens. As a group, these rooms comprised the grand-ducal winter apartments and as such served only nonpublic functions.[213] By 1687 the Sala della Stufa had become the most private room in the palace, and the superintendent of the Guardaroba was constrained to exclude it from his inventory, noting simply, "In the . . . room . . . with two windows on the Cortile Nuovo painted in fresco with the Four Ages by the hand of Pietro da Cortona with pavement of terracotta. In this [room] one is not allowed to enter since His Highness [Cosimo III] keeps the key upon his person."[214]

[210] Gombrich, *Norm and Form*, 30.

[211] A. R. Masetti, "Il casino Mediceo e la pittura fiorentina del seicento," a two-part article in *Critica d'Arte*, IX, March-April 1962, 1ff., and IX, Sept.-Dec. 1962, 77ff. The room under consideration is discussed in detail in part I of this article.

[212] Florence, A.S.F., Guardaroba Medicea F. 725 (inventory begun on December 30, 1663), cc. 57v-58r.

[213] *Ibid.*, c. 58r-62r.

[214] Florence, A.S.F., Guardaroba Medicea, F. 934, c. 78r: "Nella . . . stanza . . . con due finestre sul Cortile Nuovo dipintovi a fresco le quattro Età di mano di Pier da Cortona con pavim[ent]o di Terra Cotta. In questa non vi si è potuto entrare, stanti, che S. A. S. tiene le chiavi app[ess]o di se."

II. The Planetary Rooms

INTRODUCTION

The Planetary Rooms [Figs. 20, 27, 42, 89, 96, 97, 116, 117] are, as E. K. Waterhouse has observed, "more significant for the history of Pietro as an architectural decorator than as a painter."[1] And this is correct, for Cortona, who never planned a building specifically to receive fresco decorations, is, nevertheless, the architectural decorator par excellence. In his earliest work in this field, he depended heavily on Renaissance decorative traditions as seen through Annibale Carracci's Roman work, especially the Farnese Gallery.[2] This orientation dominates the early phase of his decorative style (c. 1622-1630) including the Gallery in the Mattei Palace, the Gallery in the Sacchetti Villa (now Chigi) at Castelfusano, and the ceiling in the Villa Sacchetti (or del Pigneto). In the Mattei Gallery [Fig. 163] Cortona, working as the assistant of an older but modest painter, Pietro Paolo Bonzi, was employed to provide scenes from the life of Solomon painted as *quadri riportati* for a *quadratura* system that was wholly analogous to the surface of the vault.[3] The Castelfusano Gallery was planned initially as a bold, illusionistic exercise in which the *quadratura* was to have been reduced to an airy, architectural structure enlivened with clambering *ignudi* [Fig. 164]. This preparatory scheme reflects the impact of Michelangelo's crouching *ignudi* and *quadratura* in the ceiling of the Sistine Chapel and also the atlantes in the Farnese Gallery. Another important and more immediate source was Lanfranco's recently completed loggia decorations (1624-1625) in the Villa Borghese [Fig. 165]. In the actual gallery, a conservative interpretation of *quadratura con quadri riportati* obtains [Fig. 166].[4] Only at the corners of the vault, where a reprise of the Farnese Gallery corners occurs [Fig. 167], is a truly bold, spatial note struck. The ceiling [Fig. 141] of the now destroyed Villa del Pigneto demonstrates an approach close to that considered but not carried out at Castelfusano.

The Salone Barberini [Figs. 142, 143] marks an important departure for Cortona. Started in 1632 or 1633, this ceiling reduces the *quadratura* to a minimal structure that defines the joints of the major planes of the vault, dividing the ceiling into a large rectangular central section and four trapezoidal subsidiary segments, one to each wall of the Salone. In so lightening and piercing the *quadratura* system, Cortona was following the lead of Giovanni Lanfranco's fresco decorations in the Villa Borghese. The effect

[1] Waterhouse, *Painting*, London, 1962, 162.

[2] For discussions of the sources of the decorative system and illustrations of the Farnese Gallery see Martin, *Farnese Gallery*, *passim*, and D. Posner, *Annibale Carracci*, London, 1971, I, 93ff.

[3] For discussion and illustrations see Briganti, *Pietro*, 160ff., and Pls. 8-11 and 15-20.

[4] For illustrations and discussion of the Castelfusano Gallery see Briganti, *Pietro*, 177ff. and Pl. 77.

suggests a continuous ground plane at the cornice level. What is radically new, however, is that the figures in these trapezoidal areas seem to be enframed by the *quadratura* armature but not constrained by it, for they move sideways and also backward and forward in space; that is to say, they appear free to occupy space beyond that defined by the vault surfaces and also to exist within the vaulted space where they are able to move in front of the *quadratura* armature. Total mobility also obtains in the central rectangular section of the vault where figures hover in the open air, moving both within the architectural space and soaring high above it. This system has infinite possibilities. It offers the possibility of an airy space enlivened with freely moving forms, and thus in its potentials adumbrates those fragile miracles of light and color of the great Venetian eighteenth-century ceiling decorator, Giovanni Battista Tiepolo. Cortona, however, used it to produce a lavish and powerful spectacle—the most dazzling Baroque "machine" in the history of the painted ceiling.

The decorative scheme Cortona adopted in the Salone appears to have been the product of a long and difficult germination period. Work in the room from c. 1632 to 1637 may have consisted of false starts and re-appraisals, and the ceiling as we know it may have been executed between the time of Cortona's return from his north Italian sojourn of 1637 and late 1639. Thus the final scheme may be the product of his experience of Lombard and Venetian painting, as Marco Boschini insisted in his intensely pro-Venetian *La carta del navegar pitoresco*.[5] Certainly it is from north Italian illusionistic painting that Cortona derived the fiction of a ground plane coincident with the cornice line, a device brilliantly exploited by Giulio Romano in the Sala di Troia [Fig. 168] at Mantua, and he adopted the almost vertical stacking of figures in the central rectangular area of the Salone vault from the Venetians. In the Salone Barberini Cortona achieved a brilliantly successful amalgam of Roman formal structure and Venetian colorism. With the Sala della Stufa frescoes, Cortona imported his Roman Baroque style (with its Venetian tendencies) to Florence. In the Planetary Rooms, he proceeded to develop and explore the possibilities of his dual sources in a variety of ways.

The Planetary Cycle is a series of five thematically related rooms and as such constitutes a throwback to sixteenth-century decorative traditions that had fallen into disuse in the early decades of the seventeenth century. Virtually all early *seicento* commissions involved single rooms rather than rooms in series. Even when one artist executed several rooms in one palace, the rooms as a rule formed neither a physical nor a thematic series. For widespread use of sequential arrangements of decorated rooms we must turn to the sixteenth century. One thinks immediately of obvious examples such as Raphael's *Stanze*, Giulio Romano's decorations in the Palazzo del Tè and the

[5] M. Boschini, *La carta del navegar pitoresco* (first published 1660). Critical edition, A. Palluchini, ed., *La carta del navegar pitoresco*, Rome and Venice, 1966, 521. Boschini's statement has won scholarly support, cf. Briganti, *Pietro*, 199; Waterhouse, *Painting*, 49; and W. Vitzthum, "Review of G. Briganti, *Pietro da Cortona . . .*," *Burlington Magazine*, cv, No. 722, May 1963, 216.

Palazzo Ducale at Mantua, the splendid rooms created in the Doge's Palace, Venice, and of course Giorgio Vasari's cycle for Grand Duke Cosimo I in the Palazzo Vecchio, Florence. Vasari's decorations in the Palazzo Vecchio were certainly the example of the room-in-series tradition of immediate importance to the organization of the Planetary Rooms.

From Venice must have come the idea of the rich interplay of massive stucco enframements and painted areas [Fig. 169]. Rome provided sources for the use of virtually autonomous stucco figures climbing between painted scenes. In contrast to the Pitti decorations, however, these figures usually appear in the areas of the wall, rarely the vaulting proper [Fig. 170].[6] Only in illusionistically painted *quadratura* had Roman decorators made full use of the possibilities of the human figure as an active supporting element. The Farnese Gallery is the prime source for this approach, and it is the one utilized by Cortona, with one exception, in his Roman ceilings until the Salone Barberini. The exception is the ceiling in the Chapel of the Concezione in S. Lorenzo in Damaso (c. 1635), which is now destroyed save for the stuccoes [Fig. 171].[7] The stuccoes reveal Cortona's interest in utilizing real as opposed to *quadratura* enframements for fresco decorations even before his 1637 trip to Venice.

The Planetary Rooms reflect a highly varied series of explorations of illusionistic space. In the first room, the Sala di Venere [Figs. 20 and 27], and in the last, the Sala di Saturno [Figs. 116 and 117], executed by Ciro Ferri, a modified *quadro riportato* was used in the central area of the ceilings. As the Italian term suggests, a *quadro riportato* is painted as if it were a wall painting transferred to a ceiling location. In the examples for the Planetary Rooms, however, one edge of the picture plane serves as the demarcation of the ground line, from which the principals together with the space they occupy recede sharply back into space, creating what might be termed a three-quarter *di sotto in su*. This space-creating device, though it occurs elsewhere, is most profusely employed by the Venetians.[8]

The exploration of illusionistic space is greater in the Sala di Giove [Fig. 96] and the closely related Sala di Apollo [Fig. 42]. In both the quatrefoil design of the Sala di Giove and the circular shape of the Sala di Apollo, a fuller *di sotto in su* is used. In these ceilings the limitations of the *quadro riportato* formula, still present in the Sala di Venere, are overcome by a ring of figures close to the periphery of the vault segments who read more or less correctly from every vantage point within the room. This use of a spatially free arrangement would seem to suggest Venetian sources, but in fact few

[6] An interesting variation is provided by Domenichino's telemons in the vault of the Cappella della Strada Cupa in S. Maria in Trastevere, in which stucco figures occur in the vault but are treated as if they were associated with a perfectly vertical wall plane (R. Spear, "The Cappella della Strada Cupa: A Forgotten Domenichino Chapel," *Burlington Magazine*, CXI, Jan. 1970, 12ff.).

[7] V. Forcella, *Inscrizioni delle Chiese . . . di Roma*, Rome, 1874, V, 203, and Passeri, *Vite*, 383 and n. 2.

[8] For an excellent review of the Venetian ceiling types see the richly illustrated monographic study by J. Schulz, *Venetian Painted Ceilings of the Renaissance*, Berkeley and Los Angeles, 1968.

Venetian ceilings employed it, and those that did probably derived the scheme from examples by central Italian masters such as Giulio Romano, who used this device at the Palazzo del Tè.[9] One Venetian painter must, however, be singled out for his contribution to these two ceilings. Paolo Veronese is the Venetian master to whom Cortona turned for inspiration again and again, and the vaults of the Sala di Giove [Pl. IV] and the Sala di Apollo are not exceptions. The grouping of figures seen *di sotto in su* in a circular band with one figure (or more, in the case of Cortona) placed in the central field of this band is a compositional scheme that Veronese used with great effect in his fresco of Olympia at the Villa Maser.[10]

The most spatially developed of the Planetary Rooms is the Sala di Marte [Fig. 89]. Here Cortona exceeded his Venetian and other north Italian prototypes in the creation of a sense of total *di sotto in su* to the level of the cornice. This ceiling is really a further exploration of the Salone Barberini ceiling, but with the *quadratura* armature removed. The Sala di Marte ceiling might be described as a composite of four three-quarter *di sotto in su* panels arranged around the four sides of the vault at the cornice line and fused at their upper edges with a central rectangular panel painted in a more nearly "true" *di sotto in su*. Part of the brilliance of this ceiling is due to the fact that the spectator is not aware of the parts that combine to create a single coherent whole. The transition from one curving surface of the vault to another is effortlessly achieved, and a sense of recession is created without marshaling densely packed figures into stacked tiers. Instead scattered groups and single, hovering, foreshortened figures puncture the aerial canopy creating the sense of seemingly limitless space. Unlike the Salone Barberini, where figures move freely not only within the spectator's space and beyond it but also across the *quadratura* that defines the structural surface of the vault, the frescoed scenes in the Planetary Rooms, except for a humorous passage in the Sala di Giove in which a painted laurel branch appears to hang over the stucco frame into the spectator's space, exist within their stucco settings and behind the mural plane on which they are depicted. Even the vault in the Sala di Marte can be likened to a transparent, unbroken membrane through which we view the scene above the cornice line.

Venice alone does not account for Cortona's decorations in the Planetary Rooms, but the Venetian tradition explains their special splendor. Venice provided sources for the ornamental richness of white stucco and gilding. Likewise, Venetian artists, especially Paolo Veronese, offered *exempla* for the sensually rich and brilliant color employed by Cortona in the Planetary Rooms. The direction in which Cortona was

[9] One Venetian example of this type was Veronese's central panel for a room in the Palazzo Pisani a Santo Stefano (cf. *ibid.*, Cat. No. 54, Fig. 64), but this is really the exception that proves the rule, for most Venetian examples employ what we have described above as a three-quarter *di sotto in su*, for even when no ground line is included, the figures are massed on an imaginary plane set at about a sixty-degree angle to the surface of the ceiling. For example, see the ceiling paintings of Palma Giovane and Leonardo Corona in San Giuliano (*ibid.*, Cat. No. 6, Pl. 136).

[10] For an illustration see G. Fiocco, *Paolo Veronese*, Bologna, 1928, Pl. XLIII.

moving in the late 1630's was clearly toward Venetian colorism. The fact that this development coincided with the desires of the Medici to reform the Florentine style and specifically to reorient it toward the Grand Style as it had been practiced by the masters of the High Renaissance made Florence in 1637 an appropriate, if less than perfect, place for Cortona to undertake the cycle of ceiling decorations that was to occupy him for nearly a decade.[11]

FURNISHINGS AND FUNCTION

Published *seicento* sources provide meagre information about the purpose of the Planetary Rooms. Gualdo Galeazzo stated in 1668 that the rooms by Cortona were two in number and served as *appartamenti*.[12] Giovanni Cinelli in his revision of Bocchi's *Le Bellezze della Città di Firenze* published in 1677 did not comment on the rooms.[13] In his 1689 guide to Florence, Jacapo Carlieri merely associated the rooms with the *reali appartamenti*.[14] Two hundred years later, Narciso Fabbrini proposed that the Grand Duke, in consultation with his brothers, had decided to establish a picture gallery in the rooms in question and that the ceiling decorations were intended to ornament this pinacotheca.[15] He gave no sources for his observation, which in all probability was inspired by the condition of the rooms in 1892 at which time they served, as they do today, to house part of the Galleria Palatina. Fabbrini wrote without benefit of the descriptions of the Planetary Rooms provided by diaries which have since been published and without consultation of extant Medici inventories, or floor plans of the palace, or the manuscript guide to Florence of Giovanni Cinelli.[16] Of these seventeenth-

[11] For an interesting and critical discussion of the Florentine milieu see Briganti, *Pietro*, 92ff.

[12] G. Galeazzo, *Relatione della città di Fiorenza e del Gran Ducato di Toscana*, Florence, 1668, 6f.: "Ma fra gl'altri sono due appartamenti con stantie quadrate, così grandi, alte, & adorne di freggi d'oro, e di Pitture di Pietro di Curtona [sic], che di meglio non si trova in alcun Palazzo d'Italia."

[13] F. Bocchi and G. Cinelli, *Le bellezze della città di Firenze*, Florence, 1677.

[14] J. Carlieri, *Ristretto delle cose più notabili della città di Firenze*, Florence, 1689, 109f.: "Passando poscia ne' reali appartamenti, vedremo cose di maraviglia. Sono le stanze del Granduca regnante, e molte ancora degli altri Principi tutte dipinte & adorne di Stucchi, di mano de' più rari maestri de' nostri tempi, fra quale, il famoso Pietro Berrettini da Cortona, più d'ogn'altro s'immortalò."

[15] Fabbrini, 47: "Il Granduca in quel tempo, d'accordo con i propri fratelli Leopoldo e Carlo dei Medici, aveva stabilito di ridurre a pinacoteca cinque grandi sale del secondo piano di palazzo Pitti, sua residenza, per collocarvi i quadri classici da loro posseduti, o che successivamente avrebbero comperati. Conveniva però innanzi tutto ridur quelle stanze a ricettacolo degno dell'arte, facendole ornare da un frescante abilissimo."

[16] Among the more useful of the diaries are: G. Bonnard, *Gibbon's Journey from Geneva to Rome . . . 20 April–2 October 1774*, London, 1961, and N. Tessin, *Studieresor: I Danmark, Tyskland, Holland, Frankrike och Italien*, edited by O. Sirén, Stockholm, 1914. The useful floor plan of 1658 (Florence, Biblioteca Nazionale Centrale, MS Magliabechiano, XIII, 36) prepared by G. M. Marmi was exhibited in the Mostra Documentaria e Iconografica di Palazzo Pitti e Giardino di Boboli held at Archivio di Stato, Florence, in 1960 (see the catalogue by the same title by F. Morandini, 24, Cat. No. 81). The most useful inventories are: Florence, A.S.F., Guardaroba Medicea, F. 535 (1638) and F. 725 (1663-1664). The Cinelli MS is now in the Biblioteca Nazionale Centrale in Florence (MS Magliabechiano, XIII, 34).

century sources, the inventories, floor plans, and the Cinelli manuscript are the most useful for reconstructing the original condition and establishing the intended function of the Planetary Rooms.

It will be useful to commence our investigation with a summary of a 1638 inventory that provides a description of the contents of the rooms in question prior to the execution of Cortona's decorations and then to compare this inventory with the first available one made after Cortona completed his share of the cycle.[17] This comparison yields important facts. First, the room that ultimately became the Sala di Venere (floor plan, p. 69) was originally two rooms. Second, except for the Sala di Venere, which was originally a vestibule and guardroom, the rooms in question served as the official grand-ducal reception and audience rooms before and after Cortona's decorations. Third, although the furnishings and wall hangings were completely redone after the completion of Cortona's decorations, certain iconographic motifs were retained. And fourth, neither before nor immediately after the Cortona decorations were the rooms organized as a pinacotheca. In comparing these inventories, we will adhere to the sequence in which the rooms were recorded, that is to say, the order in which the rooms would have been viewed by a seventeenth-century visitor arriving at the *piano nobile* by the monumental flight of stairs that rises from a vestibule located in the northwest corner of the central courtyard of the palace. The stairway admitted the visitor to a long corridor with windows overlooking the courtyard and, beyond, the Boboli Garden. At the midpoint of this corridor a monumental doorway admitted the visitor to the large room located directly above the central portal of the palace (floor plan, p. 69). This room had three windows facing the piazza in front of the palace. Identified in the 1638 inventory as the "Salone di S[ua] A[ltezza], detto delle Nicchie," it was hung with red damask and contained a baldachin made of the same material.[18] An enormous painting depicting the *Oath of Allegiance Offered to Grand Duke Ferdinand II* by Justus Sustermans served as an overdoor in the lunette above the *porta principale* of the room.[19] The other paintings in the room seem to reflect no precise theme, for they included the *Sacrifice of Abraham*, *Lot and His Daughters* (identified as by Gregorio Pagani), and the *Drunkenness of Noah*. There was also a painting of "several nude women with

[17] An inventory for the last room in the cycle, completed by Cortona's pupil and chief collaborator, Ciro Ferri, is provided by an inventory made in 1687-1688 (Florence, A.S.F., Guardaroba Medicea, F. 932). This inventory, it should be remarked, does not indicate significant changes in the furnishings of the other rooms in the cycle.

[18] A.S.F., Guardaroba Medicea, F. 535, c. 43 left.

[19] For illustration and comment see M. Winner, "Volterranos fresken in der Villa della Petraia," *Mitteilungen des Kunsthistorischen Institutes in Florenz*, x, Feb. 1963, 243f. and Fig. 25. The painting was meticulously described by F. Baldinucci in his *vita* of the artist (*Notizie*, IV, 479ff.), who gives its original destination as precisely the location recorded in the above cited inventory: ". . . fu dato luogo sopra la porta prima della Sala di palazzo per la quale si passa a i regi appartamenti. . . ." At some later date the painting, which was shaped to fit in a lunette, was cut down in length and filled out to form a rectangle. Badly damaged, it hung until recently in the Library of the Uffizi Gallery. At the time of this writing it is undergoing restoration.

Floor plan: East wing of the *piano nobile* of the
Pitti Palace in the seventeenth century

LEGEND

1. Piazza Pitti
2. Cortile Grande
3. Sala delle Nicchie
4. Sala di Venere
5. Sala di Apollo
6. Sala di Marte
7. Sala di Giove
8. Sala di Saturno
9. Sala della Stufa

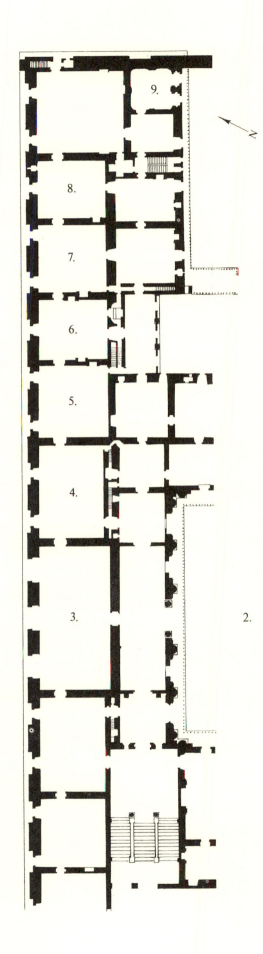

Venus with a swan and an *amorino* asleep on the ground."[20] The most striking feature of the room was a series of ten niches in which were displayed antique statues ranging from two to three *braccia* in height. Four antique busts served as overdoors. There were also two statuettes of marble, one of which was a woman in antique dress and the other a *putto* who pretends to urinate. From the foregoing description, this large *salone* would seem to have been intended to serve as an antiquarium and also, in view of the baldachin, as an audience room. As we shall see, however, it was not the principal audience room; rather it was a monumental reception room for the grand-ducal apartments, which were entered through the door in the eastern wall of the room. From this point of entry, the first room in the series was the Sala di Venere, which in 1638 was two modestly proportioned rooms that served as vestibule and guardroom to the grand-ducal apartments.[21]

On October 25 of the same year a fire broke out in the Pitti Palace.[22] Although the rooms that concern us were not directly affected, Alfonso Parigi, grand-ducal architect, reports in his diary that he suggested to Ferdinand that since the conflagration had rendered the palace uninhabitable, it would be expedient "to make the two *salotti* on either side of the Sala delle Nicchie where before there were *camerini*"[23] Two of the *camerini* in question are of course the rooms whose functions we have just reviewed, and the *salotto* into which they were transformed was the room destined to become the Sala di Venere.

The next room, later the Sala di Apollo (floor plan, p. 69) was identified in the 1638 inventory as the "first room of the new apartment."[24] The walls of this room were hung with red damask decorated with flowers and vases. This room boasted eight paintings as its principal embellishments. The paintings were all Medici portraits. One group (all measure five *braccia* by three *braccia*) included the portraits of the Grand Dukes Cosimo I, Francesco, Ferdinand I, Cosimo II, and also Popes Leo X and Clement VII. The two remaining paintings were smaller in size and depicted the two great ladies of the Medici house, the Queens of France, Marie and Catherine. The first set of paintings is of particular interest because, as we shall see, the same portraits will be incorporated into Cortona's stucco decorations in the Sala di Venere.

The adjacent room, later to become the Sala di Marte (floor plan) is referred to in the 1638 inventory as the "second room of the new apartment."[25] In this room the walls were hung with a light brocade, green enriched with a gold background and

[20] A.S.F., Guardaroba Medicea, F. 535, c. 43 left: ". . . un quadro in tela entrovi dipinto più donne ingiude [sic] con Venere con il cigno e un amorino che dorme in terra." (*Leda and the Swan?*)

[21] Florence, A.S.F., Guardaroba Medicea, F. 535, cc. 44 left–45 left. The first room is described as "Primo ricetto per entrare nell'appartamento dell'Altezze," and the second is designated the "salotto che segue doppo il ricettino." The inventory under discussion is a duplicate of another (Florence, A.S.F., Guardaroba Medicea, F. 525) which bears the working dates 26 February 1637 [1638]–6 May 1638.

[22] The fire broke out during the night of October 25, 1638; see M. Costa, *Per l'incendio de' Pitti*, Florence, 1638, and also the emergency payments recorded in Florence, A.S.F., Fabbriche Medicee, F. 75 bis, especially cc. 116-118.

[23] Florence, Biblioteca Nazionale Centrale, MS Palatino, 853, cc. 69r–70r.

[24] Florence, A.S.F., Guardaroba Medicea, F. 535, c. 45 left.

[25] *Ibid.*, c. 46 left.

designs of leaves, fleurs-de-lis, and animals. Furnishings consisted of a few low chairs and a massive table. In the southern wall of this room there was a low-arched window. This window, covered by a heavy iron grill, opened onto a small chapel. Admittance to the chapel was gained through a narrow corridor hidden in the thickness of the wall.[26]

The fourth room in the series, the future Sala di Giove (floor plan), was also hung with light brocade, which was of red silk with a gold background enriched by designs of lions, vases, flowers.[27] The room was dominated by an enormous baldachin that clearly indicates that it served as a throne room. There were eight paintings in the room. Six paintings—an *Assumption*, a *Seated Madonna*, *St. Martin and the Beggar*, a *Sacrifice of Abraham*, *Tobias and the Angel*, and a painting of *Christ*—hung on the walls, and two more paintings were installed as pendant *sopra finestrone*, a *David with the Head of Goliath*, and a *Judith with the Head of Holofernes*.

The fifth room in the series did not have continuous floor to ceiling hangings and was more modestly furnished.[28] It contained incidental furnishings and nine religious paintings. These included an *Annunciation*, *Christ Walking on the Waters*, *St. Peter Freed From Prison*, *St. Jerome in the Desert*, a series of four paintings depicting the *Creation of Adam*, the *Creation of Eve*, the *Temptation*, and *Expulsion*. The scribe also recorded a *Rest on the Flight into Egypt* by Pietro da Cortona.[29] This room, now the Sala di Saturno (floor plan) completes the cycle of rooms decorated by Pietro da Cortona and his assistant Ciro Ferri. The vault of the last room in this series, which occupies the northeastern corner of the palace, was not decorated until the nineteenth century. In 1638, this room contained sculpture and forty paintings.[30]

From our survey of the rooms that were ultimately decorated by Cortona, it is evident that in 1638 the rooms to the east of the Sala delle Nicchie, the point of entry into the series, consisted of a vestibule and guardroom, followed by two rooms which were antechambers for the throne room. All of these rooms were sparsely furnished, but richly hung with brocaded velvets and a choice selection of paintings, many of which were Medici portraits or subjects of particular iconographical significance to Florence (*David and Goliath*, *Judith and Holofernes*). The small number of paintings involved indicates that in 1638 these rooms were not organized as a pinacotheca. The room immediately behind the throne room, a location surely less accessible to the general public or even to the court, does seem to have served such a purpose.

[26] The chapel, now hidden from view by Rubens' *War and Peace*, which hangs over the window, contains fresco decorations, possibly the work of Poccetti, which are in poor condition. I am indebted to Anna Maria Ciaranfi, Former Directress of the Galleria Palatina, for bringing the chapel to my attention and for the attribution of its decorations.

[27] Florence, A.S.F., Guardaroba Medicea, F. 535, cc. 46 left–47 left.

[28] *Ibid.*, cc. 47 left–48 left.

[29] Not listed in the catalogue raisonné of Briganti. *Pietro.* I have not been able to locate the Cortona *Flight*, which is the only painting in this room attributed to an artist by the scribe of the inventory. The entry in question reads: "Un quadro in tela alto br. 4 largo br. 3, dipintovi la Madonna a sedere, che contempla e tiene nostro Signore bambino in su le ginocchia, con S. Giuseppe e 2 Angioli in terra inginocchioni, che fanno il simile, e 4 Angioli in aria, che reggono una croce, con paese e lontananze, con adornamento intagliato e dorato tutto, mano di Pietro da Cortona, c. 121 . . . n. 1" (c. 48 left).

[30] Florence, A.S.F., Guardaroba Medicea, F. 535, cc. 49 left–52 left.

With the 1638 condition of the rooms in mind, we can examine the next inventory, that of 1663-1664, in which is recorded the contents of all but the last room in the planetary series.[31] From this inventory, we know that the Sala delle Nicchie remained virtually unchanged.[32] The Sala di Venere is described as "the first room, with two large windows on the piazza, with the vault with figures and worked with gilded stuccoes, where is painted the representation of Venus by Pietro da Cortona."[33] According to the manuscript of Giovanni Cinelli, this room served as a "general antechamber for every class of person,"[34] a use supported by the presence of a secret listening post situated behind the lunette of *Antiochus and Stratonice* (note the window in the lunette inscription, Fig. 34) which would have provided surveillance of the proletarian crowd this room frequently accommodated. In addition to an assortment of tables and chairs, this room was decorated with six large wall tapestries with scenes from the life of St. John the Baptist and one overdoor depicting the Visitation. These tapestries, woven in the grand-ducal tapestry factory, were made from the cartoons of Agostino Melissi and derived from the frescoes of Andrea del Sarto in the Cloister of the Scalzo.[35] No paintings are mentioned in the entry.

The next room (Sala di Apollo) is described in the 1663-1664 inventory as the

[31] Florence, A.S.F., Guardaroba Medicea, F. 725. This inventory was made between December 30, 1663, and November 30, 1664, by Giacinto (also written Diacinto) Maria Marmi, who had recently assumed the post of grand-ducal *guardarobiere*.

[32] Florence, A.S.F., Guardaroba Medicea, F. 725, cc. 57r and 57v.

[33] Prima stanza, con due finestroni che rispondano in Piazza, con la volta con fighure e lavorata di stucchi dorati, dipintovi la rappresentazione di Venere da Pietro da Cortona.

Un letto a tavolino, d'albero, con suo lettino sotto, lungo br. [blank] e largo br. [blank]

Due materasse di traliccio e lana	n° 2
Un capezzale simile	n° 1
Un coltrone di tela gialla, imbottito con bambagia	n° 1
Un panno da letto, di lana bianca	n° 1

Un sopra tavolino di domasco verde a opera grande, a fiori, con un fregio attorno di broccatello, a opera a rabeschi e uccelli, gialla e bianca, guarnito attorno di frangia di seta verde e oro, con quattro cascate alla Romana, lungo br. 3½ e largo br. 2 in circa, cioe in piano foderato di tela n° 1

Un sopra tavolino di corame rosso scaccato, con quattro cascatine orlate di nastrino, lungo br. 4½, largo br. 1½ n° 1

Due casse panche d'albero a sgabelliera, con sue maniglie di ferro e serrami, lunghe br. 2 e larghe br. 1 in circa n° 2

Due sgabelloni di albero, color di noce, filettati d'oro, con arme di S. A., alti br. 3 n° 2

Un paramento d'arazzo, entrovi la storia di S. Gio. Batista, in pezzi 6, alto br. 9¾, cioe un pezzo largo br. 13½, br. 13¼, br. 13½, br. 8½, br. 9⅙, br. 6⅙, in tutto br. 64.1.8, armato di canavaccio n° 1

Un sopraporto simile, entrovi la Visitazione di S. Elisabetta, alto br. 5 largho br. 3⅝, armato di canavaccio n° 1

Un sopraporto simile, cioe spalliera, entrovi in mezzo l'arme di S. A., alto br. 3, largha br. 6½ n° 1

Una colonna simile, entrovi scudetti con fighurine, alta br. 9¾, largha br. 2⅓ n° 1 (Florence, A.S.F., Guardaroba Medicea, F. 725, c. 51v).

[34] Florence, Biblioteca Nazionale Centrale, MS Magliabechiano, XIII, 34, c. 156v. See Doc. Cat. No. 126.

[35] Several sets of tapestries appear to have been made from Melissi cartoons. One set, possibly those in question, now hangs in the Sala di Cinquecento in the Palazzo Vecchio. One series was on the looms of Pietro Fevére in 1651. Other parts of the series were woven by Bernardino Vanasselt in 1665. For additional information see C. Conti, *Ricerche storiche sull'arte degli Arazzi in Firenze*, Florence, 1875, 68, 73f.

"Antechamber for Gentlemen."[36] This room, like the preceding one, was simply furnished and hung with six wall tapestries and three overdoors. The tapestries continued the life of St. John the Baptist as represented in Andrea del Sarto's fresco cycle. Two of the overdoors in this room related to the wall tapestries. One depicted the Visitation and the other the Baptism. The third overdoor represented the Supper at Emmaus. No paintings are recorded here.

The 1663-1664 inventory designates the third room in the series (Sala di Marte) as the "Antechamber of the Courtiers."[37] This room was furnished in much the same

[36] Confirmed by the description of Cinelli (Florence, Biblioteca Nazionale Centrale, MS Magliabechiano, XIII, 34, c. 159v); see Doc. Cat. No. 126.

Seconda stanza che segue, che serve per anticamera de' gentilhuomini.

Un letto a tavolino, d'albero, con suo lettino sotto, lungo br. 3½ e largo br. ¾ nº 1
Due materasse di traliccio e lana nº 2
Un capezzale simile nº 1
Un coltrone di tela verde, imbottito con bambagia
. nº 1
Un panno di lana bianca da letto nº 1
Un sopra tavolino di domasco verde, opera grande a fiori, con un fregio attorno di broccatello, opera gialla e bianca a fogliami e uccelli; detto fregio largo br. ⅔ in circa, lungo il piano br. 3½ e largo br. 1½, con frangia attorno di seta verde e oro, con quattro cascate alla romana, foderate di tela verde nº 1
Un sopra tavolino di corame rosso, scaccato, orlato con nastrino, lunga br. 4 e larghe br. 3 in circa
. nº 1
Tre sgabelloni d'albero, color di noce, filettati d'oro con arme di S. A., alti br. 3 nº 3
Due casse panche d'albero, lunghe br. 2 in circa, larghe br. ½, che in una vi è il serrame . . . nº 2
Uno strapuntino per una delle suddette panche, di corame rosso ripieno di crino, lungho br. 2 in circa e largo br. ½ nº 1
Dua panche di noce, con piedi e spalliera a balaustro, lunghe br. 3 e larghe br. ¾ nº 2
Cinque panche di noce, con piedi torniti a balaustro, con spalliera tutta di noce, lunghe br. 3⅓ e larghe br. ¾ in circa nº 5
Un paramento d'arazzo, entrovi la storia di S. Gio. Batista, compagnia del di contro paramento, con fregio attorno, con fighure, scudi, leoni e festoni, in pezzi 6, alto br. 9¾, cioe:
 un pezzo di br. 12.15.–
 un pezzo di br. 12.13.4
 un pezzo di br. 13.10.–
 un pezzo di br. 13.–

un pezzo di br. 13.10.–
un pezzo di br. 5.6.8
 in tutto br. 20.15.– in [circa] nº 1
Tre sopraporti compagni, entrovi in uno la Visitazione di S. Elisabetta, nel'altro il nostro Signore battezzato da S. Gio. Batista, e nel'altro il nostro Signore a cena con due pellegrini in Emaus; armati di canavaccio, alti br. 4⅔, larghi br. 3⅚ in circa nº 3
Tre portiere d'arazzo simile che una fa paramento, entrovi per ciascheduna l'arme di S.A.S. foderate di tela rossa, alte br. 5¼, larghe br. 3⅔, che una di dette è nella di contro scritta nº 3
(Florence, A.S.F., Guardaroba Medicea, F. 725, c. 52r).

[37] Terza stanza che segue, che serve per Anticamera de' cortigiani

Quattro panche di noce con piedi a balaustro torniti, con la spalliera tutta di noce, lunghe br. 3⅓ e larghe br. ¾ in circa nº 4
Quattro seggiole di noce, con fusti diritti, sedere, spalliera, e balze, di sommacco rosso, guarnite di passamano di seta rossa e oro, con frangie alte di seta rossa e oro, confitte con bullette d'ottone dorate a sonaglio, con mensole intagliate e dorate, che a una manca la frangia di dietro nº 4
Un tavolino d'alabastro bianco, incassato in una lavagnia con piedi a telaio, a balaustro, e che posono sopra quattro palle, filettati con poco d'oro, lungo br. 2⅞ e largo 2⅓ nº 1
Una tavola d'al[a]bastro cotognino, con cornice attorno, con piedi a telaio, a balaustro, che posono sopra quattro palle, filettati con poco d'oro, lungo br. 2½ e largho br. 1½ nº 1
Quattro torcieri, in forma di puttini di legnio con una basa in capo di frutte intagliate, con festone a mezzo il busto, con piede che termina in triangolo, che dua altri br. 3 incirca e dua alti br. 2⅓, intagliati e dorati in parte tinti di nero
. nº 4
Un par d'arali di ferro massicci, con fusti d'ottone lisci a balaustro, alti br. 1½ nº 1

73

manner as the two preceding ones. It, too, was hung with a tapestry series, a seven-piece ensemble illustrating scenes from the life of Moses.[38] The room was artificially illuminated by four standing torches.

In the 1664 inventory, the fourth room (Sala di Giove) is identified as the "Audience Room of His Serene Highness."[39] As had been the case in 1638, this room was

Una paletta et un par di molle di ferro con vasetto d'ottone . n⁰ 1

Un paramento d'arazzo di stame e seta, entrovi la storia di Moisé, con fregio attorno di pilastri, festoni e puttini, in pezzi sette, che vi sono due pezzi compagni, entrovi quando il Padre eterno porge la leggie a Moisé, alto br. 8⅛ cioè:
 un pezzo di br. 14.–
 un pezzo di br. 13.3.4
 un pezzo di br. 6.10.–
 un pezzo di br. 7.10.–
 un pezzo di br. 6.13.4
 un pezzo di br. 8.13.4
 un pezzo di br. 6.16.8, in tutto br. 63⅓, armato di canavaccio n⁰ 1

Due sopraporti simili, differenti, che in uno entrovi uno scudo con una femmina con un putto e un Ariete, e nell'altro una femmina entro a una aovato con una spada in mano, che rappresenta la Giustizia. Alti. br. 4½ larghi br. 3⅞ incirca, armati di canavacci n⁰ 2

Una portiera d'arazzo, entrovi l'arme di S.A.S. foderata di tela rossa, alta br. 5¼ largha br. 3¾ . n⁰ 1

(Florence, A.S.F., Guardaroba Medicea, F. 725, c. 52v).

[38] These scenes were on the grand-ducal tapestry looms several times in the mid-seventeenth century, starting in 1658 and continuing until 1659 (Florence, A.S.F., Guardaroba Medicea, F. 543, *passim*; F. 663, *passim*).

[39] Quarta stanza che segue, quale serve per l'Audienza di S.A.S.

Una tavola di pietra di paragone, con piedi di granatiglia fatta a piramide, profilati con legnio pardo, lunga br. 3½ e larga br. 2 n⁰ 1

Un sopratavolino di broccatello a opera grande, rosso, verde e bianco, con fondo giallo, con poca lama d'oro, con fregio attorno di broccatello simile, lungo br. ½, opera verde con fiori bianchi, con fondo giallo, guarnita attorno con frange di seta rossa e oro, con tre cascate alla romana, lungo il piano br. 3½ e largo br. 2, foderata di tela rossa n⁰ 1

Un sopratavolino di vacchetta rossa, fine, con quattro cascatine, guarnito con nastrino di seta paonazza e oro, lungo br. 4 e largo br. 2½ . . . n⁰ 1

Un parafuoco di tabì turchino, a onde, doppio, guarnito con frangiolina di seta turchina e oro, con fusto di noce, con piede a quadrangolo, lungo br. 4½ e largo br. 3⅓ n⁰ 1

Un quadro in tavola, entrovi dipinti grandi al naturale S. Agostino, S. Lorenzo, S. Pier Martire, S. Francesco, S. Bastiano, Santa Maria Maddalena, di mano di Andrea del Sarto, con adornamento di legnio intagliato, tutto filettato d'oro, alto br. 4½ e largo br. 3½ n⁰ 1

Un quadro in tavola, entrovi dipinta la Madonna santissima, con il Nostro Signore in braccio, in piedi, con S. Bastiano, S. Lorenzo, S. Giovanni Battista, S. Iacopo et altri Santi, di mano di Andrea del Sarto, con adornamento intagliato e tutto dorato, alto br. 4½ e largo br. 3½ . . . n⁰ 1

Un quadro in tavola mezzo aovato, entrovi dipinto l'Angiol Raffaello che tiene per mano Tobbia, S. Lorenzo et un altro Santo, con Dio Padre nelle nuvole, con adornamento di legnio a frontespizzi, intagliatovi dentro dalle bande, lampade et sestili ecclesiastici, con cartella appiede di detto adornamento, tinta color turchino, tutto intagliato e dorato, largo br. 3⅔ e alto br. 4⅚ in circa, di mano di Andrea del Sarto n⁰ 1

Un baldacchino da residenza, di teletta gialla, a opera fiorita e broccata a vaso, festoni e fogliami, con tre pendenti doppi et uno scempio, foderati di taffettà color di Isabella, et il cielo piano con 5 teli di teletta broccata con fiori d'argento, et il telo del mezzo di teletta d'argento, broccata e arricciata a opera a fiori d'oro, seta e argento, rossi e maví, e tutto guarnito di frangie alte, mezzane e basse, di seta rossa e oro, lungo br. 4 . n⁰ 1

Un tappeto da residenza, lungo br. 12 e ⅔ e largo br. 6 . n⁰ 1

Due seggiole di noce, con fusti diritti, sedere, spalliera e balze ricamate di seta con fondo giallo a fiori, animali e viticchi di più e diversi colori, dintornati di vergola d'oro e argento, confitte con bullette d'ottone dorate, le balze guarnite con guarnizioni a scacchi d'oro e argento, guarnite di frangiolina simile, con mensole sotto i bracciuoli e le spalliere intagliate e dorate . n⁰ 2

dominated by a residential baldachin beneath which were placed two richly decorated chairs. This baldachin was planned as an integral part of Cortona's decorations and, as described in a set of directions for installing the hangings in this room, was in fact hung from hooks set in the outstretched hands of two of the stucco figures in the vault [Fig. 101].[40] The two figures are placed at the midpoint of the eastern wall of the room. The walls of the throne room were hung with a seven-piece set of tapestries depicting the Four Seasons taken from cartoons designed by Lorenzo Lippi and Jacopo Vignali.[41] Across the three doors were hung matching portieres woven of silk and gold with the grand-ducal coat of arms. Three paintings, all by Andrea del Sarto, embellished the walls of the throne room: the *Disputation on the Trinity*,[42] *Madonna with Six Saints*,[43] and the *Tobias Altar*.[44]

The next room in the series (Sala di Saturno) is described in the 1664 inventory as the "fifth room that follows after that of the Audience, where there are painters working; there is nothing (in it)."[45] In an inventory compiled in 1687-1688, however, the room is referred to as the "room . . . that serves for the secret audiences of His Serene Highness, called the Sala di Saturno."[46] At the time of this inventory, the contents of

Un paramento d'arazzo, di stame seta e oro, entrovi le quattro stagioni, con fregio attorno di puttini a chiaroscuro, con festoni, in pezzi sette, alto br. 9½ in circa, armato di canovaccio, cioè:
un pezzo di br. 10.5.–
un pezzo di br. 7.15.–
un pezzo di br. 8.–.–
un pezzo di br. 10.3.4
un pezzo di br. 4.–.–
un pezzo di br. 8.5.–
un pezzo di br. 4.–.–, in tutto br. 52.8.4 . . n° 1
Tre portiere d'arazzo simile, con seta e oro, entrovi l'arme di S.A.S., foderate di tela rossa, con suo campanello da capo e cordone, alte br. 5¼ e larghe br. 3¾ n° 3
(Florence, A.S.F., Guardaroba Medicea, F. 725, cc. 53r-53v).

[40] Giacinto Marmi drew up elaborate instructions for the installation of the hangings in the Sala di Giove. These instructions read in part: "Adì 16 Gennaio 1657[1658]. Ricordo del modo che deve tenersi per parare il paramento del velluto turchino ricamato d'oro, a prospettiva, nella Camera di Giove dell'Audienza del Ser.mo Gran Duca . . . il baldachino . . . si ferma con cordone a uno oncino di ferro dorato che è alla mano di una statua di stucco . . ." (Florence, Uffizi Gallery, Gabinetto Disegni e Stampe, 5277A r. and v.).

[41] These tapestries were put on the looms of Bernardino Vanasselt in 1643. Although the seven-piece ensemble is referred to as *Le Stagioni*, it actually consisted of the Four Seasons (cartoons

by Lippi) and Morning, Evening and Day (cartoons by Vignali). In addition there were subsidiary decorative pieces on the designs of Salviati (see Florence, A.S.F., Guardaroba Medicea, F. 531, c. 41; F. 543, c. 8 and Conti, *Arazzi*, 65).

[42] The *Trinity with Saints Augustine, Lawrence, Peter Martyr, Frances and Mary Magdalen* is still in the Pitti Palace (No. 172). Cf. S. Freedberg, *Andrea del Sarto*, Cambridge, Mass., 1963, Catalogue Raisonné, No. 40, Figs. 82, 83, and J. Shearman, *Andrea del Sarto*, Oxford, 1965, II, No. 51; I, Pl. 66b. Shearman cites this inventory.

[43] The *Madonna and Child with Saints Onophrius, Lawrence, Sebastian, Roch* (or James?), *John the Baptist and Mary Magdalene*, often referred to as the Gambassi altar, is still in the Galleria Palatina (No. 307). Cf. Freedberg, *Andrea*, Catalogue Raisonné, No. 70, Fig. 195, and Shearman, *Andrea*, II, No. 76; I, Pl. 137. Shearman cites this inventory.

[44] The *Archangel Raphael, Tobias, St. Leonard and a Donor* is now in the Kunsthistorisches Museum, Vienna (No. 650). Cf. Freedberg, *Andrea*, Catalogue Raisonné, No. 12, Fig. 24, and Shearman, *Andrea*, II, No. 20; I, Pl. 25a. Shearman cites this inventory.

[45] Florence, A.S.F., Guardaroba Medicea, F. 725, c. 54r: "Quinta stanza che segue passato dell'Audienza dove di pitture vi lavorono; non vi è niente."

[46] Nella quinta camera che segue, con la finestra sulla piazza, che serve per udienza segreta di S.A.S., detta la Camera di Saturno
Uno paramento d'arazzo di stame, seta e filaticcio,

the room included a baldachin, two tapestry overdoors featuring female figures of Charity and Justice and portieres with the grand-ducal arms, and six tapestries illustrating the life of Grand Duke Cosimo I.[47] This inventory also records the larger baldachin in the Sala di Giove, and so, clearly, the baldachin in the Sala di Saturno was not a replacement, but a subsidiary one intended for the private audiences held there.

Thus, the evidence indicates that, prior to their decoration as a series, the rooms destined to become the Planetary Rooms were already functioning as royal reception chambers. After the completion of the fresco cycle, the rooms continued to serve their former purposes. Even the position of the throne room remained unchanged.

Contrary to Fabbrini's theory, no attempt was made to organize a real pinacotheca

detto dell'Azzioni del Gran Duca Cosimo primo, in pezzi VI, alto br. 9½, con fregio attorno architettura di colonne e imbasamenti, ornato di canovaccio nº 1 pezzi 6

Un pezzo d'arazzo del suddetto paramento,
largo br. 11.3.4
Un simile, largo . . br. 9.10.–
Un simile, largo . . br. 7.10.–
Un simile, largo . . br. 13.10 pezzi 6
Un simile, largo . . br. 9.–.–
Un simile, largo . . br. 9.–.–

br. 59.13.4

Due sopraporti d'arazzo di stame e filaticcio, alti br. 4 s. 12, larghi br. 3⅞, entrovi in uno di essi una femmina in uno aovato, che rappresenta la Giustizia, e nell'altro in tondo una femmina con putto, che rappresenta la Carità, armati di canovaccio . nº 2

Una porta d'arazzo, entrovi arme de' Medici e due puttini che reggono la corona, alta br. 5 s. 12, larga br. 3¾ nº 1

Due ferri da portiera, con sue puleggie . . . nº 2

Un baldacchino a residenza, a teli di velluto rosso e teletta rossa broccata d'oro con riccio e sopra" riccio, a opera a rabeschi e tronchi, alta br. 10, in teli cinque, cioè tre di teletta e due di velluto, guarnita sulle cuciture e dalle bande di trina d'oro e argento, larga s. 1.4, cielo simile, con tre pezzi di pendenti doppi di teletta e velluto simile, guarnito su tutte le cuciture della suddetta trina, con frangie alte, mezzane e basse di seta rossa, oro et argento nº 1

Un telaio d'albero con tutte le sue appartenenze per il suddetto baldacchino nº 1

Una tavola di marmo bianco, commessovi diverse pietre dure, cioè lapislazzero, agate, diaspro e corniola, che parte quadre, altre tonde et altre aovate, di più grandezze, a spartimenti, tutte contornate di marmo bianco, lunga br. 2 s.14, larga br. 1⅝, con piedi di noce torniti et in parte intagliati e filettati d'oro nº 1

Tre cascate per la suddetta, di velluto rosso, piano,

alte br. 1¼, che una larga br. 2 s.12 e l'altre due br. 1⅔, guarnite attorno di tre bande di trina d'oro e argento, larga s.1.4, e grangiolina di seta rossa, argento e oro nº 3

Un buffetto grande, impiallacciato d'ebano, lungo br. 2⅔, largo br. 1 s. 8, con un tondo nel mezzo, di cristallo, e sotto un oriuolo con mostra di rame dorato e lancietta simile, con piedi d'albero tinti di nero, con trave di ferro nº 1

Un oriuolo da notte, d'ebano, a uso di tabernacolo, con mostra di velluto nero rapportatovi uno cerchio d'argento, dove sono segnate l'ore, e lancietta d'argento simile, con sportello davanti e cristallo da aprire e serrare, con uno imbasamento sotto, dipintovi sul rame, si crede, la Geometria e diversi puttini che reggono l'arme della Ser.ma Casa, con sportello e cristallo davanti, d'aprire e serrare, come il suddetto, alto br. 1⅛ . nº 1

Due seggiole di noce, fusti diritti, con sedere spalliere e balze di velluto rosso piano, guarnite di trina d'oro e argento a rosette, e frangie alte e basse di seta rossa e oro nº 2

Quattro torcieri d'argento a colonnette lisce, con tre palle sotto, d'argento simile, pesano con fusti di ferro e anime di legno, libbre 150 once 10 . nº 4

Un tappeto grande alla Calvina, lungo br. 12⅔ largo br. 5 . nº 1

Un paro d'arali di ferro, con palle d'ottone . . nº 1
(Florence, A.S.F., Guardaroba Medicea, F. 932, cc. 73v-74v).

[47] Some of these tapestries were on the looms before 1653, but most of the series was executed in the 1660's (Conti, *Arazzi*, 23, 69, 71-74). The full series was actually composed of seven pieces for which the cartoons were executed by Giacinto Gimignani, Cosimo Ulivelli, Vincenzo Dandini, and Agostino Melissi (Florence, A.S.F., Guardaroba Medicea, F. 665, *passim*; F. 531, c. 183; F. 663, *passim*). Two of these tapestries are now in the museo degli Argenti, Pitti Palace.

on the *piano nobile* of the palace until after the death of Grand Duke Ferdinand II. The first record of a series of rooms specifically devoted to the display of paintings occurs in the palace inventory of 1687-1688, long after the death of Grand Duke Ferdinand II and during the reign of his son, Cosimo III.[48] At that time, the paintings belonging to Grand Prince Ferdinand were arranged in his principal apartments, the rooms adjacent to the Sala delle Nicchie on the west that balance the planetary series.[49] In fact, even when much of the palace was organized as a grand-ducal pinacotheca by Cosimo III, the Planetary Rooms, with the exception of the Sala di Saturno, were excluded. This information is provided by an inventory made just before Cosimo's death in 1723 in which the Sala di Saturno is described as housing the paintings that Grand Duchess Vittoria della Rovere had bequeathed to her youngest son, Francesco Maria, and which he in turn had willed to his elder brother, Grand Duke Cosimo III, whom he predeceased in 1711.[50] Andrea del Sarto's *Madonna of the Harpies* from the collection of former Grand Principe Ferdinando also hung in the Sala di Saturno, which is described in this inventory as the *Udienza Privata*. For Cosimo III, as for his father, the Planetary Rooms dedicated to Venus, Apollo, Mars, and Jupiter functioned as places of rulership and as such were set apart from the rest of the principal rooms of the palace where paintings crowded the walls and a politically declining grand dukedom celebrated its still formidable artistic wealth.

DECORATIONS OF THE PLANETARY ROOMS

The five Planetary Rooms in the Pitti Palace are ranged *enfilade* across the front of the *piano nobile* (floor plan, p. 69). Today they constitute part of the Palatine Gallery, and it is therefore important to remember that the present organization of this collec-

[48] Florence, A.S.F., Guardaroba Medicea, F. 932.

[49] *Ibid.*, cc. 50v sqq. A fragmentary MS guide to the palace, written after 1713, describes the *quadreria* of the defunct Grand Prince Ferdinand and the other rooms devoted to the exhibition of paintings: "Ritornando nel Salone delle Nicchie, a man sinistra ha l'ingresso l'Appartamento che serve per il Ser.mo Gran Principe di Toscana, ornato tutto di ricchissime supellettili e di preziosi quadri de' più eccellenti pittori, che parte di essa già furono del Ser.mo Cardinale Leopoldo de' Medici e parte acquistati dal fu Ser.mo Gran Principe Ferdinando. Al quale Appartamento ne aggiunse l'A.S. un altro di piccole stanze e gallerie, ripieno pure non meno del primo di rari quadri e altre galanterie di sommo pregio, da esso abitato del verno" (Florence, Biblioteca Nazionale Centrale, MS Magliabechiano, XIII, 26). For an excellent discussion of Grand Prince Ferdinand and his collection see Haskell, *Patrons and Painters*, 228ff.

[50] Florence, A.S.F., Guardaroba Medicea, F. 1304 terzo, cc. 32v. sqq. There is a duplicate inventory in the possession of the Biblioteca della Soprintendenza alle Gallerie, Florence (MS No. 79). From these inventories we learn a number of important facts. First, that the paintings were thought of as a collection, not simply as furnishings (they had previously been recorded in general inventories whereas this one pertains exclusively to paintings). Second, the collection came from three major sources: the collection of Grand Duke Cosimo III (1642-1723) and the estates of Cardinal Leopoldo (1617-1675) and Grand Prince Ferdinand (1663-1713). Third, this vast collection was dispersed in practically every major apartment in the palace. These included: the former apartments of Grand Prince Ferdinand, the apartment of Princess Violante, the private apartment of the Grand Duke, the apartment of the Electress of Palatine, the former mezzanine rooms of Grand Prince Ferdinand and the former apartment of Prince Matthias on the third floor, as well as several unidentified rooms.

tion is such that the visitor enters through a nineteenth-century stairway added to the easternmost wing of the palace, and consequently the five rooms are viewed in reverse order from that originally intended. In the seventeenth century, access to the *piano nobile* was provided by the stairway at the northwest corner of the Cortile Grande. On the *piano nobile* this stairway led to a vestibule which in turn opened onto three rooms: a large reception room known as the Salone dei Forestieri, the first room of the apartment of Cardinal Carlo de' Medici, and a secondary vestibule. The latter room was followed by a long gallery that occupied most of the northern side of the Cortile. The German Guard of the Grand Duke was posted in this corridor, and when operas, masques, or other entertainment were presented in the Cortile, it served as an enormous balcony from which the court watched the performance.[51] At the far end of the gallery a door permitted access to the Grand Duchess's apartment, and at its midpoint a large portal opened onto the Sala delle Nicchie, or, as it was sometimes called, the Salone delle Statue. This room provided a prelude to the room adjacent to its eastern wall, the Sala di Venere [Fig. 20], first of the Planetary Rooms.

Before commencing our consideration of the Sala di Venere and the four adjacent rooms, it will be useful to investigate briefly the problem of the completeness of this series in its present condition. The sequence of deities in the Planetary Rooms—Venus, Apollo, Mars, Jupiter, and Saturn—though lacking the two planets preceding Venus, Mercury and the Moon (usually represented by Diana), follows the hierarchy of the Ptolemaic cosmology. This suggests that the original scheme must have called for two additional rooms. Indeed, two seventeenth-century sources support such a hypothesis. Giovanni Battista Passeri in his biography of Cortona states that, "In the Palace at Florence Pietro was to paint seven [rooms] all in a row and one at the end of these rooms, called the stufa."[52] Giovanni Cinelli in a manuscript for a guidebook of Florence identifies the Sala delle Nicchie as one of the rooms in the seven-room ensemble: "Also this room [Sala delle Nicchie] was to have been painted by Pietro da Cortona, and this was the thought, but the vicissitudes of time which often oppose our wishes were such that this work was never carried out."[53]

A glance at the floor plan of the Pitti Palace reveals, however, that the implied westward expansion of the series into the Sala delle Nicchie raises a problem. If the decorated rooms were to adhere to the Ptolemaic order and the positions of the executed rooms to remain unchanged, the series would have had to extend into the Sala delle Nicchie (which would have become the Sala di Mercurio) and beyond to the first room of the western apartments, which would then have become the Sala di Diana.

[51] For the most recent review of these entertainments see Nagler, *Theatre Festivals*, *passim*.

[52] Passeri, *Vite*, 383: "Nel Palazzo di Fiorenza detto de' Pitti vi è un nobile appartamento nel piano, et ivi da quell' Altezza fu destinato Pietro a dipingerne sette [stanze] tutte in fila, et una nell'estremo di quelle camere chiamata la stufa."

[53] Florence, Biblioteca Nazionale Centrale, MS Magliabechiano, XIII, 34, c. 154v: "Doveva anche questa sala (Sala delle Nicchie) esser da Pietro da Cortona dipinta, e così fu il pensiero, ma le vicende del tempo ch'a' i nostri voleri bene spesso si oppongono fecero sì, che restò in asso l'eseguzione."

Such a reconstruction upsets the symmetry of the *piano nobile* apartments and would have necessitated a replanning of the approach to the Planetary Rooms from the grand stairway.

Several possibilities may be suggested as alternatives to an invasion of the western apartments. The simplest and perhaps least satisfactory would be the dedication of the Sala delle Nicchie to both Mercury and Diana, an arrangement that not only creates iconographic complications but also fails to meet Passeri's statement that originally a seven-room ensemble was planned. A more reasonable hypothesis is that the seven-planet cycle was to be initiated in the Sala delle Nicchie and terminated in the room to the east of what is now the Sala di Saturno. This arrangement poses two problems. The first problem is slight; namely, that this distribution stretches the series eastward beyond the range of rooms used for official audiences before the Cortona commission. The second problem stems from the fact that once the third Ptolemaic planetary deity— Venus—was placed in her present location, an eastward expansion of the series was not possible.

Consideration of events just prior to the start of work in the Sala di Venere suggests another explanation that does confine the series to the limits of the original reception rooms. This reconstruction is based upon the fact that the Sala di Venere was initially two rooms.[54] Prior to the alteration of these two rooms to a single space in 1638, it would have been possible to create a seven-room series commencing with the Sala delle Nicchie and ending in the present Sala di Saturno, thus explaining the comments of Passeri and Cinelli on the extent of the projected series. Of course the decision to transform two of the rooms to the single space now occupied by the Sala di Venere eliminated this solution for the distribution of the seven-planet series. Furthermore, as we have already noted, the dedication of this new room to Venus rendered unfeasible the most satisfactory distribution of the Ptolemaic planetary system. It is therefore very likely that a seven-planet scheme had been abandoned by the time Cortona started work on the first room to be executed in the cycle, the Sala di Venere (1641), and possibly as early as 1638, when this room was created.

One further point regarding the Ptolemaic aspect of the cycle deserves consideration before we turn to the decorations of the rooms, namely, the seemingly paradoxical, not to say ironic, fact that a decorative program based on this ancient hierarchy of the planets should have been introduced into the principal rooms of the grand-ducal palace just one year before the death of the great Florentine scientist, Galileo Galilei, the man most responsible for destroying the scientific validity of that geocentric planetary system. A dishonor it would seem to the scientist who in 1610 discovered four of the satellites of Jupiter and named them the Medicea Sidera in honor of the reigning grand duke, Cosimo II.[55] This is especially the case when we consider that Galileo had served

[54] No extant plan of the Pitti depicts the Sala di Venere in its earliest state.

[55] G. Galilei, *Sidereus Nuncius*, Venice, 1610, *passim*. The book was dedicated to Cosimo II, who had been a student of Galileo.

as the tutor of Grand Duke Ferdinand II, to whom he had dedicated his most significant—if politically disastrous—work, *Dialogo dei Massimi Sistemi*, which had demolished the scientific validity of Ptolemaic astronomy. In light of these circumstances it does seem incredible to modern eyes that a repudiated cosmological system could have been the basis for the iconography of the Planetary Rooms.[56]

The lesson of the "Barberini Bees" as explained by Erwin Panofsky should remind us, however, that by the 1630's the compartmentalization of science and art was such that Cortona, when called upon to paint the bees of the Barberini coat of arms on the ceiling of the Salone in the Barberini Palace [Fig. 143], ignored readily available, scientifically correct representations and chose instead to depict the bees in a conventionalized manner, flying upside down, in spite of the fact that their *concetto* depended upon their acceptance by the spectator as living bees flying in formation against an open sky.[57] However, the infusion of scientific discovery into the work of art, as in the case of the scientifically correct depiction of the moon in Ludovico Cigoli's fresco of the *Assunta* (1612) in the chapel of Paul V in S. Maria Maggiore, is rare in the seventeenth century. Indeed, when all the evidence is read, it seems unlikely that Galileo himself, given his preference for the normative and conventional in art, would have been perturbed to find that a cycle of allegorical ceilings followed the discredited Ptolemaic cosmology.[58] He would instead have judged them on the Horatian principles of fidelity to the *istoria*, clarity, and decorum rather than on the degree of their scientific veracity. Therefore restoration of the Ptolemaic system as a valid, scientific cosmology should not be construed from the Planetary Rooms, for it is unlikely that discredit to Galileo's scientific achievements was intended. True measures of Galileo's status at the Tuscan court are the handsome stipend the Grand Duke paid the exiled scientist and, more significant for the planetary cycle, the display of Galileana in the large room to the east of the last room in the series, which was hung with major works of art and filled with

[56] Cf. W. Vitzthum, *Pietro da Cortona a Palazzo Pitti*, Milan, 1965, 4: ". . . la grande ironia della decorazione del palazzo del Granduca di Toscana consiste nel fatto che fu iniziata un anno prima che Galileo morisse proprio in quella Firenze ai cui governanti egli aveva dedicato le sue Stelle Medicee"

[57] E. Panofsky, "Artist, Scientist, Genius: Notes on the 'Renaissance-Dämmerung,'" in W. Furguson et al., *The Renaissance*, New York, 1962, 179, and Figs. 26, 27. A scientifically correct representation was published in a book dedicated to the Pope's nephew, Cardinal Francesco, shortly before Cortona started the ceiling.

[58] For a discussion of the art theory of Galileo see E. Panofsky, *Galileo as a Critic of the Arts*, The Hague, 1954, where Cigoli's fresco is reproduced, Fig. 2. Furthermore, Galileo would in all

probability have reacted favorably to the stylistic qualities of the Planetary Rooms. Galileo, an Anti-Mannerist, was an ardent supporter of the Grand Manner, and when he attacked the literary *maniera* of Tasso and defended the style of Ariosto, he likened Tasso's complexity and fantasy to a museum of the Wunderkammer type and, in contrast, compared Ariosto to the grandeur and clarity of a museum of his preference whose description is remarkably close to the Farnese Gallery of Annibale Carracci. For the Tasso-Wunderkammer comparison see *Le opere di Galileo Galilei*, national edition, Florence, 1899, IX, 69. The contrasting description reads: ". . . quando entro nel *Furioso*, veggo aprirsi . . . una galleria regia, ornato di cento statue antiche de' più celebri scultori, con infinite storie intere, e le migliori, di pittori illustri"

sculpture.[59] In this room were displayed two portraits of Galileo, six cosmological charts, two cosmological globes, and a painting of the moon as it had been seen in Galileo's telescope.[60] Thus, although compartmentalized in presentation, the glories of art and science were celebrated under one roof.

Furthermore, the same blending of the rival planetary systems is present in the writings of the contemporary English poet, John Milton, who was in the Grand Duchy of Tuscany in 1638 and again the following year and who, probably during his first visit, had an interview with Galileo. Milton, for reasons of convention and literary tradition, accepted Ptolemaic astronomy, but he also made frequent and explicit reference to the discoveries of Galileo, employing the telescope in a metaphorical sense and also putting Galilean astronomy into the words of the angel Raphael.[61]

In truth, it is the utilization of the literary, nonscientific tradition associated with the Ptolemaic order which keeps the *concetto* of the Planetary Rooms, as it were, in orbit. Obsolete in the world of science and technology, the Ptolemaic order was the perfect cloth from which to tailor a *De Regimine Principum*, a conservative, absolutist allegory whose primary purpose was to promote Medici dynastic pretensions, not to proclaim their scientific or intellectual achievements.

As already noted, the five ceilings in the series are arranged so that the seventeenth-century visitor saw them in succession according to the astronomy of Ptolemy, that is: Venus, Apollo (for the sun), Mars, Jupiter, and Saturn, a hierarchy based on their purported distances from the planet Earth, which resided at the center of the planetary system. The physical sequence is not, however, the order of their actual execution. An extensive discussion of the chronology of the rooms is given in Appendix I of this study, where all known documentation is reviewed. This chronology can be briefly summarized. The Sala di Venere (1641-1642, except for the Medici portraits probably completed 1644/5) was the first room in the series to be executed. When it was ostensibly finished in 1642, Cortona had scaffolding erected in the Sala di Apollo, for which he had probably prepared some designs, but instead of proceeding with this room, the second in physical sequence, he went on to the fourth in the cycle, the Sala di Giove (1642-1643/4). When this room was finished, he decorated the Sala di Marte (1644-

[59] As evidence of grand-ducal financial support of Galileo, a payment—to the best of my knowledge unpublished—may be cited: Florence, A.S.F., Depositeria Generale, F. 1045, No. 356. "Adì 16 di maggio 1640. Io Vincenzio Galileo come procuratore di M.o Galileo Galilei mio padre ho riceuto dalla Depositeria Generale di S.A.S. scudi cinquecento di moneta per la solita provisione di d.o M.o Galileo di sei mesi decorsi . . . sc. 500. Vincenzio Galilei—m[ano] p[ropria]."

[60] See Florence, A.S.F., Guardaroba Medicea, F. 735 (Inventory of 1664), cc. 54r–57r. The paintings in the room included works by Andrea del Sarto, Bronzino, Salvatore Rosa, Pietro da Cortona and Giovanni da San Giovanni. The portraits of Galileo are not attributed in the inventory. The entry for the illustration of the moon reads: "un aovato, miniato, overo dipinta la dimostrazione della luna, con ochiale del Galileo . . ." (c. 56). This depiction of the planet was probably executed by Galileo's close friend, the artist Ludovico Cigoli (for references to the Galileo-Cigoli relation see Panofsky, *Galileo*, *passim*).

[61] E. Allodoli, *Giovanni Milton e l'Italia*, Prato, 1907, 18ff.

1646), the third room and then returned to the Sala di Apollo (1645-1647). When he left Florence in 1647, the Sala di Apollo was incomplete. In 1659 Ciro Ferri came to Florence to complete the Sala di Apollo (1659-1661). Later Ferri returned to Florence to execute the last room in the series, the Sala di Saturno (1663-1665). This sequence is obviously important for our later consideration of the stylistic development of Cortona's ceiling decorations; however, for the sake of both the function of the rooms and their thematic program, we will consider the decorations of the Planetary Rooms in the order of their physical sequence.

SALA DI VENERE

Upon entering the Sala di Venere, the mid-seventeenth-century visitor would have beheld a room whose physical shape has remained unchanged to the present day, but whose general effect has been altered considerably. Instead of a sumptuous picture gallery whose ceiling serves merely to complement the paintings hanging frame to frame on every wall [Fig. 20], he would have viewed a room hung with tapestries depicting scenes from the life of St. John the Baptist and completely dominated by the spectacle taking place overhead. There, in an airy realm separated from the observer by intervening space and set in massive and richly figured white and gold stucco frames, Cortona frescoed the scenes of history and allegory that initiate the Planetary Cycle.

The Sala di Venere consists, in its most schematic terms, of a rectangular space measuring roughly 14.6 meters in length and 9 meters in width. As is true in the other rooms in the series, the height of the walls to the top of the cornice is 7.2 meters, and the crest of the vault is 10.2 meters above the pavement. The northwesterly wall overlooking the piazza Pitti is punctured by two windows. Access to the room is provided by three doors located in each of the three remaining walls. The ceiling is a barrel vault supported by pendentives at the midpoint of each wall. The pendentives of the longitudinal walls are unusually wide, the result perhaps of the removal of a partitioning wall in 1638. The lunettes between the pendentives penetrate the vault and create spandrels that, because the lunettes are paired in the corners of the room, are conjoined to form what is referred to in Italian as an *angolo velato*. The resultant room might be described as consisting of three major architectural surfaces: the wall planes, including the lunettes; the vault proper, which would include the pendentives in its curved profile; and third, transitional areas described by the spandrels of the lunettes.

On this relatively simple, traditional structure Cortona imposed a rich decorative system composed of quite different surface divisions. This he did by interrupting the surface continuities of vault and pendentives and of lunettes and walls by introducing cornices. The principal cornice, elaborately profiled and articulated by white dentils and small scalloped forms on a gold ground, was placed where the pendentives join the walls. This massive cornice serves to separate emphatically the richly decorated area above it from the wall surfaces below. Interrupting the continuity of lunette and wall,

the cornice forces us to experience the lunettes, spandrels, pendentives, and vault proper as a totality. In the center of the vault, Cortona created a long rectangular zone by introducing another massive cornice, placed so that its outer edge touches the arcs described by the sets of spandrels at each corner.[62] The cornice combines with the lower, major cornice and the lunette frames to isolate a third zone composed of the pendentives and spandrels. This imposed relation between spandrels and pendentives, not present as we have noted in the ceiling in its undecorated state, is reinforced by the rich profusion of stucco decorations that encrust these surfaces and contrast, in their dense plasticity, with the two-dimensional surfaces of the frescoes in the lunettes [Fig. 21] and the central *plafond*. Such a prosaic description does no justice to the effect of this ensemble, to the color and brio of the frescoes, to the splendor of the dusky gilt and pure white stuccoes, to the seemingly riotous profusion of animate and inanimate forms, or to the fascinating interplay of architectural elements that seem to be endowed with potential movement. In spite of the manifest opulence of the ceiling, however, one is always aware that it is composed of two independent elements. There is no merger of fresco and sculpture; no *trompe l'oeil* effects of this order are employed. The frescoes are consistently set within their stucco settings, and there is no suggestion that their scenes penetrate the space within the room.

Cortona's introduction of stuccoes into his arbitrarily created zone of spandrels and pendentives has an important effect on the ensemble, for it serves to neutralize the structural role of the enframed areas in the center of the vault and the lunettes that were to receive frescoes. Thus the heavy cornice on the ceiling minimizes, in visual terms, the curvature and physical weight of that portion of the vault contained within it. Consequently, one is scarcely aware that the central fresco of the vault is painted on a concave surface. Similar, too, is the effect of the lunette frames. Above all, it is the decoration of the pendentives and spandrels that seems to relieve the central field of the vault and the surfaces of the lunettes of their structural obligations. The rich overlay of moldings and panels combines with life-size figures in action to absorb and concentrate, in visual terms, the immanent pressures and forces of the vault. Thus the stuccoes minimize the theoretical violation of mural surface that is inevitable when frescoed scenes are painted as *quadri riportati*, that is, as if they were framed wall paintings transferred to their ceiling location.[63] It is to this stuccoed zone, both in terms of its *concetto* as a visible expression of the structure of the vault and in terms of its hedonistic display of the splendor of burnished gold and pure white stucco, that we may now direct our attention.

[62] The use of a cornice—real or painted—above the points of the spandrels follows a long-established tradition. For further comment see C. de Tolnay, *Michelangelo II: The Sistine Ceiling*, Princeton, 1945, 14ff.

[63] For a discussion of the philosophical and theoretical problems created by *quadro riportato* see

C. Goldstein, "Studies in Seventeenth Century French Art Theory and Ceiling Painting," *Art Bulletin*, XLVII, No. 2, June 1965, 231ff., especially Part II, 240ff. See also R. E. Spears, "On the Relationship Between Subject and the Decorative Modes in Baroque Fresco Cycles," *Acts International Congress, 1969*, Budapest, 1972, 13ff.

The Stuccoes

The stucco decorations in the Sala di Venere consist of a rich figural and architectural overlay that visually expresses—and exaggerates—the structural tensions of the actual vault. Mere reflection of the surfaces of the vault in the decorative panels and moldings would have resulted in simple geometric patterns similar to those found on innumerable Renaissance decorated ceilings. In contrast, Cortona seeks to intensify the actual masonry profiles and planes and to suggest thereby that these areas of the ceiling are in a state of severe compression. This deliberate amplification of structural stress by formal means is achieved in several ways.

One method of amplification that Cortona employs is the repetition of forms in depth; thus the curved surfaces of the pendentives are repeated in what appear to be the multilayered groups of ornamental pendentives that decorate their surfaces [Fig. 22]. Each of these ornamental pendentive groups appears to consist of overlapping pendentives that diminish in size with each succeeding layer, resulting in a pleated effect when the edges of the fictitious pendentives are read in depth. The bases of these ornamental pendentives—the points where they theoretically join the wall and where the pressures of the vault converge—are obscured from view by elaborate aedicular structures that demonstrate another of Cortona's methods of enrichment and elaboration, that of superimposition of different architectural elements.

The aediculae reflect the configuration of the pendentives by becoming wider at the top. Within these aediculae, a strong interaction of elements is obtained. On the short walls, the vertical oval form of the portrait medallions set within them seems to account for the shape of the curved inner pediments [Fig. 22], which read as having once been straight cornices. On the long walls, the double portrait medallions press against the triangular pediments and also appear to have produced internal pressures that find expression in the lobe-like cartouche forms within the aediculae [Fig. 23]. Potential mobility of the aediculae is reinforced by the fact that their upper edges cut off the rinceaux panels on the central stucco panels of the pendentives. This overlapping of forms indicates that the aediculae are set before the pendentives, which by implication extend as uninterrupted surfaces behind them. The aediculae appear to be held in place by free-standing gilded stucco figures who struggle purposefully against their weight and without whom we surmise these elements and the stucco portraits mounted within them would topple to the floor. The corners of the room [Fig. 21], by comparison with the pendentive areas, are de-emphasized. The corner is, as it were, removed from the main cornice, which is curved at the point where the two wall planes join. A drooping garland tends to break the horizontal continuity of the cornice line at either side of the curve and to direct the spectator's attention upward toward the vault. In each corner, directly above the main cornice, two female figures cling to the bases of term figures who take both male and female forms. The term is placed so as to follow the line marking the union of the two corner spandrels. To either side of the term lie

the concave fields of the spandrels, whose form is that of a spheroidal triangle. The shapes of the spaces are repeated in a molding on their surface, and inside of this molding a beribboned coat of arms executed in high relief appears to be tacked onto the spandrel, its ribbons fluttering against the vault.

The curved cornices of the lunettes situated immediately below the spandrels are designed to imply that the ornamental architectural system is under compression. The basic form of these cornices is that of an inverted volute. Visually, the spectator is led to believe that these cornices do not merely follow the curve formed by the juncture of spandrel and wall but rather are springs that have been pinched under tension into high curved shapes capable of exerting powerful lateral pressures. One has the impression that, if these inverted volutes were permitted to expand laterally, they would flatten like carriage springs, closing the areas at present allotted to the lunette frescoes, and their "key stones," which serve as plaques for the fresco inscriptions, would come to rest on the small pedestals between the two coiled cornucopias that lie beneath the lunettes.

Immediately above the stuccoes thus far considered we encounter the elaborate stucco frame of the ceiling fresco [Fig. 27], which provides an upper boundary for the ornament below it and also a final statement of Cortona's intentions. At points of contact with the pendentives, this cornice is pressed in toward the central field of the vault as though a vertical thrust had been exerted against it by the compressed pendentives, which in turn appear activated by the tensely coiled springs that enframe the lunettes. This inward thrust along the sides of the frame appears to have caused acute deformations at its corners. These corners, which are curved, have not moved inward with the straight sections of the frame. Instead they have become isolated segments. Portions of this frame are acutely bent, but at no point are they broken.

The pressures that find expression in Cortona's ornamental architecture are strong but steady and symmetrical and therefore different from the unruly, violent forces that appear in similar ornamentation of the sixteenth century.[64] Integration, not disjunction, is his goal, and to achieve it he combines the concepts of dislocation and potential mobility with continuity of form. The result, while physically impossible, is visually highly satisfactory. Cortona is able to enrich the ornamental surfaces of the vault with a decoration that expresses visually the dormant forces in the vault itself (by suggesting a state of compression), yet at the same time no portion of the decoration is broken or fragmented.

Precisely because these stuccoes are ornamental and not functional, Cortona can use them to express in ideal terms the intrinsic qualities of the underlying structure with such eloquence. This *concetto* suggests that the ceiling decoration was intended for a room of twice the dimensions of the Sala di Venere and that it has been willfully com-

[64] See also R. Wittkower's comment (*Art and Architecture*, 160f.) on the hypothetical mobility of the semidomes in the vestibule of S. Maria in via Lata which Cortona visually creates, then checks by the introduction of a continuous cornice molding for side walls and apse.

pressed to fit its present location. As mentioned before, at no point is there an actual physical invasion of the mural fresco surfaces. This can be demonstrated in the cornice of the central ceiling fresco, where an inner frame overlapped by ornamental heads at its four corners modulates the wrenching interactions in the outer portions of the cornice; by the time the spectator's eye reaches this inner edge of the cornice an essentially stable rectangularity has been achieved. Furthermore, the inner portions of this frame, like the fresco proper, are set well within the massive outer cornice, and thus it can be argued that these portions of the ceiling would not be invaded but rather covered by the more plastic portions of frame where potential mobility of structure has been implied. Much the same situation is obtained in the lunettes. True, the lunette scenes appear to have been "revealed" by the upward flexed springs that form their cornice, but they seem to be recessed well within their enframements and out of danger if the ornamental architecture were to close over them. Here too a moderating zone has been established at the inner edge of the stucco frame where a continuous molding follows but does not participate in the convolutions of the frame. Although it does not seem justified to speak of the ornamental architecture in the Sala di Venere as strongly directional—it seems in fact to have achieved a moment, however precarious, of stasis—one is nevertheless left with a sense of upward movement.

To study the rich assemblage of ornamental and figural forms in the stucco decorations of the Sala di Venere is to realize that they are the work of an artist who reacts to structural form with an architect's sensibilities. Furthermore, it is apparent that the aesthetic here expressed is in fact that of an architect who conceives of his structures in sculptural terms, which links Cortona, and specifically Cortona's decorative architecture in the Sala di Venere, with the work of the great sculptor-architect, Michelangelo. The importance of Michelangelo to Cortona's architecture has been noted several times; it may, however, be reiterated in the present context.[65] For both artists, the ligatures of the actual structure find visual expression in architectural forms that suggest contraction and compression. In the vision of both artists, the apparent inertia of undecorated masonry surfaces comes to life. No less fundamental, however, are the concepts not held in common; one looks in vain in Cortona's work for the architectural shocks of Michelangelo's unorthodoxy. Cortona rejects the bitter turn of Michelangelo's intellect and in doing so achieves something quite different from the Renaissance master. He gives free play to an artistic sensitivity which is less cerebral, but incredibly sensitive to the visual and tactile sensuality of interacting forms. Perhaps it is elementary to speak here of a Baroque release, but surely something of the sort has occurred.

Of course Cortona's vocabulary of ornament is not derived exclusively from that

[65] See especially E. Hubala, "Entwürfe Pietro da Cortonas für SS. Martina e Luca in Rom," *Zeitschrift für Kunstgeschichte*, xxv, 1962, 125ff., and also Wittkower, *Art and Architecture*, 155ff. I follow Ackerman on the aspects of Michelangelo's approach here considered (J. S. Ackerman, *The Architecture of Michelangelo*, 2 vols., London, 1961, *passim*). Only after this material was written did I have the opportunity to consult the in general concurrent discussion in K. Noehles, *La chiesa dei SS. Luca e Martina nell'opera di Pietro da Cortona*, Rome, 1970.

of Michelangelo. As Wittkower has observed, Cortona borrowed freely from the late sixteenth–early seventeenth-century repertory of architectural forms, using richly plastic strap work, scrolls, and cartouches found in the work of Buontalenti, the Taccas, and Giovanni Bologna and also the harshly angular types of moldings and overlapping pilasters and panels found in the work of Giovan Antonio Dosio.[66] In the context of the Planetary Rooms, it does not seem appropriate to investigate these sources in terms of individual motives, for to do so would entail a study of the formation of Cortona as an architect. These forms were indigenous to his style before the Medici commissions.[67]

Although it is appropriate to stress the fact that Cortona's ornamentation is essentially architectural, the effect Cortona has produced cannot be explained solely by enumeration of architectural sources, for in large part these decorations are a direct expression of the material from which they are made: stucco. In the Sala di Venere and in the later rooms in the series, stucco as material does not merely serve as an alternative to stone, the material for which it often provides an economical substitute. Instead of imitating stone statues, the figures in the Sala di Venere clamber along the edges of the main cornice and cling from the vault in locations denied to heavy figures in stone. In the later rooms, these figures are left pure white, reminding us of the substance of which they are made. Even the hard-edged panels are clearly formed by casting—how else to explain the fact that moldings are virtually seamless as are the hypothetically laminated edges of groups of "stacked" panels or pilasters? The more sensual portions of the decorations, the bloated moldings and the often voluptuous cartouches—most of which are also pure white—celebrate the hydrous stage of their creation. These undulant shapes, similar to the residual mortar left on the exterior of a brick wall by a hasty mason, in their relation to the firmer geometric forms around them create highly tactile and often amusing incidents in their sudden appearance in sections of otherwise relatively orthodox architectural ornamentation.

Although the cartouche and related forms are an important part of the effect made by the white stuccoes in the Sala di Venere, they are overshadowed by the stucco portraits of the Medici [Figs. 22-25]. These portraits frankly admit their sources in similar portraits on antique sarcophagi, but here the double portrait is explored in terms of Baroque naturalism and animation.[68] The portraits depict the Medici with a candid naturalism, catching them in spontaneous attitudes as they converse or peer out upon the occupants of the room. Although they are easily recognizable, each is accompanied

[66] Cf. Wittkower, *Art and Architecture*, 167.

[67] Cortona's career as an architect started with early training provided by his uncle Francesco Berrettini (died 1608) and, in all probability, by his older cousin, Filippo (1582-1664), who had connections with competent minor Florentine architects. His father was a mason; his uncle, an architect-contractor. The uncle is usually credited with teaching Cortona the rudiments of architecture (cf. Fabbrini, *Vita*, 2); however, Cortona may have learned much from Filippo Berrettini, who was more active as an architect and who in important works such as the facade of the Palazzo Casali at Cortona consulted with Florentine architects, such as in this case Gherardo Mechini (active c. 1589-1616).

[68] See for example G. P. Bellori, *Admiranda Romanarum Antiquitatum . . .*, Rome, 1693, Pl. 78, for an example of such a sarcophagus once in the Palazzo Barberini (engraved by Pietro Bartoli).

by his personal device, which appears on an elegantly curled stucco escutcheon tenuously fastened to the triangular fields of the spandrels by fluttering stucco ribbons. As an ensemble, the Medici portraits present a gathering of distinguished male members of the family—living and dead—who engaged in or, in the case of the youthful Grand Prince Cosimo, were destined to engage in secular or ecclesiastical rule. The direct descendants of the line of Cosimo Pater Patriae are represented by the two Popes; whereas the secular figures all pertain to the grand-ducal line of the family whose direct blood lines descend from Cosimo Pater Patriae's brother, Lorenzo il Vecchio. With the obvious exception of the Medicean Popes, Leo X and Clement VII [Fig. 24], the groupings of the figures follow a father-son pattern.

The two ecclesiastics of the assembled Medici appear on the pendentive of the southern wall. In his portrait, Leo X is clad in ecclesiastical robes, broodingly regarding all who enter the room, gripping an arm of his chair with one hand while the other clasps a small missal. His features suggest the same petulant personality disclosed in Raphael's famous portrait, which undoubtedly served as a model for the stucco. His escutcheon, situated immediately above him and to his right, features an ox yoke with the motto: SVAVE (gently).[69] Leo X shares his position with Clement VII, who is also seated and, holding a missal in his left hand, raises his right in a gesture of benediction. In the spandrel to his left there is a crest consisting of a tree and a crystal supported on a tripod through which rays from the sun pass and are thus intensified so that wherever they strike the tree it bursts into flames. This device bears the motto: CANDOR ILLAESVS (unblemished brightness).[70]

On the opposite wall toward the piazza Pitti, a medallion that echoes that of the Medici Popes contains Cosimo I and his son, Francesco I [Fig. 23]. The two men lean comfortably on the frame of their tondo and face each other in friendly conversation. Cosimo I wears richly decorated armor and holds a baton. His son wears ermine robes and offers him a small book. Cosimo's device is a tortoise from whose shell protrudes a mast with a wind-filled sail above which is inscribed the motto: FESTINA LENTE (make haste slowly), a favorite proverb, according to Suetonius, of Augustus Caesar.[71] On Francesco's escutcheon, a weasel carries a branch of laurel or bayberry with the motto: AMAT VICTORIA CVRAM (victory loves [follows naturally upon] taking pains).[72] On the short wall adjoining the Sala delle Nicchie, the Grand Dukes Ferdinand I and Cosimo II [Fig. 22], the grandfather and father, respectively, of Ferdinand II, share a single tondo. Ferdinand I is dressed in heavy armor and holds a baton, much as he appears in his equestrian monument in the Piazza della SS. Annunziata. Ferdinand's coat of arms consists of a double circle of bees containing a bee at the

[69] P. Giovio, *Dialogo dell'imprese militari et amorose*, Lyon, 1574, 45.

[70] *Ibid.*, 51.

[71] Although it is not possible to establish connections between the other portraits or their accompanying devices and the adjacent lunette frescoes, it does seem more than coincidence that this device with its Augustan motto should have been placed directly over the lunette depicting the meeting of Augustus and Cleopatra (Fig. 38).

[72] Cf. G. Bianchini, *Dei gran duchi di Toscana della reale casa de Medici*, Venice, 1741, 47.

center and bears the motto: MAIESTATE TANTVM (by majesty alone).[73] Cosimo II, presented in his grand-ducal robes of ermine, is somewhat crowded to one side of the tondo, owing to the greater displacement of Ferdinand I. His device consists of a laurel wreath with the motto: NON IVVAT EX FACILI (that which comes easily does not please).[74]

The wall toward the Sala di Apollo contains the last set of portraits. Here Grand Duke Ferdinand II and his young son Cosimo (later Cosimo III) [Fig. 25] lean out of their medallion to survey the populace gathered below. Ferdinand wears full armor and a lace collar and leans on a baton. With his left hand, Ferdinand grasps his own plumed helmet and holds it above the head of his son, as if to signify his desire that Cosimo succeed him to the grand-ducal throne. On Ferdinand's escutcheon, there is a bunch of roses and the motto: GRATIA OBVIA, VLTIO QVAESITA (favor is freely offered; vengeance sought out).[75] His son's escutcheon consists of a cornucopia and a sheaf of wheat and bears the motto: FRVCTVS VICTORIAE FELICITAS (the fruit of victory is happiness), which is undoubtedly intended as a pun on the name of his mother, Vittoria della Rovere.

A preparatory drawing [Fig. 26] related to the pendentive ornamentations has been located that provides some information about the genesis of the portrait ensembles.[76] Previously considered to be a study for a sepulcher, this drawing was correctly identified and partially reproduced by Moschini. The left portion of the drawing (not reproduced by Moschini) contains two sketches of a cornice profile that amply demonstrate the complexity of Cortona's molding and cornices. The right section of this drawing is an early study for one of the stucco portrait medallions and its supporting figures. In this scheme, the medallion displays one portrait seen in profile. The pediment is more or less equivalent to those of the final version; even the laurel garlands are indicated, but instead of hanging loosely they are grasped and held aloft by the flanking figures, which in the drawing are Tritons. This preparatory drawing suggests that at the time of its conception four, or, as is far more likely, assuming that it is a sketch for a short wall and that double portraits were planned from the first for the long walls, six such portraits were intended. If six portraits were at first planned, they were undoubtedly to have been of the five grand dukes and the heir apparent. The use of a profile portrait in the preparatory drawing suggests an antique cameo or coin. A more immediate source, or intermediary, however, is the portrait medallions of the great military rulers that ornament the pendentives of the vault in the Sala della Stufa [Fig. 158]. The change to more animated poses may have resulted from a decision to repeat in stucco the six Medici portraits that were—as we have noted in our discussion of the function

[73] *Ibid.*, 72.

[74] *Ibid.*, 90.

[75] *Ibid.*, 115. In 1665, Ferdinand II issued a silver coin with the value of 5 *lire*, 13 *soldi* and 4 *denari* on which this motto and device appeared. The coins were referred to as *Pezze della Rosa.* See

I. Orsini, *Storia delle monete de' granduchi di Toscana della casa de' Medici* . . . , Florence, 1755, 91f. and Pl. 18, No. xix. According to the same source, the motto was composed by Francesco Rondinelli, author of the program of the Planetary Rooms.

[76] Drawing Cat. No. 53.

of the Planetary Rooms—a feature of the Sala di Apollo prior to Cortona's decorations and to add to their number living members of the family, Ferdinand II and his son, the future Cosimo III.

As discussed extensively in Appendix I of this study, literary sources provide a basis for giving the Medici portrait groups in the Sala di Venere to Cosimo Salvestrini with the crucial collaboration of Cortona himself, in spite of the fact that available documentary evidence indicates that most of the stucco decorations are the work of the Roman *stuccatori*, Sorrisi, Frisone, and Castellacio, who, as we know, left Florence in February 1644. The portraits themselves corroborate these sources and argue for their execution at a later date. The portrait of Cosimo III, born August 14, 1642, depicts him as a child of about four years of age, when in fact he would have been only one year and six months of age at the moment the Roman *stuccatori* left Florence. Significantly, the near-contemporary description of the decorations by Giovanni Cinelli refers to the portrait of Cosimo III as that of a *fanciullo*, and F. S. Baldinucci speaks of him as in "età puerile," terms appropriate to the age at which we have suggested he was portrayed.[77] Furthermore, an avviso sent to Modena in November 1645 can be interpreted to refer to the official opening of the Sala di Venere.[78] This conforms well with the physical appearance of the young Cosimo III in the stucco portraits.

Salvestrini's abilities as a portraitist are evidenced in a document dated December 8, 1640, requesting payment for a portrait of the Grand Duke by Salvestrini [Fig. 172].[79] Unfortunately, so little is known about Salvestrini that an attribution on the basis of stylistic comparisons is extremely difficult.[80] Although he was a competent sculptor, it is scarcely possible that Salvestrini's skills account for the astonishing quality of these

[77] For Cinelli's observations, see Doc. Cat. No. 126. In describing the Medici portraits F. S. Baldinucci writes: ". . . e fra questi vedesi quello del Ser.mo Cosimo Terzo in età puerile allato a Ferdinando Secondo suo padre" (Ludovici, "Vite," 85). Further corroboration of the Salvestrini attribution is given by F. Inghirami; *Descrizione dell'Imp. e R. Palazzo Pitti di Firenze*, Florence, 1819, 22, n. 1. Marabottini (*Mostra di Pietro da Cortona*, Rome, 1956, 13, n. 25) states—but without supporting evidence—that the *stuccatori* were under the direction of Salvestrini and that he executed the portrait busts.

[78] Doc. Cat. No. 107. For discussion of this document see pp. 204f. of this study.

[79] Florence, A.S.F., Fabbriche Medicee, F. 140, Fol. 104. This minute contains a list of payments to be made to Salvestrini; among them is one for: ". . . uno ritratto di S.A.S. cioè testa di porfido fu stimata e pagata senza il busto scudi dugento e sse fusse di marmo varebbe scudi dodici in circa per le fatiche e spese che sono a lavorare il porfido giornalmente, si vede da l'esempio suddetto e altri

i lavori di porfido in comparatione del marmo si pagano più di sedici volte" The portrait in question is probably the unattributed bust of Ferdinand II (Fig. 172) in which the head is cut of porphyry. If this is the bust in question, it can be dated, on the basis of the payment, within a year or so of 1640 and, consequently, provides further proof that the stuccoes can be dated as post-1644, for the age difference between the Ferdinand II depicted in the bust and that in the Sala di Venere must be at the very least four years.

[80] The two cupids with bows and arrows on the south side of the balustrade that surrounds the Isola of the Boboli Gardens can be given to him with considerable certainty (G. Chiari, *Catalogo delle Statue del R. Giardino di Boboli colla notizia dei loro autori*, Florence, n.d., 8 and Pl. 20; G. Cambiagi, *Descrizione dell'Imperiale Giardino di Boboli*, Florence, 1757, 55). The porphyry figure of Moses in the grotto of the Pitti Palace Cortile was finished by Salvestrini, and he also had a share in the installation of Pietro Tacca's Boar as a fountain in the Mercato Nuovo.

portraits. Their quality derives from Cortona's intervention in their execution, a problem that will be considered in greater detail when we examine the Sala di Giove.

The studied dignity with which the portrayed Medici communicate with one another or acknowledge their spectators is the work of a master artist. Some of this quality can surely be explained by the fact that Cortona designed the figures. But the naturalism and vivid immediacy of the portraits and the superb rendering of details such as the slit puffs in the sleeves of Cosimo III, the intricate lace collar worn by his father, and the wisps of ermine on the robe of Cosimo II and that of Francesco I suggest that both design and execution reflect the intervention of Cortona. Just how remarkable these portraits are can perhaps best be demonstrated by comparison with the portrait groups Bernini and his collaborators produced for the Cornaro Chapel in S. Maria della Vittoria during the 1650's.[81] Without resorting to the use of an illusionistic architectural setting or to such unconventional devices as the lost profile, Cortona achieves a level of immediacy and verisimilitude that challenges the work of the great master of Baroque portrait sculpture. The Medici alternately acknowledge one another or lean out of their frames, heightening their contact with spectators gathered beneath them. In keeping with their less dramatic situation and appropriate to their more conventional role in the decorative ensemble, their gestures are not nearly so dramatic as those of the Cornaro family; they remain portrait groups and are not transformed into *tableaux vivants*.

The Frescoes

The frescoes in the Sala di Venere occupy the rectangular central field of the vault and eight lunettes immediately below the spandrels of the vault. When the spectator enters the Sala di Venere from the Sala delle Nicchie, the customary point of entry in the seventeenth century, his attention is caught by the largest fresco, that of the vault where a dramatic scene unfolds [Fig. 27]. In an Arcadian wood, a sumptuous banquet presided over by Venus, who occupies a couch set on a podium, has been interrupted by the air-borne arrival of Minerva and Hercules. Minerva has snatched a blond-haired youth (whom for convenience we shall refer to as the prince)[82] from the couch of the goddess of love. The fresco presents the event in three-quarter foreshortened perspective arranged so as to be read by the visitor arriving from the Sala delle Nicchie; that is to say, the section of cornice nearest to the piazza Pitti enframes open sky, and the opposite cornice section defines the ground plane of the painting. The inscription of the lower cornice, legible as one enters the rooms, succinctly describes

[81] For date and illustration see H. Hibbard, *Bernini*, Baltimore, 1965, 130 and Pl. 70.

[82] The inscriptions in the Sala di Venere refer to this individual as a youth, and this description is followed by G. Cinelli (Florence, Biblioteca Nazionale Centrale, MS Magliabechiano, XIII, 34,

c. 156v; Doc. Cat. No. 126), who calls him a *Gioventù*. This becomes awkward as he advances in age in the rooms that follow; consequently, I have adopted Fabbrini's terminology and refer to him as the prince (see Fabbrini, *Vita*, 67).

the event: ADOLESCENTIAM PALLAS A VENERE AVELLIT (Pallas, i.e. Minerva, tears the youth from Venus). The prince looks back to Venus regretfully, but she, taken unaware, can only reach forward imploringly. Overhead, *amorini* support Venus's canopy, probably torn loose by swift-flying Minerva, and Eros or Cupid, distinguished from the *amorini* by his wings, clutches at the cloak of Venus's departing admirer. As yet many of the other revelers have barely perceived what has so unexpectedly occurred. One of the bacchantes raises a crystal goblet, brimful with red wine, and, lifting aside her cloak, reveals her charms—obscured from the spectator by the rim of a gilded oval table—to the rapidly ascending youth. Nearby, a bearded satyr raises his pipes aloft in astonishment,[83] and further to the left a magnificently fleshy nymph, sprawled at full length, leans against an amphora and languidly regards the youth's departure [Pl. II]. Other inhabitants of this lush domain seem oblivious to the unfolding drama, or simply indifferent. These include a *putto* who has practically fallen into an enormous urn (presumably both are wine-filled), a nymph atop a pedestal who narcissistically regards her reflection in a mirror supported by a gesturing *amorino*,[84] and two suggestively entwined nymphs in the background. At the far right a fountain consisting of a dolphin, emblem of Venus, with a personification of Cupid astride his back spews water from his nostrils.

Above Venus's lascivious revelers, a cloud-borne Hercules, recognizable by his club and lion's skin, waits to receive Minerva's charge. Hercules is accompanied by a winged *putto* who holds aloft a laurel crown. In position and gesture this little figure is linked to Hercules much as Eros is linked to Venus. The placement of these two figures—the only winged *putti* in the scene—at antithetical locations on the principal diagonal in the composition makes clear the identity of the upper figure as Anteros in his role of Divine or Virtuous Love and rival of Eros, his earthly counterpart.[85] Anteros as *Amor Virtutis*, enemy rather than willing reciprocator of Eros's affections, is a variant (if not a mistaken) interpretation of the classical significance of Anteros as *Amore reciproco* and appears to have been first formulated by the sixteenth-century emblematist, Andrea Alciati. According to Alciati and other emblematists, Anteros's attributes are four laurel wreaths (one for each cardinal virtue).[86] Anteros as *Amor Virtutis* often holds three of his wreaths and wears one, identified as that of Prudence by Cesare Ripa.[87]

[83] The satyr with pipes is of course a traditional symbol of sensuality (see C. Ripa, *Nova Iconologia*, Padua, 1618, 460, under *scandolo*).

[84] The mirror is an attribute of Venus herself and also associated with false love and lasciviousness (see *ibid.*, 172 and 304, under *Falsità d'Amore* and *Lascivia*).

[85] For the literature and summary of the Eros-Anteros thesis see Martin, *Farnese Gallery*, 86ff. There is an iconographic tradition for the association of virtuous Cupid with Hercules. See V. Catari, *Imagini delli Dei de' Antichi*, Venice, 1674, 242. Further to the Eros-Anteros problem, see

E. Panofsky, "Der Gefesselte Eros," *Oud Holland*, L, 1933, 193ff., and R. V. Merrill, "Eros and Anteros," *Speculum*, XIX, July 1944, 265ff.; and for recent literature, C. Dempsey, "'Et Nos Cedamus Amori': Observations on the Farnese Gallery," *Art Bulletin*, L, No. 4, Dec. 1968, 364f.

[86] A. Alciati, *Emblemata cum Commentariis Amplissimis*, Padua, 1621, emblema CX, and Ripa, *Iconologia*, 20, under *Amor di Virtù*.

[87] *Ibid.* Alciati favors Sapientia, which he considers a kind of extension of the cardinal virtue, Prudentia.

Our Anteros holds a single wreath—surely the prudential one—which he is anxious to bestow upon Minerva's charge.[88] Anteros's wreath has a counterpart in the cortege of Venus, where one of the goddess's maidens holds aloft a floral wreath that may be associated both with Venus (it contains roses and myrtle) and with Cupid [Fig. 28].[89] Until a moment before, this flowery crown, rather than its laurel counterpart, had been destined for the head of the departing youth, but the swift intervention of Minerva has altered the situation.

Although Minerva's method of severing the youthful prince's relation with Venus has been drastic indeed, such action is in accord with her circumscribed powers.[90] Best known as the goddess of prudence, of intelligence, and of military strategy, she is also the special custodian of virginity and youth.[91] As the guardian of moral virtue, she prevails over Cupid, whom she may disarm on occasions such as the one depicted by Cortona.[92] The implications of the scene are clear enough; Prudence, Reason, and Intelligence, symbolized by Minerva accompanied by Anteros, carry impetuous youth from Venus, her cohort Eros, and her corterie, who represent the passions of the senses and sensual love, to Hercules, exemplar of the virtuous life.[93] The principals in this scene present its message, and the composition serves to underscore its content.

In composing this fresco, Cortona has disregarded his earlier exploration of the potentialities of the *di sotto in su* in the Salone Barberini and favored a more moderate system of three-quarter foreshortening that does not imply total aerial space, but rather a drama enacted on a stage considerably above eye level. A sense of upward movement is given to the composition of the fresco by the diagonal running from the couch of Venus in the lower right corner of the painting to Hercules in the upper left. This diagonal forms the principal corridor of action in the painting, and it is also a unifying device to which other elements in the composition are related. The struggling ascent of the prince, humorously echoed in the startled flight of one of Venus's doves, is placed on this axis. Illumination and color also accentuate this ascending diagonal. The principal light source located in the upper left corner of the scene conforms to it, and the effect of this illumination is enhanced by the fact that we view the scene from below, and thus the principal protagonists are seen against the sky. In the right side of the fresco the diagonal is bounded by the porphyry-red draperies of Venus's bed and canopy,[94] which also serve to isolate and set off Venus, who is partially covered by a white

[88] The wreath is not for Hercules, who already wears a similar one.

[89] For flowers, especially roses, as an atttribute of Cupid see Alciati, *Emblemata*, emblema CVII. Following Alciati, Ripa (*Iconologia*, 206, under *Forza d'Amore*) describes Cupid as holding a bunch of flowers, but illustrates him holding a floral wreath. The flowers signify his power over the earth. For roses and myrtle as symbols of Venus, see Catari, *Imagini*, 258, and also Ripa, *Iconologia*, 66, under *Carro di Venere*.

[90] Alciati, *Emblemata*, especially embleme I and XIX.

[91] *Ibid.*, emblema XXII. [92] *Ibid.*

[93] The foregoing description agrees in essential details with Cinelli (see Doc. Cat. No. 126). The account of F. S. Baldinucci (Ludovici, "Vite," 85), which is at variance, can be discounted because he has confused Hercules and the Prince.

[94] Porphyry may be identified as the color of Venus (see G. P. Lomazzo, *Trattato dell' arte della pittura, scultura, et architettura*, Milan, 1585, 209).

chemise. On the left, the verdant greenery of the woodland, enriched by the azure blues and golden browns of the garments of Venus's compatriots, gives form to this diagonal. Within this ascendant corridor the colors are lighter, paler. The prince is clad in a *changeant* cloak of yellow-orange tones, connoting perhaps good fortune,[95] and Minerva wears a flowing cloak of pale lavender over a white garment.[96]

It is evident that the fresco in the center of the ceiling of the Sala di Venere is similar in many respects to the well-known theme of the Judgment of Hercules—more popularly known as Hercules at the Crossroads, or Hercules between Virtue and Vice—with, however, two magistral differences; in the fresco, Hercules is no longer the central figure, and the young prince, his replacement, is not permitted the luxury of a decision.[97] The two female protagonists are not, strictly speaking, Virtue and Vice, but rather the deities most effectively representing them; in this respect the handling of the theme is related to the Judgment of Paris, or *Paris Typus* as Panofsky has characterized it, from which the use of the two goddesses has been derived.[98] This change, slight and amply supported by precedents within the Judgment of Hercules theme, was of course essential for the introduction of the theme into its planetary context.[99] To reinforce the planetary aspect of Venus, Cortona adorned her with a traditional emblem, her star, which blazes forth from the top of her head.[100]

The close relationship of this fresco to the Hercules at the Crossroads theme is apparent when we study a Cortona drawing that presents an early *pensiero* for this scene [Fig. 29].[101] In this pen study, the emblematic character of the traditional pre-sensation of the Hercules theme is in good part put aside, but the youthful prince's feet are on the ground, and he seems to be delivering a rhetorical farewell to Venus. In this sketch, he is not directed toward a goal beyond our view, the motif that gives impetus to the room-to-room sequence in the executed version, but rather toward a temple, identifiable as the Temple of Virtue, within the drawing. A prone figure looks up in surprise, a brief suggestion out of which develops Venus's numerous cohorts in the fresco. Hercules is present, but instead of participating directly in the struggle between Minerva and Venus, he functions as an exemplum of virtuous action. Exactly who or what Hercules attacks is not altogether clear from the briefly sketched indica-

[95] A color befitting the young man's circumstance. Lomazzo states that yellow: "Fù da gl'antichi tenuto di ottimo augurio, come si mostra per il pico uccello Martiale, che ha la maggior parte delle penne di questo colore . . ." (*Trattato*, 207).

[96] Lomazzo (*Trattato*, 661) describes Minerva as "vestito di panno purpureo."

[97] For the classic study to which I am much indebted see E. Panofsky, *Hercules am Scheidewege*, Leipzig, 1930.

[98] *Ibid.*, 104ff.

[99] Proof that Cortona was normally highly conventional (and well advised) about such matters may be deduced from the fact that when he deals with a Judgment of Hercules in "pure" form, he adheres to the canonical iconography for the Hercules theme (*ibid.*, Figs. 87, copy; 88, engraving).

[100] The star is a traditional symbol of Venus as a planetary deity. Wings are also an attribute of the Planetary Venus, but they also refer to celestial Venus in her role as the opposite of the earthly Venus of sensual love and so would not have been appropriate (see for discussion and examples L. Soth, "Two Paintings by Correggio," *Art Bulletin*, XLVI, No. 4, Dec. 1964, 539ff.).

[101] Drawing Cat. No. 55.

tions; however, he may be in combat with Hydra.[102] There is at least a slight possibility that Cortona considered unleashing him on recumbent members of Venus's retinue. At this point in the formation of the scene, Hercules functions as a counterbalance—iconographically as well as compositionally—for the figure of Venus; but, in contrast to the other protagonists, he is a static emblematic conceit and not as yet integrated with the central action of the composition. In the later stages of the evolution of the composition, his role changes from that of an *exemplum* of virtue to participating guide and companion. This drawing, which firmly links the subject to the traditional Hercules at the Crossroads theme, introduces motifs that will prove enduring in Cortona's final presentation: an airborne Minerva and a youth who protests departure from Venus or, at the very least, reluctantly accepts Minerva's intervention.

A drawing now in Budapest [Fig. 30] contains the germinal stages of a series of variations that also contribute to the scene as finally executed.[103] In this brilliant pen study, the *locus* of the scene has been moved to the sky. Venus, depicted twice in alternative postures, extravagantly protests. Venus appears twice in this drawing, first immediately adjacent to Minerva and the youth and then in more definitive form in a lower position, thus marking the first step in the creation of the powerful, ascending diagonal that crosses the frescoed version, passing through the figures of Venus, Minerva, the prince, and Hercules. In this sketch, the principal protagonists are present, and even the secondary motif of Cupid clutching the cloak of the departing prince has been established. All the figures in the drawing are airborne, and terra firma is merely hinted at by the appearance of a round temple in the lower left corner. The second sketch of Venus (in the lower right corner of this drawing) not only documents the shift from a predominantly horizontal to a diagonal composition but also further clarifies the goddess's pose. She is now clearly in a semi-reclining position with right arm extended and perhaps offering a floral crown to her departing consort. In desperation she raises her cloak, exposing her body as a final enticement. Although Venus does not retain this gesture, it is repeated in the fresco, much more discreetly, by a nymph who raises a wine goblet behind the large oval banquet table. In the far left, Hercules, club over his shoulder, sits on a cloud awaiting the arrival of Minerva and her charge. His position, below the other protagonists and back in space, increases his psychological unity with the other figures in a way that was notably absent from the first pen study we considered, but tends to mitigate the emphatic rising right to left movement of Minerva and the youth, a movement essential to our comprehension of this action as a part of a sequence of events that is continued in the adjacent room, the Sala di Apollo. Of these two early *pensieri*, the second appears to have most interested Cortona, for the surviv-

[102] Precisely why this labor might have been considered is not clear. Perhaps the repulsiveness of the many-headed monster led to his selection as the epitome of evil, or perhaps his habitat, a swamp at the foot of Mount Pontinus, provided an appropriate topographical setting for Venus' abode, one that could be contrasted with the elevated site of the temple of virtue.

[103] Drawing Cat. No. 54.

ing studies include several variations closely related to it which lead directly to the final solution.[104]

The drawings in question focus, like the second sketch, on the pose and ambience of Venus. In one related drawing [Fig. 31], also in Budapest,[105] Cortona extended both of Venus's arms imploringly, and the raised cloak motif has been absorbed by two *putti* behind her who hold aloft a cloak or coverlet from which eventually evolves the enormous red canopy in the fresco. Although she is still seated on her cumulous perch, there is now a suggestion of a pillow between cloud and goddess.

The next stage of Venus's evolution is recorded in a red chalk study at the Uffizi [Fig. 32], which substantially repeats the pose of Venus considered in the second version of the goddess in the first Budapest pen drawing.[106] A major change, however, is the introduction of a low-bodied chariot with a conch shell back, a vehicle that looks more like a wheeled couch than a bona fide chariot.[107] The chariot, which rests on a cloud, is to be specifically associated with Venus as a planetary deity.[108] A set of traces hangs from the front of the vehicle. At this stage, the presentation of Venus has a source in Cortona's earlier oeuvre, for about 1620 he had painted a *quadro riportato* of the Goddess of Love aboard a chariot drawn by doves and accompanied by Cupid.[109] In this early painting she also wears her planetary star.

Another Uffizi drawing—also in red chalk—provides a cluster of studies on the same theme [Fig. 33].[110] The proximity of these three *pensieri* on a single sheet, their almost organic growth, which produces an enlarging and enriching of the scene in each succeeding sketch, and their placement in a descending right to left diagonal across the page evidence the alacrity with which Cortona worked. Our concern at the moment is the drawing in the left section of the sheet in which the chariot and its occupant have been located in the lower right corner of the composition. We are now quite close to the final version. The two figures behind Venus are indicated, as is the gesture of one who holds up a floral crown in the fresco. The position of these two figures is that generally assumed by the Three Graces, whose station is immediately behind Venus at the back of her chariot. It would seem that Cortona considered introducing the Three Graces into the scene since they are a traditional element in Venus's iconography, then

[104] The first drawing does not appear to have produced any progeny; at least none have been located to date.

[105] Drawing Cat. No. 56.

[106] Drawing Cat. No. 66.

[107] The resultant arrangement is a variation on the traditional chariot of Venus. See Ripa, *Iconologia*, 66, under *Carro di Venere*, and Catari, *Imagini*, 256f., under *Venere*, who describe her as a deity who uses a chariot for air transport and a conch shell for nautical travels.

[108] Lomazzo, *Trattato*, 563: "E furono i carri dati ai Dei, prima per maggior sua maestà, poi perchè con quelli si viene a dimostrare il rotare della sfere

loro"

[109] This painting, once in the Sacchetti collection and now in the Palazzo Senatorio on the Campidoglio, Rome, is first mentioned in the literature of art by Fabbrini, *Vita*, 267, Cat. No. 4. Later Briganti listed it under "Opere inedite o poco note di Pietro da Cortona nella Pinacoteca Capitolina," *Bollettino dei musei comunali di Roma*, IV, 1957, 8, Fig. 4 and also published the painting as an *Aurora*, a title he derived from a 1649 inventory. The iconography of the figure indicates Fabbrini's identification.

[110] Drawing Cat. No. 67.

suppressed the allusion because the Graces in conjunction with Venus may be taken to refer to *concorde matrimonio* and *ardente amore*,[111] qualities at variance with Venus as the *Dea della libidine e della lascivia*, her role in Cortona's fresco.[112] Other new and permanent features are present in this drawing. These include the startled dove and a large oval table.[113] Most important, the Goddess's chariot is no longer in flight. The minimal indications next to the wheels of her conveyance are ambiguous. They could be either plants or clouds, but the position of the goddess at the bottom of the scene and the indications of the table speak for the terrestrial location utilized in the actual fresco. With Venus's domain established, it was possible for Cortona to introduce her numerous retinue including a nymph admiring herself in a mirror in the fresco, who appears in an early formative stage in the lower right corner of the red chalk sketch.

After these drawings, the scheme underwent another major revision, the transformation of Venus's chariot into a couch. The emergence of the couch as Venus's locus coincided with the suppression of another of her attributes, the conch shell that had served as a backboard on her chariot. In the actual fresco, its concave scalloped form has been transformed into the bulging, burnished surface of the curved headboard of the couch. At first glance this would seem an impoverishment of Venus's attributes, but in fact it possibly resulted from the cautious intervention of Cortona's mythographer. The conch shell is understood to allude to her marine birth and her sea passage atop the shell.[114] According to Cicero's elaborated genealogy of the Gods, there are not one but four Venuses.[115] She, born of the sea foam, the second Venus of Cicero, was the mother of a cupid—Eros—fathered by Mercury.[116] Cortona's Venus is another, Cicero's third, the daughter of Jupiter and Diana and wife of Vulcan, mother of Anteros (in the sense of love returned) by an adulterous relation with Mars. It is she, the sensual Venus who in this fresco vainly seeks dominion over the youth. The introduction of a sumptuous couch, the traditional *dramatis locus* of the Mars-Venus tryst in representational art, reinforces the lascivious and adulterous aspect of her nature.

The several mutations we have here reconstructed define and particularize Cortona's Venus. She is a planetary deity, hence, the blazing star on her forehead. She is, however, without the "good" characteristics of celestial Venus; hence, she has no wings, has exchanged her high-flying chariot featured in the preparatory for a sumptuous bed, and was not permitted her full complement of three graces. Seemingly arbitrary, Cor-

[111] Catari, *Imagini*, 259.

[112] *Ibid.*, 254ff.

[113] The dove, here in close proximity to a set of traces, is to be connected in iconographic source to Cortona's c. 1620 representation of a chariot-borne Venus (see footnote 109 above).

[114] Catari, *Imagini*, 255, under *Venere*, provides a second significance for the shell, but not one that seems to have received popular subscription: "Benchè vogliono alcuni, che perchè la conca marina nel coito tutta s'apre, e tutta si mostra, sia

data à Venere, per dimostrare quello, che nei Venerei congiongimenti si fa, e nei piaceri amorosi."

[115] Cicero *De Natura Deorum* III. xxiii. 59.

[116] It is this "family" of the celestial Venus of which Correggio depicted in his so-called *Education of Cupid* in the London National Gallery. Soth, "Correggio," 539ff. Cicero (*Natura Deorum*, 59) refers to the Cupid in question as the "second Cupid." The "first Cupid" he informs us was born of a union of Mercury and the first Diana and thus need not concern us.

tona's changes in attributes establish the exact character of Venus, *Dea della libidine e della lascivia*. The change from chariot to couch served two purposes; it left Venus without means of pursuit and, second, made far more explicit the nature of her enticements. The inclusion of Venus's bower further enhanced this aspect of the subject, making possible the presence of her numerous followers who illustrate the gamut of sensual pleasures. Cortona's final solution for this scene is strikingly similar to one of the side sections in the ceiling of the Salone Barberini in which Venus is surprised in her bowery bed by Chastity.[117] In the Barberini ceiling, the struggle is directly one of Virtue versus Vice rather than over the conduct of a central protagonist placed between the two. In the earlier commission, the physical aspects of the confrontation are enacted by representatives of Divine and Earthly Love—Eroses and, in his Alciatian guise, Anteroses—who battle with one another.

Lacking an exact *topos*, Cortona's fresco is, as we have noted, closely related to the Hercules at the Crossroads theme, particularly to those versions in which Minerva and Venus are featured as representatives of Virtue and Vice.[118] Most striking, however, is that, in the Sala di Venere, the Herculean dilemma of choice is eschewed; the youth is summarily torn, from all appearances, involuntarily by Virtue from the arms of *amor carnalis*. This forceful intervention by Virtue suggests that Cortona had knowledge of an engraving by Pierre Perret derived from a painting by Otto Van Veen entitled *Youth between Virtue and Vice* [Fig. 173], composed in 1594-1595.[119] As in the fresco, Virtue, personified by Minerva, snatches the youth from the embrace of Vice, portrayed by Venus. In each stage of its evolution, the Cortona conception shares, in addition to the central protagonists, common elements with Van Veen's work. Although the temple that appears in several early stages of Cortona's composition could have been derived directly from the temple that frequently terminates the *via fama* or the *via virtutis* in the Choice of Hercules,[120] it also occurs in *Youth between Virtue and Vice*. Other motifs such as the gesture of the proffered wide-brimmed wine goblet, the good genius who holds aloft a laurel crown, and the tugging on the youth's garments by the revelers—a task which Cortona allots to Cupid—can all be found in the engraving. Two of the Uffizi studies for Venus incorporate a chariot similar to that used in the engraving, and one of these drawings also included the fluttering doves. In the final scheme, the possible links with the engraving have become obscured, and Cortona has replaced the chariot with a canopied bed and added a general scene of revelry, a theme he may

[117] For an illustration see Briganti, *Pietro*, Pls. 126, 127.

[118] Within this subgroup it belongs to a typos in which the position of Hercules is subsumed by another individual (see Panofsky, *Hercules*, *passim*, for numerous examples).

[119] The painting is now in Stockholm. For further discussion and illustration see F. M. Haberditzl, "Die Lehrer des Rubens," *Jahrbuch der Kunsthistorischen Sammlungen des Allerhöchsten Kaiser-* *hauses*, XXVII, No. 5, 1908, *passim*, and Fig. 39; G. Swarzenski, "Un quadro di Luca Giordano in Francoforte sul Meno," *Bollettino d'Arte*, I, July 1922, 17ff., and Fig. 1 (the engraving); and also S. Speth-Holterhoff, "Un cabinet d'amateur anversois du XVIIe Siècle entre au Musée Royal d'Art Ancien de Bruxelles," *Bulletin Musées Royaux des Beaux-Arts*, IX, Nos. 1-2, March-June 1960, 75ff.

[120] For an example see Panofsky, *Hercules*, Fig. 61.

have already included in a lost painting of the Choice of Hercules.[121] Cortona's fresco is a fusion of the traditional iconography of the Choice of Hercules and that of the Van Veen composition. Cortona, however, has overcome the static, emblematic qualities characteristic of both *topoi*, incorporating their iconography in a vivid and dramatic, if less didactic, representation.

The central fresco in the vault is, as we have observed, most comprehensible when seen as one enters the room from the doorway to the Sala delle Nicchie. From this position, the inscription already alluded to is legible. After the room has been traversed and some, if not all, of the lunettes viewed, the second inscription is right side up. It reads: RADIX AMARA VIRTVTIS FRVCTVA SVAVIA (The root of virtue is bitter, its fruit sweet). The inscription is not only a fitting epitaph for this ceiling but also summarizes the content of the eight lunettes in which ancient heroes nobly resist the temptations of sensual love for the sake of virtue gained.

It does not matter in what order one peruses these frescoes, and so we shall begin with the lunette in the left portion of the long southern wall. This lunette depicts the discovery by a court physician that young Antiochus is dying of unrequited love for Stratonice, his youthful stepmother and wife of King Seleucus I, who in an extraordinary act of parental devotion relinquishes his young queen to his son [Fig. 34].[122] Valerius Maximus provides the oldest extant source for this frequently repeated story, and it is from this version that Cortona's lunette derives.[123] The scene bears a laconic inscription—due in part to the fact that a large portion of its tablet is occupied by the window of a listening post—which reads: FILIVS AMANS ET SILENS VAFER MEDICVS PATER INDULGENS (The son in love and silent, the physician clever, the father indulgent). The expiring Antiochus, too weak to wear his crown that lies nearby, is reclining upon a couch and attended by the court physician.[124] His father and stepmother are seated at the foot of the couch. As noted by Wolfgang Stechow, Cortona has compressed every major element of the tale into a single, seemingly uncomplicated, presentation.[125] Antiochus, though scarcely a wasted, pallid youth, has half swooned at the sight of Stratonice, who regards him with averted eyes. Simultaneously, the doctor realizes the cause of the youth's racing pulse and makes known his diagnosis to the king, who gestures his willingness to relinquish his young wife and to permit true love to run its course. Stratonice, with disconcertingly little outward emotion, accepts her changing fortune. In an effort to emphasize King Seleucus's act of self-

[121] *Ibid.*, Fig. 87. For the literature related to this painting see S. von Below, *Beiträge zur Kenntnis Pietro da Cortonas*, Murnau, 1932, 95.

[122] The subject has received full attention in W. Stechow, "'The Love of Antiochus with Faire Stratonica' in Art," *Art Bulletin*, XXVII, No. 4, Dec. 1945, 221ff. (for the discussion of Cortona's fresco, see especially 227f. and Fig. 3).

[123] *Facta et Dicta Memorabilia* v. vii. 1. The other versions (Plutarch *Lives* (Life of Demetrius,

xxxviii); Appian *De Rebus Syriacis* 59 sqq.; and Pseudo-Lucian *De Dea Syria* 17 sqq.) all involve a ruse whereby Seleucus is forced to give up his queen, a version entirely out of keeping with the themes of continence and compassion that the lunettes illustrate.

[124] Cf. Cinelli's description (Florence, Biblioteca Nazionale Centrale, MS Magliabechiano, XIII, 34, c. 157v; Doc. Cat. No. 126).

[125] Stechow, "Antiochus," 227.

denial, Cortona has minimized the more sensational aspects of the drama, the essentially adulterous passions of the two young people involved.

In general composition, the Stratonice lunette—which should be referred to in this context as the Seleucus lunette[126]—finds its source in antique sarcophagi compositions featuring a deathbed scene, such as that of Alcestis, whose husband Ademetus sometimes appears to be taking her pulse.[127] The pose of Antiochus is closely related to Michelangelo's Adam of the Sistine ceiling's *Creation of Adam and Eve*, and his left hand and arm are a direct quotation from Michelangelo's *Evening* in the Medici Chapel. Wrapped in a pale lavender coverlet and white bed sheets with richly crocheted edges, the young prince is paired in the left section of the lunette with the old physician. Their physical proximity is reinforced by a wall that defines their space and the color of the bed curtain immediately behind the doctor that repeats the lavender of the prince's coverlet. To the far right, dressed in white save for a gold bejeweled border on her bodice and demurely echoing the pose of her lover, is Stratonice. Although they are separated in space, we cannot ignore her psychological unity with Antiochus. They are related by their pendant positions, by the lavender drapery behind her, and by the gesture of the physician, which is reinforced by the enclosing arc of the lunette. Their gazes do not meet, but the reciprocity of their passions is scarcely hidden, for we should note that although her downcast visage suggest decorous modesty, Stratonice's gaze has fallen upon the right foot of Antiochus, which extends beyond the bed sheets. Next to Stratonice, wearing a cloak the color of burnt orange, sits Seleucus, his form silhouetted against a verdant forest and blue sky. Eyes on his son, he motions toward him with an open hand, a gesture that suggests the selflessness of his gift and, coupled with the pointing gesture of the physician, the instantaneousness of his response to the latter's diagnosis.

If we move clockwise, the Seleucus lunette shares the southern wall of the Sala di Venere with a lunette depicting the Meeting of Alexander and Sisigambis [Fig. 35]. This dramatic moment, rich in sentiment, in which the frightened and helpless women of defeated Darius, King of the Persians, face their Macedonian conqueror, who generously promised clemency and protection of their persons, was often described by the ancient historians.[128] The two best known examples of the scene in the history of art prior to Cortona's treatment of the subject are those of Sodoma and Veronese.[129] Cortona must have known these paintings, for his lunette reveals the absorption of motifs from both of them. The essential source is Sodoma's fresco [Fig. 174] which supplied the germinal motif of Sisigambis's being tenderly requested to rise to her feet from a suppliant position by Alexander. The introduction of Alexander's hardy warriors as witness to the event would also seem to derive from Sodoma's composition. From Vero-

[126] It is of interest that Luca Berrettini (G. Campori, *Lettere Artistiche*, Modena, 1866, 505ff.) referred to it as the "Storia di Seleucus."

[127] C. Robert, *Die Antiken Sarkophag-Reliefs*, Berlin, 1892, III, Fig. 26.

[128] Plutarch *Lives* (Life of Alexander, xxi); Quintus Curtius *History of Alexander* III. xii. 15 sqq.; Valerius Maximus *Factorum et Dictorum Memorabilium* IV. vii. 2.

[129] D. Posner, "Charles Lebrun's 'Triumphs of Alexander,' " *Art Bulletin*, XLI, No. 3, Sept. 1959, 240 and Figs. 2 and 3.

nese's painting [Fig. 175], Cortona adapted two secondary motifs: the surprised youth who leans on a shield to watch the meeting, and the depiction of other members of Darius's family as young women in kneeling positions. In both instances, Cortona has radically transformed Veronese's groupings to meet the exigencies of the lunette form within which he was working. However, not all of Cortona's adjustments of his sources are motivated by compositional necessities, for he seeks to elucidate a very specific interpretation of the scene and one that is quite different from that of Veronese and also somewhat different from that of Sodoma.

Cortona's two predecessors followed descriptions of the encounter of Alexander and Sisigambis by Valerius Maximus and Quintus Curtius, both of whom describe a visit by the Macedonian to the tent of Darius where the captive family was being held. These sources mention the presence of Alexander's best friend Hephestion, who, being taller, was mistaken for Alexander by Sisigambis, who knelt before him. Her error, according to these sources, was corrected by a servant (visible immediately behind the kneeling queen in Sodoma's fresco), and the queen, horrified by her mistake, begged the forgiveness of Alexander, who raised her up and assured her, "You were not mistaken, Mother, for this man too is Alexander."[130] As pointed out by Jean Paul Richter, Veronese's *Alexander and the Family of Darius* is a portrait of the Pisani family and also an allegory of friendship based on the words of Alexander.[131] Sodoma's intention was quite different, for combined with its pendant, the *Wedding of Alexander and Roxanne*, he used the *Alexander and the Family of Darius* to illustrate one aspect of their joint theme, succinctly described by Donald Posner as "Amor Vincit Originem," in which the encounter illustrates Alexander's control of base passion for the beauty of Darius's nubile children as opposed to his "purer" passion for Roxanne, who was poor and of obscure birth.[132] To emphasize the paternal qualities of Alexander's treatment of the queen and her family, Sodoma picked the moment when Alexander stepped forward to raise Sisigambis to her feet and called her "mother" and suppressed the presence of Hephestion, who stands to one side, thus de-emphasizing the friendship gesture that dominates Veronese's painting.[133]

In Cortona's hands, the central motif of Sodoma's fresco is greatly intensified. Every other aspect of the dramatic narrative yields to this central theme. The kneeling figure of Sisigambis, wrapped in a cloak of brilliant blue shot through with highlights, and that of Alexander, wearing a red cape and silver armor enriched with ornament of

[130] Quintus Curtius *History of Alexander* III. xii. 16 sqq. and Valerius Maximus *Facta et Dicta Memorabilium* IV. vii. 2.

[131] J. P. Richter, "'The Family of Darius' by Paolo Veronese," *Burlington Magazine*, XLII, No. 361, April 1933, 181ff. Richter's deduction that Veronese illustrates the text of Valerius Maximus on "Friendship Between Great Men" (*ibid.*) is surely correct.

[132] Posner, "'Triumphs of Alexander,'" 240.

[133] *Ibid.*, 240, n. 25, in which similarities are noted to fifteenth-century *cassoni* where the two subjects are linked and where, it might be added, the role of Hephestion and the mistaken identity theme are suppressed just as they are in Sodoma's fresco (P. Schubring, *Cassoni*, Leipzig, 1923, II, Pl. XXX, Fig. 150).

worked gold, dominate the central field of the fresco. Sisigambis's kneeling form is reflected in the curvature of the lunette, and the diagonals of the three nearest spears repeat her bowing motion. Similarly, the lunette curve follows the rising movement of Alexander from a seated position on an elaborate faldstool to the eventual embrace with Sisigambis. The Macedonian and the Queen Mother bend toward one another, pressed together by the enclosing arch of the lunette. But Cortona does not depend solely upon composition to carry the message of the scene. The visor-shaded face of Alexander, which emphasizes the modesty of his downcast gaze, the welcoming motion of his right arm and hand, and the features of Sisigambis, all reveal our artist to be a master of significant gesture. The tent of Darius, usually the *locus dramaticus* of the event, has been eliminated. So, too, has Hephestion and, with his removal, all possible confusion with the mistaken identity-friendship themes. Stateira, the beautiful wife of Darius, along with her daughters, is relegated to a secondary plane. Even their dress is informed with colors of modulated hue, bleached blue, beige on rose-lavender, which make them a weak visual signal to the observer in contrast to the central group.[134] In the process of crystallizing the narrative into dramatic image, Cortona also eliminated Darius's young son, who is easily discernible among the cortege of women in Sodoma's version and who plays a prime part in Quintus Curtius's description by fearlessly embracing Alexander after the latter's declaration of clemency.[135]

The simplicity of Cortona's composition is due in part to the limitations of the space at his disposal. There is nonetheless good reason to believe that these deviations from Sodoma's canonical representation of the event are also due to a shift of emphasis from the customary textual sources of Quintus Maximus and Valerius Maximus to that of Plutarch.[136] In Plutarch's account, there is neither mention of the incident of mistaken identity involving Hephestion nor any description of a scene at the tent of Darius. Darius's son is not mentioned, and the encounter is not later linked with Alexander's marriage to Roxanne.[137] Plutarch does stress the continence of Alexander, of which Cortona's fresco is the visual embodiment. "But Alexander," Plutarch states, "as it would seem, considering the mastery of himself more kingly than the conquest of his enemies, neither laid hands upon these women, nor did he know any other before marriage, except Barsiné [whom he took as a concubine] But as for the other captive women, seeing that they were surpassingly stately and beautiful, he merely said jestingly that Persian women were torments to the eyes. And displaying in rivalry with their fair looks the beauty of his own sobriety and self-control, he passed them by as though they were lifeless images for display."[138] The dependency of Cortona's lunette on this passage may be seen from its inscription: EN ALEXANDRI PECTVS

[134] The pearls and precious stones that these three figures wear follow the description of Quintus Curtius: "He [Alexander] gave orders that all their ornaments should be returned to the women, and the captives lacked nothing of the splendor of their former fortune except confidence" (*History of Alexander* III. xii. 23 sqq.).

[135] *Ibid.*, 26.

[136] Plutarch *Lives* (Life of Alexander, xxi).

[137] Cf. Quintus Curtius *History of Alexander* VII. iv. 25 sqq.

[138] Plutarch *Lives* (Life of Alexander, xxi).

PVDICITAE MVNIMENTO PERSICIS OCVLORVM TORMENTIS INEX-
PVGNABILE (Behold the heart [literally, breast] of Alexander, fortified by modesty,
and so unconquerable by Persian torments of the eyes).[139]

If we continue our clockwise investigation of the lunettes, we next face the two
lunettes in the westerly wall of the Sala di Venere. These two lunettes, situated at the
spectator's back when he first entered the room, are, in terms of subject, both the most
obscure and the least appropriate in the cycle. The lunette adjacent to *Alexander and
Sisigambis* is the more obscure and depicts an anecdote from ancient history for which
there is apparently only one source, Plutarch's *Moralia*, where, under "Sayings of
Kings," it is related that Antiochus III, "seeing the priestess of Artemis [i.e. Diana]
surpassingly beautiful in her appearance, he straightway marched forth from Ephesus,
for fear that even against his determination he might be constrained to commit some
unholy act." [Fig. 36.][140] As recorded in the inscription, Rondinelli's version specifies
departure by ship, which was taken for granted in the original account, and heightens
the drama by introducing an approaching storm: ANTIOCHVS IRATO MARI SE
COMMITTERE QVAM BLANDIENTI AMORI VELA PANDERE TVTIVS
EXISTIMAVIT (Antiochus considered it safer to entrust himself to an enraged sea
than to spread his sails to [the wind of] coaxing love). The lunette is dominated by the
central figure of the priestess, who, dressed in white, appears in a pose derived from
an antique crouching Venus. The raising of her veil, the central action in the scene, is
alluded to in the inscription where *velum* is used to mean sail but is also a play on words.
In the right background, Antiochus, wearing a plum colored cloak, leans across an altar
and gasps with amazement when he beholds the countenance of the priestess. This
event has momentarily interrupted the priestess's sacrificial libations, and, still holding
a patera in her extended right hand, she turns toward Antiochus. To her right is the
statue of the Goddess. The kneeling assistant to the priestess is dressed in a white gown.
Her standing compatriot wears blue, and the kneeling acolyte is dressed in green. The
composition of the *Antiochus III and the Priestess of Diana* lunette accentuates the con-
trasting themes of duty and desire. To this end, a massive wall and column in the mid-
dle distance divide the lunette emphatically into two segments, in one of which appears
the flaming altar attended by virginal acolytes and in the other the love-struck king.

[139] The reason this phrase was introduced in the
epithet and the reason Plutarch says Alexander jest-
ingly referred to the Persian women in this manner
is only fully apparent if we are aware of a story
related by Herodotus in which a delegation of Per-
sians in Macedonia, flushed with feasting and wine,
requested that their Macedonian hosts bring their
wives and concubines into the banquet hall. When
this was done and the women seated apart from
them, the Persians proclaimed that "it were better
that the women had never come at all than that
they should come and not sit beside the men, but

sit opposite them to torment their eyes" (*Herod-
otus*, trans. A. D. Godley, Loeb Classical Library,
New York, 1922, v, 18).

[140] Plutarch *Moralia* "Sayings of Kings," 183f.
Antiochus the third is presumably Antiochus the
Great, and this anecdote is in all probability to be
connected with his winter on Ephesus in 196 B.C.
(Livy xxxiii. 38). It is not mentioned in the his-
torical accounts (cf. A. F. von Pauly and G. Wis-
sowa, *Pauly's Realencyclopädie der Classischen
Altertumswissenschaft*, Stuttgart, 1901, I, Cols.
2459ff.).

The priestess acts as the pivotal figure in the composition, who, though engaged in a religious rite, is nevertheless receptive to the impassioned admiration of the king.

In the other lunette in the west wall, a young man, dressed in a purple cloak and tangerine tunic and with arms raised in alarm, flees from the sight of an attractive blond-haired woman wearing a yellow dress and blue cloak who has seductively thrown herself upon a couch and commenced to open her bodice [Fig. 37]. The inscription reads: CRISPO INNOCENTIA MAGNO STETIT SED ILLA PRETIO QVOLIBET CONSTAT BENE (Crispus's innocence cost him high, but that [virtue] is cheap at any price). The story of virtuous Crispus is undoubtedly the least suitable subject in the cycle, and its inclusion must have resulted from the problem posed in producing appropriate exemplars for the eight lunettes. According to ancient sources (now questioned in modern scholarship), Crispus, the oldest son of the Emperor Constantine the Great, was falsely denounced by his stepmother, Fausta, who claimed that he had carnally attacked her, and put to death by his father.[141] The grim conclusion of this tale is such that Crispus's virtue is more an example of moral sacrifice than of moral fortitude. It is hardly surprising, therefore, that Cortona's scene is devoted to the opening act in the melodrama in which Fausta is presented as an active seductress forcefully rejected by her virtuous stepson. In contrast to the Alexander and Sisigambis lunette, in which the curving field was used to emphasize the coming together of the two principals, Cortona here used the shape of the lunette to accentuate the sudden, violent rupture of their relation. What little area its curving form provides is limited by the bed, which is placed parallel to the picture plane and thus presses the figures into a shallow foreground area. From above, the tablet bearing the inscription physically intervenes, splitting the protagonists asunder. The illumination of the scene is also used to heighten the drama; thus, iniquitous Fausta lies within a shadowy, canopied area while Crispus flees toward the balcony and the sunlit woodland. One side of the curve of the lunette reiterates the downward, supine movement of Fausta and on its other half the turning, left to right movement of Crispus. The rift between Fausta and Crispus is accentuated by the wedge of space that separates them. Shaped like a triangle turned on its apex, its function is enhanced by the sumptuous mass of grey-green drapery which fills this area. The suddenness of this rupture is emphasized by the contrasting distances between their heads and the proximity of the right feet of Fausta and Crispus. Although their bodies form sharply divergent diagonals, their feet almost touch and seem to be hinged to the same spot, attesting to their intimacy of a moment earlier. The curving form at the foot of the long couch and the low, horizontal balustrade in the lower right portion of the lunette impart an additional thrust to the movement of Crispus. The confutation of Fausta by Crispus is rare in art, and Cortona seems to have depended upon the representations of *Joseph and the Wife of Potiphar* for general compositional

[141] The story was believed into the eighteenth century. L. de Tillemont, *Histoire des empereurs*, Venice, 1732, IV, 222ff., article lxii, and also Pauly and Wissowa, IV, Cols. 1722ff.

devices.[142] For the eloquently posed figure of Crispus, however, he turned to a specific source; namely, the figure of Adam in Michelangelo's *Expulsion from the Garden of Eden* in the Sistine Chapel.[143]

The lunette adjacent to *Crispus and Fausta* in the north wall illustrates the historic encounter of Augustus Caesar and Cleopatra [Fig. 38]. Its inscription reads: AVGVSTVS REGIAM NILI SIRENA CERA PRVDENTIAE AVRE OBSE-RATA CONTEMNIT (Augustus, his ears [literally, his ear] stopped with the wax of forethought, scorned the royal siren of the Nile), an allusion, of course, to the fact that Odysseus similarly plugged his ears to the Sirens' songs. Undoubtedly, one may infer that Augustus, like Odysseus, was aided by Minerva (who, as we have seen, appears in the fresco of the vault as the symbol of prudence and reason) in resisting the overtures of the notorious Egyptian queen. Cortona's fresco records a specific moment in the meeting, that in which Cleopatra plays her last card, so well described by Dio: "Now Caesar was not insensible to the ardour of her speech and the appeal to his passions, but he pretended to be; and letting his eyes rest upon the ground, he merely said 'Be of good cheer woman . . . for you shall suffer no harm.' She was greatly distressed because he would neither look at her nor say anything about the kingdom nor even utter a word of love, and falling to her knees, she said with an outburst of sobbing: 'I neither wish to live nor can I live, Caesar' "[144] Arms spread in a gesture of appeal and elegantly attired in a white dress shot through with rose and covered by a brown-gold cloak, Cleopatra is depicted by Cortona in the act of kneeling on a cushion thrust into place by a handmaid. Her handmaids, dressed in blue-green dresses of varying intensities, formally and coloristically complement her gently subsiding figure. The downward, diagonal movement of Cleopatra is echoed in a series of repeats across the composition, once in the similarly posed handmaid behind her and again in a line formed by the left forearm of Augustus. The slightly receding row of columns ranged across the background of the fresco establishes a strong right-to-left rhythm of increasing force as the spectator's eye follows the widening pattern of intercolumniation and simultaneously moves steadily closer to the picture plane. The central column divides the composition into two virtually equal segments, and, emphasizing the lack of cordiality between the two protagonists, it also serves to separate the spaces occupied by the

[142] The subject of Crispus and Fausta is not listed in the encyclopedic compilation, A. Pigler, *Barock-themen*, 2 vols., Budapest, 1956, where the lunette is identified as *Joseph and the Wife of Potiphar* (1, 78). The lunette has a superficial resemblance to the Raphael shop fresco of the same subject in the Vatican loggia (see G. Gronau, *Raffael*, Klassiker der Kunst Series, Stuttgart and Berlin, 1922, 188).

[143] The only significant deviation from the source occurs in the positioning of the figure's right arm (for an illustration see Tolnay, *Sistine Ceiling*, Fig. 40). I am indebted to Rensselaer W. Lee for this connection.

[144] *Dio's Roman History*, Book LI, Loeb Classical Library, New York, 1917, VI, 35f. The other prime account of this event, Plutarch *Lives* (Life of Antony, lxxxiii), describes her as sunken of visage, hair and face in terrible disarray and her breast covered with visible evidence of self-inflicted wounds.

male and female figures in the scene. The two narrowly spaced columns (or so they appear viewed from an oblique angle) behind Cleopatra accentuate her frailty. Augustus, in contrast, stands in the ample space between the two nearest columns that enframe him. In pose, Augustus represents a subtle fusion of several sources. It would seem that Cortona started with a statue of a standing Roman emperor (probably a statue of Augustus) but breathed life into its form by intensifying the *contrapposto* pose, adding something of the easy athletic grace and disinterested nonchalance of Renaissance David types.[145] As in Dio's description, Augustus averts his gaze from Cleopatra. He reveals no sign of emotional involvement, save for his right hand which, obscured from Cleopatra's view, nervously clutches at his red cloak, which he wears over silver armor.[146] Aspects of this scene, especially the pose of Cleopatra, have sources in early works of Cortona,[147] but, as an ensemble, this lunette, like others in the Sala di Venere, reveals above all Cortona's careful study of Veronese's festive historiographies such as *The Queen of Sheba Offering Gifts to Solomon* [Fig. 176] now in the Galleria Sabauda, Turin.

The other lunette in the northern wall bears the inscription: CYRVS NE A CAPTIVA CAPERETVR PANTHEAM FVGIENDO VICIT (Cyrus, lest he be captured by his captive, conquered Panthea by fleeing). In the fresco [Fig. 39] Panthea, deemed the most beautiful woman in all Asia, has been brought before Cyrus, who has just defeated her husband, King Abradatas, and the Lydian King Croesus.[148] She is presented to Cyrus as a part of his booty, but he, not willing to fall under the spell of her beauty, does not even wish to set eyes on her and puts her into the protection of Araspas, one of his most trusted men.[149] A strict reading of the text, then, implies that Cyrus chose not even to meet Panthea, but Cortona introduces a direct encounter to dramatize Cyrus's decision. He tells the story simply. Panthea stands with quiet dignity, and Cyrus, seated on a low-backed stool,[150] raises his right hand and turns away, commanding that the prize be sent away. His soldiers crowd around registering varying degrees of alarm and amazement. At the periphery of his composition Cortona has set in motion a series of centripetal motifs. On the left are a youth dressed in a grey cloak who stares at the central figures and a soldier wrapped in a rust-colored cloak who carries a staff or spear and strides forward just behind Panthea. The spear-bearer has a pendant on the right in the form of a soldier dressed in a lavender cloak, green tassels, and tunic who leans on his shield and steps forward. All of these figures exert an inward

[145] Verrocchio's in the Bargello comes to mind especially in the akimbo position of his left arm.

[146] The use of the hidden hand in this manner follows a tradition that extends at least to the similar and also psychologically pregnant motif in Donatello's St. Matthew on Orsanmichele.

[147] The general pose of Cleopatra and specifically her hand gestures are very close to the figure of Solomon as he appears in a Cortona fresco of the *Thanksgiving of Solomon*, c. 1623, in the gallery

of the Palazzo Mattei di Giove (see Briganti, *Pietro*, Pl. 18) and also the even earlier *Daniel in the Lions' Den* at the Villa Arrigoni (now Muti) in Frascati (*ibid.*, Pl. 1).

[148] Xenophon *Cyropaedia* v. i. 7.

[149] *Ibid.*, v. i. 1 sqq., especially 7-9.

[150] An antique stool similar in type appears in a Bartoli engraving (Bellori, *Antiquitatum*, Pl. 27) where it is occupied by Jupiter.

pressure that is resisted on the left by the calm, stately figure of Panthea, who, dressed in a lavender and rose *changeant* fabric, echoes in posture the standing portrait statues of Roman matrons. To her left, Cyrus is seated on a gold stool and dressed in a flowing golden brown cape and silver armor. The straight-armed gesture and averted gaze of Cyrus establish his unequivocal rejection of involvement with the captured queen. The lunette repeats fully and richly the substance, if not the precise circumstances, of Xenophon's account of Cyrus's deportment toward his war prize. Surprisingly, Cortona turned to his earlier depiction of the *Continence of Scipio Africanus* in one of the octagonal medallions in the ceiling of the Salone Barberini [Fig. 143] for a general source for the poses of Panthea and the spear-carrying soldier immediately behind her.[151]

In the adjacent lunette on the east wall [Fig. 40], the Roman general Publius Cornelius Scipio Africanus frees a princess, the fiancée of Allucius, captured in the course of his Carthaginian campaign. Accompanied by her father and fiancé, the comely princess kneels before Scipio, who gestures toward the maiden, indicating that he will return her unmolested to her parents and declaring that the gold offered as her ransom shall serve instead for her dowry.[152] Seated on a low dais, Scipio, in uniform and wearing a dark red cloak, dominates the left section of the lunette. The spectator's attention tends to move from the kneeling woman to the gold ransom to the figure of Scipio, who, seen in profile and gesturing toward the girl, carries us once more into the center of the fresco where the scene is given dramatic expression in a soliloquy of hands. As in the *Stratonice and Antiochus* lunette, sequential events have been compressed into a single image. Thus the father, grey-bearded and wrapped in a lavender-blue cloak, points with one hand at the ransom and with the other at his daughter. Allucius, wearing a green cloak, stands immediately behind his intended bride and also gestures toward her. At the same time Scipio returns her to her beloved with an open, generous gesture. The plaque above the lunette states Scipio's decision and its purpose: HOSTIVM CORPORA SCIPIO FERRO VINCERE VALVIT ANIMOS CONTINENTIA VINCIRE VOLVIT (Scipio, able to subdue the bodies of the enemy with iron, wished to bind their souls by his self-control).[153] Earlier, as we have already noted, Cortona depicted this scene in monochrome in one of the octagonal medallions of the Salone Barberini.[154] The lunette offered space for a fuller interpretation, and the two compositions have little or nothing in common, although the Barberini version was an important source for the *Cyrus and Panthea* lunette.

The *Continence of Scipio* shares the east wall with the most moving story in the lunette series [Fig. 41], the tragedy of *Masinissa and Sophonisba*. The event portrayed took place when the Numidian king Masinissa, an ally of the Romans against Carthage,

[151] For illustration see Briganti, *Pietro*, Pl. 131 (upper right hand corner).

[152] The fullest account, which includes Allucius, is Livy xxv. 50. Polybius (x. 19. 3) does not mention Allucius or the use of the ransom as a dowry.

[153] An allusion to the fact that Allucius and many other Celtiberians thereafter went over to the Romans (Livy xxvi. 50).

[154] The octagon medallion is visible in the upper right corner of Briganti, *Pietro*, Pl. 131.

decisively defeated Syphax, the rival monarch of Numidia, seized the latter's capital of Cirta and captured the wife of his enemy, Sophonisba.[155] So greatly was Masinissa affected by her beauty that he not only promised to spare her from captivity but, to prevent her from falling into the power of the Romans, determined to marry her himself. Their nuptials were accordingly celebrated without delay, but Scipio, the Roman general, refused to accept the arrangement and, upbraiding Masinissa for his weakness, insisted on the immediate surrender of the princess. Wishing neither to violate his pact with the Romans nor to break his promise to his new wife to spare her the humiliation of captivity and exhibition in Rome, the heartbroken Masinissa provided her with a bowl of poison which she drank.[156]

In the lunette Masinissa, wearing silver armor and a blue robe, has collapsed and points despairingly at Sophonisba, to whom he has dispatched a pewter-colored vase on whose sides can be discerned the first three letters of *venenum*. Its carrier, dressed in a green tunic *changeant* with rose and white, looks back at Masinissa and moves across the center foreground plane of the picture. A negro servant has drawn a reddish-yellow canopy aside so that the king may look for the last time at Sophonisba, who, attended by maids, returns his gaze and calmly awaits her fate. The inscription above the lunette reads: EODEM POCVLO MASINISSA FIDEI IN ROMANOS, LIBER-TATI SOPHONISBA LITAVIT (From the same cup Masinissa poured an offering of loyalty to the Romans, Sophonisba to liberty).

The lunette of *Masinissa and Sophonisba* is contiguous with that of *Antiochus and Stratonice*, and completes our tour of the lunettes. Taken individually, each of the lunettes is a masterpiece. As a series they constitute one of the most splendid cycles of heroic scenes produced during the Baroque period. Not only do these Olympian figures move with seemingly unhindered ease within their constricted spaces, but one is scarcely aware that the lunettes themselves vary considerably in size. Those on the east and west walls are considerably smaller than the others. Cortona cleverly masked this fact by adjusting the positions of the freestanding stucco figures and by so designing the lunettes that all their arcs rise to the same height.

SALA DI APOLLO

The Sala di Venere was started in the late summer or early fall of 1641. When Cortona's share in the decorations was finished early in 1642, he proceeded to the Sala di Giove, the fourth room in the series. The decision to skip the two intervening rooms was probably precipitated by problems of court functions, for the Sala di Giove was the throne room both before and after the installation of Cortona's decorations, and the Medici were in all likelihood anxious to have it available in its redecorated state as swiftly as possible. As first suggested by Giuliano Briganti (and discussed at length in

[155] Livy xxx. 12.

[156] *Ibid.*, 13 sqq.

Appendix I of this study), some preliminaries may have been under way in the Sala di Apollo [Fig. 42] before the decision was made to decorate the fourth room. In any event, the physical sequence of the rooms in the planetary cycle is of such importance to the content of the cycle that it is appropriate that our consideration of the rooms follows the order in which a seventeenth-century visitor to the palace would have experienced them.

The Stuccoes

The Sala di Apollo is the second room in the planetary series (floor plan, p. 69). When viewed in sequence, it represents a startling shift from the Sala di Venere. For here, the lush architectural forms that seemed to exude the temperament of the Goddess of Love give way to a style of Apollonian elegance. Again, one must think away the painting-crowded walls—the tapestries portraying the Life of St. John the Baptist continued in this room—and imagine the almost square space measuring approximately 11.4 meters in length by 10.4 meters in width entirely dominated by a vault filled with stuccoes of white and gold and frescoes of pale luminous colors.

The vaulting system in the Sala di Apollo is extremely simple. The vault proper is carried by four pendentives placed at each corner of the room. The vault and pendentives form a continuous curving surface. Since the room is nearly square, the effect is that of a sail vault or, as it is often called, a handkerchief dome. Each wall terminates in a large lunette. Cortona enriched this stark construction by introducing a massive oval cornice [Fig. 42] at the juncture of the bases of the pendentives and the wall planes. Cornices also enclose the upper curving edges of the four lunettes. At the center of each lunette, tabernacles [Fig. 43] have been superimposed over the curving lunette cornices. Each tabernacle carries a triangular pediment, and to either side of this pediment short, broken, reversed segmental pediments. On each side of the tabernacle, a tightly wound scroll appears to hold it in place. Against each scroll a satyr twists and grimaces [Figs. 44-51]. Wild, probably inebriated, each of these marvelous figures actively seeks to maintain a precarious balance and clutches at a goatskin drapery, vines, or shepherd's pipes as well. From behind each satyr a Buontalentesque curled and scalloped shell form fans out across the remaining area of the lunette.[157] These satyrs are similar in position and posture to those found in the stucco decorations in Annibale Carracci's Farnese Gallery [Fig. 177], but the prototypes are anemic by comparison. More physically robust, more vigorous in pose, Cortona's satyrs are more alike in character to the ones Annibale executed in grisalle in the Camerino Farnese ceiling, and, more significantly, they refer back to figures in Cortona's own oeuvre. At a young age, Cortona prepared a series of anatomy studies that remained unpublished until the

[157] These shells are very reminiscent of similar forms in the architectural vocabulary of Buon- talenti. (See, for example, the stairs once in SS. Trinita and now relocated in S. Stefano al Ponte.)

eighteenth century.[158] Among these plates, several of which are dated 1618, there are figures in poses [Fig. 178] that are strikingly similar to the satyrs in the Sala di Apollo.

The pendentives are separated from the ceiling proper by a wide circular cornice on which appear four medallions. The frames of the medallions are formed of elaborated cartouche shapes, rolled and curled as though they were made of dough or some equally pliable substance. In contrast, the scenes within the medallions are enclosed in a simple oval frame. These scenes, executed in high relief, depict episodes from the life of Apollo, all of which have a common source in Ovid: *Apollo and Python* [Fig. 52],[159] *Apollo and Daphne* [Fig. 53],[160] *Apollo and Marsyas* [Fig. 54],[161] and the *Apollo and Hyacinthus* [Fig. 55].[162] Each scene is treated with originality and humor. The snaggle-toothed and grinning serpent hardly warrants Apollo's bold attack. Buxom Daphne has burst into foliage barely in the nick of time, for Apollo has seized her tresses. Almost in mid-air she has sprouted roots and leaves. Her right hand, already leafy, breaks over the frame of the relief, adding impetus to her hysterical flight. Apollo vigorously plays a violin, a not unusual substitution for the more correct cithara or lyre.[163] King Midas gestures his preference for the music of Marsyas, and at the same instant he has sprouted ass's ears. Marsyas perches on the cornice of the relief, fat-bellied and with cloven hooves dangling in space, while another figure, presumably the river god Timolus, brusquely motions him to be silent. In the last relief the flower that bears his name sprouts from the side of dead Hyacinthus, who, adored by the Sun God, was accidentally killed by him.

Above each of these cartouches, a head is set within elaborated scrolls. These heads, like those placed between the garlands above the scenes in the Sala della Stufa, display emotional reactions appropriate to their medallion scenes, ranging from fear (Apollo and Python) to sorrow (Apollo and Hyacinthus). Each medallion is set on the circular cornice at a midpoint above a pendentive. From either side of each medallion a massive garland of fruit and flowers creates a swag that droops below the cornice and is obscured from view by the pediments of the lunette tabernacles. The garlands are not, however, elements independent of the cornice, for pincer-like forms evolved out of large cartouches clamp them firmly to the cornice. The juncture—if such it may be called—between circular cornice and tabernacle pediments is obscured by pairs of chubby *putti* [Figs. 56-59] who rest on the pediments and exchange or share a laurel

[158] C. Petrioli and P. Berrettini da Cortona, *Tabulae Anatomicae*, Rome, 1741.

[159] Ovid, *Metamorphoses*, trans. F. J. Miller, Loeb Classical Library, New York, 1926, I. 438 sqq.; Apollodorus I. iv. 1.

[160] Ovid *Metamorphoses* I. 452 sqq.; Hyginus *Fabula* 203.

[161] Ovid *Metamorphoses* VI. 382 sqq.; *Fasti* VI. 703 sqq.; Apollodorus I. iv. 2; Diodorus Siculus III. lix. 2 sqq.; Hyginus *Fabula* 165 sqq.; Pliny *Natural History* XVI. 240. Only Hyginus connects Midas

and Timolus with the contest, and according to him Midas was foolish enough to prefer the music of the satyr, for which Apollo gave him ass's ears.

[162] Ovid *Metamorphoses* X. 162 sqq.; Apollodorus I. iii. 3; Philostratus the Younger *Imagines* I. 24.

[163] Cf. E. Winternitz, "Archeologia musicale del rinascimento nel Parnaso di Raffaello," *Atti della Pontificia Accademia Romana di Archeologia*, XXVII, Fasc. III-IV, 359 (especially 365-371 for Apollo with the *lira da braccio*).

crown while clinging to the pediment and to the circular cornice. These *putti*, like the satyrs below them, suggest comparison with their counterparts in the stuccoes of the Farnese Gallery, and, in fact, considered as an ensemble, this comparison superbly illustrates the differences between the early and developed Baroque styles [Figs. 43 and 177]. Directly beneath the recumbent *putti* and within the tabernacle pediments, inscriptions have been placed on extruded cartouches that curl over the profiles of their enclosures. Before considering these inscriptions that refer to the ceiling fresco, however, let us turn our attention once more to the circular cornice and the scene it encloses.

The relation of the circular cornice, which defines the crown of the vault, to the lunette architecture beneath it is highly ambiguous [Figs. 42 and 43]. It is neither wholly integrated with the lunette architecture nor is it an entirely independent structure. Similarly, its role with regard to the surface of the vault is not altogether clear. It causes us to focus on the ceiling proper as a compositional entity, yet it does not give absolute definition to the space of the vault, for the cloud-filled sky of the vault continues into the four pendentives.

The Frescoes

Within this circular cornice, the theme of the first room, the Sala di Venere, has been continued. Accompanied by Fame, recognizable by her trumpet and laurel wreath,[164] the youthful prince, lately departed from the couch of Venus, here receives instruction from Apollo, who, leaning on his seven-string lyre, points to a star-studded globe with zodiac band that is held aloft by a bearded figure lacking attributes, but who is most certainly Hercules [Fig. 60].[165] Atlas is, of course, even more readily associable with this task; however, it is Hercules who is usually depicted supporting a globe containing the zodiac, whose twelve signs may be connected with his twelve labors.[166] Furthermore, the use of a celestial, rather than a geographic, globe in conjunction with Hercules alludes to the interpretation of this labor that maintains that Atlas was an astronomer from whom Hercules learned the science of the heavens; thus, Hercules with a celestial globe is appropriately emblematic of divine wisdom.[167] It is noteworthy that, in the earliest detailed description of the room, Giovanni Cinelli, though he erroneously included Mercury in the gathered panoply, quite correctly identified the bearer of the globe as Hercules, whose burden is, he observed, a celestial sphere, which "practically states the theme of 'sapiens dominabitur astris.' "[168] This identification of the globe-bearing figure is not only appropriate but necessary in order to preserve the iconographic continuity of the cycle; Hercules appears as the prince's guide in all the other

[164] See Ripa, *Iconologia*, 172, under *Fama*.

[165] His cloak is close in color to that of Hercules in the Sala di Venere.

[166] Servius *Commentarii in Aeneidos* vi. 395.

[167] *Ibid.*, i. 745. See also J. R. Martin, "Immagini della Virtù: The Paintings of the Camerino Farnese," *Art Bulletin*, xxxviii, No. 2, June 1956, 96, n. 31, and Martin, *Farnese Gallery*, 27f.

[168] Doc. Cat. No. 126 at c. 159v.

ceilings. Additional proof that this figure is intended to be Hercules is a preparatory study by Cortona that will be discussed in detail presently [Fig. 61].[169] For the moment, however, it should be noted that in the preparatory study both of Hercules's traditional attributes, the skin of the Nemean lion and an olive club, are clearly visible.

From the center of the vault, the sun blazes down upon these central figures and those collected below and around them. Around the central figures appears a ring of twelve females, presumably representing the twelve months of the year, who offer up such diverse flora as leeks and coral to the beneficial rays of the sun.[170] Near to the figure of Hercules, one of the latter figures raises her veil as protection against the chilling blasts of a wind god while a rainbow takes form over her shoulder. In each of the four pediments of the lunettes, an inscription has been placed that describes this scene. Among the inscriptions, no particular order appears to exist. When a visitor enters the room from the Sala di Venere and reads the most immediately visible inscription first, i.e. the one in the same position as the first inscription in the Sala di Venere, and continues in clockwise direction, the following order is obtained: SOL MVNDI OCVLVS ANIMI SAPIENTIA (The sun is the eye of the world, the wisdom of the soul); FLORES FIRMAT SOL EDVCAT IMBER AVREAM DILIGE MEDIOCRITA-TEM (Flowers are strengthened by the sun, brought forth by the rain; cultivate the golden mean); VOLVPTATVM SITIM PELLERE SI AVES VINVM SAPIEN-TIAE IMPIGRE HAVRIAS (If you desire to banish thirst for pleasure, drink deep of the wine of wisdom); EN IMITARE SOLEM MEDIO TVTISSIMVS IBIS (Behold, imitate the sun; your safest course will be in the middle).[171] Hortatory in nature, these mottoes stress moderation in thought and deed. With learning, the physical desires are abated, and in matters of state and person the ruler is admonished to seek the moderation that is defined in time-honored terms as the middle course and the golden mean. Thus in the Sala di Apollo the novice prince is presented with an antidote to the temptations of the central fresco in the Sala di Venere.

Below the central fresco and separated from it by the circular cornice, eight of the nine Muses appear in the four pendentives of the vault.[172] Distributed in groups of two, the Muses are portrayed not as static emblems, but in animated conversation. Although iconographic liberties have been taken, each muse possesses enough conventional attributes that even without their inscriptions they would be easily recognizable when compared with their descriptions in an emblem manual such as Ripa's *Iconologia*. In one lunette Urania and Euterpe appear together [Fig. 62]. Urania, the Muse of Astronomy and the Divination of the Heavens, is dressed in white, wearing a blue mantel, and

[169] Drawing Cat. No. 89.

[170] Some of the twelve females carry attributes, but their precise identification remains unclear.

[171] "Medio tutissimus ibis" is the advice Apollo had given his son Phaethon at the start of his ill-fated journey in the sun chariot. Repeated in the numerous versions of the myth in classical litera-ture, it was a frequently quoted motto in the sixteenth and seventeenth centuries. See, for example, O. Van Veen, *Q. Horatii Flacci Emblemata*, Antwerp, 1607, *passim*.

[172] The missing muse is Terpsichore, muse of dance and of choral singing.

turns to speak to Euterpe. With the aid of a smiling *putto* who mimics Hercules in the vault, Urania clasps a globe to her side with her right arm. Across the globe appears a zodiac band with the sign of Libra clearly visible. At her feet are several triangles. Euterpe, Muse of Music, especially that of the flute and lyric music in general, listens attentively to her companion. She wears a garland of flowers in her hair and holds a bundle of wind instruments in her right arm. If we move clockwise, the next pendentive contains Polyhymnia and Erato. Polyhymnia [Fig. 63], Muse of Sacred Music, points to heaven with her right hand and with her left clasps a book on which the inscription *svadere* appears. She is dressed in a green and yellow garment instead of the usual white. Her companion is Erato, who, with one elbow on Polyhymnia's lap, listens intently to her discourse. A lyre lies at Erato's feet, and nearby flutters Cupid, who holds aloft a flaming torch. The presence of the lyre and Cupid identify her as the Muse of Lyric and Amatory Poetry. The next pendentive contains Thalia, the Muse of Comedy, who, crowned with an ivy wreath, hides a comic mask behind her back with her left hand while she converses with Clio, the Muse of History [Fig. 64]. Clio, in turn, may be identified by her laurel wreath, trumpet, and book in which is written the name of Tucidides (Thucydides), the Greek historian. In the last pendentive, Calliope, the Muse of Epic Poetry, leans upon three volumes (symbolic of the *Odyssey*, *Iliad*, and *Aeneid*), wears a gold band around her waist, and places a wreath of laurel on the head of her companion [Fig. 65]. In the distance appears Pegasus, attribute of the Poetic Muse. Melpomene, the eighth and last Muse in this series, accepts the wreath of Calliope, a fit award to the Muse of Tragedy. She is richly dressed in robes of yellow, green, and red and holds a scepter in her left hand. On a rock to her left appear a crown and a sword. The presence of eight, rather than nine, Muses does not seem to have been dictated by anything more recondite than the need for paired groups for the spaces available. The choice of pairs, however, reflects a selection based on complementary qualities.

The presence of the muses emphasizes Apollo's role as the God of Culture, for it was the Sun God who had brought the muses down from Mount Helicon to Delphi, tamed their wild frenzy, and led them in formal and decorous dances.[173] In classical times, in point of fact, music, poetry, philosophy, astronomy, mathematics, medicine, and science were all under his jurisdiction, enhancing the appropriateness to his presence in the planetary cycle in the role of instructor and adviser of the youthful prince.

Within the tabernacles we have already described, at the center of each lunette a fresco is painted as if it were a framed painting. Each of these four frescoes celebrates the wisdom or culture of an ancient ruler. In the lunette fresco of the eastern wall, Augustus Caesar sits lost in thought while Virgil reads the *Aeneid* aloud [Fig. 66]. To the left, two figures wait impatiently to speak with the Emperor, and in the far left one page boy motions another to be silent. Beneath the fresco there is the following inscrip-

[173] Homer *Iliad* I. 603 sqq. and Plutarch *On the Pythian Oracles* xvii.

tion: AVGVSTVS IANO CLAVSO MVSIS VACVAS AVRES COMMODAT (Augustus, having closed [the temple of] Janus [i.e. brought peace to the empire] puts his unoccupied ears to the disposal of the Muses). The inscription clearly stresses Augustus as a military and culture hero based on episodes recorded by Suetonius.[174]

If we move clockwise around the room, the next lunette shows Alexander the Great about to retire for the night during one of his campaigns [Fig. 67]. His pages have commenced to remove his armor, and he has just given his sword to one of them in exchange for a copy of the *Iliad*, which as the inscription explains, he will place beneath his pillow: ALEXANDER ILIADA BELLI VIATICVM SVB CERVI-CALE DORMITVRVS REPONENS HOMERVM SVI TRIVMPHI SOCIVM ASSERIT (Alexander, by placing the *Iliad*, his traveling companion in war, under his pillow when about to sleep, makes Homer a sharer in his triumph). Both Plutarch and Quintus Curtius relate this anecdote in which the so-called "*Iliad* of the casket," a rendition of Homer's famous work by Aristotle, was carried in a casket in Alexander's Asia Minor campaigns and placed under his pillow at night.[175]

In the third lunette—that of the western wall—Justinian, seated upon a throne, orders the old and superseded law books burned [Fig. 68]. The inscription beneath it reads: IVSTINIANVS ORBEM RESTITVIT PLVRIMIS LEGIBVS EVM COR-RVMPENTIBVS AD PAVCAS REDACTIS (Justinian restored the world by reducing the laws that were corrupting it by their multitude). The scene, of course, refers to the creation of the collection and revision of Roman laws undertaken by the Emperor Justinian.[176] The motif of burning the superseded codices was obviously an effective way to dramatize an essentially legislative act by the ruler. Cortona had already used this device to illustrate the suppression of the memorials by Constantine in one of the cartoons he prepared for the Barberini to complete the Life of Constantine tapestry cycle given to Cardinal Francesco by Louis XIII of France.[177]

The last lunette fresco [Fig. 69] depicts Julius Caesar in the act of ordering a scholar, who has half-risen, to remain seated. Two pages have brought books for the Emperor, who intends, as the inscription indicates, to read them standing up: STANDO CAESARES DISCVNT VT IMPERATORES POSTEA STANTES MORI SCI-ANT (The Caesars study standing up so that the later emperors may know how to die standing up). Apparently this scene is without an ancient literary source.[178]

Our tour of the frescoes of the Sala di Apollo completed, we may now turn to

[174] Suetonius *The Lives of the Caesars* ii. xxii and ii. xxi sqq. For Augustus's habit of using readers see also ii. lxxviii.

[175] Plutarch *Lives* (Life of Alexander, xxvi.1 and viii.2) and Quintus Curtius *History of Alexander*, Loeb Classical Library, New York, 1946, i, 11. See also Cinelli description (Doc. Cat. No. 126 at c. 160v).

[176] For confirmation see Cinelli description (Doc. Cat. No. 126 at c. 161r).

[177] See D. Dubon, *Tapestries from the Samuel H. Kress Collection at the Philadelphia Museum of Art. The History of Constantine the Great Designed by Peter Paul Rubens and Pietro da Cortona*, London, 1964, Cat. No. 10, 120f., Pl. 71.

[178] See also Cinelli description (Doc. Cat. No. 126 at c. 161r).

problems of attribution, for this room was left in an incomplete state in October 1647, when Cortona left Florence, and was completed by Ciro Ferri, his pupil, between 1659 and 1661 (see Appendix I). A court diary states that four or five of the figures in the vault are actually the work of Cortona,[179] and this is confirmed by the notes of Giovanni Cinelli, who identifies the figures by him as including the youthful prince, Apollo, and Hercules.[180]

In distinguishing the roles of Cortona and pupil in the completion of this room we have two prime sources of information: documents and drawings.[181] The first document related to the commission and postdating Cortona's departure in October 1647 is a letter he sent to Prince Leopold on June 10, 1656, in which he requested that he be sent copies, reduced in scale by *palmi romani*, of the cartoons he had prepared in Florence in 1647.[182] From this communication, we may assume that Cortona left a set of cartoons in Florence in 1647. Unfortunately, the original cartoons have never been located; they would have provided a means for determining the 1647 program and of ascertaining the differences between this scheme and that completed by Ferri in 1660. The post-1647 changes could then be compared with the relevant drawings by Cortona and Ferri, and a more accurate appraisal of the post-1647 contributions of both artists could be obtained. Without benefit of the evidence of the 1647 cartoons, however, any consideration of an assessment of Ferri's contribution that is based on drawings by that artist must be made with the awareness that these drawings need not reflect original ideas on his part, but instead could derive from the copies of the 1647 cartoons Cortona ordered sent from Florence in 1656 and which, given the Grand Duke's desire to see the series completed, were undoubtedly prepared and dispatched to Rome.

Another letter was sent to the Grand Duke by Monanno Monanni in July 1659,

[179] Doc. Cat. No. 117.

[180] Doc. Cat. No. 126 at c. 160r. The frescoes themselves yield no clear cut division between the work of master and pupil, even under close scrutiny. Throughout the frescoes in the Sala di Apollo, color has been applied by a uniform technique that leaves a stippled surface. This technique seems to have been favored by Ferri, who also used it in the later Sala di Saturno, whereas Cortona, though he used the same device, did not employ it exclusively, but instead favored mixed systems of shading that incorporated crosshatching. The possibility that Ferri destroyed the few figures Cortona had completed must not be ruled out. On the basis of this information we may conclude that the frescoes were under way, but only recently started. It would follow that Cortona had probably prepared all or very nearly all of the cartoons for the decorations.

[181] On two occasions Walter Vitzthum has attempted a reconstruction of the relative contributions of Cortona and Ferri to the Sala di Apollo ("Pietro da Cortona's Drawings For the Pitti Palace at the Uffizi," *Burlington Magazine*, cvii, No. 751, Oct. 1965, 525, and "Inventar eines Sammelbandes des Späten Seicento mit Zeichnungen von Pietro da Cortona und Ciro Ferri," *Studies in Renaissance and Baroque Art Presented to Antony Blunt on His Sixtieth Birthday*, London, 1967, 114). In both instances Vitzthum used previously unpublished drawings that rendered clearer the role of the two masters, but unfortunately he failed to incorporate the important published correspondence in his deductions. Thus the fact that Cortona had designed and left in Florence a set of cartoons for the Sala di Apollo, that reduced copies of these cartoons were ordered sent to Rome in 1656, that Cortona prepared a *modello* for "ornati" (most certainly destined for the Sala di Apollo) in 1659, and finally that Monanno Monanni in 1659 described the procedure followed in preparing new cartoons in Rome are not considered in his remarks (for a discussion of these documents see below).

[182] Doc. Cat. No. 113.

in which the arrangements agreed upon and also the progress made to that date are described.[183] According to Monanni, a set of cartoons was to be prepared in Rome by Ciro in the presence of Cortona and with his assistance. These cartoons were to be based on the *pensieri* (ideas or sketches) provided by Cortona "so that one will be able to say that the cartoons—not only in *pensieri* but also in design [*disegno*]—will be by Pietro and that they have been colored and executed in fresco by Ciro." The use of the word *pensieri* in Monanno's descriptions is, to this point, ambiguous, and this may have been his intention, for it gave him the opportunity to stress Cortona's role in the work in progress in Rome. Further on he mentions the arrival of letters from notables in Florence including one from Rondinelli with the program, apparently in verse (*suggetti di poesie*) and also another containing the measurements and adds that "he (meaning Ferri) has immediately begun the work of gluing the cartoons and in the meantime he will make sketches of the ideas (*skizzi* [sic] *de' pensieri*) in order to press on with all speed, for he is well aware of the urgency" The latter comments provide a clearer definition of *pensieri*, suggesting that it has been used throughout his letter to describe ideas rather than actual sketches, or, in any event, if applicable to sketches it must refer to those of a minimal nature. In sum, Cortona's role in the execution of the 1659 cartoons emerges as that of an overseer who criticizes and comments but engages in little or none of the manual execution. The surviving drawings thus far located support this thesis.

Of the known Cortona drawings for the Sala di Apollo, most are today in the drawing cabinet of the Uffizi Gallery. Like most of the drawings attributed to him in the Uffizi collection, they were part of the drawings amassed by the great Florentine collector-connoisseur, Cardinal Leopold.[184] That they were executed prior to his departure in 1647 is confirmed both by their presence in the Uffizi and by their stylistic compatibility with the studies for the earlier rooms in the same collection. The drawings for the Sala di Apollo in this category are nine in number.[185] One of these drawings records an advanced stage in the formation of the stucco decorations [Fig. 70]. Another has been identified as an early stage in the composition of the Justinian lunette [Fig. 71]. The group is completed by eight figure studies, which, with the exception of two studies for ceiling figures later suppressed, can be related to figures in the ceiling and lunette frescoes. From this small nucleus of 1647 drawings we would be justified in concluding that the essential character of the stuccoes and the frescoes was determined in 1647 and that the cartoons prepared by Ciro Ferri in 1659 were, as Monanni stated, executed by him but based in the main on the *pensieri* of Cortona. Examination of all the extant studies supports this assumption with, however, some qualifications.

[183] Doc. Cat. No. 115.

[184] For the association of these preparatories with the Collection of Cardinal Leopold, see Campbell, *Mostra*, 10ff.

[185] Drawing Cat. Nos. 87, 92-97, 108-109. An-other drawing in the Uffizi (Drawing Cat. No. 91) which is part of the nineteenth-century Santarelli Collection and therefore cannot be connected with certainty to the Cardinal's Collection.

Let us consider first the Cortona drawings for the ceiling fresco. Of the surviving drawings, a composition study now in the Farnesina for the central field of the vault is of special importance [Fig. 61].[186] The figures display numerous *pentimenti*, and individual figures and figure groups have been sketched several times. In addition, the sheet has been cut into two pieces, then glued together in such a way that it is evident that what is now the left portion of the verso [Fig. 72] was once the right section of the recto. After working intensely on the posture of the globe-bearing Hercules, Cortona cut the original sheet in half, reversed the right section and then added the figures that now occupy this section of the recto. In this drawing, a rapid sketch in pen and ink over chalk, the chief protagonists appear much as they do in the fresco. Along the perimeter of the stucco ring that encloses the fresco, however, we are presented with a different solution, for in the sketch there are, in highly abbreviated form, indications of hovering, recumbent forms. There are two studies for just such figure types—one of which we here illustrate [Fig. 73]—in the Uffizi collection.[187] The principal figure in this study, an aged and bearded figure wrapped in a cloak, must be the wind god Boreas, who is associated with the winter season and with old age. Both style and location of the collection argue for a c. 1647 date. The existence of these figure studies is evidence that this scheme was carried to an advanced stage; in fact, in all probability the hovering figures in question were incorporated into the cartoons that Cortona left in Florence in 1647. The foregoing argues strongly for 1647 as a *terminus ante quem* for the Farnesina drawing, a fact that its present Roman location mitigates but does not rule out. If, however, it postdates Cortona's last Florentine sojourn, then it is certainly one of those preliminary *pensieri* he was to have prepared for Ciro Ferri's execution of the new cartoons, and, as such, its points of marked variance with the executed frescoes must for the most part reflect the c. 1647 ceiling composition.

On the basis of the Farnesina composition study and the Uffizi figure studies it can be ascertained that the original cartoons by Cortona called for a central figure group very much like the ones now visible in the fresco. There would, however, have been an additional figure in this group seated behind Fame. The precise significance of this figure is not easily determined, but it does appear to be female and to be carrying a shield. Possibly she is an allegory of Fortitude, or, more probably, she reflects Cortona's consideration of preserving Minerva, who participated so actively in the Sala di Venere ceilings, as well as Hercules as a companion to the prince on his planetary travels. Uffizi studies for Apollo [Fig. 74] and the prince [Fig. 75] leave no doubt that their poses were determined in 1647.[188] The peripheral figures would have been quite different, however, consisting of hovering wind gods and, presumably, a few other scattered figures.[189] Although the major changes between the Farnesina composition study and

[186] Drawing Cat. No. 89.
[187] Drawing Cat. Nos. 94 and 95.
[188] Drawing Cat. Nos. 96 and 97.
[189] The seated figure with shield in this area is probably a reconsideration of the pose and location of the figure immediately above her in the central group.

117

the actual fresco may have occurred during the preparation of the 1647 cartoon, it seems more likely that the alterations in the peripheral area of the ceiling were made during the execution of the 1659 cartoons and were the result, perhaps, of the new "*suggetti di poesie*" Rondinelli sent to Rome at that time.

Support of a 1659 date for changes in the figures along the edge of the cornice is provided by a detailed composition study [Fig. 76] by Ciro Ferri now in Düsseldorf.[190] Extremely close to the final version, this drawing records the omission of the club of Hercules, a defect present in the fresco. Even the revisions in the areas of the ceiling fresco that probably post-date 1647 in execution cannot be regarded as entirely based on the design of Ciro Ferri in an independent capacity. In the case of the wind god adjacent to the celestial globe who appears in Ferri's Düsseldorf drawing but not in Cortona's study in Rome [Fig. 61], there exist figure studies by Ferri [Fig. 78] and Cortona [Figs. 77 and 79].[191] Two important drawings [Figs. 80 and 81] can be associated with the female allegorical figures who replace the hovering wind gods we have connected with the 1647 design.[192] These drawings are by Ferri although they are extremely close to the style of his master and not easily separated from his work. Both of these drawings evince a soft repetitious line that is a Ferri characteristic based on Cortona's own style of draftsmanship. Ferri tends to create a decoratively calligraphic effect in his use of repetitious line, whereas in his master's drawings there is greater economy, and repetitious definition of form ceases as soon as the form is minimally clarified and at times is even canceled by the superimposition of a harsh, angular stroke. When one compares contemporaneous drawings by the two masters, the balance in my opinion swings slightly in favor of Ferri's authorship. The problem in this instance is especially complex because Cortona, like most major artists, not only changes his style with the passage of time, but also works in more than one drawing style at a given moment in time. In addition to the presence of drawings by Cortona attesting to his involvement in the project after 1647, the documents already reviewed clearly attest to his role in the execution of the 1659 cartoons for the ceiling fresco. At most, Ferri may have enjoyed a partially free hand in the designs for the female allegories in the ceiling, but the evidence makes even this unlikely.[193]

In the case of the pendentives, the evidence—what little there is—points to Ciro Ferri's execution in fresco of the groups planned by Cortona in 1647 with virtually no alterations. For proof we can turn to a study for one of the pendentives [Fig. 82], datable in style c. 1647, which leaves no doubt that Cortona had planned to decorate these areas with sets of muses.[194] Furthermore, a Cortona figure study [Fig. 83] also dating

[190] Drawing Cat. No. 88.

[191] Drawing Cat. Nos. 98, 99 and 102.

[192] Drawing Cat. Nos. 99 and 101. Three drawings for nymphs have also been attributed to Cortona (Drawing Cat. Nos. 90, 91 and 100).

[193] A similar situation obtains for the other frescoed areas in the Sala di Apollo, providing further

confirmation (see below).

[194] Drawing Cat. No. 103. As first pointed out by Vitzthum, this drawing is so close to one for the cupola of the Chiesa Nuova (started 1647) in Rome that there can be no serious doubt about the date of its execution. For further corroboration it should be noted that the Farnesina composition

in style from the same period presents the exact pose utilized in Ferri's frescoed version of Calliope [Fig. 65].[195]

In the lunette scenes [Figs. 66-69], Ciro Ferri appears to have had slightly more freedom. Two c. 1647 Cortona drawings, one for the Augustus lunette [Fig. 84] and another for the Justinian [Fig. 71], have been located.[196] The composition study for the Augustus lunette, in contrast to the fresco, depicts the Emperor in a less frontal pose and Virgil declaiming from a seated position. The modification of the poet's pose may be given to the younger artist, at least until a figure study attributable to Cortona that records the change is found; however, the changes in the pose of Augustus are documented in a Cortona study [Fig. 85] and almost certainly date from c. 1647.[197] The drawing for the Justinian lunette must have been executed at a very early stage of Cortona's work on the room, for its segmental top enframement (which is similar to a type used by Raphael in his Vatican Loggia) would have required a different setting from that executed. As attested by a series of composition studies (of which one is here illustrated, Fig. 86) and figure studies Ferri reworked the Justinian lunette.[198] As demonstrated by these studies as well as by the final version, Ferri eschewed both the compactness of Cortona's 1647 sketches and the spatially rich movement of figures they suggest. Instead he used a frieze-like composition in which most figural movement is placed parallel to the picture plane, an arrangement reminiscent of similar, early Cortona compositions such as his *Queen of Sheba before Solomon* of 1622-1623 in the Palazzo Mattei, Rome.[199]

In contrast to the Justinian lunette, the other lunette frescoes present a principal figure more or less frontally disposed and with the other protagonists arranged about him. This format—which we can consider an aspect of the original 1647 scheme—is even maintained in the Julius Caesar lunette [Fig. 69], for which a detailed composition study by Ferri has been located in Darmstadt [Fig. 87].[200] The existence of such a detailed study, squared for enlargement and extremely close to the frescoed scene, would seem certain proof that he was operating with considerable freedom, but in fact the Uffizi collection contains a figure study by Cortona for the half-standing old man [Fig. 88] (style and location point to a 1647 date) which is closer to the executed version of the figure in question.[201] The Alexander lunette [Fig. 67], for which no drawings have been located, is also of this compositional type. In summary, Ferri's contribution to the fresco compositions consisted primarily of the design of the secondary figures ranged

study for the central section of the vault (Fig. 61) and the Uffizi study for the stuccoes (Fig. 70) both of which I would date c. 1647 give indication of foliage in the pendentives.

[195] Drawing Cat. No. 104.

[196] Both drawings were first identified by W. Vitzthum (see Drawing Cat. Nos. 105 and 109). I had considered the drawing in the Uffizi to be a preparatory for an allegorical scene, in part be-

cause the figure in the lower right corner appeared to be in a prostrate position. I now accept Vitzthum's identification.

[197] Drawing Cat. No. 106.

[198] Drawing Cat. Nos. 110-116.

[199] For an illustration see Briganti, *Pietro*, Pl. 15.

[200] Drawing Cat. No. 107.

[201] Drawing Cat. No. 108.

around the edge of the ceiling fresco and of the redesign of the Justinian lunette. Even in these areas he was, as attested by the relevant correspondence, closely supervised by Cortona.

It remains to consider the authorship of the stucco decorations. In December 1659 Cortona wrote to the grand-ducal court announcing the completion of a *modello* of the *ornati* of the "room of the Grand Duchess."[202] Although the designation of the room poses some problems, this *modello* was in all probability for the Sala di Apollo and specifically for the stucco decorations.[203] Cortona mentioned that the *modello* was made some three years earlier, that he was pleased with it when he reexamined it, although he made some emendations, and that it had taken him eight days to put it in order for shipment. Thus the preparatory study [Fig. 70] for the stucco decorations may date as early as 1642 if there had been, as we have noted, a "false start," but more likely it dates between 1646 and 1656, at which latter date his letter indicates a *modello* was prepared.[204] The fact that the drawing is now in the Uffizi collection slightly favors the thesis that the drawing was executed during Cortona's last Florentine sojourn and thus not later than 1647.[205] In any event, the sketch presents us with an interesting stage in the evolution of the Sala di Apollo stuccoes. The major features of the final scheme are already present in this pen sketch and in more than embryonic form. The tabernacles, the crouching satyrs, the scalloped shell ornaments in the segments of the lunettes are all present in a manner close to, but not identical with, their final execution. Among the more striking differences between this drawing and the actual stuccoes are the substitution in the final version of recumbent *putti* for the sphinxes atop the tabernacles, the modification in the tabernacle pediments, and the enrichment and enlargement of the stucco ring that enframes the central fresco of the vault. Changes in the tabernacle pediment may be the result of mere whim, but the removal of the sphinxes and the enlargement of the stucco ring in the ceiling are more striking, the first because it is a mystic beast admirably suited to the intellectual themes of the room and the latter because it succeeds by sheer weight and mass in deadening the space-creating effect of the vault and pendentives that are treated in fresco as a continuous space. In both preparatory drawing and in executed form, this ring is to be understood as a form located slightly above and behind the lunette tabernacles, but whereas the leafy, garland form of the ring in the preparatory is credible as such, the weighty ring actually used in the

[202] Doc. Cat. No. 116. A. Crinò ("Documenti relativi a Pietro da Cortona, Ciro ferri . . . ," *Rivista d'arte*, xxxiv, 1959, 152), who first published this letter, interpreted its date as October rather than December.

[203] See Appendix I of this study for a discussion of the connection between this letter and the Sala di Apollo. Crinò (*ibid.*) assumed that the *modello* in question was for the frescoes; however, princi-

pal seventeenth century interpretations of *modello* and *ornato* argue for a plastic model of the stucco decorations (cf. F. Baldinucci, *Vocabolario Toscana dell'arte del disegno*, Florence, 1681, 99f., under *modello*, and 114f., under *ornato*).

[204] Drawing Cat. No. 87.

[205] The drawing is stylistically consonant with Cortona's pre-1647 pen style.

Sala di Apollo is entirely unconvincing as an unsupported enframement. It seems highly likely that the ring actually realized was not a part of Cortona's *modello*, but an alteration designed by Ciro Ferri. Indeed, such a conclusion is supported by the medallions that embellish it; they add much to its weight, but little to the thematic substance of the room decorations, for they can scarcely be said to elucidate either the intellectual or prudential capacities of the Sun God. Even the composition of the ring suggests that it achieved its present massiveness by an additive process, for its central band composed of coiled grape vines is a variant on the acanthus leaf band proposed in the preparatory drawing to which has been added a series of at least four unrelated bands. Possibly this enlargement of the circular cornice was introduced to mask problems encountered in adjusting the cartoons made in Rome to the configuration of the vault.

Thus we can conclude that the c. 1647 program for the Sala di Apollo was very similar to the one that Ciro Ferri completed in 1659-1661. As we have indicated, at some point, changes occurred in the central area of the ceiling; a female figure, presumably Minerva, was suppressed, and recumbent male figures around the periphery of the ceiling were replaced with female allegories. Probably only one lunette, that of Justinian, was significantly recomposed. Finally, changes were made in the stucco decorations. For the most part, these were minor, with the exception of the alterations in the circular frame of the central fresco. The earliest state of the scheme we have been able to reconstruct is certainly datable not later than 1647. Given the fact that Cortona may have initiated preparations for the Sala di Apollo before starting the Sala di Giove, the conception of this decorative may date in its essentials as early as 1642.

THE SALA DI MARTE

The Sala di Marte ceiling executed between 1644 and 1646 constitutes Cortona's boldest exploitation of *di sotto in su* [Fig. 89]. The room measures about 9 meters by 10.4 meters and is one of the smallest in the series. As if to offset its relatively diminutive size, the stucco decoration is restricted to a small area along the cornice, and virtually the entire vault is devoted to a frescoed panorama of open sky. This treatment of the vault has been facilitated by the fact that Cortona did not have to contend with a vaulting system involving lunettes, spandrels, and pendentives. Instead, the ceiling is coved; the vault curves inward and upward on all sides with a marked flattening in the central section of the plafond. Most of the figures in the ceiling are distributed in a band within this coved area. We view these figures from below as though we, the occupants of the room, were looking up at them from within a deep pit. In this respect, the effect is similar to the earlier Salone Barberini [Fig. 142], where the figures along the cornice also appear to inhabit richly landscaped ledges around the edge of the room. In the Sala di Marte, the frescoes extend the real space of the room, but, in contrast to the Salone Barberini, they do not appear to intrude into the actual physical space. The most

striking contrast, however, is the fact that there is no *quadratura* to create an armature that coincides with the true dimensions of the vault. Instead, the ceiling has been visually severed at the cornice line, leaving the drama of the vault to unfold in a limitless and undefined space.

While the Salone Barberini is certainly the essential prototype for the Sala di Marte ceiling, its conception was undoubtedly conditioned by earlier attempts at a *cielo aperto* affect such as Cherubino Alberti's ceiling of about 1592 in the Sala Clementina and the unattributed ceiling in the Casino Ludovisi, Rome [Fig. 179].[206]

Another, earlier, ceiling is of utmost importance in the formulation of the Sala di Marte. The ceiling in question is that of the Sala di Troia [Fig. 168] in the Palazzo Ducale, Mantua, by Giulio Romano and assistants.[207] In this ceiling, dated 1538, Giulio produced a *cielo aperto* plafond that terminates in a landscape edging at the cornice line. Tempered by Roman adaptations by artists such as Giovanni Lanfranco and Andrea Sacchi, Cortona adapted this source to the design of the Salone Barberini by adding an illusionistic stucco armature to define the vault and to divide it into five sections. In the Sala di Marte, in contrast, Cortona has eschewed all definition of the vault surface, revitalizing the total openness of Giulio Romano's ceiling.

While prototypes such as the ceilings we have noted may have sparked Cortona's imagination, in the final analysis these ceilings were no more than a challenge. Cortona's Sala di Marte is in fact more a criticism than an adaptation of earlier attempts at a full *cielo aperto*. The earlier ceilings could provide Cortona with figural motifs and certain compositional techniques, such as the use of strongly foreshortened central figures and the distribution in rings of figures near the cornice, but the real impulse for optical effects came from Venice. Less easily isolated or defined, it is the brio of Venetian ceilings that accounts for the color, for the sense of movement in the Sala di Marte. These Venetian elements are so totally a part of the chemistry of Cortona's art that they are not to be filtered out. They are an inseparable part of his artistic solutions. In this room, one is more acutely aware than in the others of the fact that Venice provides the source for the aerial effects of Cortona. In the ceiling decorations of Veronese especially there is the same ease of movement, the same pervasive illumination and coloristic excitement. Although conceived on a more limited scale, Veronese's ceilings in the Villa Maser could have been highly instructive to Cortona. More even than Titian or Tintoretto, Veronese's *cielo aperto* effects are cognate to Cortona's.

[206] For another attempt at open space, see the abortive effort of Francesco Albani in the Gallery of the Palazzo Giustiniani-Odescalchi at Bassano di Sutri (1609-1610) illustrated in M. Brugnoli, "Gli affreschi dell'Albani e del Domenichino nel Palazzo Bassano di Sutri," *Bollettino d'arte*, XLII, 1957, 268. For information and illustrations of Alberti's Sala Clementina ceiling, see F. Würtenberger, "Die Manieristische Deckenmalerei in Mittelitalien," *Römisches Jahrbuch für Kunstge-* *schichte*, IV, 1940, *passim*, and N. Wibiral, "Contributi alle ricerche sul Cortonismo in Roma," *Bollettino d'arte*, XLV, 1960, 123ff.

[207] For illustration see Schulz, *Ceilings*, *passim*, and Fig. 17. The ceiling is heavily restored and our illustration, a drawing by Jacopo Strada, now in Düsseldorf, more accurately records the original design. Egon Verheyen kindly provided a photograph of the Strada drawing.

The Frescoes

In this, the third room in both chronological and physical sequence, we are confronted with the activities of the prince, whose impressment into virtuous service we saw in the Sala di Venere and whose educational preparation was illustrated in the Sala di Apollo. The Sala di Marte is without mottoes; indeed, none is needed. The action speaks for itself [Fig. 89]. From one corner, an enemy galley appears about to lurch, bow first, into the actual space of the room. The warriors aboard the vessel have been thrown into dismay by the onslaught of the prince, who still dressed in his cloak of orange impales one of the crew with a spear. From an adjacent corner of the vault, the prince's comrades press eagerly forward and seem about to propel their war ships across the intervening space of the room. Overhead, Mars, a sword in one hand, a meteor in the other, plunges earthward to assist the prince, his brilliant red cloak flying, his silver armor gleaming in the reflected light of his fire bolt.[208] The Dioscuri, the famous warrior twins Castor and Pollux, carry arms earthward, and Hercules, who is in the midst of building a trophy of captured arms in one corner of the vault turns to shout his encouragement to the heroic prince. Hercules is accompanied by a winged figure of Victory, who is placing a wreath of palm and laurel branches on the trophy.[209] Around the remaining rim of the vault, a military conquest is celebrated. The enemy soldiers march before a triumphal arch and beg for mercy from Justice,[210] dressed in white with a red robe and recognizable by her bundle of fasces, while Peace acts as an intercessor.[211] Peace wears a laurel crown and holds an olive branch. She is dressed in white and wears a lavender robe. Beside her, Liberality,[212] nude to the waist, throws grain and gold coins to the impoverished populace.

Although most of these figures are disposed in a band near the cornice of the room, a few of them—notably Mars and the Dioscuri—are placed so as to appear to be free agents in space. Mars plunges earthward, directing our attention to the prince in the heat of combat. The location of the prince is further signaled by the creation of an emphatic diagonal movement that starts with the gesticulating Hercules, is continued by the Dioscuri, and terminates in the driving motion of the prince's spear. This diagonal moves from the southwestern corner of the room, where Hercules stands, to the prince, who is placed near the northeastern corner. When the spectator enters the Sala di Marte from the Sala di Apollo, that is, through the door located in the western wall near the northwest corner, this diagonal dominates his point of view. Since this diagonal carries

[208] Cf. Catari, *Imagini*, 193, under *Marte*.

[209] Cf. Ripa, *Iconologia*, 575, under *Vittoria*, and Catari, *Imagini*, 198f., under *Vittoria*.

[210] Cf. Ripa, *Iconologia*, 221, under *Giustizia*. Identified by Cinelli as *Magnificenza* (Doc. Cat. No. 126 at c. 131r).

[211] Cf. Ripa, *Iconologia*, 393f., under *Pace*, and Catari, *Imagini*, 157, under *Pace*.

[212] This identification is confirmed by Cinelli (Doc. Cat. No. 126 at c. 131r). This figure has been previously identified as Abundance (Fabbrini, *Vita*, 81). The fact that she is dressed in white (under a purple robe), not green, and is depicted in the act of distributing money and grain identify her as Liberality (compare Ripa, *Iconologia*, 1, under *Abbondanza*, and 308, under *Liberalità*).

the major action of the vault, its position makes the theme of the decorations instantly comprehensible. It also serves another purpose, namely, to isolate and draw attention to the principal motif within the section of the sky immediately above these figures, the magnificent, soaring coat of arms, the *stemma Mediceo* [Fig. 90].

It is the grand-ducal *stemma* that is principally responsible for imparting to the vault of the Sala di Marte a seemingly limitless space. Tilted on angle and located just to one side of the vault, it exerts an extraordinary space-creating effect on the entire ceiling. The *stemma* consists of a form molded like a gigantic pie crust and scalloped at its edges upon which has been affixed a cartouche that carries, on its bulging, elaborately curved surface, five enormous red *palle* and one of blue, decorated with gold *gigli*. The cartouche and its support are gold, as is the grand-ducal crown held aloft directly over it. Partially enframed in a wreath of antique weaponry which lags slightly behind it, the *stemma* appears to rush heavenward, its swift ascent aided by squirming *putti*.

So compelling is this image of the ascending coat of arms that one scarcely realizes that its author is extending and enriching a long tradition of a coat of arms as a ceiling embellishment frequently encountered in the ceilings and vaults of the Renaissance.[213] With few exceptions, these coats of arms, regardless of the medium in which they were executed, appear to be transfixed to or set into the surface of the vault in a position horizontal with the floor. In several early ceilings—that of the Gallery in the Palazzo Mattei and the Villa del Pigneto [Figs. 163 and 141]—Cortona adhered to this traditional style. The *stemma* in the Salone Barberini [Fig. 142] is essentially of this same type. The Barberini *stemma*, composed of three gigantic bees, crowned by the papal tiara, and framed in wreaths sustained by female figures representing the Theological Virtues, moves in a distinctly horizontal path. Although the apotheosis of Urban VIII (and with him, the Casa Barberini) is implied, the placement of the *stemma* creates an ambiguity in that it appears to hover, rather than to rise vertically into space. Aside from the tour de force of creating a coat of arms out of a swarm of flying bees seen against open sky, Cortona did not choose to utilize the potentiality of an ascending coat of arms that this open sky would have permitted.[214]

The ascending, as opposed to the hovering, type of coat of arms was first used by

[213] A casual perusal of A. Colasanti, *Volte e Soffitti Italiani*, Milan, 1926, will produce a dozen or more examples.

[214] Cortona was experimenting with the motif of bees in formation seen against the sky around 1633, the date of the Audran engraving of the Death of Flora, used as an illustration in G. B. Ferrari's *Flora, sive de florum cultura*, Rome, 1638. This engraving is based on a drawing now at the Prado, Madrid (cf. A. Blunt and H. L. Cooke, *The Roman Drawings of the XVII and XVIII Centuries in the Collection of Her Majesty the Queen at Windsor* *Castle*, London, 1960, 76 and Fig. 57). By November 1633 a Cortona-designed ceiling for a baldachin in the "History of Constantine the Great" tapestry series containing the same tour de force was on the looms (see Dubon, *Tapestries*, 19 and Fig. 4). These uses of the theme give Cortona precedence over Bernini in the use of the motif in a blue glass window with Barberini bees in the memorial to Urban VIII in the church of S. Maria in Araceli, Rome, which was executed c. 1634-1636 (cf. R. Wittkower, *Gian Lorenzo Bernini*, London, 1955, Cat. No. 37, Fig. 47).

Cortona in the open corners of the Galleria in the Villa Sacchetti (now Chigi) at Castel-
fusano (1626-1629),[215] where *stemmi* placed against open sky at the corners of the
vault are propelled upward by *putti* [Fig. 167]. In a corridor in the Palazzo Barberini,
Cortona again used this type, but added the *concetto* of the *stemma in arrivo* by depict-
ing it as though it had just reached but not yet assumed its designated position in the
vault.[216] In this earlier ceiling, the essential elements of the *stemma* in the Sala di Marte
are present except that the coat of arms is still confined within the actual space of the
room. Once embarked in this spacial exploration, Cortona must have seen the possi-
bility of a *cielo aperto* ceiling that incorporated landscape and figures along its cornice
as Giulio Romano had done at Mantua [Fig. 168] and realized the potential effect of a
hovering coat of arms seen against open sky as in the unattributed but certainly earlier
ceiling decorated for Cardinal Ludovisi in the Casino Ludovisi [Fig. 179].

Within the oeuvre of Cortona, the Salone Barberini was the major stepping stone
to the composition of the Sala di Marte. The true importance of the earlier ceiling is
readily apparent when the preparatory studies for the Sala di Marte are examined. The
evolution of the Sala di Marte is partially recorded in the composition studies thus far
located. One of these, now in the British Museum [Fig. 91], includes the prince, who
dispatches an enemy with his spear, and one of the Dioscuri.[217] In this study, the prince
has leaped aboard the enemy vessel directly from dry land. In the right section of the
drawing there is a seated priestess who holds a book upright on an altar and directs
winged Fame (who clutches her trumpet in a discarded *pentimento*) to decorate the
prince with a laurel wreath. The figure of Fame is derived, with much alteration, from
the figure who holds aloft a crown of stars in the Salone Barberini. The shrouded,
seated figure with a book is a conflation, borrowing the garments of Divine Love in the
Salone and the book and general pose of Divine Intelligence from the same ceiling. In
back of the attendants of the seated female there is a temple, lightly sketched and unsat-
isfactorily foreshortened. This drawing gives no indication of the shape or form of the
ceiling, and, except for the Dioscouros, none of the figures is posed in true *di sotto in su*.
In another preparatory, now at the Uffizi [Fig. 92],[218] roughly the same section of the
vault is considered. In this rapid pen sketch, the women at the temple no longer suggest
obvious connections with the Salone, and, most important, there are the first hints of
the curving, vee-shaped joint that Cortona was ultimately to use in the corners of the
ceiling. Another drawing, also in the Uffizi [Fig. 93],[219] represents a similar stage in
the evolution of Justice and Peace and the little genius who flutters over their heads.
The conception of Justice differs radically from the fresco, for in the preparatory she
is shown thrusting a firebrand into a heap of military accoutrements. A triumphal arch,
later moved to a different location, is seen from a foreshortened position. These prepara-

[215] For dating and illustrations see Briganti,
Pietro, 177ff. and Pl. 77.

[216] A. Blunt, "The Palazzo Barberini: The Con-
tributions of Maderno, Bernini and Pietro da Cor-
tona," *Journal of the Warburg and Courtauld In-
stitutes*, XXI, 1958, 286, Pl. 31c.

[217] Drawing Cat. No. 119.

[218] Drawing Cat. No. 117.

[219] Drawing Cat. No. 118.

tory drawings suggest that Cortona studied sections of the ceiling almost as though they were individual scenes set apart by enframements as in the Salone Barberini, then gradually worked the architectural elements and the figures into foreshortened positions and achieved the final composition by interchanging portions of these separate scenes and fusing the sections considered in them into a single, panoramic composition.

The Stuccoes

The stucco decoration, which in this room plays a subordinate role, serves as a transition from the rigid, rectangular space of the room to the indefinite illusionistic space of the fresco. Executed in white stucco enriched with gilding, the ornamental architecture consists of four major elements: a rectilinear band magnificently embellished with reliefs of military arms, segmental pediments placed at the midpoint of each wall [Fig. 94], and *exedra* forms that rise to peaks at the corners of the room, at which point they become backrests for the last of the four elements, the recumbent figures who sit back to back at each corner [Fig. 95]. The segmental pediments serve several functions which bear further examination.

The primary element in the pediments is the curved scroll form that we have already seen employed in the Sala di Venere as an enframement for the lunette. In this case, the coil spring is held in contraction by the vise-like pressure of the pediment, the upper segment of which appears to have been ruptured by the upward thrust of the coil. On three of the walls, this coil contains a helmet; on the fourth, it frames the oval window that forms the top of the windows opening onto the piazza Pitti. In the other rooms in the planetary series, this oval window was filled in. Here it has been left open because the Sala di Marte has only one window and consequently needed all available illumination. In complete contradiction of the visual forces he has thus set in motion in this motif, Cortona playfully placed little *putti* innocently stepping between the pincer-like segments of the broken pediments and the coil springs. Both Agostino Tassi and Annibale Carracci utilized this motif. The poses of Cortona's *putti* point to other sources, too, such as the Christ child in Michelangelo's *Bruges Madonna* and the similar figure in Raphael's *Madonna del Cardellino*.[220]

The recumbent corner figures, as observed by Wittkower, owe much to the figures on the Medici tombs in the New Sacristy in San Lorenzo.[221] It should be noted, however, that Veronese's reclining figures, in particular that of Vulcan in the Villa Maser, may have aided Cortona's design of these resting forms.[222] The long, curved *exedra* forms that visually create a sense of depth behind the segmental pediments by

[220] Tassi used similar *putti* in a c. 1630 frieze in the Palazzo Pamphili (see V. Golzio, *Il Seicento e il Settecento*, Turin, 1950, 422 and Figs. 448, 449). For the use of similar figures by Annibale Carracci in the Farnese Gallery see Martin, *Farnese Gallery*, Figs. 47ff. As reported by Dürer, Michelangelo's statue was in Bruges by 1521 (L. Goldscheider, *Michelangelo*, London, 1953, 11 and notes 5-8), but the figure would have been well known and certainly available in engravings or replicas.

[221] Wittkower, *Art and Architecture*, 167.

[222] Fiocco, *Veronese*, Pl. XXXIX, 2.

rising gradually into the high stucco peaks at the corners of the room, where they provide a backdrop for the recumbent figures, should not be underestimated in importance. This same form was used on a more minor scale in the Sala di Venere, where space is similarly scooped out behind the small plinths underneath the elaborate frames of the Medici portraits on the long side walls [Fig. 24], and it will again be used by Cortona in his solution to the small piazza space of S. Maria della Pace [Fig. 180], where it functions in the same manner as in the Sala di Marte to create depth behind the upper story of the church facade.

Of the five ceilings of the Pitti cycle, the Sala di Marte is the most important contribution to the history of Baroque fresco decoration. Executed immediately after the War of Castro, it constituted a political as well as a stylistic challenge to the Salone Barberini.

SALA DI GIOVE

The third room in physical sequence and the second to receive decorations (1642-1643/4) was the Sala di Giove [Fig. 96]. In this room, a throne with a baldachin was placed. The walls were hung with tapestries representing the seasons and with three large paintings by Andrea del Sarto. The Sala di Giove is nearly square, measuring approximately 10 meters by 10.4 meters. The vault is carried by pendentives placed at the center of each wall. As in the Sala di Venere, the spandrels are conjoined at the corners of the room forming a traditional *angolo velato*, and the ceiling zone is defined and separated from the vertical wall planes by a massive cornice that places the lunettes within the organization of the vaulting system. Here, as in the first room, the ornamental architecture is confined to the areas of the pendentives and to the spandrels [Fig. 97]. In contrast to the first room, the areas of stucco ornament are markedly reduced, and the fresco on the central field of the vault has been greatly expanded, so much so in fact that the actual curvature of the vault is drastically negated. Only by the most careful observation does the spectator become aware that the surface of the ceiling fresco is in fact composed of a major and several minor concave planes, the latter forming parts of the spandrels and pendentives that do not stop where the massive quatrefoil cornice induces the spectator to presume their termination. The complexities of this cornice also mask the manipulations of mural surface. We are permitted to read the central field as a neutralized zone in structural terms, for the dynamic forces of structure are concentrated in the areas of stucco ornament.

The Stuccoes

A preparatory study for the stuccoes of the Sala di Giove has been located [Fig. 98].[223] Rather surprisingly, not one motif present in the study survived to the final

[223] Drawing Cat. No. 133.

stage of the design of the room. Two aspects of the drawing are, however, of special interest. First, a number of its principal motifs were used in the third and fourth rooms (in order of execution) in the series, that is, the Sala di Marte (the tondo windows with pendant *putti*) and the Sala di Apollo (the circular cornice). It should be kept in mind that the design of the Sala di Apollo stuccoes may have preceded that of the Sala di Giove, and hence the latter motif may have been inherited from the Sala di Apollo. And second, the preparatory does reveal some interesting things about the program of the Sala di Giove. It suggests, in fact, that the fresco program below the central field of the plafond was not precise at the inception of Cortona's work on the decorations. In the drawing, these areas, which are occupied by a series of deities in the actual decorations in the room, were to be filled by stucco *putti* who flank circular forms. Exactly how these circular forms would have functioned is not clear, but in all probability the two located in lunettes overlooking the piazza Pitti would have been opened to admit light, for they would have coincided with the pre-existing fenestration.[224] If this interpretation of the drawing is correct, it would seem that some of the deities who appear in the actual lunettes would necessarily have been placed in the pendentives or entirely suppressed.

In execution, the opulent stuccoes of the Sala di Giove are closer to those of the Sala di Venere than in the preparatory drawing discussed above. In many respects the motifs in this room derive from sources in Cortona's work that precede the earlier planetary room. In fact, the major source for the vault and its supporting figures may be found in the 1635 decoration of the vault of the Cappella dell'Immagine di Maria Vergine della Concezione in S. Lorenzo in Damaso in Rome [Fig. 171].[225] The damage suffered by this church, first through its use as an armory by Napoleon and then in consequence of two restorations, one by Valadier and a second by Vespignani, have absolved Cortona from any connection with the painting now visible in the chapel; however, the stuccoes that were a part of the original decorations by Cortona still exist. These stuccoes, designed and possibly even executed by Cortona, are the earliest known example of his work in stucco. As such they constitute a most important prototype for the Planetary Rooms. The importance of this earlier work to the Sala di Giove is, therefore, twofold, for here the connection is not only one of medium, but of composition. The elaborated quatrefoil shape of the frame of the vault fresco in this room almost exactly mirrors that used in the chapel, just as the *putti* cavorting on the spandrels of the chapel vault are repeated with more adult figures in the Sala di Giove.

The shape of the vault decorations in the Sala di Giove is not the only element in this decorative scheme that derives from Cortona's decorative vocabulary of the 1630's. As in his earlier decorations, the latent energies of Cortona's system in the Sala di Giove

[224] The facade windows on the *piano nobile* consist of long rectangular apertures capped by an ocular window. In both the Sala di Venere and the Sala di Giove these ocular windows have been sealed and the areas used for lunette frescoes.

[225] Forcella, *Iscrizione delle chiese*, v, 203; Passeri, *Vite*, 383 and n. 2.

are expressed in a conventional architectural vocabulary and also in the human forms capriciously placed along the ribs of the vault. These figures, along with the Tritons and dolphins who wiggle along the cornice, soften the sober rigidity of the architecture, filling it with the movement and life of animate forms. The stucco figures in the Sala di Giove are, in comparison with those of the Sala di Venere, more relaxed. Their earnest endeavor in the earlier room here gives way to a *joie de vivre* in which figures gesticulate from precarious perches along the profiles of the pendentives, where, nonchalant in their gravity-defying poses, they individually pirouette or embrace a companion. The poses of the figures are related to the Villa del Pigneto decorations, but more directly to the figures in the corners of the Salone Barberini, here translated into real stucco. In the Sala di Venere, the ornamental stucco architecture exhibited manifest signs of severe pressures, and the figures reacted accordingly. In contrast, although the stucco architecture in the Sala di Giove seems to have opened, revealing the central frescoed scene of the vault, this state of dilation appears to have been achieved without severe contractions or pressures, and it is as an expression of this condition that the stucco figures successfully function. The closeness of mood maintained between figural decoration and stucco architecture is graphically illustrated if we observe the close proximity of the struggling figures posed on the main cornice of the Sala di Venere and the massive spring that defines the segmental curve of the adjacent lunettes [Fig. 21] and compare them to the male youths in precarious attitudes on the pendentives in the Sala di Giove [Fig. 99] who are directly associated with thin, flattened, leaf spring forms.

The initial appearance of Tritons in the Pitti rooms occurred in a preparatory study for the decoration of the Sala di Venere [Fig. 26],[226] where they clearly derive from those that writhe around the hexagonal reliefs in the Salone Barberini. Dropped from the decoration of the Sala di Venere, they surface in more Rubensian form in the Sala di Giove. Although they may ultimately derive from a stylistic source in that master's work, it should be noted that they have been in Cortona's repertory for nearly three decades. They can be found at the Villa del Pigneto, where they once frolicked in a pool in front of the villa [Fig. 181].[227] The grinning dolphins who act as supporting figures for the Medici coats of arms at the corners of the room can be found cavorting in pairs along the frescoed architrave in the Salone Barberini. The grimacing heads that decorate the cornice of the Sala di Giove also appeared, but in much more diminutive form, on the cornice of the Salone.[228]

As already noted in our consideration of the function of the Planetary Rooms, the

[226] Drawing Cat. No. 53.

[227] Their early use as fountain sculpture at the Villa del Pigneto may well have been a major influence on Bernini's revolutionary Triton fountain, executed about ten years later. For Bernini's fountain see Wittkower, *Bernini*, Cat. No. 32 and Pl. 55.

[228] The larger size of those in the Sala di Giove and their combination with garlands of oak suggest that Cortona had studied the frescoes of Annibale Carracci in the Palazzo Magnani in Bologna, where the motif serves the same purpose in the frescoed frieze.

Sala di Giove contained a baldachin and served as the grand-ducal audience chamber. On the basis of another document, it is possible to locate the position of the baldachin in the room. Among the drawings of Giacinto Marmi there is a description, dated 26 January 1657, of the method of arranging the hangings and furnishings of the "Camera di Giove dell'Audienza del Ser.mo Gran'Duca" that includes instructions for the assembly of "the baldachin which one fixes with rope to a hook of gilded iron that is at the hand of a statue of stucco."[229] On the eastern wall of the room there are, in fact, two stucco Tritons flanking the central inscribed plaque who fit this description. Each of them holds in its outstretched hands a gilded iron hook [Fig. 101]. Thus the seventeenth-century visitor entering the Sala di Giove from the Sala di Marte would have faced the throne as he entered the room. Directly above the baldachin he would have read the inscription between the two Tritons: VIRTVTEM IVPPITER PRVDENS AEQVE AC IVSTVS PRAEMIIS EXTOLLIT (Jupiter, as prudent as he is just, exalts virtue with rewards).

The Frescoes

In the central fresco [Pl. IV, Fig. 96], all reference to terra firma has been eliminated. Through its quatrefoil frame we peer into an open space, a celestial realm. The principal figures, seen *di sotto in su*, form a circle near the cornice. A ring of clouds supports them and reinforces their circular compositional form. These figures actually constitute two separate groups who, starting from a point slightly to the left of the observer when he enters the room, appear to move in opposite directions around the vault and converge at the point slightly to the right of the diagonally opposite corner. Of these two sets of figures, the one which follows an arc over the head of the spectator forms a cortege behind the prince. Next to the prince is Hercules, who has lent him his club and personally assists him forward to receive a crown from the hand of Jupiter. Flanking Hercules, a female figure, recognizable by her nude torso, wind-blown cape, and wheel as Fortune,[230] also guides the prince. Facing the prince, Jupiter, bare-torsoed and with lower body wrapped in a cloak, sits in a characteristic pose with an eagle at his feet and a lightning bolt in his left hand. Directly overhead, flying on a steep diagonal out of the very center of the ceiling appears his cupbearer, Ganymede,[231] blond-haired, wrapped in a brilliant white cloak and carrying the blazing star of

[229] Florence, Uffizi, Gabinetto dei Disegni, No. 5577 F, recto: "il baldichino quale si ferma con cordone a un uncino di ferro dorata che è alla mano di una statua di stuccho."

[230] Ripa, *Iconologia*, 205, under *Fortuna buona*. The color of her cloak is not specified by Ripa.

[231] Fabbrini, *Vita*, 82f., and Briganti, *Pietro*, 235, identify this figure as Apollo and the nearby constellation as ursa major, the constellation ". . . che mai tramonta" as Fabbrini describes them. Actually the constellation in the vault contains six major and two minor lights. Ursa major may have been intended and if this is so its use as a symbol of steadfastness would well apply to the ceiling. An early drawing of Ganymede exists in which this figure is shown equipped with tiny wings (Drawing Catalogue No. 134A), leaving little doubt that Jupiter's cupbearer is intended, not Apollo.

Aquarius, rushes toward Jupiter. Ganymede's plunging form implies vast space above the figures who ring the vault and also points out the central action in the vault—the conferring by Jupiter of a crown upon the prince, whose ascent to fame and glory is recorded in the preceding rooms.

Directly behind Jupiter, a group of four female allegorical figures are seated who, at the behest of that deity, donate portions of their apparel to the prince as tributes to his valor and virtue. Although the identification of these figures presents difficulties, neither the fresco nor a splendid preparatory study for them [Fig. 107] makes clear their attributes; however, they surely represent virtuous governance.[232] The fasces held by the first figure identifies her as Justice.[233] It is surely her gold crown that a *putto* has just carried to the outstretched hand of Jupiter.[234] Dark-haired, she wears a white dress and over it a brilliant red cloak. The three females seated behind Justice are not easily identified. Narciso Fabbrini confidently describes them as Glory, Generosity, and Grace, identifications which were accepted by Giuliano Briganti.[235] These identifications are, however, uncertain. If the seated figure dressed in white with a blue cloak holds a *patera* in her left hand, she is probably Liberality, rather than Generosity or Glory.[236] The second member of the group, dressed in a light green cloak and white headdress is not identifiable with any certainty. Fabbrini's identification of the last figure in the group, who is nude to the waist, wears a cloak of gold over a white skirt, and holds a palm branch, as Grace is probably correct.

Below Jupiter appears another group of even less particularized figures—three females, a *putto* who stares down from within a branch of olive branches, and to his right three almost indiscernible male figures. The olive branches that surround the *putto* mark the only instance in the entire cycle in which Cortona violates the careful separation of fresco and stucco ornament, for here he jokingly permits several branches to fall across the massive stucco frame. The three females have been identified by Briganti as Prudence, Temperance, and Fortitude.[237]

The figures thus far considered are balanced by a second group who form a pendant arc. The action here commences with two *putti* who push a battered galley while others carry heavenward a suit of armor, consisting of gold and silver armor, a white plumed helmet, and a blue cloak.[238] In front of them appear two enemy soldiers in chains. They sit disconsolately among their weapons while a youth with a flowing red cloak shows a lance-pierced cuirass to Victory, who clutches a palm branch in one hand

[232] Drawing Cat. No. 134.

[233] Cf. Ripa, *Iconologia*, 221, under *Giustizia*. Fabbrini and Briganti concur in this identification.

[234] *Ibid.* The gold crown may be associated especially with divine justice.

[235] Fabbrini, *Vita*, 82; Briganti, *Pietro*, 235.

[236] Cf. Ripa, *Iconologia*, 308, under *Liberalità*.

[237] Briganti, *Pietro*, 235. Fabbrini's account (*Vita*, 81) is extremely confused. He concludes among

other things that the *putto* in the olive branches is Fortitude, identifying the olives as oak branches.

[238] Fabbrini, *Vita*, 82, identifies the galley as that of the Argonauts. He also identifies the arms carried by the *putti* as those given to the prince by the Dioscuri in the preceding room (the Sala di Marte), but this is unconvincing because the colors are completely different.

and writes upon a burnished shield with the other.[239] The two sections of the ceiling described above, one composed of allegorical figures and the other consisting of the presentation of trophies in honor of the prince's conquests to Victory, form parenthetical groups on either side of the central scene, in which Jupiter crowns the prince. The group representing the prince's valorous deeds appears behind the prince and his escorts. They are also closest to the Sala di Marte, in which the prince demonstrated his prowess. The other group, in contrast, is bestowing honors upon the prince. Thus one group represents glory achieved, and the other symbolizes honors conferred in recompense. When interpreted in this manner, the figures in the Sala di Giove form a transition between the hectic adventures of youth, as portrayed in the Sala di Marte, and the more contemplative life of the virtuous and aging ruler, which is the subject of the last room in the cycle, the Sala di Saturno.

Two inscriptions placed on the pendentives of the eastern and western walls of the room aptly describe the ceiling fresco. The one on the west wall and thus closest to the Sala di Marte reads: MATVRA AETAS VIRTVTE ET FORTVNA DEDVCENTIBVS IOVI DECORANDA SISTITUR (In the prime of life [the prince], led by virtue and fortune, stops to be honored by Jupiter). This inscription is immediately below the figure of Victory in the procession of figures who form the cortege of the prince. The second inscription, placed directly beneath the figure of Justice in the ceiling, reads: VIRTVTEM IVPPITER PRVDENS AEQVE AC IVSTVS PRAEMIIS EXTOLLIT (Jupiter, as prudent as he is just, exhalts virtue with rewards). As companion pieces to these two inscriptions, two identical cartouches appear on the northerly and southerly walls in the same positions. On the former plaque, Jupiter strikes down the Giants with his thunderbolts [Fig. 100], and in the latter he hurls Phaeton from Apollo's chariot [Fig. 99]. The message of these reliefs is obvious; both illustrate attempts to gain the Olympian heights by other than virtuous means and Jupiter's consequent punishment of the offenders.

In the four corners of the room, partially supported by twin dolphins, the Medici *stemma* appears, in each case surmounted by an inscription. Over each inscription an appropriate device has been placed. Starting from the entrance and moving in a clockwise direction, the inscriptions and accompanying symbols are as follows: SERVATA-TIS CIVIBVS (Citizens preserved) with laurel branches, PACATO MARI (The sea peaceful) with prows of galleys, SECVRITAS PARTA (Safety brought forth) with oak branches, and TRIVMPHALIS HOSTIBVS (Triumphal over foes) with olive branches.

The lunettes in the Sala di Giove are untitled and connect with the vault in a less

[239] Cf. Ripa, *Iconologia*, 576, under *Vittoria*. Fabbrini (*Vita*, 82) states that she is writing the first letters of *merenti*, but the letters are in fact not at all clear. Cortona had earlier used a similar Victory in an overdoor of the "History of Constantine the Great" tapestries where she is writing "Constantine" on a shield. See Dubon (*Tapestries*, 21 and Fig. 6), who identifies the allegory as an angel.

precise fashion than those in the Sala di Apollo or in the Sala di Venere. In the left lunette of the eastern wall [Fig. 108], Vulcan has ceased to forge the arms of war and rests beside his anvil. In the background his brutish assistants, the Cyclopes, passively await his orders. In the lunette to the right in the same wall, Apollo [Fig. 109], recognizable by his lyre and quiver, is seated in a forest glade. He seems to have noticed Diana, who sleeps peacefully in the adjacent lunette in the south wall [Fig. 110]. The hunt over, Diana, dressed in white and red-orange and wearing her half moon, leans against her quiver while her hunting dogs rest at her feet. In the lunette to the right in the same wall [Fig. 111], Minerva, holding an olive branch,[240] instructs Cecrops, King of Athens, in the planting of the olive tree. She is recognizable by her golden helmet and shield, at whose centers appears the ghastly snake-haired head of Medusa. Cecrops is depicted as a sturdy youth and without the lower body of a serpent given to him in some of the accounts. He grasps an uprooted olive tree and listens attentively to the Goddess's directions. In the background can be discerned a wall that is probably a side of the well containing the sea water that Poseidon had given to the city of Athens in an attempt to make himself tutelary deity in place of Minerva (Athena). In the adjacent lunette [Fig. 112], located in the westerly wall, two figures struggle to break their bonds. Fury, represented by a black-bearded male whose face seethes with anger, violently attacks the heavy chain that is attached to his armor and that also bars a doorway. Within the doorway appears a female accomplice, Discord, who brandishes a torch and spits flames.[241] Their combined efforts are to no avail. The other lunette in the western wall contains Mercury, who, wearing his winged helmet, sandals, and carrying the caduceus in one hand and a trumpet in the other, flies rapidly past architecture whose form seems to reflect the upward direction of his flight [Fig. 113]. In the adjacent lunette [Fig. 114] the warrior twins, Castor and Pollux, clutch spears and guide their fierce horses.[242] The last lunette depicts a warrior who rides a winged steed [Fig. 115]. Fabbrini has identified him as Mars and his mount as Pegasus.[243] The horse is undoubtedly Pegasus, but there is no mythological connection between the winged charger and the god of war.[244] Consequently, it is more likely that the youthful soldier is Bellerophon, who tamed the winged horse with the aid of a golden bridle (and the bridle depicted in the lunette is of gold), the gift of Minerva.[245]

The iconographic relation of the lunettes to the central vault does not seem to

[240] The fact that Cortona has placed an olive branch in Minerva's hand either indicates his knowledge of some particularly accurate antique iconographic source or simply reflects horticultural experience since the cultivated olive does not breed true and must be grafted on the oleaster, or wild olive, and, therefore, Minerva need only have presented Athens with a cultivated branch. This knowledge could easily have come to Cortona from the olive-bearing farms of his native Cortona.

[241] Fabbrini, *Vita*, 83, and Briganti, *Pietro*, 235.

The two figures are in accord with some of the attributes of *Discordia* and *Furore* (cf. Ripa, *Iconologia*, 141f. and 210ff., under the appropriate citations).

[242] Fabbrini, *Vita*, 83, correctly identified them.

[243] *Ibid.*

[244] Cinelli identified Pegasus in this lunette but left a blank in his manuscript in place of the name of the rider (Doc. Cat. No. 126 at c. 206r).

[245] Apollodorus II. iii. 1.

reflect a close-knit program, and the elucidation of specific and profound themes does not seem intended. As an ensemble, they indicate that peace reigns on earth, that the furies are checked, and that the gods and heroes rest or fly heavenward to receive Jupiter's further commands. The somewhat peripheral contribution these figures make to the program is not surprising, since, as we have already noted, the solution proposed in an early preparatory for this room either did not include them or in any event would only have permitted their presentation in drastically reduced form [Fig. 98].

THE SALA DI SATURNO

The decorations in the last room in the planetary cycle, the Sala di Saturno [Figs. 116 and 117], were executed entirely by Cortona's pupil and assistant, Ciro Ferri, between July 1663 and August 1665. The dates of this room are fully documented. In contrast, the authorship of the designs for the decorations is problematic. Lorenzo Magalotti writing from Florence on August 18, 1665, just after the unveiling of the room emphatically states that the cartoons for the Sala di Saturno were prepared in Florence, noting that, in consequence, Ferri deserved full credit for their quality. According to Magalotti, the young artist had followed this procedure to scotch his competitors and critics, "who had had no other attack on the Sala di Apollo than to say that Ciro had brought cartoons made by Pietro in Rome. These [for the Sala di Saturno] he decided to make here and everyone has been able to see them for himself."[246]

Magalotti's assertions sound entirely reasonable and logical, and his knowledge-ability about the iconography of the room as evidenced by a description contained in the same letter supports the fact that he had more than a passing interest in the commission. However, his statement in support of Ferri's independence from his master in this case is seriously discounted by the existence of a number of drawings in Cortona's hand for the room and by a letter he wrote to the Grand Duke.[247] Writing from Rome on June 17, 1663, less than two weeks before Ferri arrived in Florence to start the decorations, Cortona informed the Grand Duke that Ferri had finished the cartoons with much success and that he, Cortona, is "convinced that in execution they will be to the satisfaction of Your Highness," and he expresses his own deep displeasure at not being able to come in person to serve the Grand Duke.[248] This letter makes it a virtual certainty that Ferri had in fact prepared the cartoons in Rome and that Cortona must have had, at the very least, unofficial supervision of their execution, a situation more akin to the circumstances under which the final cartoons for the Sala di Apollo were prepared than Ferri cared to have either his Florentine advocates or adversaries know. A major difference between the two commissions, however, is that the evidence avail-

[246] Doc. Cat. No. 125.

[247] Vitzthum, "Drawings," 525, attempted to define the roles of Cortona and Ferri in the Sala di Saturno, but as in the case of his exploration of a similar problem posed by the Sala di Apollo, he considered only some of the drawings relevant to the decorations and none of the documentary material here considered.

[248] Doc. Cat. No. 121.

able indicates Ferri did not in the later decorations inherit an unexecuted scheme for the frescoes. To date, no Cortona preparatory studies for compositions or single figures have been located for the frescoes in the Sala di Saturno. As we shall presently consider, a number of Ciro Ferri drawings including *primi pensieri* have been identified, a situation that strongly suggests, but does not absolutely prove, that Cortona did not take chalk or pen in hand in their preparation.[249]

In contrast, Cortona was involved in the preparation of the stucco decorations. Three drawings by his hand attest to his participation in their formulation, and at a highly advanced stage [Figs. 118-120].[250] Furthermore, as Vitzthum first indicated, these drawings are in Cortona's late style and thus can be placed with virtual certainty to the period of Ferri's involvement in the Sala di Saturno.[251] To these arguments must be added an entry in a Court Diary mentioning that Ciro Ferri arrived in Florence on June 29, 1663, and that he started work in the Sala di Saturno on July 3.[252] Although this briefly worded entry does not give absolute proof that the actual decorations were commenced four days after his arrival, an impossible situation if he had to draw up the cartoons in Florence, it certainly casts further doubt on Magalotti's partisan assertions.

The Sala di Saturno shares with the Sala di Marte the smallest dimensions in the planetary series, measuring approximately nine by ten and one half meters. As in the Sala di Marte, light is admitted from only one window, but here no attempt was made to save the oculus, which is covered by the lower cornice and the decorations immediately above it. In terms of its physical relation to the preceding rooms in the series, the Sala di Saturno is wider than it is long. The vaulting is unusual. Each side wall rises to form a lunette. The lunettes on the short sides of the room are described by a shorter and slightly higher arc than those of the long walls and carry a barrel vault, which merges with the curve of the other two lunettes. This vaulting arrangement suggests a compromise; the lunettes would usually be accompanied by corner pendentives and a low handkerchief vault, and conversely a barrel vault would normally have lunettes on only its shorter walls, the vault being carried directly by the longer side walls.[253] As in the preceding rooms, the lower cornice is massive and serves to separate emphatically the wall of the room from the decorated vault.

The Stuccoes

The evidence presented by the preparatory studies suggests that the vaulting was in its present shape when the first of these schemes was formulated and that the studies for the ceiling gradually evolved to satisfy the form of the vault. Three of these drawings (all, as we have noted, by Cortona) have been located, of which a study now in

[249] Drawing Cat. Nos. 148-156.
[250] Drawing Cat. Nos. 144, 145, 147. Also attributable to him, No. 146, a sketch for an ornamental detail in the decorations.
[251] Vitzthum, "Drawings," 525.

[252] Doc. Cat. No. 123.
[253] As in the earlier rooms, there is no information about the degree to which pre-existing vaulting was altered for the decorations.

Hamburg is undoubtedly the earliest [Fig. 118].[254] The decorations proposed in it reflect little interest in the articulation of the vault. Closest in composition to the earlier Sala di Marte, the drawing presents a slightly modified *cielo aperto* effect. The stucco decorations are confined to the lower margins of the vault, rising at the corners in accumulations of ornamental forms that include grinning heads and candelabrum. There is an echo of the more animated corners of the Salone Barberini [Fig. 143], for even the motif of rampant animals is reused. In the study for the Sala di Saturno it is the Florentine lion, the Marzocco, that is portrayed. At the center of each side wall, this early drawing called for a scene enframed in laurel and partially supported by *putti*. The edges of these decorations are open and irregular, and there can be no doubt that the ceiling fresco penetrated these areas or that sky was intended because they are designated as *aria* in Cortona's own hand.

In sum, the drawing appears to be a variation on the plans for stucco decorations of the Sala di Marte, whose divergencies—and they are numerous—can be explained by references to even earlier Cortona work. It would be interesting to know the precise date of this study. When were changes made in the program that caused the elimination of the laurel-enframed scene of Mucius Scaevola thrusting his hand into a flaming altar? Cortona had already used this allegory of Fortitude in the *quadratura* decorations of his panegyric to the power and glory of the Barberini family in the Salone of the Barberini Palace with which, as we have noted, there are many other correspondences in this drawing.[255] At this stage in the conception of the ornamentation of the Sala di Saturno, Cortona was clearly involved with a program which included four medallions, one at the center of each wall, depicting allegories of the traditional cardinal virtues: Fortitude, Justice, Prudence, and Temperance.

Another drawing for the Sala di Saturno stuccoes provides a solution much closer to that finally adopted. This drawing, now in the Royal Library at Windsor Castle [Fig. 119], presents an expansion of the areas receiving stucco decorations.[256] In the Windsor drawing, the stuccoes separate and define the fresco areas of the lunettes and ceiling. Oval fields are provided for the lunette frescoes and the ceiling is enframed by an irregular polygon. The Windsor drawing contains one especially problematic feature; namely, the indication in the corner of at least one and probably two arches intersecting the lower edge of the main cornice. Precisely what Cortona's intentions were at these junctures is not clear. Very possibly a new set of doorways was intended, for it is unlikely that any changes in fenestration can have been considered.

The Hamburg and Windsor drawings are important not only because they provide information about the evolution of the decorations of the Sala di Saturno and their attribution to Cortona, but also because they document a marked change in Cortona's decorative style. This new development is marked by a lessening of interest in decora-

[254] Drawing Cat. No. 145.
[255] For an illustration see Briganti, *Pietro*, Pl. 132. Note the similar juxtaposition of the lion, an-
other symbol of Fortitude.
[256] Drawing Cat. No. 147.

tive elements that emphatically reflect the structural forms to which they are applied. In the Windsor drawing, volutes and moldings do not function visually as if they were the tendons of the muscles of the vault. Instead, these forms play more capricious roles. The large volute on which the young woman in the drawing rests her right knee, for example, is wholly different from analogous forms in Cortona's earlier work; for here and in the Hamburg drawing, Cortona's tautly contracted form has been replaced by a shape that rises in a segmental curve, breaks sharply forming a point, then curves again and ends at its upper extremity in a double coil, which has been arbitrarily imposed on the larger form, truncating and effectively checking any sense of contraction or tension in it. The double coil is a familiar Cortona motif, but whereas earlier examples of its use could be said to have reinforced the form to which it was applied, its use here does not act as a reinforcement and in fact obstructs the possibility of a satisfactory concluding form to the already broken curve of the volute.[257] Cortona has moved toward what might be termed a controlled distortion or negation of the more normative Baroque concentration of form, for the small double coil breaks out in a curving foliate growth along its outer edge, which disrupts its smoothly enclosed shape and counters with this outward sweeping vegetal form the inward turning configuration of the double coil. To varying degrees the same phenomenon exists in other portions of the decoration. Significant, too, is the fact that the changes in the handling of decorative motifs are accompanied by a changing attitude toward the decorated fields as well, for the ornamental reliefs are now applied to broad planes, which are left unpatterned. In place of Cortona's earlier interest in stacks or bundles of richly molded planes, we find smooth surfaces with individual ornaments applied to them, often in isolation.

In a third study, now in Berlin [Fig. 120], Cortona achieved a formulation that was carried into execution with only minor changes.[258] This drawing contains a *pentimento* for a polygonal frame for the central fresco, a fact that supports its placement after the Windsor drawing in the evolution of the stucco decorations. Another *pentimento*, faintly visible, on one lunette records a tentative consideration of a lunette fresco enframement with short vertical sides capped by a segmental pediment. This shape points to ties with the rectangular lunette fresco enframements in the Sala di Apollo and even closer links with the frame proposed in an early preparatory for the Justinian lunette [Fig. 71] in that room. Compared to the other preparatories for the Sala di Saturno, this drawing presents a more conventional Cortonesque solution. Typically, the ornamental elements articulate a much firmer architecture, and the effect is closer in character to the earlier rooms. Even so, the new qualities manifest in the Hamburg and Windsor drawings find expression in the fact that the conventional elements that define lunettes, spandrels, tondos, and the like dissolve into foliate forms that are generated within the interior fields or that are so shaped and placed as to reduce their forceful articulation of the architecture. The decorations in this drawing are so close

[257] See, for example, its use on the frames of the lunettes in the Sala di Venere (Fig. 21).

[258] Drawing Cat. No. 144.

to the actual decorations that there can be no serious doubt about the attribution of the design of the executed work to Cortona. Contrary to Magalotti's assertions, the role of Ciro Ferri with regard to the stucco decorations of the Sala di Saturno can have been little more than that of Cortona's amanuensis.

In many respects, the organization of the Sala di Saturno is a fusion of the Sala di Venere and the Sala di Apollo. As in the latter room, the lower areas of the vault are occupied by four lunettes of varying dimensions, but in this room the east and west walls are the longest. In an effort to make the sides appear equal (the room measures 10.4 by 9 meters), the four lunettes are treated with an equivalent decorative system, which has been expanded or contracted to fit the appropriate space. In the Sala di Apollo this arrangement produced four rectangular lunette frescoes of varying proportions. In the Sala di Saturno a tondo form has been employed, which similarly varies from an almost perfect circle to a nearly ellipsoid form to compensate for changes in the lunette spaces. As in the Sala di Apollo, the cornice of each fresco is flanked by two figures and capped by a triangular pediment on which two *putti* recline [Fig. 121]. The Sala di Venere appears to be the immediate source for the rectangular ceiling fresco contained by a massive gilt cornice with heads (each representing a season) at the four corners.[259]

For the source of the decorative architecture in the Sala di Saturno, another of the earlier rooms must be examined. If a lunette of the Sala di Saturno [Fig. 121] is compared to the stucco decoration that occurs at the middle of the cornice on each wall of the Sala di Marte [Fig. 94], it is apparent that the motif of a curved double scroll enclosed within a broken, segmental pediment has been expanded and used as the basis of the decoration for the entire lunette. This has been done by capping the tondo fresco with a double scroll, hollowing out the space behind this element with a shallow *exedra*, and by placing the segments of the pediment at the far corners of the lunette. In the Sala di Saturno, the two pincer-like pieces of the pediment have been placed at such a great distance from the tondo and its double scroll that the tension-filled compressive qualities of the earlier composition are suppressed. What little sense of potential movement remains in these elements is further mitigated by the fact that the two segments of the pediment are treated as solid architecture that continues behind the tondo and by the triangular pediment on top of the tondo, which makes no sense as either a continuation or a fragment of the broken segmental pediments at the corners of the lunettes.

The executed decorations are very close to those presented in the Berlin drawing already discussed; in fact, the only significant difference is the substitution of richly elaborated moldings in the final work for the simpler, smoother moldings in the drawing. The change is important, for the moldings in the drawing restate a Cortona tradition that extends back to his earlier work such as the interior decorations of SS. Luca e

[259] There is also another source for the shapes of the fresco spaces in the Sala di Saturno; namely, the galleria in the Palazzo Pamphili, 1651-1654, in which Cortona placed the center scene in a rectangular cornice of simulated stucco and two smaller scenes in simulated oval frames.

Martina. There seems, however, little reason not to attribute the strikingly different effect of the final version to Cortona, for the small-scale foliate forms appear on the moldings in the other preparatory drawings, especially the one at Windsor. The use of the more elaborate decorations is combined with an avoidance of stacked or bundled moldings used in the earlier rooms. When strongly expressive forms are used, they are deployed in such a way as to mitigate the functions they served in the earlier rooms. In the Sala di Saturno, separated by over twenty years from the Sala di Venere, decoration is more an expression of ornamental pattern or enriched surface than a visual statement of structural stress or weight.

The documents attribute the execution of the stucco decoration of the Sala di Saturno to a staff of *muratori* and *capo muratore* headed by the Roman *stuccatore*, Giovanni Battista Frisone.[260] These sources also indicate that Ferri, as we have surmised Cortona to have done in the earlier rooms, took personal direction of some of the work. Frisone was one of the men from the Algardi shop that had been called to Florence when Cortona started work in the Sala di Venere. Stylistic comparison further supports this attribution. Although the heavy gilding tends to obscure the more subtle nuances of their molding, the figures in the Sala di Saturno are the same type who appear in the Sala di Venere.

In spite of their stylistic connections with the figures in the earlier rooms, it would be unjustifiable to consider the Sala di Saturno figures as entirely derivative. In keeping with the qualities of distention in the architectural ornamentation, the figures in the stucco decorations are more casually disposed. Playing a virtually nonsupportive role, they lean from the main cornice and from the pediments above the fresco tondos [Figs. 122 and 123] regarding the spectator as well as one another. Their glances, reinforced by the garlands that loop across the corners, penetrate the real space of the room and thus encourage the spectator to move from one lunette to another. Although functionally effective, this feature is not truly progressive, for, in fact, the use of figure interaction in essentially decorative sculpture finds clear expression in much earlier sculpture.[261]

The Frescoes

In contrast to the stucco preparatory studies of which all extant examples are attributable to Cortona, the located drawings for the frescoes in the Sala di Saturno are all associated with Ciro Ferri. Although the cartoons for the frescoes must have been completed in Rome as the comments in Cortona's letter of 17 June 1663 indicate, and not in Florence as Magalotti states, Magalotti seems to be correct in assigning their execution to the younger artist.

[260] See Appendix I.
[261] An example is to be found in the angels on the high altar of the Pauline Chapel in S. Maria Maggiore, dated in the first decade of the seventeenth century. For an illustration and attribution see A. Venturi, *Storia dell'arte Italiana*, Milan, 1940, x, Pt. 3, 376f.

Three and possibly four drawings, all by Ciro Ferri, can be associated with the central fresco in the Sala di Saturno [Fig. 124]. One of these drawings is a pen sketch [Fig. 125] that has been previously identified simply as an apotheosis.[262] The presence of a male figure who kneels before a female (identifiable as Eternity because of the circle she holds aloft) and their cloud-borne location argue for a *primo pensiero* for the Sala di Saturno ceiling. This identification is important because a *primo pensiero* in Ferri's hand strongly supports the argument that he was the designer as well as the executant of the frescoes in this room.

In the next drawing connected with the central panel, a male figure is carried aloft by two female figures [Fig. 126].[263] He is welcomed to the cloudy heights by a female figure who holds a crown in her extended left hand. In the lower left corner, there is a rougher, earlier study for the main protagonist and the two figures who support him. The fact that the lower left cornice angle has been sketched in for the main figure group on this sheet is informative. These two intersecting lines indicate that a rectangular frame had been established for the central fresco, evidence that the fresco composition was developed to this stage only after the stucco decorations had reached at least the stage documented in Cortona's detailed study now in Berlin [Fig. 120]. Furthermore, the introduction of even a partial cornice line documents what could only be surmised from Ferri's drawing for the frescoes discussed; namely, that at first a horizontal composition rather than the vertical one was planned. This situation is of some importance because, given the shape of the room, the diagonal movement of the chief protagonists in a horizontal composition would have drastically interrupted the room-to-room sequence of the action in the ceilings of the preceding rooms. As depicted in these drawings, the composition of the central fresco would have directed the action of the chief protagonists in this scene back upon the earlier ceilings. The two remaining drawings, one of which is in the Farnesina [Fig. 127], the other, an extremely faint sketch in a private collection, establish the vertical format of the actual fresco and carry the composition almost to its final arrangement.[264]

The lunettes, whose plaques were never inscribed but whose subjects are known from a description by Magalotti, reflect aspects of the final phase of rulership. Appropriately, these include, commencing with the northern wall toward the palace facade, Cyrus personally tending the plants in the royal garden [Fig. 128], Sulla enjoying the pleasure of the hunt [Fig. 129], Scipio embellishing his kingdom with architectural projects [Fig. 130], and, in a lunette scene from the life of Lycurgus [Fig. 131], the final phase of rulership is recorded in which the trust of the deceased king is honored and his younger brother places the rightful heir, the king's own son, on the throne.[265]

[262] Drawing Cat. No. 150.

[263] Drawing Cat. No. 148.

[264] Drawing Cat. Nos. 149 and 151.

[265] The literary sources for several of these scenes are unclear. Although the principal *vita* of Cyrus—Xenophon *Cyropaedia*—refers to the impe-rial gardens of the Persian King, there is no mention of the anecdote of Cyrus personally tending his garden (and in fact, as we shall see, Ferri at first planned to show Cyrus directing the installa-tion of a garden, a scene that could have evolved from mention of his extensive palace gardens). The

The preparatory studies that have been located all confirm Ciro Ferri's authorship of the lunettes as well as the central fresco of the vault. For the lunette depicting Cyrus tending his garden, two studies are known. The earliest of these drawings is a red chalk study now in the Uffizi [Fig. 132] in which Cyrus directs the installation of a palace garden. In the actual fresco, Cyrus sheds his padronal role and personally waters an orange tree in a large urn. His pose in the fresco derives from that of the laborer in the far left of the Uffizi drawing and occurs with little difference from the fresco, save for reversal, in the other preparatory study, which is too indistinct for illustration. Extremely close stylistically to the last named drawing is another in the same collection for the Scipio tondo, which differs from the final version only in the placement of secondary figures. Also, the condition of this drawing does not permit reproduction. Finally, there is a fine and very advanced study, squared for transfer, for the Sulla tondo [Fig. 133]. The fact that the preparatories for the lunette tondos, like those for the ceiling fresco, represent both early and developed stages in the compositions and are all by Ferri argues clearly for his authorship of the designs.[266]

For a description of the central fresco and the scenes in the ovals of the lunettes we can return to Magalotti's observations, here quoted in full:[267]

Just one new item. Sig. Ciro Ferri, the day of His Highness's birth [14 July] opened the camera di Saturno, that is the one behind the other of the Baldachin. The work received great applause and His Highness has demonstrated full satisfaction. It is entirely true that his rivals, who had no other attack in that of Apollo than to say that Sig. Ciro had brought cartoons made at Rome by Sig. Pietro, are much distressed by it. These [the cartoons for the Sala di Saturno] he has wished to make here, and everyone has been able to see for themselves. The arrangement of the paintings is most beautiful, and the magnificence of the stuccoes has turned out most sumptuously; so that without doubt this [room] for ornament of gold is the richest of the whole apartment. The paintings consist of a field of vast dimensions in the middle of the vault, two tondi at the ends [of the room], and two great ovals at the sides. In the [central] painting there is the continuation of the conceit expressed in all the other rooms. The hero, already grey-haired, is represented flying between Prudence and Valor to the breasts of Glory and Eternity, who is in the act of crowning him [Fig. 124]. Meanwhile Hercules remains on the ground, burning on Mount Etna, after having conducted him to heaven with his guidance. The figure of Hercules is placed on a funeral pyre in a marvelous position of foreshortening; and more marvelous is the flight with which Saturn is depicted bestowing the splendors of his star on the head of the hero, in whom, under the beard one recognizes the

Scipio lunette and the Sulla lunette are even more confounding. None of the Scipios were famous builders, and the presence of Sulla is truly surprising in view of his appalling reputation. Plutarch *Lives* (Life of Sulla, v) does mention his interest in hunting and combats involving wild beasts. Whereas the Scipio and Sulla lunettes raise ques-

tions of identification, the Lycurgus lunette is unproblematic (see Plutarch *Lycurgus* ii).

[266] This conclusion seems secure even though we have to date no preparatory drawings for the Lycurgus lunette. For the known drawings discussed above, see Drawing Cat. Nos. 153-156.

[267] Doc. Cat. No. 125.

mien of the same face, represented always the same, but at different ages in the rooms of the other planets. In the principal tondo [Fig. 130] there is Scipio in the act of considering the plan of a building, shown to him by an architect, which is the same as the magnificent architecture [under construction]. In looking opposite one sees an admirable nude who is raising a stone cut by him for the building. In the tondo opposite there is Cyrus in the act of watering an orange tree, with a view of a royal garden [Fig. 128]. The head of Cyrus is my favorite. One recognizes there the air of an oriental, the regal majesty, and also the taste and the application to the task of watering which he has undertaken. Because this tondo derives from a story sparse in figures, Sig. Ciro has found a method of enriching it by representing on the marble vase a sacrifice in chiaroscuro with several very graceful figures. In the oval opposite to the portal there is Sylla [Sulla] on horseback in the act of spearing a boar that flees the chase of two dogs, wounded in the flank by an arrow fired at it by a hunter who, together with others, one sees in the wood with [his] bow now discharged [Fig. 129]. In the other oval there is Lycurgus, who in a meeting of the senators puts on the throne the son born posthumously to the king, his brother [Fig. 131]. Again this is a group of three old men [on the left side of the fresco] that it would be hard to imagine more handsome. In sum, the universal conceit is stated, and it is that it is more to the glory of Sig. Pietro that there are these two rooms of Sig. Ciro, for if all of the apartment had been finished by his [Cortona's] hand, then one would see only his ideas, where now one sees what he did and that which he had thought to do, but which others have done so well. In essence, if one does not wish others [to be involved], then others are not able to paint for comparison.

Magalotti's letter is an important source of information about the Sala di Saturno and the relationship of this room to the earlier ones. Magalotti definitely states that this room continues the iconographic program of the earlier rooms in its portrayal of an individual whom he identifies as the hero in old age, at which time he experiences apotheosis and consequent immortality. This interpretation is, it should be noted, in accord with the two inscriptions that accompany the central fresco on the vault: TOT RERVM DISCRIMINA EMENSO GLORIA ATQVE AETERNITAS IVRE MERITO OCCVRRVNT (To one who has gone through so many vicissitudes of life [literally, vicissitudes of things], glory and eternal life come rightly and well deserved) and SIC ITVR AD ASTRA SIC LABORIOSAE IVVENTVTIS CORONA TRANQVILLA SENECTVS FRVITVR (Such is the way to the stars; thus tranquil age enjoys the crown of a toilsome youth).

The frescoes of the Sala di Saturno reflect an effort to conform stylistically with the earlier rooms. The figures throughout derive in type from Cortona's repertory. More bland in tonality than Cortona's frescoes, these are not infused with the richly coloristic chiaroscuro of his scenes. Considered together, the evolution of the stucco decorations and the frescoes reflects a growing conservatism on the part of Cortona and his colleague. According to our reconstruction, the ceiling stuccoes were initially conceived as an irregular enframement at the cornice line for a fully illusionistic *cielo*

aperto ceiling whose figural representations would most assuredly have been depicted *di sotto in su* [Fig. 118]. As in the Sala di Marte, here too the focal point of the central fresco (and concurrently the finale of the cycle) would have been deep in space at the center of the vault. In the later stages of the design, the central fresco was restricted to progressively smaller areas. The consideration of a polygonal, then a rectangular, frame marks the shift from a *di sotto in su* composition, compatible with the polygonal enclosure, to the more conservative *quadro riportato* implicit in the rectangular frame. The placement of the inscriptions reading *aria* in the first stucco study leaves little doubt that Cortona initially planned a vault of open sky even bolder in its *di sotto in su* illusionism than that of the Sala di Marte, where the frescoed portion of the ceiling had included a ground plane populated by figures at the cornice line.

The striking illusionism of the earliest drawing for the stuccoes is not reflected in the preparatories for the frescoes. In the case of the ceiling fresco, all of these studies present a modified *quadro riportato* composition set in a rectangular frame in which the figures are moderately foreshortened. In most of these studies, as in the executed fresco, a ground plane is included, and the composition follows the long-standing perspective system of modified *quadro riportato* that the sixteenth century decorators of the Doges' Palace—Veronese, Tintoretto, Titian, and others—had so effectively employed and with which Cortona had commenced the cycle in the Sala di Venere.

In the tondos, an emphasis on architectural settings, manifest in the use of steps and podia, is to be noted. Whereas Cortona had used architectural settings as mere foils for his figural action in the lunettes of the Sala di Venere, the tondi in the Sala di Saturno depend on architecture as an armature for the figures. The one scene lacking such an architectural quality, that of Sulla hunting [Fig. 129], is derived from a Hadrianic relief on the arch of Constantine [Fig. 182].

Close adherence to the *quadro riportato* tradition, compositions of a marked architectonic quality, the direct use of antique sources, and stucco ornament that consists in the main of pattern applied to static planes are stylistic characteristics of the Sala di Saturno. Of the earlier rooms, only the Sala di Apollo was nearly so un-Venetian in color and effect. A *post festum* reading of these indications is vulnerable to excessive overinterpretation, but when the art of Pompeo Batoni, Anton Raphael Mengs, or Gavin Hamilton is compared to these decorations, it seems justifiable to speak of Late Baroque classicizing qualities in both the ornamental stuccoes and the frescoes in the Sala di Saturno. Even if Magalotti's praise is excessive, the decorations of the Sala di Saturno do provide an adequate closure to the High Baroque planetary series, and, Janus-like, they give stylistic indications of the Late Baroque style.

The Sala di Saturno is the last of the five-planet series. As we have seen from our consultation of the palace inventories, it was a quasi-private room. Closed for public audiences that terminated in the throne room, the Sala di Giove, it served for secret audiences. According to the inventories, a baldachin of lesser grandeur than that used in the Sala di Giove was placed here. As attested by a drawing now in Berlin [Fig.

134], it was Ferri's intention to replace or enhance the baldachin with an aedicular structure.[268] From the roughly sketched indications that frame the portico-like structure, it appears that the throne was to be placed against a short wall in the room. The only possible choice, therefore, is the southern wall (the opposite short wall is punctured by the window of the facade) where, situated beneath the Scipio lunette [Fig. 116], its secondary hangings would have coincided with the breaks in the corners of the massive cornice above. In this position, the aedicular structure—which does not appear to have been realized—would have broken the direction of the spectator's sequential movement through the rooms, turning him at right angles to the axis along which he had progressed through the series and placing him in proper alignment to view the apotheosis in the ceiling overhead.[269] It should be recalled that Magalotti had distinguished the scene dedicated to Scipio as the *tondo principale*.

THE PROGRAM OF THE PLANETARY ROOMS: A RECAPITULATION

The program of the Planetary Rooms has not survived in written form, or at least it has not been found. What we know about it is scant indeed. There is no serious doubt that, as we have already noted, the program was prepared by Francesco Rondinelli, and there is no evidence that it was ever published. These circumstances suggest that no very great value was placed on the written program, that the spectator was to be sufficiently informed of the content of the frescoes by "reading" them aided only by the inscriptions planned in the decorative ensemble. The frescoes bear out such an interpretation of the program, for they are without the encyclopedic references to literary themes or to historical situations that are present in many cycles. When viewed as an ensemble, the vault scenes and the lunettes seem to be the representation of a rather loosely stated program in which references to scenes from specific sources are made, but the individual scenes are not supported by elaborate descriptions. Possibly little more was included in these references in the written program than the brief, hortatory inscriptions that accompany or were intended to accompany many but not all of the frescoes. If the program had been fully and explicitly written out, it is unlikely that changes such as the relocation from sky to ground as recorded in the preparatory drawings for the central fresco in the Sala di Venere would have occurred. In the Sala di Apollo, preparatory drawings record major changes in personnel. For example, aged wind gods are removed in favor of youthful nymphs. In the Sala di Giove, we noted that many secondary figures carry no attributes whatsoever, and even several of the major allegorical figures can only be given generalized appellations. More to the point, the earliest composition studies for the ceiling of the Sala di Saturno leave strong doubt

[268] Drawing Cat. No. 157.

[269] The first preserved inventory of the palace (1687) following the completion of the decorations in the Sala di Saturno lists a baldachin-type throne furnishing which does not conform to the drawing (Florence, A.S.F., Guardaroba Medicea, 932, c. 73 verso).

as to whether Hercules expiring on Mount Ida was present in the initial stages of the design of this fresco or whether he was introduced—as seems to have been the case— late in the development of the composition when a *quadro riportato* format was decided upon. A survey of the preparatory studies for the stucco decorations further supports our argument for a somewhat imprecise program, for in several instances (as we have noted earlier) the drawings provided no spaces, or drastically reduced spaces, for subsidiary scenes included in the final designs. These examples suggest that the text was of sufficiently epigramatic character as to preclude detailed descriptions.

Archival researches have failed to unearth Rondinelli's program for the Planetary Rooms. Another program also in the form of a poem (*soggetto di poesie* Cortona had called Rondinelli's) for an allegorical *stemma* of the Casa Medici has been found, however, which presents a few parallels to the program of the Planetary Rooms. The program for the *stemma*, devised by Giovanni Rimbaldesi in 1663, is based on a *concetto* in which the five *palle* of the Medici *stemma* are interpreted as the planet Jupiter and its four satellites, the Stellae Mediceae, discovered and named by Galileo. According to Rimbaldesi's invention, the four satellites also represent the four Cardinal Virtues, and in turn each of these virtues is associated with one of the four Grand Dukes who reigned before Ferdinand II, all of whom are gathered around Jupiter, who is identified with the reigning Grand Duke. This emblem is then completed by having each of Ferdinand's predecessors bestow an attribute of his particular Virtue upon the Prince of Tuscany, Cosimo III, heir apparent to the grand-ducal throne.[270] Rimbaldesi specified

[270] L'invenzione dello Scudo sta appoggiata sopra le quattro Stelle Medicee, Compagne di Giove (come le chiamano li moderni Mattematici) nelle quale figurandosi le quattro virtù cardinali: Prudenza, Giustizia, Fortezza e Temperanza rappresentate ne' primi 4 Ser.mi Antecessori del nostro Ser.mo Ferdinando 2.do s'invitano ad instruire et ammaestrare il Ser.mo Gran Principe nel governo, al quale si va disponendo.

Questo Scudo conterrà due parte, una superiore, e l'altra inferiore. Nella superiore verranno rappresentati li S. Ser.mi G. Duchi stati sin hoggi.

In mezzo sarà situato il Ser.mo Ferdinando 2.do hoggi regnante, come Giove in mezzo delli suoi quattro compagni, o stipatori con questo titolo, o altro simile:

Medicei Jovis Sydus Ferdinandus 2dus

Dalla mano destra nel primo luogo apparirà Cosimo Primo rappresentante uno de' compagni di Giove. Il titolo sarà Comes primus Cosimi primi prudentia.

A lato di questo verso Ferdinando 2.do sarà Francesco p.mo rappresentante un altro de' Compagni di Giove. Il titolo sarà

Comes Secundus Justitia Fran.ci Primi

Dalla parte sinistra a lato a Giove sarà Ferdinando primo rappresentante il 3.o de' Compagni

di Giove. Il titolo sarà

Comes Tertius Ferdinandi Primi Fortitudo

Dalla medesime parte all'ultimo luogo sarà Cosimo 2.do rappresentante la 4.a stella ex Jovis Comitibus. Il titolo sarà

Comes Quartus Cosimi 2.di Temperantia

Al basso nella 2.da parte dello Scudo vi sarà il Ser.mo G. Principe Cosimo 3.o in mezzo delle quattro virtù, che tutte l'inviteranno a sè, con offerirle ciascuna qualche simbolo della virtù che rappresenta. Il titolo sarà:

Magnum Jovis Incrementum Cosimus 3.s

Verso del medesimo da tutti li quattro serenissimi Gran Duchi antecessori saranno pure inviati al medesimo Gran Principe diversi altri simboli delle virtù, che rappresentano, et in particulare da Ferdinando 2.o regnante Suo Ser.mo Principe rappresentante Giove li saranno inviati lo scettro, la corona, la clamide e portate dall' aquila, putti volanti, e simili etc.

Il Titolo universale del libretto nel quale saranno stampate diverse ode in lode di tutti li personaggi soprad.tti, da cantarsi anco nella musica, sarà l'appresso:

Medicei Jovis Comitatus / Seu / De quattuor Virtutibus Cardinalibus / In quatuor Medicaeis

that Ciro Ferri should carry out the design and confer on its form with Pietro da Cortona, and this appears to have been done [Fig. 183].

A poem of this type, devoted to the planetary system in general rather than solely to Jupiter and its satellites and enriched with brief references to the allegorical figures encountered in the vaults and the historical-mythological allusions found in the lunettes, could easily explain the program of the cycle. Such an arrangement would have accounted for the lack of single sources for the lunette scenes that come from varied texts and, in the Sala di Giove, do not seem to have been derived from any specific literary source. With this sketchy program reconstruction before us, let us return to the decorations and to the problem of their dedication.

To look at the vaults of the Planetary Rooms as an ensemble is to realize that they constitute a series of *exempla* for the ideal ruler. Taken together, they constitute a *de regimine principum* but of a very different sort from the manuals related to Machiavelli's *The Prince* or the educational manuals produced for the instruction of princes.[271] In Rondinelli's program we are presented with the awarding of the qualities of rulership by divine bestowal, not, it should be noted, by a Christian deity, but rather from a panoply of pagan ones. This attitude toward divine bestowal of the qualities and attributes of rulership makes this cycle, in a limited way, a paganized version of Dante's *De Monarchia*,[272] in which the Tuscan poet set out to defend the Divine Right of Kings as power bestowed directly by God, not delegated through papal authority, a political concept that must have had adherents in the Medici court.

In the planetary cycle, bestowal of the virtues of rulership occurs in a sequential order. This sequence is evolutionary in character, for as the prince matures from childhood to youth, he ascends from a land-based Venus to a sky-borne Apollo. In the Sala di Marte, the prince is once more on earth, but Mars has descended from the high heavens to aid him. In the Sala di Giove, we find the prince before enthroned Jupiter and high among the clouds once more. Finally the Sala di Saturno returns him to earth

Syderibus / Jovis Comitibus adumbratis / Quibus Sereniss.a Mediceorum Prosapia / Ad prenobilem Etruria Principatum / Hoc est / Ad duodecim olim Regnorum Imperium / est evecta.

Per sostrato di tutta questa comitiva sarà un cielo stellato, che rappresentarà la stella di Giove, e delle quattro sue compagne, ciascheduna delle quali verrà a cadere sopra la testa di quello, dal quale verrà rappresentata. Le figure esprimeranno al naturale il personaggio, che rappresentano con simboli della virtù, che figurano.

Il disegno sarà fatto dal Sig. Ciro, che lo conferirà col Sig. Pietro da Cortona; per l'intaglio o da Monsù Spier solo, o unitamente col Brumarti per spedirlo più presto.

(Florence, A.S.F., Miscellanea Medicea, F. 3, ins. III, Fol. 61.) Note: "Monsù Spier" and "Brumarti" are the engravers F. Spierre and A. Bloemart, who were employed in the execution of the Rubeis edition of the engravings of the frescoes in the Sala di Venere, the Sala di Marte and the Sala di Giove. The panegyric poem was published in Rome under the title *Iovis Mediceae* . . . in 1664.

[271] These manuals are of importance not only for the history of education for rulership but for general education as well and have therefore received considerable scholarly attention. But these studies shed no light on the allegorical processes in the Planetary Rooms.

[272] First published by Andrea Alciati at Basel, 1559. See Dante Alighieri, *Monarchia*, critical ed., P. G. Ricci, Milan, 1965.

again, but the apotheosis depicted implies a final ascent to ultimate heights. The concept of the ascent and, for that matter, the linear progress of the spectator are both traditional *concetti* for describing the moral or intellectual enlightenment of an individual. The *locus classicus* of the *concetto* in post-classical literature is Dante's *Divine Comedy* in which the author's heavenly ascent carries him through the spheres in accord with the Ptolemaic cosmology, beginning with the moon and ascending to Saturno, the final staging for passage to the empyrean. As Walter Vitzthum has noted, this Dantesque cosmological structure can be related to the Medicean court via Vasari's projected decorations for the dome of the Cathedral of Florence, whose program was prepared by Vincenzo Borghini, Cosimo I's court iconographer.[273]

At the initiation of the planetary cycle, in the Sala di Venere, the prince is snatched by Minerva from the pleasures of Vice personified by Venus and presented with an appropriate mentor, Hercules. The inference that this transaction is accomplished without any exercise of will on the part of the young prince is clear from the representation, for, if anything, his is an unwilling participation. His is a choice between Virtue and Vice shorn of the cognitive efforts endured by Hercules of the Crossroads. The traditional example for Hercules as a companion and guide is of course that of his participation in the search for the Golden Fleece. Hercules's relation to the prince has parallels with his participation in the adventures of Jason and the Argonauts, but this is not apparent in the first ceiling in the cycle until we recall that in the Jason myth it was Hercules who roused the Argonauts from their pleasure-taking with the husband-less women of Lemnos by beating upon the doors of the houses of Aryrine with his club and summoning his comrades back to duty by force. In the Sala di Venere, the reinforcement of the central theme of continence is provided by the lunette scenes, which record, as we have seen, the manifold forms of continence as displayed by great leaders of the past. Between the lunettes on the pendentives of the vault appear portraits of the famous Popes and Grand Dukes of the Medici house, including the heir apparent, Grand Prince Cosimo (later Cosimo III). With the obvious exception of the reigning Grand Duke and his young son, these portraits constitute a gallery of famous ancestors similar to the sculpture portraits in the Salone dei Cinquecento in the Palazzo Vecchio, where Popes Leo X and Clement VII, Grand Dukes Cosimo I and Francesco, Duke Alessandro and Cosimo I's father, Giovanni delle Bande Nere, appear as part of the decorations of the *udienza*.

In the Sala di Apollo, the young prince is instructed by the Sun God, and Hercules supports the celestial globe. The four lunettes connect great rulers with the benefits of education. In the next room, the Sala di Marte, the mature prince, aided by Mars and encouraged by Hercules, is shown defeating his enemies and tempering his victory

[273] Vitzthum, *Cortona a Palazzo Pitti*, 5. The actual connection between Vasari's decorations and the Planetary Rooms is slight. (Cf. P. Barocchi, *Vasari pittore*, Milan, 1964, 73ff., for a review of the dome decorations based on surviving preparatory studies. For a schematic outline of the program, see G. Milanesi, *Vasari opere*, Florence, 1883, VIII, 224f.)

with clemency and mercy for the defeated. Virtue is rewarded in the Sala di Giove, and the prince, now in his full maturity, is ushered before the ruler of Olympus by Fortune, who serves to reinforce the importance of divine ordination and the now familiar guide, Hercules. In a half-circle, the honors to be bestowed upon him are assembled as allegories, and in a pendant half-circle his deeds as a heroic leader are indicated by the captured trophies, the prisoners, and the war-scarred galleys, the latter a reprise—as first noted by Fabbrini—of the Argonaut theme.[274]

The themes of virtue rewarded and honored obviously link this room with the iconography of the preceding rooms. In the Sala di Venere, we witnessed the divinely induced victory of Virtue over Vice. The next two rooms demonstrated the two aspects of the virtuous life, for, according to antique writers and the Renaissance neo-Platonists, the prince would have had three alternative modes of life conduct open to him: the *vita contemplativa*, the *vita activa* and, in contrast to these two *vitae*, the *vita voluptuosa*.[275] The elimination of the latter in the Sala di Venere permits the prince to participate in both of the other two. The next room of the series, dedicated to Apollo, clearly represents the contemplative life, and that of Mars, of course, celebrates the active life, both as aspects of rulership and as stages in the education and maturation of the prince. The Sala di Giove was, as we have noted, the throne room and for most visitors the culmination of the series.

The Sala di Saturno must be regarded as a coda to the sequence, for it served, we recall, as a private audience and council chamber. Completed late in Ferdinand's reign, the ceiling celebrates the apotheosis of the virtuous prince, whose progress was recorded in the preceding rooms. In the same fresco, his constant companion Hercules is depicted upon his funeral pyre on Mt. Ida. Appropriately, the theme of three of the lunette scenes reflects events in the lives of rulers who are in the closing years of their distinguished careers, and one refers to the passage of the throne of the deceased ruler to his rightful heir. Thus, the full cycle of the divine right of monarchs is spread upon the ceilings of the Planetary Rooms, its message reinforced by historical *exempla* provided by the lunettes in several of the rooms.

Furnishings in the Planetary Rooms alluded to rulership or to the civic glory of Florence. These include paintings of *David with the Head of Goliath*, *Judith with the Head of Holofernes*, and the tapestries that in the Sala di Venere and the Sala di Apollo celebrate the Life of St. John the Baptist and in the Sala di Marte depict scenes from the Life of Moses, leader of the Israelites, whom, we may recall, Rondinelli had previously used as the ideal ruler in the grotto of the Cortile Grande. In the last room of

[274] Fabbrini, *Vita*, 82.

[275] *Mythologiae* II. 1 (De Judicio Paridis): "Philosophi tripartitam humanitatis voluerunt esse vitam, ex quibus primam theoreticam, secundam practicam, tertiam philargicam voluere: quas nos Latine contemplativam, activam, voluptariam nun-cupamus" Similar definitions are found in *Mythographus Secundus* 206 (G. H. Bode, *Scriptores Rerum Mythicarum Latini Tres*, Celle, 1834, I, 144), and *Mythographus Tertius* II. 22 (*ibid.*, 241). Cf. also Panofsky, *Hercules*, 59f., and *Marsilii Ficini Florentini . . . opera*, Basel, 1576, 919f.

the series, the Sala di Saturno, the tapestries memorialized the founder of the grand-ducal Medici dynasty, Cosimo I.

The Cosimo I tapestries open an area of speculation that has not been—and perhaps cannot be—fully answered; namely, to whom are the ceilings dedicated? Indeed, if the seven-room theory had been more supportable, the consequent inclusion of birth and infancy of the prince would have suggested parallels with the great Baroque allegorical-biographical cycle created by Rubens for Maria de' Medici, in which her life is illustrated in epic fashion. This is not the case, however, and the theory that Rondinelli's program "may be regarded as a kind of astro-mythological calendar to the life and accomplishments of Cosimo I" is one of fairly modern invention. None of the admittedly scarce contemporary notices yields any such interpretation; the theory first emerges in Inghirami's guidebook published in the early nineteenth century.[276] Late in the same century Fabbrini refuted it, arguing that the life of Cosimo I had already been portrayed in the Palazzo Vecchio and that it would have been of little value to repeat it.[277] In contrast, Fabbrini adhered to the contemporary descriptions of the cycle and regarded it as an allegorical presentation of the virtues requisite to the various stages of the life of a prince if he wishes to achieve fame and immortality.[278]

The evidence of a connection with Cosimo I is slight. He is present among the Medici portraits in the Sala di Venere, but so are seven other prominent members of the Medici house, and his portrait is in no way given special emphasis. The lusty blond youth snatched from the couch of Venus bears little physiognomic similarity to him. True, of all the grand dukes, only in Cosimo I's career are there martial exploits that closely parallel those described on the ceiling of the Sala di Marte. The decorations could be interpreted to allude to the conquest of the city state of Siena and to the activities of the seafaring Order of Santo Stefano, but there are no elements in the scenes that provide specific points of reference to these events. The most convincing allusion to the iconography of Cosimo, however, is the use of Hercules, who frequently appeared as Cosimo's *emblema*, as the guide and mentor of the prince. From the Sala di Apollo decorations, we may adduce several potential references to Cosimo I. The first grand duke was born on June 12 under the zodiac sign of the Gemini and the protection of the planetary deity to whom this room is dedicated. Furthermore, Capricorn is displayed on the astrological globe supported by Hercules. Cosimo frequently used Capricorn as his *impresa* (but never, to the knowledge of this writer, Gemini) because it had been the astrological sign of Augustus Caesar and also that of the reigning German Emperor, Charles V. Also, the lunette depicting a scene from the life of Augustus is prominently placed on the eastern wall of the room in direct line with the passage of the spectator to the next room in the series, the Sala di Marte. Immedi-

[276] Inghirami, *Descrizione*, 21. The hypothesis has received continued support (cf. Wittkower, *Art and Architecture*, 166f. and quoted above).

[277] Fabbrini, *Vita*, 67, especially n. 44.
[278] *Ibid.*

ately above this lunette appears a cautionary epitaph, part of which, MEDIO TVTISSIMVS IBIS, is the advice Apollo gave his son Phaeton before his ill-fated ride in the sun god's chariot. This motto is also associated with the iconography of Augustus, and its strategic location together with the lunette may be interpreted as giving Augustus special weight in the decorative ensemble and, by indirect reference, thereby paying honor to Cosimo I. At the same time, however, the hortatory form of this motto, like many of the other mottoes, better serves to admonish a living prince than to glorify a deceased one. Finally, as we have noted, the tapestries in the last room of the series were devoted to the *Fasti di Cosimo*, which would seem to support a connection between the fresco cycle and the first grand duke.

Several points can be made against specific association of the cycle with Grand Duke Cosimo. Taken as a group, the ceiling cycle bears a minimal resemblance to the career of Cosimo. As for the presence of Hercules, it should be recalled that several Medici grand dukes made emblematic use of the demigod, and furthermore Hercules had served as a Florentine protector long before the Medici rose to power. In fact, Hercules enjoys such common currency as the protector, patron, or emblem of so many kings and princes that his presence is scarcely conclusive evidence of an intended relation between Cosimo and the ceiling cycle under consideration. The Sala di Apollo does contain motifs associable with Cosimo I, but they are all appropriate to the planetary deity, and they are not repeated in the other rooms. Probably the most salient link with Grand Duke Cosimo I is provided by the presence of tapestries portraying significant events in his reign on the walls of the Sala di Saturno. But even here, the validity of such a specific connection is open to question, for on what basis do we justify a relation between frescoed ceiling and tapestried wall? The ceilings present a progression, self-contained and self-sufficient from the opening in the Sala di Venere to the climax in the Sala di Saturno. Even the lunettes are autonomous, for they depict themes that parallel but do not directly impinge upon the dramatic events in the ceilings. It is more likely, then, that the Cosimo tapestries bear an indirect relation to the ceilings as is the case with the St. John the Baptist and the Moses tapestries.[279] The tapestries devoted to Cosimo are to be interpreted in a similar manner and not as any literal extension of the ceiling narrative or a revelation of its chief protagonist's identity.[280] Furthermore, if the tapestries in the Sala di Saturno link the planetary cycle with the first grand duke, then it is difficult to surmise why Cortona would have considered incorporating in the stucco decorations of that room an *impresa* that has no special reference to Cosimo I and was in fact devised for Lorenzo the Magnificent. The crest

[279] One of the latter presents Andrea del Sarto's portrayal of the Life of St. John the Baptist, who is the primary patron saint of Florence. Juxtaposed with this New Testament hero, another tapestry ensemble is devoted to the Old Testament hero and leader of his people, Moses. The other tapestry group, the Seasons, does not appear to provide any direct thematic enhancement of the ceilings.

[280] Also, the Sala di Saturno was used for private audiences and hence the usefulness of the Cosimo tapestries as a key to the decorations would necessarily have been limited and scarcely sufficient to popularize their connection.

in question, a diamond ring (derived from the three-ring crest of Cosimo Pater Patriae) superimposed on three feathers signifying Faith, Hope, and Charity,[281] appears in a study for a stucco cartouche and in a preparatory study for the ceiling stuccoes of the Sala di Saturno [Fig. 120].[282] Nothing in the planetary cycle suggests that it can be associated with Lorenzo, and in all probability the intention was to use it simply as a Medicean symbol, for, as Paolo Giovio points out, the crest, though created for Lorenzo, "was assumed by all successors of the house."[283] There are, however, alternative personages who must be considered.

We may note, for example, that Ferdinand II took Gemini (his ascendant constellation) as his astrological sign.[284] The Gemini, that is to say Castor and Pollux, the Dioscuri twins, are prominently featured in two of the rooms. In the Sala di Marte it is they who bring helmet and sword to the young prince, and in the Sala di Giove they appear twice, once as infants in the sky above Jupiter and again in one of the lunettes. When the frescoes Cortona painted in the mezzanine rooms of the Pitti Palace for Cardinal Giovanni Carlo are considered in this context, it is clear that neither the warrior twins nor the ship in the Sala di Marte were casually included in the decorations, for they are repeated in the main room of the mezzanine suite [Fig. 184].[285] The fact that the Cardinal chose two *imprese* that also appear as motifs in the Sala di Marte suggests that he wanted his room—and himself—to be associated with the Planetary Rooms and with their commissioner, his older brother. The presence of the Dioscuri in the Cardinal's room argues for a strong connection because both men used this zodiacal sign under which the Cardinal was born (June 3) as an *impresa*.[286]

However, when we search for scenes alluding to Ferdinand's career, it is difficult to establish concrete links. For one thing, Ferdinand was at the threshold of his career when the cycle was initiated, and the likelihood of connections with actual events or even prognostications is scarcely convincing. The Sala di Marte could be construed to be an allusion to the War of Castro, but in truth it appears to be a more generalized response to Cortona's ceiling in the Salone of the Barberini Palace. Only in the Sala di Saturno is it possible to suggest connections. For this room, executed late in the reign of the commissioner of the planetary cycle, Rondinelli had, it will be recalled, sent a program to Rome at the close of negotiations with Ciro Ferri, and thus it is possible that the program was revised to suit the circumstances and time of the completion of the cycle. It would seem, therefore, no accident that the final room in the cycle was unveiled on Grand Duke Ferdinand's birthday or that an effort had been made in the

[281] Cf. Giovio, *Dialogo*, 47f.

[282] Drawing Cat. Nos. 144 and 146.

[283] Giovio, *Dialogo*, 47ff.

[284] Florence, A.S.F., Guardaroba Medicea, F. 958, c. 116. This *filza* is a manuscript of all the *imprese* of the Medici and was prepared by Alessandro Segni in 1685 and presented to Grand Principe Ferdinando.

[285] M. Chiarini and K. Noehles, "Pietro da Cortona a Palazzo Pitti: un episodio ritrovato," *Bollettino d'arte*, LII, Oct.-Dec. 1967, 233ff. The reader is referred to this important publication for further details and illustrations.

[286] See Florence, A.S.F., Guardaroba Medicea, F. 958, c. 1100 for the association of Gemini with Cardinal Giovanni Carlo.

lunettes to refer via recondite events to the seniority of the ruler in terms at least vaguely applicable to Ferdinand. Thus Cyrus tending his gardens would be a reference to Ferdinand's completion of an aqueduct—the Acqua Ferdinanda—to the Boboli Gardens; Scipio overseeing a building project, an allusion to the expansion of the Pitti Palace; Sulla depicted at the hunt, an allusion to Ferdinand's fondness for the chase (as discussed in Appendix I, Ferri was delayed from finishing the lunette because the Grand Duke was afield with the fiercest hunting dogs he wished to use as models); and the theme of the Lycurgus lunette perfectly suits the situation at hand: Ferdinand, who was fifty-five when the cycle was completed, had two brothers still living, and his son Cosimo was just twenty-three years old.

The selection of scenes in these lunettes may reflect aspects of the reign of Ferdinand II, at least as he must have believed it to have been and as his courtiers would have publicly described it. All of these scenes are appropriate to the neo-Platonic conception of the planetary deity to whom the last room in the cycle is dedicated.[287] Neo-Platonism stressed the positive aspects of Saturn and also Mars, both of whom had previously been generally considered to be astrologically evil forces. In neo-Platonic thought, Platonic concepts and Aristotelian ideas were fused. The Platonic hierarchy of metaphysical principles according to which the genitor took precedence over the generated (a doctrine that gave Saturn as the "father of the gods" special importance) was linked with Aristotelian topological thinking that gave greater metaphysical value to that which occupied a higher position in space (Saturn, farthest planet from the earth, the center of the Ptolemaic cosmology, again gains in importance). In neo-Platonic thought, Saturn, in keeping with his now exalted position in the pantheon of the gods, is to be interpreted as the symbol of the intellect, as the benign ruler of the Golden Age, the inventor of agriculture, builder of cities and the keeper of wealth. The role of Saturn as ruler of the Golden Age deserves further attention; however, before pursuing this subject, another motif that connects the Planetary Rooms with their commissioner and subsequently with his son, Cosimo III, must be considered.

As noted above, it is peculiar that Cosimo I's portrait in the Sala di Venere was given no special emphasis if the cycle of decorations had been intended to celebrate his reign. In point of fact, none of the portraits in question is given any truly signal distinction; however, the portrait group of Ferdinand II and his son, the future Cosimo III, are slightly emphasized by position and gesture. Situated on the easterly wall of the Sala di Venere, the reigning Grand Duke and his heir apparent were on axis with the seventeenth-century visitor's line of vision as he progressed toward the Sala di Apollo. Both of these personages deserve special attention in the present context.

The position of Ferdinand II at this focal point would have prepared the spectator for confrontation with the Grand Duke in the flesh enthroned against the easterly wall of the Sala di Giove. Furthermore, special references are made to Ferdinand in the

[287] For a consideration of the evolution of the attributes of Saturn, see R. Klibansky, E. Panofsky and F. Saxl, *Saturn and Melancholy*, London, 1964, especially "Kronos-Saturn in Neoplatonism," 151ff.

room and potential references appear in other rooms. Ferdinand's emblem, a cluster of roses, decorates the underside of the window lintels in the Sala di Venere. The emblems accompanying the other portraits appear only adjacent to their respective portraits.

The most convincing evidence that the Planetary Rooms allude to the Grand Duke, however, is provided by the Medici *stemma*, which floats heavenward in the ceiling of the Sala di Marte. On the inner rim of the grand-ducal crown of the *stemma* there is inscribed the name of the ruling Grand Duke [Fig. 90] and commissioner of the cycle. His name on the *stemma* definitely tends to particularize what had at first appeared to be a generalized apotheosis of the Casa Medici. Yet the sum of these allusions is scarcely convincing. The ceilings do not present the *vita* of Ferdinand II any more than they provide literal commentary on the life of Cosimo I. One more figure remains to be considered: Cosimo, the young son of Ferdinand II, Prince of Tuscany and heir apparent to its throne, the history of whose reign was still a *tabula rasa*.

In the Sala di Venere, Cosimo's portrait, along with that of his father, is given some slight emphasis due to its location in the wall adjacent to the Sala di Apollo [Fig. 25]. At first glance, it is Ferdinand, dressed in regal armor and clutching a baton, who appears to be the unqualifiedly dominant figure. In contrast, the young Cosimo is pressed against the lower curve of the frame from which point he leans out more with curiosity than royal dignity, one hand braced against the laurel band of the frame, the other clutching his father's cloak. Although he is bareheaded as are all the other portrait figures (except for the two Popes, who wear the close-fitting *zucchetto*), a plumed helmet firmly grasped by his father is held immediately above the Prince's head. The grand-ducal helmet is a cogent reminder that the grand-ducal crown also hovers above the head of the heir apparent. The attention given to the youthful Cosimo is modest, emphatic, and sufficient to give special place to the young Grand Prince of Tuscany and future Grand Duke, here presented—together with the once and living grand dukes and the great ecclesiastics of the family—to the populace gathered in the first room. In a sense, this presentation is repeated less emphatically among the past grand dukes too, for each tondo contains a father with his eldest son.

All of those portrayed in the stucco tondi share the glories of the youthful prince whose exploits begin in the frescoed vault above—none, however, to a greater degree than the young Cosimo whose reign lies in future time. For him, the ceiling can be read as a prediction rather than a record. Still a *bambino*, it is with the next major phase in his life that the ceiling cycle commences directly overhead. Of all the members of the dynasty gathered in the tondi, it is for him that the ceiling epitaph first legible to the spectator has vital significance: ADOLESCENTIAM PALLAS A VENERE AVELLIT. For him alone the career that arcs the heavens in the ceilings of the Planetary Rooms provides a model for emulation. The hortatory voice of many of the inscriptions is especially appropriate if they are considered to be addressed to the young heir to the Grand Duchy. For example, the admonition of Apollo to his son Phaeton, EN IMITARE SOLEM MEDIO TVTISSIMVS IBIS, is, in the Sala di Apollo,

inscribed on a cartouche in close physical proximity to the depiction of Apollo instructing the young prince in the ceiling fresco. The ceilings honor their commissioner, Grand Duke Ferdinand; his emblems occur in the stuccoes, and his name is inscribed on the grand-ducal crown that surmounts the ascending Medici escutcheon in the Sala di Marte, but its message is directed to Cosimo III and the future scions of the Medici house. Thus the central significance of the ceiling program and that of Rimbaldesi's poem, which may have been patterned after it, are, though not identical, very close in content.

The ceiling decorations were started in the summer or early fall of 1641, almost a year before Vittoria della Rovere gave birth to Cosimo III,[288] and as noted elsewhere, it is very likely the portraits discussed above were installed several years after the completion of the rest of the decorations in the Sala di Venere. The conclusion we must draw from this fact is that the cycle was planned from the first in the hopes of an heir, that this preoccupation that played such a magistral role in the program of the Sala della Stufa in 1637 still applied in 1641. We may conclude that the youth at the foot of the oak who promises the return of the Golden Age and the slightly older youth so bruskly ushered from Venus's bed and bower are one and the same. Both are the fruit, promised though not yet realized, of the Medici-Rovere union.

The program of the Planetary Rooms was probably planned for Vittoria's first child, who was born on December 20, 1639, but lived for only a few hours. He too was named Cosimo. The unusual reuse of this name for the third child born to the grand-ducal couple suggests that the iconography of the first born was, in a manner of speaking, inherited by the younger, but first surviving son.[289] The bestowal of the same name on the two brothers also reflects a desire on the part of the Medici to stress dynastic continuity. The name Cosimo with its obvious associations with Cosimo Pater Patriae (1389-1464), founder of the elder branch of the family, Cosimo I (1519-1574), founder of the grand-ducal branch of the family, and with Cosimo II (1590-1620), father of Ferdinand II, was the most "Medicean" name available.

As early as 1637 Buonarroti's intention to make his Four Ages an epithalamium to the much desired fertility of Vittoria della Rovere must have been common knowledge to the poet's circle of friends, which included Francesco Rondinelli.[290] It is therefore not surprising that, when Rondinelli reinherited the incomplete program for the Salone Terreno, he co-ordinated it with that evolving in the Sala della Stufa. Whereas Mannozzi had planned to close the narrative on the walls of that room with a scene symbolizing the Return of the Golden Age in Tuscany and to link this event with an allegory of the Medici-Rovere marriage in the ceiling, Rondinelli, in the revised program, devoted all of the wall frescoes to the life of Lorenzo and concluded with an Allegory

[288] Cosimo III was born 14 August 1642.

[289] The second child (31 May 1641), an unnamed daughter, died at birth.

[290] The considerable correspondence of Buonarroti to Rondinelli and the poems dedicated to the latter by him now deposited in the Biblioteca Marucelliana attest to a close or at least cordial relation.

154

of the Death of Lorenzo the Magnificent, which, as we have seen, links his death with the *end* of the Golden Age and the coming of a new, destructive Age of Iron. In the new program, the Marriage Allegory, located above the cycle dedicated to Lorenzo, signals the commencement of a new era, and we move thematically from the marriage to the Sala della Stufa, where the Four Ages, when read counterclockwise, appropriately celebrate the marriage with an epithalamium promising a new Golden Age with the birth of a Medici-Rovere heir. In the Sala della Stufa, the birth that will signal the Return of the Golden Age is presented beneath a ceiling honoring the virtues of great warrior-emperors, an association that in turn adumbrates the *concetto* of the decorations in the Sala di Venere, the Sala di Apollo, and the Sala di Saturno, where, however, the frescoes depicting the exploits of the young prince occupy the central area of the vaults and his ancient prototypes will be reversed. The relationship of these themes in the Sala della Stufa was in large measure fortuitous because Rosselli's ceiling decorations antedate the Four Ages, but it may have given Rondinelli the inspiration for the incorporation of *exemplum virtutis ab antiquis* in the planetary cycle.

When the artist who had executed the Sala della Stufa was selected to undertake the decoration of the public rooms of the *piano nobile*, Rondinelli must have seen the possibility of developing a program that would continue the epithalamic theme of the Four Ages and illustrate the history of an ideal prince endowed with the attributes of a virtuous ruler by divine will and, at the same time, celebrate the promised but not achieved progeny of the Medici-Rovere union. Thus the male heir to the Grand Duchy heralded in the blond youth seated beneath the oak in the *Age of Gold* is he whose future is predicted in the succession of ceilings that comprises the Planetary Rooms. By the time Cortona commenced work on the Sala di Venere in 1641, Vittoria had suffered two unsuccessful pregnancies. What had begun as a subtle and humorous epithalamium in the counterreading of the Four Ages must have become an *idée fixe* in the court by the time the Sala di Venere was started. A few months later the *concetto* of the barely initiated Planetary Rooms and that of the Virgilian Return of the Golden Age in the Sala della Stufa were given promise of possible fulfillment by the Grand Duchess's pregnancy. On August 14, 1642, the future Cosimo III was born. Only then could Rondinelli resolve the portraits and mottoes destined for the easterly wall of the room. When the portraits were installed, that of Cosimo III was accompanied by an escutcheon with symbols of plenitude, a sheaf of wheat and a cornucopia, and an especially appropriate motto: FRVCTVS VICTORIAE FELICITAS (The Fruit of Victory [that is to say, Vittoria] is Happiness). The motto, coined for the occasion by Rondinelli, could scarcely have been more apt. It was through Grand Principe Cosimo that the allegories of the Salone Terreno, the Sala della Stufa, and the Planetary Rooms were to have been fulfilled in the immediate future.

The principal association of the cycle with Prince Cosimo stems from the fact that he, still a youth, can most fully profit from its usefulness as an instrument of instruction. The *Age of Gold* heralded Cosimo's birth, and if we can identify the youth

155

seated beneath the oak tree in that fresco as the same, though older, youth who is wrested from the couch of Venus in the Sala di Venere, then both the Return of the Golden Age theme in the Sala della Stufa and the planetary cycle program are addressed to the Grand Prince and constitute an integrated series. The youth depicted in the *Age of Gold* enters the planetary cycle as an adolescent, the age when, according to cosmological tradition, an individual is under the influence of the planet Venus. Thereafter, the hero of the planetary cycle moves successively through the series, passing under the influence of the particular planet associated with his advancing physical age.[291] In a very real sense, the *Age of Gold* adumbrates the state of the young Cosimo as he appears in his stucco portrait in the Sala di Venere and in the ceiling fresco of that room, and the successive ceilings of the planetary cycle predict his future, without, however, illustrating his horoscope.[292] Prince Cosimo would nonetheless have seen himself reflected in the ceilings. Such an association may even account for his use in maturity of an *impresa* consisting of the club of Hercules crowned by an oak wreath, which thus combines the *rovere* of his mother's family with the chief weapon of Hercules, which is in the hands of the triumphant prince in the ceiling of the Sala di Giove.[293]

The points of reference suggestive of associations between Prince Cosimo and the planetary cycle indicate relationships between the Planetary Rooms and the decorations of the Sala della Stufa. These relationships can be extended to the Salone Terreno, started before Cortona's arrival by Giovanni da San Giovanni and finished after the initiation of Cortona's cycle in the Sala della Stufa by Cecco Bravo, Ottavio Vannini, and Francesco Furini between 1639 and 1642. In the executed version of the Salone Terreno decorations, the wall scenes celebrate the life of Lorenzo the Magnificent as a Golden Age in Florentine history in which the arts routed from Parnassus immigrate to Tuscany. In the last wall scene, we are presented with an *Allegory on the Death of Lorenzo the Magnificent* [Fig. 154], in which the close of a Golden Age is announced. On the ceiling, the marriage of Grand Duke Ferdinand and Vittoria della Rovere is symbolically enacted [Fig. 152], and a new era, it is to be inferred, has commenced.

[291] In his classic article, F. Boll ("Die Lebesalter," *Neue Jahrbücher für das Klassiche Altertum*, xxxi, Ser. 3, 1913, 121f.) distributes the planetary influences on the ages of man as follows:

Age	Planet
1-4	Moon
5-14	Mercury
15-22	Venus
23-41	Sun
42-56	Mars
57-68	Jupiter
69-	Saturn

[292] The four major astrological planets (Venus, Mars, Jupiter, and Saturn) are present, and so are several constellations: Hercules (all the rooms), Aquarius (Ganymede in the Sala di Giove), Gemini (the Sala di Giove, and as Castor and Pollux in the Sala di Marte); however, the constellations associated with Jupiter do not make sense astrologically, let alone astronomically. Mars, on the other hand, is within the house of Gemini in June and July, and thus the juxtaposition of a *descending*, i.e. waning, Mars with Gemini and in *ascending* Medici stemma surmounted by a crown inscribed with *Ferdinandus II* might be argued to be intended to pay special homage to the commissioner of the cycle who was born during that month.

[293] Florence, A.S.F., Guardaroba Medicea, F. 958, c. 123. Stefano della Bella did an engraving based on this *impresa*.

156

The promise of the Return of the Golden Age during their reign is made explicit by the reverse reading of the Four Ages of Man cycle in the Sala della Stufa in which the commencement of another Golden Age is associated with both the marriage and with the birth of a male heir. The planetary cycle, in turn, honors the Medici dynasty in general and its commissioner in particular. It serves as well to educate the princely heir apparent and to predict the course of his future reign. In the last room of the cycle, officially opened on the fifty-fifth birthday of Ferdinand II, the final years of the ruler are described and dynastic succession assured. Here Saturn holds dominion over old age. As the lunettes attest, his positive attributes are stressed, recalling to our minds the fact that it is he, though older and more remote than the other gods, who ruled the Golden Age. Thus the Sala della Stufa frescoes of Cortona offer a key to the reading of the planetary cycle, and that cycle in turn closes with a reference to the frescoes in the Sala della Stufa. The connection between the two cycles and the implied reference to a specific grand duke and *gran' principe* was a family matter rather than a public declaration, for the Sala di Saturno served only for *udienze segrete*, and the Sala della Stufa was one of the more inaccessible rooms in the private apartments of the grand duke. The planetary cycle *per se* was intended to articulate universal truths applicable to grand dukes and their first-born sons for generations to come. It is therefore not surprising that the prince in the frescoes does not bear the likeness of a particular Medici.

THE PLANETARY ROOMS AND THE ARCHITECTURE OF THE PITTI PALACE

One of the most striking features of the program of the Planetary Rooms is its vaunted *prepotenza*. The promise of a Return to the Golden Age in the counterclockwise reading of the Sala della Stufa frescoes and its Virgilian sources, coupled with the *de regimine principum* of the Planetary Rooms suggests imperial, rather than grand-ducal, iconography. Although the Medici can scarcely have entertained imperial dynastic pretentions, they must have been anxious to connect themselves as closely as possible to imperial tradition (Ferdinand II was, it should be recalled, a nephew by marriage to the Hapsburg Ferdinand II, Emperor of the Holy Roman Empire, 1619-1637, who had died just before the Medici-Rovere marriage) and to the absolutist concepts of rulership. The ornamented ceiling, especially one with planetary decorations, is part of the iconography of Roman emperors, a tradition of which the Medici must have been well aware. The famous dining hall of Nero as described by Suetonius and Dio Cassius's allusion to the stars emblazoned on the ceilings of the halls in which Septimus Severus gave judgment in his Imperial Palace on the Palatine Hill come immediately to mind.[294] A brief review of the history of the Pitti Palace from the time Cosimo I purchased it,

[294] For these and other useful examples see K. Lehmann, "The Dome of Heaven," *Art Bulletin*, xxvii, March 1945, 1ff. A useful compendium of ancient texts with references to the Imperial Palace on the Palatine is provided in D. R. Dudley, *Urbs Roma*, London, 1967, 165ff.

together with Cortona's unrealized projects, supports the thesis that in all probability Cosimo I and certainly Ferdinand II contemplated the creation of a *palatina domus* modeled at least sketchily on the Palatine palaces of the Romans.

As we have already discussed, the palace was part of the legacy of Grand Duke Cosimo I. It was his wife, Eleonora di Toledo, who had purchased the palace, then an unfinished hulk, from the disgraced and bankrupt Pitti family, and who, by so doing, had moved the family seat to the southerly bank of the Arno River, far from the old family palace and the parochial church of San Lorenzo, which the Grand Duke proposed to convert into a family funeral chapel by adding the huge Cappella dei Principi to the apse of the Brunelleschi structure.

The location of the Pitti Palace must have appealed to Cosimo for a variety of reasons. Locating the grand-ducal residence in a less populous and less distinguished area must have made it easier for him to acquire the area now occupied by the Boboli Gardens, and ultimately the grand-ducal presence must have enhanced land value in the Oltrarno district. The strategic aspect of the location, close to the future site of the Forte Belvedere with its commanding view of the city, must have been a consideration of the wily Cosimo, as evidenced by the construction of the corridor linking the bureaucratic center of his government, the Uffizi and the Palazzo Vecchio, to the massive Pitti Palace, and thus providing a maximum security route between government and residence. The purchase of the Pitti Palace and the subsequent acquisition of adjacent lands to the south produced a residence that is unique among Florentine palaces, a structure with a facade based on the city *insula*, austere and fortress-like in its urban aspect, but open at the rear to an immense garden in the manner of a suburban villa. Later additions to the palace retained and enhanced these characteristics. Thus the courtyard was left partially open to the south, its southern boundary defined by a grotto and a terrace to provide access to the Prato Grande, a grassy area originally defined by sloping banks that formed a natural amphitheatre. Even the lateral extension of the palace, started by Cosimo II and continued by Ferdinand II, consisted of a repetition of the urban palace facade of the original nucleus.

The Renaissance city palace *cum* garden has no parallel on this scale save the unrealized scheme proposed for the Farnese Palace in Rome by Michelangelo that called for bridging the Tiber River and linking the huge city palace with the suburban gardens of the Villa Farnesina. In all probability both Michelangelo's scheme for the Farnese Palace and that initiated by Cosimo I for the Pitti Palace derived from the palace *cum* garden tradition exemplified by the Imperial Roman palaces on the Palatine Hill and from the immense extra-urban residences of the emperors. Typical of developments in Florence, it was Cosimo I who provided the germ for this idea at the Pitti and the succeeding generations of grand dukes who attempted to execute the scheme, although not in a wholly coherent fashion.

It remained for Cortona to propose a solution that—if it had been executed—would

have unified the palace *cum* garden scheme. Cortona's involvement in this project had probably occurred by the time he left in the autumn of 1637, or, in any event, before he started the Planetary Rooms in 1641, for it seems likely that the Medici simultaneously offered him the architecture and painting commissions and that it was these dual possibilities that kept him working in Florence intermittently for six more years. This interpretation of events would explain the depth of his disillusionment with architecture expressed in his letter to Cassiano dal Pozzo of January 1646, in which he bitterly declares that henceforth architecture would be only for his entertainment.[295] By this time, he must have been convinced that the architectural projects for the Grand Duke would never be realized.

Of all the architectural projects in Florence, the Pitti Palace renovation must have been the most challenging. According to Cortona's nephew, Luca Berrettini, the artist prepared a model of the proposed renovation and enlargement of the palace.[296] To date, no trace of that model has been found. However, a group of drawings of which the most important are in the Uffizi Gallery confirm the existence of the project and provide an idea of its scope.

One of the Uffizi drawings [Fig. 185],[297] more highly finished than the other two, is a proposal for alterations of the facade of the palace [Fig. 145]. This drawing illustrates the actual condition of the facade and two alternative schemes for its renovation. The left-hand side of the sheet illustrates the existing facade and provides a scheme calling for a two-storied rusticated frontispiece articulated by bolstered engaged doric and ionic columns capped by a broken segmental pediment, which in turn is topped by the Medici grand-ducal crest. On this side of the drawing, the rest of the immense facade is left virtually unchanged, except for the construction of a basement plinth, the addition of a more massive cornice, and the enrichment of the window surrounds on the *piano nobile* and the floor above it. Each of these windows illustrates an alternative solution to the treatment of the fenestration.

The right-hand portion of the sheet illustrates a more ambitious and costly renovation of the facade. On this side of the drawing, Cortona's additions include a basement plinth and an upper cornice and, more significantly, the reworking of the entire facade. On the ground floor, the original rusticated stone would have been recut to more nearly resemble ashlar and would have been given an overlay in the form of engaged piers placed so as to form flanking units for the small square windows in this area. The *piano nobile* would have been more forcefully articulated by bolstered engaged ionic columns that would have profoundly changed the original window arcade. The uppermost floor would have received similar Corinthian engaged columns, and the voussoirs of the window arcade would have been recut. Strongly stated cornices would have given clear demarcation to the three-storied facade. The central frontis-

[295] Doc. Cat. No. 109.
[296] Campori, *Lettere*, 508.
[297] Florence, Uffizi, Gabinetto dei Disegni, No. 3512A. Marabottini and Bianchi, p. 62f.

159

piece for this scheme is very similar to the one already discussed, except that the outer columns were to be doubled, and this system was to have been repeated in the story above the frontispiece.

It is clear that these two alternative schemes were intended to emphasize the central portal of the palace and to create a loggia above the entrance for public appearances of the grand duke. Obviously, the right side of the drawing goes much further, inasmuch as it would have transformed the strongly horizontal and relatively undifferentiated facade by strengthening the three-storied divisions of the facade and would counter its horizontality by creating vertical units, achieved by adding engaged columns and by supplanting the original arcaded fenestration with a rectangular bay system. What both schemes share is Cortona's interest in transforming the Pitti Palace facade, which is actually an immense version of the traditional Florentine Renaissance palace facade of the type the merchant princes of the city had built, into a royal residence. Clearly, the central frontispiece is the essential element in this transformation, for it incorporates a columnar facade and a loggia above the main portal to the palace.[298] The portal frontispieces Cortona proposed for the Pitti Palace are similar to but far more monumental than those on the facades of Roman Renaissance palaces such as the Farnese and Lateran Palaces. In fact, in scale, Cortona's system of bolstered engaged columns and his use of a layered wall in the ground story of the right section of the drawing for the Pitti facade are similar to the ancient city gates of Rome, such as the Porta Maggiore, and to the city gates of Verona designed by Michele Sanmicheli.[299]

In Cortona's scheme, the enriched portal was to serve as a monumental entrance to the palace and also as a gateway to an impressive architectural garden. This fact is borne out by another drawing in the Uffizi [Fig. 186],[300] a rough sketch that includes a study for the portal frontispiece in immediate conjunction with an early study for the architectural garden as it would appear when viewed from the main courtyard—known as the Cortile Grande—of the palace [Fig. 146]. This close relation is further substantiated by the fact that Cortona's elaborate facade design was clearly based on the architectural system of Ammannati's courtyard facades. It should be recalled that public access to the *piano nobile* of the Pitti Palace was in this period confined to the large double stairway located at the juncture of the westerly wing of the courtyard with the main body of the palace and that this stair can only be reached from the courtyard arcade from which point the architectural garden would have been in full view.

Cortona's intentions, roughly sketched in the drawing discussed above, are more precisely stated in a third drawing in the Uffizi [Fig. 187].[301] From these three draw-

[298] For consideration of these traditional architectural symbols of rulership see E. B. Smith, *Architectural Symbolism of Imperial Rome and the Middle Ages*, Princeton, 1956, especially 22ff. (Adventus Augusti) and 31ff. (the Gallery in the Palace Facade).

[299] For illustration see Venturi, *Arte Italiana*, XI,

Pt. 3, Figs. 269-270 (Porta Nuova) and Figs. 273-277 (Porta Palio).

[300] Florence, Uffizi, Gabinetto dei Disegni, No. 2141A. Marabottini and Bianchi, p. 63.

[301] Florence, Uffizi, Gabinetto dei Disegni, No. 2142A. A drawing in a private collection can also be associated with this project, which Vitzthum

ings, it is evident that Cortona intended to construct a hemicyclical arcade on the location of the amphitheatre. This arcade was to be so scaled as to conform closely to an orthogonal recession established by the cornice of the *piano nobile* of the courtyard wings of the palace, visually suggesting a conjunctive relation between the amphitheatre arcade and the wings of the palace. At its centerpoint, this arcade was to receive a frontispiece framing the central arch of the arcade. Accessible through this central arch via a series of ramps and set back at some distance on one of the upper terraces of the garden, a terminal structure was planned. The design of this structure varies in the two drawings, but in both cases a belvedere resembling a *tempietto* is intended.

The two drawings indicate that the scheme involved the coherent grouping of a series of autonomous structures and spaces consisting of the palace courtyard, the amphitheatre, and a hillside belvedere that Cortona organized to form a visually connected ensemble. What he produced was a scenographic ensemble that became a unified composition only when viewed from the palace courtyard or from the *piano nobile*. From these prime vantage points, a richly pictorial ensemble would have been experienced by the spectator, similar to the fully enclosed Cortile Belvedere of Bramante, but constructed of independent elements. The dynamics of the composition would not have depended upon the physical movement of the spectator through its spaces. In fact, the spectator would have experienced the fullest articulation of the design as he passed through the main portal of the palace and entered the northerly section of the courtyard arcade. From this position the vista would have been experienced as it appears in the more detailed surviving sketch [Fig. 187]. In contrast to the architectural garden of the Villa Giulia or the vistas of the great Genoese palaces, no stairs nor ramps are prominently featured to tempt the spectator to penetrate the sequence of spaces and architectural forms. Thus there would seem to be good reason to argue that it was conceived to create an impression as an entity. Once it had been appraised by the visitor, he would have been free to proceed to the *piano nobile* and the Planetary Rooms, for which the architectural garden would have admirably served as an overture. Unrealized at the Pitti, many aspects of the two sketches for the Boboli architectural garden were incorporated in Cortona's later Roman churches—in the articulation of the piazza of S. Maria della Pace [Fig. 180] and in the facade of S. Maria in via Lata [Fig. 188], which derives its second story from that of the *tempietto* in the more developed *cortile* projects [Fig. 187].

("Inventar," 114) identified as a shop work. This drawing, which is certainly not in Cortona's hand, contains a significant modification of the project presented in Uffizi sketches, for here the hemicyclical structure has attained monumental proportions and becomes a two-storied arcade or loggia. The effect of this alteration is to negate the scenographic qualities of the Uffizi drawings in which the one-storied hemicycle functioned as a space-creating device, giving architectural form to the middle ground of the vista from the palace and visually linking the palace and the hill-top *tempietto* or casino in the distance. It is difficult to accept this drawing as reflecting ideas seriously considered by Cortona, and in fact it may represent a later exploration of the problem by Ciro Ferri, whose authorship of the drawing is well within the realm of possibility.

When the more developed of Cortona's studies [Fig. 187] is compared to the actual condition of the site [Fig. 146], it is apparent that his project would have transformed the disparate ornamental monuments in the existing scheme into a single, coherent whole. In formal terms, his project would have imbued the Cortile Grande and the Boboli Gardens with an architectural clarity and unity commensurate with that Michelangelo bestowed on the originally fragmented complex of buildings on the Campidoglio in Rome. Furthermore, the unity achieved would not have been merely a matter of compositional adjustments, for the scheme taps a rich iconographical tradition.

The fact that two of these drawings depicting a courtyard and amphitheatre project are related to Cortona's reconstruction of the temple sanctuary of Fortuna Primigenia at Palestrina (now Praeneste), a *tenuta* purchased by the Barberini from the Colonna, has been frequently noted and never doubted,[302] and, indeed, in general disposition and architectural massing the two projects reveal connections. This, however, is not necessarily the most salient architectural source, for the Pitti Cortile scheme is a residential palace rather than a temple sanctuary site, and Cortona was conscious of the difference. The problem called for the linking of palace—courtyard—amphitheatre—garden vista, and while drawing on Palestrina with its rising ground plane, ramps, and concluding temple structure, Cortona also considered such obvious sources as the Cortile Belvedere of the Vatican, which in turn depended on the Palestrina solution for a prototype.[303] In a sense, Cortona's project is a reconstitution of Bramante's Renaissance solution rather than a direct adaptation of the antique prototype.[304]

The role of the palace and attached theatre should not be underestimated in the evolution of Cortona's design. He attended the July 1637 festivities connected with the marriage of Ferdinand and Vittoria and the staging of *spettacoli* on the Prato Grande, which by this time was defined by amphitheatre seats, and the temporary constructions of that occasion should not be discounted [Fig. 189].[305]

Although a number of palaces offer the palace *cum* theatre conceit, in most cases the latter is contained within the courtyard of the former. A notable exception is Vignola's masterpiece, the Villa Giulia, a much smaller-scaled scheme. In both the Pitti project and the Villa Giulia, an essentially city palace facade provides an entrance to an elaborate architectural garden. Another possible source is the traditional Genoese palatial dwelling as typified by the Palazzo Doria-Tursi by Rocco Lurago (begun 1564), in which the long vista from the vestibule through the courtyard to a terminal

302 For the Palestrina reconstruction, see R. Wittkower, "Pietro da Cortonas Ergänzungsprojekt des Tempels in Palestrina," *Festschrift Adolph Goldschmidt*, Berlin, 1935, 137ff. The sources for Cortona's Pitti courtyard and garden are reviewed by L. Bianchi (Marabottini and Bianchi, *Mostra*, 62f.).

303 The fundamental study is J. S. Ackerman, *The Cortile del Belvedere*, Vatican City, 1954.

304 At the beginning of his career (c. 1628) Cortona had used the Palestrina model, but again as seen through Bramante's Belvedere solution in the design of the Villa del Pigneto (for an illustration see Wittkower, "Tempels in Palestrina," Pl. xxx 1 and 2).

305 For a detailed description of these events see F. Bardi, *Descrizione delle feste fatte in Firenze per le reali nozze de Serenissimi Sposi Ferdinando II Gran Duca di Toscana e Vittoria della Rovere Principessa d'Urbino*, Florence, 1637, 23ff.

point of ascent is splendidly explored. The Pitti Palace project included no vestibule and would have lacked the sets of stairways, but the problem of achieving a coherent architectural scheme on an axis extended along a rising terrain was the same.

Thus far we have surveyed the relation of Cortona's scheme for the Pitti and the adjacent amphitheatre to a number of general prototypes. It must be kept in mind that we are concerned with a very specific building type, the urban palace with attached amphitheatre and hillside garden. When these features are considered, one source assumes special significance—the immense urban palaces of the Roman Emperors on the Palatine Hill. Just which imperial palace had captured Cortona's imagination is not known, but very likely he was fascinated by the ruins of the sprawling palaces for which the sloping sides of the Palatine Hill had served as architectural gardens. These architectural remains testify to the extent of the Imperial Palatinium but provide scant information about its shape and form. Therefore Cortona's conception of the imperial residences must have depended in the main upon literary descriptions and attempted reconstructions. From the surviving texts, Cortona and his advisors could have culled descriptions of vaulted rooms embellished with celestial signs that inspired the planetary cycle and also the clear indication that a *palatinium* included a temple linked to the palace proper by colonnades.[306] Furthermore, the possibilities of an arrangement such as that proposed by Cortona for the Cortile Grande and Prato Grande were partially adumbrated in reconstructions of the *palatina domus* such as that of J. A. du Cerceau.[307] If we are correct in stressing intended associations between the Pitti Palace project and the Imperial Palatinium, then Cortona's incorporation of motifs from the Cortile Belvedere of the Vatican Palace is even more appropriate in view of the fact that Bramante's monument had been considered a modern equivalent to the antique structures since the sixteenth century.[308]

An intriguing feature of Cortona's more developed study for the courtyard is the series of lines forming an amorphous shape in the middleground of the Cortile Grande. Very possibly this shape is the *primo pensiero* for a fountain, one that would have emphasized the presence of actively jetting water more than either the Fontana del Carciofo on the terrace of the grotto [Fig. 148] or the fountain inside the grotto at the far end of the courtyard [Fig. 149]. If we are correct in assuming the intention to display prominently a fountain at the center of the courtyard, then the symbolic as well as aesthetic import of the fountain must be acknowledged. It will be recalled that the

[306] For example, the Palatina Domus of Augustus, see Suetonius *The Lives of the Caesars* II. xxix. 3. The temple in this case was dedicated to Apollo, and the colonnades housed Greek and Latin libraries (*porticus cum bibliotecae latina graecaque*). It should be recalled that in the period under consideration the Pitti Palace housed the Grand Ducal Library, now catalogued as the Biblioteca Palatina in the Biblioteca Nazionale Centrale, Florence.

[307] *Livre des édifices antiques Romains . . . ,* Paris, 1584, Pl. 34.

[308] See, for example, the comment of Marliani that "what Biondo has written about the Imperial Palaces, now could we say the same about the Papal Palace" (*Antiquae Romanae Topographia libri septem*, 1534, III, 7, Fig. 49v, quoted in B. Lowry, "Review of J. Ackerman, *Cortile Belvedere*," *Art Bulletin*, XXXIX, June 1957, 159f. I am indebted to Shelia ffolliott for calling this passage to my attention).

water source for the extant garden fountains was the Montereggi aqueduct started by Cosimo I and completed by Ferdinand II. Within the Cortile grotto, an attempt had been made to demonstrate the completion of the aqueduct as a significant event of Ferdinand II's rule. As we have already noted, the grotto fountain was for this purpose lined with statues symbolic of the qualities of rulership: Legislation, Zeal, Clemency, and Authority, with Moses as a centerpiece [Fig. 149]. The inscription on the base of the basalt figure of Moses makes clear the fact that Ferdinand II, like Moses before him, has brought forth water from the living rock and that he, like Moses, possesses the attribute of divinely ordained rulership.[309] The fact that the waters of the Montereggi aqueduct flowed through many of the fountains of the Boboli Gardens and the palace, thence to several important city fountains renders even more explicit the intentions of Ferdinand II and his advisers. In fact, this hydraulic distribution pattern follows a tradition of great antiquity of which the Medici court may have been aware. Homer, when describing the visit of Odysseus to the palace of Nausicaa's father, Alcinous, states that the palace and its gardens received water from two springs within the garden and that the stream which flowed to the palace emerged in a courtyard fountain, whence it passed to the people of the town.[310]

Whether or not the court iconographers were aware of this Homeric precedent, the general import of the program evolved in the period c. 1636-1640 was obscured in its execution.[311] The statue of *Abundance* or *Dovizia* [Fig. 147] set atop the highest plateau in the garden is scarcely visible from the Cortile Grande [Fig. 146]. The fountain of the Carciofo is merely an ornamental incident in the vista, and, more important, the elaborate program of the grotto is completely hidden from view. In contrast, Cortona's project involving architecture, fountains, and interior decorations would have created a monumental garden and palace commensurate with the scale of the palace and the pretentions of the Medici.

It is evident that the royal connotations of Cortona's architectural garden are in keeping with his decorations on the interior of the *piano nobile* of the palace. The setting he intended to create would have made eloquently manifest the pretentions to royal power of the Medici dynasty. The fact that the program in which he was involved clearly challenged papal authority in its temporal governance would scarcely have passed unobserved in Rome, or for that matter, in the great seats of secular power in seventeenth-century Europe.

[309] For a discussion of the grotto program see Chapter I, p. 17f of this study.

[310] Homer *Odessey* VII. 111 sqq.

[311] See note 309 above.

III. *The Pitti Palace Decorations and the Baroque*

With the possible exception of Gian Lorenzo Bernini, no Italian Seicento artist more profoundly influenced the history of style in the seventeenth and the first half of the eighteenth centuries than did Pietro da Cortona. The impact of *cortonismo* derives from his total oeuvre, and thus its appraisal could be fully rendered only by considering the work of his entire career. However, as Briganti has convincingly argued and others have accepted, the Sala della Stufa and the Planetary Rooms constitute prime monuments in the evolution of what Briganti has termed the *Barocco universale*.[1] For it is in Florence, in these secular decorations of the grand-ducal palace, that Cortona achieved a successful fusion of the style of Annibale Carracci's Farnese Gallery, with its close associations with the Central Italian High Renaissance, and the chromatic richness and luminism of the Venetian tradition. The purpose of this chapter is not to attempt a comprehensive investigation of *cortonismo* or even to document those of its influential threads that lead directly back to Cortona's work in the Pitti. These influences are in fact inseparable from his other work, and therefore what follows is a broadly sketched record of the effects of these influential works on the style of the Medici court and on major artists of the seventeenth and early eighteenth centuries.

CORTONA AND THE COURT STYLE OF THE MEDICI

A tradition-bound artistic world was the immediate inheritance of Ferdinand II and his brothers, Cardinal Giovanni Carlo (1611-1663), Prince Mattias (1613-1667), and

[1] Speaking of the Planetary Rooms, Briganti writes: "Nell'immaginare, con l'ausilio della mitologia classica, una sorta di poema figurativo in sette canti [seven rooms were, it will be recalled, at first intended] per vantar le virtù anonime di un principe assoluto, la corte di Firenze mostrava di aggiornarsi al lume di quello spirito supernazionale che andava allora formando le basi dell'assolutismo in Europa, il che riflette la luce più appropriata sulla scelta dell'artista chiamato a quell'impresa e che si approntava ad affrontarla con uno stile che neppure esso può chiamarsi nazionale, né fiorentino né romano, ma nato piuttosto dai propositi universali del Barocco." (Briganti, *Pietro*, 96.) See also M. Gregori, *70 pitture e sculture del '600 e '700 Fiorentino*, Florence, 1965, 20f. The remarkable eighteenth-century scholar and critic, Luigi Lanzi (*Storia pittorica dell'Italia . . .* , Bassano, 1789), characterizes the "fifth epoch of painting in lower Italy," by which he means the second half of the seventeenth century, as the period of Pietro da Cortona and his followers in both Florence and Rome.

Cardinal Leopold (1617-1675).[2] From the death of Cosimo II in 1621 until the contractual marriage of Ferdinand and Vittoria della Rovere in 1634 the status quo in patronage was maintained. During this period, the artistic legacy of Cosimo II obtained, and, as we have observed, the Florentine school of artists secured virtually all grand-ducal commissions. Virtually all artistic production consisted of the continuation of projects initiated by Cosimo II. The 1621-1634 period was, in spite of Ferdinand's investiture as Grand Duke in 1628, an extended regency in which his mother and grandmother dominated the culture and politics of the Tuscan state.

In 1634 artistic activity at the Tuscan court greatly increased. Older monuments were adapted to new needs or given dedications that celebrated the authority of the reigning Grand Duke, and new projects were commenced. Initially these projects were in the hands of local artists; then, as we have seen, in 1637 their hegemony was abruptly broken in the field of painting by the appearance of Pietro da Cortona followed by the Bolognese quadraturists, Angelo Michele Colonna and Agostino Mitelli. Furthermore, in the autumn of 1640, another major Baroque painter, Salvator Rosa, took up residence at the Medici court. Under the protection of Cardinal Gian Carlo de' Medici, this artist remained in Florence until February 1649 when, apparently exasperated with the Florentine court, he returned to Rome. Rosa's presence in Florence underscores the fact that the 1640's constituted a brilliant cultural period in Florence. In the sciences a progressive, enlightened ambience was maintained into the 1650's, but in the arts the closeness of the departures of Cortona and Rosa signal the end of approximately a decade in which Florence flourished as a cultural center that, given the city-state political structure of Italy, can be termed international in its hospitality to Roman, Neapolitan, and transalpine artists. These included, in addition to the already named major figures, the landscapist Gaspar Dughet and one of the most accomplished *Seicento* portraitists, Justus Sustermans. To the culturally alert visitor, Florence of the 1640's must have seemed at least on the threshold, if not in the midst, of the Golden Age proclaimed by Buonarroti's epithalamium in the Sala della Stufa.[3] In such a situation Cortona must have appeared predestined to find acceptance. He was Tuscan by birth—always important in matters of patronage—and his art represented the *dernier cri* in Rome, then the undisputed center of the international art world. Furthermore, there is evidence that Medici taste would have predisposed members of the family to embrace his art enthusiastically.

This evidence is the interest accorded the paintings of Andrea del Sarto in Florence during the period under consideration. His art in many ways stylistically adum-

[2] A fourth brother, Francesco (1614-1634), does not seem to have played a role of any significance in artistic patronage and, in any event, died before Cortona appeared in Florence.

[3] No full-scale study of Seicento Florence and its art has been undertaken; however, three excellent summaries of Florentine painting of the period are provided by H. Hibbard and J. Nissman, *Florentine Baroque Art From American Collections*, New York, 1969; Gregori, *70 pitture e sculture*; and M. Chiarini, *Artisti alla corte granducale*, Florence, 1969.

brates Cortona's paintings. Even Cortona's arrival in Florence in 1637 and the conse-
quences stemming from it seem a repetition of Andrea's return to Florence in 1520 for
the express purpose of transforming the Salone of the Medici Villa Poggio a Caiano
into a royal audience chamber.[4] The later Medici who were to become Cortona's
patrons appreciated the splendor of Andrea del Sarto's paintings as is amply attested
by their efforts to purchase works of art by the Renaissance master, an activity which
the Grand Duke and other members of his family enthusiastically pursued between
1620 and 1650. During this period, at least eight paintings by Andrea del Sarto entered
the family collection, which already contained five examples of his work.[5] More impor-
tant than the number of paintings acquired, however, is the fact that the group included
several truly major works by the artist, such as the Gambassi *Madonna and Child with
Saints*, the *Passerini Assunta* and the *Sacrifice of Isaac*.[6] Furthermore, three of the paint-
ings bought at this time entered the collection housed in the Palazzo Pitti and were hung
in the grand-ducal audience chamber, the Sala di Giove: the *Archangel Raphael with
Tobias, Christ, San Leonardo and Donor* now in Vienna; *The Disputation on the Trin-
ity*; and the *Gambassi Madonna and Child with Saints*. It should also be recalled that the
first two rooms in Cortona's series, the Sala di Venere and the Sala di Apollo, were
hung with tapestry copies of Andrea del Sarto's St. John the Baptist cycle in the
Chiostro dello Scalzo, a situation that would have encouraged comparison of the work
of the two artists.[7] Indeed, a strong argument can be made for an Andrea del Sarto
revival in the 1630's and an increase in interest in him in the decade of Cortona's activi-
ties in the Medici court. The fact that many Tuscan artists of the c. 1630-1650 period
chose to emulate the rich colorism of Andrea del Sarto strengthens our case for the
importance of that Renaissance master in defining the taste of the Medici. The results
of their efforts serve to clarify Cortona's achievement and help explain the impact of his
art on both his Tuscan patrons and on contemporary Florentine painters.

 Just how overwhelming Cortona's performance in the Planetary Rooms was for
his Florentine contemporaries is reflected in an anecdote recorded by Filippo Baldi-
nucci. According to Baldinucci:

[4] M. Campbell, "Medici Patronage and the Baroque: A Reappraisal," *Art Bulletin*, XLVIII, June 1966, 140.

[5] See J. Shearman, *Andrea del Sarto*, London, 1965, II, Autograph Works, *Cat. Nos.* 20, 23, 51, 76, 78, 79, 94; Studio Works, Cat. No. 6. In several instances the precise date of acquisition is problematic; however, most of these paintings entered the Medici collection in time to be included in the 1637 Guardaroba inventory of the Pitti Palace.

[6] *Ibid.*, Autograph Cat. Nos. 76, 78 and 94.

[7] For additional material on use of the St. John the Baptist cycle in tapestries see H. Geisenheimer, "Gli arazzi nella sala dei dugento a Firenze," *Bollettino d'Arte*, III, April 1909, 137ff. and C. Conti, *Richerche storiche sull'arte degli arazzi a Firenze*, Florence, 1875, *passim*. Further evidence of Medici interest in the Scalzo frescoes is provided by attempts at restoration of the original frescoes, probably at the behest of the Medici in 1617 and 1630. At the time of the first restoration, Theodore Kruger prepared a set of engravings of the frescoes which was dedicated to Grand Duke Cosimo II. In 1626 Cardinal Carlo de' Medici paid for the installation of curtains to protect the frescoes from the weather (Shearman, *Andrea*, II, 295).

The scaffolds in the Royal Rooms [the Planetary Rooms] had been removed because the paintings of Pietro [da Cortona] had been finished when the Serene Grand Duke Ferdinand decided to exercise an act of generosity only he could bestow. And thus it was that the two oldest painters of the city, one our Matteo Rosselli and the other the Cavalier [Francesco] Curradi were the first to see them uncovered. Deciding to have them called, and in his own presence wishing to have them see [the frescoes] he was already awaiting their judgment, when Rosselli, who was the first moved to speak, without saying a word to the Serene Patron, turned to Curradi, and burst out with these words, "Oh Curradi, oh Curradi, how small the rest of us are! What do you say? What do you say? Aren't we very tiny?" The same Curradi used to tell me, that when he entered those rooms and saw those paintings, that he was overcome by an indescribable admiration and it was such that he could not believe that he was actually seeing what he had only dreamed of seeing, for such was the newness that appeared before his eyes at a single stroke.[8]

Baldinucci's account rings true, and in fact it would be hard to describe better the effect of Cortona's style on Tuscan contemporaries. It is scarcely surprising that possibly as early as 1637 and certainly no later than 1641, Cortona emerged as the purveyor of the style sought by the Medici. This thesis, it should be acknowledged, applies chiefly to large scale work in the Pitti Palace. For easel paintings, portraits, and church commissions, local artists continued to be employed, although the art of several of them underwent profound style changes. This is true of Francesco Furini [Fig. 154] and even more evident in the case of Baldassare Franceschini, called Volterrano [Fig. 190]. In the latter case the change is total, and by no means does it seem in retrospect to have been for the better.[9] In point of fact, the effect of Cortona on local Florentine artists was a mixed blessing; a freshness and a gaiety, a love of rural settings and intimate narrative were sacrificed to what Panofsky has aptly termed the "lordly racket" of the Roman High Baroque, in which style much Florentine Seicento art passes muster as merely competent exercises in a Cortonesque manner.[10]

[8] F. Baldinucci, *Notizie*, 410f.: Eransi levati i palchi stati fatti nelle Regie Camere del Palazzo Sereniss. a' Pitti per esser già restate finite le Pitture di Pietro, quando il Sereniss. Gran Duca Ferdinando volle esercitare un'atto della sua solita generosità, e fu che i primi a vederle scoperte fussero i più vecchi Pittori della Città, l'uno era il nostro Matteo Rosselli, e l'altro il Cavalier Curradi, mandolli dunque a chiamare, ed alla propria presenza volle che lo vedessero, e già ne aspettava lor giudizio, quando il Rosselli a cui toccò a parlare il primo senza nulla dire al Padron Serenissimo si voltò al Curradi, e proruppe in queste parole. O Curradi, o Curradi quanto noi altri siamo piccini, che dite, che dite non siamo noi ben piccinini? Lo stesso Rosselli soleva poi dire a me, che nell'entrar che ei fece in quelle Stanza, e veder quelle Pitture, fu preso da una non so quale insolita ammirazione, e tale, che e' non gli pareva di vedere, ma di sognare di vedere, tanta fu la novità, che apparve alle sue luci, tutta in un punto.

[9] For consideration of the impact on Furini's style both as a painter and a draftsman, see G. Cantelli, *Disegni di Furini*. For a prime example of Volterrano's style just before the impact of *cortonismo*, see the cycle of frescoes in the courtyard of the Villa della Petraia (cf. M. Winner, "Volterranos Fresken," 219ff.).

[10] The full implications of the impact in Florence of Cortona are far-reaching and beyond the confines of this study. It should be noted, however, that the style driven underground by Cortona remained alive and was supported by individual collectors, including the Medici, for smaller scale

The impact of *cortonismo* is also apparent in the work of the Late Baroque artists Jacopo Chiavistelli (1621-1698) and Anton Domenico Gabbiani (1652-1726), both of whom were frescoists in the Palazzo Pitti.[11] Chiavistelli produced decorations for ground floor rooms along the eastern side of the central courtyard that echo the work of Colonna and Mitelli in their *quadratura* effects and imitate in a softened style the frescoed scenes of Cortona in the Planetary Rooms. Gabbiani is an artist of greater substance who developed an attractive Late Baroque style heavily charged with *cortonismo*. He studied Cortona's frescoes and drew from them. A number of his careful drawings from the Sala della Stufa cycle survive in the Uffizi collection. In his paintings, he employed Cortonesque figure types and, in ceiling paintings, compositions that are often blatant adaptations of that master.[12] His colors, however, are softer, and his figures lack the volume of those of Cortona. A considerable portion of his Cortonesque effects was absorbed indirectly through his training with Ciro Ferri and through the study of Carlo Maratti and Luca Giordano. Gabbiani's immediate debt to Cortona, however, is clear in his *Triumph of the Casa Medici* [Fig. 191] in a salone in the Meridiana of the Palazzo Pitti (1691) in which he borrows directly from Cortona's ceiling in the Salone Barberini and from the Sala di Marte.

The effects of the Pitti Palace decorations by Pietro da Cortona changed Florentine monumental painting stylistically and also profoundly altered its content. This change can be succinctly documented by a comparison of the biographical and anecdotal character of the program of the Salone Terreno and the program Volterrano carried out at the Villa della Petraia with the iconography of the planetary cycle. The more generalized themes of the Planetary Rooms with their dependence on allegory, mythology, and ancient history are reflected in the later work of Volterrano and in the work of the Late Baroque masters, Chiavistelli and especially Gabbiani.

Cortona had little effect on seventeenth-century architecture in Florence, except for interior decoration, where the influence of the Pitti stuccoes was considerable. Indeed, his presence as a creative and major architect is so totally suppressed that one

works of art not associated with public places or public aspects of the court, and that this subspecies of the Baroque as practiced in Florence was probably considerably more important in the formulation of the dominant styles of the first half of the eighteenth century, loosely collected and described by the term Rococo, than has been generally acknowledged. Also, the effect of Cortona on Florentine parochial art is an example *in minuto* of the effect of his style throughout the Catholic court countries of Europe. Like such predecessors as Leonardo and Correggio, Cortona is to blame for a highly recognizable style, which in an increasingly desiccated vernacular will be repeated over and over in the decorations of churches and palaces deep into the nineteenth century, especially

in the more provincial Catholic court countries.

[11] Chiavistelli has received little attention. For a summary of his career see U. Thieme and F. Becker, *Allgemeines Lexikon der Bildenden Künstler*, Leipzig, 1912, VI, 489f. Gabbiani is the subject of an article with brief oeuvre, A. Bartarelli, "Domenico Gabbiani," *Rivista d'arte*, XXVI, 3rd Series, 1951-1952, 107ff.

[12] In light of this fact, it is interesting to note that the decorations recently correctly identified as the work of Cortona in the mezzanine rooms of the palace by Marco Chiarini (M. Chiarini and K. Noehles, "Pietro da Cortona a Palazzo Pitti," 233ff.) were given to Gabbiani by Bartarelli ("Domenico Gabbiani," 116f.).

suspects local architects must have strongly and persuasively lobbied against him. The acceptance of Cortonesque motifs rather than formal entities may have been preconditioned by the presence of the sixteenth-century tradition for such ornamental forms.

Two Cortonesque trends can be identified in Florentine decorative architecture. In extreme forms they are characterized by, on the one hand, Ciro Ferri's choir chapel in S. Maria dei Pazzi (1675-1709), in which a rather austere and conventional adaptation of Cortona's sensual architectural style is combined with lush but confined passages of ornamental work, frequently executed in contrasting materials, and, on the other hand, by G. B. Foggini's Feroni Chapel in SS. Annunziata (1691-1693), in which Cortona's sure sense of architecture as richly articulated structure is suppressed to achieve a decorative effect of great emotional intensity.[13] In both cases, the character of the work of art is quite different from Cortona's own style. These monuments and others like them deserve fuller consideration than is possible in the present context. They are hybrid variations on, rather than direct descendents of, what might be termed Cortona's planetary style.

The aspirations of the Medici were never fully realized. Cortona failed to complete the planetary cycle. His plans to transform the Pitti Palace and its gardens into a Baroque ensemble remained on paper. Yet enough of the commission was accomplished to make the completed decorations a source of ideas for later artists facing related representational and decorative problems, whether their commission consisted of a single composition, the decoration of a series of rooms, or the creation of an entire palace and its setting.

POSTSCRIPT. As this study is going to press, several developments of major importance have occurred that deserve comment. First, a reorganization of the art collections in the Pitti Palace is now underway. The principal stairway of the palace (see our plan, p. 69) has been reactivated as the access route through the palace, and the stairway which has long served as the point of entrance and exit for visitors to the Galleria Palatina will now serve only to exit visitors into the Boboli Gardens. Happily, with this change visitors to the Galleria Palatina will once more view the Planetary Rooms in the sequence originally intended: from the Sala di Venere to that of Saturn. Plans are also underway to improve the illumination of the Galleria Palatina with concern for the ceilings as well as for the paintings on the walls. A second important development was the recent exhibition, "The Twilight of the Medici" held in Detroit and at the Pitti Palace in the spring and summer of 1974. The catalogue of this exhibition (*The Twilight of the Medici. Late Baroque Art in Florence, 1670-1743*, Florence, 1974) is a monumental work that confirms and enriches the foregoing comments on the impact of Pietro da Cortona on Florentine art.

[13] K. Lankheit, *Florentinische Barockplastik . . .* , Munich, 1962, 43ff. and Pls. 1 and 2 and 86ff. and Pls. 29 and 30.

THE PLANETARY ROOMS AND THE SEVENTEENTH CENTURY

In the seventeenth century, influences traceable to the Planetary Rooms are greatly varied. In the case of Lebrun's decorations at Versailles, the *schema* of decorated ceilings dedicated to planetary deities and the recording of the influences of their cosmic forces on great rulers is borrowed in its entirety. At other times, an artist little affected by their style will nevertheless borrow a composition and employ it virtually unchanged. A case in point is a ceiling [Fig. 192] attributed to Pietro Liberi in the Palazzo Fini in Venice, which repeats part of the central scene of the ceiling of the Sala di Saturno almost exactly.[14] Another example of explicit borrowing is provided by an unknown artist who closely followed Cortona's *Antiochus and Stratonice* lunette [Fig. 34] for his more darkly illumined version of the same subject [Fig. 193].[15] In these examples, the artists assuredly had opportunities to view Cortona's works at the Pitti. Even artists who were not afforded such an opportunity could and did utilize aspects of the Pitti decorations after 1691 when a series of engravings of parts of the Sala di Venere, the Sala di Marte, and the Sala di Giove was printed.[16] More

[14] Since the Sala di Saturno was never engraved (Fabbrini, *Vita*, 96), Liberi, if he is the author of the Venetian work, must have seen the ceiling, a matter that presents a problem because he is not known to have been in Florence after 1645. Possibly the ceiling provides proof of a later trip between 1665 when Ciro Ferri finished the Sala di Saturno and 1669, the hypothetical date of the Palazzo Fini ceiling (N. Ivanoff, "Un aspetto poco noto di Pietro Liberi," *Emporium*, CXVII, 1953, 158ff., and G. M. Pilo in the catalogue, *La pittura del Seicento a Venezia*, Venice, 1959, 76, Cat. No. 117).

[15] For a full history of the iconography of the Antiochus and Stratonice theme in which Cortona's fresco plays a seminal role, see W. Stechow, "Antiochus," 221ff. Further examples are provided by A. Pigler, *Barockthemen*, Budapest, 1956, II, 348ff.

[16] *Heroicae Virtutis Imagines quas eques Petrus Berrettinus Cortonensis Pinxit Florentiae in aedibus Sereniss. Magni Ducis Hetruriae in Tribus Cameris Ioves, Martis, et Veneris . . .*, Rome, 1691. The 26 plates were engraved for the well-known publisher Giacomo Rossi (Iacobi de Rubeis) by C. Bloemart, P. Simon, J. Blondeau, C. de la Haye, Gerardin, L. Visscher, L. Coenradt, F. Spierre, A. Clouvet and B. Balliu. The following portions of the decorations were included in the publication: Sala di Giove: *Vulcan Resting* (lunette), *Apollo Resting* (lunette), *Diana Resting* (lunette), Mi-

nerva and Cecrops (lunette), *Discord and Fury* (lunette), *Mercury* (lunette), *Dioscuri* (lunette), *Bellerophon and Pegasus* (lunette), The Ceiling Fresco (engraved in two sections); Sala di Marte: Medici *stemma* (from center of ceiling) with dedication to Cardinal Francesco Maria de' Medici and four other plates devoted to portions of the ceiling; Sala di Venere: *Continence of Scipio* (lunette), *Massinissa and Sophonisba* (lunette), *Antiochus and Stratonice* (lunette), *Alexander and Sisigambis* (lunette), *Antiochus and the Priestess of Diana* (lunette), *Crispus and Faustina* (lunette), *Augustus and Cleopatra* (lunette), *Cyrus and Panthea* (lunette), ceiling fresco; and two plates depicting portions of the stucco decorations. Fabbrini (*Vita*, 49, n. 30) reports that the Sala della Stufa frescoes were also engraved. Citing Bottari, he ascribes the engravings to Vincenzo Vangelisti, who (according to Mariette) worked from copies made by Gabbiani rather than the original frescoes. Copies of Cortona's Pitti decorations are certainly numerous and no attempt has been made here to trace them. In passing, however, it is to be noted that the National Museum of Wales has an oil sketch copy of the *Age of Bronze* (P. Barlow and J. Steegman, *Catalogue of Oil Paintings, National Museum of Wales*, Cardiff, 1955, 155, No. 292), and a similar copy for the *Age of Silver* is now in a private collection in Rome (A. Marabottini and L. Bianchi, *Mostra*, No. 46-A [Addenda]). The Nelson Gallery has a copy of the Sala di Marte mounted in

171

important, however, are the examples of Pierre Puget and Charles Lebrun, who drew in a more profound way on the style of Cortona and for whom the Pitti decorations provided more than compositional prototypes. Whereas the tracing of the influences of the Planetary Rooms in the work of other artists without reference to Cortona's entire oeuvre would, in most cases, yield little of significance, the relations of the decorative cycle to the work of these two masters is sufficiently specific to warrant closer attention.

That Pierre Puget (1620-1694) had direct contact with Cortona as well as access to his work has been traditionally accepted, and Cortona has in some cases been described as Puget's master.[17] Actually, the precise nature of Puget's association with Cortona is by no means certain, for even the dates and lengths of his Italian sojourns are open to question.[18] After a three- or four-year apprenticeship in Marseilles, Puget journeyed to Italy in 1637. He is said to have gone to Florence and to have attached himself to a "sculptor of the Grand Duke," presumed to have been Pietro Tacca. At some undetermined date, he proceeded to Rome, where he is purported to have studied painting as a pupil of Pietro da Cortona. Possibly as early as 1643 and certainly by 1647, the year of his marriage in Toulon, he had returned to France. There is convincing evidence that Puget left Toulon in 1661, went to Rome, perhaps via Genoa, and stayed there until the early fall of 1662.[19] In 1662 he returned to Genoa and remained there until 1668. During this second Genoese period, he undoubtedly traveled to Florence and Rome. There may have been a third, short visit to Genoa in 1670.[20]

shadow box construction (R. E. Taggart, "Model of the Ceiling by Pietro da Cortona in the Salon of Mars in the Pitti Palace," *The Nelson Gallery and Atkins Museum Bulletin*, III, Oct. 1960, 8ff.). A New York private collection contains an almost complete set of copies of Cortona's frescoes. A case of direct borrowing from the engravings of the Pitti decorations is provided by J.-L. David, who executed his Cortona-derived *Antiochus and Stratonice* before he won the Prix-de-Rome and the opportunity to travel to Italy and view the decorations first hand.

[17] Cf. A. Blunt, *Art and Architecture in France: 1500-1700*, Harmondsworth, 1957, 218ff.

[18] A study of Puget's career is to be found in the as yet unpublished doctoral dissertation of Guy Walton ("The Sculptures of Pierre Puget," New York University, 1967). I here follow Walton's chronology of Puget but differ somewhat in the stress laid on Cortona's importance to the Frenchman, in whom I see rather more *cortonismo* (cf. Walton, "Puget," 8ff.). Walton provides an excellent review of Puget problems and the relevant literature.

[19] G. Walton, "Pierre Puget in Rome: 1662," *Burlington Magazine*, CXI, Oct. 1969, 582ff.

[20] In the foregoing chronology I follow Walton ("Puget," especially xii-xxv). Blunt's categoric statement that Puget ". . . spent the years 1640-3 in Rome and Florence working under Pietro da Cortona, principally in the decoration of the rooms in the Palazzo Pitti" (*Art and Architecture*, 218) is not easily supported. The principal sources for the activities of Puget 1635-1670 are: P. de Tournfort, *Relation d'un voyage à levant*, Paris, 1717 and 1712; J. Bourgerel, *Mémoires pour servir à l'histoire de plusieurs hommes célèbres de Provence*, Paris, 1752; R. Soprani, *Vite de pittori, scultori ed architetti genovesi*, ed. C. G. Ratti, Genoa, 1768; and L. Lagrange, *Pierre Puget*, Paris, 1868. The source for Puget's activities in Tuscany is a now lost manuscript of Jean de Dieu who wrote down his recollections of remarks made by Pierre Puget during a trip to Paris (1688-1689) which is cited by Lagrange. From the evidence available, Puget's association with Cortona in Florence is tenuous, especially in view of the fact that the contact reported by Puget's "official" biographer, Bougerel, occurred in Rome, where Puget was recommended

Although a maximum period of 1637-1647 or a minimum one of 1637-1643 provides adequate time for Puget's involvement in the Pitti decorations, he is not mentioned in any document associated with the commission or, for that matter, with any other commission executed by Cortona. Without documentation and lacking a clear case for stylistic attribution, it would seem unwise to press the case for Puget's hand in the Pitti decorations. Even if he can eventually be associated with the decorations, it will be extremely difficult to locate the actual points of his intervention, for he was a youthful sculptor (Puget was twenty years of age in 1640) whose style can scarcely have attained a truly personal form before the end of his first Italian sojourn.

Our concern with Puget is to determine the significance of the Planetary Rooms to his artistic formation rather than to trace the many strains of *cortonismo* in his art. The Pitti decorations were a specific source for figurative motifs in several of Puget's important sculpture commissions, including his earliest major work in that medium, the sculptured doorway of the Hôtel de Ville at Toulon, dated 1656-1659.[21] The most distinguished feature of this project, the struggling atlantes who, evincing both effort and anguish, sustain a balcony on their heads and shoulders, has been frequently connected with Michelangelo's bound slaves and, more recently, with Cortona's stucco figures in the Sala di Venere who also provide a source for figures purposefully engaged in similarly strenuous activity.[22]

A similar relation can be established in the case of Puget's *St. Sebastian*, dated c. 1661-1668, in S. Maria del Carignano, Genoa.[23] Executed during Puget's second Italian sojourn, the *St. Sebastian* has been associated convincingly with Bernini's *Daniel* in the Chigi Chapel, S. Maria del Popolo, Rome,[24] but the more upright position of Puget's figure and his suppression of the plane-breaking movement that typifies Bernini's work point to connections with Cortona's stucco figures in the spandrels of the Sala di Giove. The difference between these figures and Puget's *St. Sebastian* parallels the relationship of the Sala di Venere atlantes to those of Puget for the Toulon doorway. In both cases, Cortona's figures provide prototypes in gesture and action, but do not reveal the deeper psychological overtones that are an essential element in Puget's sculptures.

by an unidentified "sculptor of the Grand Duke of Tuscany," rather than in Florence. Finally, the reliability of Bougerel is open to some question, for he includes in his biography of Puget the Apelles-derived myth of a painting by the Frenchman being mistaken for one by Cortona and also the anecdote that Cortona offered his daughter's hand to Puget in an attempt to retain him as an assistant (Mémoires, 13). There is no evidence that Cortona, a confirmed bachelor, had a daughter. After the present study was completed, the important monograph by K. Herding (*Pierre Puget*, Berlin, 1970) became available to this writer. Unfortunately, it has not been possible to integrate fully the researches of Herding in the foregoing comments or to include a critical review of his contribution.

[21] For illustrations see Herding, *Puget*, Pls. 16, 28, 29, and Blunt, *Art and Architecture*, Pls. 176A, 177.

[22] *Ibid.*, 218ff. Herding, *Puget*, 38, has added the portal of the Palazzo Davia-Bargellini by Francesco Agnesini and Gabriello Brunelli, Pl. 19, as an important source. He also cites the Salone Barberini decorations.

[23] For illustrations see *ibid.*, Pls. 130, 131, 132, and Blunt, *Art and Architecture*, Pl. 176B.

[24] *Ibid.*, 220. For illustration see R. Wittkower, *The Sculpture of Gian Lorenzo Bernini*, London, 1966, 216ff., Pl. 71 and Fig. 65.

Puget's so-called *Gallic Hercules* can also be related to Cortona's stuccoes.[25] Even a cursory comparison between it and the slumbering, enchained figures at the corners of the Sala di Marte attests to the connections between these works of art that are as valid as those that relate the *Hercules* to the often cited *Ares Ludovisi* and the *Torso Belvedere*. Insistence on a direct connection must, however, be tempered by the fact that Annibale Carracci's well-known representations of *The Choice of Hercules* and *Hercules Resting* in the Camerino Farnese provide closer sources for the major aspects of the pose and iconography of Puget's *Hercules*.[26]

With a late (1680's) work of Puget, the *Faun*, firmer connections between the French sculptor's style and the Pitti decorations may be adduced.[27] Although Michelangelo's sculpture has been cited (and quite rightly so) in connection with the *Faun*, comparison of this figure with the stucco satyrs in the Sala di Apollo erases all doubt of the importance of Cortona to the idiosyncratic Baroque style of Puget.[28] The figures are so close in pose and style that it is tempting to speculate that if documentation linking Puget with the stucco decorations at the Pitti Palace is ever found, it will be with these figures that his name will be associated.

Unfortunately, an area of Puget's activity in which the influence of Cortona was enormous is, except for documentation via prints and drawings of his sumptuous ship decorations, now lost to us. In these richly carved, highly figurative and unfortunately ephemeral stern pieces executed under Puget's direction while he was artistic director of the Toulon Arsenal from 1667 to 1679, a remarkable variety of caryatids, atlantes and triton figures derived from Cortona's work, especially the Pitti Palace decorations and the Salone Barberini, were employed.[29]

Cortonesque features in French art are not limited to Puget. Charles Lebrun (1619-1690), more responsible than any other single artist for the Academic Baroque style of the French court, also turned to Cortona and specifically to his Pitti Palace decorations in evolving his decorative style. The paradoxical position of Lebrun, who talked of Poussin, Raphael, and the Antique in the theoretical conferences of the Academy, but borrowed generously from the exuberant and painterly Cortona when faced with executing an actual commission, has been noted in art historical literature.[30]

In 1642 Lebrun traveled to Italy, where he remained for four crucial years absorb-

[25] Blunt, *Art and Architecture*, 220 and 286, n. 47 and Walton, *Puget*, 187. For illustrations see also Herding, *Puget*, Pls. 64, 67, 69, 70.

[26] For illustration see Martin, *Farnese Gallery*, Fig. 11. Another painting in the same room depicting the *Choice of Hercules* (*ibid.*, Fig. 9) provides a convincing source for the physiognomy of Puget's *Hercules* and aspects of his pose. Herding, *Puget*, 55, Pl. 68, cites this source, but omits the equally essential *Hercules Resting*.

[27] For extensive illustrations see *ibid.*, 127ff., Pls. 281-286.

[28] For connection with Michelangelo (*Rebellious Slave*, Louvre) and also antique sources see Walton, *Puget*, 251.

[29] P. Auquier, *Pierre Puget, décorateur naval et mariniste*, Paris, 1928, for illustrations and comments.

[30] Blunt, *Art and Architecture*, 201, has pointed it out. The Lebrun-Cortona relation is more fully explored in D. Posner, "Charles Lebrun's 'Triumphs of Alexander,'" *Art Bulletin*, XLI, No. 3, Sept. 1959, 237ff.

ing a richly derivative artistic vocabulary that was to prove essential to his facile decorative style. Although much of his Rome-based four-year sojourn was spent under the instruction of Nicolas Poussin, it is evident from Lebrun's later work that he studied other contemporary Roman painters intensely, especially Pietro da Cortona.

Upon his return to France, Lebrun received several major decorative commissions in the period 1650-1660 including the Gallery of the Hôtel Lambert, the ceilings of the Hôtel de la Rivière, the now destroyed ceiling of the chapel in the Seminary of Saint-Sulpice, and the projected ceiling of the Chambre du Conseil, which was later realized in the Salon du Dôme of the Louvre.[31] In all of these ceilings, specific figures and even entire compositions can be related to the Barberini commission and, to a lesser degree, to the Pitti decorations.[32]

Of all these commissions, it was the now-destroyed ceiling in the Chapel of the Seminary of Saint-Sulpice, known to us through an engraving, in which Lebrun's contact with Cortona's work at the Pitti is especially evident.[33] It seems very likely that, as Jennifer Montagu has remarked, the asymmetrical arrangement of the *di sotto in su* composition, in which the Fathers of the Greek and Latin churches are grouped along an adjacent long and short side of the scene while the other two sides are opened to the illusionistic sky and occupied by clouds and a scattering of angels, was determined by the illumination of the chapel.[34] If this is the case, then the arrangement constitutes an ingenious adaptation of Cortona's scheme in the Sala di Marte, which Lebrun has here adapted to his own needs by suppressing the figural areas along the cornice line on two sides of Cortona's fresco and by utilizing the poses of the captured barbarians, who move *en file* to pay homage to three female allegories, for the church fathers who appear on one of the long sides of the chapel ceiling. The central area of Lebrun's ceiling was filled with a richly figured *Assunta*, which is positioned like the Medici *stemma* in the Sala di Marte, but whose numerous participants in several cases derive from the central section of the Salone Barberini ceiling. The heaven-bound Virgin, for example, is based on Cortona's Divine Providence in the Salone Barberini, and several of the angels who propel her upward are derived from the figures who support the papal arms and Barberini stemma in the same ceiling.[35]

[31] The best available discussion of these decorations is provided by J. Montagu, "The Early Ceiling Decorations of Charles Le Brun," *Burlington Magazine*, cv, Sept. 1963, 395ff. and Figs. 16 and 19, who notes specific sources in Annibale Carracci, Raphael, and Pietro da Cortona.

[32] A vexing point is the fact that the Lambert Gallery bears a more than superficial resemblance to the virtually contemporaneous gallery in the Pamphili Palace in the piazza Navona executed by Cortona, 1651-1654. Lebrun is assumed to have received the Hôtel Lambert commission shortly before 1650 and to have worked on it intermittently for some twelve years (see Montagu, "Charles Le

Brun," 396, especially note 17 which contains information from a MS in the Bibliothèque Nationale that I have not consulted). Very possibly the final scheme for the gallery was not evolved until after Lebrun had received descriptions—perhaps written, but more likely in the form of sketches—of Cortona's work for the Pamphili.

[33] For an illustration see Montagu, "Charles Le Brun," Fig. 17.

[34] *Ibid.*, 400.

[35] Another commission reflecting Lebrun's fusion of ideas and motifs from the Barberini Salone and the Pitti Palace decorations is the design projected for the Chambre du Conseil in the Louvre (*ibid.*,

Shortly after 1657, Louis LeVau was ordered to design the great Château of Vaux-le-Vicomte for the Surintendant des Finances, Nicolas Fouquet. In the interiors of Vaux-le-Vicomte, Lebrun produced room after room of decorations in the style adumbrated in the unexecuted Chambre du Conseil and in the Salon du Dôme. For the first time on a large scale, he exploited Cortona's Pitti formula of richly gilded stucco as a sumptuous setting for painted scenes. Only the Chambre du Roi, however, clearly recalls a Pitti room, the Sala di Giove, and even here it is the general effect rather than specific motifs or arrangements that point to a direct relation.[36] Symptomatic of Lebrun's increasingly tempered Baroque is the fact that the adjacent room, the Cabinet du Roi, received a decorative armature of ornamental architecture (the paintings were not executed) that derives from Cortona's early Villa del Pigneto ceiling and is in the tradition of Annibale Carracci's Farnese Gallery.[37]

While at work on the decorations of Vaux-le-Vicomte, Lebrun had kept before him Poussin's abortive commission to decorate the Long Gallery of the Louvre and the later work of Romanelli in the Queen Mother's apartments. It is therefore scarcely surprising that the Parisian works of these two masters were important in the evolution of his Galerie d'Apollon, also in the Louvre.[38] The result was a gallery in which the

401f., 407 and Fig. 20). A drawing for this project omits the central area of the decorations where Louis XIII was to appear in the guise of Jupiter handing a shield with the portrait of his son on it to his queen, who is in turn depicted as an allegory of Justice. The surrounding scenes were to illustrate the Four Ages of Man, which, given the subject of the central panel, can certainly be interpreted as portraying as well the Return of the Golden Age. Although the program is obviously related to the Sala della Stufa decorations, the composition for the ceiling derived its *quadratura* largely from the Salone Barberini. The ceiling for the Chambre du Conseil was never executed due to changes of plan in the Louvre, but a later commission for the decoration of an oval domed room known as the Salon du Dôme in the same palace gave Lebrun an opportunity to carry out a modified version of the scheme that now survives only in an engraving (*ibid.*, 401, Fig. 23). In addition to changing somewhat the *quadratura* (which may have been planned as real stucco), the iconography of the central scene was revised to celebrate the marriage of Louis XIV and the Peace of the Pyrenees, a subject just as compatible with the Four Ages theme as the central scene planned for the Chambre du Conseil. Furthermore, the theme of the Return of the Golden Age is here expressly stated, for when read in a clockwise sequence the Ages are arranged in an evolutionary sense, that is, from the Age of Iron to the Age of Gold. Montagu (*ibid.*, 402) states that a manuscript de-

scription prepared by Claude Nivelon provides further evidence of the evolutionary reading which is, as we have noted, implicit in the organization of the ceiling. The Barberini ceiling provided sources for the scenes depicting the Ages of Silver, Bronze, and Iron. Even though the Barberini ceiling is the major source for motifs, the Pitti Palace decorations contribute too. The general conception of Lebrun's *Age of Gold*, for example, is related to Cortona's identical Age, and the bound prisoners that appear at the corners of the cornice in Lebrun's drawing derive from Cortona's similarly disposed figures in the Sala di Marte. Also, the experimentation with a decorative lunette-shaped enframement for the Ages was derived from the more functional lunette enframements in the Sala di Venere and the Sala di Giove.

[36] For illustrations of Vaux and consideration of its dating and iconography, J. Cordey, *Vaux-le-Vicomte*, Paris, 1924, must be consulted. The Chambre du Roi is discussed on 74f. and illustrated in Pls. XIX-XXII.

[37] For illustration and discussion, *ibid.*, 75ff. and Pl. XXIII.

[38] On Poussin's Long Gallery see A. Blunt, "Poussin Studies VI: Poussin's Decoration of the Long Gallery in the Louvre," *Burlington Magazine*, XCIII, Dec. 1951, 369ff. For the Galerie d'Apollon see L. Hautecoeur, *L'histoire des châteaux du Louvre et des Tuileries*, Paris, 1927, 113ff., Pls. XXII and XXIII.

effect, as John R. Martin has noted, is a "blend of ostentation and restraint," an anomalous union achieved by a modified Baroque whose sources include, in addition to Cortona, Poussin, and Romanelli, a strong infusion of Annibale Carracci, especially Annibale's Farnese Gallery.[39] Although elements in the scheme of the Galerie d'Apollon can be sorted out and attributed to their various sources, we are here aware that Lebrun has arrived at a style so consistent with itself that such a dissection would miss the point; the fusion is complete. Most of the ornamental architectural decoration is executed in low relief, and its effect is that of a taut, relatively rectilinear pattern that conforms to the plane of the barrel vault. Cortona's rich system of forms that seem imbued with potential movement is not here recalled; only a few of the stucco figures who clamber and cling to the enframements of the paintings remind us of the Pitti decorations in both form and spirit, and many of these figures are closer to Annibale's atlantes in the Farnese Gallery.[40]

The decorative style that crystallized in the Galerie d'Apollon is the style Lebrun applied to the commission that has always been accepted as the apogee of the "Style Louis XIV," the decorations of the Château de Versailles. Unfortunately, the first rooms Lebrun decorated at Versailles have not survived, but it seems safe to assume that they, like the Grand Apartments of the King and Queen, executed between 1671 and 1681, were decorated in a style analogous to that of the Galerie d'Apollon.

An adequate history of the Versailles decorations has never been written, and obviously this is not the place for such an undertaking.[41] The decorative system employed by Lebrun at Versailles is consistent with the Galerie d'Apollon and utilizes the interplay of stuccoes, both figural and architectural, with richly colored scenes. At Versailles the *cortonismo* of Lebrun is not limited to stylistic consideration exclusively and extends, with significant reworking, to the program of the Planetary Rooms.

In the Grand Apartments of Versailles, Lebrun, his assistants and his advisers produced a seven-room ensemble that incorporated an iconographic program similar to the planetary cycle in the Pitti Palace. The original apartments consisted of a freely redistributed Ptolemaic solar system in which the visitor first ascended the Escalier des Ambassadeurs, then entered the Salon de Diane (the moon) and proceeded westward along the northern wall of the Château Neuf, passing through the Salon de Mars, the Salon de Mercure, the Salon d'Apollon and to the Cabinet de Jupiter, situated in the northwest corner of the Château Neuf. From this corner room, access to the two remaining rooms of the cycle was achieved. These two rooms, the Chambre de Saturne

[39] Martin, *Farnese Gallery*, 165.

[40] Hautecoeur, *Louvre*, Pl. XXIII.

[41] For the evolution of the Galerie des Glaces, F. Kimball, "Mansart and Lebrun in the Genesis of the Grande Galerie de Versailles," *Art Bulletin*, XXII, No. 1, March 1940, 1ff., remains the classic source. Also to be consulted: F. Kimball, "The Genesis of the Château-Neuf at Versailles," *Gazette des Beaux-Arts*, Series 6, XXXV, May 1949, 353ff. More recent comment is to be found in I.

Dunlop, *Versailles*, New York, 1970; P. Verlet, *Versailles*, Paris, 1961; A. Marie, *Naissance de Versailles*, 2 Vols., Paris, 1968; and W. Vitzthum, "Versailles, le palais du Soleil," *Burlington Magazine*, XII, Dec. 1966, 639. In addition I have profited from discussions with David Barensfeld, who wrote a Master's Thesis on Versailles, under the direction of Werner Gundesheimer, for the Department of History at the University of Pennsylvania.

and the Salon de Vénus, were located to the south along the west wall of the palace. Of this complex of rooms, the first three—the Salon de Diane, the Salon de Mars, and the Salon de Mercure—served as antechambers to the Salon d'Apollon, the throne room. The room behind the throne room, the Cabinet de Jupiter, was originally used as a chamber for the King's Council, and the two adjoining rooms, dedicated to Saturn and Venus, were private apartments for Louis XIV.

The Versailles planetary cycle is striking in both its similarities to and deviations from the Pitti Palace cycle. Clearly, there are similarities between the position of the Escalier des Ambassadeurs and the *enfilade* range of rooms on an east-west axis and the Scala Grande of the Pitti Palace and the nearby Planetary Rooms; however, Lebrun has brought the rooms and their public access route into closer physical relation, thus reinforcing the qualities of physical ascent in the case of the stairs with symbolic ascent through the Planetary Rooms. Most significant is the shift of the throne room from the Sala di Giove at the Pitti to the Salon d'Apollon at Versailles. This room, it should be noted, is the central one in the original Versailles cycle; rooms dedicated to Diana, Mars, and Mercury precede it, and others dedicated to Jupiter, Saturn, and Venus follow it. Like the Ptolemaic sun, this room is at the center of the cycle. Of course, Louis XIV had already adopted the Sun God as his favorite personification and it is no surprise that this room celebrates the glorious reign of Le Roi Soleil.[42] The pre-eminence of this room within Louis's cosmic hierarchy is reinforced by the fact that the four public rooms in the cycle and also the Cabinet de Jupiter, used by Louis as a council chamber just as the Sala di Saturno had served as a private audience room in the Pitti series, are arranged along the east-west solar axis. The fact that the sequential movement of the visitor through these rooms reflects the celestial path of the sun may be a coincidence determined by the original structure of the château, but it clearly was a coincidence that Lebrun and his advisers were disposed to exploit, just as André LeNôtre was to do in his vast east-west expansion of the gardens. In the garden, it should be recalled, the fountain dedicated to the Sun God—the Bassin d'Apollon— was placed in a pivotal location on the central east-west axis.

Later alterations to the garden side of the palace, which included the creation of the immense Galerie des Glaces and its two satellite rooms, the Salon de la Guerre and the Salon de la Paix, eliminated the original Salon de Vénus and the Chambre de Saturne. At this time, in 1678, a new Salon de Vénus was created to the east of the Salon de Diane. In these later rooms, Lebrun produced variations on his earlier decorative vocabulary.[43] The *cortonismo* is now much reduced and restrained, but this is scarcely surprising, for Cortona had been dead for nearly a decade, and the *préceptes positifs*

[42] In this light it is important to recall that several earlier commissions—the Cabinet of the Hôtel de la Rivière, the projected decorations for the dome of the Grand Salon Ovale at Vaux, and the Galerie d'Apollon at the Louvre—all featured Apollo the Sun God, who presided over the second room in the planetary series at the Pitti Palace.

[43] See the comments of Blunt, *Art and Architecture*, 195f.

delivered at the French Academy most certainly did not advocate the use of Cortonesque devices. In truth, it is surprising that so much of Cortona's intensely Italianate High Baroque exuberance gleams from these masterpieces of French seventeenthcentury classicism. The anomaly of Lebrun the facile decorator and Lebrun the stern academician is still so pronounced that one may rightly ask why and how Lebrun developed his decorative style with its considerable dependence of Cortona in the first place. Important in this context is the fact that the Academy, founded in 1648, was not reorganized into a highly structured and intensely doctrinaire institution until 1663 when Colbert, who had become Vice-Protector in 1661, obtained the Arrêt du Conseil that required even privileged painters to join the Academy.[44] The year 1663 marks the beginning of the administration of the Academy as a dictatorship, and by that date Lebrun's decorative style had already evolved through its richest and most Cortonesque Baroque phase. As we have seen, at the time the decorations of Vaux-le-Vicomte were undertaken, Lebrun had begun to temper his illusionism, and although he continued to use stuccoes, they tended generally to form relief-like patterns in contrast to the richly three-dimensional surfaces of the Planetary Rooms.

To look at the pre-1663 decorations of Lebrun is to see clearly that he must have been an artist who was temperamentally attuned to the visual possibilities of highly developed illusionistic decoration. Also, evidence that in the 1650's French taste was predisposed to accept with enthusiasm exactly what Lebrun had to offer can be adduced by a brief chronological review.

We know that Louis XIII, anxious to secure the services of a more accomplished master than Simon Vouet, negotiated with Poussin to leave Rome and come back to his homeland to work for the crown. The result of the King's efforts and those of his ministers was the brief Paris sojourn of Poussin between 1640-1642, which can scarcely be said to have pleased anyone involved. Almost simultaneously the French crown tried to secure Pietro da Cortona in 1641.[45] Cortona was presumably picked on the basis of his work in Rome, especially the recently completed Barberini ceiling, to be the ideal artist to undertake extensive decorations in the Louvre. Lebrun must have been aware even before he departed for Italy in 1642 that Poussin and Cortona had been the artists most earnestly sought by the crown. Thus Lebrun had good reason to avail himself of the work and insofar as possible the advice of these two quite diverse artists while in Rome. Furthermore, coincident with his own return to France, another effort was made to secure Cortona's services, and although these efforts were unsuccessful, they did net Cortona's by now disenfranchised student, Giovanni Francesco Romanelli, who, working in a diluted Cortonesque style, decorated the gallery of the Hôtel Mazarin

[44] H. Jouin, *Charles Le Brun et les arts sous Louis XIV*, Paris, 1889, 69ff., A. de Montaiglon, *Procès-verbaux de l'académie royale de peinture et de sculpture*, Paris, 1875, I, 205ff., and N. Pevsner, *Academies of Art*, Cambridge, 1940, 87ff. Although the position of Vice-Protector gave Colbert virtual control of the Academy, it should be recalled that absolute power and the title of Protector were not his until 1672. Furthermore, Lebrun was appointed Director only in 1683.

[45] Doc. Cat. No. 27.

(now part of the Bibliothèque Nationale) between 1646 and 1647.[46] As Martin has rightly stressed, it was really Romanelli who brought the Cortonesque style of decorations to France.[47] Evidence that his tempered *cortonismo* was a success is the fact that he was recalled in 1655-1657 to decorate the summer apartment of the Queen Mother in the Louvre,[48] where the Pitti Palace conjunction of fresco and figured stucco enframements was exploited. Romanelli's work, a blend of his two masters, Domenichino and Cortona, provided Lebrun not only with a model to be emulated but with a test case to judge his French audience and, above all, the preferences of the Royal House.

In considering Puget and Lebrun, there is ample justification for insisting not only on the significance of Cortona's influence but on the importance of the Pitti Palace decorations in the formation of their respective styles. For most artists affected significantly by Cortona, the Pitti frescoes cannot be singled out specifically; rather the *cortonismo* is more ubiquitous. A case in point is that extraordinarily adaptive Neopolitan master Luca Giordano (1632-1705). With immense facility Giordano borrowed from every conceivable source, both Renaissance and Baroque.[49] Again and again, he turned to Cortona, whose style he completely subsumed, producing numerous paintings that are variations on those of Cortona.[50]

In general, Luca Giordano found the congested figures in the vault of the Salone Barberini more to his purpose than the Pitti Palace decorations, and frequently he mined this ceiling for figural motifs.[51] However, as Ferrari and Scavizzi pointed out in their study of this artist, the Pitti Palace decorations are a pervasive influence, and the chromatic intensity and the compositions of the frescoes Giordano executed in Florence proclaim the fact.[52] Above all, this is the case in the gallery in the Palazzo Medici-Riccardi, which emulates and challenges the luminous color and the spatial tour de force of the Sala di Marte.[53] The importance of the Sala di Marte for Giordano's later ceilings

[46] It should be noted that it had been Mazarin who had sought Cortona for the King in 1641. As late as April and June 1647 correspondence reveals that the Barberini, then in exile, were attempting to get Cortona to come to France (H. Geisenheimer, *Pietro*, 33, Nos. 48, 49). Again Mazarin is involved, apparently in the hope of securing Cortona for the design of his library.

[47] Martin, *Farnese Gallery*, 164f.

[48] Hautecoeur, *Louvre*, 36ff. and Pls. VIII, IX.

[49] As Wittkower (*Art and Architecture*, 305f.) has noted: "Perhaps the first virtuoso in the eighteenth-century sense, [Giordano] considered the whole past an open book to be used for his own purposes. He studied Dürer as well as Lucas van Leyden, Rubens as well as Rembrandt, Ribera as well as Veronese, Titian as well as Raphael, and

was capable of painting in any manner he chose."

[50] This is especially true of Giordano's numerous Nativities, Annunciations, and Births of the Virgin.

[51] For example, the woman suckling an infant in *St. Nicholas of Bari Saving a Child* in S. Brigida, Naples, 1655 (for illustration see O. Ferrari and G. Scavizzi, *Luca Giordano*, Naples, 1966, III, Fig. 55), who is derived from an identical figure in the scene in the Barberini ceiling depicting *Hercules Driving Out the Harpies* (see Briganti, *Pietro*, Fig. 130). Further to this connection see W. Vitzthum's review of the Ferrari-Scavizzi monograph (*Burlington Magazine*, CXII, April 1970, 243) where Giordano's drawing after the Cortona fresco is published (Fig. 68).

[52] Ferrari and Scavizzi, *Giordano*, I, 91ff.

[53] For illustration, *ibid.*, III, Fig. 197.

is apparent from even a cursory viewing of the *Glory of St. Lawrence* in the Escorial and the *Triumph of Judith* in S. Martino, Naples.[54]

The *cortonismo* of Giordano is as obvious as it is general; in contrast, Giovanni Battista Tiepolo (1696-1770) borrows with such subtlety that influences of a pedantic kind cannot be traced. It is in Tiepolo's art, however, that Cortona's debt to Venice is paid in full, for Cortona's adaptation of the ceilings of Veronese are a crucial element in Tiepolo's perfect rendition of airy, open space in fresco. In all probability, the Venetian visited Florence as early as 1725 and had access to the Sala di Marte, which, with its figured border and central garland of figures, provides the basic formula for innumerable Tiepolo ceilings. Tiepolo, the last grand master of the decorated ceiling, is also the last truly major artist whose debt to Cortona's Pitti decorations depends upon an interpretation of the problems created by stuccoed enframement and frescoed space.

During the eighteenth century, numerous artists of vastly diverse artistic persuasions were to find the Pitti frescoes a rich repository of artistic possibilities. Of these, Fragonard, who borrowed from the Pitti frescoes motifs useful in his hedonistic paintings, is the outstanding example.

Like Tiepolo and Giordano, Jean-Honoré Fragonard (1732-1806) was a master transmogrifier of the art of other artists. He, too, voraciously absorbed the work of a host of artists and so completely transformed his sources as to make the artistically derivative parts of which they are composed virtually impossible to sift out. Granted, there is much of Cortona in the finished paintings of Fragonard; yet in establishing his precise debt to the Roman Baroque master it would seem that the Goncourt brothers, writing before the middle of the last century, have had the first and last word in defining his debt to Cortona to be the borrowing of "his trembling sunbeams, his uncertain, dancing light"[55]

Consideration of Fragonard's drawings, however, will clarify his debt to the Italian master, for among the immense number of drawings he did after the work of other artists there are several sketches based on Cortona's Pitti Palace decorations. These drawings are especially significant because they can be associated with Fragonard's first Italian sojourn (1756-1761) and, furthermore, to the period following his association with the French Academy in Rome. While at the French Academy, Fragonard is reported to have made a copy of Cortona's *Restoration of the Sight of St. Paul*, but in general he addressed himself to the work of the Carracci and the Bolognese School as advised by the Director of the Academy, Natoire.[56] In early April 1761, Fragonard started for Paris in the company of the Abbé de Saint-Non. As reported by Natoire, the Abbé "will break his journey wherever he finds beautiful things to see . . . the young

[54] *Ibid.*, III, Figs. 351 and 504, respectively.
[55] E. and J. de Goncourt, *French XVIII Century Painters*, trans. R. Ironside, London, 1948, 266.

[56] G. Wildenstein, *The Paintings of Fragonard*, Aylesburg, Bucks, 1960, 7 and 49. Wildenstein cites primary sources.

artist will make sketches wherever they stop."[57] An important stopover, as indicated by the inscriptions in Saint-Non's hand on the drawings, was the Pitti Palace, where Fragonard executed sketches after Cortona's frescoes as well as after paintings in the grand-ducal collection by Giovanni da San Giovanni, Rubens, and Andrea del Sarto.[58] These drawings (together with some he had made one year earlier in Venice) constitute a nucleus of markedly hedonistic subject matter that is in contrast to the sketches he had made under the direct tutelage of the French Academy in Rome. As attested by the drawings, Fragonard, presumably encouraged by Saint-Non, while visiting the Grand-Ducal Gallery sought out those masters who were to provide the stylistic basis of his erotic paintings and engravings.

Given his predilections, it is scarcely surprising to find that the subject of the central scene in the Sala di Venere [Fig. 27] interested Fragonard in terms of figure groupings whereas the other ceilings were primarily sources of individual figures. Thus, on one sheet [Fig. 194] we are presented with a single figure from the Sala di Marte and the entire figure grouping in the left half of the central fresco in the Sala di Venere.[59] Fragonard concentrated on the nymphs who provide a court for Venus, but treated them as an independent group by suppressing certain iconographic and compositional details such as a mirror held by a *putto*, the fountain, the inebriated *putto*, and the pipes held by the recumbent girl in the foreground. The result is a more self-contained group. It should be noticed that the girl resting on the garden wall now admires herself in the liquid contents of the urn rather than in a mirror held further to one side, a shift that is important not only compositionally but iconographically, for whereas she coyly viewed only her face in Cortona's fresco, it is her body and specifically her head and breasts that are reflected in the urn. If the number of extant versions is any indication of enthusiasms then it was the right half of the central fresco in the Sala di Venere [Pl. III] that sparked Fragonard's interest because he made at least one copy of it [Fig. 195].[60] The drawings related to the Sala di Venere fresco are significant not only for what they include but for what they omit: Hercules does not appear in the sketches. In Fragonard's drawing, Cortona's moral theme is confounded; what was heroic in the fresco dissolves.

The decorations of the Planetary Rooms remained a reservoir for ceiling painters for as long as the air-borne figure was a viable artistic conceit and as long as sculptors

[57] *Ibid.*, 50.

[58] Elizabeth Senior ("Drawings Made in Italy by Fragonard," *British Museum Quarterly*, XI, 1936, 6) states that there are three Fragonard sketches made at Florence which are dated April 1761.

[59] A. Ananoff, *L'oeuvre dessiné de Jean-Honoré Fragonard. Catalogue Raisonné*, Paris, 1968, III, Cat. No. 1851 and Fig. 464. For identification, the catalogue provides only the annotation on the drawing: "du Cortone. Palais Pitti. florence." Another drawing, this time with one counterproof, con-

nects Fragonard to the Sala di Marte frescoes (Cat. No. 1855, 1856 and Figs. 468, 469). This drawing can be related to two allegorical figures and the two captives who bow before them in the ceiling in question. With regard to Cat. No. 1856, see also IV, Addenda et Corrigenda III, Cat. No. 1802.

[60] *Ibid.*, Cat. No. 1852, Fig. 466, and for counterproofs see Cat. No. 1853, Fig. 467 and Cat. No. 1854. For additional comment on Cat. No. 1853 see IV, Addenda et Corrigenda III, Cat. No. 1802.

continued to investigate the expressive potential of the human figure as a load-bearing form. By the end of the eighteenth century, however, the relationship between the Pitti Palace decorations and the work of artists who borrow from them has changed decisively. For example, it is highly probable that Eugène Delacroix used some of Cortona's figure groupings as the basis for his frescoes in the Library of the Palais Bourbon (1838-1847) and that the struggling figures of Auguste Rodin and the monumental bathers of Pierre-Auguste Renoir descend from some of the stuccoed and frescoed figures in the Planetary Rooms. But the planetary cycle no longer offers an important key to our understanding of the art of these later masters. They are not a prime source; rather, they have become what they are today: a part of the historic past and a major monument in the history of decorative architecture [Pl. IV] and mural painting [Pl. I].

Appendix I. The Chronology of the Planetary Rooms

The first serious attempt to reconstruct the chronology of the Planetary Rooms was made by Hans Geisenheimer, who in 1909 published the extraordinary quantity of relevant documents his archival researches had located.[1] Actually, Geisenheimer proposed two reconstructions. The first and principal one was the following: Sala di Venere (1641-1642), Sala di Marte (1643-1644), Sala di Giove (1645), and the Sala di Apollo (1646-1647), which Cortona left unfinished.[2] In a footnote Geisenheimer suggested an alternative sequence that, however, he considered less acceptable: Sala di Venere (1641-1642), Sala di Giove (1643-1645), Sala di Marte (1646-1647), and Sala di Apollo (1647).[3] Except for the chronology of Von Below and a radical proposal by Briganti, the second reconstruction of Geisenheimer has, with occasional adjustments in dating, won general acceptance.[4] For the completion of the Sala di Apollo by Ciro Ferri and his execution of the last room in the series, the Sala di Saturno, Geisenheimer produced documented datings of 1659-1660 and 1663-1665, respectively.[5] These dates have never been challenged.

[1] H. Geisenheimer, *Pietro*.

[2] *Ibid.*, 6f.

[3] *Ibid.*, 7, n. 1.

[4] O. Pollak, U. Thieme and F. Becker, *Allgemeines Lexikon der Bildenden Künstler*, Leipzig, 1912, VII, 489f.:
 Sala di Venere: 1641-1642
 Sala di Giove: 1643-1645
 Sala di Marte: 1646
 Sala di Apollo: 1646-1647
H. Voss, *Die Malerei des Barock in Rom*, Berlin, 1924, 541f.:
 Sala di Venere: 1641-1642
 Sala di Giove: 1645
 Sala di Marte: 1646
 Sala di Apollo: 1647
S. von Below, *Beiträge zur Kenntnis des Pietro da Cortonas*, Murnau, 1932, 77:
 Sala di Venere: 1641-1642
 Sala di Marte: 1643
 Sala di Giove: 1644-1646
 Sala di Apollo: 1646-1647
A. Marabottini and L. Bianchi, *Mostra*, 13, n. 25:
 Sala di Venere: 1641-1642
 Sala di Giove: 1643-1645
 Sala di Marte: 1646

 Sala di Apollo: 1647
R. Wittkower, *Art and Architecture*, 166 and n. 56:
 Sala di Venere: 1641-1642
 Sala di Giove: 1643-1645
 Sala di Marte: 1646
 Sala di Apollo: 1647
G. Briganti, *Pietro*. Briganti adduces two divergent and mutually exclusive reconstructions. The first appears in his chronology of Pietro's life (141ff.):
 Sala di Venere: 1641-1642
 Sala di Giove: 1644-1645
 Sala di Marte: 1646
 Sala di Apollo: 1647
The second, argued in greater detail, appears in his catalogue raisonné of the artist (225, 235ff.):
 Sala di Venere: 1641-1642
 Sala di Apollo: 1642-1643
 Sala di Giove: 1643-1646
 Sala di Marte: 1646-1647
M. Campbell, *Mostra*, 17ff.:
 Sala di Venere: 1641-1642
 Sala di Giove: 1644-1646
 Sala di Marte: 1646
 Sala di Apollo: 1647

[5] Geisenheimer, *Pietro*, 7.

Although the chronological reconstruction presented here is based upon richer documentation than was available to Geisenheimer, the qualitative results are not markedly changed; this redounds to the credit of Geisenheimer, who based his researches on primary sources in the form of highly descriptive letters and cost estimates. In contrast, much of the documentation here published for the first time is of a lower order and consists mainly of weekly payment records that often merely confirm or make more precise Geisenheimer's deductions.

Furthermore, the following chronology is presented in awareness that new documents and a deepening knowledge of an historic period inevitably reduce successive chronologies to mere stages in a continuing dialogue. The discussion that follows is therefore understood to be subject to future revision. If it fills some of the chinks and crevices in previous chronologies, it will have served its purpose.

SALA DI VENERE, 1641-1642

Indicative of the situation is the precision with which Geisenheimer dated the commencement of the first room in the summer of 1641 and its completion in 1642.[6] Even the most scrupulous assessment of accounts not examined by Geisenheimer effects little change in these estimations. Furthermore, his identification of the first room in the series to receive decorations as the Sala di Venere [Fig. 20], an identification based on Giovanni Battista Passeri's biography of Cortona in which the first room decorated by the artist in the Palace is identified as the Sala della Stufa and the second as the Sala di Venere, cannot be challenged.[7]

It is not known at precisely what date Pietro da Cortona was tendered the commission to decorate a series of rooms on the *piano nobile* overlooking the piazza di Pitti in the northeast wing of the palace. The first hint of the commission in the correspondence of the artist appears in a letter Cortona wrote to Cassiano dal Pozzo on August 17, 1641, in which he mentions but does not describe negotiations with the Grand Duke.[8] From this letter, one would assume the negotiations to be in initial stages; however, as we shall presently see, work on the first room had been under way for at least two weeks at the time. Thus, Fabbrini's assertion that the commission was agreed upon before Cortona left Florence in 1637 is doubtful.[9] Strong support for the 1641 date is provided by the letter of August 24, 1641, in which Michelangelo Buonarroti the Younger, writing to his friend Arrigucci, notes with exasperation that "Sig. Pietro meanwhile has had new work of months and months"[10] It is evident that Buonarroti at least was not aware of the second enormous commission until after Cortona's return to Florence

[6] *Ibid.*, 6.

[7] *Ibid.* The relevant phrases in Passeri read: "La sala è la maggiore, e fu la seconda ad esser dipinta da lui perchè già haveva incominciata la stufa . . . ," followed by ". . . Finita la stanza detta della Dea Venere . . ." (G. B. Passeri, *Vite*, 383 and 384, n. 3).

[8] Doc. Cat. No. 19.

[9] N. Fabbrini, *Vita*, 66.

[10] Doc. Cat. No. 22.

in the spring of 1641. In view of the principal role Buonarroti played in getting the artist to return, it seems unlikely that he would have been excluded from any negotiations between the Medici and Cortona during 1637-1641, when, as he himself pointed out, he was called upon by persons of the grand-ducal court to explain the artist's absence during the three-and-a-half-year interruption in the decorations in the Sala della Stufa. We may therefore conclude that Cortona was offered the commission during the short period between his arrival in May 1641 and July 15, 1641, the date of the first official correspondence relative to the commission, a letter of recommendation for the *capo muratore e stuccatore* Giovanni Maria Sorrisi called to Florence to assist in the decorations.[11]

The next item of correspondence, sent from Rome on July 27, 1641, and written by Monanno Monanni, Tuscan envoy to the Papal See, provides a more complete picture of the negotiations for the Roman *stuccatore* to come to Florence to "work in stucco where commanded."[12] This letter, which is to all intents and purposes a contract, names Sorrisi's associates, Maestro Batista Frisone and Maestro Santi Castellaccio, and states that they are being sent to Florence by Monanni at the command of Cardinal Gian Carlo de' Medici. The *stuccatori*, according to the terms of Monanni's letter, are to be conducted to Florence and returned to Rome when the work is finished at the expense of the Grand Duke. They are to receive sixty *scudi* per month, payable to their *capo*, Maestro Gio. Maria. In addition they are to be accommodated in furnished rooms. Furthermore, they are to be paid a wage from the time of their departure from Rome until their return. The contract became effective on the following day (July 28) when, we may assume from the stipulated conditions, the three *stuccatori* set out for Florence. The next document, dated August 3, 1641, is a request by Andrea Arrighetti (Soprintendente delle Fabbriche) addressed to the Grand Duke for an allotment of four hundred and fifty *scudi* against the cost of the room—which we would identify as the Sala di Venere—that Pietro da Cortona "has to paint" and specifically to cover the expense of the mortar, cement, iron work, other equipment.[13] "And in addition to this (450 *scudi*)," Arrighetti continues, "seventy *scudi* likewise per month for such time as this work shall last, both for the maintenance of those three men about whom they write from Rome to have bargained that seventy *scudi* be given per month . . ." exclusive of the painter's recompense, which he describes as "that other reckoning that must in the end be given to . . . Cortona," from which it would appear that the remuneration of the painter was already fixed, but not to be bestowed until the completion of at least the first room, if not the entire project.

The estimate drawn up by Arrighetti coincides with the earliest specific mention

[11] Doc. Cat. No. 14. Actually it may be possible to narrow the dates within which the commission was officially proposed to June 11, 1641-July 15, 1641, for Cortona's letter to Cassiano dal Pozzo on the former date (Doc. Cat. No. 13) makes no mention of the new work; on the contrary, he informs dal Pozzo that the frescoes of the Sala della Stufa are nearly finished and that he hopes to return to Rome in November.

[12] Doc. Cat. No. 15. [13] Doc. Cat. No. 16.

of work in the Planetary Rooms in the Bilancio della Fabbrica de' Pitti, a weekly account book, which first records activity there during the week ending on the third of August 1641, stating laconically, "Men to the room Pietro da Cortona paints."[14] Thereafter payments associated with work in the room occur at regular intervals for the rest of the month. The fact that Cortona was frescoing in the room before August 3 is seemingly corroborated by a letter of Arrighetti to the Grand Duke written on May 20, 1642, in which he refers back to the August 3 estimate as being drawn up for the first room "which Pietro da Cortona had already begun to paint."[15]

On August 9, a messenger, Vicenzio Salvadori, was paid for having conducted the *stuccatori* from Rome, which would indicate that these specialists arrived in Florence sometime between the third and the ninth of the month.[16]

The work recorded for August must have greatly pleased the Medici, for when Buonarroti wrote to Cardinal Sacchetti on August 17, 1641, his notes for the letter initially included reference to "the satisfaction Sig. Pietro gives to all these Serene Highnesses, serving them with his exquisite works, for which as for his praiseworthy ideas, he has come to be loved greatly by all the virtuosi and all of the good people of this city."[17] The phrase was then canceled, but almost certainly not because it was inaccurate.

Pietro da Cortona also wrote a letter on August 17.[18] The correspondent in this case was Cassiano dal Pozzo, another member of the Barberini circle. In his letter Cortona mentions Buonarroti, makes recommendations for the engraving of the Salone Barberini, and comments on the publication of a book by G. B. Ferrari for which he had provided illustrations.[19] From his discussion of his present circumstances, it is evident that Cortona is distressed by a situation developing at the grand-ducal court, the precise nature of which is not stated, but which must relate to his work in the palace.

[14] Doc. Cat. No. 17.

[15] Doc. Cat. No. 65.

[16] Doc. Cat. No. 18. If the accuracy of the Depositeria Generale accounts can be trusted, the *stuccatori* did not draw wages until August 15 (see Doc. Cat. No. 52). The exact circumstances are by no means clarified by the fact that on September 28, 1641, a payment of 120 *scudi* is recorded to "Gio. Maria Sorrisi e compagni stuccatori di Roma per loro prov.ne di mesi dua e a buon conto" (Doc. Cat. No. 28).

[17] Florence, Biblioteca Laurenziana, Archivio Buonarroti, 40 (minute di lettere di Michelangelo Buonarroti il Giovane), c. 99v.: "Al S.r Card.le Sacchetti addì 17 di Agosto 1641. Persuaso dal S.r Pietro da Cortona mio [cancelled: gratissimo e discretissimo] ospite, che la mia non sia per essere importunità, io mi presenterò chiamato inofficiosamente e intempestivo a baciar la veste a V. Em.a [cancelled: con significar a quello la soddisfazion

che egli dà (a) queste AA. servendole con l'esquisite sue fatiche, stimate e amate grandemente da tutti i virtuosi di questa città]. M'inclino con ogni più umil devozione recordevole degli obblighi particolari che io tengo all'umanità di V. Em. e generalmente a tutta la cortesissima casa sua, mentre io significo a V. Em.a la sodisfazion che esso Sig.r Pietro dà a tutte queste Ser.me AA. servendole con l'esquisite sue fatiche per le quali, come per li laudevoli suoi pensieri, viene amato grandemente da tutti i virtuosi e da tutti i buoni di questa città." This letter and the following one were found by Gino Corti. On the same day Buonarroti also wrote to Cav. del Borro (Archivio Buonarroti, 40 [minuti di lettere di Michelangelo Buonarroti il Giovane], cc. 99v.-100r.). The letter also mentions Cortona but provides no new information.

[18] Doc. Cat. No. 19.

[19] The book in question was G. P. Ferrari's *Horti Hesperides*, Rome, 1646.

"The Grand Duke," Cortona writes, "is a very shrewd prince and this is a business to be treated with much dexterity, and if it comes to a critical point, I, though little adapted, will cope in the manner that your Most Illustrious Serenity indicates." In all probability the negotiation in question involved the terms of agreement concerning the decoration of the Planetary Rooms.

In any event, the negotiations for the Planetary Rooms prompted Buonarroti to write a long and confidential letter to Luigi Arrigucci on August 24, 1641.[20] In this letter, which we have quoted often, he relates the history of the Sala della Stufa commission and his own role in its extended negotiation, his long service as the Florentine host of the painter during months of work, the inadequacy of his accommodations for such a purpose, and the difficulties occasioned by his own ill health. To this he adds that a new undertaking has commenced that represents months and months of work, and that his own endurance is now exhausted. He pleads for help in the removal of his guest with all possible diplomacy, but also with dispatch. How Buonarroti's plight was resolved is not known. No mention of a change in the painter's lodging appears in the grand-ducal ledger. Perhaps he was simply moved into the Pitti Palace, or possibly Buonarroti remained burdened with his guest until he died in 1647. We do know, however, that later in Cortona's Florentine sojourn relations between the two were not perfect. On February 8, 1643, when Cortona was in Rome, Buonarroti wrote his confidant Luigi Arrigucci the following ironic lines: "If Sig. Pietro da Cortona should speak evil of me, you can believe anything he says. If I should speak well of Monsig. Malaspina, don't believe me."[21]

Early in the fall of 1641 a request was made for the services of Cortona in France. The negotiations are described in a letter written by Cardinal Jules Mazarin, on behalf of Richelieu and Louis XIII, to Cardinal Giulio Sacchetti, who turned the missive over to Cardinal Antonio Barberini, in whose archives it now resides.[22] The letter, dated September 24, 1641, opens a firm attempt to secure the services of Cortona for the French crown. Chantelou has served as an intermediary and has already informed Mazarin that Cortona was pleased with his *impegno* with the Grand Duke in the summer just past, i.e. the arrangements, financial and otherwise, for the finishing of the Sala della Stufa, and these terms it is assumed could serve as a gauge for the painter's recompense. Through the rather terse wording gleams the sharp metal of French political power. Mazarin is quite sure that Sacchetti can work it all out, but offers also to write to Cav. Giovanni Battista Gondi, who was formerly the Grand Duke's ambassador to France, to encourage the Grand Duke to put off the completion of the work under way in his palace so that Cortona can make the trip to France immediately. Everyone, it seems, is to be handsomely rewarded if the project materializes, especially the artist,

[20] Doc. Cat. No. 22.
[21] Florence, Biblioteca Laurenziana Medicea, Archivio Buonarroti, 40 (minute di lettere di Michelangelo Buonarroti il Giovane), c. 113r.: "Se il Sig.re Pietro da Cortona dicesse mal di me, gli presti fede in tutto e per tutto. Se io dicessi io ben di Mons.r Malaspina, non mi creda."
[22] Doc. Cat. No. 27.

whose treatment while in France is certain to equal at the very least that accorded Leonardo da Vinci. Mazarin also points out that the French galleys anchored at Civitavecchia can be used to bring the artist to France.

During the crisis in the Casa Buonarroti and the French attempt to secure Cortona's services, the grand-ducal accounts indicate that work went on steadily during August, September, October, November, and December 1641.[23] The same sources provide information relevant to the Roman *stuccatori*, such as payment to their hotel keeper, their monthly payments, and rental payments for the house in which they were finally installed.[24]

At this juncture, a problematic document must be introduced. This document, a letter written by Cortona to Cassiano dal Pozzo, contains the important information about the status of work in the first room: "Right now," Cortona wrote, "I am moving ahead on the work of His Highness and within two months I will have finished the fresco of the first room and then I will be able to prepare the second"[25] This letter was first published by Giovanni Bottari with the date 20 December 1644. Hans Geisenheimer, in the light of other documents published by him, redated the letter to 1641.[26] He assumed that Cortona referred exclusively to his own share of work in the decorations and that the slower labor of the *stuccatori* would account for the completion of the room in the following December (in spite of the fact that Cortona's December 30, 1642, letter states that he has finished *painting* the room he has just finished).[27] New documentation covering the spring and summer months of 1642 provides surer support for Geisenheimer's placement of the letter found by Bottari in 1641. This documentation, to be considered below in detail, consists of accounts of gilding in the Sala di Venere and of preliminary work in the second room starting in March 1642 and a previously unpublished estimate for the third room in February 1644. This evidence would make the date of December 1641 a virtual certainty rather than a conjectural probability were it not for the fact that one document appears to record work by the *stuccatori* in the first room from March to the end of May 1643 and an avviso sent to the Court of Modena on November 21, 1645, announces the opening of a room in the series—described as the *anticamera segreta*—and preparations for work on the *seconda camera*. Although it is possible that the isolated payment may be in error as to where the *stuccatori* were working (errors as to names and places frequently occur in the grand-ducal accounts and inventories) and the avviso may be inaccurate (the first room in the series

[23] Doc. Cat. Nos. 17, 18, 20, 21, 23-26, 28-39, and 41-43.

[24] Doc. Cat. No. 26 (for hotel keeper); Nos. 28, 32, 37 (for monthly payments to the Roman *stuccatori*); and No. 35 (for house rental).

[25] Doc. Cat. No. 40. On the basis of this letter we may assume that Cortona had abandoned his projected December trip to Rome mentioned by Buonarroti in his August twenty-fourth letter

(Doc. Cat. No. 22).

[26] Specifically the May 20, 1642, assessment of work on the first room and estimates for the second (Doc. Cat. No. 65) and the news contained in a letter Cortona wrote to Cardinal Barberini on December 30, 1642, that "having finished the room of S.A., I hope to be in Rome at the end of January . . ." (Doc. Cat. No. 78).

[27] Geisenheimer, *Pietro*, 6 and 31, No. 28.

was not an anticamera), a more likely explanation is that the Sala di Venere was largely completed in 1642 and that Cortona and, as we shall suggest below, his *stuccatori* returned to complete the Medici portraits at a later date. When these were completed, the room was officially unveiled, an event the Modenese Ambassador dutifully recorded. The payments entered in the weekly accounts indicate that the traditional 1642 completion date for the Sala di Venere must be correct even if some additional activity occurred in that room later or if a special ceremonial opening was enacted as late as 1645.

SALA DI APOLLO, 1642 (?), AND SALA DI GIOVE, 1642-1643/44

During January and February of 1642 there are steady reports of activities in the "first room of Cortona."[28] Also there are receipts covering the payments of the estimate of August 3, 1641, drawn up by Arrighetti and of the Roman *stuccatori* for their first six months of work.[29] In March, operations continue with no change until the twenty-second, when, in addition to the usual reference to the first room, there is another item: "Men to the second room Pietro da Cortona is painting."[30] From this notice, it is clear that work had started in the second room during the seven-day period preceding March 22, 1642, approximately on schedule with the artist's statements in his letter of December 20 to Cassiano, in which he had predicted that he would have preparations for the second room under way in two months' time.[31] Further proof that the first room was nearing completion is the appearance of payments made to Giovanni Battista Rosati against the cost of gilding the first room (referred to as the Camera delli Stucchi) on March 29th, after which date these payments occur consistently until the last page of the account book, dated July 24, 1642.[32] Logically, the work of gilding the stucco figures constitutes the last phase of operations and, therefore, indicates that both Cortona and his *stuccatori* had completed, or nearly completed, their work in the first room.[33]

Record of work in the room identified as the *seconda camera* occurs in the account book for three weeks' duration; then there is an intermezzo from April until the last week of June, after which this room is mentioned constantly until the last entry in this ledger, dated July 24, 1642.[34] This delay may have been due to the time needed to draft an estimate of the expected expenses of the second room and to render an

[28] Doc. Cat. Nos. 43-50.
[29] Doc. Cat. Nos. 51 and 52. For Arrighetti's estimate see Doc. Cat. No. 16.
[30] Doc. Cat. Nos. 53-56.
[31] Doc. Cat. No. 40.
[32] Doc. Cat. Nos. 57, 59-61, 63-64, 66, 68, 70, 72-74.
[33] It should be remembered that the application of gold leaf was the final stage in the decoration of the Salone Barberini as Cortona described in a letter to Michelangelo Buonarroti the Younger: ". . . now I am at the termination of the work of the Sala . . . now the great cornice that goes around [the ceiling] will be gilded" (Doc. Cat. No. 11).
[34] For the three-week work period in the *seconda camera* see Doc. Cat. Nos. 56-58 (March 22-April 5). Mention of this room next occurs in the entry for June 28 (Doc. Cat. No. 71) and thereafter in the remaining entries (Doc. Cat. Nos. 72-75).

accounting of the cost of the first, a document Andrea Arrighetti presented to the Grand Duke on May 20, 1642.[35] It is also possible that the *seconda camera* in which the account book records work in late March and early April is not the same *seconda camera* for which Arrighetti's estimate was drawn up or for which the late June and later entries apply. Such an interpretation, though tenuous, would conform to Giuliano Briganti's theory of an abortive campaign in the Sala di Apollo, the room adjacent to the Sala di Venere, in which scaffolding was erected and then (possibly after the execution of some work) the decision was made to move directly to the Sala di Giove, the throne room.[36]

Arrighetti's letter gives full account of the expenses for the first room and the projected expenses of the second. Alluding to the preliminary estimate for the first room prepared on August 3, 1641, this report states that, "On the third of August just past, it was presented to Your Highness that in order to go ahead on the first room, which Pietro da Cortona had already started to paint, there was needed in the first place an allowance of 70 *scudi* a month for the entire time the work lasts, to pay the three *stuccatori* that were brought from Rome with a *muratore* and *manovale*, and besides 450 *scudi*, for the moment enough for the costs of the Pozzolanian sand, the Pisan lime, timbers, iron work, and other manufactures. And in conformity to this, Your Highness ordered the assignment on the fifteenth day of the same [month].[37] Today this work is so reduced that by the end of July or a little more one is assured that it will be completed. And one is able to see almost to a point at what level these same expenses will reach and also that of the gold which one could not state then [August 1641] because it was not known what would be the *concetto* of the painter. Now we have word for Your Highness that the first expense of seventy *scudi* a month [for the *stuccatori*] will come to 840 *scudi*; the second of 450 [mentioned in the estimate of August 1641 to cover cost of materials], to be much increased, will come to 880 *scudi*, and that of the gold to at least 1000 *scudi*, taking account that there are to be used more than 80,000 pieces of gold. Thus all the cost of the first room, without that which Your Highness will give to Cortona, will be 2720 *scudi*, and also one is able to reckon what the second will cost which is ready to be commenced. Now it is therefore necessary that Your Highness in the first place order 430 *scudi* be paid above the 450 [requested], and a thousand *scudi* for the cost of the gold for the expense of the first room, and for the cost of the second grant me an allowance of 70 *scudi* per month for the period the work will last, and order paid one thousand eight hundred and eighty *scudi* for the gold and other stores and manufactures as above. In total [aside from the 70 *scudi* a month] that is three thousand three hundred ten *scudi*"

This document confirms our assertion that Cortona started painting the first room, the Sala di Venere, shortly before August 3, 1641. It reveals that not only were the

[35] Doc. Cat. No. 65.
[36] Briganti, *Pietro*, 235ff.

[37] For the estimate of August 3, 1641, and the rescript of August 15 see Doc. Cat. No. 16.

painter's ideas about the gilded stucco decorations not fixed at the time of the August 3 estimate but that the basic expenses of the work were underestimated. Arrighetti's wording also suggests that the cost of gilding was much more than anticipated. The room, however, is to be finished by July, or shortly thereafter, and the cost of the *stuccatori*, at 70 *scudi* a month, will come to 840 *scudi* which would be exactly twelve months of work. Since we know that the *stuccatori* started in August 1641, we may assume that they were expected to have finished their labors in the first room during July 1642. Finally, we are given an estimate—presumably a more accurate one than that initially provided for the Sala di Venere—for the second room: 1880 *scudi* for all expenses except the *stuccatori* and, of course, the remuneration of the artist. The rescript dated May 25 of this document adheres to conventional phrasing; there is no hint of grand-ducal reaction to the soaring cost of his decorations. We may assume, therefore, that sometime between May 25 and the week ending June 28, 1642, Pietro da Cortona started the frescoes in the second room in the series.[38]

Before pursuing the chronology of the Planetary Rooms, we must determine which room in the series was in fact the second to be decorated. One room can be immediately ruled out, the last room in the series, the Sala di Saturno, decorated much later (1663-1665) by Ciro Ferri. This reduces the candidates to three rooms: the Sala di Marte, the Sala di Giove, and the Sala di Apollo. The Sala di Marte was the first choice of Geisenheimer, who argued that its small zone of stucco decorations and large areas of fresco would have permitted Cortona to proceed unimpeded by the slowness of the *stuccatori* whom he assumed, on the basis of an isolated payment, to have been still working full time in the Sala di Venere in May 1643.[39] But the selection of the Sala di Marte creates major problems with interpretation of documentary sources, not the least of them being the enormous outlay requested for supplies and gold for the second room (1880 *scudi* worth in the estimate of May 20, 1642), and the dispersion of these funds, which are often listed on the receipts in the Depositeria Generale as specifically for gold for the second room, between December 1643 and April 1644.[40] How could the gold and other supplies for the Sala di Marte possibly cost as much as those for the Sala di Venere? Faced with this problem, Geisenheimer qualified his reconstruction of the chronology and admitted that the Sala di Giove might actually have been room number two in the chronology, adding that the Depositeria Generale documents "do not permit any stringent conclusions."[41]

Let us consider the primary reason for Geisenheimer's placement of the Sala di Marte as the second room undertaken by Cortona; namely, the necessity that he and his *stuccatori* work in chronological conjunction. Surely the technique employed in making the stuccoes is an issue here, although Geisenheimer never alludes to this question. Stucco figures and ornamental architectural members of the size involved in

[38] All published chronologies place the Sala di Venere 1641-1642.

[39] Doc. Cat. No. 82. Geisenheimer, *Pietro*, 6.

[40] Doc. Cat. Nos. 84, 86-91, 93-96, 98-103.

[41] Geisenheimer, *Pietro*, 7, n. 1.

the Planetary Rooms were most certainly not executed in situ. Instead, elaborate templates would have been made of the vaults, and, with these as guides, the stucco elements would have been made either on the floor of the room in question or elsewhere in the palace. Some of the elements to be produced in stucco would have been formed in clay from which molds would have been taken and from which, in turn, the stuccoes would have been cast. Others, such as the figural portions of the decorations, were probably built up on armatures of bone, wood, or iron. Cleaning, polishing, and cutting would have been finished largely before the stuccoes were fastened into place with screws, cleats, or with a binding material. Of course final adjustments and finishing including gilding, would have been completed in situ. With this process in mind, it scarcely seems essential for Cortona and the *stuccatori* to work at the same pace; it would surely be to Cortona's advantage to finish fresco areas before their stucco surrounds were in place and merely to return after the *stuccatori* were finished to execute final touching up.

There is, therefore, no need for the second room in order of execution to have been the one in which there is relatively little stucco work. This leaves us free to consider one of the two elaborately stuccoed rooms: the Sala di Giove or the Sala di Apollo.

The Sala di Apollo is the second room in the series in terms of its physical position in the palace; therefore on grounds of rational order it would seem a likely candidate were it not for one crucial fact. The room was left unfinished when Cortona left Florence in 1647, which argues for its position as fourth in order of execution. Recently, however, Briganti advanced the theory that it was the second room in chronological order, at least in terms of the execution of its stucco work.[42] The principal support for this argument is the statement found by Geisenheimer in the *Diario del Corte* dated February 23, 1661, that the Sala di Apollo had been opened that day and that the room had had "those rickety structures for eighteen years"—meaning its scaffolding. As Briganti pointed out, this indicates that the vaults were accessible to painter and *stuccatori* as early as c. 1642-1643.

At best the argument for the Sala di Apollo as the second room would seem to be that it was the scene of a "false start," that construction of the scaffolding did take place there, probably early in 1642, but for reasons discussed below the order of execution was changed and all estimates and probably all payments for work in the "second room" certainly refer to the third room in the series, the Sala di Giove. It would follow from this explanation that, while little or, more probably, no work was carried out in the Sala di Apollo in 1642, preliminary stages in its design were undertaken at this time. This is an attractive and reasonable hypothesis because the design of this room has many affinities with that of the Sala di Giove, which is in many ways a more developed

[42] Briganti, *Pietro*, 235ff.

decorative program in its integration of illusionistic space and ornamental architecture and in the deployment of figures in a bolder *di sotto in su*.

The arguments for the Sala di Giove and against the Sala di Apollo as the second room to be executed are, however, considerable. The Sala di Giove is the one room in the series that approximates the dimensions and splendor of the Sala di Venere; hence it follows that its costs should be similar in terms of materials and gold. In contrast, the Sala di Apollo, though sumptuous, is much smaller. Besides it is possible that the scaffolding was constructed well in advance of the commencement of work in the Sala di Apollo. Also, if the *stuccatori* started in the Sala di Apollo immediately after the Sala di Venere and Cortona worked elsewhere, then we must reconcile ourselves to two meanings for the *seconda stanza* in the documents, one for the painter and another one for the *stuccatori*, a most unlikely situation. On the other hand, the jump to the Sala di Giove, the third room in the series, is rendered less inexplicable when we recall that it was destined to be the throne room, and hence there was good reason to rush its completion. Thus the choice brings us back to the Sala di Giove, the only room that resolves all conditions as the second in the series to be executed. This room, which Geisenheimer advanced as the room in question in his "second" reconstruction, has been accepted—on the basis of Geisenheimer's documents—by Marabottini, Pollak, Posse, Voss, Wittkower, and at one point in his monographic study by Briganti.[43]

New evidence can now be brought to bear on the problem of the identity and chronology of the second and third rooms to be executed in the series. First there is a document, dated February 12, 1644, that requests the sum of 1400 *scudi* for the third room to be painted by Cortona and specifically states that this sum "will be less than half of that which Your Highness assigned for each of the other two, the first and second [rooms]."[44] The Sala di Marte is the smallest room in the series, and it has practically no stucco work and consequently almost no gilding. These facts combine to connect it securely with the third room referred to in this document. As conclusive evidence for the Sala di Marte as following the Sala di Giove in order of execution we have Filippo Baldinucci's biography of Livio Mehus, in which it is stated that Livio (born 1630) was thirteen or fourteen years of age when he left his native city of Milan and traveled to Florence. "In the city of Florence," Baldinucci informs us, "Livio was presented with [a] . . . fortunate coincidence, and it was that at precisely that time the great painter Pietro da Cortona was painting for the Most Serene Grand Duke the royal chambers of the Pitti Palace, and having finished that of Jupiter, he was put-

[43] According to Geisenheimer's "second" reconstruction, the Sala di Giove is the second room and is to be dated 1643-1645, and the Sala di Marte is placed third and dated 1646-1647 (*Pietro*, 7 and n. 1). For the acceptance of this reconstruction— with slight differences in dates—see Marabottini and Bianchi, *Mostra*, 13, n. 25; Pollak, Thieme, and Becker, *Allgemeines Lexikon*, VII, 490; Voss, *Malerei*, 541; Wittkower, *Art and Architecture*, 166 and n. 56; and Briganti, *Pietro*, 143ff.

[44] Doc. Cat. No. 92.

ting hand to that of Mars"[45] Baldinucci's statements confirm our identification of the third room in the series and also strongly support 1643 or early 1644 as the completion date of the Sala di Giove and the commencement of the Sala di Marte.

Our final resolution of the "second room problem" is to endorse the hypothesis that Cortona carried out preliminary designs for the Sala di Apollo after he completed the Sala di Venere and that scaffolding was constructed there at this time. Then, probably because of a strong desire on the part of the Grand Duke and the court to have the throne room decorated, Cortona moved on to the fourth room in the series, the Sala di Giove, where work began in earnest.

As work progressed in the second room, here identified as the Sala di Giove, the withdrawal of sums to cover the work continues to appear in the Depositeria Generale. The first of these, dated October 17, records the transference of 560 *scudi* to Vincenzio Coresi, Camarlingo delle Fortezze, to cover the cost of keeping the *stuccatori* for eight months,[46] as authorized by the grand-ducal rescript of August 15, 1641,[47] that is to say, for work in the first room in the series. Since we already have a similar payment recorded in the Depositeria Generale for the period stretching from August 15, 1641, to February 15, 1642,[48] we can adduce the eight-month period covered by the payment receipt in question to be from February 15 to October 15, 1642, and that during this entire period the *stuccatori* were still at work on the first room. As of October 15, it should be noted, the *stuccatori* had overextended the twelve work-month estimated on May 20, 1642, to be necessary for the completion of the first room by two months, bringing their work time in that room to fourteen months.[49]

Another withdrawal from the Depositeria Generale was recorded on December 5, 1642,[50] when 1430 *scudi* were turned over to Coresi in accordance with the grand-ducal rescript of May 25, 1642.[51] Although this document states that the funds are "for the room that Pietro da Cortona is painting," the sum accounts for the monies needed to fill the revised estimate of May 20, 1642,[52] for the first room less the amount needed to cover the *stuccatori*, who, as we have already seen, were paid by separate disbursements from the Depositeria Generale. We would therefore conclude that this withdrawal applies exclusively to the first room, whose outstanding costs it exactly covers.[53]

On December 30, 1642, Pietro da Cortona wrote to Cardinal Francesco Barberini tendering felicities for the New Year and also informing him that "having finished

[45] F. Baldinucci, *Notizie*, v, 329ff.: "In essa città di Firenze si presentò a Livio un'altra buona congiuntura, e fu, che appunto in quel tempo il gran pittore Pietro da Cortona dipigneva pel serenissimo granduca le regie camere del palazzo de' Pitti, e avendo finito quella di Giove, aveva messo mano a quella di Marte"

[46] Doc. Cat. No. 76.

[47] Doc. Cat. No. 16.

[48] Doc. Cat. No. 52.

[49] This estimate (Doc. Cat. No. 65) had allotted 840 *scudi* at 70 per month for the Sala di Venere.

The two entries in the Depositeria Generale (Doc. Cat. Nos. 52 and 76) discussed above total 980 *scudi* at the same rate of payment.

[50] Doc. Cat. No. 77.

[51] For rescript see Doc. Cat. No. 65.

[52] Doc. Cat. No. 65.

[53] The sum in question covers the 1000 *scudi* needed to gild the first room and the 430 *scudi* needed for general expenses above the sum of 450 *scudi* originally requested for that purpose in the estimate of the costs drawn up on August 3, 1641 (Doc. Cat. No. 16).

painting the room of His Highness I hope to be in Rome at the end of January."[54] This letter refers to the completion of the frescoes but not the stuccoes of the Sala di Giove.

During this period, Cortona was involved in another project for the Medici—a ceiling fresco in a palace in the via della Scala belonging to Cardinal Gian Carlo, now the Ginori-Lisci Palace. The vault depicts an *Allegoria della Quiete* in which a sleeping female figure's quiet slumber is threatened by demonic apparitions.[55] An inscription on the fresco reads: LARVE IMPORTVNE E SOGNI SPAVENTOSI/NON TURBINO ALLA QVIETE I SOAVI RIPOSI. Although we have no exact date for the fresco, a preparatory drawing for the scene now in the Uffizi bears a fragmentary inscription in a seventeenth-century hand other than Cortona's which reads: "[Pietro] da Cortona [nel(?) Palazz]o del S.e P.e Gio. Carlo. 23 li Genn.o 1642 [1643]."[56] The drawing is highly finished and may have served as a *modello* to be presented to the Cardinal, in which case the date inscribed on it may be the date of presentation.

Very shortly after the preparatory study in question received its inscribed date, Cortona, true to his promise to Cardinal Barberini, hurried off to Rome. On January 31, 1643, he wrote to Prince (later Cardinal) Leopold from Rome thanking the Grand Duke for the use of a sedan chair without which "I would not have been able to arrive in time for the Festa of S. Martina [30 January]" and closes with hopes of being honored with requests "while I remain this little time in Rome."[57]

How long did Cortona remain in Rome? On May 24, 1643, he was still in Rome when he was elected *censore* of the Academy of San Luca.[58] The next letter from the artist to the Tuscan court was written from Rome on June 1, 1643.[59] In it he acknowledges the receipt of a letter from the Grand Duke, to whom he affirms his eagerness to

[54] Doc. Cat. No. 78.

[55] See Briganti, *Pietro*, 272, Pl. 289, who mistakenly thought that the fresco was completely forgotten and unmentioned in Florentine guides. L. Passerini, *Degli Orti Oricellarj*, Florence, 1854, 28, states that the palace came into the possession of Gian Carlo in 1640 and attributes the fresco to Cortona (20). Another nineteenth-century guide book, *Illustrazione degli Orti Oricellari*, repeats the same information (19, n. 1). Both sources connect Bianca Cappello, mistress and later the second wife of Francesco I de' Medici, with the sleeping female in the scene. The association is most doubtful.

[56] Florence, Uffizi No. 7326 F. 258 × 394 mm. Pen, bister wash over pencil. This drawing together with an earlier preparatory sketch now in Berlin were published by K. Noehles in his review of G. Briganti, *Pietro, Kunstchronik*, xvi, No. 4, April 1963, 105, Figs. 3a and b. See also P. Dreyer, *Römische Barockzeichnungen Aus Dem Berliner Kupferstichkabinett*, Berlin, Jan.-June 1969, 25f. and Pl. 25.

[57] Doc. Cat. No. 79. Although the sedan chair probably indicates that the painter was not in the best of health (he had arrived on horseback in May 1641), the use of such a conveyance for a trip from Florence to Rome was far from unusual in the seventeenth century and should not be construed as indication that Cortona returned to Rome an invalid. The Prior Count Gualdo Galeazzo (*Relatione della Città di Fiorenza e del Gran Ducato di Toscana*, Florence, 1668, 106) provides a graphic description of the principal Tuscan roads: "È Fiorenza lontana da Roma 150 miglia, da Siena 36, da Bologna 55. Per queste strade si viaggia a cavallo o in letiga. Qualche carozza va a Roma; ma il camino è non poco disastroso." For the conveyances for normal travel in the period see E. S. Bates, *Touring in 1600*, London, 1911, 190ff.

[58] Rome, Archivio dell'Accademia di San Luca, Vol. 43 (Congregazioni 1634 al 1674), fol. 55r. I wish to thank J. R. Martin for calling this document to my attention.

[59] Doc. Cat. No. 81.

serve, but confesses that the "multiplicity of things commenced at Rome" will keep him there until at least the Feast of St. John the Baptist. He adds that the heat makes his return trip more and more difficult. Of the *muratori* and the *stuccatori* he states that he has nothing to say.[60] In closing, he speaks again of a short stay in Rome. All evidence suggests that Cortona's refrain of "little time here" was no more than a placebo to grand-ducal hopes of his swift return to Florence. The next correspondence in fact is a letter written by Cortona on December 27, 1643.[61] Addressed to Cardinal Francesco Barberini, the letter wishes the prelate a Happy New Year and informs him of the safe arrival of the artist in Florence. After an absence of nearly a year, Cortona was once more in the capital of Tuscany.

Although Cortona made no allusion to external political events in his correspondence with the Tuscan court during his absence in 1643, it was undoubtedly true that his decision to remain in Rome was not entirely voluntary, for the period during which Cortona worked in the Sala di Venere and the Sala di Giove witnessed the deterioration of relations between the Papacy and the Grand Duchy of Tuscany. As early as August 31, 1642, the Grand Duke had entered into a defensive treaty with his cousin Odoardo Farnese (the Duke of Parma), the Duke of Modena, and the Republic of Venice against the attempt of Pope Urban VIII to seize Castro and Ronciglione, which were held by Odoardo in fief to the Papacy. In June 1643, the same month in which Cortona wrote to Florence begging to be excused for his detention in Rome, the defensive treaty of 1642 was changed to an offensive alliance, and Tuscan forces marched against the Papacy in a minor war that culminated in the Battle of Mongiovino (September 4, 1643), in which twenty-five soldiers perished. Shortly thereafter the so-called War of Castro subsided, and on March 31, 1644, a peace treaty was signed in Venice. Even if Cortona had wished to return to Tuscany prior to a suspension of hostilities, it is extremely unlikely that his principal Roman patrons, the Barberini, would have permitted him to make the trip. On the other hand, when the fighting ceased he would have had good reason to return to Florence and continue his decorations for Urban VIII's former enemy. The depleted papal treasury had no funds for commissions, and furthermore the artist's personal connections with the Barberini would have been of small value; Urban VIII died on July 29, 1644, and there followed a decline in the family fortunes which reached their nadir in January 1646, when the Cardinals Francesco and Antonio fled from Rome to France, where they joined Taddeo, who had left Rome the previous June.

The Depositeria Generale yields four documents related to the Planetary Rooms for the period of Cortona's absence from Florence. Three of these documents are payments for the wages of the Roman *stuccatori*. The first is for a period from October 15, 1642, to the end of February 1643,[62] and thus continues without interruption the earlier

[60] It would be most interesting to know if Cortona refers here to a search for additional *stuccatori* and *muratori* or if his remark is directed at those working with him in Florence.

[61] Doc. Cat. No. 85.

[62] Doc. Cat. No. 80.

payments already discussed. This payment is followed by a second installment covering their work from March first to the end of May 1643.[63] The third and last payment made during the year of 1643 covered a five-month period from the end of May to the end of October.[64] The second payment in this series raises a complication in our reconstruction of the chronology, for whereas neither the first nor third stipulate specifically in which room the *stuccatori* were working, the second payment states that it is for the *stuccatori* "for work completed in the first that Pietro da Cortona paints." This is the source of Geisenheimer's assertion that work was continuously in progress in the Sala di Venere until the middle of 1643.[65] Such an interpretation, however, is unconvincing in the light of the documents we have already discussed, which indicate that the gilding in the first room was well under way by the summer of 1642. Furthermore, the fourth document in the Depositeria Generale dated 1643 commences a series of seventeen payments for the gilding of the second room (the Sala di Giove).[66] Written on December 18, 1643, it is drawn against the 1880 *scudi* set aside for the gilding of the second room in the Arrighetti estimate of May 20, 1642.[67] The final payment for gilding of the second room was made on April 22, 1644.[68]

About the time the gilding commenced, Cortona made a trip to his birthplace, Cortona, where he spent time examining the control of the river Chiana. This trip and his observations, subsequently reported to the Grand Duke, are discussed in a letter the artist wrote to Cardinal Francesco Barberini on January 10, 1644.[69]

SALA DI MARTE, 1644-1645/46

By the time 800 *scudi* had been expended on the gilding of the second room (nearly half the sum originally requested), a preliminary estimate for the cost of the third room had been submitted. This previously unpublished document was drawn up by Andrea Arrighetti in the form of a letter addressed to the Grand Duke on February 12, 1644.[70] "In order to carry ahead the third room to be painted by Pietro da Cortona," the letter states, "there will be needed, from what he says, an assignment of about 1400 *scudi*, which will be less than half of that which Your Highness allotted for each of the other two, the first and the second." On March 1, 1644, as indicated by the rescript, the sum in question was withdrawn from the Depositeria Generale. This letter gives us a fairly exact date for the initiation of the third room (March 1644) and, because of the relatively small sum involved, confirmation, as we have already pointed out, of the Sala di Marte as the third room in the series to be decorated.

[63] Doc. Cat. No. 82.

[64] Doc. Cat. No. 83.

[65] Geisenheimer, *Pietro*, 6.

[66] Doc. Cat. Nos. 84, 86-91, 93-96, 98-103.

[67] Doc. Cat. No. 65.

[68] These payments total 1680 *scudi*, rather than the 1880 *scudi* originally requested. This would seem to mean that the actual cost of gilding and other work came to slightly less than originally estimated. On the other hand, it may mean that some payment records are missing and that the gilding may have started slightly sooner or continued slightly longer than existing documentation indicates.

[69] Geisenheimer, *Pietro*, 19, Doc. C.

[70] Doc. Cat. No. 92.

While work was getting under way in the Sala di Marte, 280 *scudi* were withdrawn from the Depositeria Generale against the salaries of the Roman *stuccatori*, covering a four-month period from the end of October 1643 to the end of February 1644.[71] This is the last entry recording payments to the Roman *stuccatori* and therefore, barring the eventual discovery of more withdrawals from the Depositeria Generale in their name, serves as a *terminus ante quem* for their contribution as a team to the Planetary Rooms of Pietro da Cortona.[72] From our reconstruction of events, this would indicate that the stuccoes of the Sala di Giove concluded the contribution of the Roman *stuccatore* team to the Planetary Rooms. The fact that no mention is made of their stipend by Arrighetti on February 12 lends support to this hypothesis, inasmuch as the *stuccatori* were mentioned in the estimates for the first two rooms.[73] Why the Roman *stuccatori* left at this time is not known. Indeed, there are no letters or other documents describing their motives or attesting to their departure.[74]

If the *stuccatori romani* left grand-ducal employ in February 1644, then to whom did the artist turn for assistance in the execution of the stucco decorations in the Sala di Marte and, assuming its stuccoes were already under way before Cortona's departure in 1647, the Sala di Apollo? To date the records of neither the Fabbriche Medicee nor the Depositeria Generale have yielded any answers. Other sources, including one document connected with the commission, do offer a candidate: Cosimo Salvestrini, whose name appears in the postscript of a letter written by Monanno Monanni in 1659 concerning the arrangements for the completion of the Sala di Apollo, which, as we have already noted, was left unfinished by Cortona when he left Florence in 1647.[75] From the postscript, it is clear that Salvestrini, along with others intimately connected with the commission in question, Arrighetti and Rondinelli, received an accompanying letter, the contents of which, unfortunately, are not known. In addition, sources of a more secondary nature connect Salvestrini with the commission. These sources must, however, be used with some caution, for they are biased in favor of Florentine artists and do not so much as mention the contribution of the Roman *stuccatori* whose importation, as Wittkower has argued, is proof that Cortona did not find in Florence the specialists he needed.[76] With this fact in mind we can turn to the information provided by the literature of art.

[71] Doc. Cat. No. 97.

[72] As we shall later see, one of their number returned to help in the execution of the stuccoes of the Sala di Saturno decorated by Ciro Ferri.

[73] Cf. Doc. Cat. Nos. 16 and 65.

[74] Wittkower's statement (*Art and Architecture*, 362, n. 19) that the fact that the capo of the Roman *stuccatori* worked with Algardi on decoration of the Villa Doria Pamphili (commenced in 1644) provided a motive for the departure of the *muratori* is unconvincing. Howard Hibbard has pointed out to this writer that no *stuccatori* of this quality would have been needed for this Roman project

until much later in the building program.

[75] Doc. Cat. No. 115. Very little is known about Salvestrini beyond the fact that he was a pupil of Francesco Curradi, who taught him how to work porphyry. His best known work is the restoration and transformation of an antique draped torso into a Moses for the grotto of the Cortile Grande of the Pitti Palace. This work was started by Curradi and carried to completion by Salvestrini. See U. Thieme and F. Becker, *Allgemeines Lexikon der Bildenden Künstler*, Leipzig, 1935, XXIX, 360, and Baldinucci, *Notizie*, 1846, IV, 428.

[76] Wittkower, *Art and Architecture*, 360, n. 58.

Filippo Baldinucci states that Cosimo Salvestrini ultimately completed the stuccoes of the first room and also executed parts in the other rooms "on some of which Pietro himself worked at times, especially on some smallish female figures dressed in draperies according to the finest ancient Roman style."[77] Baldinucci's son, Francesco Saverio, makes this tantalizing bit of information even more specific. In his biography of Pietro da Cortona he locates the two female figures in the Sala di Giove and describes them: "two of these women of stucco, placed in the corner [of the room] to the right of the entrance were made entirely by our Pietro and therefore they do not lack that design, elegance, and softness of others made by excellent sculptors of that time"[78] The figures in question are readily identifiable [Figs. 102 and 103]. Quite apart from Baldinucci's attribution, their strikingly high quality sets them apart from even the superb quality of the other stucco groups [Figs. 104-106] in the Sala di Giove. The white stucco surfaces of this interlocked couple ripple with life and vitality; they seem powdered flesh in contrast to the relative stylization of the other figures that embellish the enframement of the central fresco. Another source, closer to Cortona than the Baldinucci, father or son, strongly supports the assertion of the artist's intervention in the execution of the stucco decorations. In his letter to Ciro Ferri relating the life of his uncle, Luca Berrettini states that Cortona executed stuccoes as well as frescoes in the Planetary Rooms.[79] The fact that he contributed to the stuccoes in the Sala di Giove is scarcely surprising, for, as our documentation amply attests, this room was just reaching completion (the gilding records extend to April 1644) when the Roman *stuccatori* on whom Cortona had depended relinquished their tasks at the Pitti (February 1644).

It can therefore be argued that it was during this period, early 1644, that Cortona took on Salvestrini, whom he in effect personally trained by executing the two female figures discussed above. It follows that the stuccoes in the Sala di Marte are also by Salvestrini with continuing crucial contributions of Cortona himself. Armed with this experience, Salvestrini, as Filippo Baldinucci stated, carried to completion the stuccoes of the first room. I would argue that the intervention of Salvestrini in the first room in the series, the Sala di Venere, also postdates the departure of the Roman *stuccatori* early in 1644. The gilding of the Sala di Venere was completed years earlier and therefore all areas not pure white stucco can be eliminated from this late intervention. This leaves us, however, with some very significant portions of the room's stucco decorations, including the splendid Medici portraits that gaze down on the spectator from tondos at the center of the springing of the vault on each side of the room. These portraits [Figs. 22-25] I would give to Salvestrini under the direction and collaboration of Cortona and would date between 1644-1647 and, for reasons reviewed below, probably in 1645. The association of the portraits with Salvestrini is not new. Giovanni Cinelli in his manuscript version of a guidebook to Florence associates the portraits with Salvestrini: "All these stuccoes of the intended figures [the portraits] were made

[77] Baldinucci, *Notizie*, 1846, IV, 428.

[78] S. Samek Ludovici, "Le 'Vite' di Francesco Saverio Baldinucci . . . ," *Archivi*, XVII, 1950, 87.

[79] L. Campori, *Lettere Artistiche Inedite*, Modena, 1866, 508. The letter was apparently written in 1679.

by Salvestrini."[80] Francesco Inghirami, writing in 1819, cites Cinelli and reiterates the same attribution.[81] And this would seem a plausible assessment, provided that one accepts the direct intervention of Cortona, who had the requisite abilities and was in any event the designer of the stucco ensembles.[82]

As we have already noted, the outlays for gold leaf for the second room continued until April 24, 1644, when 80 *scudi* were disbursed against the 1880 *scudi* originally requested for these decorations. The fact that this sum matches the last two digits of the original request (whereas the other payments had been made in 100 *scudi* installments) suggests that this is in fact the last payment, and thus its date may serve as at least an approximate though, given the slowness with which the Depositeria Generale disbursed funds, late completion date for the decorations of the room.

From this assessment of available documentation we may reasonably conclude that Cortona's frescoes in the Sala di Giove were finished in late 1642 and that the stuccoes were completed late in 1643 or, at the latest, early in 1644. Cortona finished the frescoes of the Sala di Giove by late December 1642. He returned to Rome in January 1643, and remained there until December of the same year and therefore had been in Florence a little more than a month before the estimates for the Sala di Marte were submitted to the Grand Duke on February 12, 1644. This would be sufficient, but scarcely excessive, time in which to develop the *concetto* of the decorations upon which Arrighetti based his estimates of expenses.

Possibly before, or in any event very shortly after, Arrighetti submitted the estimate for the third room, Cortona departed Florence for Venice. Three sources attest to this trip in the spring of 1644, although none precisely defines the length of Cortona's stay. We are informed of this trip by passages in Marco Boschini's *La carta del navegar pitoresco* published in 1660, by references in a letter written by Paolo del Sera in 1658, and by an ambassadorial dispatch from Venice to the Court of Modena written in April 1644.[83] All of these sources connect Cortona's Venetian sojourn with

[80] See Doc. Cat. No. 126 for transcription.

[81] F. Inghirami, *Descrizione*, 22: "Sopra la prima parete [of the Sala di Venere] sono i ritratti di Ferdinando I, unitamente a Cosimo II. Sopra la seconda sono i Pontifici Leone X, e Clemente VII. Sulla terza è Ferdinando II che ha Cosimo III ancor fanciullo accanto. Sopra la quarta sono i ritratti di Cosimo I e Francesco. Questi stucchi eseguiti più che a mezzo rilievo furono fatti da Salvestrini, non però gli altri ornati della volta dove gli stucchi sono messi a oro."

[82] See Drawing Cat. No. 53 for a preparatory study for the Sala di Venere stuccoes.

[83] For these sources see: M. Boschini, *La carta del navegar pitoresco*, first published 1660. Critical edition, A. Pallucchini, ed., *La carta del navegar pitoresco*, Rome and Venice, 1966, 243, n. 20; Del Sera's letter is quoted in footnote 119 of this appendix. The text of the Modenese Ambassadorial Dispatch is as follows: Ser.mo Sig.re e Padron Col.mo . . . Pietro da Cortona che è qui col Sig.r Carlo Bichi, dice che li quadri sono bellissimi, che li tre che sono in l'atrio [?] vagliono 3 mila ducati [illegible: d'argento?] et in mano di V.A. vagliono un tesoro; et in gondola ne ha discorso questa mattina con detto Sig.r Cav.r dice però che non possono valer quel danaro se bene [or si bene] differisse [?] assai dal detto Pietro da Cortona che sempre più li va laudando, dicendo che Paolo Veronese non ha fatto opera migliore. Egli lauda anche li altri due quadri, ma non tanto . . . Di Venezia li 18 Aprile 1644 (Modena, A.S.M., Cancelleria Ducale, 102 [Dispacci del residente ducale, Marchese Ippolito Tassoni estense da Venezia, 1644] [filed by date]).

the presence of Cardinal Bichi, who was in the Venetian Republic as a representative of Louis XIV at the settlement of the War of Castro, together with representatives of the Venetian allies (including the Medici) and the Holy See. Bichi arrived in Venice in December 1643 and presumably left at some time following the ratification of the peace treaty in the Cathedral of San Marco on May 1, 1644.[84] The date of Cortona's return to Florence is not known, but the fact that the Grand Duke ordered the disbursement of 500 *scudi* to the artist on July 17, 1644, argues for his presence in Florence by that time.[85] No indication is given of what portion of Cortona's work this sum was to cover.

From July 1644 to January 1645 there is a lacuna in the documentation of Cortona's activities at the palace. On January 2, 1645, the artist received 1000 *scudi* "in account for work he is doing," which implies payment for work in progress, though presumably at an advanced stage, judging from the amount involved.[86]

Sixteen days later Prince Leopoldo wrote to Arrighetti from Pisa a note that was accompanied by one Giovanni Bellini, a gilder.[87] It is possible that Bellini was sent to work in the Planetary Rooms, though the connection is tenuous, consisting only of the fact that his name is here associated with Pietro da Cortona, who in the same note and in the name of the Grand Duke is requested to prepare a design for the facade of the Duomo. Unfortunately no further documents or drawings associable with this project have come to light.

The next reference to Cortona is in connection with another architectural commission. On May 28, 1645, the Fathers of the Chiesa Nuova (S. Filippo Neri) recorded the placing of a cornerstone for their new church, which was to be built according to his design.[88] In a letter dated December 20, 1645, the artist wrote rather sheepishly to

[84] Boschini, *Navegar*, 194, notes for lines 1ff. Cardinal Bichi can be identified as Alessandro Bichi, Bishop of Carpentras, who was promoted to the rank of Cardinal in 1633 by Urban VIII (C. Eubel, *Hierarchia Catholica Medii Aevi*. Monasterii, Regensberg, IV, 1935, 24, 49, 136, 210).

[85] Doc. Cat. No. 104.

[86] Doc. Cat. No. 105.

[87] Doc. Cat. No. 106.

[88] Florence, A.S.F., Carteggio Mediceo, F. 750, Fol. 49v; Geisenheimer, *Pietro*, 32, No. 40. For an attempted reconstruction and attribution of the Cortona preparatory drawings for this church see K. Janet Hoffman, "Pietro da Cortona's Project for the Chiesa Nuova di San Filippo Neri in Florence," unpublished Master's thesis for New York University, Institute of Fine Arts, 1941. See also W. and E. Paatz, *Die Kirchen von Florenz*, Frankfurt, 1941, II, 102, nn. 14, 15. Cardinal Gian Carlo de' Medici has been identified as the member of the Tuscan court who had a special interest in this church (see note 91 below), and this is in all probability correct; however, the Grand Duke was also involved, and it was to him that the Oratory turned when in need of stone which he freely gave from the Boboli quarry. This transaction is recorded in Florence, A.S.F., Fabbriche Medicee, F. 140, c. 54 *interno*: "Ser.mo Gran Duca. I Preti della congregaz[io]ne dell'Oratorio di S. Filippo Neri, humilissimi oratori di S.A.S., desiderando di potere cominciare quanto prima la fabbrica della nuova chiesa, e non havendo pronto comodità di sassi, supplicano l'A.V.S. ad aumentarli le sue grazie, col concederne loro qualche quantità di quei che si cavano di Boboli" The request was approved and twelve *braccia* of stone was donated to the Oratorians on May 7, 1645 (see Florence, A.S.F., Fabbriche Medicee, F. 140, c. 54). For further information about the history of this commission, which became available too late for detailed inclusion in the present study, see A. Cistelli, "Pietro da Cortona e la chiesa di S. Filippo Neri in Firenze," *Studi secenteschi*, XI, 1970, 27ff. Another study has recently appeared with attempts,

Cassiano dal Pozzo, who had apparently advised him not to become involved in architectural projects (advice, in all probability, that Pozzo intended only for Florentine projects), that he had in fact taken on the design of a church for the Filippini. A model had been made and construction was now under way. Furthermore, he admitted, it was because of this project that he had not been able to finish "the room of His Highness before now," adding, "in that which I now begin I have almost prayed for no intrigues."[89] Of primary concern to us is the reference to "the room of His Highness" which, according to Cortona, should already have been finished. The room in question is certainly the third room in the series, the Sala di Marte, begun in the late spring or summer of 1644. A month later he again wrote to Cassiano dal Pozzo thanking him for his encouragement not to abandon the architectural project at hand, adding disconsolately, "I have truly seen and know that in said things I always have bad luck."[90] The words which follow are bitter with disappointment. It is clear that Cortona had received a shattering setback. "And if I have remorse," he adds ruefully, "it is only not to have known more of the profession of painting; only for this there remains in me the spirit and good will to continue studying. Architecture, then, serves only for my entertainment." Cortona, however, persevered with the Fathers of the Chiesa Nuova, and as late as 1666 he was still protesting against alterations to his model for the church, although by that time the project was far more a millstone than an opportunity.[91]

On November 21, 1645, a dispatch sent from the Tuscan Court to Modena reports that a room in the Planetary Cycle had been ceremoniously opened.[92] The room is described as the Private (*Segreta*) Antichamber of the Grand Duke. Cortona's contributions to the ceiling are lauded, and it is stated that "the cornice that encircles the chamber is embellished by fantastic reliefs entirely gilded. And now it is said they commence work on the second chamber which is to be painted by the same painter." The information contained in this dispatch at first appears confusing, for surely the date is much too late for the first room in the series, the Sala di Venere; yet the comments about "stuccoes entirely gilded" most aptly fit this room and certainly do not apply to the Sala di Marte, the room that other documentation places in closest proximity to this date.

The Modena dispatch actually clarifies Cortona's movements. First, the description *anticamera segreta* can be treated as a generalized appellation describing the status

but with little conclusiveness, to provide an analysis of the drawings associated with the S. Firenze commission in the Uffizi collection (E. Rasy, "Pietro da Cortona. I progetti per la 'Chiesa Nuova' di Firenze," *Architettura barocca a Roma*, ed. M. F. dell'Arco, Rome, 1972, 345ff.).

[89] Doc. Cat. No. 108.

[90] Doc. Cat. No. 109.

[91] In September 1660 Cardinal Gian Carlo de' Medici, who, according to Fabbrini (*Vita*, 183),

had induced Cortona to undertake the project, wrote to Cortona, who was then in Rome, asking that he approve certain modifications of his model (Florence, A.S.F., Lettere Artistiche, Vol. III, Fol. 99; Geisenheimer, *Pietro*, 36, No. 85). For Cortona's protestations to alterations see Florence, A.S.F., Lettere Artistiche, Vol. III, Fol. 119; Geisenheimer, *Pietro*, 26f., Doc. P.

[92] Doc. Cat. No. 107.

rather than the function of the room and as such is not inappropriate to the Sala di Venere. Second, reference to the extensiveness of the gilding (*rilievi tutti dorati*) most aptly fits the Sala di Venere, where, in contrast to all of the other rooms except the much later Sala di Saturno, most of the supporting figures as well as the purely architectural ornament are gilded. Third, the portraits of the Medici probably postdate completion of the rest of the stuccoes and are probably the work of Cosimo Salvestrini, who can have entered into the commission only after the Roman *stuccatori* had departed for Rome in February 1644. The completion of the portraits of distinguished members of the Medici House including Ferdinand's heir, Prince Cosimo, born in 1642 [Fig. 25], would have been an occasion of sufficient importance to warrant the recording of the clearing out and opening up of the room. It follows that the *seconda camera* mentioned in the document is the second in physical sequence (not chronological order), and thus this document provides us with an approximate *terminus post quem* for the start of the Sala di Apollo and consequently an approximate *terminus ante quem* for Cortona's work in the Sala di Marte.

On May 1, 1646, Princess Anna married Archduke Ferdinand Karl of Austria in the Sala di Giove.[93] Geisenheimer attached considerable importance to this document, using it as a *terminus ante quem* for the completion of the Sala di Giove.[94] According to the chronology we have established, the Sala di Giove was the second room in the series undertaken by Cortona and consequently was completed long before this notice of 1646.

On November 5, 1646, the French traveler Balthassar Monconys visited the Pitti Palace and the Boboli Gardens with the scientist Torricelli as his guide. After mentioning the sights he considered of particular note—the magnificent view from the gardens, the Neptune Fountain, the antique statues, and a cow with two udders—he alludes to a visit with "Pietro da Cortona, the great painter who paints the vaults of the rooms. I talked with him for a long time and saw his work."[95] Monconys' description betrays the *Wunderkammer* mentality that typified seventeenth-century travelers. However, his account gives evidence that Cortona was at work on the decorations in November 1646. Although the evidence available is admittedly slight, we would surmise that the Sala di Marte was completed sometime before the autumn of 1646 and that when Monconys met the artist he was in all probability at work on the Sala di Apollo.

SALA DI APOLLO, 1645-1647 (?)

To date no documents or letters have been found substantiating Cortona's probable activity in the Sala di Apollo sometime from late 1645 to October 1647, when he

[93] Florence, A.S.F., Carteggio Mediceo, F. 755, c. 293; Geisenheimer, *Pietro*, 13, Doc. III.

[94] Geisenheimer, *Pietro*, 7.

[95] B. Monconys, *Journal des Voyages*, Lyon, 1665, I, 129: ". . . Pietro da Cortona, grand peintre qui peinte les voûtes des chambres, ie l'entretins long-temps & le vis travailler. . . ."

departed Florence. Briganti's theory that work was done earlier in this room may obtain, but barring more concrete evidence, it is more likely that Cortona's substantial efforts in execution—if not design—date near the close of his stay in Florence. In contrast to the lack of evidence for dating his work in the Sala di Apollo, a number of sources attest to his other activities during this, his closing period in Florence.

Two weeks after Monconys talked with Cortona it was announced at an assembly of the Operai di S. Maria Nuova that the Men's Hospital of S. Maria Nuova was to be improved and enlarged "all on the design and architecture of Pietro da Cortona."[96] A notice dated June 28, 1646, allots the sum of 99 *scudi*, 17 *soldi*, and 4 *denari* for a silver necklace to be made for Cortona in recognition of his design for the hospital.[97] Burdened with this additional project during the winter of 1646, Cortona, now fifty-one years old, began to suffer seriously from ill health. On April 8, 1647, he wrote to Cardinal Francesco Barberini, "When I received the letter (an invitation to join the Cardinal in France, written on March 15) I was in bed, and now, as of two days ago, I have started to move around the room with some weakness still in the feet."[98] Apparently Cortona was under pressure from the Cardinal not only to join him but to undertake an extensive project in France, for he adds that the eight or nine months' sojourn suggested by the Cardinal would not be time enough to undertake a significant commission. Declining both invitation and commission, Cortona announced his intention of journeying to Rome in October in order to commence the frescoes of the cupola of S. Maria in Vallicella.[99]

Cortona wrote again to Cardinal Francesco Barberini on June 14, 1647.[100] It is not a cheerful letter. His health has but little improved. He is willing to send the Cardinal easel paintings, but he is now even more emphatic about his disinterest in coming to France and more specific about the project tendered him from there—a large public

[96] G. Targioni-Tozzetti, *Notizie degli Aggrandimenti delle Scienze Fisiche in Toscana . . .*, Florence, 1780, III, 363: ". . . in ultimo fu mostrata da Monsig. Spedalingo alli Sigg. Operai la Fabbrica che si va facendo accanto allo Spedale grande degli Huomini dalla banda degli Orti . . . il tutto con disegno et Architettura di Pietro da Cortona, da lui con gran carità e diligenza invigilato." See also Paatz, *Kirchen*, IV, 2.

[97] Florence, A.S.F., S. Maria Nuova, F. 4591, c. 43r.: "A spese generali scudi 99 di moneta, lire -.17.4, e per dette pagati al Sig.r Bastiano Guidi orefice, che tanti sono per la valuta di una catinella d'argento . . . per donare al Sig.r Pietro da Cortona ingeniere di S.A.S. per ricognitione delle fatiche fatte nel dare il disegno e assistere alla nuova fabrica dello spedale. . . ." I am indebted to James Holderbaum for bringing this document to my attention. It is possible that this necklace did not reach Cortona for nearly twenty years. On April

12, 1664, he wrote the following to Cardinal Gian Carlo de' Medici (Florence, A.S.F., Lettere Artistiche, Vol. III, Fol. 107): ". . . Ho ricevuto da Sig.re Agostino Monanni il regalo della Collana che V.A. si è compiaciuta di farmi, quale ha ecceduto assai, al quel poco, che ho operato per che no so meritavole di tanto regalo, e tanto honore; ma la benignità e magnificenza di V.A. è stata causa che ha ecceduto in me alche no posso corrispondere, se no con una buona volontà, che ho senpre di servirla con la mia poca habilità, se mi fare degno di suoi commandamenti. . . ."

[98] Doc. Cat. No. 110.

[99] Cortona actually began work on the cartoons for the cupola and the tribune of S. Maria in Vallicella in November 1647 (Rome, Biblioteca Vaticana, Codex Barberini Latina, 6458, Fol. 69; Geisenheimer, *Pietro*, 34, No. 52).

[100] Doc. Cat. No. 111.

library commissioned by Cardinal Mazarin. He declines the project respectfully but emphatically. Clearly, Cortona is anxious to be in Rome, not France. Again he mentions his failing health and the Chiesa Nuova (S. Maria in Vallicella) fresco commission that awaits him there. To this he now adds the "Confessione of S. Martina" (the crypt of SS. Luca e Martina), which he states he is "making in accordance with my declining vigour and I am eager to see it finished as it suits me to be able to have this consolation, that I have finished it, because of the others that I have begun I have not been able to see a single one finished; but this which depends on my will I have hopes of seeing [completed]." This letter, too, is marked by bitterness and rancor over the failure of his architecture to achieve the acclaim and acceptance accorded his painting in Florence. Clearly this failure contributed in no small part to his desire to return to Rome in the coming October as projected in his letter of April 8, 1647. He also mentions the recent death of Buonarroti (January 11, 1647), whose example he takes as support of his desire to finish the Confessione of SS. Luca e Martina, for according to Cortona the poet was much distressed to have failed to complete certain projects. Re-emphasizing the magnitude of the S. Maria in Vallicella project, he states, "I turn to repeat that it does not seem possible for me to complete the work in the Chiesa Nuova so quickly, unless I leave the last room of the Grand Duke incomplete, since the winter air of Florence does me much harm and thus to finish it in a more temperate season." This is the artist's last known communication from the Grand Duchy of Tuscany.

An entry in the diary of Andrea Cavalcanti, dated August 26, 1647, indicates that Cortona was still at work on the Pitti decorations and still being consulted by the Grand Duke.[101] On that date, the removal of the paintings that had been installed in the Duomo by Buontalenti in 1589 for the wedding of Grand Duke Ferdinand I and Cristina of Lorraine was started on the advice of Cortona, who, the entry informs us, "was then painting the rooms in the Pitti Palace."

Cortona's mention of Buonarroti's death in his last communication from Florence brings to mind the work executed by the artist for his long-suffering Florentine host. The date of Cortona's contributions—designs for intarsia panels and a small fresco—to Buonarroti's famous gallery in the Casa Buonarroti are not known, but the death of the poet and playwright provides a secure *terminus ante quem*.[102]

In addition to his work for Buonarroti, Cortona found time during his intermittent Florentine sojourns to produce a number of easel paintings. With few exceptions, Cor-

[101] C. Guasti, *Le Carte Strozziane del R. Archivio di Stato in Firenze*, Florence, 1884, I, 61f.: "A dì 26 agosto 1647 si cominciò a levare i quadri grandi e altre pitture che adornavano il Duomo; et era stato ornato con disegni di Bernardo Buontalenti, alias delle Girandole. E dette pitture erano di Goro Pagani, Domenico Passignano, Ludovico Cigoli, Bernardo Poccetti, Santi di Tito e Iacapo da Empoli. E furono levate per consiglio di Pietro Berrettini da Cortona che allora dipigneva le stanze del Palazzo de' Pitti."

[102] For known details of these minor commissions see U. Procacci, *La Casa Buonarroti a Firenze*, Milan, 1965, 16, 18 and 38, n. 81 (for earlier citations and sources and a convincing discussion of the probability that these works were done during Cortona's stay in 1637: 179, 180, 183, 198, 211, 224, 227, 228, Pls. 43, 44, 51, 74 and Figs. 2, 3).

tona's work in the late 1630's and 1640's is not precisely documented; however, at least three paintings executed during this period were for the Medici: *The Return of Hagar to Abraham*, *Herminia Among the Shepherds*, and a *Death of St. Mary Egyptica*.[103] Also, a preparatory sketch now in the Uffizi drawing collection attests to a plan for a painting, a glorification of Grand Duke Ferdinand II.[104]

Although no attempt is made here to review exhaustively the work Cortona undertook while in Florence, one commission that came to light after this study was virtually completed must be considered, for these decorations are in the Pitti Palace. The decorations in question, first correctly identified by Marco Chiarini, comprise a suite of two rooms on the mezzanine floor between the ground floor and the *piano nobile* of the western wing of the central courtyard.[105] The presence of a cardinal's hat prominently displayed in the central field of the vault of the large room together with the use of the motto VASTVM PIVS AEQVOR ARANDVM leave little doubt that the decoration of these two rooms was commissioned by Cardinal Gian Carlo de' Medici, younger brother of the Grand Duke, who was raised to the purple in November 1644. It follows that this commission must postdate his elevation, and of course Cortona's final departure from Florence in 1647 serves as a *terminus ante quem*. As Chiarini has suggested, the fresco in the larger room would seem to commemorate the conferment of this holy office, and therefore a date of execution close to that event is very likely. Chiarini has presented convincing arguments for the attribution of the lunette frescoes depicting the *Finding of Moses*, the *Burning Bush*, *Tobias and the Angel*, and *Hagar in the Desert* to Salvatore Rosa. The adjacent room was transformed into a nymphaeum by Cortona, who designed the ornamental architecture and fountain and painted a *Sacrifice of Noah* on the ceiling.

PERIOD OF INTERRUPTION IN THE DECORATION OF THE PLANETARY ROOMS, 1647-1659

By the latter part of October 1647 Cortona had left Florence, never to return again. His next letter, written from Rome and dated October 27, was addressed to the Grand Duke: "Most Serene Grand Duke. I give notice to Your Highness that my arrival here in Rome has been with very good health for the grace of God and with most beautiful days which go in succession. I hope soon to commence to paint. I have not yet been to

[103] See Briganti, *Pietro*, 217f., 220f. and 222f., Pls. 179-181, 184 and 195. For another candidate, brought to the writer's attention too late for inclusion in the text, see Chiarini, *Artisti*, No. 45, Fig. 35.

[104] Florence, Uffizi No. 11739F. 390 × 260 mm. Black chalk heightened with white on grey paper.

[105] M. Chiarini and K. Noehles, "Pietro da Cortona a Palazzo Pitti," 233ff. Contrary to indicated date of publication, this important article was not printed until late 1970, when this study was at a stage that prevented extensive treatment of these interesting decorations. For further comment on the iconography and style of these decorations, the excellent article by Chiarini and Noehles should be consulted. The relationship of these rooms to the Planetary Rooms is briefly considered in Chapter II of this study. At the time of this writing (spring 1972) the frescoes in the two rooms are under restoration.

Frascati in order to pay respects to Sig. Cardinal Sacchetti and to salute him in the name of Your Highness. While I am absent [from Florence] I am, however, expecting to be favored with your commands which I shall always be most prompt to execute and to record myself most humble, devoted, and obliged servant, Pietro Berrettini."[106]

What other motives precipitated Cortona's departure from Florence? Was it his original intention never to return? Baldinucci states that he left Florence because he was angered and hurt by remarks that unthinking courtiers, annoyed at the presence of his scaffolding, made when they passed through the rooms in which he was working.[107] In this context the caustic observation in the Court Diary when the Sala di Apollo was opened in 1659 should be noted: "Today . . . it was opened at last The room has been with those rickety structures eighteen years."[108] Were the complaints of the courtiers limited to the scaffolding or did they extend to Cortona's decorations? We have already encountered evidence in connection with his architectural projects that Cortona was highly sensitive about the reception of his art. Combined with his humble birth and ingenuousness, his temperament would have made him an easy mark for Florentine wit and invective.

Fabbrini suggests two other reasons for Cortona's departure in 1647 and his refusal thereafter to return to Florence. According to Fabbrini, Luca Berrettini, in his letter to Ciro Ferri, attributed his uncle's departure in part to resentment over the failure of the Grand Duke to intercede for one of Cortona's kinsmen who wished to secure an ecclesiastical prebend in the Collegiata of S. Maria Nuova of Cortona.[109] Curiously, however, there is mention of the matter neither in Campori's publication of the letter nor the original document in the Biblioteca Nazionale Centrale in Florence.[110] But we should not therefore entirely discount Fabbrini's assertion, though he must have confused its source, for it is entirely plausible that Cortona would have interceded for a relative; he had already done so for his cousin, the architect Filippo Berrettini, in regard to a commission for an altar in S. Antonio de' Servi in Cortona.[111] Also, as late as 1652,

[106] Doc. Cat. No. 112. This letter was followed by another similar one to Prince Leopoldo written on November first (Florence, A.S.F., Lettere Artistiche, Vol. III, Fol. 81; Geisenheimer, *Pietro*, 3, No. 51).

[107] Samek Ludovici, "Vite," 85.

[108] Doc. Cat. No. 117.

[109] Fabbrini, *Vita*, 85f.

[110] Campori, *Lettere*, 506ff.

[111] Florence, A.S.F., Fabbriche Medicee, F. 141, *interno* 193, *inserto* of *biglietti* and *lettere* in disorder. This letter, written by Filippo Berrettini to Piero Franchi is dated January 15, 1642. The altar in question was to receive a copy, prepared in 1643 by Adriano Zabarelli, of the Passerini *Assunta* by Andrea del Sarto which was given to the Grand Duke by Cav. Cosimo Passerini for his collection in October 1639 (for a different attribution see

A. della Cella, *Cortona Antica*, Cortona, 1900, 110, who claims to quote Fabbrini's *Memorie* in the Biblioteca Communale, Cortona, where the copy, according to Cella, is ascribed to Baccio Bonetti). An anonymous writer in 1768 noted Zabarelli's name on the painting and the date. Bonetti was a practicing artist when Cortona was a boy (see Fabbrini, *Vita*, 2) and the painting is surely the work of Zabarelli, 1610-1680, a minor Cortonese follower of Pietro. See Florence, A.S.F., Depositeria Generale, F. 801, c. 65r (May 18, 1639) which records the expenses involved. For the transport of the *Assunta* from Cortona to Florence see Florence, A.S.F., Depositeria Generale, F. 1045, No. 360 (dated April 10, 1640) where the expenses incurred are recorded including the cost of having the painting carried on the backs of twenty-four men, presumably with cross poles (cf. G. Vasari, *Le*

long after Cortona had left the immediate employ of the Medici, he suffered no doubts as to the weight of his name in settling a case involving a grand-ducal customs auditor and a Cortonese merchant, Pietro Ambrogini.[112]

Again claiming to quote the letter of Luca Berrettini to Ferri, Fabbrini reports another circumstance which contributed to Cortona's unwillingness to resume his work in Florence; namely, that Florentines were slow to pay him for his labors and had failed to pay the full sum that was his due.[113] In support of this contention it should be noted that only three payments for his work in the Pitti have been located—one dated July 27, 1644, for 500 *scudi*;[114] another drafted on January 2, 1645, for 1000 *scudi*;[115] and a payment of 600 *scudi* that was made nearly ten years after the artist left Florence.[116] On the other hand, André Félibien claimed that Cortona received 10,000 *scudi* for his services at the Pitti, a sum more nearly commensurate, though scarcely generous, for his work.[117]

Another anecdote, first related by Félibien and repeated by Pascoli and Fabbrini, was that either the uncle of the Grand Duke, Cardinal Carlo, or Prince Leopoldo (the story varies) had purchased from Cortona certain Venetian paintings whose authenticity was later called into doubt by other painters and courtiers who resented Cortona's popularity, and that these accusations caused him to leave the Grand Duchy.[118] Apparent confirmation that Cortona's judgment in authorship was not infallible is provided by a letter written from Venice in 1658 by Paolo del Sera and directed to Prince Leopold in which he criticizes the consultation of painters in matters of attribution, noting that "Pietro da Cortona, who is that great man everyone knows, was deceived when Cardinal Bichi was here because he bought a copy that was derived from a Paolo Veronese for an original."[119] Whatever mistakes Cortona may have made in Venice, there is no record of his unloading doubtful works on relatives of the Grand Duke. Although Prince Leopoldo once criticized Cortona for a Raphael attribution, ample correspon-

Vite de' più eccellenti pittori, scultori ed architettori, ed. G. Milanesi, Florence, 1880, v, 34, n. 2). In his letter, Filippo Berrettini requested three hundred *scudi* to construct the altar, exactly the sum the Grand Duke had set aside for the work in 1641 (see Florence, A.S.F., Fabbriche Medicee, F. 140, Fol. 134 and *interni*, correspondence from June 16, 1641, to October 30, 1641).

[112] Florence, A.S.F., Lettere Artistiche, Vol. III, Fol. 89; Geisenheimer, *Pietro*, 34, No. 61 (where it is cited as Fol. 90). The case was promptly settled in favor of the merchant (Florence, A.S.F., Lettere Artistiche, Vol. III, c. 90; Geisenheimer, *Pietro*, 34, No. 64, as Fol. 91).

[113] Fabbrini, *Vita*, 86.

[114] Doc. Cat. No. 104.

[115] Doc. Cat. No. 105.

[116] Doc. Cat. No. 113.

[117] A. Félibien, *Entretiens sur les . . . plus excellens peintres*, Paris, 1666-1688, II, 449. Félibien gives no source for his information. Ciro Ferri, it should be noted, received 1500 *scudi* for finishing the Sala di Apollo (Doc. Cat. Nos. 117 and 118).

[118] *Ibid.*; L. Pascoli, *Vite de' pittori, scultori, ed architetti . . .* , Rome, 1730, I, 6f.; Fabbrini, *Vita*, 86f. Pascoli and Félibien identify the recipient of the falsification as the Cardinal-uncle of the Grand Duke. Fabbrini identifies the recipient as Cardinal (Prince) Leopoldo.

[119] Florence, A.S.F., Lettere Artistiche, Vol. v, c. 313 (Letter No. 191): ". . . Pietro da Cortona chi è quel grand' huomo che ogn' un sa, s'inganno quando fu qua Card.le Bichi per che compro una copia che veniva da Paolo Veronese per originale." I am indebted to Michelangelo Muraro for bringing this document to my attention.

dence proves that in general the Medici court trusted his connoisseurship, using him as an agent in the negotiations for a Titian and in the purchase of drawings in the post-1647 period.[120]

Even if relations between Cortona and the Medici were strained after 1647, they were sufficiently cordial for him to continue to be favored with commissions. These included an ivory crucifix with the Madonna, St. John the Evangelist, and Mary Magdalen; landscape sketches in aquarelle; a painting of the Temple of Fortune at Palestrina and a self-portrait (for Prince Leopold's gallery of artists' self-portraits); and also an altarpiece in San Gaetano, Florence, a painting of the Virgin, a drawing of a bacchanal, and an as yet unidentified statue for Cardinal Giovanni Carlo.[121] Cortona also continued to receive gifts from the Medici household even after it must have been quite obvious that it would not be possible for him to return to his labors at the Pitti Palace. The presents he received included a necklace, a small casket lined with silver, and a clock.[122] Furthermore, it is unlikely that the Grand Duke would have acted as intercessor on behalf of Cortona during the competition for the east facade of the Louvre in 1664 if unpleasant relations existed between them.[123]

[120] The letter in which Leopoldo, writing to Prince Mattias de' Medici, criticizes Cortona's Raphael attribution (written May 7, 1651) is cited by M. Del Piazzo, *Pietro da Cortona, mostra documentaria, archivio di stato*, Rome, 1969, 34, Cat. No. G-7. For the Titian reference, see Florence, A.S.F., Lettere Artistiche, Vol. III, Fol. 79; Geisenheimer, *Pietro*, 21, Doc. F. This letter, dated February 6, 1648, contains the following critique: ". . . il quadro de Tiziano della venere, quale è simile a quella che è nella galleria del G. Ducha, cioè nei stanzini, ma assai inferiore a quella, poichè questa non è finita, solo ci è de più un ritratto che sona un leuto, quale è un pocho più ridotto, il paese poi si pol dire abossato, ma quella che mi parve più di sproposito, il padrone ne dimanda cinque cento dopie, alche stimo sarebbe assai meglio il quadro de Verona de Paulo Veronese." For references to the purchase of drawings for the Medici: Geisenheimer, *Pietro*, 24, Doc. M; 25, Doc. N; 38, No. 99; 25f., Doc. O; 26f., Doc. P. In addition, the use of Cortona's expertise by Volumnio Bandinelli, who wished to sell drawings to Prince Leopoldo, may be cited. Bandinelli held Cortona's judgment of drawings, and especially Venetian ones, in high esteem. Writing to Cardinal Leopoldo de' Medici from Rome on September 28, 1658, he states: "Le mando hora quello [a drawing] di Titiano del quale, benchè sia stata fra questi valent'huomini qualche discrepanza, m'assicura Pietro da Cortona non doversi dubitare, et io credo più a lui che agl'altri, perchè per non essere stati a Venetia n'hanno minor pratica" (Florence, A.S.F., Lettere

Artistiche, Vol. IV, c. 261). For additional references to Bandinelli's use of Cortona's—and other artists'—expertise see: Florence, A.S.F., Lettere Artistiche, Vol. IV, cc. 256, 258, 260, and 294. I wish to thank Gino Corti for the Bandinelli citations. Further evidence of Cortona's services in this area for the Medici is provided by references in Del Piazzo, *Pietro*, Cat. Part G, *passim*.

[121] Commissions for Prince Leopoldo: Cortona designed the crucifixion group and Cosimo Fancelli prepared a model to be copied in ivory by Baldasar Stockhammer. For description and documentary sources, see K. A. Piacenti, *Il Museo degli Argenti a Firenze*, Milan, 1967, Cat. No. 371, with preceding bibliography. Concerning the landscape sketches, see Geisenheimer, *Pietro*, 26f., Doc. P. For correspondence for the unlocated painting of the Temple of Fortuna see Del Piazzo, *Pietro*, 35, Cat. No. G-17. Pertinent documentation and preceding bibliography for the self portrait is provided by Briganti, *Pietro*, 268, Pl. 286, No. 24. Commissions for Cardinal Giovanni Carlo: Briganti, *Pietro*, 253f., provides most essential documentation and bibliography for the altarpiece in San Gaetano. The painting of the Virgin, the bacchanal drawings, and the statue are mentioned in correspondence cited by Del Piazzo, *Pietro*, Cat. Nos. G-5, 8, 9, 10 and 14.

[122] For references to the following see: Geisenheimer, *Pietro*, 37, No. 93 (necklace); 38, No. 102 (casket); Campori, *Lettere*, 514 (clock).

[123] Marabottini and Bianchi, *Mostra*, 19, n. 42; for recently published documents relating to the

Another sign of continuing grand-ducal favor is that Cortona was made a citizen of his native town of Cortona on April 15, 1652.[124] The award was made in recognition of his fame as a painter and for his contribution to the embellishment of the sepulchre of Santa Margherita da Cortona. Citizenship, the highest honor a town could bestow upon an inhabitant, was in this case conferred without the usual request for payment of taxes. This action required the ratification of the Grand Duke and hence may be regarded as a reflection of the esteem in which he held the artist, a fact which did not escape Cortona, who wrote of his gratitude to Ferdinand as well as to other members of the Tuscan court.[125]

In addition to these numerous indications that Cortona remained within the good graces of the Medici, it should be pointed out that his departure was no hasty flight. As we have noted, he informed Cardinal Francesco Barberini as early as April 1647 that he intended to travel to Rome during late autumn in order to commence the frescoes of S. Maria in Vallicella and to remain there for the winter. In his letter of June 1647 Cortona had explained to Cardinal Barberini that the winter climate of Florence was too severe for frescoing and that henceforth he would work there only in the more temperate seasons (and again stressed the urgency of the frescoes in S. Maria in Vallicella). Not only did his departure in late October 1647 coincide with the onset of winter, but the cordial letter which he immediately dispatched to the Grand Duke implies that his stay in Rome was to be temporary.[126] Furthermore, on December 23, 1647, Cortona wrote notes to Prince Don Lorenzo de' Medici and to Cardinal Giovanni Carlo that were indirectly intended to assure the Grand Duke of his intention to return when the winter had passed.[127]

From a review of the stories that cluster about Cortona's departure one is forced to conclude that the motives governing his departure and his failure to return were

project see A. Crinò, "Documenti relativi a Pietro da Cortona, Ciro Ferri . . . ," *Rivista d'Arte*, XXXIV, 1959, 152f. For the Louvre project, see K. Noehles, "Die Louvre-Projekte von Pietro da Cortona und Carlo Rainaldi," *Zeitschrift für Kunstgeschichte*, XXIV, 1961, 40ff.

[124] Samek Ludovici, "Vite," 84. Fabbrini, *Vita*, 116f., for details of the award.

[125] For the letters, see Florence, A.S.F., Guardaroba Medicea, Lettere Artistiche, Vol. III, c. 90; Geisenheimer, *Pietro*, 34, No. 64, as Fol. 91; and also Philadelphia, University of Pennsylvania Library, Lea MS temporary No. 23, unnumbered folios: "Dovevo molto prima ringratiare V.S.Ill.ma dell'honor fattomi in Cortona, dove col mezo del suo favore mi trovo aggregato da que' Signori alla cittadinanza, sopra ogni mio merito; ma la mia trascuraggine mi farà scusa appresso la sua gentilezza, e se mai mi conoscerà buono a servirla in cos'

alcuna la supplico a commandarmi con ogni libertà, e humilissimamente la riverisco. Roma 15 Giugno 1652. Servitore devot.mo obbl.mo Pietro Berrettini (this letter, sent to Giuliano Gondi, was found and transcribed by Gino Corti).

[126] Doc. Cat. No. 112.

[127] The letter to Prince Don Lorenzo (Florence, A.S.F., Carteggio Mediceo, F. 5164, c. 48; Crinò, "Documenti," 151) reads: "Ser.mo Principe. Con occasione delle Santissime feste di Natale vengo a ricordare a V.A. l'antica e devota mia servitù pregandole dal Signore ogni vera felicità e assicurandola che a primavera mi metterò di proposito a servirla non havendolo sin hora potuto fare per l'imbarazzo grande in che mi trovo travagliando continuamente ne' cartoni di questa Cupola" The message to Cardinal Giovanni Carlo is similar in content (cited in Del Piazzo, *Pietro*, 34, Cat. No. G-1).

multifold. Several of these, however, stand out and seem to deserve further attention. Failing health, which echoes throughout his correspondence from 1643 onward, compounded by the rigors of the Florentine winters of which he continually complained certainly was an influence. Still, one must not overemphasize the sheer burden of labor in the Planetary Rooms, because their author shouldered a not dissimilar burden in the decorations of the Chiesa Nuova immediately upon his arrival in Rome. One suspects that Cortona's illness in Florence was at least in part psychological—a world-weariness aggravated by what must have seemed to him a parochial grand-ducal court environment compared to the glitter and brilliance of the constellation of personalities who had gathered about Urban VIII before the War of Castro.[128] His sense of isolation in Florence must have been heightened when the death of Buonarroti the Younger extinguished what was his only real—if somewhat tenuous—friendship in Florence. One suspects, too, that remuneration for his services to the Grand Duke was slow in arriving and distinguished more by parsimony than benevolence. Above all, however, special note should be made of the fate of Cortona's architectural projects in Florence and the effect it had on the artist, for as Wittkower has noted, it is hard to believe that Cortona, as he had once stated, truly regarded architecture as "solely for entertainment."[129] The later statement was, in fact, an outcome of his bitter experience with architectural commissions in Florence, where each of his architectural projects had the same depressing history. Beyond the request of 1645 that he draw up a facade for the Duomo there is no further mention of this project. His commission for the enlargement of the Ospedale of S. Maria Nuova came to naught, and the commission for the Chiesa Nuova in Florence dragged on until 1666 and finally fell through, leaving only a long record of litigation. In addition to these projects, sometime between 1640 and 1647 Cortona had prepared sketches and probably a model for the modification of the facade of the Pitti Palace [Fig. 185] and a scheme for the construction of a theater and architectural vista that was to form a visual extension of the central courtyard.[130] This scheme never passed beyond the initial stages recorded in the two drawings [Figs. 186 and 187]. One minor architectural project in which Cortona played a consultative role along with Buonarroti and Luigi Arrigucci was carried to completion, but in this case the commissioners were the Barberini rather than the Medici, and even so the work was not finished for twelve years, by which time the name of the executant, the Florentine architect

[128] Briganti, *Pietro*, 98f., for the negative aspects of the Florentine court.

[129] Wittkower, *Art and Architecture*, 162. For Cortona's statement see Doc. Cat. No. 109.

[130] See Campori, *Lettere*, 505ff. for the letter of Luca Berrettini to Ciro Ferri, which contains the first mention of the project and states that a wooden model was prepared. For more recent discussions of the project: G. Giovannoni, "Il Restauro Architettonico di Palazzo Pitti nei Disegni di Pietro da Cortona," *Rassegna d'arte*, VII, Nov.-Dec. 1920, 292ff.; V. Moschini, "Le Architetture di Pietro da Cortona," *L'Arte*, XXIV, Sept.-Dec. 1921, 191ff.; A. Muñoz, *Pietro da Cortona*, Rome, 1921, 9f.; Marabottini and Bianchi, *Mostra*, 12, n. 22 and 62f., Nos. 60-62, Pls. 64-66; R. Wittkower, "Pietro da Cortonas Ergänzungsprojekt des Tempels in Palestrina," *Festschrift Adolph Goldschmidt*, Berlin, 1935, 140; and Wittkower, *Art and Architecture*, 162.

Gherardo Silvani, and that of his consultant had been forgotten.[131] The commission in question, a commemorative inscription and coat of arms of Urban VIII [Fig. 144] on the wall of the Carmelite Monastery in Borgo Pinti, is described in a letter Buonarroti sent to Luigi Arrigucci in August 1642, and it is to Arrigucci that the initial design has been attributed.[132] When Cortona departed for Rome in October 1647 he surely realized that Florence held no future for his career as an architect.

In Rome, in contrast, Cortona was besieged with commissions. The frescoing of S. Maria in Vallicella turned out to be a larger commission than he had apparently anticipated; the cupola took three years, and the entire project was to occupy him intermittently for some eighteen years.[133] Evidence of the quantity of commissions available to him in Rome is given in a letter written in 1649 by Cardinal Gerolamo Verospi, Bishop of Osimo, to the Archdeacon Pier Filippo Fiorenzi explaining that Cortona had found it necessary to refund the advance paid to him by the family of the latter for a painting that he could not undertake because of the work under way in Rome and because of a forthcoming commission in Naples.[134] Cortona, the Cardinal's letter informs us, was already involved in three years' worth of commissions. But the Cardinal's estimate of the Roman commissions that would be given to Cortona was conservative. The projected trip to Naples was apparently abandoned in the face of a veritable cornucopia of commissions in Rome. Correspondence indicates that the Medici, through the offices of Cardinal Giovanni Carlo, were still trying to get him to return to Florence; however, Pope Innocent X let it be known that he intended to use the artist in his own palace decorations, and during 1651 Cortona started the frescoes of the Palazzo Pamphili in the piazza Navona and, also under papal auspices in the following year, preparation of the cartoons for the mosaic decorations of the vaults of S. Peter's.[135] Paolo Giordano

[131] The monument may be seen on the wall of the monastery at the intersection of Borgo Pinti and the via della Colonna. On May 25, 1654, it was unveiled, and Andrea Cavalcanti entered the event in his diary (Guasti, *Carte Strozziane*, I, Part IX, No. 10, 62). According to Cavalcanti, the coat of arms was put up "several years earlier" and was executed by the sculptor Alessandro Malavisti, who is known principally for his work in mosaic.

[132] Florence, Biblioteca Medicea Laurenziana, Archivio Buonarroti, 40, c. 111r. This letter, which was found by Gino Corti, contains a detailed account of various schemes for the monument. Buonarroti had been asked by the Barberini to prepare a suitable inscription. For Arrigucci's role in the commission and for additional information about this minor architect who served as *architetto camerale* to Urban VIII, see R. Battaglia, "Luigi Arrigucci architetto camerale d'Urbano VIII," *Palladio*, IV, 1942, 174ff.

[133] Wittkower, *Art and Architecture*, 153; Marabottini and Bianchi, *Mostra*, 14, n. 26; Briganti, *Pietro*, 145, 147.

[134] For the letter of Cardinal Verospi see A. M. Gabrielli, "Un Quadro Ignorato del Castiglione," *Commentari*, Anno VI, 1955, 261, n. 1. The nature of the commission requiring the presence of the artist in Naples is not known; however, Gabrielli's suggestion that Pietro sent the *Ecstasy of S. Alessio* (S. Filippo Neri, Naples) in lieu of this trip is untenable because the painting dates from the late 1630's. See Marabottini and Bianchi, *Mostra*, 40f.; E. K. Waterhouse, *Baroque Painting*, 57; Voss, *Malerei*, 546; Briganti, *Pietro*, 141.

[135] On August 15, 1650, Cardinal Giovanni Carlo received a letter from Alfonso Puccinelli which underscored in firm language the intentions of the Pope (Del Piazzo, *Pietro*, 34, Cat. No. G-6). For references to work in the Gallery and St. Peter's see Florence, A.S.F., Lettere Artistiche, Vol. III, Fol. 91; Geisenheimer, *Pietro*, 34, No. 64 and 35, No. 65; Marabottini and Bianchi, *Mostra*, 15; Briganti, *Pietro*, 146 and 250ff.

Orsini, when writing to Queen Christina of Sweden on July 26, 1652, specifically mentioned that Cortona was at work on the two last named commissions, adding that it would be a long time before he will be able to return to either the decorations of the tribune of the Chiesa Nuova or the grand-ducal rooms.[136] Cortona finished the Aeneas Gallery for Pope Innocent X Pamphili in 1654 and turned his attention to the tribune of the Chiesa Nuova in spring 1655.[137] In the same year he took on another fresco commission—the extensive decorations in the Palazzo Quirinale, where the newly elected Pope Alexander VII called on him to work in a supervisory capacity.[138] Cortona must have been pleased with the numerous requests he received for easel paintings and fresco decorations, but after his lack of success in Florence as an architect, he must have been particularly pleased to see work started once more on SS. Luca e Martina, which had remained unfinished and unusable since 1641. At the time of his return to Rome, however, Cortona apparently held out slim hope for its completion. He stated in a letter to Cardinal Francesco Barberini that he would at least finish the *confessio*, that is, the crypt, for which he was personally providing the funds.[139] Political circumstances, however, were destined to work in Cortona's favor. In February 1648, Cardinal Francesco returned to Rome unexpectedly as the representative of the French government, and Pope Innocent X was obliged to resume construction of the church in which the cardinal had strong personal interest for the sake of appearances. Medici hopes for the completion of the Planetary Rooms must have declined steadily when Cortona turned to the reconstruction of the facade and piazza of S. Maria della Pace in 1656, which was followed by the redesigning of the facade and flank of S. Maria in via Lata in 1658.[140] In view of his experience with architectural projects in Florence, these commissions must have been especially gratifying.

SALA DI APOLLO, 1659-1661

Even though submerged by Roman commissions, and in spite of declining health, Cortona clung to the belief that he would eventually find time to return to Florence and finish the decorations.[141] For their part, the Grand Duke and his representatives con-

[136] Geisenheimer, *Pietro*, 35, No. 65.

[137] Briganti, *Pietro*, 147.

[138] Geisenheimer, *Pietro*, 35, No. 71. For a detailed study of this commission see N. Wirbal, "Contributi alle ricerche sul Cortonismo in Roma: i pittori della Galleria di Alessandro VII nel Palazzo del Quirinale," *Bollettino d'arte*, XLV, Jan.-June 1960, 123ff.

[139] Rome, Bibl. Vat. Barb. lat. 6458, f. 62. For a full discussion of the resumption of work at SS. Luca e Martina, see K. Noehles, *La chiesa dei SS. Luca e Martina*, Rome, 1969, 105ff.

[140] Fabbrini, *Vita*, 176ff.; Marabottini and Bianchi, *Mostra*, 17f.; Briganti, *Pietro*, 147.

[141] On December 23, 1651, Cortona wrote to the Grand Duke that ". . . oramai mi trovo quasi ricuperata la mia sanità, poichè in tutta questa istate passata ho operato pochissimo . . ." (Geisenheimer, *Pietro*, 34, No. 60). Again on December 18, 1655, in a previously unnoted letter Cortona wrote to a secretary of the Grand Duke mentioning his poor health but unflagging desire to return to Florence (Florence, A.S.F., Mediceo, F. 1013, c. 563). Just before negotiations commenced to secure Ciro Ferri's services to execute the Sala di Apollo, Cortona wrote to Prince Leopoldo on June 7, 1659, ". . . quest'invernata a me è stato delle più fastidiose che habbi havute per il mio male et è stata

tinued to seek Cortona's return to Florence. On May 27, 1656, Gabriello Riccardi, *Residente in Corte di Roma* for the Grand Duke, wrote to Giovanni Battista Gondi stating that by order of Cardinal Gian Carlo de' Medici he was going to put pressure on the artist to return to Florence. Riccardi reminded Gondi that he had tried on other occasions to get the artist to agree to return, but that there were always excuses, especially on grounds of poor health. The *Residente* promised to do all in his power, "knowing how great is the need . . . [for Cortona] . . . to finish the apartment of the Most Serene Grand Duke."[142] Shortly thereafter, on June 10, 1656, Riccardi again wrote to Gondi indicating that Cardinal Gian Carlo and Cortona have been in contact, adding that he did not have much hope of getting the artist to leave Rome.[143] The meeting with Cardinal Gian Carlo must have had some effect on Cortona, however, because on the same day he wrote a letter that may have been addressed to Prince Leopold from which we learn that he received 600 *scudi* from the Cardinal.[144] In this letter Cortona states: "I shall avail myself [of your commands] when it pleases God to grant me enough health and strength that I am able to put myself on the road in order to execute what I must and most desire. I very much supplicate Your Highness to condescend to order that the cartoons be sent to me in reduced size with [their measurements indicated in] Roman *palmi* in order to be able to more promptly serve you." This letter is followed by another addressed to Cardinal Gian Carlo from Cortona on August 10, 1656, in which the artist alluded to an agreement that had been reached whereby he was to prepare the cartoons in Rome for the "room I have commenced," a clear reference to the Sala di Apollo.[145] Because he had forgotten some details of the program, he requested that Rondinelli again provide him with *il soggetto*. Gondi's suspicions appear, however, to have been correct. Three years pass before more concrete steps are taken to complete the Planetary Rooms.

comune a tutti che hanno patito e patiscono di simile male . . . adesso incomincia a stare un poco meglio . . ." (Florence, A.S.F., Lettere Artistiche, Vol. III, Fol. 98; noted, but not transcribed in Geisenheimer, *Pietro*, 36, No. 80). Even in July 1659 during the final stages of the negotiations for the execution by Ciro Ferri of the Sala di Apollo decorations, the Tuscan Envoy to Rome wrote Prince Leopoldo that, "It is necessary, however, to use dexterity because Sig. Pietro is very sensitive . . ." (Doc. Cat. No. 115), a statement that suggests that the negotiators had difficulty convincing Cortona to relinquish the commission to his former pupil.

[142] In the postscript of a letter from Rome, May 27, 1656, Riccardi wrote to the Balì Gondi [Giovanni Battista Gondi]: "Vado adesso di ordine del S.r Principe Cardinale a trovar Pietro da Cortona per dargli una stretta a venire a Firenze, ma questa non sarà la prima, e l'ho trovato sempre che ha preso scuse, e particolarmente della sanità. Io farò le mie parti, conoscendo quanto sia il bisogno della sua persona per finire l'appartamento del Ser.mo Gran Duca." Florence, A.S.F., Mediceo, F. 3382 (Carteggio di Gabriello Riccardi, Residente in Corte di Roma, 1654-1656), unnumbered pages. I wish to thank Gino Corti for locating and transcribing this important note.

[143] He stated: "Della venuta di Pietro da Cortona il S.r Principe Cardinale ne ragguaglierà V.S.Ill.ma, et io farò le mie diligenze con non molta speranza di haverlo a cavar di Roma." Florence, A.S.F., Mediceo, F. 3382 (Carteggio di Gabriello Riccardi, Residente di Corte in Roma, 1654-1656), unnumbered pages. This information was found and transcribed by Gino Corti.

[144] Doc. Cat. No. 113.

[145] Doc. Cat. No. 114.

On July 5, 1659, Monanno Monanni, Tuscan Envoy to Rome, wrote a letter to Prince Leopoldo that opened a new stage in the chronology of the Planetary Rooms. This letter contains a detailed description of the final arrangements made for the completion of the Sala di Apollo.[146] The frescoes were to be finished by Ciro Ferri, but "the cartoons would be made here [at Rome] by the said Ciro in the presence and with the assistance of Sig. Pietro, derived from the *pensieri* that Sig. Pietro makes for him, again according to the same cartoons, so that one will be able to say not only the *pensieri*, but the design will be by Sig. Pietro, that the coloring and working out of the fresco will be by Ciro" Monanni also reports on the state of the work, explaining that the younger artist "has rapidly set about gluing the cartoons, and in the meantime he will make the sketches of the *pensieri* in order to continue straight on with all speed, for he has very well appraised the urgency . . . he has told me, however, that the cartoons will take up two month's time, namely this (month) and all of August, and I believe him, but all the time that one spends in making the cartoons will bear fruit twofold in putting them to work." The letter closes with a postscript indicating that letters written by Pietro da Cortona were enclosed for Arrighetti, Rondinelli, and Salvestrini, all of whom, as we have noted, were connected with the commission before Cortona left Florence in 1647. The fact that Salvestrini was the recipient of one of the letters is of especial significance, for it reinforces his connection with the Planetary Rooms and specifically with the Sala di Apollo stuccoes, which we therefore assume were not as yet completed.

From a letter Cortona wrote to the Grand Duke on December 20, 1659, we may surmise that the area of unexecuted stucco was considerable, for Cortona explains that he has just spent eight days getting in order a "model of the ornaments that must be made in the room of the Grand Duchess, it being already three years since the model was made."[147] The reference to the Grand Duchess is curious. It raises the possibility the model might be for some room other than one in the planetary series, possibly for the stucco ornaments in the vault frescoed by Baldassarre Franceschini (called Volterrano) in Grand Duchess Vittoria's wing of the palace [Fig. 190].[148] Several points, however, may be adduced in favor of a model for the Sala di Apollo. In all probability the phrase acknowledges the Sala di Apollo either as one occasionally used by the Grand Duchess, for its position in the floor plan of the palace is such that the room would have been the most accessible of the series from her private apartments which were located in the eastern wing of the central courtyard of the palace, or else one for which she was furnishing Cortona's stipend for the work. Cortona's statement that the model had been made some three years earlier also argues its association with the Sala di Apollo. It will be recalled that precisely three years earlier he had requested the cartoons of that room be copied in reduced size and sent to him in Rome, proof that he

[146] Doc. Cat. No. 115.
[147] Doc. Cat. No. 116.
[148] The precise date of this work is not known.

See Baldinucci, *Notizie*, 1846, v, 168; Wittkower, *Art and Architecture*, 225 (who suggests c. 1652); and M. Gregori, *70 pitture e scultore*, 26.

was involved with that room at the time he was working on the model.[149] The present whereabouts of the model—if it still exists—is unknown. Presumably it was an elaborate mock-up of the stucco decorations, executed in either stucco, clay, or wood. The fact that it took Cortona eight days to prepare it for the trip to Florence argues for a three-dimensional work, rather than an elaborate drawing or oil sketch.[150]

Apparently Ferri's promise to have the cartoons completed by the end of August was optimistic, for the actual frescoing of the Sala di Apollo did not commence until the fall of 1659. Fifteen months were required for its completion. The unveiling of the room is recorded in the Court Diary: "Today 23 . . . [February 1661] at last the Stanza d'Apollo or del Sole or della Gioventù has been unveiled. Painted by Ciro Ferri, disciple of Pietro da Cortona, it has been painted in 15 months. There are in the middle of the vault four or five figures made by Pietro. The room has had those rickety contraptions [reference to the scaffolding] for eighteen years. I hear that he has received 1500 *scudi* and the expenses and the house."[151] Three days after this minute was written, the payment of 1100 *scudi* was requested from the Grand Duke by Andrea Arrighetti on behalf of Ferri, who, the note states, had already received 400 *scudi* for his labors in the fourth room of the apartment of His Highness commenced by Pietro Berrettini, his master.[152] On March 13, the Court Diary records the departure of Ciro Ferri and a young assistant (who is not named) for Rome.[153] Once back in Rome he hurried to Cortona and reported the success of the Sala di Apollo. Cortona then wrote a letter to the grand-ducal court that seems to emit genuine satisfaction and delight in the Florentine reception of the fourth room.[154]

SALA DI SATURNO, 1663-1665

In all probability Ciro Ferri was tendered the commission for the fifth room, the Sala di Saturno, while he was at work on the Sala di Apollo. In the case of this last room in the series, no ambassadorial letters survive (or at least none have been located) in which the division of labor between Ferri and his master is defined. Ferri's official dependency on Cortona in the Sala di Apollo appears to have distressed him, for as related by Lorenzo Magalotti, this was the one reservation made by some of his Florentine critics who argued that the cartoons had been made in Rome and hence were entirely Cortona's and that Ferri had merely acted as an executant.[155] According to Magalotti, the younger artist scotched this criticism in the fifth room "by preparing the cartoons here [at Florence] and everyone has been able to see them for themselves" Magalotti says he has been an enthusiastic observer and adviser in the execution of the frescoes

[149] Doc. Cat. No. 113.

[150] See F. Baldinucci, *Vocabolario Toscana dell'Arte del Disegno*, Florence, 1681, 100, under *modello*, where it is stated that "one makes *modelli* of various materials such as wood, wax, clay, stucco, or of other [materials]."

[151] Doc. Cat. No. 117.

[152] Doc. Cat. No. 118.

[153] Doc. Cat. No. 119.

[154] Doc. Cat. No. 120.

[155] Doc. Cat. No. 125.

of the Sala di Saturno, and it would seem therefore that he speaks with some authority, a claim supported indeed by his knowledgeable description of subject matter of the decorations. The weight of evidence suggests, however, that despite the assertions of Magalotti, the bulk of the preparatory work on the cartoons and designs for the stucco decorations of the fifth room must have been carried out in Rome, and, on the basis of the surviving preparatory studies, which are discussed elsewhere, Cortona maintained a major role in the design of the stuccoes. For information about actual work in the Sala di Saturno, a group of payments in the Fabbriche Medicee, though very fragmentary and limited to a minor aspect of the commission (namely, the wetting down of the stuccoes at night and on holidays when work was not in progress) are eminently useful. These payments indicate the rather surprising fact that the stuccoes were under way at least as early as February 1663, four months before Ciro Ferri returned to the Palace to execute the frescoes.[156] Thus, with regard to the stuccoes there can be no doubt that either designs were left in Florence when Ferri departed for Rome in March 1661 or else he sent the required designs from Rome well in advance of his own return. As for the cartoons, we now know, due to a letter recently discovered by Anna Maria Crinò, that contrary to Magalotti's assertion they were in large part prepared in Rome. The letter was written by Pietro da Cortona in Rome and addressed to Grand Duke Ferdinand on June 17, 1663.[157] The letter reads in part: "Sig. Ciro, having finished the cartoons . . . I am convinced that they will produce in application an effect to the satisfaction of Your Highness. I deeply regret not to have been able to come and serve you myself, as I have always desired . . ." and thus leaves no doubt that Cortona saw at least a nearly complete set of cartoons in Rome.

Ten days later on the eve of Ferri's departure for Florence, Cortona wrote to Florence again. This time his remarks were addressed to Prince Leopoldo, whom he informs of his desire to avail himself of the opportunity to send a painting of the Madonna "on the occasion that Sig. Ciro comes to the service of Their Highnesses."[158] This letter must have been written at the moment of Ferri's departure and carried to Florence by him along with the aforementioned painting, because as reported in the Court Diary, Ciro Ferri, with his wife, small daughter, and a cousin, arrived in Florence on June 29 and took up residence in a house that had been previously put at his disposal.[159] Four days later, the same source announced the start of work on the "room of Saturn, that is being made from the history of Lycurgus," which would strongly suggest that frescoing was immediately under way and that work started with one of the lunettes portraying a scene from the life of Lycurgus [Fig. 131], causing the chronicler to assume that the whole room was to be dedicated to Lycurgus. This situa-

[156] Florence, A.S.F., Fabbriche Medicee, F. 76, Entry February 26, 1662[1663] (unnumbered folios). The account book recording the wetting down starts on this date; therefore, it is not clear how long work had been in progress on the stuc-

coes before this entry.

[157] Doc. Cat. No. 121.

[158] Doc. Cat. No. 122.

[159] Doc. Cat. No. 123.

tion supports our argument that extensive work was done on the cartoons in Rome; four days is no time at all for working up a cartoon. As we know from the documents, Ferri, working under the pressure of constant observation, had taken at the very least two months to prepare those of the Sala di Apollo.

The entry in the Court Diary quoted above argues that Ciro Ferri commenced the decorations in the lunettes rather than above in the center of the vault. Perhaps this was because a significant portion of the stuccoes was already in situ. In any event he appears to have continued to expend his efforts on the lunette scenes, for the next communication is a letter he wrote on February 4, 1664, to Grand Duchess Vittoria in which he thanks her for the loan of a boar, which he has used as a model for the one that appears in the lunette depicting a scene from the life of Sulla [Fig. 129] on the wall opposite.[160] He explains that he has not yet painted the beast in fresco because he must paint the dogs first and this was not possible until the Grand Duke returned (he was evidently on a hunt) with "the large fierce dog." He also assures the Grand Duchess that he is at the mid-point of the work and that he is moving ahead with dispatch. At the time Ferri wrote to Grand Duchess Vittoria, he had been at work in the Sala di Saturno for approximately eleven months. In that length of time, we would surmise from his letter, he had nearly completed the lunette scenes.

In his letter of April 26, 1664, to the Congregation of Santa Maria Maggiore at Bergamo explaining the conditions under which he will work for them, Ferri notes that the room he is painting for Grand Duke Ferdinand will not be finished until the next July and that they should send him the measurements of the frescoes they wish him to paint so that "in these few remaining months I may make the *abbozzetti*"[161] He then explains that once the general arrangements are settled he can proceed to designing the cartoons, "and when I arrive I will be able to immediately start painting." While it is helpful to know that he was hard at work on the Sala di Saturno in April 1664 and to have as well proof that for the sake of efficiency he would make cartoons of his projects prior to arriving on the site, this letter as published by Bottari raises chronological problems inasmuch as the frescoes in Florence were most certainly not finished until a year later, in July 1665. Either Bottari's date for the letter is erroneous or else the Sala di Saturno decorations took much longer than expected. In any event, Ferri did not arrive in Bergamo until September 1665, following the successful unveiling of the Sala di Saturno on July of that year.[162]

In contrast to the correspondence connected with the frescoing, the only sources of information for dating the stuccoes are the minimal entries in the Fabbriche Medicee accounts to which we have already alluded. Although these entries are for expenses peripheral to the actual fabrication of the stuccoes, they nevertheless inform us of aspects of the work, and, most important, they provide the names of the persons

[160] Doc. Cat. No. 124.

[161] G. Bottari, *Raccolta di Lettere sulla Pittura, Scultura ed Architettura*, Milan, 1822, III, 352f.

[162] For an account of Ferri in Bergamo see F. Haskell, *Patrons and Painters*, New York, 1963, 217ff.

involved.[163] From February 26, 1663, to December 17, 1663, the names recorded are those of a *capo muratore*, Andrea Ferroni, and various *muratori*.[164] Then on December 24, 1663, we are informed that Maestro Giovanni Battista Frisone, *stuccatore*, worked evenings on the stuccoes starting in October 1663 and also that Ciro Ferri had kept the same *veglie*, as they are described.[165] In contrast to the anonymity of the names entered earlier in the accounts, the presence of Frisone is important, for it will be recalled that he was one of the Roman *stuccatori* who executed large portions of the stuccoes in the Cortona rooms. There can be little doubt that we have here the name of the chief executant of the Sala di Saturno stuccoes. After the December entry, Frisone's name appears in the accounts frequently until April 7, 1664. On February 23, 1665, the account book in question comes to an end. To date no other accounts have been located.

The next document related to the Sala di Saturno has already been noted. It is the description of the room in a letter written by Lorenzo Magalotti to Ottavio Falconieri on August 18, 1665, which mentions that Ciro Ferri finished the room in time for its unveiling on Grand Duke Ferdinand's birthday (July 14).[166] According to Magalotti, the decorations were received with the greatest applause, and His Highness showed full satisfaction. Thus, nearly a quarter of a century after its inception, the great fresco cycle of the Planetary Rooms was completed.

[163] Florence, A.S.F., Fabbriche Medicee, F. 76, unnumbered folios. This account book runs from February 26, 1662[1663], to February 23, 1664 [1665], and contains over ninety entries relative to the Sala di Saturno commission. As discussed below, however, most of these accounts are of such a minor character, except for those specifically noted, as not to warrant citation, let alone transcription.

[164] Florence, A.S.F., Fabbriche Medicee, F. 76, unnumbered folios. The first entry relative to the work in question was made on February 26, 1663, and provides for the sum owed to Francesco Ponziani for wetting down the stuccoes during the feast days in February. There is no evidence that Ponziani was more than a *muratore*. On June 17, payment is made for slaking and straining the whitening to be used in making the stuccoes. For this work, Ponziani was assisted by Lorenzo Mugelli, another *muratore*. Two weeks later two new names appear, that of Andrea Allegrini, another *muratore* or *manovale*, and Maestro Andrea di Piero Ferroni, *capo muratore* and son of the *capo muratore* Piero Ferroni who assisted Giovanni da San Giovanni in the Salone Terreno (M. Campbell, "Medici Patronage and the Baroque: A Reappraisal," *Art Bulletin*, XLVIII, June 1966, 134). Starting on July 30, 1663, the name of Ponziani's son Giovanni Antonio appears. The name of An-

drea Ferroni's father Pietro appears from time to time starting with the entry of August 20, 1663. On September 24, 1663, the name of a Maestro Bartolomeo Casini appears. He apparently was assigned to the stuccoes, but did no work. His name appears again, much later, on February 26, 1664. For many weeks between February 1663[1664] and February 1664[1665] the vouchers for the *veglie* written on separate sheets and inserted in the *filza* are in the hand of Ciro Ferri. It seems worthwhile to list the dates of these vouchers inasmuch as their dates may eventually prove useful in the reconstruction of this artist's chronology. The first autograph voucher is dated February 26, 1663[1664]. They occur thereafter as follows: March 3, 10, 17, 24, 1663[1664]; March 31, 1664; April 2, 21 (undated but filed under this date), 1664; May 5, 19 (no date but filed under this date), 1664; June 4, 1664; July 7, 28 (no date but filed under this date), 1664; September 9, 15, 27, 1664; January 5, 19, 26, 1664[1665]; February 3, 9, 16, 23, 1664[1665].

[165] It should be borne in mind that the account here consulted covers, in the case of Frisone, only evening work. It is therefore possible that he was at work on the stuccoes for a considerable time before October 1663.

[166] Doc. Cat. No. 125.

Chronology

To date little is known about Ciro Ferri's work at the Tuscan court aside from the decorations under consideration, and, in fact, it is during the reign of Ferdinand's son, Cosimo III, that he is actively employed by the Medici and other Florentines.[167] One project can, however, be assigned to the period of his work in the Planetary Rooms. Probably at the time of his work in the Sala di Saturno, Ferri designed a throne enframement [Fig. 134].[168] In view of the fact that the Sala di Giove already had an elaborate throne and baldachin, this scheme was presumably intended for the Sala di Saturno.

The chronology adduced here for the contributions of Pietro da Cortona and Ciro Ferri to the Planetary Rooms can be stated in abbreviated form. For Pietro da Cortona (including completion of stuccoes): Sala di Venere (1641-1642) (except for the Medici portraits, which were probably executed 1644/45); Sala di Giove (1642-1643/44) (preceded possibly by preliminary designs for the Sala di Apollo, construction of a scaffold there, and some work, 1642); Sala di Marte (1644-1646); and Sala di Apollo (1645-1647). For Ciro Ferri: Sala di Apollo (1659-1661) and Sala di Saturno (1663-1665).

[167] The recent exhibition *Artisti alla Corte Granducale* (catalogue compiled by M. Chiarini, Florence, 1969) lists only two paintings for Ciro Ferri (Cat. Nos. 54 and 55). For his later Florentine connections see K. Lankheit, *Florentinische Barockplastic* . . . , Munich, 1962, 39ff.

[168] Drawing Cat. No. 157.

Appendix II. Document Catalogue

Remarks

The documents contained in this catalogue have been transcribed with minimal adjustments in orthography. Only documents that have direct bearing on the Pitti commissions or on their chronology have been included. In most cases in which the document has been previously published, it has been retranscribed in full for publication here. The Florentine calendar commenced the new year with the feast of the Annunciation (*ab Incarnatione*) on March 24. Therefore all documents not previously published with adjusted dating for the period January 1 to March 24 are presented with their *stile communale* date followed by their adjusted one in brackets thusly: 1 de gennaio 1646[1647]. I am deeply indebted to Dr. Gino Corti for checking transcriptions and for the discovery of several important documents in the catalogue.

Abbreviations

Manuscript Sources

ASF	Archivio di Stato, Florence
ASM	Archivio di Stato, Modena
BMLF	Biblioteca Medicea Laurenziana, Florence
BNF	Biblioteca Nazionale, Florence
BVR	Biblioteca Vaticana, Rome

Published Sources

Bottari-Ticozzi	G. Bottari, *Raccolta di Lettere sulla Pittura, Scultura ed Architettura scritte da' più personaggi dei secoli XV, XVI, e XVII*, 2nd edition enlarged by S. Ticozzi, Milan, 1822-1825.
Geisenheimer	H. Geisenheimer, *Pietro da Cortona e gli Affreschi nel Palazzo Pitti*, Florence, 1909.
Gualandi	M. Gualandi, *Memorie Originali Risguardanti le Belle Arte*, Bologna, 1840.

No. 1

*Luigi Arrigucci to Michelangelo
Buonarroti the Younger*

MAY 16, 1637

Molto Ill.re Sig.r mio Padron Oss.mo
Se fusse stato in mio potere il servir V.S. del
disegno chiestomi, ella non arebbe a accusarmi
della tardanza. Il Sig.r Pietro da Cortona, per
esser occupatissimo, non ostante il desiderio
che ha auto di servir lei e far piacere a me, si è
ridotto a finirlo questa sera alle ventiquattro;
ed io subito ho mandato il mio servitore a farlo
consegnare al procaccio, in un cannone di latta,
con il soprascritto a V.S., e se il mio servitore
mi saprà dire il nome del procaccio, lo noterò
in piè di questa, acciò ella abbia più facilità in
ritrovarlo Di Roma li 16 maggio 1637.
Di V.S. Molto Ill.re

<div align="right">

Der.mo et obbl.mo ser.re
LUIGI ARRIGUCCI

</div>

Source: BMLF, Archivio Buonarroti, 41 (Lettere
di varii a Michelangelo Buonarroti il Giovane),
no. 158.

Comment: This letter was found and transcribed
by Gino Corti.

No. 2

*Pietro da Cortona to Cardinal
Francesco Barberini*

JULY 20, 1637

Emin.mo e Rev.mo Sig. mio colend.mo
Io o reverito le ecel.me monache de sua Emin.za
quale ano sentito piacere del bona salute de sua
Emin.za, e o visto il monasterio quale mi è parso
asai grande per quello che si pol comprendere
di fori, e aparisce il più bello che sia qua si
comme ancho la ciesa è asai grande e bene
ornata. Credevo potere dare aviso a Sua Em.za
di tutto il viagio del Sig. cardinal Sacchetti, ma
mi è bisogniato tratenermi qua in Fiorenza, per
fare dua quadri in fresco a S.A., che uno è
l'età del oro e laltro del argento, e a la fine di
agosto li averò finiti sicuro, e poi, se è con gusto

di Sua Em.za, seguiterò il viagio. Il viagio del
sig. cardinal Sacchetti in sin a qua è stato
filicisimo, poi che non si è sentito molto caldo,
e con bona salute de tutti e in particolare del
sig.r Cardinale. Qua i primi giorni che si arivò
qua ci fece gran caldi; e nel partire che si fecero
per Bolognia si era gominciato a rinfreschare, si
che spero che sia senpre il steso fresco questo
tenpo che io starò qua in Firenze. Prego Sua
Emin.za in onorarmi de i sua comandamenti, e
con ricordarmili obligatisimo servitore e pre-
gandoli da Nostro Signore ogni filicita, baci-
ando a Vostra Eminenza umilisimamente la
veste. Di Firenze di 20 di luglio 1637.
Di V.E.R.ma

<div align="right">

Umil.mo e obblig.mo servitore
PIETRO BERETTINI

</div>

Source: BVR, Cod. Barb. Lat. 6458, fol. 94.

Publication: Geisenheimer, pp. 17-18, doc. A.

Comment: The transcription here published is
taken from Geisenheimer. It should be noted that
Geisenheimer cites the document according to an
older pagination as Barb. Lat. 6458, fol. 47.

No. 3

*Pietro da Cortona to Cardinal
Francesco Barberini*

SEPTEMBER 13, 1637

Emin [entissi]mo e R[everendissi]mo Sig.r
Ricevei il favore che Sua Emi[nen]za mi fece
in onorarmi di una sua lettera nela quale
riconoscho l'obligo che io devo verso Sua
Emi[nen]za, che con tanta benignità si tiene
memoria dei suoi servitori comme so' io e ancho
di Rafaello, quale sotto la protezione de
Vos[tra] Em[inenza] so' sicuro che non si
porrà portare se non bene. Io qua mi trovo ala
fine dele due istorie però il fresco, solo mi
mancha il ritocarle, che una è quela del oro e
l'altra del argento; in questa stanzia ci man-
cherebe quella del rame e del ferro. S.A. mi
dimandò se io avevo pensiero di fare il viagio
di Lombardia finite le dua e al ritorno ripassare
per Firenze e fare le altre dui. Io li risposi che io
avevo pensiero di ritornare per la strada di
Loreto, e cosi non se disse altro; ma S.A. hè

informato benisimo de' oblig[h]i che i'ò con
Sua Emi[nenza] per tante favori che io ò
ricevuto, e mostra di avere gusto che Sua
Emin[enza] mi abbi tenuto sotto la sua protezi-
one. Tuta via i' non mi son inpegniato di
parola veruna, ma questi Sig. senpre mi
dichi[n]o che S.A. desidera che voria che io la
finissi questa stanzia, quale a finirla ci vorebe
dui altri mesi. Io non so' per fare se non quello
che Sua Emin[enza] mi ordina che io faccia.
Io qua so' senpre alogiato in casa del Sig.
Michelangelo Bonaroti, che così mostrò di
ave[r] gusto il Sig. Cardinal Sacchetti quale mi
disse che se non mi fussi piaciuto, che fussi
andato dai Sig. Sacchetti. E così da S.A. io ci sto
solo la matina, e la sera torno continuamente
da' Sig. Michelangelo, quale con molta cortesia
mi onora for de og[ni] mio merito. Ho reverito
più volte la Ecelen.ma Su' Sorella, quale sta
con bonisima salute. E mi scusi Vos[tra]
Emin[enz]a se io sarò stato cosi lungo, e con
suplicarla di volermi onorare de i suoi comanda-
menti, con baciarli le veste e pregarli da nostro
Signore ogn[i] magiore filicità e ricordarmli
devotisimo servitore. Di Firenze, 13 di setenbre
1637.
Di V. Emin[enz]a R[everendissima]

Devotissimo Servitore
PIERO BERETTINI

Source: BVR, Cod. Barb. Lat. 6458, fol. 96 recto
and verso.

Publication: Bottari-Ticozzi, V, pp. 311-313,
letter no. CXIV.

Comment: The transcription published here is
taken from the original document. Bottari pub-
lished a heavily edited, slightly abbreviated version
of this document and omitted mention of the
source.

No. 4

*Jacopo Soldani to Michelangelo
Buonarroti the Younger*

SEPTEMBER 16, 1637

Ill.mo Sig.r mio Oss.mo
S.A.za sta in dubbio se Pietro da Cortona farà
punto sabato sera all'opera del suo gabinetto,

o se tirerà avanti a due altri scompartimenti
che vi restano, e la resoluzione dependerà dal
Pittore, perchè S.A.za non intende non
solamente di sforzarlo a rimanere, ma nè
anche di pregarlo. Se finirà, se ne andrà subito,
e per 3 o 4 giorni non mette conto di farci
alcun'opera che si parta dal suo ospizio. Se
harà a finir queste altre due storie, sono
assicurato che si farà in maniera che egli resti
in Palazzo con quelle cautele che V.S. desidera,
cioè che venga dal Gran Duca a far in maniera
che ora che crescono le veglie non habbia a
partirsi. Desideravo di venir a darle questo
ragguaglio io in persona, ma perchè oggi non
posso dovendo servire il Ser.mo Principe a 21
ora, non ho voluto mancare di non rispondere
al viglietto che ella mi scrisse. Noi credo che
partiremo martedì prossimo, ma prima sarò
a riverir V.S. e a ricever i suoi comandamenti,
de' quali supplicandola con tutto l'animo la
reverisco. Di casa, 16 settembre 1637.
D.V.S.Ill.ma

Obblig.mo Ser.re
IACOPO SOLDANI

Source: BMLF, Archivio Buonarroti, 54
(Carteggio di Michelangelo Buonarroti il
Giovane, XIV, So-St), no. 1871.

Comment: This document was found and
transcribed by Gino Corti.

No. 5

*Pietro da Cortona to Michelangelo
Buonarroti the Younger*

NOVEMBER 1637

Molto Ill.e Sig.r e Patr[one]
Credo che vosignoria mi averà per scusato se
prima di questo tenpo io non abi scritto a
vosignoria per essere io stato senpre in viagio e
non esendomi io fermato in logo con più longa
fermata di qua che è in Venezia, che ci starò
dieci giorni. E però vengo a riverirla con questi
dui versi e darli conto che io ò auto assai
migliore viagio di quello che conporta la
stagione, perchè con tutto che qua sia piovuto,
non si sono ancora rotte le strade e è stato il
tenpo tanto a proposito, che ò potuto vedere

queste opere così belle. Però desidero che se di
qua io fussi bono a servirlo in qualche cosa, mi
onorassi in comandarmi e ricordarmi Servitore
al sig.r Sigismondo Bonaroti e ai signori
Balducci, con salutarli a mio nome. Con
ques[t]o mi ricordo servitore obligatisimo
e con pregarli da Nostro Sig[no]re ogni sua
filicità. Di Venezia il dì [blank] novembre 1637.
Di V.S. Molto Ill.re

Servit[ore] aff[ezionatissi]mo
PIERO BERETTINI

Source: BMLF, Archivio Buonarroti, 43 (Lettere
di varii a Michelangelo Buonarroti il Giovane),
no. 407.

Publication: Gualandi, III, p. 68.

Comment: Published by Gualandi without
citation of source. The version published here
was transcribed from the original document by
Gino Corti.

No. 6

*Pietro da Cortona to Michelangelo
Buonarroti the Younger*

DECEMBER 19, 1637

Molto Ill.re Sig.r e Patro[ne]
Non vorei infastidirla con troppe lettere,
poichè li oblig[h]i che io tengo con vosignoria
mi fano pigliare ardire di scriverli, con darli
parte comme ai quindici di questo io arivai in
Roma per la Dio grazia, con bona salute. E
con l'essere i[o] qua in Roma, desidero che
dove vede che io la possi servire, mi comandi.
E con l'ocasione del santi[ssi]mo Natale li
augurio da Nostro Sig[nore] le bone feste, sì
comme le do ancora al Sig. Sigismondo suo
nipote. E per fine li prego da nostro Sig[nore]
Dio ogni suo bene e li bacio le mani. Di Roma
il dì 19 di dicenbre 1637.
Di V.S. Molto Ill.re

Servitor Oblig.mo
PIERO BERETTINI

Source: BMLF, Archivio Buonarroti, 43
(Lettere di varii a Michelangelo Buonarroti il
Giovane), no. 408.

Publication: Cited but not transcribed by
Geisenheimer, p. 30, no. 30.

Comment: The transcription published here was
prepared by Gino Corti.

No. 7

*Pietro da Cortona to Michelangelo
Buonarroti the Younger*

JANUARY 9, 1638

Molto Ill.re Sig.r e Pat[rone]
Le due gratisime che mi à favorito mandarmi,
una in particulare che me l'à ricapitata il Sig.r
Lovigi Ariguci nela quale mi à portato
grandisimo contento poichè mentre dice di
augurarmi il bon capo di anno con molti
apresso, quali spero poterli godere vivendola
costà o dove mi favorirà in comandarmi. Che
io mi scordi di Firenze, dove io ò riceute tante
cortesie, io serei ingrato, qual vizio io non
voglio avere, poichè con l'afetto io porto a
vosignioria, mi fa desiderare cotesta città, oltre
l'oblig[h]i che tengo verso coteste Altezze.
Desidero che mi faccia grazia salutare il Sig.
Sigismondo a mio nome, sì ancora i signiori
Balducci sui nipoti. E con pregarli da Nos[tro]
Sig[nore] Dio ogni sua filicità, e li bacio le
mani. Di Roma 9 di genaio 1638.
Di V.S. Molto Ill.re

Serv[itore] Oblig.mo
PIERO BERETTINI

Source: BMLF, Archivio Buonarroti, 43
(Lettere di varii a Michelangelo Buonarroti il
Giovane), no. 409.

Publication: Cited but not transcribed in
Geisenheimer, p. 30, no. 14.

Comment: The transcription published here was
prepared by Gino Corti.

No. 8

*Pietro da Cortona to Michelangelo
Buonarroti the Younger*

JANUARY 16, 1638

Molto Ill.e Sig.r e Patr[one]
Con la venuta di Francescho, ò riceuto il favore

dele rime di Michelangelo Bonaroti mandateme da vosignoria, quale le stimo sì per essere bellisime sì ancora per l'autore, ma più per essermi mandate da vosignoria, quale io stimo tanto per tanti favori riceuti, dei quali ne tengo memoria e in particulare di queste poesie. Credo che sarà arivato costà il Sig. Andrea [A]rig[h]etti, e mi dispiace che quando lui si partì io non fui a riverirlo. Vosignoria potrà fare mia scusa quando lo vede, che l'averò per favore e soplirà a una mia mala creanza; e si ricordi che io li vivo servitore e li prego da nostro Signore Dio ogni suo bene e li bacio le mani. Di Roma il dì 16 di genaro 1638.
Di V.S. Molto Ill.re

Servit[ore] Aff.mo
PIERO BERETTINI

Source: BMLF, Archivio Buonarroti, 43 (Lettere di varii a Michelangelo Buonarroti il Giovane), no. 410.

Publication: Cited, but not transcribed by Geisenheimer, p. 30, no. 15.

Comment: The present transcription was prepared by Gino Corti.

No. 9

Pietro da Cortona to Michelangelo Buonarroti the Younger

DECEMBER 25, 1638

Molto Ill.re Sig.r e Pa[trone]
Per essere stato negligente la posta passata in dare le bone feste a vosig[noria], sarà ocasione de includervi ancora il bon capo di anno, quale li desidero filicissimo, e anchora per ricordarmili servitore conforme che senpre li ò professato obligatissimo. Io non farò altre cerimonie, solo starò atendendo i soi comandi. Desiderarei sapere comme sta madonna Camilla, sì ancora Andrea suoi servitori, sebene spero a primavera [in] persona li [*sic*] rivede[r]li, sì comme vosignoria di servire. E con questo li p[r]ego da nostro Sig. Dio ogni suo bene e li bacio le mani. Di Roma li 25 Di[cem]b[re] 1638.
Di V.S. Molto Ill.re

Serv[itore] Aff.mo
PIERO BERETTINI

Source: BMLF, Archivio Buonarroti, 43 (Lettere di varii a Michelangelo Buonarroti il Giovane), no. 411.

Publication: Cited but not transcribed in Geisenheimer, p. 30, no. 16.

Comment: The transcription published here was prepared by Gino Corti.

No. 10

Michelangelo Buonarroti the Younger (minutes of a letter) to Luigi Arrigucci

JUNE 11, 1639

Al S.r Luigi Arrigucci, Roma, 11 Giugno 1639 . . . Stavamo aspettando il S.r Pietro da Cortona. Alla settimana passata gli scrissi. Non ho risposta, però la voce viva e sicura di V.S. gli significhi detta lettera. So che ha da far, servendo costà in gran cose, i Padroni, ma il suo valore il fa desiderar per tutto. . . .

Source: BMLF, Archivio Buonarroti, 40 (Minute di lettere di Michelangelo Buonarroti il Giovane), c. 74 verso.

Comment: This transcription was prepared by Gino Corti.

No. 11

Pietro da Cortona to Michelangelo Buonarroti the Younger

SEPTEMBER 24, 1639

Molto Ill. sig.r e Padrone oss.
Non vorei essere tenuto per malcreato se questo signiore, che mi à dato la gratisima lettera di vosig., con l'essere venuto a casa mia non mi à ritrovato, e io non son anchora ito a visitarlo, poi che adesso sto nel terminare l'opera de la sala dei sig. Card.i Barberino quale sto al fine, e di già ò cominciato a levare parte de i ponti, il che mi à portato più tempo che io non credevo, sì per essere l'opera grande sì anchora per essere in Roma, dove è necesario le cose ridurle bene per essere opere che di

questa grandezza non se ne fano ogni giorno, e io non ò voluto manchare di farci quella diligenzia che potevo, però spero che per un mese e mezzo ci sarà da fare, che ancho adesso si dorerà il cornicion, che ci gira in torno; sichè per essere la stagione innanzi, fo pensiero che a marzo di essere costì, se mentre sarà di gusto di S.A. che finischi la stanza cominciata. Che le vicini si dolg[h]ino di madonna Camilla àno molto ben ragione, poichè ne son causa io per non avere mandato i guanti che io promessi, sichè speravo di partarli io stesso. Alora averebero ragione, se fussi venuto e non li avessi portati, e averei caro de la misura, poichè quella che mi dettero l'o smarita; e se io li avessi promesso una corona, credo che se ne averebeno scordato. Però una parola di vosig. aggiusterà queste querele, e io mi racomando a madonna Camilla se però lei stia in bona con Andrea, e mi li ricordo servitore obligatisimo e la prego volermi onorare de' suoi comandi e li bacio le mani. Di Roma li 24 di setenbre 1639. Di V.S. Molto Ill.re

Ser.re Oblig.mo
PIETRO BERETTINI

Source: BMLF, Archivio Buonarroti, 43 (Lettere di varii a Michelangelo Buonarroti il Giovane), no. 412.

Publication: Geisenheimer, p. 18, doc. B.

Comment: The transcription published here is taken from the original document.

No. 12

Pietro da Cortona to Michelangelo Buonarroti the Younger

DECEMBER 21, 1639

Molto Ill.e Sig. e Patron Oss.mo
Con l'ocasione dele feste del Santo Natale, non ò voluto manchare di augurarli le filicisime feste, quale li disidero queste con molte altre apresso. Io intanto sto sbrigando che io possi essere in ordine al tenpo che io li scrissi, aciò vosignoria non rimanga inganata conforme che mi acenna. E in questo tenpo che io sto qua, mi favorischa d'onorarmi de' soi comandi e mi li ricordo servitore e li

bacio le mani. Questo dì 21 di dicenbre 1639, di Roma.
Di V.S. Molto Ill.re

Servitore Oblig.mo
PIETRO BERETTINI

Source: BMLF, Archivio Buonarroti, 43 (Lettere di varii a Michelangelo Buonarroti il Giovane), no. 413.

Publication: Cited but not transcribed by Geisenheimer, p. 30, no. 18.

Comment: This transcription was made by Gino Corti.

No. 13

Pietro da Cortona to Cassiano dal Pozzo

JUNE 11, 1641

L'onore che V.S. si è degnata farmi di scrivere una sua lettera in raccommandazione di questo Ferdinando, lo stimo singolarissimo per essersi degnata commandarmi, ma riputo a mia disgrazia che avendolo proposto ai capi di galleria, m'hanno risposto che i luoghi che sono per vacare sono promessi da cinque in sei anni innanzi, ed i raccomandati sono dieci, sebbene io intesi dal sig. Gio. Carlo, (mentre mi faceva mostrare i lavori di pietre) che voleva ritenere i migliori, e licenziare gli altri per sminuir quelli che vi sono. Sento mortificazione in non poterla servire per compensar in parte a tanti obblighi che tengo con V.S.ill. Io sto sbrigando l'opera, che di già è a bonissimo termine circa il fresco. A novembre sarò costì a reverirla di persona: pertanto la supplico avolermi onorare de' suoi commandi, e me le ricordo obbligato servitore. Io sto in casa del sig. Michelangelo Bonarroti [*sic*], il quale riverisce V.S.ill., e si è compiaciuto di scrivere qui sotto questi due versi. E la prego Di Fiorenze, gli 11 giugno 1641.

Source: Paris, Institut Néerlandais, Fritz Lugt Collection.

Publication: Bottari-Ticozzi, vol. I, pp. 413-414, no. CLXVIII and cited in F. Lugt, *Le Dessin italien*

dans les collections hollandaises, Paris, 1962, p. 101, cat. item N.

Comment: The version published here is taken from the Bottari-Ticozzi transcription.

No. 14

Mario Frangipani to Grand Duke of Tuscany (?)

JULY 15, 1641

Seren.mo Sig.r et Patron mio Colendissimo
Mastro Gio. Maria Sorrisi, capo Muratore et Stucchatore, vien chiamato a Fiorenza per servitio dell'Al.za vostra, mi ha pregato di volerlo accompagnare con una lettera stimando che li habbi da servire per prova la mia testificatione. Non mi è parso di negarli l'uffício, tenendo per certo che nelle opere che farà debbia dare intera satifatione a V.Alt.za per essere molto accurato et diligente nelle sue opere, com' anco per essere huomo da bene et molto trattabile. Et con questa occhasione vengo a rifreschar la memoria a V.Alt.za della mia devotissima servitù, la quale in tutti gl'accidenti sarà la medesima che li ho dedicato, et li faccio umilissima riverenzia. Del Castel S. Angelo li 15 luglio 1641.
Di V.Alt.za Serenissima
 Umilissimo et Devot.mo Servitore
 MARIO FRANGIPANI

Source: ASF, Carteggio Mediceo, F. 1004, fol. 637.

Publication: Cited (as ASF, Carteggio Mediceo, F.1103, ins. XIII, no. 637) by Geisenheimer, p. 12, n. 1, and p. 31, no. 22.

Comment: Geisenheimer transcribes Sorrisi as Sorriti. We would follow Wittkower (*Art and Architecture*), who accepts the former spelling.

No. 15

Monanno Monanni to Cavalier Pandolfini

JULY 27, 1641

Ill.mo Sig.r et P.ron Oss.mo
L'apportatore di questa sarà maestro Gio.
Maria Sorriso, maestro Batista Frisone, e maestro Santi Castellaccio, stuccatori, quali sono spediti da me per Fiorenza per comandamento del Ser.mo S.r Principe Gio. Carlo nostro Sig.re per lavorare di stucco dove sarà loro comandato. Et per loro provisione son restato d'accordo con loro che devino esser trattati così.

Che sieno levati di Roma e condotti a Fiorenza senza spesa, et ricondotti a Roma finito l'opera.

Che per loro provisione li si paghi sc. 60 il mese in mano a maestro Gio. Maria suddetto et sieno di giuli X per scudo, et egli è obligato a mantenere gl'altri dui maestri.

Che sia accomodato loro di commodità di stanza, letto e masseritie le più necessarie.

Che li cominci a correre la provisione il primo giorno che partano di Roma, che sarà domattina alli 28 di Luglio 1641, et duri sin che saranno rimessi in Roma. Et loro si obb[l]igano di obedire, servire et dare ogni maggiore sotisfatione possibile. Supplico V.S.Ill.ma però di rappresentare tutto a S.A.S. et di comandare a me se in altro la devo servire et le fo reverenza affett.ma. Di Roma li 27 luglio 1641.
Di V.S.Ill.ma
 Dev.mo et obbl.mo Servitore
 MONANNO MONANNI

S.r Cav.r Pandolfini

Source: ASF, Fabbriche Medicee, F. 140, fol. 131 interno.

No. 16

Andrea Arrighetti to Grand Duke Ferdinand

AUGUST 3, 1641

Ser.mo Sig.re
Si è fatto conto che spese ci possino bisogniare per conto della stanza che ha da dipignere Pietro da Cortona, et si trova, che per levare et porre gli tre huomini che si sono fatti venire di Roma, per le spese delle calcine che si hanno a far venire di Pisa, delle Pozzolane, legniami, ferramenti, et altri

ammannimi et manifature ci vorrà un
assegniamento di scudi quattrocentocinquanta
di moneta et oltre a questo di scudi settanta
simili il mese per quel tempo che durerà questo
lavoro, tanto per mantinimento di questi tre
huomini, e quali scrivano di Roma haver
pattuito che si dia scudi settanta[1] il mese,
quanto per le opere di un muratore et di un
manovale, che ha d'assi[s]tere a detto lavoro,
senza fare per adesso altro conto di quello che
in fine si sia per havere a dare al medessimo
Cortona; et a V.A. fo umilliss.ma reverentia.
Di Casa 3 Agosto 1641.
Di V.A.S.

> *Vasallo e Serv.re dev.mo*
> ANDREA ARRIGHETTI Sopraintend.te

Rescript:
Fer[dinando]
Il Depositario Gen.le faccia paghare a
Vincenzio Coresi li sudetti scudi
quatrocentocinquanta per li sudetti lavori,
et settanta scudi il mese di più per il
mantinimento de' sudetti huomini et altro,
approvando S.A. il patto fattosi loro in Roma,
e tutto senza diminuire de' soliti
assegniamenti.

> PERSIO FALCONCINI, 15 Agosto 1641.

Source: ASF, Fabbriche Medicee, F. 140, fol. 131.

Publication: A copy of this document, ASF,
Depositeria Generale, F. 1049, no. 179, is cited by
Geisenheimer, p. 11, n. 1 and p. 31, no. 23.

Comment: For the document recording the receipt
of the 450 *scudi* for materials by Vincenzio
Coresi, see Doc. Cat. No. 51.

No. 17

AUGUST 3, 1641

Persone alla Stanza dipigne Pietro da Cortona
opere 29 sc. 5.1.4.–

[1] The monthly stipend of the *stuccatori* is variously
entered as 60 and 70 *scudi* per month (cf. Doc. Cat.
28), possibly as a result of the evaluation of the Floren-
tine *scudo* versus the evaluation set in the original
agreement which stipulated ". . . sc. 60 il mese . . . et
sieno di giuli X per scudo . . ." (Doc. Cat. No. 15).

Source: ASF, Fabbriche Medicee, F. 75 bis
(Ristretto della Fabbrica de' Pitti per dare in
camera del Ser.mo Gran Duca), c. 260.

No. 18

AUGUST 9, 1641

Persone alla stanza dipigne Pietro da Cortona
opere 41½ sc. 7.5.18.8
Vinc.o Salvadori procaccio per haver
condotto di Roma li stuccatori sc. 21.–.16.8

Source: ibid., c. 261.

No. 19

*Pietro da Cortona to
Cassiano dal Pozzo*

AUGUST 17, 1641

Ringrazio infinitamente V.S.ill. della lettera
che mi ha favorito la settimana passata di
mandarmi insieme con quella del sig.
Michelangelo Bonarroti, a cui la detti
subito, e ne mostrò grandissimo piacere.
Le resto obbligatissimo dell'avvertimento
di far disegnare i leoni con gli altri animali,
poichè per mera trascuraggine non si avevo
pensato. Il sig. Girolamo Tezio di già m'ha
mandati alcuni disegni della sala del sig.
cardinal Barberini, e, per quanto mi accenna,
di già li fa intagliare. Ho inteso che uno ne
fa il Greuter, il quale è buono. Gli altri non
so come li abbia spartiti, acciò possa essere
uniforme coll'opera tutta insieme. Circa l'opera
del P. Ferrari io ne sono informato, e dubito
che tenga il piede in più staffe, e credo che
cerchi quello che possa far maggiore spesa, nè
compirla per esserci molti pezzi da intagliare.
Il Granduca è principe molto accorto, e
questo è negozio da esser trattato con molta
destrezza; e venendo la congiuntura, io,
sebbene poco atto, lo farò nel modo che V.S.ill.
mi accenna. Me le ricordo obbligatissimo
servitore, e starò attendendo l'onore de' suoi
comandi. . . . Di Firenze, li 17 agosto, 1641.

Publication: Bottari-Ticozzi, vol. I, pp. 415-416, no. CLXXX.

Comment: The transcription published here is taken from Bottari-Ticozzi.

No. 20

AUGUST 17, 1641

Persone alla stanza dipigne Pietro da Cortona
opere 16 sc. 2.1.6.8
Calcina bianca per li stuccatori sc. 9.3.10.–

Source: ASF, Fabbriche Medicee, F. 75 bis
(Ristretto della Fabbrica de' Pitti per dare in
Camera del Ser.mo Gran Duca), c. 263.

No. 21

AUGUST 23, 1641

Persone alla stanza dipigne Pietro da Cortona
opere 10 sc. 4.6.3.4

Source: ibid., c. 264.

No. 22

*Draft of a letter of Michelangelo
Buonarroti the Younger to Luigi
Arrigucci*

AUGUST 24, 1641

Con V.S. che ama assai, come fo io, il S.r
Pietro da Cortona e ama parimente me,
conviene che io discorra con somma e segreta
confidenza di quel che passa, per poter ricever
da V.S. favore e consiglio per salvar una capra
e certi cavoli insieme, cioè il mio necessario
commodo e mantener salva la benevolenza
in me del S.r Pietro, al quale desidero ogni
massimo bene, chè è un de' migliori huomini
del mondo sì come egli è valentissimo e dà
a questi Padroni somma sodisfazione, onde
l'amano grandemente. Quattro anni sono il

S.r Pietro passando di qua col'Em.mo S.r
Card.l Sacchetti, fu proposto da me a queste
Altezze per via d'interpetre, come e' non si
sarebbe dovuto lasciar partir di qua senza far
loro qualche opera. Il mio parere passò. Lo
invitai a casa mia. E avendo pur anche stanze
in palazzo, non ostante che io stessi a casa
assai lontano a Pitti e la stagion caldissima,
persuaso del S.r Card.le, accettò l'invito.
E venne a casa mia con un giovane di rispetto,
e ci stette circa a 4 mesi, mentre io vissi sempre
malato e invero, in quella state, non senza
molto mio scommodo. E partendo poi senza
finir l'opera, mi disse che, vedendo il suo
grande scommodo per la lontananza della mia
casa, che quando tornasse a Firenze voleva
prender proprio alloggiamento verso i Pitti etc.
Partì, andò per la Lombardia a veder le cose
belle e tornò a Roma. [Sento che voi avete a
far cose belle di nuovo e vi tratterrete costà
più mesi, ma siatemi tuttavia da Mich.lo
B.ti perchè e' non soleva aver casa se non ha
murato, che potesse molto commodamente
alloggiar forestieri. So che non vi eran se non
due camere di servitù, l'una all'altra giudico
che sia da considerarvi etc. Bisogna a' miei
amici ne Egli è ben vero che io voglio
prima patire ogni sorte di disagio e ogni
incommodo, che perder punto della
benevolenza del Sig.r Piero o d'essergli
sospetto di e anche aver passar questo offizio
nè con V.S. nè con altri che cagioni in lui
diffidenza o malvolere. Molte cose son
necessarie farsi per liberarsi da vessazioni che
non son poi ben prese da chi vi ha interesse e
gli par di patirne. Io l'ho auto caro, ma V.S.
sente il caso et è discreta. E soggiungo che se
mi venisse occasione d'alloggiar un altro
forestiero, io non ho dove, perchè ho murato
a pompa e non a commodo e la mia casa è parte
della casa di mio padre, che quando ella si
riunirà con quella de' miei nipoti, che sarà
presto, sarà migliore e più formata.

Il Sig.r Piero ha la parte di Palazzo, nè egli nè
io la possiam mutare e non vorrei che egli o
altri si credesse che io ci facessi incetta e a
lungo andar questa cosa non mi piace. E forse
che qualcun ne murmura, e forse che egli
(che so io?) o chi è seco ci crede il mio avanzo.
E ciò mi spiace. La mia casa vive al suo solito e

poi alloggia due forestieri e con la cucina e
con le camere e con la mia servitù e con tutto
quel scaldare una casa agli amici e ben
volentieri. E il mio servitore che è vecchio,
va da casa a' Pitti due volte il dì il più della
volte. È vero che per sua commodità quando il
S.r Piero lavora, la mattina mangia a Pitti. In
sustanza, io non posso lungamente tener
forestieri in casa e solo gli posso tenere quando
il non gli tenere mi pregiudicasse l'amicizia loro.
V.S. discretissima mi vuol bene e vuol bene
al S.r Pietro sì come al medesimo voglio io,
il cui alloggio mi è stato favore e onore, giachè
quando venne e che il Gran Duca seppe che
veniva da me m'ebbe a dire (non so con che
intenzione): "Voi me l'avete tolto," al che io
mi ristrinsi nelle spalle e senza saper che
rispondere tacqui. Nè senza qual[che] mio
commodo è stato da me già due volte, mentre
che e' me ha donato alcune carte di disegni e
cartoni e mi ha consigliato e consiglia intorno
a certe tarsie che io fo.][1] Mi fu da questi di
camera di S.A. più volte domandato nel'
intermezzo di circa a 3 anni e mezzo, quando
sarebbe tornato a finir l'opera per S.A. Gli
scrivevo e egli si scusava con l'opera che faceva
per li SS.ri Barberini, e va bene. In ultimo mi
scrisse di Gennaio che sarebbe venuto presto.
Gli offersi che venisse a scavalcar a casa mia
etc. Il dì 2 del'ultimo maggio mi comparse a
casa a cavallo il suo giovane e dissemi che il
Sig.r Pietro mi salutava a che era fuor di porta.
Il rimandai indietro con invito che venisse a
casa mia; presi una carrozza, andai a incontrarlo
e lo condussi a casa, e la sera fummo egli
prima et io poi, dal Granduca, onde il Gran
Duca mi disse che io li avevo tolto messer
Pietro. Venuto poco appresso mi disse che
sarebbe stato qua sino a settembre, che eran 4
mesi. Taqui, non senza considerare il mio
grande incommodo d'alloggio di due persone
di rispetto. A lui diedi, di due camere che ho,
la migliore e luminosa, e mi riserbai la scura
et entrar l'una nell' altra; al suo giovane il
dominio di 3 camere terrene, dove il S.r
Pietro, perchè è andata la state un poco fresca
e per altro, il S.r Pietro non à gustato scendere.
Io so' qui, e il S.r Piero intanto ha havuto

nuovo lavoro di mesi e mesi, a talchè il S.r
Pietro lavorandovi fino a Natale, volendo
(dice) tornar a Roma per suoi affari, nol
finirà e dice tornare. Ora, S.r mio, io ho un
gran bisogno che V.S. destramente mi aiuti a
sollevarmi di un grandissimo incommodo.
E qualche volta avviene, o per una cagione o
per m'altra, che se io non mi mettesse a patire,
che si avrebbero a far tre tavole, senza quella
della servitù, massimamente quando la mattina
mangiano a casa. Sono stato così lungo per
figurare il caso a V.S., acciochè io [non] le
paia malcreato con questo mio concetto, chè,
come ho detto, son necessitato a parlare. Ella
mi consigli prima che far altro, e tra sè solo
ci faccia un po' di riflessione, perchè veramente
è contra il mio genio il pensare a tormi di casa
gli amici, e scusi V.S. la vecchiaia e la
fantascheria. E se pare a V.S. che questa
cosa si debba fare mentre il S.r Pietro sta qua,
ora è la congiuntura perchè egli inprende
nuovo lavoro, il che può dar parte di materia
a V.S. di mettersi così per lettera a muover
questi ragionamenti. Il mio ruolo è stretto; se
serve amendue loro, non può servir me, nè
posso dividerlo servando loro per andar talora
in villa et esser servito. E per questa cagione
non mi par di doverlo accrescere, potendo
essere essi serviti del palazzo, pronto per loro
e a cui servono. Intenda V.S. caramente e
discretamente per grazia.

Michelangelo suol tener poca famiglia, è
vecchio, suol aver bisogno d'esser ragguanato,
E la mia casa è costituita in modo che io non
posso alloggiare un forestiero al mio piano, che
io non mi metta in una angustissima servitù.

Source: BMLF, Archivio Buonarroti, 40 (Minute
di lettere di Michelangelo Buonarroti il Giovane),
c. 100 recto–101 recto.

Comment: This document was found and
transcribed by Gino Corti.

No. 23

AUGUST 31, 1641

Persone alla stanza dipigne Pietro da Cortona
opere 36 sc. 5.6.–.–

[1] The section of text between brackets was excluded
from the text of the letter actually sent.

Scarpellini all'appartamento nuovo
opere 9 sc. 2.4.–.–
Persone a 'nnaffiare li giorni festivi e
intonacare a' pittori sc. 2.3.–.–

Source: ASF, Fabbriche Medicee, F. 75 bis
(Ristretto della Fabbrica de' Pitti per dare in
camera del Ser.mo Gran Duca), c. 265.

No. 24

SEPTEMBER 7, 1641

Persone alla stanza dipigne Pietro da Cortona
opere 36 sc. 6.–.–.–

Source: ibid., c. 266.

No. 25

SEPTEMBER 14, 1641

Persone alla stanza dipigne Pietro da Cortona
opere 30 sc. 5.1.–.–

Source: ibid., c. 267.

No. 26

SEPTEMBER 20, 1641

Persone alla stanza dipigne Pietro da Cortona
opere 20 sc. 3.4.–.–
Franc.o Pesci Albergatore per haver tenuto li
stuccatori di Roma sc. 3.4.–.–

Source: ibid., c. 268.

No. 27

*Cardinal Jules Mazarin to Cardinal
Giulio Sacchetti*

SEPTEMBER 26, 1641

*Eminentissimo e Reverendissimo Signor
mio Padron Colendissimo*
Il Sig. Pietro da Cortona diede intentione a

Monsieur di Chantalù ultimamente di voler
far un viaggio a questa Corte subito che si fosse
sbrigato da un'opera ch'era impegnato con il
Gran Duca di finire a Firenze ma desiderando
il Cardinal Duca mio Signore con estrema
passione di vederlo quanto prima e sperando
di poter ricevere questa sodisfatione col mezzo
di Vostra Eminenza, non solamente mi ha
commandato di supplicarne vivamente
l'Eminenza Vostra per sua parte, ma ha voluto
scrivergliene la congiunta lettera. Il medesimo
Signor di Chantalu ha referto che il Signor
Pietro havrebe sodisfatto all'impegno in che
era con il Gran Duca nell' estate già passata,
onde tanto più si crede che non riuscirà
difficile a Vostra Eminenza il farlo incaminar a
questa volta, ma per maggior cautela ha Sua
Eminenza voluto scriver al Gran Duca et al
Cavalier Gondi, che fu già Presidente per S.A.
appresso Sua Maestà, afinchè l'Altezza sua si
contenti differir per un poco a far perfettionar
l'opera incominciata dal Sig. Pietro e permetterli
di venir a travagliar per breve tempo in Francia.
Ma se potrà negotiarsi che il Signor Pietro
venghi senza che le suddette lettere sieno
presentate, il Signor Cardinal Duca ne remarrà
maggiormente contento, e goderà di doverne
tutte le obbligationi a Vostra Eminenza, la
quale mi assicuro si ralegrerà non poco quando
intenderà li trattamenti, che havrà ricevuti il
Signor Pietro gli applausi che si faranno alla
sua vertù. Io scrivo particularmente al Signor
Pietro et inviando a Vostra Eminenza la lettera
aperta è superfluo il replicar le medesime cose.
Il Benedetti mio segretario che havrà l'honore
di presentar il mio piego a Vostra Eminenza
ha ordine di eseguire puntualmente quanto li
sarà dall' Eminenza Vostra ordinato, di maniera
che non trovandosi costì il Signor Pietro, e
giudicando ella proposto che si spedischi
qualcheduno a Firenze, o che il Benedetti
medesimo vi si trasferischi per presentar le
lettere al Gran Duca et al Gondi e parlar al
Signor Pietro per parte di Vostra Eminenza,
farà quanto li sarà accennato e provederà il
denaro, e qualunque altra cosa possi esser
necessaria al Signor Pietro per far il viaggio
con intiera sodisfatione. Il Signor Cardinal Duca
ha tanta premura in voler qualche quadro della
sua galleria di Richelieu fatto per le mani del

miglior Pittore che si trovi, che non saprei esprimere a Vostra Eminenza quanto strettamente li rimarrà obligato venendo per suo mezzo favorito della persona del Signor Pietro il quale non potrà scusarsi di far ancora qualche cosa per il Re, nè riceverà da Sua Maestà e da Sua Eminenza accoglienze e dimostrationi minori di quelle furono fatte dal Re Francesco a Leonardo da Vinci. Sono note a Sua Eminenza le obligationi ch'io devo a Vostra Eminenza et alla sua casa e l'honore che l'Eminenza Vostra ne fa d'amarmi non ordinariamente, onde la supplico a confermarla in questo concetto, facendo se sarà possibile che il Signor Pietro se ne venghi sopra le galere che havranno condotto a Civitavecchia il nuovo Ambasciatore. Non sono considerabili le difficultà che restano a superarsi per l'unione de' Plenipotentiarii in Monster onde ho giusta occasione di credere che alla fine del prossimo mese m'incaminarò a quella volta, e risponderei adesso della Pace, se ne fosse da Sua Santità commessa la mediatione a Vostra Eminenza, la cui prudenza e destrezza singulare farebero ben presto goder la cristianità d'un sicuro riposo et a Vostra Eminenza faccio humilissima riverenza. Di Roma 26 settembre 1641.
Di Vostra Eminenza Reverendissima

> *Humilissimo Devotissimo et*
> *obligatissimo Servitore*
> GIU[LIO] MAZARINI

Source: BVR, Cod. Barb. Lat. 8403, fol. 13-14.

Publication: Geisenheimer, p. 6, n. 1, cited this document and published a few lines.

No. 28

SEPTEMBER 28, 1641

Persone alla stanza dipigne Pietro da Cortona
opere 24 SC. 4.2.–.–
Gio. Maria Sorrisi e compagni Stuccatori di
Roma per loro provisione di mesi dua e a
buon conto SC. 120.–.–.–

Source: ASF, Fabbriche Medicee, F. 75 bis (Ristretto della Fabbrica de' Pitti per dare in camera del Ser.mo Gran Duca), c. 269.

No. 29

OCTOBER 5, 1641

Persone alla prima stanza dipigne
Pietro da Cortona
opere 20 SC. 3.4.–.–

Source: ibid., c. 270.

No. 30

OCTOBER 12, 1641

Persone alla prima stanza dipigne
Pietro da Cortona
opere 24 SC. 4.2.–.–

Source: ibid., c. 271.

No. 31

OCTOBER 19, 1641

Persone alla prima stanza dipigne
Pietro da Cortona
opere 24 SC. 4.2.–.–

Source: ibid., c. 272.

No. 32

OCTOBER 26, 1641

Persone alla stanza dipigne Pietro da Cortona
opere 24 SC. 4.2.–.–
Gio. Sorrisi e compagni Stuccatori per
loro provisione SC. 51.3.–.–

Source: ibid., c. 273.

No. 33

NOVEMBER 2, 1641

Persone alla stanza dipigne Pietro da Cortona
opere 17½ SC. 3.1.–.–

Source: ibid., c. 274.

No. 34

NOVEMBER 9, 1641

Persone alla stanza dipigne Pietro da Cortona
opere 24 sc. 4.2.–.–

Source: *ibid*., c. 275.

No. 35

NOVEMBER 16, 1641

Persone alla stanza dipigne Pietro da Cortona
opere 24 sc. 4.2.–.–
Giulio Turchi per la pigione della casa
delli Stuccatori sc. 3.–.–.–

Source: *ibid*., c. 262.

Comments: Out of order in the pagination of the *Filza*, this page is here placed in correct chronological order.

No. 36

NOVEMBER 23, 1641

Scarpellini al nuovo Appartamento
opere 18 sc. 5.1.–.–
Persone alla stanza dipigne Pietro da Cortona
opere 24 sc. 4.2.–.–

Source: *ibid*., c. 276.

No. 37

NOVEMBER 29, 1641

Scarpellini al nuovo appartamento
opere 15 sc. 4.2.–.–
Persone alla stanza dipigne Pietro da Cortona
opere 15 sc. 2.6.–.–
Maestro Gio. Maria Sorrisi e compagni
stuccatori di Roma per lor salario sc. 57.3.–.–

Source: *ibid*., c. 277.

No. 38

DECEMBER 7, 1641

Persone alla stanza dipigne Pietro da Cortona
opere 18 sc. 3.3.–.–

Source: *ibid*., c. 278.

No. 39

DECEMBER 14, 1641

Persone alla stanza dipigne Pietro da Cortona
opere 47 sc. 7.2.3.4

Source: *ibid*., c. 279.

No. 40

*Pietro da Cortona to
Cassiano dal Pozzo*

DECEMBER 20, 1641

Non ho voluto lasciar passare il santo Natale senza riverire V.S.ill., al quale tengo tanti obblighi. Le prego pertanto da nostro sig. Iddio quelle felicità che sa desiderare. Pur tuttavia sto tirando avanti l'opera di S.A., e fra due mesi averò finito il fresco della prima stanza, per poter poi preparare la seconda; e frattanto che io mi trattengo qua, averò per favore di esser onorato de' suoi comandi Di Fiorenza, 20 dicembre, 1641.

Publication: Bottari-Ticozzi, vol. I, p. 416, no. CLXXXI.

Comments: Bottari dated this document December 20, 1644. Geisenheimer (pp. 6, 31) correctly assigned it to 1641. The transcription published here is taken from Bottari-Ticozzi but with the indicated adjustment in the date.

No. 41

DECEMBER 20, 1641

Persone alla Camera dipigne Pietro da Cortona
opere 38 sc. 5.6.13.4

Persone hanno vegliato alla Camera dipigne
Pietro da Cortona sc. 2.6.–.–

Source: ASF, Fabbriche Medicee, F. 75 bis
(Ristretto della Fabbrica de' Pitti per dare in
camera del Ser.mo Gran Duca), c. 280.

No. 42

DECEMBER 28, 1641

Persone alla prima stanza dipigne
Pietro da Cortona
opere 26 sc. 4.–.10.–

Source: *ibid.*, c. 281.

No. 43

JANUARY 4, 1641 [1642]

Persone alla prima stanza dipigne
Pietro Berrettini
opere 40 sc. 6.2.10.–

Source: *ibid.*, c. 282.

No. 44

JANUARY 11, 1641 [1642]

Persone alla prima stanza dipigne
Pietro Berrettini
opere 39 sc. 6.1.3.4.

Source: *ibid.*, c. 283.

No. 45

JANUARY 18, 1641 [1642]

Persone alla prima stanza di Pietro Berrettini
opere 49 sc. 7.5.15.–

Source: *ibid.*, c. 284.

No. 46

JANUARY 25, 1641 [1642]

Persone alla prima stanza di
Pietro da Cortona
opere 54 sc. 8.5.10.–

Source: *ibid.*, c. 285.

No. 47

FEBRUARY 1, 1641 [1642]

Persone alla prima stanza dipigne
Pietro Berrettini
opere 25½ sc. 5.1.–.–
Gio. Maria Sorrisi e compagni
stuccatori per 2 mesi sc. 114.2.–.–

Source: *ibid.*, c. 286.

No. 48

FEBRUARY 8, 1641 [1642]

Persone alla prima stanza dipigne
Pietro Berrettini
opere 24 sc. 4.5.10.–

Source: *ibid.*, c. 287.

No. 49

FEBRUARY 15, 1641 [1642]

Persone alla stanza dipigne Pietro Berrettini
opere 24 sc. 4.5.15.–

Source: *ibid.*, c. 288.

No. 50

FEBRUARY 22, 1641 [1642]

Persone alla stanza dipigne Pietro Berrettini
opere 24 sc. 4.5.10.–

Source: *ibid.*, c. 289.

No. 51

FEBRUARY 28, 1641 [1642]

Io Vincentio Coresi Camarlingo delle Fortezze
ho riceuto dalla Depositeria Generale di S.A.S.
per straordinario sc. quattrocento cinquanta
di moneta per servirmene per pagare come
di là è narrato, a me detto sc. 450.

Source: ASF, Depositeria Generale, F. 1049,
no. 179v.

Comment: This is a receipt filed with a copy of
the estimate of the cost of materials for the first
room which was drawn up for the Grand Duke on
August 3, 1641 (Doc. Cat. No. 16).

No. 52

FEBRUARY 28, 1641 [1642]

Io Vincentio Coresi Cam.o delle Fortezze ho
riceuto dalla Depositeria Generale di S.A.S.
per straordinario sc. quattrocentoventi di
moneta et sono per l'assegnamento di sei mesi a
sc. 70 il mese per mantenimento delli huomini
che lavorono nella Stanza di Pietro da Cortona,
et sono per sei mesate da 15 Agosto prossimo
passato sino a 15 del presente mese di Febbraio,
a me detto contanti sc. 420.

Source: ASF, Depositeria Generale, F. 1049,
no. 180.

Publication: Cited by Geisenheimer, p. 12, n. 1.

No. 53

MARCH 1, 1641 [1642]

Persone alla prima stanza dipigne
Pietro Berrettini
opere 20 sc. 3.6.10
Gio. Maria Sorrisi e compagni stuccatori per
loro opere del mese di febbraio a sc. 60
il mese di Roma sc. 57.1.–.–
Gio. Maria Sorrisi per suo rimborso per
porto di un sacchetto di terra gialla venuta
di Roma sc. –.2.13.4

Source: ASF, Fabbriche Medicee, F. 75 bis
(Ristretto della Fabbrica de' Pitti per dare in
camera del Ser.mo Gran Duca), c. 290.

No. 54

MARCH 8, 1641 [1642]

Persone alla stanza dipigne Pietro Berrettini
opere 24 sc. 4.5.–.–

Source: ibid., c. 291.

No. 55

MARCH 15, 1641 [1642]

Persone alla Camera dipigne
Pietro Berrettini
opere 24 sc. 4.6.–.–
Giulio Turchi a conto della pigione della
casa per li stuccatori sc. 5.–.–.–

Source: ibid., c. 292.

No. 56

MARCH 22, 1641 [1642]

Persone alla Camera dipigne
Pietro Berrettini
opere 20 sc. 3.6.10.–
Persone alla 2da Camera dipigne
Pietro Berrettini
opere 53 sc. 14.3.10.–

Source: ibid., c. 293.

No. 57

MARCH 29, 1642

Persone alla Camera dipigne
Pietro Berrettini
opere 20 sc. 3.6.10.–

Persone alla 2da Camera dipigne
Pietro da Cortona
opere 27 sc. 4.5.6.8
Gio. Maria Sorrisi e compagni stuccatori di
Roma per il presente mese sc. 57.1.–.–
Gio. Batt.a Rosati e compagni mettidoro a
conto della Camera delli Stucchi sc. 80.–.–.–

Source: *ibid.*, c. 294.

No. 58

APRIL 5, 1642

Persone alla prima Camera dipigne
Pietro Berrettini
opere 24 sc. 4.5.–.–
Persone alla 2da Camera dipigne il Berrettini
opere 51 sc. 7.6.4.–

Source: *ibid.*, c. 295.

No. 59

APRIL 12, 1642

Persone alla prima Camera dipigne
il Berrettini
opere 30 sc. 6.4.–.–
Gio. Batt.a Rosati e compagni mettidoro a
conto del'oro per li Stuccatori sc. 70.–.–.–

Source: *ibid.*, c. 296.

No. 60

APRIL 19, 1642

Persone alla prima Camera di
Pietro Berrettini
opere 36 sc. 8.2.5.–
Gio. batt.a Rosati e compagni mettidori,
a buon conto sc. 150.–.–.–

Source: *ibid.*, c. 297.

238

No. 61

APRIL 26, 1642

Persone alla prima stanza dipigne
Pietro Berrettini
opere 16 sc. 3.1.–.–
Gio. Maria Sorrisi e compagni
Stuccatori di Roma sc. 57.1.–.–
Gio. Batt.a Rosati e compagni mettidoro
a conto di metter d'oro la prima Camera
di Pietro Berrettini sc. 80.–.–.–

Source: *ibid.*, c. 298.

No. 62

APRIL 30, 1642

Persone alla prima stanza di
Pietro da Cortona
opere 12 sc. 2.2.10.–

Source: *ibid.*, c. 299.

No. 63

MAY 10, 1642

Persone alla prima stanza dipigne
Pietro Berrettini
opere 24 sc. 4.2.–.–
Gio. Batt.a Rosati e compagni mettidoro,
a buon conto sc. 60.–.–.–

Source: *ibid.*, c. 300.

No. 64

MAY 17, 1642

Persone alla prima Camera dipigne
Pietro Berrettini
opere 18½ sc. 3.3.10.–

Gio. batt.a Rosati e compagni mettidoro,
a conto della stanza dipigne
Pietro Berrettini sc. 40.–.–.–

Source: *ibid.*, c. 301.

No. 65

*Andrea Arrighetti to Grand Duke
Ferdinand*

MAY 20, 1642

Ser.mo Granduca

Sotto dì 3 d'agosto prossimo passato si
rappresentò a V.A. che per tirare innanzi la
prima stanza, che haveva di già cominciato a
dipigniere Pietro da Cortona, ci voleva in
primo luogo un assegnamento di sc. 70 il mese
per tutto il tempo che doveva durare quel
lavoro, per pagare li tre stuccatori che si erano
fatti venire di Roma con un muratore et un
manovale, et in oltre sc. 450 per una volta
tanto per le spese della Pozzolana, Calcina di
Pisa, legniami, ferramenti et altre manifatture,
et in questa conformità V.A. ne comandò
l'assegniamento sotto dì 15 del medesimo.
Hoggi questo lavoro è ridotto in grado che
per tutto luglio o poco più se fa conto che sia
per restare finito, e si può vedere quasi per
l'appunto a che segno sieno per arrivare queste
medesime spese et quella dell'oro ancora, che
non si rappresentò allora perchè non si sapeva
quale fusse il concetto del Pittore. Peró si dà
parte a V.A. come la prima spesa delli sc. 70
il mese arriva a sc. 840; la seconda de' 450,
per essere ricresciuta assai, arriverà a sc. 880,
et quella dell'oro a sc. 1000- almeno, facendosi
conto che vi sieno per andare sopra pezzi
80 mila d'oro. Sì che tutta la spesa di questa
prima stanza, senza quello che V.A. darà al
Cortona, sarà sc. 2720 e tanto si puol far conto
che sia per costare anco la seconda, alla quale
si sta in procinto di mettere mano. Resta
adesso che V.A. ordini in primo luogo che
per conto della prima stanza sieno pagati li sc.
430 che si spenderanno altre alli 450, et sc. 1000
per conto dell'oro; et per conto della seconda
confermi l'assegnamento delli sc. 70 il mese
per il tempo che durerà tal lavoro, e comandi

che sieno pagati gli sc. 1880 per le spese dell'oro
e altri ammannimi, e manifatture come sopra,
che in tutto, oltre alli sc. 70 il mese, sono sc.
3310. Mentre le sto facendo humilissima
reverenza. Di Casa 20 Maggio 1642.
Di V.A.S.

Vass.o e Serv. Dev.mo
ANDREA ARRIGHETTI soprintendente

Rescript:
Fer[dinando]
Il Dep.rio G.le paghi in mano del Camarl.o
Coresi li scudi 420 che si fa conto per spendersi
oltre alli 450, et li sc. 1000 per l'oro per la
prima stanza. Et per la seconda, sèguiti di
somministrare l'assegnamento delli sc. 70 il mese
per il tempo che duri il lavoro. Et di più li
1880 per le spese dell'oro et altro, come si
propone, senza ritenzione delli altri
assegnamenti per la fabbrica.
PERSIO FALCONCINI, 25 Maggio 1642.

Source: ASF, Fabbriche Medicee, F. 141, fol. 27.
The *interno* of this folio is another copy.

Publication: A copy of this document (ASF,
Depositeria Generale, F. 1051, no. 1150 *interno*)
was published without rescript by Geisenheimer,
pp. 11-12, doc. 1a.

No. 66

MAY 24, 1642

Persone alla prima Camera dipigne
Pietro Berrettini
opere 24 sc. 5.4.–.–
Gio. batt.a Rosati e compagni pittori a metter
a oro la camera dipigne Pietro Berrettini
 sc. 50.–.–.–

Source: ASF, Fabbriche Medicee, F. 75 bis
(Ristretto della Fabbrica de' Pitti per dare in
camera del Ser.mo Gran Duca), c. 302.

No. 67

MAY 31, 1642

Persone alla prima stanza di
Pietro Berrettini
opere 15½ sc. 2.2.–.–

Source: *ibid.*, c. 304.

No. 68

JUNE 7, 1642

Persone alla prima |stanza| di
Pietro Berrettini
opere 24 sc. 4.2.–.–
Gio. Batt.a e compagni mettidoro alla
stanza di Pietro Berrettini sc. 60.–.–.–

Source: *ibid.*, c. 303.

No. 69

JUNE 14, 1642

Persone alla prima Camera dipigne
Pietro Berrettini
opere 16 sc. 2.6.–.–

Source: *ibid.*, c. 305.

No. 70

JUNE 21, 1642

Persone alla prima stanza di
Pietro Berrettini
opere 20 sc. 3.4.–.–
Gio. batt.a rosati e compagni mettidoro alla
stanza di Pietro Berrettini sc. 60.–.–.–

Source: *ibid.*, c. 306.

No. 71

JUNE 28, 1642

Persone alla prima stanza di
Pietro Berrettini
opere 10 sc. 1.3.–.–
Persone alla seconda stanza di
Pietro Berrettini
opere 10 sc. 2.1.–.–

Source: *ibid.*, c. 307.

No. 72

JULY 5, 1642

Persone alla prima stanza di
Pietro Berrettini
opere 12 sc. 1.5.–.–
Persone alla 2da stanza di d.o Berrettini
opere 12 sc. 2.4.–.–
Gio. Batt.a Rosati e compagni mettidoro
alla p.a stanza di Pietro Berrettini sc. 15.–.–.–

Source: *ibid.*, c. 308.

No. 73

JULY 12, 1642

Persone alla prima stanza dipigne
Pietro Berrettini
opere 12 sc. 1.5.–.–
Persone alla 2da stanza di Pietro suddetto
opere 12 sc. 2.4.–.–
Gio. Batt.a Rosati e compagni mettidoro
alla stanza di Pietro Berrettini sc. 25.–.–.–

Source: *ibid.*, c. 309.

No. 74

JULY 19, 1642

Persone alla prima stanza di
Pietro Berrettini
opere 12 sc. 1.5.–.–
Persone alla 2da stanza di Pietro suddetto
opere 12 sc. 2.4.–.–
Gio. Batt.a Rosati e compagni mettidoro
alla stanza di Pietro Berrettini sc. 20.–.–.–
Giulio Turchi per pigione della Casa dove
habitano li stuccatori sc. 6.1.13.4

Source: *ibid.*, c. 310.

No. 75

JULY 24, 1642

Persone alla prima stanza di Pietro Berrettini
opere 8 sc. 1.1.–.–
Persone alla 2da stanza del sud.o Berrettini
opere 8 sc. 1.5.–.–

Source: ibid., c. 311.

No. 76

OCTOBER 17, 1642

Io Vincentio Coresi Cam.o delle Fortezze
ho riceuto dalla Depositeria Generale di
S.A.S. per straordinario sc. cinquecento
sessanta di moneta, et sono per mesate otto per
pagare li stuccatori come per rescritto di
S.A.S. del 15 Agosto 1641, a me detto
contanti sc. 560.

Source: ASF, Depositeria Generale, F. 1051,
no. 973.

No. 77

DECEMBER 5, 1642

Io Vincentio Coresi Camarlingo delle
Fortezze ho riceuto dalla Dep.ria Generale
di S.A.S. per straordinario sc. millequattrocento
trenta di moneta, come per rescritto di S.A.S.
de' 25 Maggio 1642, per conto delle stanze che
dipignie Pietro da Cortona, a me detto
contanti sc. 1430

Source: ASF, Depositeria Generale, F. 1051,
no. 1150.

No. 78

*Pietro da Cortona to Cardinal
Francesco Barberini*

DECEMBER 30, 1642

 Emin.mo e Rev.mo Sig.re e Pat.e mio Cole.mo
Avendo io manchato de reverire V.S.E.a con

l'ochasione del Santo Natale non o voluto far
manchamento di darli il bon capo de anno
con molti filicissimi apresso, e con questo
ochasione dar parte a V.S.E. che avendo io
finito dipignere la stanzia di S.A. spero di
essere alla fine di gennaro a Roma e per tanto
io saro sempre prontissimo a ricevere il onore
de soi comandi e con recordarmisi obligatissimo
servitore e da nostro Sig. Dio. li desidero ogni
sua felicita e li faccio umilissima reverenzia con
baciarli le veste, di fiorenza li 30 di dicembre
1642.

 Umil.mo e dev.mo Serv.re Obl.mo
 PIETRO BERETTINI DA CORTONA

Source: BVR, Cod. Barb. Lat. 6458, fol. 99.

Publication: Partially published by Geisenheimer,
p. 30, no. 28, and published in its entirety by
O. Pollak, "Italienische Kunstlerbriefe ans
Barockzeit," *Jahrbuch der Königlich Preuszischen
Kunstsammlungen*, 1913, vol. XXXIV, p. 11.

Comments: The transcription published here is
from Pollak. Both Pollak and Geisenheimer
cite this document by its old pagination, i.e. as
fol. 49.

No. 79

*Pietro da Cortona to Prince (later
Cardinal) Leopoldo de' Medici*

JANUARY 31, 1643

 Seren.mo Prencipe
Non ò voluto manchare di non dare parte a
V.A. del mio arivo in Roma, quale è stato
con bonissima salute, et insieme ringraziarla
del favore che si è conpiaciuto farmi della
lettiga, quale non mi è stato permesso di potere
conseguire tanto onore mediante il tardare
che averebe fatto per il viagio, poichè non sarei
potuto arivare in tenpo alla festa di S. Martina,
quale desideravo eserci. E mentre io starò
questo pocho tenpo qua in Roma, stimarò
grandissimo favore il essere onorato de' soi
comandi. E da nostro Sig. Dio li desidero ogni
filicità e li faccio umilissima reverenzia. Di
Roma 31 di gennaio 1643.

 Umil.o e Devo.mo Serv.e Oblig.mo
 PIETRO BERETTINI

Source: ASF, Lettere Artistiche, vol. III, fol. 77.

Publication: Reproduced in facsimile in C. Pini and G. Milanesi, *La Scrittura di artisti italiani*, Florence, 1876, vol. III, no. 283, and cited in Geisenheimer, p. 31, no. 29.

Comment: The transcription published here is taken from the original document. Both published sources cite the document as fol. 78, a now superseded pagination.

No. 80

APRIL 29, 1643

Io Vincentio Coresi Camarlingo delle fortezze ho riceuto dalla Depositeria Generale di S.A.S. per straordinario per conto a pparte della fabbrica di Pitti sc. trecento quindici di moneta, et sono per pagare li stuccatori fatti venire di Roma et sono per mesi quattro e mezzo, cioè da 15 8bre 1642 sino a tutto febbraio passato, a me detto contanti sc. 315.

Source: ASF, Depositeria Generale, F. 1053, no. 377.

Publication: Cited in Geisenheimer, p. 12, n. 1.

No. 81

Pietro da Cortona to a Grand Ducal secretary

JUNE 1, 1643

 Ill.mo Sig.e Padron. mio Colendissimo
Ho riceuto dal Sig.r abate Altobrandini l'amorevolissima lettera di V.S.Ill.ma, di che non mi stenderò con troppe parole a significarli il desiderio che ò di servire S.A. con quella maggiore prestezza che si pole, ma credo che V.S.Ill.ma resterà ancho facilmente persuasa che la moltiplicità de le mie cose incominciate mi tengono opresso in modo che sino a S. Giovan[n]i non credo di potere avere dato incaminamento da potere essere seguitate e Vosig. Ill.a si asicuri che a me dispiace a non potere essere costì presto per conto de i caldi

che veranno è senpre più dificile il viagiare; de il muratore e stucchatore non ò che dire e per fine mi li ricordo obligato e non mi scordo della pergamena. La preg[o], comme abbi ocasione di essere da S.A., di volerlo reverire a mio nome e ringraziarlo della memoria che tiene di me avendo ordinato che io riceva la lettera di V.S.Ill.ma di suo ordine. E io mentre sto questo pocho tenpo qua averò per favore di essere onorato de' soi comandi e li preg[o] da N.o Sig.r Dio ogni sua maggiore filicità e la reverischo. Di Roma primo di giugno 1643. Di V.S.Ill.ma

 Servitore Oblig.mo
 PIETRO BERETTINI

Source: ASF, Fabbriche Medicee, F. 141, fol. 37.

Publication: M. Campbell, "Contributo alla cronologia di Pietro da Cortona a Palazzo Pitti," *Rivista d'arte*, vol. XXXIV, 1961, pp. 109f.

No. 82

OCTOBER 2, 1643

Io Vincentio Coresi Camarlingo delle Fortezze ho riceuto dalla Depositeria Generale di S.A.S. per straordinario sc. dugento dieci di monta et sono per tre mesate per spese fatte nella prima stanza che dipignie Pietro da Cortona per pagare li Stuccatori, et sono dal primo Marzo prossimo passato a tutto Maggio, a me detto contanti sc. 210.

Source: ASF, Depositeria Generale, F. 1054, no. 946.

Publication: Geisenheimer, p. 12, doc. 1b and p. 31, no. 30.

Comment: Transcription taken from original document.

No. 83

OCTOBER 27, 1643

Io Vincentio Coresi Camarlingo delle Fortezze ho riceuto dalla Depositeria Generale di S.A.S.

per straordinario sc. trecento cinquanta di moneta et sono per pagare li Stuccatori da tutto Maggio a tutto 8bre stante, per pagare li Stuccatori che dipingono nella stanza di Pietro da Cortona, a me detto contanti sc. 350.

Source: ASF, Depositeria Generale, F. 1054, no. 1040.

Publication: Cited by Geisenheimer, p. 12, n. 1.

No. 84

DECEMBER 18, 1643

Io Vincentio Coresi Camarlingo delle Fortezze ho riceuto dalla Depositeria Generale di S.A.S. per straordinario sc. cento di moneta et sono a conto di un rescritto di S.A.S. de' 25 Maggio 1642 di sc. 1880, per l'oro della 2da stanza che dipignie pietro da Cortona, a me detto contanti sc. 100.

Source: ASF, Depositeria Generale, F. 1054, no. 1206.

Publication: Cited by Geisenheimer, p. 31, no. 31.

No. 85

Pietro da Cortona to Cardinal Francesco Barberini

DECEMBER 27, 1643

Emin.o e Rev.mo Sig. Pat.e mio Colen.mo Con la ochasione augurarli il bon capo di anno a V.S. il quale li desidero felicissimo con molta apresso. Li do parte anchora del mio arivo qua in Fiorenza quale è stato con bonissima salute de dove io mi li ricordo senpre esserli obligatissimo servitore e essere prontissimo a ricevere il onore de soi comandi deve conosire che voglia il mi pocho talento quivi senpre io desideroso di servirla e per fine da nostro sig. Dio li desidero ogni sua felicita e li faccio humilissima reverenzia con baciarli i vesti. di fiorenza li 27 dicembre 1643.

Umil. e Dev.o Ser.e Oblig.o
PIETRO BERETTINI

Source: BVR, Cod. Barb. Lat. 6458, fol. 101.

Publication: Cited but not transcribed in full by Geisenheimer, p. 32, no. 32.

Comment: Geisenheimer's citation of fol. 50r is now superseded.

No. 86

JANUARY 8, 1643[1644]

Io Vincentio Coresi Cam.o delle Fortezze ho riceuto dalla Depositeria Generale di S.A.S. per straordinario sc. cento di moneta a conto di sc. 1880 che impone S.A.S. si sieno pagati per suo benignio rescritto, quali devono servire per pagare l'oro della 2da stanza che dipignie Pietro da Cortona, il quale rescritto contiene altri negotii, a me detto contanti sc. 100.

Source: ASF, Depositeria Generale, F. 1055, no. 26.

No. 87

JANUARY 14, 1643[1644]

Io Vincentio Coresi Cam.o delle Fortezze ho riceuto dalla Depositeria Generale di S.A.S. per straordinario sc. cento di moneta et sono a conto di sc. 1880 di moneta per pagare l'oro della 2da stanza che dipignie Pietro da Cortona, nel qual rescritto sono altri negotii, a me d.o contanti sc. 100.

Source: ASF, Depositeria Generale, F. 1055, no. 46.

No. 88

JANUARY 23, 1643[1644]

Io Vincentio Coresi Cam.o delle Fortezze ho riceuto dalla Depositeria Generale di S.A.S. per straordinario sc. cento di moneta a conto di un mandato di sc. 1880 per pag.re l'oro della 2da stanza che dipignie Pietro da Cortona, a me detto contanti sc. 100.

Source: ASF, Depositeria Generale, F. 1055, no. 79.

No. 89

JANUARY 28, 1643[1644]

Io Vincentio Coresi Cam.o delle Fortezze ho
riceuto dalla Depositeria Generale di S.A.S. per
straordinario sc. cento di moneta a conto di sc.
1880 di moneta per conto della stanza che
dipignie Pietro da Cortona, a me detto
contanti sc. 100.

Source: ASF, Depositeria Generale, F. 1055, no. 97.

No. 90

FEBRUARY 5, 1643[1644]

Io Vincentio Coresi Camm.o delle Fortezze
ho riceuto dalla Depositeria Generale del
S.A.S. per straordinario sc. cento di moneta et
sono a conto di sc. 1880 della 2da stanza che
dipignie Pietro da Cortona, a me d.o
contanti sc. 100.

Source: ASF, Depositeria Generale, F. 1055,
no. 128.

No. 91

FEBRUARY 11, 1643[1644]

Io Vincentio Coresi Cam.o delle Fortezze ho
riceuto dalla Depositeria Generale di S.A.S.
per straordinario sc. cento di moneta et sono
a conto di sc. 1880 quali devono servire per
pagare la 2da stanza che dipignie Pietro da
Cortona, a me detto contanti sc. 100.

Source: ASF, Depositeria Generale, F. 1055,
no. 146.

No. 92

*Andrea Arrighetti to Grand Duke
Ferdinand*

FEBRUARY 12, 1643[1644]

 Ser.mo Gran Duca
Per tirare innanzi la terza stanza da dipignersi

da Pietro da Cortona ci vorrà, per quanto
egli dice, un assegnamento di circa a sc.
millequattrocento, che sarà la metà manco
di quello che V.A. ha assegnato per ciascuna
dell'altre due, prima e seconda. Compiacendosi
V.A. potrà ordinare al Depositario Generale
che faccia pagare la suddetta somma in mano a
Vincenzio Coresi Camarlingo delle fortezze e
fabbriche, oltre agl'altri assegnamenti. Et a
V.A.S. bacio umilmente la veste. Di Casa 12
febb.io 1643[1644].
Di V.A.S.
 Vasallo e Servitore Devotissimo
 ANDREA ARRIGHETTI, Sopraintendente

Rescript:
Fer[dinando]
Il Depos.o Generale faccia pagare in mano di
Vincenzio Coresi Camarl.o delle fortezze e
fabriche, senza ritentione de' soliti assegnamenti,
li sudetti scudi millequattrocento per l'effetto
sopradetto.
 PERSIO FALCONCINI, primo Marzo
 1643[1644]

Source: ASF, Fabbriche Medicee, F. 141,
fol. 30 interno.

Comment: The folio proper is a duplicate of this
document. The interno appears to be the original.

No. 93

FEBRUARY 18, 1643[1644]

Io Vincentio Coresi Cam.o delle Fortezze ho
riceuto dalla Depositeria Generale di S.A.S.
per straordinario sc. cento di moneta per conto
di 1880 di moneta che servono per pagare
l'oro che dipignie Pietro da Cortona, a me
detto contanti sc. 100.

Source: ASF, Depositeria Generale, F. 1055,
no. 163.

No. 94

FEBRUARY 26, 1643[1644]

Io Vincentio Coresi Cam.o delle Fortezze ho
riceuto dalla Depositeria Generale di S.A.S.

per straordinario sc. cento di moneta a conto
di sc. 1880 di moneta per pagare l'oro della
2da Stanza che dipignie Pietro da Cortona,
a me detto contanti sc. 100.

Source: ASF, Depositeria Generale, F. 1055,
no. 188.

No. 95

MARCH 3, 1643[1644]

Io appiè sottoscritto ho ricevuto dalla
Depositeria Generale di S.A.S. per
estraordinario sc. cento di moneta, a conto
di sc. 1880 moneta per pagare l'oro della
seconda stanza di Pietro da Cortona, a me
detto contanti sc. 100 m.ta.
 VINCENTIO CORESI CAM.O

Source: ASF, Depositeria Generale, F. 1055,
no. 231.

No. 96

MARCH 11, 1643[1644]

Io appiè sotto scritto ho riceuto dalla
Depositeria Generale di S.A.S. per straordinario
ducati cento di moneta e sono acconto di
ducati 1880 per pagare l'oro della seconda
stanza che dipignie Pietro da Cortona, a me
detto contanti sc. 100.
 VINCENTIO CORESI CAM.O DELLE FORTEZZE

Source: ASF, Depositeria Generale, F. 1055,
no. 244.

Comment: In Seicento Florence *ducati* and
scudi are equivalent monetary values.

No. 97

MARCH 17, 1643[1644]

Io appiè sotto scritto ho ricevuto dalla
Depositeria Generale di S.A.S. per

estraordinario sc. Dugento ottanta di moneta,
quali devono servire per pagare gli stucchatori
di Roma, e sono per quattro mesate da tutto
Ottobre a tutto Febbraio prossimo passato
a sc. 70 il mese a me detto contanti sc. 280.
 VINCENTIO CORESI CAM.O

Source: ASF, Depositeria Generale, F. 1055,
no. 258.

Publication: Listed in Geisenheimer, p. 12, n. 1.

No. 98

MARCH —, 1643[1644]

Io appiè sottoscritto ho riceuto dalla
Depositeria Generale di S.A.S. per straordinario
sc. cento di moneta, e sono a conto di sc.
1880 per pagare l'oro della seconda stanza
che dipignie Pietro da Cortona, a me detto
contanti sc. 100.
 VINCENTIO CORESI CAM.O DELLE FORTEZZE

Source: ASF, Depositeria Generale, F. 1055,
no. 257.

Comment: Although the day of the month is not
indicated, this document is filed among others
dated 17 March and was probably drawn up on
the same date.

No. 99

MARCH 23, 1643[1644]

Io appiè sottoscritto ho riceuto dalla
Depositeria Generale di S.A.S. per straordinario
sc. cento di moneta, e sono a conto di sc.
1880 per pagare l'oro della stanza seconda
che dipignie Pietro da Cortona, a me detto
contanti sc. 100.
 VINCENTIO CORESI CAM.O DELLE FORTEZZE

Source: ASF, Depositeria Generale, F. 1055,
no. 281.

No. 100

MARCH 31, 1644

Io appiè sottoscritto ho riceuto dalla
Depositeria Generale di S.A.S. per straordinario
sc. cento di moneta, sono a conto di sc. 1880
per pagare l'oro della seconda stanza che
dipigne Pietro da Cortona, a me detto
contanti SC. 100.
 VINCENTIO CORESI CAM.O

Source: ASF, Depositeria Generale, F. 1055,
no. 307.

No. 101

APRIL 7, 1644

Io appiè sottoscritto ho riceuto dalla
Depositeria Generale di S.A.S. per straordinario
sc. cento moneta a conto dell'oro della stanza
che dipigne Pietro da Cortona, a me detto
contanti SC. 100.
 VINCENTIO CORESI CAM.O

Source: ASF, Depositeria Generale, F. 1055,
no. 328.

No. 102

APRIL 14, 1644

Io appiè sottoscritto ho riceuto dalla
Depositeria Generale di S.A.S. per straordinario
ducati cento di moneta per servirmene per
l'oro della stanza che dipigne Pietro da
Cortona, a me detto contanti SC. 100.
 VINCENTIO CORESI CAM.O

Source: ASF, Depositeria Generale, F. 1055,
no. 353.

Comment: This document is dated 18 April by
the scribe, but corrected by Coresi when he
signed the document (the signature and the
number 14 have both faded and to an equal
degree). The terms *ducato* and *scudo* are

interchangeable in seicento Tuscan monetary
denominations.

No. 103

APRIL 22, 1644

Io appiè sottoscritto ho riceuto dalla
Depositeria Generale di S.A.S. per straordinario
ducati ottanta di moneta a conto dell'oro per la
stanza che dipigne Pietro da Cortona, a me
detto contanti SC. 80.
 VINCENTIO CORESI CAM.O

Source: ASF, Depositeria Generale, F. 1055,
no. 384.

Publication: This document is listed in
Geisenheimer, p. 32, no. 35.

Comment: The terms *scudo* and *ducato* are
interchangeable seicento Tuscan monetary
denominations.

No. 104

*Giovan Battista Gondi to Grand
Duke Ferdinand*

JULY 27, 1644

 Ferdinando Secondo Gran Duca di Toscana
Sen.re Cosimo del Sera nostro Depositario
Generale, mettete a uscita a Pietro da Cortona
sc. cinquecento moneta, che havete mandati in
camera nostra, e consegnati a noi medesimi,
perchè sono serviti per dare a detto Pietro da
Cortona, che vi saranno fatti buoni in virtù
di questo nostro mandato. Dato de' Pitti li
27 Luglio 1644.
sc. 500
Il Gran Duca di Toscana
 GIO. B.A GONDI

Source: ASF, Depositeria Generale, F. 1056,
no. 688.

Publication: Listed but not transcribed in
Geisenheimer, p. 32, no. 36.

No. 105

Ferdinando Secondo Gran Duca di Toscana
Sen.re Cosimo del Sera Nostro Depositario
Generale, metterete a uscita a Pietro da
Cortona li sc. mille moneta che sino sotto dì
31 di Dicembre havete mandato in Camera
Nostra, quali haviamo ricevuti e dati al med.mo
Pietro a conto di lavori che fa, et a voi saranno
fatti buoni in virtù di questo mandato.
Dato questo dì 2 Gennaio 1644 [1645].
Sc. 1000 m.ta

IL GRAN DUCA DI TOSCANA

Source: ASF, Depositeria Generale, F. 1057, no. 14.

Publication: Listed but not transcribed in
Geisenheimer, p. 32, no. 37.

No. 106

*Prince (later Cardinal) Leopoldo de'
Medici to Andrea Arrighetti*

Sig:r Andrea. L'apportatore di questa sarà
Giovanni Bellini Indoratore, al quale ho dato
licenza, che lasci i miei lavori, et a ogni ordine
di V.S. metta mano al lavoro. Saluti Pietro da
Cortona per mia parte e li dica, che il Ser.mo
Gran Duca havrebbe caro, che facessi un
disegno della facciata di S.M. a del Fiore, et il
Sig.re la conservi.
Di Pisa 18 Genn[aio] 1644[1645].
Sig. Andrea Arrighetti

Amorevole di V.S.
IL PRINCIPE LEOPOLDO

Source: ASF, Fabbriche Medicee, F. 141, fol. 39.

No. 107

*Avviso From the Medici Court to the
Ducal Chancellory at Modena*

. . . .
L'Anticamera segreta del Granduca, che

giovedì appunto si spalcò e scoperse, è riuscita
molto vaga e bella, dipinto il cielo per mano di
Pietro da Cortona che viene stimato persona
insigne nella professione di dipingere a guazzo.
È lavorata la cornice che circonda la camera
di bizzarri rilievi tutti dorati; et ora dicesi che
siano per applicare al lavoro della seconda
camera, con farla dipingere al medesimo
Pittore.

. . . .

Source: ASM: Cancelleria Ducale, 5192 (Avvisi,
1645), inserto: "Avvisi da Firenze."
Publication: M. Del Piazzo, *Pietro da Cortona.
Mostra Documentaria (Archivio di Stato)*
(Rome, 1969), p. 22, cat. no. 165 (not transcribed).

Comment: The transcription published here was
made from the original document by Gino Corti.

No. 108

*Pietro da Cortona to Cassiano
dal Pozzo*

Coll'occasione delle feste del santo Natale, le
quali le desidero da Dio colme d'ogni felicità,
vengo a riverirla com'è mio debito, e
ricordarmele servitore obbligatissimo per
tanti favori ricevuti. Io mi devo accusare di
non aver ubbidito così puntualmente ai
consigli di V.S. illustrissima nell'astenermi
dalle cose dell'architettura, ma la congiuntura
è stata tale che non ho potuto dire di no. Mi
trovo aver finito un modello di una chiesa
dei Padri della Chiesa Nuova di qui, e già è
incamminata la fabbrica. Conosco che da ciò è
provenuto il ritardo di non aver finita la
stanza di S.A. prima d'adesso. In questa, che
ora comincio, ho mezzo fatto voto di non
voler intrighi, poichè mi son ricordato molte
volte del salutare consiglio di V.S.ill., ma ai
padroni non ho saputo dire sempre di no. Me le
ricordo obbligatissimo, e desidero esser favorito
de' suoi comandi Di Fiorenza, 20
dicembre, 1645.

Publication: Bottari-Ticozzi, vol. I, pp. 417-418,
no. CLXXXIII.

Comments: The original source is unknown. The
version published here is taken from the
Bottari-Ticozzi transcription.

No. 109

*Pietro da Cortona to Cassiano
dal Pozzo*

JANUARY 19, 1646

Ringrazio infinitamente V.S.ill.
dell'amorevolissima lettera che si è
compiaciuta scrivermi in risposta d'una mia.
Per non infastidirla con mie spesse lettere ho
voluto con questa sodisfare a più obblighi
insieme; l'uno con riverirla, e l'altro con
invitarla alla festa di s. Martina; ed il mio
desiderio saria di poterlo fare di presenza, e
anche ringraziarla del molto affetto che mi
mostra nell' animarmi a non lasciare, ma
proseguire le opere incominciate d'architettura.
Io veramente ho visto e conosciuto che in
dette cose ho sempre avuta cattiva fortuna, e
credo forse che sia stata la causa non il non
aver avuto l'animo grande, comme m'hanno
apposto i miei poco amorevoli, ma il non
essermi accomodato forse a' costumi che si
sogliono usare da quelli che fanno le dette
opere per approvecciarsi, del che io non ebbi
mai tale pensiero, ma solo di operare conforme
conveniva a un par mio; il quale se ho errato, è
stato per non saper accomodarmi al simulare;
di che non mi pento; e se pure devo avere
rammarico, non è per altro che di non aver
saputo più nella professione della pittura, per
la quale m'è rimasto solo l'animo e la buona
volontà di andare studiando. L'architettura poi
serve solo per mio trattenimento; e mentre
sarò per servire V.S.ill., la prenderò in primo
luogo, e stimerò ben impiegata ogni fatica.
E desiderando ricevere i suoi comandi, i quali
sarò prontissimo ad eseguire, e con ricordarmele
obbligatissimo, servitore, le desidero ogni
felicità, e la riverisco. Da Fiorenza, 19 gennaro,
1646.

Source: Unknown. Geisenheimer, p. 32, no. 42,
reported the letter to be in the autograph
collection of a Mr. Morrison in London.

Publication: Bottari-Ticozzi, vol. I, pp. 418-420,
NO. CLXXXIV.

Comments: The transcription published here is
taken from Bottari-Ticozzi.

No. 110

*Pietro da Cortona to Cardinal
Francesco Barberini*

APRIL 8, 1647

Avendo ricevuto una lettera de V.E., scritta li
15 de marzo, dove mi acenna de avere ricevuto
una mia, scritta a V.E. per ringraziamento delle
robbe imprestate per la festa di S. Martina, io
non avevo ancho ricevuto la lettera del invito,
che V.E. si era compiaciuta farmi del vedere
la Francia, del quale io ne rendo infinite grazie
a V.E., e quando ricevei la lettera ero in letto,
e al presente, da dui giorni in qua, io comincio
a levarmi per camera con qualche debolezza
ancora de piedi; e ancho in risposta, della quale
credo che V.E. a questora labbia riceuta, le
acennavo che al ottobre io pensavo di essere
in Roma a dipingere la cupola della Ciesa
Nova, che l'istate passata avevo promesso a que
padri de fare, e sopravenendo linvito de V.E. io
avevo giudicato, se però con gusto de V.E., il
pigliare il sogetto che io dovevo essere
impiegato per studiarlo, e se f[usse] a olio io
intermetterei listessa opera per trame[tt]ere
ora luna e ora laltra ochasione per servire V.E.
p[iù] prontamente: e questo era il tenore della
lettera che acennai, e sogiunsi che i sei o otto
mesi che V.E. pareva che io dovessi stare in
cotesti paesi, non mi pareva tenpo
proporzionato a potere intraprendere opera
che fussi riguardevole; il che il tutto rimetto
alla prudenza di V.E. ecc. De Fiorenza 8 de
aprile 1647.

> *Umiliss.o ecc.*
> PIETRO BERRETTINI

Source: BVR, Cod. Barb. Lat. 6458, fol. 119.

Publication: Transcribed in full in Geisenheimer,
pp. 19-20, doc. D.

Comments: Geisenheimer from whom this
transcription is taken, cites this letter according
to an older pagination, as fol. 61.

No. 111

Pietro da Cortona to Cardinal Francesco Barberini

JUNE 14, 1647

Il raguaglio che V.E.M.za mi dà della publicha libreria che fa fabrichare il Sig.r Cardinale Mazarrino sia della grandezza de quella de V.E.M.za, mi persuado che sia per essere pur de molta considerazione. E mentre mi acenna che al mese de febraro io possi essere sbrigato dal opera della C[h]iesa Nova, in quest[o] conoscendo la mia pocha abilità nel'operare, mi rende inpossibile il poterla finire e trovandoci io più dificoltà che non si persuad[e] V.E.M.za sì per la qualità e grandezza del'opera comme ancho per la pocha sanità, cagionatami da catarri che quest'anno ò patiti, comme acennai nel'altra mia lettera a V.E.M.za. E però conoscendo non potere in tutto corispondere al suo desideri[o] e alla mia obligazione, però mi esebischo de novo quanto posso fare per servire V.E.M.za, che con tramezzare il tenpo, aciò resti servita con fare i quadri a olio che probabilmente ci devono andare. E mi sforzerò con tutta la mia pocha sanità spedirli, sperando ancho in questo tenpo de perfezionare la Confessione de S. Martina, qual io vado facendo secondo le mie debole forze e anbischo de vederla finita comme conviene per potere avere questa consolazione che ò di conpirla, poichè dell'altre che i'ò cominciate non ò potuto vederne veruna finita, ma questa che depende dalla mia volontà ò speranza de vederla, e credo che V.E.M.za sarà per comendare questo mio desiderio. E tanto più è stato maggiore il motivo si è la morte seguita del Sig. Michelangelo Bonaroti, quale non avendo finite certe sue cose, ne sentiva qualche poco de senso. E però torno a replicare che lo spedire l'opera della C[h]iesa Nova non mi pare potersi spedire così presto; oltre che io lasso l'ultima stanza del Gran Ducha inperfetta, stante che l'inverno l'aria de Fiorenza mi riesce assai nociva, e cosi[1] finirla in stagione più tenperata. E per fine mi ricordo essere oblig.mo

[1] A verb such as *spero* or *vorrei* has been omitted.

a V. Em.za, e con desiderarli da nostro Sig. Dio ogni sua maggiore felicità le faccio umilissima reverenzia con baciarli le veste.
De Fiorenza li 14 di giugno 1647.

Umiliss.o . . .
PIETRO BERRETTINI

Source: BVR, Cod. Barb. Lat. 6458, fol. 121.

Publication: Transcribed by Geisenheimer, pp. 20-21, doc. E.

Comment: The pagination cited in Geisenheimer (fol. 62) has been superseded. The transcription published here is taken from Geisenheimer (with a few minor changes).

No. 112

Pietro da Cortona to Grand Duke Ferdinand

OCTOBER 27, 1647

Serenissimo Gran Ducha
Do parte a Vostra Altezza comme il mio arivo qui in Roma è stato con bonissima salute per la Dio grazia e con bellissime giornate, quale tuttavia vanno seguitando, alchè spero presto cominciare a depingere. Io non ò ancho fatto reverenzia al Sig. Cardinale Sacchetti per essere a Fraschati, e salutarlo a nome di V.A. Io ment[r]e sto assente sto però atendendo de essere favorito de' suoi comandi, quali sarò senpre prontissimo a esseguirli. E con recordarmili umilissimo servitore e obligatissimo, reverischo Vostra Altezza.
De Roma 27 de Ottobre 1647.
De V.A.

Umilissimo e Dev.mo Ser.re Oblig.mo
PIETRO BERRETTINI

Source: ASF, Lettere Artistiche, vol. III, fol. 79 recto.

Publication: Noted, but not transcribed by Geisenheimer, p. 33, no. 50.

Comment: Listed as fol. 80 recto by Geisenheimer.

Document Catalogue

No. 113

*Pietro da Cortona to Prince
(later Cardinal) Leopoldo (?)*

JUNE 10, 1656

Serenisimo Sig.r
Resto ogni giorni più confuso per tante
grazie et onori che continovamente ricevo da
V.S.S.a e ora particolarmente che il Sig.r
Prencipe Cardinale Gio. Carlo mi à mandato
un ordine di seicento scudi a nome di V.A.,
del quale anchorchè io mi conoscha del tutto
immeritevole, non dimeno per ubidire a' suoi
cenni mi valerò quanto piaccia a Dio di
concedermi tanta sanità e forza che possa
mettermi in viaggio per eseguire quanto io
devo e sommamente desidero. Suplicho intanto
V.A. a degniarsi di ordinare che mi siano
inviati i cartoni ridotti in piccholo con il palmo
Romano per potere più prontamente servirla
e rendendole umilissime grazie profondamente
l' inchino. Roma li 10 giugnio 1656.
Di V.A.S.ma
Umil.mo Devot.mo Oblig.mo Servitore
PIETRO BERRETTINI

Source: ASF, Lettere Artistiche, vol. III, fol. 97.

Publication: Transcribed and published by
Geisenheimer, p. 22, doc. H.

Comment: The transcription published here is
taken from the original document.

No. 114

*Pietro da Cortona to Cardinal Giovanni
Carlo de' Medici*

AUGUST 10, 1656

Emm. e Rev.mo Sig.
Avendo ricevuto la lettera di V.S.A.
inviatomi dal Sig. Ambasciatore nella quale
ò inteso il gusto de V.S.A. che io facci qua i
cartoni delle camere che io cominciai del
Seren.mo Gra[n] Ducha anche io ho sempre
desiderato avvantagiare li studi e a facilitare
l'opera [blot of ink] che io ne piglierò di
novo dal sig. Rondinelli il sugetto poiche non

mi soviene tutte le particolarità necessare a
esprimermi nelle istorie alche io le starò
stendendo per potermi aplicare e servire
V.S.A.. E mi le ricordi umilissimo e
devotissim[o] servitore e prontissimo a suoi
comandi con farli umilissima reverenzia e
umilmente me li inchino.
De Roma li 10 agosto 1656
De V.S.Alt.ma
Umiliss.mo e Devot.mo Ser. Oblig.mo
PIETRO BERRETINI

Source: ASF, Mediceo?

Publication: M. Del Piazzo, *Pietro da Cortona.
Mostra Documentaria (Archivio di Stato)*
(Rome, 1969), p. 34, cat. no. G-12.

Comments: Location not given in publication.
The transcription published here was made from
notes taken by Allan Ceen at the exhibition cited
above.

No. 115

*Monanno Monanni to Prince (later
Cardinal) Leopoldo de' Medici (?)*

JULY 5, 1659

Ser.mo P.rone etc.
... Il Sig Anbasciadore mi ha ordinato ch'io
accenni a V.A.S. quello s'è ritratto dal Sig.
Pietro da Cortona, in ordine al fare terminare
le stanze di S.A.S. da lui cominciate.
Havend'egli deliberato che Il Sig. Ciro suo
Allievo le proseguisca avanti, ha risoluto che
li cartoni si faccino qui dal detto Ciro alla
presenza et assistenza del S.r Pietro, cavati da'
pensieri che il S.r Pietro farà lui, sì come li
medesimi cartoni ancora, a tale che non solo
i Pensieri, ma il disegno ancora si potrà dire
che sarà del S.r Pietro, che coloriti et messi in
opera a fresco da Ciro, suggetto in oggi di
Valore, si crede che porterà avanti tall opere
con molta sotisfazione di Loro A.S.—Intanto
havendo egli riceuto lettere dal S.r Sen.e
Arrighetti et S.r Rondinelli di suggetti di
Poesie et misure mandateli, egli ha fatto
subbito metter mano a fare incollare li cartoni,
et intanto farà li schizzi de' pensieri per
mettervi mano con ogni celerità, per haver
egli molto bene appreso l'urgenza che così

grande verte della spedizione dell'opera insinuatali da S. Ecc.a largamente; mi ha detto però che li cartoni porteranno via dui mesi di tempo, cioè questo e tutto Agosto, et io lo credo, ma tutto il tempo che si spenderà nel fare i cartoni frutterà a doppio nel metterli in opera.

Il Giovane è franco e speditivo, che importa assai, et assiduo et di ottime qualità. Il Sig. Anbasciadore andrà spesso a vedere perchè veramente si portino avanti tali cartoni senza intermittenza, ch'è quello che importa, et così si spera di conseguire il bon servizio di S.A.S. et in tempo debito. Il Sig. Anbasciatore che ha letto quanto sopra ho scritto a V.A.S. sopra questo particolare, la supplica di participarlo a Ser.mo Sig. Principe Cardinale Gio. Carlo ancora, et al Ser.mo Gran Duca, mentre però V.A. lo stimi necessario, poichè egli si rimette a quanto scrivo all'A.V. et egli insisterà che li cartoni si faccino con la celerità possibile, et con andare spesso a rivederli, et forsi ci manderà me ancora; bisogna però usare destrezza, perchè il S.r Pietro è dilicato assai, et già S. Ecc.za è informato del tutto
Di Roma li 5 di luglio 1659.
Di V.A.Ser.ma

> *Hum.mo Dev.mo et Obbl.mo Ser.re*
> MONANNO MONANNI

Postscript:
Il S.r Pietro da Cortona mi ha mandato le qui tre lettere accluse per il S.r Sen.e Arrighetti, S.r Rondinelli et Salvestrini, che tutte sono in ordine al servizio di S.A.S.

Source: ASF, Lettere Artistiche, vol. IX, no. 3.

Publication: Transcribed almost in full in Geisenheimer, pp. 13-14, doc. IV.

Comment: The transcription published here is taken from the original document.

No. 116

Pietro da Cortona to Grand Duke Ferdinand

DECEMBER 20, 1659

Altezza Seren.ma
L'infinite obligationi che professo a V. Alt.za

Seren.ma per tanti favori, et gratie riceute, mi hanno fatto trattenere questi otto giorni di mandare il modello delli ornati che si devono fare nella stanza della Ser.ma Granduchessa, et essendo già tre anni che feci il modello, havendolo hora revisto mi è parso bene emendarlo acciò V. Alt.za ne resti maggiormente servita, et io ne venga in parte a sodisfare al mio debito, non mancando per l'ordinario futuro mandarlo compito vivendo desiderosissimo de suoi commandi. Augurandoli felicissime queste Sante feste. Roma li 20 Xbre 1659.
Di V. Alt.za Seren.ma

> *Humil.o et Devot.mo Ser.re*
> PIETRO BERRETTINI

Source: ASF, Mediceo, 1017, c. 103.

Publication: A. M. Crinò, "Documenti relativi a Pietro da Cortona, Ciro Ferri . . . , *Rivista d'Arte*, vol. XXXIV, 1959, p. 152.

Comment: Transcription published here taken from the original document.

No. 117

Court Diary

FEBRUARY 23, 1661

Adì 23 detto si scoprì finalmente la stanza d'Apollo o del Sole o della Gioventù, dipinta da Ciro Ferri, discepolo di Pietro da Cortona; l'ha dipinta in 15 mesi, vi sono nel mezzo della Volta quattro o cinque figure fatte da Pietro. La stanza è stata con quei trabiccoli diciotto anni. Sento che egli habbi havuto 1500 scudi e le spese e la casa.

Source: ASF, Guardaroba Mediceo, Diario d'Etichetta di Toscana, 7 (1660-1661), c. 60 recto e verso.

Publication: Geisenheimer, p. 14, doc. V.

Comment: The transcription published here is taken from the original document.

No. 118

Andrea Arrighetti to Grand Duke Ferdinand

FEBRUARY 26, 1661

Seren.mo Gran Duca
Ciro Ferri ha finito di dipignere la 4.a
stanza dell' Appartamento di V.A.
cominciato da Pietro Berettini suo Maestro,
e conforme gl'è stato rappresentato da me in
voce son restato seco d'accordo che detta
opera gli deva esser pagata scudi mille
cinquecento di moneta, sichè sèndosegli fin
adesso pagati in dua volte scudi quattrocento,
resterebbe avere scudi mille cento, quali V.A. è
supplicata a comandare al Depositario Generale
che paghi in mano a Lorenzo Ruspoli
Camerlingo delle fortezze e fabbriche, nel
modo che ho rappresentato a V.A.S., acciò
si possi saldare detto conto, mentre io resto
facendole umilissima riverenza. Di casa li
26 febbraio 1660[1661].
Di V.A.S.ma
> *Vassallo e Ser.re Dev.mo*
> ANDREA ARRIGHETTI Sopraintendente

Rescript:
Fer[dinando]
Vuole S.A. che il Sen.e Tempi Depositario
Generale paghi prontamente a Ciro Ferri sopra
detto li scudi millecento, dico 1100, che
avanza come sopra, sborsandoli in mano a
Lorenzo Ruspoli nella suddetta conformità.
Desiderio Montemagni, 28 febb. 1660[1661].

Adì 2 marzo 1660[1661]
Io Lorenzo Ruspoli Cam.o delle fortezze,
ho riceuto li suddetti sc. millecento moneta, e
sono per straordinario a conto delle fabbriche,
a medetto detto contanti sc. 1100.
Di V.A.S.ma
> LORENZO RUSPOLI manopropria

Source: ASF, Depositeria Generale, F. 1074,
no. 437.

Publication: Listed in Geisenheimer, p. 14, n. 1.

Comment: A copy of this document, less the
record of transference of March 2, 1661, is to be
found in ASF, Fabbriche Medicee, F. 130,
c. 24 verso.

No. 119

Court Diary

MARCH 13, 1661

Domenica a dì 13 Ciro Pittore partì per Roma;
la sua parte costava scudi quarantacinque il
mese; haveva seco un Giovane.

Source: ASF, Guardaroba Mediceo, Diario
d'Etichetta di Toscana, 7 (1660-1661), c. 61 recto.

Publication: Geisenheimer, p. 15, doc. V.

Comment: The transcription published here is
taken from the original document.

No. 120

*Pietro da Cortona to Prince Leopoldo
(later Cardinal) de' Medici (?)*

MARCH 21, 1661

Seren.mo Prencipe e Pat. Cole.mo
Ho inteso con grandissima satisfazione e gusto
che il sig. Ciro si sia portato in maniera che
abbia satisfatto il gusto de V.A., et insieme
che si sia adenpito l'obligo che teneva di
portarsi bene, ringraziando V.A. dell'onore
che mi ha fatto in significarmi havere il sig.
Ciro conpita l'opera con bona satisfazione di
tutti, sapendo quanto mi era a cuore che restasse
terminata conforme al desiderio che tenevo
restasero servite le loro Altezze. Io intanto
piglio questo ardire de inviarli un pocho di
abozzo de stanpa della Galleria che dipinsi
per la santa memoria de Papa Inocenzio, se
bene non revista e male condizionata, e non
mancherò di avere particolare premura in
conpire il quadro de V.A. aciò resti servita
conforme desidera, vivendo ansiosisimo de'
suoi comandi ed' incontrare il suo gusto,
ricordandomili obligatissimo servitore.
Di Roma li 21 marzo 1661.
De V.A.S.ma
> *Oblig.mo e Devot.mo Servitore*
> PIETRO BERRETTINI

Source: ASF, Lettere Artistiche, vol. III, fol. 99.

Publication: Geisenheimer, p. 23, doc. J.

Comment: The transcription published here is taken from the original document.

No. 121

Pietro da Cortona to Grand Duke Ferdinand

JUNE 17, 1663

Ser.mo Granduca P.ron Col.mo
Havendo il Sig.re Ciro compiti li Cartoni, quali, stante che li suggetti riescono assai nobili et esprimono bene, mi persuado che in opera riusciranno di sodisfattione di V. Alt.za, dispiacendomi sommamente non essere in stato di poter io venire a servirla, conforme ho sempre desiderato, et desidero, sperando se il S.re mi concederà salute venire di persona a riverirla per poter ricevere li suoi commandi, essendo anco a ciò tenuto per l'infiniti oblighi che li professo, et la mia servitù richiede, alla quale non è cosa, che più prema quanto d'haver occasione d'impiegarsi nelli commandi di V. Alt.za Seren.ma alla quale per fine faccio humilissima riverenza. Roma li 17 giugno 1663.
Di V. Alt.za Seren.ma
 Devotissimo et obligatissimo S.re
 PIETRO BERRETTINI

Source: ASF, Carteggio Mediceo, F. 1017, c. 271.

Publication: A. M. Crinò, "Documenti relativi a Pietro da Cortona, Ciro Ferri, etc.," *Rivista d'Arte*, vol. XXXIV, 1959, p. 152.

Comment: Transcription published here taken from the original document.

No. 122

Pietro da Cortona to Prince Leopoldo (?)

JUNE 17, 1663

Seren.mo Principe P.ron Col.mo
Con occasione che il Sig. Ciro viene al servitio delle loro Altezze, ho inviato il quadro della Madonna, quale, se non sarà conforme ho sempre desiderato, supplirà la buona volontà che ho sommamente hauto di servirla, richiedendolo l'infiniti oblighi che professo a V. Alt.za Seren.ma facendoli per fine humil.ma riverenza. Roma li 17 giugno 1663.
Di V. Alt.a Seren.ma
 Devot.mo et Oblig.mo Ser.e
 PIETRO BERRETTINI

Source: ASF, Lettere Artistiche, vol. III, fol. 106.

Publication: Partially transcribed by Geisenheimer, p. 37, no. 91.

Comment: The transcription published here is taken from the original document.

No. 123

Court Diary

JULY 3, 1663

Adi detto Ciro Pittore cominciò la stanza di Saturno, che si fece dalla storia di Licurgo. Arrivò di Roma venerdì sera 29 di Giugno con la moglie, con una figliuola piccola et un suo cognato; sta a casa a lato alla dispensa al solito.

Source: ASF, Guardaroba Mediceo, Diario d'Etichetta di Toscana, F. 6 (1659-1663), c. 105v.

Publication: Geisenheimer, p. 15, doc. VI.

Comment: The transcription published here is taken from the original document.

No. 124

Ciro Ferri to Grand Duchess Vittoria

FEBRUARY 4, 1663[1664]

Ho ricevuto l'honore fattomi da V.A.S. del cignale domandatole in occasione dell'istoria di Silla et è stato totalm[en]te à proposito, e ne rendo humiliss[im]e grazie alla somma benignità di V.A.S. Non l'ho però ancora dipinto à fresco, ma si bene à olio, perchè

bisogna che dipinga prima il cane il quale dipingerò quando sarà tornato il ser.mo Gran Duca, perchè voglio disegnare il cane grosso di spaurito. Ho cominciato il sito di mezzo e seguito a tirare avanti con sollecitudine, et a V.A.S. fo hum.ma riverenza. Firenze 4 febb.o 1663 [1664].
D. V.A.S.

> Hum.mo Divot.mo et oblig.mo serv.e
> CIRO FERRI

Source: Unlocated.

Publication: C. Pini and G. Milanesi, *La Scrittura di Artisti Italiani*, vol. III, Florence, 1876, no. 295 and Geisenheimer, p. 15, doc. VII.

Comment: The transcription here published is taken directly from the Pini-Milanesi facsimile.

No. 125

Lorenzo Magalotti to Ottavio Falconieri

AUGUST 18, 1665

Una sola nuova e non più. Il Sig. Ciro Ferri il giorno della nascita di S.A. scoprì la camera di Saturno, che è quella dietro all'altra del baldacchino. L'opera ha avuto grandissimo applauso; e S.A. ne ha dimostrato piena sodisfazione: è ben vero, che altrettanto se ne sono afflitti i suoi emuli, i quali non ebbero altro attacco in quella d'Apollo, che il dire, che il Sig. Ciro avea portati i cartoni fatti a Roma dal Sig. Pietro. Questi egli ha voluti fargli quì, ed ognuno ha potuto chiarirsene. La disposizione della pittura è bellissima, e la magnificenza degli stucchi è riuscita sontuosissima; tantochè senza dubbio questa per l'ornamento dell'oro, è la più ricca di tutto l'appartamento. La pittura consiste in un quadro di grandezza vasta nel mezzo della volta, in due tondi nelle testate, e due grandi ovati da' fianchi. Nel quadro v'è il proseguimento del concetto espresso in tutte l'altre camere, e rappresenta l'eroe già canuto volare in mezzo alla prudenza, e al valore, in seno alla gloria, ed all'eternità, la quale sta in atto di coronarlo, mentre Ercole rimasto in terra, dopo averlo con la sua scorta condotto al cielo, abbrucia sul monte Etna. La figura di quest'Ercole è collocata sul rogo in una positura d'uno scorcio maraviglioso; e più maraviglioso è il volo, col quale si conduce Saturno a influire gli splendori della sua stella in sulla testa dell'eroe, nel quale anche sotto la barba si riconosce l'aria del medesimo volto, rappresentato sempre l'istesso, ma in diverse età, nelle stanze degli altri pianeti. Nel tondo principale v'è Scipione in atto di considerare una pianta d'una fabbrica, mostratagli da un architetto, la quale è l'istessa, che di magnifica architettura. Si vede inalzarsi al dirimpetto dove è mirabile un ignudo, che sta sollevando una pietra da lui lavorata per la fabbrica. Nel tondo dirimpetto v'è Ciro in atto di adacquare un arancio, con una prospettiva d'un giardino reale. La testa di Ciro è la mia favorita, riconoscendovisi d'aria d'un orientale, la maestà regia, e insieme il gusto, e l'applicazione all'opera, ch'egli ha tra mano, dell'adacquare. Questo tondo perchè riusciva in riguardo dell'istoria, povero di figure, il Sig. Ciro ha trovato modo d'arricchirlo con rappresentare nel vaso di marmo un sacrifizio di chiaro scuro con parecchie figure graziosissime. Nell'ovato in faccia alla porta v'è Silla a cavallo, in atto di ferire un cignale, che fugge la caccia di due cani, ferito in un fianco da una freccia tiratagli da un cacciatore, che insieme con altri si vede nel bosco con l'arco allora scarico. Nell'altro ovato v'è Licurgo, che in un consesso di Senatori mette sul trono il figliuolo nato postumo al Re suo fratello. Questa istoria è bellissima ancor ella, e fra l'altre v'e un gruppo di tre vecchi, che non si può veder cosa più bella. In somma, il concetto universale è stato, ed è, che maggior gloria sia del Sig. Pietro, che vi sieno queste due stanze del Sig. Ciro, che se tutto l'appartamento fosse stato finito di sua mano; poichè allora si sarebbe veduto solamente quello, che egli sapeva fare, dove adesso si vede quel, ch'ei sa fare, e quello che ha saputo fare, che altri facciano così bene. La sustanza si è, che non ci voleva altri, nè altri poteva mettersi a dipingere a quel paragone. Altro non ho che dirvi per questa sera; però finisco con salutarvi affettuosamente. Firenze 18. Agosto 1665. Lor. Mag.

Source: Unknown.

Publication: *Delle lettere familiari del Conte Lorenzo Magalotti e di altri insigni uomini a lui scritte*, vol. I, Florence, 1769, pp. 145ff., letter no. 45; partially reproduced in Geisenheimer, p. 16, doc. VIII.

No. 126

Giovanni Cinelli, manuscript excerpts from notes for a guide book to Florence

c. 131r

Nella camera di Marte nella volta vi è Marte che dal cielo precipitando si getta; vi sono Castore e Polluce a cavallo ed . . . [description interrupted] in mano . . . [description interrupted]

Vi è Ercole ed l'arme della casa seren.ma app.o Vi è la magnificenza, e la Liberalità che sorge la monete; Da una [di] queste alcuni prigioni sono condotti, vi son molte spighe. Questa è opera superba [?] e vi è un fregio di Basso relievo di trofei per ornamento fatto di stucchi; le pitture di questa stanza son tt.e di Pietro.

 Giove

Qui Ercole con pelle di leone ornato per la faticosa virtù figurato, è davanti a Giove condotto

 opera tt.a di Pietro

c. 139r

Segue dipoi la

 Stufa del Padron Ser.mo quale è tutta da Pietro da Cortona vagamente a fresco dipinta; in ogn'una delle facciate è una delle 4 Età dipinta; Vedesi in prima l'età dell'oro ove molti fanciulli domesticamente col Lione scherzando si stanno mentre altri a'lor passatempi intenti di sollazzar si studiano. Quivi è la dilicatezza del mondo, e la gioia, e l'allegrezza tutta racchiusa, ed ognuno a quelli spassi che piu gli aggradano se ne sta applicato. segue l'

 Età dell'Argento, nella quale a varie opere boscherecce, e di campagna stanno le genti intente, scherzano molti con l'uve, altri le pecore mugnendo il latte raccolgono.

 Età del Rame, ove molti soldati le cicatrici per le ferite ricevute nelle battaglie al Dittatore mostrando son da esso con larghi premi rimunerati, e le fatiche loro ricompensate.

c. 139v

Nell'altra è l'

 Età del Ferro, nella quale alcuni soldati, mentre in un tempio si sacrifica furiosamente in quello entrando, non solo de' vasi e paramenti al sagrifizio destinati lo spogliano, ma tratti da furor militare anche da'capelli delle caste donzelle con mano armata per saziar lor avide brame le gioie imbolano; son tutte queste molto vaghe e di stima, e del luogo ov' elle sono d'esser collocate ben degne—

c. 155v

Or piegando su la mano manca e nella Sala de[lle] Nicchie, ove i parafrenieri trattengonsi, entrando, dieci nicchie nel muro incavate sono, nelle quali altrettante statue di marmo antiche, del naturale minori, collocate si stanno; son queste, dalla sinistra, prima una Venere gnuda, 2a [blank], 3a un Zodiaco col capricorno a' piedi, statua del Bandinello. Doveva anche questa sala esser da Pietro da Cortona dipinta, e così fu il pensiero, ma le vicende del tempo ch'a'nostri voleri bene spesso si oppongono fecero sì, che restò in asso l'esequzion. Sopra la porta era prima il mezzo cerchio di Giusto, oggi vi è un quadro del Ligozzi ove la Maestà è da' due stati Firenze e Siena coronata con molti trofei a' piedi del trono.

c. 156r

Sono su la man destra cinque camere principali per l'appartamento del Gran Duca destinato, con rarissimi ornamenti quanto mai la mente umana comprender possa, a segno che non vi è Principe nel Mondo, non che in Europa, che stanze sì nobili, e così bene addobbate quali son queste posseggia, le quali sono a' cinque Pianeti dedicate, o pur col nome di essi chiamate. La prima è detta di Venere per la benignità simboleggiata ed intesa, la 2.da di Apollo per lo splendore figurato, la 3.a di Marte per le terrore delle Leggi accennato, la 4.a di Giove per la Regia maestade e per lo premio a' meritevoli insegnato, la 5.a di Mercurio della Prudenza e possesso delle più elevate Scienze immagine, e queste con l'ordine com' elle stanno, non per l'ordine de' Pianeti descrivo.

c. 156v

Sopra la prima stanza che di Venere è detta, e che per comune anticamera ad ogni qualità di personne è destinata, s'alza vaghissima volta tutta di stucchi parte dorati e parte no, con pitture divisata. Nel mezzo di questa, Pallade nella sommità maggiore si vede che ritogliendo la Gioventù dal letto di Venere per non lasciarla nelle mollezze, e nell'ozio impigrire, in compagnia di Mercurio, ad Ercole simbolo della fatica e delle Virtù la conduce e consegna, l'altra fra morbidezze ed agi di ricco et addobbato letto tutta scontenta restandosi, e con essa una mano d'amorini e lascivie la perdita di essa sospirando; leggesi in piè di questa un motto che dice *Iuventutem a Venere Pallas avertit.* Ne' peducci della volta che nelle quattro pareti a terminar vanno, son di stucchi
c. 157r
altrettante Nicchie da due Fauni maggiori del naturale dorati poste in mezzo, in ognuna delle quali due ritratti di stucco di più che mezzo rilievo, e del naturale maggiori graziosamente collocati si veggono. In quella ch'è volta a Levante li due gran Pontefici Leon Decimo e Clemente Settimo con bella attitudine son collocati, nell'altra Cosimo primo e Francesco Gran Duchi, nella terza Ferdinando primo e Cosimo secondo, e nell'ultima Ferdinando 2.do e Cosimo terzo regnante ancor fanciullo. Fra l'uno e l'altro de' peducci l'imprese de' Principi nelle nicchie effigiati scolpite sono. Tutti questi stucchi furon fatti dal Salvestrini delle figure intendendo. Nelle otto lunette che lo 'ntero circuito della stanza constituiscono, bellissime
c. 157v
storie a fresco al freno delle passioni col quale la Gioventù dee regolarsi adattate, felicemente espresse sono. Vedesi primieramente Seleuco, che della matrigna Stratonica ardentemente immorato nel letto disteso langue, ed Erasistrato presente lo Re suo Padre il polso in mano tenendogli de gli smoderati affetti di lui verso Stratonica chiaramente si accorge, in questo di quel Principe la costante modestia mostrando anzi a morir disposto, che l'amore traboccevole verso la matrigna qual altro avvoltoio le viscere divoravagli sfacciatamente palesare.

Nell'altra il Grand'Alessandro domator del mondo ma più di sè stesso si vede mentre

nell'essergli presentate del Persiano Regno le spoglie, la moglie, e le figliuole di Dario donne bellissime condotte avanti gli sono, ed egli con
c. 158r
animo di vero Principe fatto, dell'indomita passione della libidine gloriosamente vincitore, anzi che le prigioniere nè pur col solo guardo contaminare, quello se stesso vincendo altrove prudentemente rivolge.

Nelle due lunette nell'altra parete opposta effigiate, che sopra le finestre espresse sono, Augusto si vede, che con cera di prudenza serrato il varco a gli orecchi, alle 'ngannatrici lusinghe della Sirena del Nilo fede non presta e da esse col lume della ragione si schermisce, e si scansa; nell'altra Ciro che dalle lusinghevoli parole di Pantea, bellissima sua prigioniera, liberandosi, piegar a niun patto si lascia.
c. 158v
Nelle due lunette verso Tramontana vedesi sopra la porta che passa nell'altra camera Scipione, ch' avendo generosamente con la spada i nemici superati e vinti volse con generosità sovrumana di sè stesso vincer gli affetti, la dolce conversazione di femmine prigioniere ancorchè bellissime rifiutando; è nell'altra la storia di Massinissa e Sofonisba effigiata.

Nell'altre dell'opposta parete Antioco effigiato si vede, ch'anzi di goder placida calma fra le braccia di donna amante e supplichevole qual'ora, che vezzi e contenti gli prometteva,
c. 159r
quegli spregiando amò più tosto dar le vele a'venti in tempo di fierissima borrasca, e consegnar se stesso alle tempeste d'irato mare, che rimaner absorto in mezzo alla quiete dalle procelle insuperabili d'un cuore innamorato: Nell'altra è Crispo di Constantino che della femmina amante che sua matrigna era per non contaminar l'onor del Padre, le lusinghe ed i premi sprezzando fugge.

Qui terminano di questa celebre stanza le storie, che dall'illustre e rinomato pennello di Pietro Berrettini da Cortona con somma industria e diligenza condotte furono.
c. 159v
Camera d'Apollo, o del Sole, per lo splendore e magnificenza figurata, che di prima Anticamera alla nobiltà ordinaria è destinata.

È questa dell'antecedente più ricca, gli stucchi della volta tutti dorati essendo, ed a' peducci della medesima figure intere maggiori del naturale, di mensole e capitelli servendo, con molti altri rabeschi di fogliami e viticci a foggia di grottesche ne' contorni, che fanno superba mostra. In mezzo della volta la Gioventù dalle due Deitadi Pallade e Mercurio è ad Apollo presentata, dal quale Ercole simboleggiato per la virtù ch' ha una sfera con le stelle, ove i moti celesti distinguonsi, gli è additato, quasi dir voglia quel "sapiens dominabitur astris," alla cui contemplazione ed imitazione alla virtude incitandola quel lucido Pianeta l'invita.

c. 160r

Bellissima è della Gioventù la figura, che attonita e sospesa alle parole d'Apollo, che con attenzione ascolta, confusa restar mostrando, come che non solo ciò nuovo gli giunga, ma di sua elezzione dubbiosa ed inrisoluta, tutta pensosa con una mano al mento in atto di contemplazione si rimane. Questa con alcune altre poche figure di questa volta, che sono l'Apollo ed Ercole, furono dal diligente pennello di Pietro da Cortona con sommo studio ed artifizio dipinte, per le quali lode immortale ha meritato; ed il restante di tutte le pitture sì della volta, che da lui non so per qual cagione fu lasciata imperfetta, benchè alcuni per non esser stato giusta suo desiderio ricompensato abbin detto, come delle pareti son di Ciro suo degno scolare che co' cartoni del maestro opera così vaga doppo molto tempo con gran diligenza e sapere al disiderato fine condusse.

c. 160v

Ne' quattro cantoni o peducci della volta son le muse effigiate, due per ciaschedun luogo veggendosene.

Vaghissimi ancora son gli architravi, cornicione egregio [cancelled in the text] con i fogliami ed altri vaghi ornamenti come si è detto tutti dorati altresì: Sotto al cornicione che da per tutto rigira quattro storie con bell'industria effigiate si veggono.

Nella prima ad Alessandro, che viaggiar debbe, un paggio l'Iliade di Omero per sotto al capezzale collocarlo porge, la stima che quel Monarca di tal opra facea in quest'azzione mostrando, compagno di suo trionfo chiamandolo

Nella 2.da è Augusto effigiato, che dopp'aver chiuso il Tempio di Giano a sedere comodamente adagiatosi, alle muse, ed agli studi con molta soddisfazzione volentieri apre le orecchie.

c. 161r

Cesare nella 3.a si vede che la gioia pregiatissima del tempo irrecuperabile a chi 'l perde, anche stando in piedi, per non gettarlo, la lettura de' libri di buona voglia ascolta a ben vivere imparar proccurando, volendo in ciò spezialmente gli Principi ammaestrare perchè a ben morire imparino, e che doppiamente murore chi oziosamente vive.

Nell'ultima l'Imperador Giustiniano che tralasciata la multiplicità de' volumi, mediante Triboniano, Teofilo e Doroteo suoi savi, quella riduce, dimostra.

c. 161v

Segue ora la 3a, che Camera di Marte per lo terror delle leggi inteso è detta . . .
[description interrupted]

c. 206r

Pitti

La 4a Camera è di Giove ov'Ercole per la virtù figurato è da una figura con pelle di Leone ornata della fatica figura condotta a Giove insieme con bella Donna acciò gli dia la corona premio della virtù; siedono intorno le Grazie e la Fama con penna e palma in mano, con l'ali, vestita di bianco dal mezzo in su, dal mezzo in giù di rosso: nelle lunette è Diana che dorme, Pallade in altra: Vulcano: il Pegaso con ———, Mercurio con l'Astrolabio, il Carro del Sole, Adone, o Endimione di Pietro da Cortona

5.a Saturno

La Prudenza e Marte portano il povero, e lo sollevano al Cielo mediante la virtù di Dio

Source: BNF, MS Magliabechiano, XIII, 34.

257

Appendix III. Catalogue of Drawings

This catalogue provides a listing and summary description of the known drawings by Pietro da Cortona and Ciro Ferri for the decorations in the Sala della Stufa and the Planetary Rooms of the Pitti Palace. Completeness has been attempted, but it is assumed and indeed hoped that new drawings will be located in the future. Indeed, just after this catalogue was submitted for final editing, seven interesting drawings appeared in private collections. These drawings, all figure studies for the ceiling of the Sala di Marte (Cat. Nos. 126-132) do not significantly enlarge our knowledge of the evolution of the decorations to which they are related. They do, however, demonstrate the quantity of figure studies Cortona must have produced for each figure in the frescoes and thus remind us that we presently possess only a fraction of the original drawings.

Where the drawings are executed on white or near-white paper, the color of the paper has not been noted in the entries. Collection marks of special interest have been recorded, but when the marks are those of the public collection in which the drawing is to be found, they are not commented upon. The height of the drawing is indicated first. The bibliography for each drawing is arranged in chronological order. For bibliographical items that occur five or more times, abbreviations have been used. Entries for individual drawings are minimal. No attempt has been made to fully pursue the relationships between drawings or to deal with attribution problems. When directly relevant to the decorations, these matters have been considered in the text.

The following bibliographical abbreviations are used in the catalogue:

Marabottini-Bianchi:	A. Marabottini and L. Bianchi, *Mostra di Pietro da Cortona*, Rome, 1956.
Briganti:	G. Briganti, *Pietro da Cortona o della pittura barocca*, Florence, 1962.
Campbell:	M. Campbell, *Mostra di disegni di Pietro Berrettini da Cortona per gli affreschi di Palazzo Pitti*, Florence, 1965.
Campbell-Laskin:	M. Campbell and M. Laskin, Jr., "A New Drawing for Pietro da Cortona's 'Age of Bronze,'" *Burlington Magazine*, CIII, No. 703, Oct. 1961, 423-427.
Lugt:	F. Lugt, *Les Marques des collections de dessins et d'estampes . . .*, Amsterdam, 1921; *Supplément*, The Hague, 1956.
Stampfle-Bean:	F. Stampfle and J. Bean, *Drawings from New York Collections*, Vol. II: *The Seventeenth Century in Italy*, New York, 1967.

Vitzthum, *Blunt*: W. Vitzthum, "Inventar eines Sammelbandes des Spaten Seicento mit Zeichnungen von Pietro da Cortona und Ciro Ferri," *Studies in Renaissance and Baroque Art Presented to Antony Blunt on His Sixtieth Birthday*, London, 1967.

Vitzthum, "Drawings": W. Vitzthum, "Pietro da Cortona's Drawings For the Pitti Palace at the Uffizi," *Burlington Magazine*, CVII, No. 751, Oct. 1965, 522-526.

Vitzthum, "Review": W. Vitzthum, "Review of G. Briganti, *Pietro da Cortona* . . . ," *Master Drawings*, II, No. 2, Summer 1963, 49-51.

Drawings for the Sala della Stufa

AGE OF GOLD

COMPOSITION STUDIES

1. Florence, Uffizi, Inv. No. 18477F.
[Fig. 9]

427 x 287 mm. Pen and brown ink over sanguine, squared in black chalk. In the lower left corner, inscribed in pencil in modern script: *Allori*. This early study for the *Age of Gold* contains numerous variants to the executed version in the fresco. Several studies for figures appearing in this drawing but not in the actual fresco have been located (Cat. Nos. 5, 17, and 19).

ARTIST: Pietro da Cortona.

LIT.: O. H. Giglioli, "Disegni inediti nella Galleria degli Uffizi," *Bollettino d'Arte*, N.S. II, May 1923, 507ff. and ill., 520; A. Stix, "Barockstudien," *Belvedere*, XII, 1930, 180ff. and Fig. 123; Marabottini-Bianchi, 10, n. 21; F. Morandini, *Mostra documentaria e iconografica di Palazzo Pitti e giardino di Boboli*, Florence, 1960, 26, Cat. No. 90; Campbell-Laskin, 423, n. 5; W. Vitzthum, "Correspondence: 'Pietro da Cortona's Camera della Stufa,'" *Burlington Magazine*, CIV, No. 708, March 1962, 121 and Fig. 28; Briganti, 301; M. Campbell, "Correspondence," *Burlington Magazine*, CIV, No. 708, March 1962, 121ff., and Fig. 28; Campbell, 23f., No. 1; Fig. 1.

2. Munich, Staatliche Graphische Sammlung, Inv. No. 6771.
[Fig. 8]

232 x 273 mm. Black chalk.

This drawing contains compositional and figural references to the frescoes of the *Age of Gold* and the *Age of Silver*.

ARTIST: Pietro da Cortona.

LIT.: M. Campbell, "Correspondence: 'Addenda to Pietro da Cortona,'" *Burlington Magazine*, CVII, No. 751, Oct. 1965, 526f. and Fig. 42; B. Degenhart and A. Schmidtt, *Italienischen Zeichnungen 15-18 Jahrhundert, Staatliche Graphischen Sammlung, München*, Munich, 1967, 70, No. 57; Pl. 68.

FIGURE STUDIES

3. Florence, Uffizi, Inv. No. 11677F.

Left arm. 400 x 260 mm. Black chalk heightened with white on grey paper.

Study for left arm of the youth in an oak tree in the *Age of Gold*.

ARTIST: Pietro da Cortona.

LIT.: Briganti, 290; Campbell, 26, under No. 5.

4. Florence, Uffizi, Inv. No. 11685F.

Female figure. 398 x 194 mm. Black chalk, heightened with white, on grey paper.

Study for the central figure in the dancing trio in the *Age of Gold*.

ARTIST: Pietro da Cortona.

LIT.: Briganti, 291; Campbell, 29, No. 13.

5. Florence, Uffizi, Inv. No. 11695F.

Hands (recto); *putti*, an arm and a female head seen in lost profile (verso). 397 x 250 mm. Black chalk heightened in white on grey paper. Inscribed in bister on upper margin center of recto *17* and on verso *16*.

Recto: Hand studies can be associated with female appearing in left side of composition study for *Age of Gold* (Cat. No. 1) and with the hands of Justice in the ceiling of the Sala di Giove.

Verso: Female head in lost profile appears in the dancing trio in the *Age of Gold*. The *putti*

were, like the hands on the recto, used in the Sala di Giove ceiling.

ARTIST: Pietro da Cortona.

LIT.: Briganti, 292; Vitzthum, "Review," 49; Campbell, 24, No. 3.

6. Florence, Uffizi, Inv. No. 11704F.

Putto. 219 x 130 mm. Black chalk, heightened with white. Inscribed in upper margin, center, *24*.

Study for the *putto* carrying oak branches in the *Age of Gold.*

ARTIST: Pietro da Cortona.

LIT.: Marabottini-Bianchi, 61, No. 57 and Pl. LXI; Briganti, 293; Campbell, 27, No. 9.

7. Florence, Uffizi, Inv. No. 11705F.

Drapery study (recto); head of a *putto* and left shoulder of a male youth (verso). 398 x 382 mm. Black chalk, heightened with white on grey paper.

Recto: Detailed study of drapery, probably for the cloak of the female who holds a flute to the mouth of a *putto* in the *Age of Silver.*

Verso: Study for the head of the recumbent, laughing *putto* in the *Age of Gold* and a study for the right shoulder (reversed) of the youthful male who dances with two females in the *Age of Gold.*

ARTIST: Pietro da Cortona.

LIT.: Briganti, 293; Vitzthum, "Review," 49; Campbell, 28, under No. 10.

8. Florence, Uffizi, Inv. No. 11707F.

Drapery study (recto); striding figure (verso). 398 x 253 mm. Black chalk, heightened with white, on grey paper. Inscribed in bister on upper margin of recto *13* and in upper margin on verso *14*.

Recto: Connection with frescoes uncertain.

Verso: Study for right-hand figure in the dancing trio in the *Age of Gold.*

ARTIST: Pietro da Cortona.

LIT.: Briganti, 293; Campbell, 30, No. 15 (Fig. 10).

9. Florence, Uffizi, Inv. No. 11710F.

Two interlocked hands. 397 x 256 mm. Black chalk, heightened with white, on grey paper. Inscribed in bister in upper left margin, *37*.

Study for the hands of two dancing figures in the *Age of Gold.*

ARTIST: Pietro da Cortona.

LIT.: Briganti, 294 and Fig. 173; Campbell, 29, No. 13.

10. Florence, Uffizi, Inv. No. 11731F.

Kneeling woman. 395 x 250 mm. Black chalk, heightened with white, on grey paper. Inscribed in bister in upper margin left, *19*.

Study for a young woman in lower right corner of the *Age of Gold.*

ARTIST: Pietro da Cortona.

LIT.: Briganti, 295; Campbell, 28, No. 11 (Fig. 7).

11. Florence, Uffizi, Inv. No. 11750F.

Head and right hand of a youth. 180 x 257 mm. Black chalk. Inscribed, in bister, in upper left margin, *26*.

Study for the youth in an oak tree in the *Age of Gold.*

ARTIST: Pietro da Cortona.

LIT.: Briganti, 297; Campbell, 26, No. 6.

12. Florence, Uffizi, Inv. No. 11753F.

Recumbent female figure (recto); *putto* (verso). 250 x 398 mm. Black chalk, heightened with white on grey paper. Inscribed in bister, on

recto in lower margin, *7* and on verso, in upper margin, *8*.

Recto: Study for a female figure in the *Age of Silver*.

Verso: Study for *putto* carrying oak branches in the *Age of Gold*.

ARTIST: Pietro da Cortona.

LIT.: Briganti, 298; Campbell, 31, No. 19.

13. Florence, Uffizi, Inv. No. 11754F.

Putti. 254 x 394 mm. Black chalk, heightened with white, on grey paper. Inscribed in bister, in upper right margin, *28* and in upper left, *29*. Studies for *putti* in the *Age of Gold*.

ARTIST: Pietro da Cortona.

LIT.: Briganti, 298; Campbell, 28, No. 10 (Fig. 4).

14. Florence, Uffizi, Inv. No. 11755F.

Youth (recto); youth (verso). 397 x 260 mm. Black chalk, heightened in white, on grey paper. Inscribed in bister in upper margin of recto, *34*, and in upper margin of verso, *33*.

Recto: Study for the youth in the oak tree in the *Age of Gold*.

Verso: Study for the youth in the right middle ground of the *Age of Gold*.

ARTIST: Pietro da Cortona.

LIT.: Briganti, 298 and Fig. 172; Vitzthum, "Review," 50; Campbell, 26, No. 5 (Fig. 9).

15. Florence, Uffizi, Inv. No. 11757F.

Putto. 397 x 255 mm. Black chalk, heightened with white, on grey paper. Inscribed in bister in left margin center, *35*.

Study for the *putto* carrying oak branches in the *Age of Gold*.

ARTIST: Pietro da Cortona

LIT.: Briganti, p. 298; Campbell, p. 27, no. 8.

16. Florence, Uffizi, Inv. No. 11758F.

Head and shoulders of a young woman. 398 x 256 mm. Black chalk, sanguine, traces of white heightening, on grey paper. Inscribed in upper margin, *36*.

Study for the woman sitting in the lower right foreground of *Age of Gold*.

ARTIST: Pietro da Cortona.

LIT.: Briganti, 298 and Fig. 287, No. 42; Campbell, 28, No. 12 (Fig. 8).

17. Florence, Uffizi, Inv. No. 11768F.

Seated youth (recto); two *putti* heads and a young girl (verso). 400 x 227 mm. Black chalk, heightened in white, on grey paper. Inscribed in bister with *30* in the upper margin of recto and on the verso, *31* (upper margin) and *31* (lower left margin).

Recto: Study for the seated youth in the left section of the *Age of Gold*.

Verso: Study for a *putto* who appears in a composition study for the *Age of Gold* (Cat. No. 1) and for a *putto* and young girl in the fresco.

ARTIST: Pietro da Cortona.

LIT.: Briganti, 299; M. Campbell, "Correspondence," *Burlington Magazine*, CIV, No. 708, March 1962, 122 and Fig. 27; Vitzthum, "Review," 49; Campbell, 25f., No. 4.

18. Florence, Uffizi, Inv. No. 11770F.

Half-length figure of a young woman. 395 x 290 mm. Black chalk, sanguine, traces of white heightening on grey paper. Inscribed in bister in the upper margin at the center, *25*.

Study for the young woman who places a wreath on the head of her male companion in the left section of the *Age of Gold*.

ARTIST: Pietro da Cortona.

LIT.: Briganti, 299; Vitzthum, "Review," 50; Campbell, 27, No. 7 (Fig. 5).

19. Florence, Uffizi, Inv. No. 13909F.

Two female figures. 238 x 262 mm. Black chalk, traces of white heightening.

The two entwined female figures appear in the left portion of a composition study for the *Age of Gold* (Cat. No. 1), but were replaced by a male and female couple in the actual fresco. Drawing contains a second study of the neck and right shoulder of one of the figures.

ARTIST: Pietro da Cortona.

LIT.: Briganti, 300; M. Campbell, "Correspondence," *Burlington Magazine*, CIV, No. 708, March 1962, 122 and Fig. 25; Vitzthum, "Review," 50; Campbell, 24, No. 2 (Fig. 2).

20. Florence, Uffizi, Inv. No. 13913F.

Upper body of a youth. 390 x 252 mm. Black chalk, heightened with white, on grey paper. Inscribed in bister in upper left margin, *38*.

Study for the male figure in the dancing trio in the *Age of Gold*.

ARTIST: Pietro da Cortona.

LIT.: Briganti, 300 and Fig. 171; Campbell, 30, No. 16 (Fig. 6).

21. New York, Metropolitan Museum of Art, Bequest of Walter C. Baker.
[Fig. 7]

Two figures. 323 x 247 mm. Black chalk. In lower left margin, mark of Sir Joshua Reynolds (Lugt, 2364); William May (Lugt, 2799).

Study for the youthful couple who appear seated beneath the oak tree in the left section of the *Age of Gold*.

ARTIST: Pietro da Cortona.

LIT.: T. Borenius, "Drawings and Engravings by the Carracci," *Print Collectors' Quarterly*, IX, April 1922, 114 and ill., 104; K. T. Parker,

Catalogue of the . . . Collection . . . Formed by . . . Henry Oppenheimer, London, 1936, 41, No. 766; Campbell, 23, under No. 1; *Christie's Sales Catalogue, Earl of Harewood Collection*, London, 1965, No. 124, with ill.; Stampfle-Bean, 48f., No. 60 and Pl. 60; W. Vitzthum, "Review of M. Campbell, *Mostra di disegni di Pietro Berrettini da Cortona . . .*," *Master Drawings*, IV, No. 1, 1966, 63 (Pl. 40).

22. New York, Metropolitan Museum of Art, Bequest of Walter C. Baker.

Seated male figure. 286 x 260 mm. Black chalk. Inscribed at lower right in black chalk: *P. Cortona*.

Collections: J. Skippe; J. Martin; Mrs. A. D. Raynor-Wood; E. H. Martin.

Study for the youth seated beneath an oak in the left portion of the *Age of Gold*.

ARTIST: Pietro da Cortona.

LIT.: *Vasari Society*, II, London, 1906, No. 17 (as Ludovico Carracci); *Italian Art of the Seventeenth Century* (Illustrated Catalogue for an Exhibition at the Burlington Fine Arts Club), No. 3, 1925, Pl. 12; A. E. Popham, *Italian Drawings Exhibited at the Royal Academy, Burlington House*, London, 1930, 81, No. 301, Pl. CCLIIIA; Briganti, 308; Campbell, 23, under No. 1; Stampfle-Bean, 49, No. 61 (Pl. 61) (see for full bibliography, provenance and list of exhibitions).

23. Paris, Louvre, Inv. No. 519.

Kneeling woman. 225 x 341 mm. Black and red chalk heightened with white.

Study for a young woman who appears in the lower right of the *Age of Gold*.

ARTIST: Pietro da Cortona.

LIT.: Briganti, 314 and Fig. 287, No. 52; Campbell, 28, under No. 11.

24. Rome, Gabinetto Nazionale delle Stampe, Fondo Corsini, Inv. No. 124324.

Seated youthful figure. 356 x 246 mm. Black chalk on grey paper.

Study for the youth seated beneath an oak tree in left section of the *Age of Gold*.

ARTIST: Pietro da Cortona.

LIT.: Marabottini-Bianchi, 60, under No. 56; Briganti, 318.

25. Rome, Gabinetto Nazionale delle Stampe, Fondo Corsini, Inv. No. 124329.
[Fig. 6]

Half-length female figure. 333 x 257 mm. Black chalk heightened with white on grey paper.

Study for the young woman who places a wreath on the head of her male companion in the left section of the *Age of Gold*.

ARTIST: Pietro da Cortona.

LIT.: Marabottini-Bianchi, 60, No. 56 and Pl. LX; P. Barocchi, *Disegni italiani di cinque secoli*, Florence, 1961, 67, No. 102 and Fig. 75; M. Campbell, "Correspondence," *Burlington Magazine*, CIV, No. 708, March 1962, 122 and Fig. 26; Briganti, 319; Campbell, 27, under No. 7.

26. Vienna, Albertina, Inv. No. 24554.

Kneeling female figure. 285 x 210 mm. Black chalk. Inscribed: *Pietro da Cortona*.

Study for a young woman who appears in lower right section of the *Age of Gold*.

ARTIST: Pietro da Cortona.

LIT.: A. Stix and F. Frohlich-Bum, *Beschreibender Katalog der Handzeichnungen in der Graphischen Sammlung Albertina*, III, Vienna, 1932, 71, No. 704 and Pl. 158; Briganti, 326 and Fig. 170; Campbell, 29, under No. 12.

AGE OF SILVER

COMPOSITION STUDIES

27. Munich, Staatliche Graphische Sammlung, Inv. No. 6771.
(See Cat. No. 2.)

FIGURE STUDIES

28. Florence, Horne Museum, Inv. No. 5604.

Recumbent female. 355 x 245 mm. Black chalk and sanguine heightened with white on grey paper.

Study for a female figure at the center foreground of the *Age of Silver* (see also Cat. Nos. 31, 33 and 34).

ARTIST: Pietro da Cortona.

LIT.: L. Ragghianti Collobi, *Disegni della Fondazione Horne in Firenze*, Florence, 1963, 15, Cat. No. 31 (Fig. 25).

29. Florence, Uffizi, Inv. No. 11678F.

Drapery study. 250 x 398 mm. Black chalk, heightened with white on grey paper.

Study for drapery suspended from branches in the upper right corner of the *Age of Silver*.

ARTIST: Pietro da Cortona.

LIT.: Briganti, 291; Campbell, 35, No. 27.

30. Florence, Uffizi, Inv. No. 11689F.

Female figure. 398 x 251 mm. Black chalk, heightened with white, on grey paper. Inscribed in bister in upper margin, *8*.

Study for the woman who holds a flute for a *putto* in the *Age of Silver*.

ARTIST: Pietro da Cortona.

LIT.: Briganti, 292; Campbell, 33, No. 23 (Fig. 15).

31. Florence, Uffizi, Inv. No. 11699F.

Two arms. 395 x 253 mm. Black chalk, heightened in white, on grey paper. Inscribed, in bister in upper margin, 11 [?].

Studies for the arms of the recumbent female in the *Age of Silver*.

ARTIST: Pietro da Cortona.

LIT.: Briganti, 293; Campbell, 33, No. 22 (Fig. 16).

32. Florence, Uffizi, Inv. No. 11705F.
(See Cat. No. 7.)

33. Florence, Uffizi, Inv. No. 11732F.

Arm (recto); rough architectural sketch (verso). 117 x 230 mm. Black chalk, heightened with white. Inscribed in bister in upper margin of the recto, 27.

Recto: Study for left arm of recumbent female in *Age of Silver*.

Verso: Rough sketch is not associable with Pitti decorations.

ARTIST: Pietro da Cortona.

LIT.: Briganti, 296; Campbell, 32, No. 21.

34. Florence, Uffizi, Inv. No. 11743F.

Recumbent female figure. 251 x 398 mm. Black chalk, heightened with white, on grey paper. Inscribed in bister in upper margin, 12.

Study for a female figure in the *Age of Silver*.

ARTIST: Pietro da Cortona.

LIT.: Briganti, 297; Campbell, 32, No. 20 (Fig. 17).

35. Florence, Uffizi, Inv. No. 11746F.

Seated male (recto); female head (verso). 344 x 244 mm. Black chalk, red chalk (verso only), heightened with white, on grey paper. Inscribed on recto upper left margin, 40.

Recto: Study does not pertain to the executed Pitti Palace decorations.

Verso: Study for the head of the young woman carrying a sheaf of grain on her head in the *Age of Silver*.

ARTIST: Pietro da Cortona.

LIT.: Briganti, 297; Campbell, 34, No. 26.

36. Florence, Uffizi, Inv. No. 11748F.

Kneeling young male. 398 x 252 mm. Black chalk, heightened with white, on grey paper. Inscribed in bister in upper margin, 15.

Study for the boy who squeezes grapes into an urn in the *Age of Silver*.

ARTIST: Pietro da Cortona.

LIT.: P. N. Ferri, *Catalogo . . . di disegni . . . posseduta dalla R. Galleria degli Uffizi . . .*, Rome, 1890, 184; Briganti, 297 and Fig. 174; Campbell, 31, No. 18 (Fig. 12).

37. Florence, Uffizi, Inv. No. 11749F.

Youthful figure. 397 x 260 mm. Black chalk, heightened with white, on grey paper. Inscribed, in bister, in upper left margin, 39.

Early study for the youth squeezing grapes in the *Age of Silver*. The study was later used to develop the figure of the youth abducted from Venus's couch in the ceiling of the Sala di Venere.

ARTIST: Pietro da Cortona.

LIT.: Briganti, 297; Campbell, 44, No. 38 (Fig. 28).

38. Florence, Uffizi, Inv. No. 11752F.

Female head seen from the back. 238 x 212 mm. Red chalk. Inscribed in bister, in upper left margin, *28* [?].

Studies for the head of a woman in the right section of the *Age of Silver*.

ARTIST: Pietro da Cortona.

LIT.: Marabottini-Bianchi, 60, No. 55 and Pl. LIX; Briganti, 298; Campbell, 34, No. 25 (Fig. 14).

39. Florence, Uffizi, Inv. No. 11753F.
(See Cat. No. 12.)

40. Florence, Uffizi, Inv. No. 11756F.

Upper body of a male figure. 397 x 254 mm. Black chalk, heightened with white, on grey paper. Inscribed in bister in upper margin, *12*.

Study for a hunter carrying a small animal over his shoulder in the *Age of Silver*.

ARTIST: Pietro da Cortona.

LIT.: Briganti, 298; Campbell, 31, No. 17 (Fig. 11).

41. Florence, Uffizi, Inv. No. 13912F.

Seated female figure. 400 x 251 mm. Black chalk, heightened with white, on grey paper.

Study for a woman who appears in far right section of the *Age of Silver*.

ARTIST: Pietro da Cortona.

LIT.: Briganti, 300 and Fig. 175; Campbell, 33, No. 24 (Fig. 13).

AGE OF BRONZE

COMPOSITION STUDIES

42. Florence, Uffizi, Inv. No. 5516A.
[Fig. 162(r); Fig. 14(v)]

Architectural study (recto); composition study (verso). 280 x 200 mm. Pen and bister.

Recto: Sketch of the partially completed church of SS. Luca e Martina in Rome.

Verso: Composition study for the *Age of Bronze*.

ARTIST: Pietro da Cortona.

LIT.: K. Noehles, "Review of G. Briganti, *Pietro da Cortona . . . ,*" *Kunstchronik*, XIV, No. 4, April 1963, 105 and Fig. 4a; Vitzthum, "Drawings," 525; K. Noehles, *La Chiesa dei SS. Luca e Martina*, Rome, 1970, 103, n. 209 (Fig. 91).

43. Munich, Staatliche Graphische Sammlung, Inv. No. 2627.
[Figs. 15, 15A]

333 x 260 mm. Pen and bister over black chalk. Collection: Stengel.

Composition drawing for the *Age of Bronze*. Note the original version of upper right corner under movable flap (Fig. 15A).

ARTIST: Pietro da Cortona.

LIT.: Campbell-Laskin, 423ff. and Figs. 20, 21; Briganti, 308; W. Vitzthum, "Correspondence: 'Pietro da Cortona's Camera della Stufa,'" *Burlington Magazine*, CIV, No. 708, March 1962, 121; K. Noehles, "Review of G. Briganti, *Pietro da Cortona . . . ,*" *Kunstchronik*, XIV, No. 4, April 1963, 105 and Fig. 4b; Campbell, 17; Stampfle-Bean, 49f., under No. 62; B. Degenhart and A. Schmidtt, *Italienischen Zeichnungen 15-18 Jahrhundert, Staatliche Graphischen Sammlung, München*, Munich, 1967, 70, No. 58 (Pl. 69).

44. New York, Metropolitan Museum of Art, Bequest of Walter C. Baker.
[Fig. 18]

405 x 270 mm. Pen and brown ink and brown wash over black chalk.

Composition study for the *Age of Bronze*.

ARTIST: Pietro da Cortona.

LIT.: W. Vitzthum, "Drawings," 526 and Fig. 37; Stampfle-Bean, 50, No. 63 (Fig. 63).

45. New York, Metropolitan Museum of Art, Rogers Fund, Inv. No. 64.48.2. [Fig. 17]

235 x 172 mm. Pen and bister over black chalk. Inscribed in lower margin: *n° 5.* Formerly in collection of Prof. J. Isaacs.

This drawing is a composition study for the *Age of Bronze.*

ARTIST: Pietro da Cortona.

LIT.: Vitzthum, "Drawings," 526 and Fig. 36; Stampfle-Bean, 49f., No. 62 (Fig. 62).

46. Prague, National Gallery, Inv. No. K.10.344 [Fig. 16]

338 x 265 mm. Pen and bister over red chalk.

Composition drawing for the *Age of Bronze.*

ARTIST: Pietro da Cortona.

LIT.: Campbell-Laskin, 423ff. and Fig. 18; W. Vitzthum, "Correspondence: 'Pietro da Cortona's Camera della Stufa,'" *Burlington Magazine,* CIV, No. 708, March 1962, 121; Stampfle-Bean, 49f., under No. 62.

47. Rome, Private Collection [?]. [Fig. 13]

200 x 190 mm. Pen and ink, traces of coloring. Probably once in the collections of Queen Christina of Sweden, Cardinal Azzolino, and Don Livio Odescalchi.

Probably a *primo pensiero* for the *Age of Bronze.*

ARTIST: Pietro da Cortona.

LIT.: Vitzthum, *Blunt,* 116, No. 66 (Fig. 2) (published as in the collection of John Hardings, New York).

FIGURE STUDIES

48. Rome, Gabinetto Nazionale delle Stampe, Fondo Corsini, Inv. No. 125387.

Male figure. 345 x 230 mm. Black chalk, heightened with white, on grey paper.

Study for the warrior receiving a crown in the *Age of Bronze.*

ARTIST: Pietro da Cortona.

LIT.: Campbell-Laskin, 424 and Fig. 22; Briganti, 319.

AGE OF IRON

COMPOSITION STUDIES

49. Princeton, University Art Museum, Inv. No. 48-722. [Fig. 19]

312 x 257 mm. Pen and brown ink over red chalk on light brown paper. Collections: W. Y. Ottley, D. F. Platt (Lugt, No. 2066b and No. 750a).

Preparatory composition study for the *Age of Iron.*

ARTIST: Pietro da Cortona.

LIT.: F. J. Mather, Jr., *Bulletin of the Department of Art and Archaeology, Princeton University,* June 1944, 4 and Fig. 2; D. R. Coffin, *Record of the Art Museum, Princeton University,* XIII, No. 2, 1954, 33ff. and Fig. 1; Campbell-Laskin, 423ff. and Fig. 23; W. Vitzthum, "Correspondence: 'Pietro da Cortona's Camera della Stufa,'" *Burlington Magazine,* CIV, No. 708, March 1962, 121; Campbell, 17, n. 3, 23f.

FIGURE STUDIES

50. Cambridge, Fitzwilliam Museum, Inv. No. 12-1956.

Male figure. 174 x 309 mm. Black chalk, heightened with color. Inscribed in upper right, *51,* and at bottom center, *cinquantuno.*

Study for the old man pinned to the ground in the center of the *Age of Iron.*

ARTIST: Pietro da Cortona.

LIT.: W. Vitzthum, *Il Barocco a Roma*, Milan, 1970, 83 (Pl. xv).

51. Rome, Gabinetto Nazionale delle Stampe, Fondo Corsini, Inv. No. 124322.

Female figure. 185 x 260 mm. Black chalk, heightened with white, on grey paper.

Study for the kneeling female in the right section of the fresco of the *Age of Iron.*

ARTIST: Pietro da Cortona.

LIT.: Briganti, 318.

52. Rome, Gabinetto Nazionale delle Stampe, Fondo Corsini, Inv. No. 127058.

Female head. 145 x 165 mm. Red chalk. Inscribed in the lower left corner: *Pie. da Cortona.*

Study for the head of the kneeling woman in the right section of the *Age of Iron.*

ARTIST: Pietro da Cortona.

LIT.: Briganti, 320.

Drawings for the Sala di Venere

ARCHITECTURAL DECORATIONS

53. Florence, Uffizi, Inv. No. 6875A.
[Fig. 26]

Architectural decoration and a molding seen in profile. 172 x 237 mm. Black chalk, pen and brown ink. The right section of this sheet contains an early study for the tondos containing Medici portraits.

ARTIST: Pietro da Cortona.

LIT.: A. Muñoz, *Pietro da Cortona*, Rome, 1921, Pl. xiv; V. Moschini, "Le Architetture di Pietro da Cortona," *L'Arte*, xxiv, Sept.-Dec. 1921, 192, n. 1; Campbell, 39, No. 28 (Fig. 18).

CEILING FRESCO

COMPOSITION STUDIES

54. Budapest, Museum of Fine Arts, Inv. No. 2301. [Fig. 30]

145 x 210 mm. Pen and bister. Collection: Esterházy (Lugt, No. 1965).

Composition for the ceiling in the Sala di Venere.

ARTIST: Pietro da Cortona.

LIT.: Campbell, 18, n. 2; 39, under No. 29 (Pl. 1a).

55. Rome, Private Collection [?].
[Fig. 29]

162 x 235 mm. Black chalk over pen and brown ink. Probably once in the collections of Queen Christina of Sweden, Cardinal Azzolino, and Don Livio Odescalchi.

Early study for the ceiling fresco in the Sala di Venere.

ARTIST: Pietro da Cortona.

LIT.: Vitzthum, "Drawings," 526 and Fig. 43; Vitzthum, *Blunt*, 113, No. 1 (published as in the Collection of John Hardings, New York).

FIGURE STUDIES

56. Budapest, Museum of Fine Arts, Inv. No. 2300. [Fig. 31]

Recumbent female figure. 72 x 76 mm. Pen and bister. Collection: Esterházy (Lugt, No. 1965).

Early study for figure of Venus in ceiling of Sala di Venere.

ARTIST: Pietro da Cortona.

LIT.: Campbell, 18 n. 2, 39, under No. 29.

57. Florence, Uffizi, Inv. No. 11675F.

Female legs. 400 x 260 mm. Black chalk, heightened with white, on grey paper. Impressed mark of Cardinal Leopoldo de' Medici (Lugt, No. 1712) appears in lower margin of sheet.

Study for the semi-recumbent nymph in the left portion of the ceiling of the Sala di Venere.

ARTIST: Pietro da Cortona.

LIT.: Briganti, 290; Campbell, 44f., under No. 39.

58. Florence, Uffizi, Inv. No. 11676F.

Legs of a woman. 402 x 262 mm. Black chalk, heightened with white, on grey paper. Inscribed in bister in upper left margin, *72*.

Study for the legs of Venus in the ceiling of the Sala di Venere.

ARTIST: Pietro da Cortona.

LIT.: Briganti, 290; Campbell, 42, No. 34 (Fig. 24).

59. Florence, Uffizi, Inv. No. 11692F.

Female figure. 385 x 253 mm. Black chalk, heightened with white, on grey paper. Inscribed in bister, in lower right margin, *11*.

Study for Venus in the ceiling of the Sala di Venere.

ARTIST: Pietro da Cortona.

LIT.: Briganti, 292; Vitzthum, "Review," 49; Campbell, 41, No. 31 (Fig. 21).

60. Florence, Uffizi, Inv. No. 11693F.

Hands (recto); female figure (verso). 399 x 258 mm. Black chalk, heightened with white, on grey paper. Inscribed on recto in bister in upper margin, *48*, and in lower margin, *49*.

Recto: Study for hands of the three young women in left section of lunette of *Alexander and the Family of Darius*.

Verso: Early stage in the formation of Venus in the ceiling of the Sala di Venere.

ARTIST: Pietro da Cortona.

LIT.: Briganti, 292; Campbell, 42, No. 33 (Figs. 23, 36).

61. Florence, Uffizi, Inv. No. 11701F.

Figure study. 395 x 253 mm. Black chalk, heightened with white, on grey paper. Inscribed in bister in lower margin, *90*.

Study for the figure of Venus in the ceiling of the Sala di Venere.

ARTIST: Pietro da Cortona.

LIT.: Briganti, 293; Campbell, 41f., No. 32 (Fig. 22).

62. Florence, Uffizi, Inv. No. 11703F.

Right arm and drapery of a seated figure. 259 x 399 mm. Black chalk, heightened with white, on grey paper. Inscribed in lower left margin in bister, *45* [?].

Studies pertaining to a female figure who admires her own reflection in the left portion of the ceiling of the Sala di Venere.

ARTIST: Pietro da Cortona.

LIT.: Briganti, 293; Campbell, 44, No. 37 (Fig. 26).

63. Florence, Uffizi, Inv. No. 11708F.

Female legs. 401 x 258 mm. Black chalk heightened with white.

Study for the semi-recumbent nymph in the left portion of the ceiling of the Sala di Venere.

ARTIST: Pietro da Cortona.

LIT.: Briganti, 293; Campbell, 44f., under No. 39.

64. Florence, Uffizi, Inv. No. 11714F.

Right arm and hand. 241 x 399 mm. Black chalk, heightened with white, on grey paper. Inscribed in bister in left margin, *75*.

Study for an arm of the youth abducted from Venus's couch in the ceiling of the Sala di Venere.

ARTIST: Pietro da Cortona.

LIT.: Briganti, 294; Campbell, 44f., No. 39.

65. Florence, Uffizi, Inv. No. 11717F.

A Nereid and drapery. 254 x 389 mm. Black chalk, heightened with white, on grey paper. Inscribed in bister in left margin, *67*.

Study for the carved footboard of the couch of Venus in the ceiling of the Sala di Venere.

ARTIST: Pietro da Cortona.

LIT.: Briganti, 294; Vitzthum, "Drawings," 49; Campbell, 43, No. 35 (Fig. 25).

66. Florence, Uffizi, Inv. No. 11724F.
[Fig. 32]

Recumbent female in a chariot. 192 x 273 mm. Red chalk. Inscribed in bister on verso, *Pietro da Cortona*. Mathematical calculations appear on verso of drawing.

Study records early stage for the figure of Venus in which she appears in a chariot in the ceiling of the Sala di Venere.

ARTIST: Pietro da Cortona.

LIT.: Briganti, 295; Campbell, 39f., No. 29 (Fig. 19).

67. Florence, Uffizi, Inv. No. 11725F.
[Fig. 33]

Semi-recumbent female figures. 205 x 270 mm. Red chalk. Mathematical calculations appear on verso.

Studies pertain to the figure of Venus in the ceiling of the Sala di Venere.

ARTIST: Pietro da Cortona.

LIT.: F. Morandini, *Mostra documentaria e iconografica di Palazzo Pitti e Giardino di Boboli*, Florence, 1960, 26, No. 89; Briganti, 295; Campbell, 40f., No. 30 (Fig. 20).

68. Florence, Uffizi, Inv. No. 11742F.

Figure studies. 283 x 222 mm. Red chalk. Inscribed in bister in upper margin, *43*.

Studies for figures in the ceiling of the Sala di Venere.

ARTIST: Pietro da Cortona.

LIT.: Marabottini-Bianchi, 62, No. 59 and Pl. LXIII; Briganti, 297; Campbell, 43, No. 36 (Fig. 27).

69. Florence, Uffizi, Inv. No. 11749F.
(See Cat. No. 37.)

LUNETTES

Antiochus and Stratonice

COMPOSITION STUDIES

70. Florence, Uffizi, Inv. No. 11719F.

Study for a lunette. 158 x 221 mm. Pen, bister. Inscribed on the verso, *Pietro da Cortona*.

Study for one of the lunettes in the Sala di Venere. Analogies can be made to the scene of *Antiochus III and the Priestess of Diana* and, by reversing the composition, to *Antiochus and Stratonice*.

ARTIST: Pietro da Cortona.

LIT.: Briganti, 294; Campbell, 45f., No. 40 (Fig. 30).

*Alexander the Great and the Family
of Darius*

FIGURE STUDIES

71. Florence, Uffizi, Inv. No. 11680F.

Female figure. 399 x 257 mm. Black chalk, heightened with white, on grey paper. Inscribed in bister in lower right margin, *65*.

Study in reverse for one of the young women in the left portion of the *Alexander the Great and the Family of Darius* lunette.

ARTIST: Pietro da Cortona.

LIT.: Briganti, 291; Campbell, 50, No. 52 (Fig. 35).

72. Florence, Uffizi, Inv. No. 11693F.
(See Cat. No. 60.)

73. Florence, Uffizi, Inv. No. 11734F.

Standing male figure. 368 x 237 mm. Black chalk, heightened with white, on tan paper. Inscribed in bister in the upper margin, *62*, and on the verso, *Pietro da Cortona*.

Study for the figure of Alexander the Great in the *Alexander the Great and the Family of Darius* lunette.

ARTIST: Pietro da Cortona.

LIT.: Briganti, 296; Campbell, 50f., No. 53 (Fig. 38).

Antiochus III and the Priestess of Diana

COMPOSITION STUDIES

74. Florence, Uffizi, Inv. No. 11719F.
(See Cat. No. 70.)

75. Florence, Uffizi, Inv. No. 11709F.

Female figure. 397 x 257 mm. Black chalk, heightened with white, on grey paper. Inscribed in bister in upper left margin, *82*.

Study for the kneeling priestess of Diana in the *Antiochus III and the Priestess of Diana* lunette.

ARTIST: Pietro da Cortona.

LIT.: Briganti, 293; Campbell, 46, No. 41 (Fig. 29).

76. Florence, Uffizi, Inv. No. 11712F.

Hand holding a plate. 401 x 260 mm. Black chalk, heightened with white, on grey paper. Inscribed in bister in upper margin, *73*.

Detail pertains to the priestess in the *Antiochus III and the Priestess of Diana* lunette.

ARTIST: Pietro da Cortona.

LIT.: Briganti, 294; Campbell, 46f., No. 42.

77. Florence, Uffizi, Inv. No. 13910F.

Head. 152 x 151 mm. Black chalk. Inscribed in bister in upper margin, *2*.

Study for the priestess in the *Antiochus III and the Priestess of Diana* lunette.

ARTIST: Pietro da Cortona.

LIT.: Briganti, 300; Campbell, 47, No. 43 (Fig. 32).

78. Florence, Uffizi, Inv. No. 11683F.

Drapery study for a kneeling figure. 255 x 397 mm. Black chalk, heightened with white, on grey paper. Inscribed in bister in upper margin, *81*.

Study for the kneeling acolyte in the *Antiochus III and the Priestess of Diana* lunette.

ARTIST: Pietro da Cortona.

LIT.: Briganti, 291; Campbell, 47, No. 44.

79. Paris, Louvre, Inv. No. 529.

Kneeling female figure. 313 x 240 mm. Black chalk, heightened in white, on grey paper. Inscribed in the lower left, in pencil: *Pietro da Cortona*; in the upper left appears *179* and in the lower right: *cento settanta nove*. Collection: Robert Strange [?] (Lugt, No. 2239).

Study for the kneeling girl who assists the priestess in the *Antiochus III and the Priestess of Diana* lunette.

ARTIST: Pietro da Cortona.

LIT.: Briganti, 315 and Pl. 287, No. 51; Campbell, 47, under No. 43.

Crispus and Fausta

FIGURE STUDIES

80. Florence, Uffizi, Inv. No. 11711F.
Left arm of a female figure. 263 x 405 mm. Black chalk, heightened with white, on grey paper. Inscribed in bister in right margin, *83*, and on verso, *Pietro da Cortona. 19*.

Study for Fausta in the *Crispus and Fausta* lunette.

ARTIST: Pietro da Cortona.

LIT.: Briganti, 294; Vitzthum, "Drawings," 49; Campbell, 49, No. 48.

Augustus and Cleopatra

FIGURE STUDIES

81. Florence, Uffizi, Inv. No. 11688F.

Standing female figure. 396 x 257 mm. Black chalk, heightened with white, on grey paper. Inscribed in bister in the right margin, 77 [?], and on the verso, *Pietro da Cortona.*

Study for Cleopatra in the *Augustus and Cleopatra* lunette.

ARTIST: Pietro da Cortona.

LIT.: Briganti, 292 and Fig. 287, No. 49; Campbell, 47f., No. 45 (Fig. 33).

82. Florence, Uffizi, Inv. No. 11713F.

Hands and wrists. 259 x 404 mm. Black chalk, heightened with white, on grey paper. Inscribed in bister in right margin, *88*.

Studies for the hands of Cleopatra in the *Augustus and Cleopatra* lunette.

ARTIST: Pietro da Cortona.

LIT.: Briganti, 294; Campbell, 48, No. 47.

83. Florence, Uffizi, Inv. No. 11733F.

Standing female figure. 394 x 265 mm. Black chalk, heightened with white, on grey paper. Inscribed on the verso, *Pietro da Cortona.*

Study for the figure of Cleopatra in the *Augustus and Cleopatra* lunette.

ARTIST: Pietro da Cortona.

LIT.: Briganti, 296; Campbell, 48, No. 46 (Fig. 34).

Cyrus and Panthea

FIGURE STUDIES

84. Florence, Uffizi, Inv. No. 11738F.

Standing female figure. 404 x 235 mm. Black chalk, heightened with white, on grey paper. Inscribed on the verso, *Pietro da Cortona.*

Study for Panthea in the *Cyrus and Panthea* lunette.

ARTIST: Pietro da Cortona.

LIT.: Briganti, 296; Campbell, 49, No. 49 (Fig. 31).

Continence of Scipio

FIGURE STUDIES

85. Florence, Uffizi, Inv. No. 11686F.

Drapery study of the lower portion of a kneeling female figure. 396 x 255 mm. Black chalk, traces of white, on grey paper. Inscribed in bister in lower right margin, *98*.

Study for the young woman kneeling before Scipio in the *Continence of Scipio* lunette.

ARTIST: Pietro da Cortona.

LIT.: Briganti, 291; Campbell, 50, No. 51.

86. Florence, Uffizi, Inv. No. 11728F.

Kneeling female figure. 345 x 233 mm. Black chalk, traces of white, on grey paper.

Study for the young woman kneeling before Scipio in the *Continence of Scipio* lunette.

ARTIST: Pietro da Cortona.

LIT.: Briganti, 295; Campbell, 49, No. 50 (Fig. 37).

Drawings for the Sala di Apollo

ARCHITECTURAL DECORATIONS

87. Florence, Uffizi, Inv. No. 18 Orn.
[Fig. 70]

Lunette and vault decorations. 242 x 312 mm. Pen, bister.

Study for the stucco decorations in the Sala di Apollo.

ARTIST: Pietro da Cortona.

LIT.: P. N. Ferri, *Catalogo . . . di disegni . . . posseduta dalla R. Galleria degli Uffizi*, Rome, 1890, 184; Marabottini-Bianchi, 61, No. 58 and Pl. LXII; Briganti, 301; Campbell, 67, No. 67 (Fig. 46).

CEILING FRESCO

COMPOSITION STUDIES

88. Düsseldorf, Kunstmuseum, Inv. No. FP 14150. [Fig. 76]

Study for a ceiling. 427 x 569 mm. Black chalk on brownish paper.

Composition study for the ceiling of the Sala di Apollo.

ARTIST: Ciro Ferri.

LIT.: E. Schaar, *Italienischen Handzeichnungen des Barock* (Exhibition Catalogue), Düsseldorf, 1964, 28, No. 43.

89. Rome, Gabinetto Nazionale delle Stampe, Fondo Corsini, Inv. No. 124327. [Fig. 61 (r); Fig. 72 (v)]

Study for a ceiling (recto); fragmentary figure studies (verso). 277 x 268 mm. Pen, bister over black chalk.

Recto: Composition study for the ceiling of the Sala di Apollo.

Verso: Studies for the figure of Hercules supporting the globe.

ARTIST: Pietro da Cortona.

LIT.: Briganti, 319; Campbell, 67f., under Nos. 68, 69, 70 and Pl. 1b; M. Campbell, "Correspondence: 'Addenda to Pietro da Cortona,'" *Burlington Magazine*, CVII, No. 751, Oct. 1965, 526f. (Fig. 44).

FIGURE STUDIES

90. Corsham Court, Collection of Lord Methuen.

Head of a female. 183 x 235 mm. Black chalk.

Study for a nymph in the ceiling of the Sala di Apollo.

ARTIST: Pietro da Cortona.

LIT.: Briganti, 289. A. Blunt, *Italian 17th-Century Drawings from British Private Collections*, Edinburgh, 1972, Cat. No. 8 (ill.).

91. Florence, Uffizi, Inv. No. 3015S.

Female figure. 250 x 165 mm. Black chalk, heightened in white. Santarelli Collection stamp (Lugt, No. 907) in lower right corner.

Study, probably for an allegorical female figure in the ceiling of the Sala di Apollo.

ARTIST: Pietro da Cortona.

LIT.: Briganti, 302.

92. Florence, Uffizi, Inv. No. 11679F.

Legs of a male figure. 400 x 260 mm. Black chalk, heightened with white, on grey paper.

Study for the figure of Apollo in the ceiling of the Sala di Apollo.

ARTIST: Pietro da Cortona.

LIT.: Briganti, 291; Vitzthum, "Review," 49; Campbell, 68f., No. 71 (Fig. 51).

93. Florence, Uffizi, Inv. No. 11718F.

Head, torso, and right arm of a male figure. 258 x 395 mm. Black chalk, heightened with white, on grey paper. Inscribed, in bister in the upper margin, *25* [?].

Study for the figure of Apollo in the ceiling of the Sala di Apollo.

ARTIST: Pietro da Cortona.

LIT.: Briganti, 294; Campbell, 69, No. 72.

94. Florence, Uffizi, Inv. No. 11726F.
[Fig. 73]

Hovering figures. 270 x 407 mm. Black chalk, heightened with white, on grey paper.

Probably studies for figures planned in an early stage of the ceiling of the Sala di Apollo.

ARTIST: Pietro da Cortona.

LIT.: Briganti, 295; Vitzthum, "Review," 49; Campbell, 67, No. 68 (Fig. 47).

95. Florence, Uffizi, Inv. No. 11727F.

Recumbent figure. 260 x 362 mm. Black chalk, heightened with white, on grey paper.

Probably a study for a figure planned in an early stage of the ceiling of the Sala di Apollo.

ARTIST: Pietro da Cortona.

LIT.: Briganti, 295; Vitzthum, "Review," 49; Campbell, 68, No. 69 (Fig. 48).

96. Florence, Uffizi, Inv. No. 11737F.
[Fig. 74]

Seated male figure. 370 x 268 mm. Black chalk, heightened with white, on grey paper.

Study for the figure of Apollo in the ceiling of the Sala di Apollo.

ARTIST: Pietro da Cortona.

LIT.: Briganti, 296; Vitzthum, "Review," 49; Campbell, 68, No. 70 (Fig. 50).

97. Florence, Uffizi, Inv. No. 11745F.
[Fig. 75]

Male figure. 480 x 343 mm. Black chalk, heightened with white, on grey paper.

Study for the youthful figure who listens to Apollo in the ceiling of the Sala di Apollo.

ARTIST: Pietro da Cortona.

LIT.: Briganti, 297 and Fig. 287, No. 45; Campbell, 69f., No. 73 (Fig. 49).

98. New York, Metropolitan Museum of Art, Whitelsey Collection, Inv. No. 61.129.1. [Fig. 79]

Figure study. 189 x 333 mm. Black chalk, heightened with white, on grey paper. Collections: G. Hibbert; N. Hibbert; H. Holland; the 1st Viscount Knutsford; L. G. Duke.

Study for the wind god in the ceiling fresco of the Sala di Apollo.

ARTIST: Pietro da Cortona.

LIT.: *Drawings by Old Masters, Royal Academy of Arts*, London, 1953, 42, No. 151; J. Bean, *Metropolitan Museum of Art Bulletin*, Jan. 1962, 159 and Fig. 2; Briganti, 307 and Pl. 287, No. 53; Vitzthum, "Review," 50; J. Bean, *100 European Drawings at the Metropolitan Museum of Art*, New York, 1964, No. 33; Campbell, 20, n. 2; Stampfle-Bean, 50f., No. 64 (Fig. 64).

99. Rome, Gabinetto Nazionale delle Stampe, Fondo Corsini, Inv. No. 124347. [Fig. 80(r); Fig. 78(v)]

Group of female figures (recto); head and torso of a youthful male (verso). 262 x 360 mm. Black and red chalk (recto); black chalk (verso).

Recto: Preparatory studies for female allegorical figures in the ceiling fresco of the Sala di Apollo.

Verso: Figure study for wind god in the ceiling fresco of the Sala di Apollo.

ARTIST: Ciro Ferri.

LIT.: Campbell, 20, n. 2; Vitzthum, *Blunt*, 115, under No. 39a.

100. Rome, Private Collection [?].

Two female figures. 84 x 174 mm. Chalk and ochre. Probably once in the collections of Queen Christina of Sweden, Cardinal Azzolino, and Don Livio Odescalchi.

Study for female allegorical figures in the ceiling fresco of the Sala di Apollo.

ARTIST: Pietro da Cortona.

LIT.: Vitzthum, *Blunt*, 115, No. 39a (published as in the collection of John Hardings, New York).

101. Rome, Private Collection [?]. [Fig. 81]

Group of cloud-borne figures. 97 x 142 mm. Pen and bister over black chalk. Probably once in the collections of Queen Christina of Sweden, Cardinal Azzolino, and Don Livio Odescalchi.

Study for a group of female allegorical figures in the ceiling fresco in the Sala di Apollo.

ARTIST: Ciro Ferri.

LIT.: Vitzthum, *Blunt*, 113, No. 3b (published as in the collection of John Hardings, New York).

102. Rome, Private Collection [?]. [Fig. 77]

Figure studies. 130 x 93 mm. Pen and ink. Probably once in the collections of Queen Christina of Sweden, Cardinal Azzolino, and Don Livio Odescalchi.

Studies for the wind god in the ceiling fresco of the Sala di Apollo.

ARTIST: Pietro da Cortona.

LIT.: Vitzthum, *Blunt*, 115, No. 26b (published as in the collection of John Hardings, New York).

PENDENTIVE FRESCOES

COMPOSITION STUDIES

103. Edinburgh, Keith Andrews
Collection. [Fig. 82]

157 x 190 mm. Pen and brown ink.

Study for a pendentive fresco in the Sala di Apollo. Probably to be associated with *Calliope and Melpomene*, although the figures also resemble (reversed) the composition of the pendentive depicting *Thalia and Clio*.

ARTIST: Pietro da Cortona.

LIT.: Vitzthum, "Drawings," 525 (Fig. 38).

FIGURE STUDIES

104. Rome, Private Collection [?].
[Fig. 83]

Female figure. 266 x 240 mm. Black chalk, heightened in white. Probably once in the collections of Queen Christina, Cardinal Azzolino, and Don Livio Odescalchi.

Study for figure of Calliope who appears in one of the spandrels in the Sala di Apollo.

ARTIST: Pietro da Cortona.

LIT.: Vitzthum, "Drawings," 525f. and Fig. 41; Vitzthum, *Blunt*, 116, No. 61 (published as in the collection of John Hardings, New York).

LUNETTE FRESCOES

Augustus Caesar

COMPOSITION STUDIES

105. New York, Cooper-Hewitt
Museum of Decorative Arts and Design,
Inv. No. 1938-88-6563. [Fig. 84]

62 x 90 mm. Pen and brown ink with brown wash. Black ink border apparently later addition.

Study for the *Augustus Caesar* lunette in the Sala di Apollo.

ARTIST: Pietro da Cortona.

LIT.: Vitzthum, *Blunt*, 114, under Nos. 10a, b, and c.

FIGURE STUDIES

106. Paris, Louvre, Inv. No. 541.
[Fig. 85]

Seated male figure. 329 x 238 mm. Black chalk, heightened with white, on grey paper. Collection stamp of Robert Strange [?] (Lugt, No. 2239) appears in lower right corner. Inscribed in ink in the upper margin, *21*, in the lower right: *vertuno*, and in the upper left corner in pencil: *Pietro da Cortona*.

Study for the figure of Augustus in the *Augustus Caesar* lunette.

ARTIST: Pietro da Cortona.

LIT.: Briganti, 316 and Fig. 235; Campbell, 70, under No. 74.

Julius Caesar

COMPOSITION STUDIES

107. Darmstadt, Hessisches
Landesmuseum, Inv. No. AE 1694.
[Fig. 87]

282 x 205 mm. Black chalk, heightened in white. Collections: Mariette (Lugt, No. 1852); Dalberg (Lugt, No. 1257 supp.).

Composition study for the *Julius Caesar* lunette in the Sala di Apollo.

ARTIST: Ciro Ferri.

LIT.: Vitzthum, "Drawings," 525.

FIGURE STUDIES

108. Florence, Uffizi, Inv. No. 11706F.
[Fig. 88]

Male figure. 386 x 230 mm. Black chalk, heightened with white, on grey paper.

Study for the elderly man in the *Julius Caesar* lunette.

ARTIST: Pietro da Cortona.

LIT.: Briganti, 293; Campbell, 70, No. 74 (Fig. 52).

Justinian

COMPOSITION STUDIES

109. Florence, Uffizi, Inv. No. 11730F.
[Fig. 71]

190 x 235 mm. Pen and brown ink. Possibly a study for the *Justinian* lunette in the Sala di Apollo.

ARTIST: Pietro da Cortona.

LIT.: Briganti, 295; Vitzthum, *Blunt*, 114, under No. 10c.

110. Rome, Private Collection [?].

130 x 181 mm. Black chalk over pen and ink. Probably once in the collections of Queen Christina of Sweden, Cardinal Azzolino, and Don Livio Odescalchi.

Composition study for the Justinian lunette in the Sala di Apollo.

ARTIST: Ciro Ferri.

LIT.: Vitzthum, *Blunt*, 114, No. 10c (published as in the collection of John Hardings, New York).

111. Rome, Private Collection [?].

79 x 56 mm. Pen and brown ink. Probably once in the collections of Queen Christina of Sweden, Cardinal Azzolino, and Don Livio Odescalchi.

Composition study for the *Justinian* lunette in the Sala di Apollo.

ARTIST: Ciro Ferri.

LIT.: Vitzthum, *Blunt*, 114, No. 10a (published as in the collection of John Hardings, New York).

112. Rome, Private Collection [?].

91 x 130 mm. Pen and brown ink over black chalk. Probably once in the collections of Queen Christina of Sweden, Cardinal Azzolino, and Don Livio Odescalchi.

Composition study for the *Justinian* lunette in the Sala di Apollo.

ARTIST: Ciro Ferri.

LIT.: Vitzthum, *Blunt*, 114, No. 10b (published as in the collection of John Hardings, New York).

113. Rome, Private Collection [?].

174 x 158 mm. Pen and ink. Probably once in the collections of Queen Christina of Sweden, Cardinal Azzolino, and Don Livio Odescalchi.

Composition study for the *Justinian* lunette in the Sala di Apollo.

ARTIST: Ciro Ferri.

LIT.: Vitzthum, *Blunt*, 114, No. 24 (published as in the collection of John Hardings, New York).

114. Rome, Private Collection [?].

98 x 156 mm. Pen and ink. Probably once in the collections of Queen Christina of Sweden, Cardinal Azzolino, and Don Livio Odescalchi.

Composition study for the *Justinian* lunette in the Sala di Apollo.

ARTIST: Ciro Ferri.

LIT.: Vitzthum, *Blunt*, 115, No. 30a (published as in the collection of John Hardings, New York).

115. Rome, Private Collection [?].
[Fig. 86]

183 x 200 mm. Pen and ink. Probably once in the collections of Queen Christina of Sweden, Cardinal Azzolino, and Don Livio Odescalchi.

Composition study for the *Justinian* lunette in the Sala di Apollo.

ARTIST: Ciro Ferri.

LIT.: Vitzthum, *Blunt*, 116, No. 59 (Fig. 6) (published as in the collection of John Hardings, New York).

FIGURE STUDIES

116. Rome, Gabinetto Nazionale delle Stampe, Fondo Corsini, Inv. No. 125687.

270 x 355 mm. Black chalk, heightened with white.

Study for figure on far left in *Justinian* lunette.

ARTIST: Ciro Ferri.

LIT.: Briganti, 319, Pl. 286, No. 55.

Drawings for the Sala di Marte

CEILING FRESCO

COMPOSITION STUDIES

117. Florence, Uffizi, Inv. No. 11735F.
[Fig. 92]

245 x 372 mm. Pen, brown ink. Inscribed on recto (but barely visible), *saturno*, and on the verso, *Di Pietro da Cortona*.

Early study for a portion of the ceiling of the Sala di Marte.

ARTIST: Pietro da Cortona.

LIT.: Briganti, 296; Vitzthum, "Review," 49; Campbell, 61, No. 59 (Fig. 42).

118. Florence, Uffizi, Inv. No. 15277F.
[Fig. 93]

Group of figures. 182 x 272 mm. Black chalk. Inscribed in lower left margin: *Pietro da Cortona*. Study for a section of the ceiling of the Sala di Marte.

ARTIST: Pietro da Cortona.

LIT.: Briganti, 300; Vitzthum, "Review," 50; Campbell, 61f., No. 60 (Fig. 43).

119. London, British Museum, Inv. No. 1954-2-13-2.
[Fig. 91]

282 x 430 mm. Black chalk. Inscribed on the verso: *Pietro da Cortona*. Collections: Hudson (Lugt, No. 2432); Reynolds (Lugt, No. 2364); Wyatsville; Knapp; Moore.

Preparatory study for a section of the ceiling fresco of the Sala di Marte.

ARTIST: Pietro da Cortona.

LIT.: Campbell, 61, under No. 59; Vitzthum, "Drawings," 525 (Fig. 46).

FIGURE STUDIES

120. Florence, Uffizi, Inv. No. 833 Orn.

Horse. 154 x 273 mm. Black chalk.

279

Study for the horse of one of the Dioscuri in the ceiling of the Sala di Marte.

ARTIST: Pietro da Cortona.

LIT.: Briganti, 301 and Fig. 287, No. 43; Vitz-thum, "Review," 50; Campbell, 63, No. 62.

121. Florence, Uffizi, Inv. No. 11684F.

Male figure. 275 x 258 mm. Red chalk.

Study for the warrior with a trumpet in the ceiling of the Sala di Marte.

ARTIST: Pietro da Cortona.

LIT.: Briganti, 291; Campbell, 64, No. 66 (Fig. 44).

122. Florence, Uffizi, Inv. No. 11690F.

Male head (recto); right leg (verso). 396 x 257 mm. Black chalk, heightened with white (recto), on grey paper. Inscribed, on recto in upper margin, *6*, and on verso in upper right margin, *5*.

Recto: Study for Hercules in the ceiling of the Sala di Marte. (See also Cat. Nos. 130 and 131.)

Verso: Not associable with any specific figure in the Pitti Palace decorations.

ARTIST: Pietro da Cortona.

LIT.: Briganti, 292; Vitzthum, "Review," 49; Campbell, 63f., No. 64.

123. Florence, Uffizi, Inv. No. 11698F.

Genuflecting figure. 385 x 254 mm. Black chalk, heightened with white, on grey paper. Inscribed in bister on upper margin, *6*.

Study for one of the defeated soldiers in the ceiling of the Sala di Marte.

ARTIST: Pietro da Cortona.

LIT.: Briganti, 292; Campbell, 64, No. 65.

124. Florence, Uffizi, Inv. No. 11715F.

Male torso. 398 x 260 mm. Black chalk, height-ened with white, on grey paper. Inscribed in bister in lower right margin, *71*.

Study for an oarsman in the ceiling of the Sala di Marte. (See also Cat. Nos. 125-127.)

ARTIST: Pietro da Cortona.

LIT.: Briganti, 294; Vitzthum, "Review," 49; Campbell, 63, No. 63.

125. Florence, Uffizi, Inv. No. 11716F.

Male torso. 260 x 400 mm. Black chalk, traces of white, on grey paper.

Study for an oarsman in the ceiling of the Sala di Marte. (See also Cat. Nos. 124, 126 and 127.)

ARTIST: Pietro da Cortona.

LIT.: Briganti, 294; Campbell, 63, No. 61 (Fig. 45).

126. Paris, Private Collection. [Fig. 196]

Male figure. 241 x 242 mm. Black chalk on grey paper.

Study for an oarsman in the ceiling of the Sala di Marte. (See also Cat. Nos. 124, 125 and 127.)

ARTIST: Pietro da Cortona.

LIT.: Unpublished.

127. Paris, Private Collection. [Fig. 197]

Male figure. 240 x 332 mm. Black chalk on grey paper.

Study for an oarsman in the ceiling of the Sala di Marte. (See also Cat. Nos. 124-126.)

ARTIST: Pietro da Cortona.

LIT.: Unpublished.

128. Paris, Private Collection. [Fig. 198]

Male figure. 410 x 252 mm. Black chalk on grey paper.

Study for an oarsman in the ceiling of the Sala di Marte.

ARTIST: Pietro da Cortona.

LIT.: Unpublished.

129. Paris, Private Collection. [Fig. 199]

Female figure. 541 x 396 mm. Black chalk on grey paper.

Study for the figure (probably an allegory of Peace) located to the right of Justice in the ceiling of the Sala di Marte.

ARTIST: Pietro da Cortona.

LIT.: Unpublished.

130. Paris, Private Collection. [Fig. 200]

Male figure. 454 x 383 mm. Black chalk on grey paper.

Study for the figure of Hercules in the ceiling

of the Sala di Marte. (See also Cat. Nos. 122 and 131.)

ARTIST: Pietro da Cortona.

LIT.: Unpublished.

131. Paris, Private Collection. [Fig. 201]

Male figure. 498 x 428 mm. Black chalk on grey paper.

Study for Hercules in the ceiling of the Sala di Marte. (See also Cat. Nos. 122 and 130.)

ARTIST: Pietro da Cortona.

LIT.: Unpublished.

132. Paris, Private Collection. [Fig. 202]

Male figure. 380 x 266 mm. Black chalk, heightened with white.

Study for one of the bearded prisoners who, wearing chains, gestures in supplication toward Justice and Peace in the ceiling of the Sala di Marte.

ARTIST: Pietro da Cortona.

LIT.: Unpublished.

Drawings for the Sala di Giove

ARCHITECTURAL DECORATIONS

133. Florence, Uffizi, Inv. No. 19 Orn.
 [Fig. 98]

Architectural decoration for a vault. 242 x 316 mm. Pen and ink, black chalk. Inscribed in bister on verso, *Cortona*.

Probably an early study for the stucco decorations in the Sala di Giove.

ARTIST: Pietro da Cortona.

LIT.: P. N. Ferri, *Catalogo . . . di disegni . . . posseduta dalla R. Galleria degli Uffizi . . . ,*

Rome, 1890, 184; Briganti, 301; Vitzthum, "Review," 50; Campbell, 55f., No. 54 (Fig. 39).

CEILING FRESCO

FIGURE STUDIES

134. Stockholm, National Museum, Inv. No. 170/1969. [Fig. 107]

Group of figures. 318 x 461 mm. Black chalk inscribed in ink, *19*, on verso where *Baccio Carpi* and *Andrea Comodi* also appear. Formerly in the collections of Sir Joshua Reynolds

(Lugt, No. 2364) and Sir John Charles Robinson (Lugt, No. 1433).

Study for figures in the ceiling fresco in the Sala di Giove.

ARTIST: Pietro da Cortona.

LIT.: "Anticipazioni," *Antichità Viva*, VIII, No. 4, 1968, 61.

134a. Düsseldorf, Kunstmuseum, Inv. No. FP7902.

Air-borne figure. 207 x 316 mm. Black chalk, heightened with white, on grey-brown paper. Inscribed in black ink *16* and *seideci* on recto and, on verso, in lead pencil *p. da Cortona* with stamp: *FP*.

Study for the figure holding star above the head of Jupiter in the Sala di Giove, here identified as Ganymede, but considered by Briganti, Schaar and Graf, apparently following Fabbrini (*Vita del Cav. Pietro Berrettini da Cortona...*, Cortona, 1896, 82f.), to represent Apollo.

ARTIST: Pietro da Cortona.

LIT.: E. Schaar and D. Graf, *Meisterzeichnungen der Sammlung Lambert Krahre, Kunstmuseum Düsseldorf*, Düsseldorf, 1969, No. 49, Fig. 50; D. Graf, *Master Drawings of the Roman Baroque from the Kunstmuseum Düsseldorf*, London and Edinburgh, 1973, No. 37 (ill.).

135. Florence, Uffizi, Inv. No. 11682F.

Male figure. 344 x 220 mm. Black chalk on grey paper.

Study for the Hercules in the ceiling of the Sala di Giove.

ARTIST: Pietro da Cortona.

LIT.: Briganti, 291; Campbell, 56, No. 56.

136. Florence, Uffizi, Inv. No. 11695F. (See Cat. No. 5.)

137. Florence, Uffizi, Inv. No. 11697F.

Putto. 400 x 260 mm. Black chalk, heightened with white.

Study for a *putto* who carries arms to Victory in the ceiling of the Sala di Giove.

ARTIST: Pietro da Cortona.

LIT.: Briganti, 292; Campbell, 56, under No. 57.

138. Florence, Uffizi, Inv. No. 11702F.

Female in a seated position. 390 x 260 mm. Black chalk, heightened with white, on grey paper.

Study for the figure of Victory in the ceiling of the Sala di Giove.

ARTIST: Pietro da Cortona.

LIT.: Briganti, 293; Campbell, 57, No. 58 (Fig. 41).

139. Florence, Uffizi, Inv. No. 11741F.

Putto. 391 x 259 mm. Black chalk, heightened with white, on grey paper. Inscribed in bister in upper right margin, *60*.

Study for the *putto* who carries a crown to Jupiter in the ceiling of the Sala di Giove.

ARTIST: Pietro da Cortona.

LIT.: Briganti, 296; Campbell, 56, No. 57.

140. Florence, Uffizi, Inv. No. 11747F.

Air-borne male figure. 243 x 367 mm. Black chalk, heightened with white, on grey paper.

Study for the Ganymede in the ceiling of the Sala di Giove.

ARTIST: Pietro da Cortona.

LIT.: Briganti, 297; Vitzthum, "Review," 50; Campbell, 56, No. 55 (Fig. 40).

LUNETTE FRESCOES

Apollo

FIGURE STUDIES

141. Paris, Louvre, Inv. No. 497.

Head of a male youth. 162 x 184 mm. Black chalk.

Study for head of Apollo for his lunette in the Sala di Giove.

ARTIST: Pietro da Cortona.

LIT.: Briganti, 314; Pl. 288, No. 54.

Diana

FIGURE STUDIES

142. Rome, Private Collection [?].

Figure studies. 122 x 112 mm. Pen and ink over black chalk. Probably once in the collections of Queen Christina of Sweden, Cardinal Azzolino, and Don Livio Odescalchi.

Figure studies for the figure of Diana in a lunette in the Sala di Giove.

ARTIST: Pietro da Cortona.

LIT.: Vitzthum, *Blunt*, 114, No. 23a (Fig. 4) (published as in the collection of John Hardings, New York).

Castor and Pollux

COMPOSITION STUDIES

143. Düsseldorf, Kunstmuseum, Inv. No. 387.

Two air-borne figures and two horses. 86 x 134 mm. Pen and ink. Inscribed with a 73 in upper right and in lower right with *settantatre*.

Study for a lunette in the Sala di Giove depicting the Dioscuri and their horses.

ARTIST: Pietro da Cortona.

LIT.: M. Chiarini and K. Noehles, "Pietro da Cortona a Palazzo Pitti: un episodio ritrovato," *Bollettino d'arte*, LII, No. 4, Oct.-Dec. 1967, 237, n. 17 and Fig. 123; Vitzthum, *Blunt*, 114, under No. 23a; D. Graf, *Master Drawings of the Roman Baroque from the Kunstmuseum Düsseldorf*, London and Edinburgh, 1973, No. 38 (ill.).

Drawings for the Sala di Saturno

ARCHITECTURAL DECORATIONS

144. Berlin, Kunstbibliothek, Inv. No. 4609. [Fig. 120]

Architectural decorations. 371 x 247 mm. Pen and ink, brown wash over black chalk.

Study for the stucco ornamentation in the ceiling of the Sala di Saturno.

ARTIST: Pietro da Cortona.

LIT.: Vitzthum, "Drawings," 525 (Fig. 45).

145. Hamburg, Kunsthalle, Inv. No. 1925/48. [Fig. 118]

Architectural decorations. 160 x 250 mm. Pen and ink over black chalk. On the recto appears the word *aria* and on the verso, *Pietro da Cortona*, inscribed twice.

Study for the stucco ornamentation in the ceiling of the Sala di Saturno.

ARTIST: Pietro da Cortona.

LIT.: Unpublished.

146. Rome, Private Collection [?].

Cartouche. 94 x 160 mm. Pen and ink over chalk. Probably once in the collections of Queen Christina of Sweden, Cardinal Azzolino, and Don Livio Odescalchi.

Study for a proposed decorative stucco cartouche in the Sala di Saturno.

ARTIST: Pietro da Cortona.

LIT.: Vitzthum, *Blunt*, 115, No. 34a (published as in the collection of John Hardings, New York).

147. Windsor Castle, Royal Library, Inv. No. 4446. [Fig. 119]

Ceiling decoration. 332 x 449 mm. Pen and brown ink, brown and grey washes over black chalk.

Preparatory study for the ornamental decorations in the ceiling of the Sala di Saturno.

ARTIST: Pietro da Cortona.

LIT.: Briganti, 327; A. Blunt and H. L. Cooke, *The Roman Baroque Drawings of the XVII and XVIII Centuries in the Collection of Her Majesty the Queen at Windsor Castle*, London, 1960, 76, No. 589; Vitzthum, "Review," 51; Vitzthum, "Drawings," 525.

CEILING FRESCO

COMPOSITION STUDIES

148. Rome, Gabinetto Nazionale delle Stampe, Fondo Corsini, Inv. No. 124348. [Fig. 126]

Composition study (recto); two figure studies (verso). 295 x 390 mm. Red and chalk (recto); black chalk (verso).

Recto: Composition study for the ceiling fresco in the Sala di Saturno.

Verso: Apparently not connected with the Planetary Rooms.

ARTIST: Ciro Ferri.

LIT.: Vitzthum, *Blunt*, 116, under No. 73.

149. Rome, Gabinetto Nazionale delle Stampe, Fondo Corsini, Inv. No. 125711. [Fig. 127]

Composition study (recto); indeterminate architectural sketch (verso). 415 x 274 mm. Red chalk.

Recto: Composition study for the ceiling fresco of the Sala di Saturno.

Verso: Architectural sketch appears to be an ornamental archway and has no apparent connection with the Planetary Rooms.

ARTIST: Ciro Ferri.

LIT.: Vitzthum, *Blunt*, 116, under No. 73.

150. Rome, Private Collection [?]. [Fig. 125]

130 x 100 mm. Pen and ink. Inscribed: *Ciro Ferri*. Probably once in the collections of Queen Christina of Sweden, Cardinal Azzolino, and Don Livio Odescalchi.

Composition study for the ceiling fresco in the Sala di Saturno.

ARTIST: Ciro Ferri.

LIT.: Vitzthum, *Blunt*, 116, No. 63a (published as in the collection of John Hardings (New York).

151. Rome, Private Collection [?].

222 x 167 mm. Black chalk. Probably from the collections of Queen Christina of Sweden, Cardinal Azzolino, and Don Livio Odescalchi.

Composition study for the ceiling fresco in the Sala di Saturno.

ARTIST: Ciro Ferri.

LIT.: Vitzthum, *Blunt*, 116, No. 73 (published as in the collection of John Hardings, New York).

FIGURE STUDIES

152. Paris, Louvre, Inv. No. 488.

Female figure. 308 x 249 mm. Black chalk.

Study for a female figure in the ceiling of the Sala di Saturno.

ARTIST: Ciro Ferri.

LIT.: Briganti, 313; Vitzthum, "Review," 50; Campbell, 20 (as in Ashmolean Museum); Vitzthum, "Drawings," 525.

LUNETTES
Cyrus

COMPOSITION STUDIES

153. Florence, Uffizi, Inv. No. 9604S.
[Fig. 132]

Tondo composition. 245 x 222 mm. Red chalk, heightened with white. Santarelli Collection stamp appears in lower right corner, and also in the lower right, *Chiro ferri Romano*.

Study for the lunette depicting *Cyrus Watering an Orange Tree* in the Sala di Saturno.

ARTIST: Ciro Ferri.

LIT.: A. Gotti, *Catalogo della . . . raccolta di designi . . . Santarelli*, Florence, 1870, 653, No. 6; Campbell, 19, n. 3.

154. Rome, Private Collection [?].

145 x 143 mm. Chalk. Probably once in the collections of Queen Christina of Sweden, Cardinal Azzolino, and Don Livio Odescalchi.

Study for the *Cyrus* lunette in the Sala di Saturno.

ARTIST: Ciro Ferri.

LIT.: Vitzthum, *Blunt*, 115, No. 42 (published as in the collection of John Hardings, New York).

Sulla

COMPOSITION STUDIES

155. Darmstadt, Hessisches Landesmuseum, Inv. No. AE1688.
[Fig. 133]

217 x 330 mm. Black chalk. Collections: Lagoy, Mariette (Lugt, No. 1852) and Dalberg (Lugt, No. 1257 supp.). Inscribed in ink in the lower margin, *Di P.o da Cortona dipinto nel Palazo* [sic] *dei Pitti*.

This study is for the lunette depicting a scene from the life of Sulla in the Sala di Saturno.

ARTIST: Ciro Ferri.

LIT.: Campbell, 19f., n. 3.

Scipio

COMPOSITION STUDIES

156. Rome, Private Collection [?].
140 x 140 mm. Chalk. Probably once in the collections of Queen Christina of Sweden, Cardinal Azzolino, and Don Livio Odescalchi.

Composition study for the *Scipio* lunette in the Sala di Saturno.

ARTIST: Ciro Ferri.

LIT.: Vitzthum, *Blunt*, 115, No. 51 (published as in the collection of John Hardings, New York).

Miscellaneous Drawings Probably Associated with the Pitti Palace Decorations

157. Berlin, Staatliches Museum, Inv. No. 23900. [Fig. 134]

Throne enframement. 232 x 181 mm. Pen and ink over black chalk.

Probably a study for a projected throne in the Sala di Saturno.

ARTIST: Ciro Ferri.

LIT.: P. Dreyer, *Römische Barockzeichnungen*, Exhibition Catalogue, Staatlich Museum, Berlin-Dahlem, 1969, 35f., No. 72 (Pl. 35).

158. Florence, Uffizi, Inv. No. 11691F.

Woman suckling an infant (recto and verso). 398 x 252 mm. Black chalk, heightened with white, on grey paper. Inscribed in bister in upper left margin, *3.*

Recto and verso: Possibly studies for a figure in an early stage in the *Ages of Gold* or *Silver*.

ARTIST: Pietro da Cortona.

LIT.: Briganti, 292; Campbell, 73, No. 75.

159. Florence, Uffizi, Inv. No. 11681F.

Putto. 400 x 260 mm. Black chalk, heightened with white, on grey paper.

This drawing cannot be associated with a specific figure in the decorations.

ARTIST: Pietro da Cortona.

LIT.: Briganti, 291; Campbell, 73, under No. 75.

160. Florence, Uffizi, Inv. No. 11687F.

Drapery study. 400 x 225 mm. Black chalk, heightened with white, on grey paper.

This drawing cannot be associated with a specific scene in the decorations.

ARTIST: Pietro da Cortona.

LIT.: Briganti, 291; Campbell, 73, under No. 75.

161. Florence, Uffizi, Inv. No. 11694F.

Drapery study. 400 x 260 mm. Black chalk, heightened with white, on grey paper.

This drawing cannot be associated with a specific scene in the decorations.

ARTIST: Pietro da Cortona.

LIT.: Briganti, 292; Campbell, 73, under No. 75.

162. Florence, Uffizi, Inv. No. 11696F.

Drapery study. 400 x 250 mm. Black chalk, heightened with white, on grey paper.

This drawing cannot be associated with a specific scene in the decorations.

ARTIST: Pietro da Cortona.

LIT.: Briganti, 292; Campbell, 73, under No. 75.

163. Florence, Uffizi, Inv. No. 11700F.

Drapery study. 395 x 250 mm. Black chalk, heightened with white, on grey paper.

This drawing cannot be associated with a specific scene in the decorations.

ARTIST: Pietro da Cortona.

LIT.: Briganti, 293; Campbell, 73, under No. 75.

164. Florence, Uffizi, Inv. No. 11705F.

Drapery study. 398 x 255 mm. Black chalk, heightened with white, on grey paper.

This drawing cannot be associated with a specific scene in the decorations.

ARTIST: Pietro da Cortona.

LIT.: Briganti, 293; Campbell, 73, under No. 75.

165. Florence, Uffizi, Inv. No. 11722F.

Drapery study. 390 x 258 mm. Black chalk, heightened with white, on grey paper.

This drawing cannot be associated with a specific scene in the decorations.

ARTIST: Pietro da Cortona.

LIT.: Briganti, 295; Campbell, 73, under No. 75.

166. Florence, Uffizi, Inv. No. 11723F.

Drapery study. 390 x 258 mm. Black chalk, heightened with white, on grey paper.

This drawing cannot be associated with a specific scene in the decorations.

ARTIST: Pietro da Cortona.

LIT.: Briganti, 295; Campbell, 73, under No. 75.

167. Florence, Uffizi, Inv. No. 11736F.

Female head seen in profile. 240 x 180 mm. Black chalk, heightened with white, on grey paper.

This drawing cannot be associated with a specific figure in the decorations.

ARTIST: Pietro da Cortona.

LIT.: Briganti, 296; Campbell, 73, under No. 75.

168. Florence, Uffizi, Inv. No. 11729F.

Female figure. 400 x 263 mm. Black chalk, heightened with white, on grey paper.

Possibly this study is to be connected with either a similarly posed young woman in the *Age of Silver* or with the one who distributes money to the populace in the ceiling fresco of the Sala di Marte.

ARTIST: Pietro da Cortona.

LIT.: Briganti, 295 and Fig. 287, No. 45; Campbell, 73, No. 76 (Fig. 53).

169. Florence, Uffizi, Inv. No. 11751F.

Head of a young female. 361 x 246 mm. Black chalk, heightened with white, on grey paper.

This drawing cannot be associated with a specific figure in the frescoes.

ARTIST: Pietro da Cortona.

LIT.: Briganti, 297 and Fig. 287, No. 48; Campbell, 74, No. 77.

170. Rome, Private Collection [?].

Figure studies. 144 x 183 mm. Pen and ink. Probably once in the collections of Queen Christina of Sweden, Cardinal Azzolino and Don Livio Odescalchi.

Figure studies close to figures in the frescoes in the Sala di Apollo.

ARTIST: Ciro Ferri.

LIT.: Vitzthum, *Blunt*, 114, No. 21a (published as in the collection of John Hardings, New York).

Selected Bibliography

Important References to Pietro da Cortona, the Pitti Palace Decorations
or the Medici Court

ICONOGRAPHIC SOURCES

Alciati, A., *Emblemata cum commentariis amplissimis*, Padua, 1621.

Bardi, F., *Descrizione delle feste fatte in Firenze per le reali nozze de Serenissimi Sposi Ferdinando II Gran Duca di Toscana e Vittoria della Rovere Principessa d'Urbino*, Florence, 1637.

Catari, V., *Imagini delli Dei de' Antichi*, Venice, 1674.

Giovio, P., *Dialogo dell'imprese militari et amorose di Monsignor Giovio*, Lyon, 1574.

Lomazzo, G. P., *Trattato dell' arte della pittura, scultura, et architettura*, Milan, 1585.

Pigler, A., *Barockthemen*, 2 vols., Budapest, 1956.

Ripa, C., *Nova Iconologia*, Padua, 1618.

Valeriano Bolzani, G. P., *Hieroglyphica sive De Sacris Aegyptiorum*, Lyons, 1610.

Veen, O. van, *Q. Horati Flacci Emblemata*, Antwerp, 1607.

DOCUMENTARY SOURCES

Bottari, G., *Raccolta di lettere sulla pittura, scultura ed architettura scritte da' più personaggi dei secoli XV, XVI, e XVII*, Milan, 1822-1825.

Campori, G., *Lettere artistiche inedite*, Modena, 1866.

Geisenheimer, H., *Pietro da Cortona e gli affreschi nel Palazzo Pitti*, Florence, 1909.

Gualandi, M., *Memorie originali risguardanti le belle arte*, Bologna, 1840.

Guasti, C., *Le carte strozziane del r. archivio di stato in Firenze*, Florence, 1884.

Pollak, O., "Italienische Künstlerbriefe aus der Barockzeit," *Jahrbuch der Königlich Preuszischen Kunstsammlungen*, XXXIV, 1913, pp. 1-77.

PRIMARY LITERATURE

Baglione, G., *Le Vite de' pittori, scultori, et architetti dal pontificato di Gregorio XIII del 1572 in fino a' tempi di Papa Urbano Ottavio nel 1642*, Rome, 1642.

Baldinucci, F., *Notizie de' professori del disegno da cimabue in qua . . .* , Florence, 1728 and 1846.

————, *Vocabolario Toscana dell'arte del disegno*, Florence, 1681.

Bellori, G. P., *Admiranda romanarum antiquitatum . . .* , Rome, 1693.

Bianchini, G., *Dei Gran Duchi di Toscana della reale casa di Medici . . .* , Venice, 1741.

Bocchi, F., and Cinelli, G., *Le Bellezze della città di Firenze*, Florence, 1677.

Boschini, M., *La Carta del navegar pitoresco* (first published 1660), A. Pallucchini, ed., Venice, 1966.

Selected Bibliography

Cambiagi, G., *Descrizione dell'imperiale giardino di Boboli*, Florence, 1757.

Carlieri, J., *Ristretto delle cose più notabili della città di Firenze*, Florence, 1689.

Coppola, G. C., *Le Nozze degli Dei*, Florence, 1637.

Costa, M., *Flora fecunda*, Florence, 1640.

————, *Istoria del viaggio d'Alemagna del Serenissimo Gran Duca di Toscana Ferdinando Secondo*, Venice, n.d.

————, *Per l'incendio de' Pitti*, Florence, 1638.

Félibien, A., *Entretiens sur les vies et sur les ouvrages des plus excellens peintres anciens et modernes avec la vie des architects*, Paris, 1666-1688.

Galeazzo, G., *Relatione della città di Fiorenza e del Gran Ducato di Toscana*, Florence, 1668.

Gigli, G., *Diario Romano, 1608-1670*, G. Ricciotti, ed., Rome, 1958.

Heroicae Virtutis Imagines quas eques Petrus Berrettinus Cortonensis Pinxit Florentiae in aedibus Sereniss. Magni Ducis Hetruriae in Tribus Cameris Ioves, Martis, et Veneris . . . , Rome, 1691.

Minozzi, P. F., *La Musa vezzegiante nelle nozze del Serenissimo Gran Duca di Toscana Ferdinando II e della Serenissima Vittoria della Rovere. Epitalmio*, Pisa, 1636.

Monconys, B. de, *Journal des voyages de Monsieur de Monconys . . .* , Lyon, 1665.

Pascoli, L., *Vite de' pittori, scultori, ed architetti . . .* , Rome, 1730.

Passeri, G. B., *Vite dei pittori, scultore, e architetti . . .* , Rome, 1772 (edited by J. Hess as *Die Kunstlerbiographien von Giovanni Battista Passeri*, Leipzig, 1934).

Petrioli, G., and Berrettini da Cortona, P., *Tabulae Anatomicae*, Rome, 1741.

Rimbaldesi, G., *Iovis Medicae . . .* , Rome, 1664.

Rondinelli, F., *Relazione delle nozze degli Dei, favola dell'Abate Gio: Carlo Coppola . . . ,* Florence, 1637.

Samek Ludovici, S., "Le 'Vite' de F. S. Baldinucci (Pietro Berrettini detto da Cortona)," *Archivi*, XVII, No. 1, 1950, pp. 77-91.

Soldani, F. M., *Il Reale giardino di Boboli*, Florence, 1789.

Tessin, N., *Studieresor, 1687-1688*, O. Sirén, ed., Stockholm, 1914.

BOOKS AND CATALOGUES

Blunt, A., *Art and Architecture in France: 1500-1700*, Harmondsworth, 1957.

Blunt, A., and Cooke, H. L., *The Roman Drawings of the XVII and XVIII Centuries in the Collection of Her Majesty the Queen at Windsor Castle*, London, 1960.

Briganti, G., *Pietro da Cortona o della pittura barocca*, Florence, 1962.

Campbell, M., *Mostra di disegni di Pietro Berrettini da Cortona per gli affreschi di Palazzo Pitti*, Florence, 1965.

Chiarelli, R., *La Galleria Palatina a Firenze*, Rome, 1956.

Chiarini, M., *Artisti alla corte granducale, mostra*, Florence, 1969.

Ciaranfi, A., *The Pitti Gallery*, Eng. trans., Florence, 1957.

Cipriani, N., *La Galleria Palatina nel Palazzo Pitti a Firenze*, Florence, 1966.

Conti, C., *Ricerche storiche sull'arte degli Arazzi in Firenze*, Florence, 1875.

Dubon, D., *Tapestries from the Samuel H. Kress Collection at the Philadelphia Museum of Art. The History of Constantine the Great Designed by Peter Paul Rubens and Pietro da Cortona*, London, 1964.

Fabbrini, N., *Vita del Cav. Pietro Berrettini da Cortona pittore ed architetto*, Cortona, 1896.

Feinblatt, E., *Agostino Mitelli Drawings: Loan Exhibition from the Kunstbibliothek, Berlin*, Los Angeles, 1965.

Forcella, V., *Inscrizione delle chiese . . . di Roma*, Rome, 1874.

Galluzzi, R., *Istoria del granducato di Toscana sotto il governo della casa Medici*, Florence, 1781 and 1823.

Giglioli, O. H., *Giovanni da San Giovanni (Giovanni Mannozzi: 1592-1636)*, Florence, 1949.

Golzio, V., *Il seicento e il settecento*, Turin, 1950.

Gregori, M., *70 pitture e sculture del '600 e '700 Fiorentino*, Florence, 1965.

Haskell, F., *Patrons and Painters*, London, 1963.

Hibbard, H., and Nissman, J., *Florentine Baroque Art From American Collections*, New York, 1969.

Inghirami, F., *Descrizione dell'Imp. E. R. Palazzo Pitti di Firenze*, Florence, 1819.

Lankheit, K., *Florentinische Barockplastik die kunst am hofe der letzten Medici, 1670-1743*, Munich, 1962.

Levin, H., *The Myth of the Golden Age in the Renaissance*, London, 1969.

Limentani, U., *La Satira nel seicento*, Milan, 1961.

Litta, P., *Famiglie celebri italiane*, Milan, n.d.

Marabottini, A., and Bianchi, L., *Mostra di Pietro da Cortona*, Rome, 1956.

Martin, J. R., *The Farnese Gallery*, Princeton, 1965.

Morandini, F., *Mostra documentaria e iconografica di Palazzo Pitti e giardino di Boboli*, Cataloghi di Mostra Documentarie No. 4, Archivio di Stato di Firenze, Florence, 1960.

Muñoz, A., *Pietro da Cortona*, Rome, 1921.

Nagler, A. M., *Theatre Festivals of the Medici, 1539-1637*, New Haven, 1964.

Noehles, K., *La chiesa dei SS. Luca e Martina nell'opera di Pietro da Cortona*, Rome, 1970.

Piacenti, K. A., *Il Museo degli Argenti a Firenze*, Milan, 1968.

Piazzo, M. Del, *Pietro da Cortona, mostra documentaria, archivio di stato di Roma*, Rome, 1969.

Pieraccini, G., *La Stirpe de' Medici di Cafaggiolo*, Florence, 1947.

Posner, D., *Annibale Carracci*, London, 1971.

Procacci, U., *La Casa Buonarroti a Firenze*, Milan, 1965.

Schulz, J., *Venetian Painted Ceilings of the Renaissance*, Berkeley, 1968.

Stampfle, F., and Bean, J., *Drawings from New York Collections*, Vol. II: *The Seventeenth Century in Italy*, New York, 1967.

Voss, H., *Die Malerei des Barock in Rom*, Berlin, 1925.

Waterhouse, E. K., *Baroque Painting in Rome*, London, 1937.

———, *Italian Baroque Painting*, London, 1962.

Wittkower, R., *Art and Architecture in Italy: 1600-1750*, 2nd ed., Harmondsworth, 1965.

ARTICLES AND PAMPHLETS

Bartarelli, A., "Domenico Gabbiani," *Rivista d'arte*, XXVII, 3rd series, 1951-1952, pp. 107-130.

Battaglia, S., "Note su Angelo Michele Colonna," *L'Arte*, XXXI, 1928, pp. 17f.

Blunt, A., "The Palazzo Barberini: the Contributions of Maderno, Bernini and Pietro da Cortona," *Journal of the Warburg and Courtauld Institutes*, XXI, 1958, pp. 256-287.

Borenius, T., "Drawings and Engravings by the Carracci," *Print Collectors' Quarterly*, IX, No. 2, April 1922, pp. 105-127.

Briganti, G., "Opere Inedite o Poco Note di Pietro da Cortona nella Pinacoteca Capitolina," *Bollettino dei Musei Comunali di Roma*, IV, 1957, pp. 5-14.

————, "Pietro da Cortona dalla volta Barberini alla Sala della Stufa," *Paragone*, XII, No. 143, Nov. 1961, pp. 3-24.

Campbell, M., "Correspondence," *Burlington Magazine*, CIV, No. 708, March 1962, pp. 121-125.

————, "Correspondence: 'Addenda to Pietro da Cortona,' " *Burlington Magazine*, CVII, No. 751, Oct. 1965, pp. 526-527.

————, "Medici Patronage and the Baroque: A Reappraisal," *Art Bulletin*, XLVIII, No. 2, June 1966, pp. 133-146.

Campbell, M., and Laskin, Jr., M., "A New Drawing for Pietro da Cortona's 'Age of Bronze,' " *Burlington Magazine*, CII, No. 703, Oct. 1961, pp. 423-427.

Chiarini, M., and Noehles, K., "Pietro da Cortona a Palazzo Pitti: un episodio ritrovato," *Bollettino d'arte*, LII, No. 4, Oct.-Dec. 1967, pp. 233-239.

Cistelli, A., "Pietro da Cortona e la chiesa di S. Filippo Neri in Firenze," *Studi secenteschi*, XI, 1970, pp. 27ff.

Coffin, D., "A Drawing by Pietro da Cortona for His Fresco of the 'Age of Iron,' " *Record of the Art Museum, Princeton University*, XIII, No. 2, 1954, pp. 33-37.

Crinò, A., "Documenti relativi a Pietro da Cortona, Ciro Ferri . . . ," *Rivista d'arte*, XXXIV, 1959, pp. 151-157.

Fortuna, A., "Giovanni da San Giovanni nel Salone degli Argenti di Palazzo Pitti," *Firme nostre*, Nos. 30-31, June 1966, pp. 3, 10.

————, "Giovanni da S. Giovanni nel Salone degli Argenti di Palazzo Pitti," *Giornale di bordo*, III, No. 4, April-May 1970, pp. 365-368.

Giovannoni, G., "Il Restauro architettonico di Palazzo Pitti nei Disegni di Pietro da Cortona," *Rassegna d'arte*, VII, Nov.-Dec. 1920, pp. 290-295.

Gombrich, E. H., "Renaissance and Golden Age," *Journal of the Warburg and Courtauld Institutes*, XXIV, 1961, pp. 306-309. Here cited from *Norm and Form: Studies in the Art of the Renaissance*, London, 1966.

Hoffman, K. J., "Pietro da Cortona's Project for the Chiesa Nuova di San Filippo Neri," Master's Thesis, New York University, Institute of Fine Arts, 1941.

Hubala, E., "Entwürfe Pietro da Cortonas für SS. Martina e Luca in Rom," *Zeitschrift für Kunstgeschichte*, XXV, 1962, pp. 125-152.

Linnenkamp, R., "Giulio Parigi architetto," *Rivista d'arte*, XXXIII, 1958, pp. 51-63.

Massetti, A. R., "Il Casino Mediceo e la pittura Fiorentina del seicento," *Critica d'arte*, IX, March-April 1962, pp. 1ff.; Sept.-Dec. 1962, pp. 77ff.

Montagu, J., "The Early Ceiling Decorations of Charles Le Brun," *Burlington Magazine*, CV, No. 726, Sept. 1963, pp. 395-408.

Morandini, F., "Palazzo Pitti, la sua costruzione e i successivi ingrandimenti," *Commentari*, XVI, Jan.-June 1965, pp. 35-46.

Moschini, V., "Le Architetture di Pietro da Cortona," *L'Arte*, XXIV, Sept.-Dec. 1921, pp. 189-197.

Noehles, K., "Die Louvre-Projekte von Pietro da Cortona und Carlo Rainaldi," *Zeitschrift für Kunstgeschichte*, XXIV, 1961, pp. 40-74.

————, "Review of G. Briganti, Pietro da Cortona . . . ," *Kunstchronik*, XVI, No. 4, April 1963, pp. 95-106.

Panofsky-Soergel, G., "Zur Geschichte des Palazzo Mattei di Giove," *Römisches Jahrbuch für Kunstgeschichte*, XI, 1967/68, pp. 111-188.

Procacci, U., *La Reggia di Palazzo Pitti*, Florence, 1966.

Rasy, E., "Pietro da Cortona. I progetti per la 'Chiesa Nuova' di Firenze" in *Architettura barocca a Roma*, ed. M. dell' Arco, Rome, 1972, 345ff.

Stechow, W., " 'The Love of Antiochus with Faire Stratonica' in Art," *Art Bulletin*, XXVII, No. 4, Dec. 1945, pp. 221-237.

Taggart, R. E., "Model of the Ceiling by Pietro da Cortona in the Salon of Mars in the Pitti Palace," *The Nelson Gallery and Atkins Museum Bulletin*, III, No. 2, Oct. 1960, pp. 8-13.

Vitzthum, W., "Correspondence: 'Pietro da Cortona's Camera della Stufa,' " *Burlington Magazine*, CIV, No. 708, March 1962, pp. 120-121.

————, "Inventar eines Sammelbandes des Späten Seicento mit Zeichnungen von Pietro da Cortona und Ciro Ferri," *Studies in Renaissance and Baroque Art Presented to Antony Blunt on His Sixtieth Birthday*, London, 1967.

————, *Pietro da Cortona a Palazzo Pitti*, Milan, 1965.

————, "Pietro da Cortona's Drawings For the Pitti Palace at the Uffizi," *Burlington Magazine*, CVII, No. 751, Oct. 1965, pp. 522-526.

————, "Review of G. Briganti, *Pietro da Cortona* . . . ," *Master Drawings*, I, No. 2, Summer 1963, pp. 49-51.

————, "Review of G. Briganti, *Pietro da Cortona* . . . ," *Burlington Magazine*, CV, No. 722, May 1963, pp. 213-217.

Winner, M., "Volterranos Fresken in der Villa della Petraia," *Mitteilungen des Kunsthistorischen Institutes in Florenz*, X, Feb. 1963, pp. 219-252.

Wirbal, N., "Contributi alle ricerche sul Cortonismo in Roma: I pittori della Galleria di Alessandro VII nel Palazzo del Quirinale," *Bollettino d'arte*, XLV, Jan.-June 1960, pp. 123-165.

Wittkower, R., "Pietro da Cortona Ergänzungsprojekt des Tempels in Palestrina," *Festschrift Adolph Goldschmidt*, Berlin, 1935, pp. 137-143.

Index

ARCHITECTURE

DRAWINGS

Illustrations

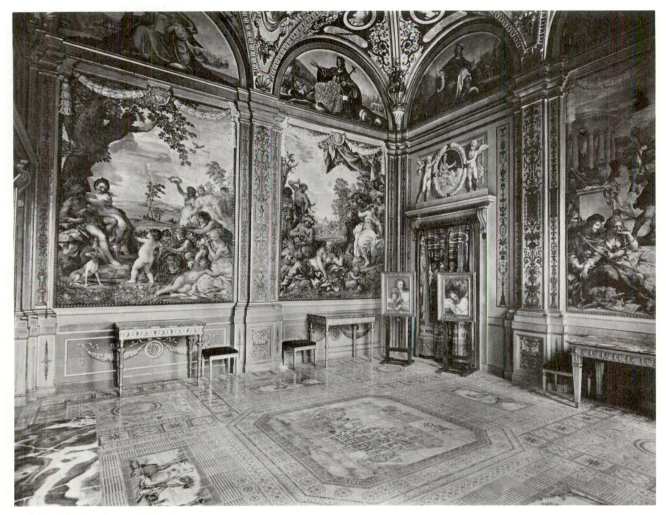

1. Sala della Stufa, general view

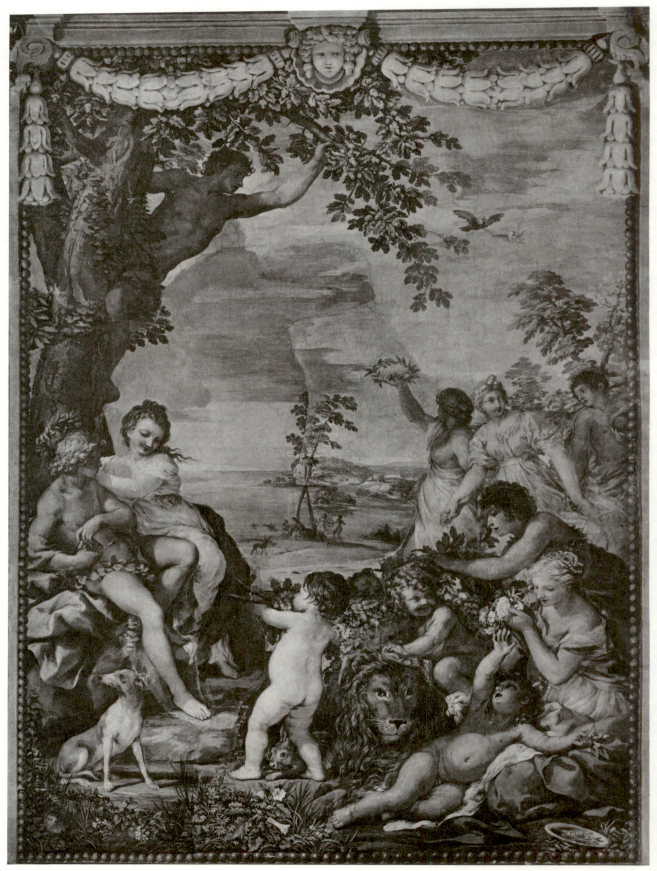

2. *Age of Gold*, Sala della Stufa

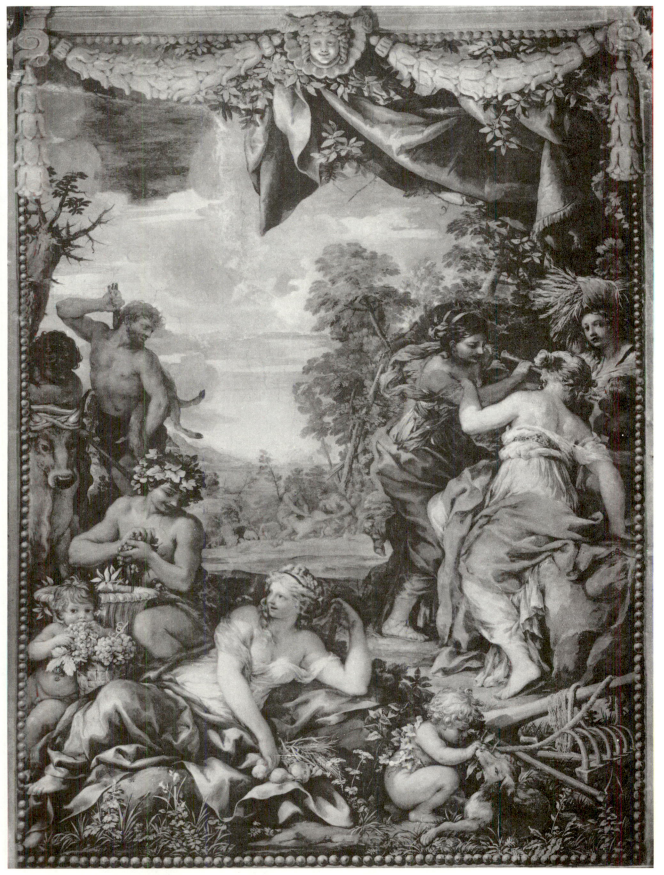

3. *Age of Silver*, Sala della Stufa

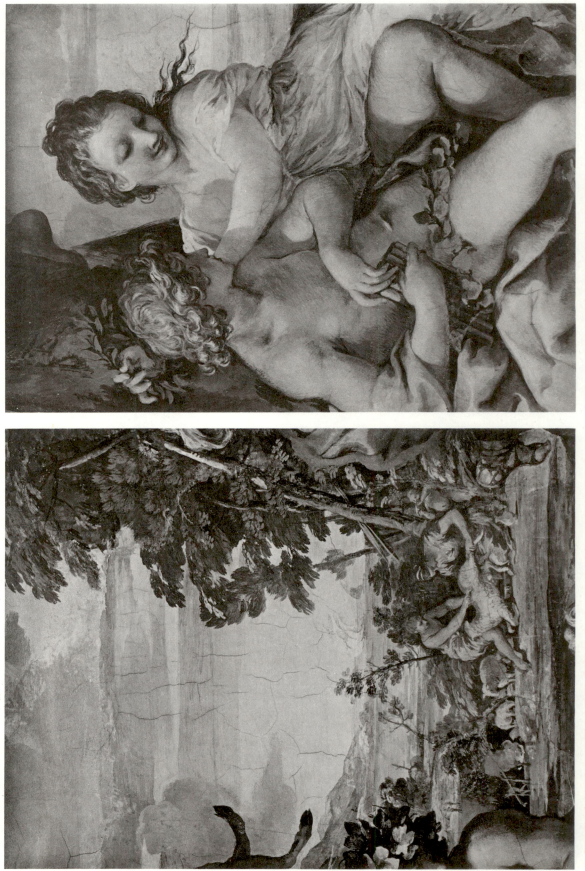

5. Detail of the *Age of Gold*, Sala della Stufa

4. Detail of the *Age of Silver*, Sala della Stufa

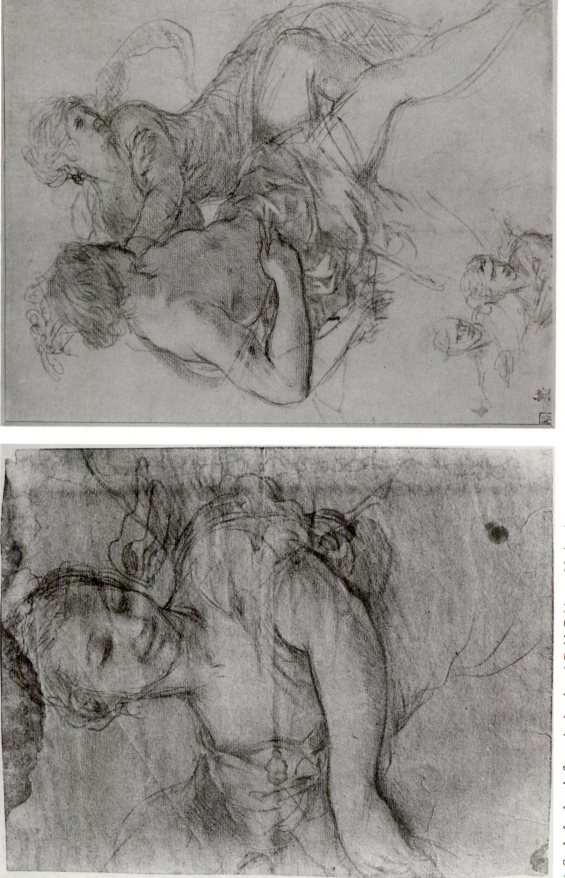

7. Study for youthful couple in the *Age of Gold*. Metropolitan Museum of Art (Walter C. Baker Bequest), New York

6. Study for female figure in the *Age of Gold*. Gabinetto Nazionale delle Stampe, Rome

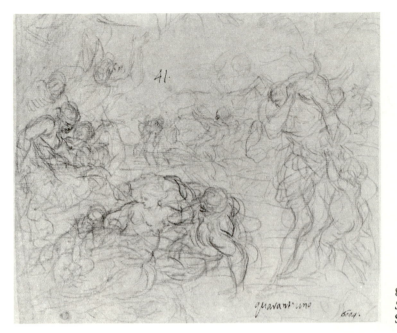

8. Study for the *Ages of Gold and Silver*. Staatliche Graphische Sammlung, Munich

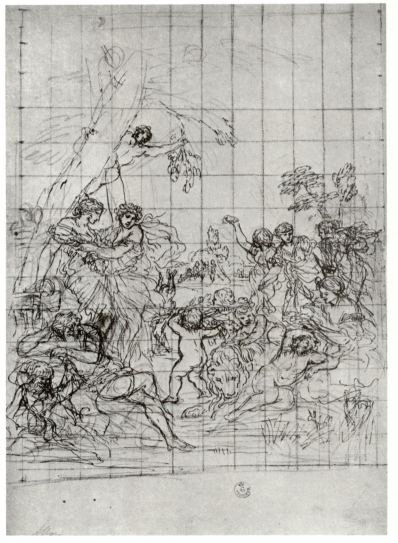

9. Composition study for the *Age of Gold*. Uffizi, Florence

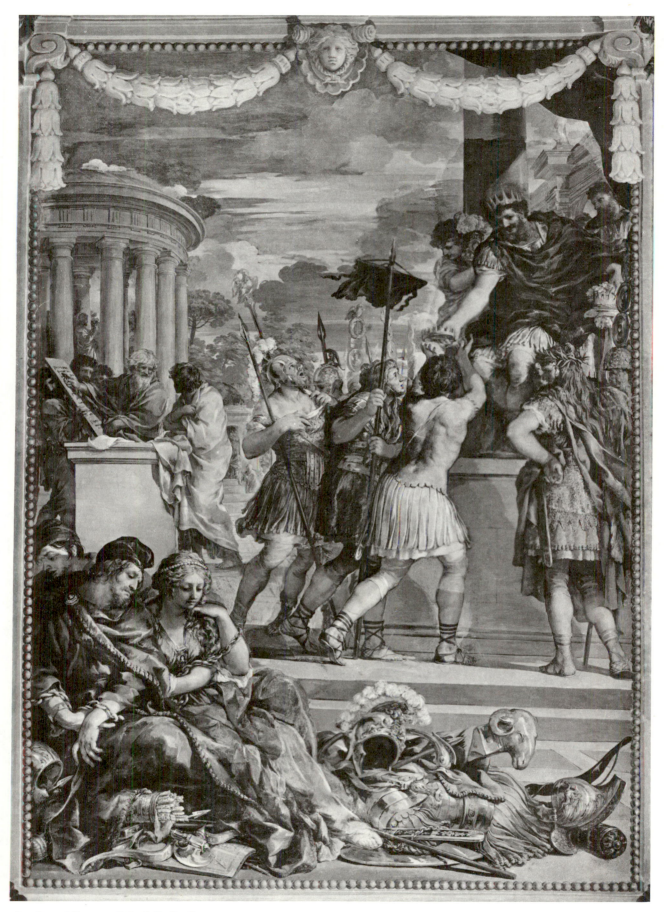

10. *Age of Bronze,* Sala della Stufa

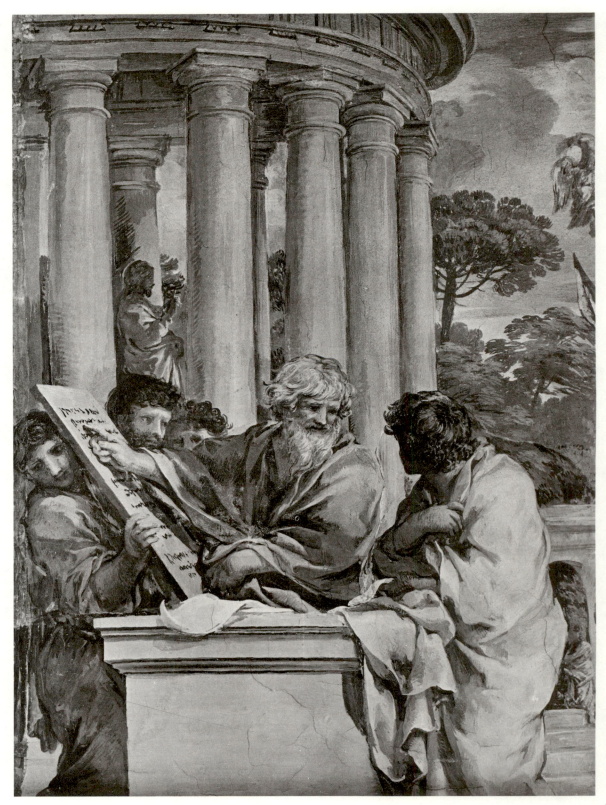

11. Detail of the *Age of Bronze*, Sala della Stufa

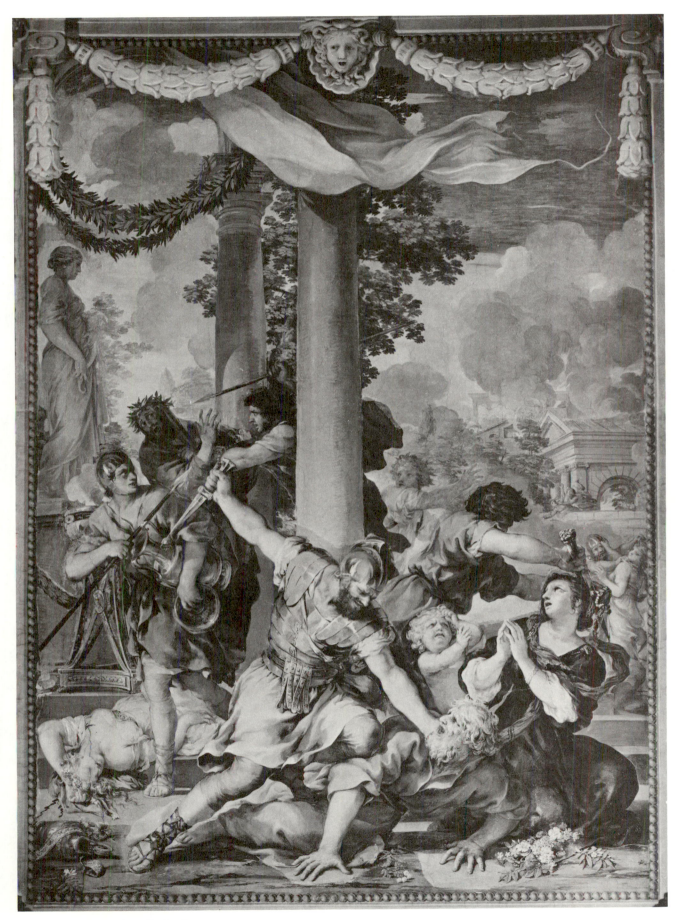

12. *Age of Iron*, Sala della Stufa

14. Composition study for the *Age of Bronze*. Uffizi, Florence

13. Study for the *Age of Bronze*. Private collection, Rome [?]

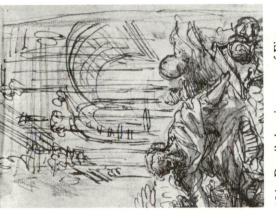

15A. Detail showing area of Fig. 15 covered by movable flap

15. Composition study for the *Age of Bronze*. Staatliche Graphische Sammlung, Munich

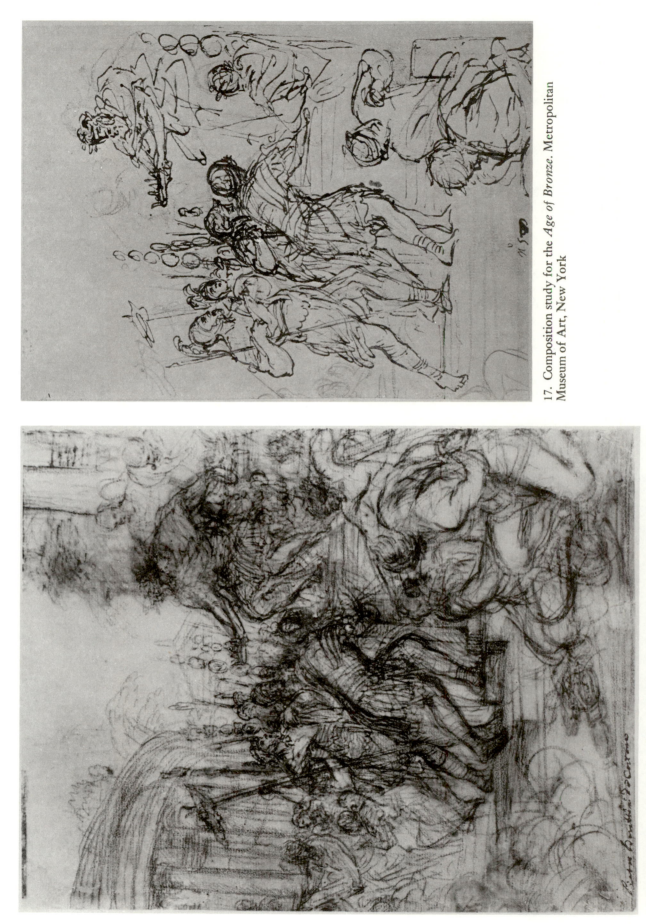

17. Composition study for the *Age of Bronze*. Metropolitan Museum of Art, New York

16. Composition study for the *Age of Bronze*. National Gallery, Prague

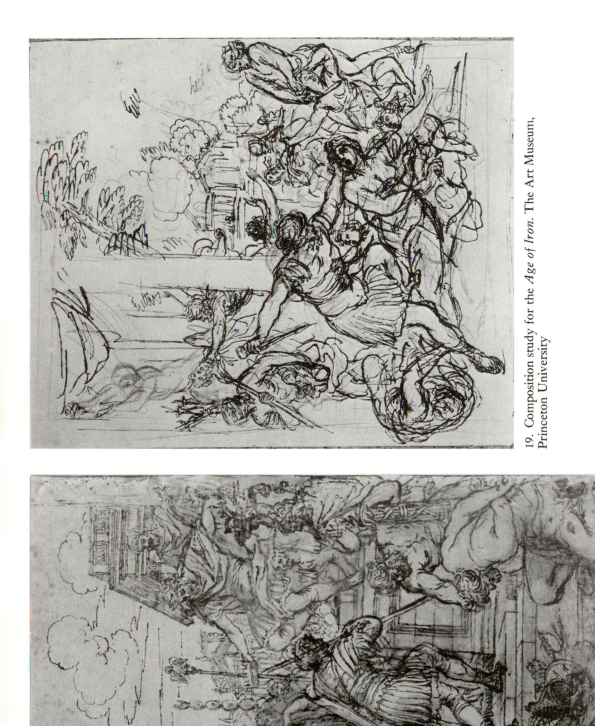

19. Composition study for the *Age of Iron*. The Art Museum, Princeton University

18. Composition study for the *Age of Bronze*. Metropolitan Museum of Art (Walter C. Baker Bequest), New York

20. Sala di Venere, general view

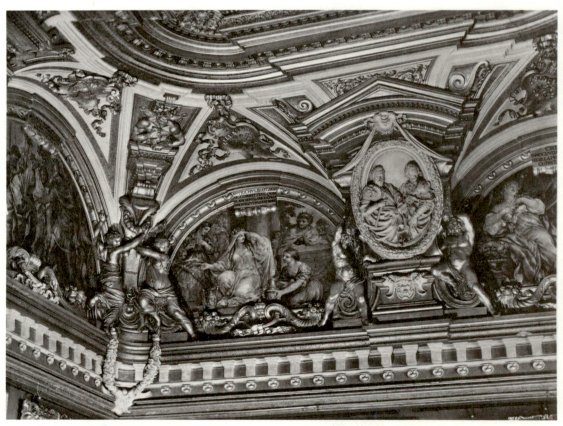

21. Sala di Venere, detail of vault

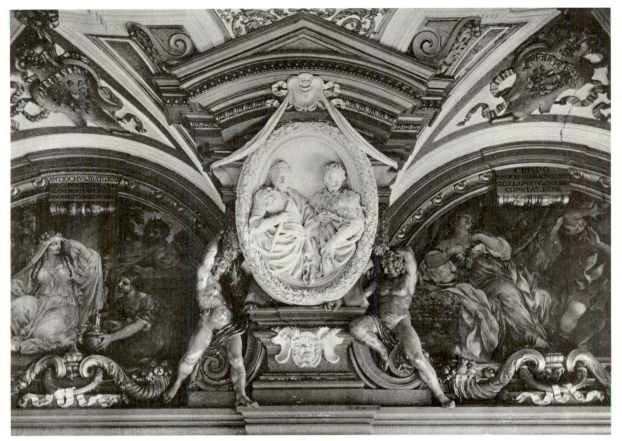

22. Stucco portraits of Ferdinand I and Cosimo II, Sala di Venere

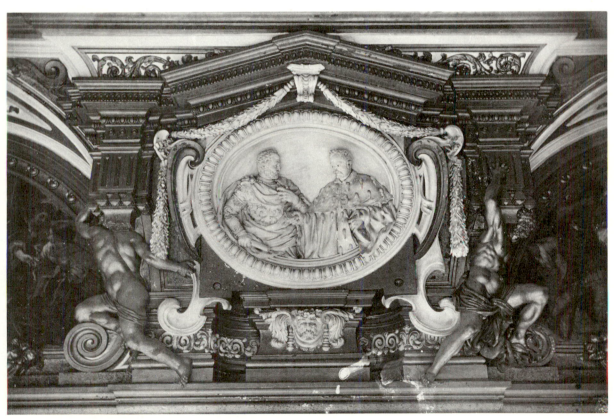

23. Stucco portraits of Cosimo I and Francesco I, Sala di Venere

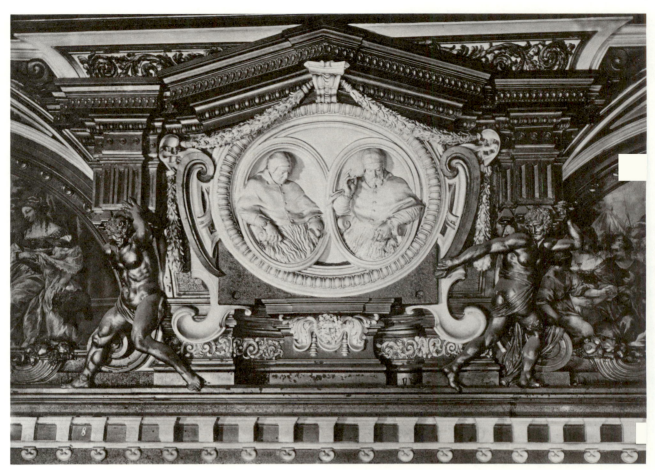

24. Stucco portraits of Popes Clement VII and Leo X, Sala di Venere

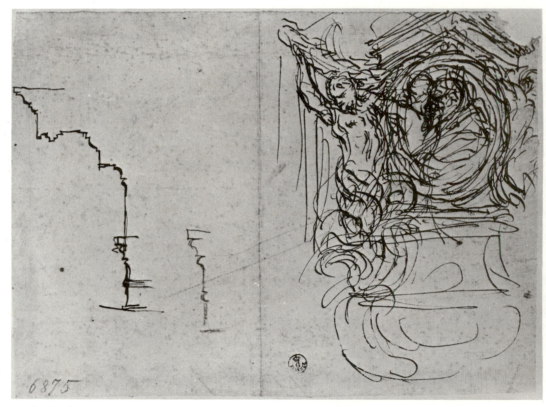

26. Study for portrait medallion, Sala di Venere. Uffizi, Florence

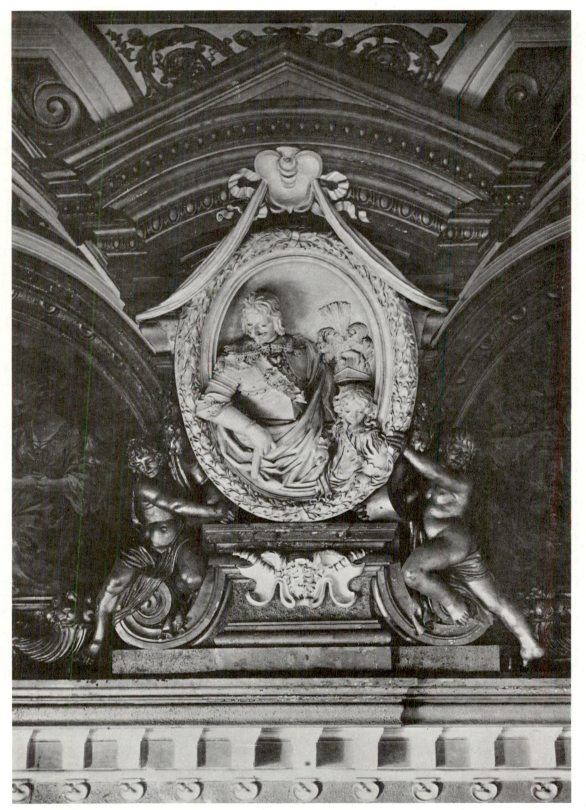

25. Stucco portraits of Ferdinand II and Cosimo III, Sala di Venere

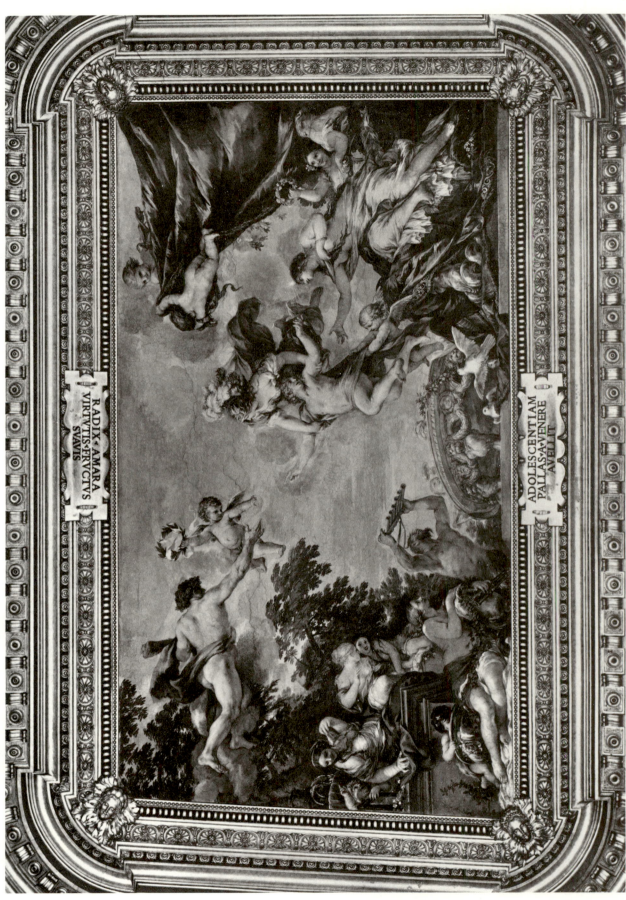

RADIX·AMARA
VIRTVTIS·FRVCTVS
SVAVIS

ADOLESCENTIAM
PALLAS·A·VENERE
AVELLIT

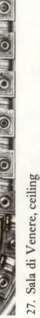

27. Sala di Venere, ceiling

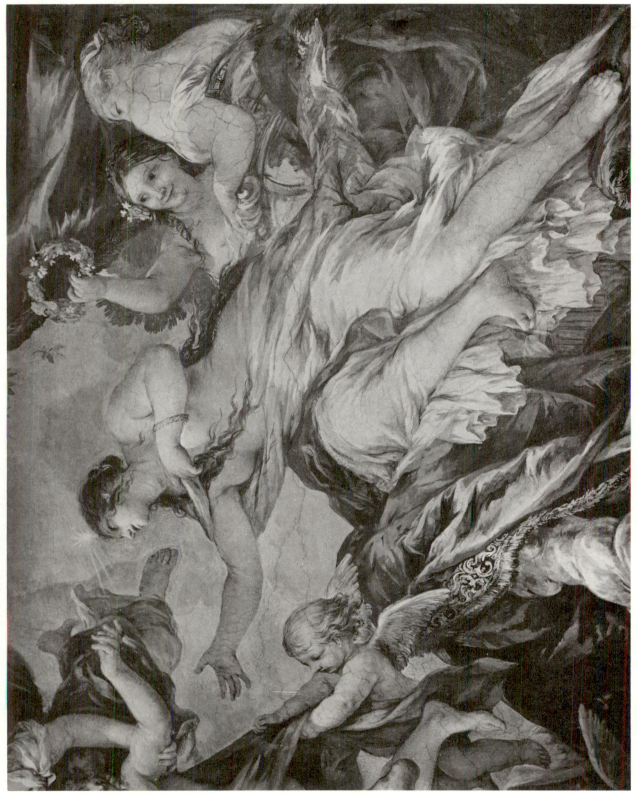

28. Venus, detail of ceiling fresco, Sala di Venere

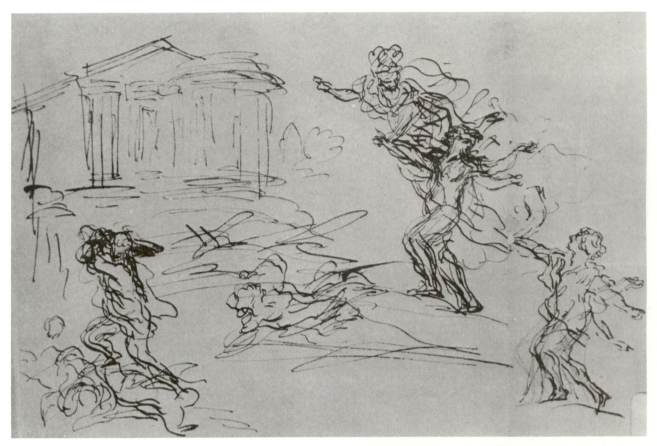

29. Composition study for the Sala di Venere ceiling. Private collection, Rome [?]

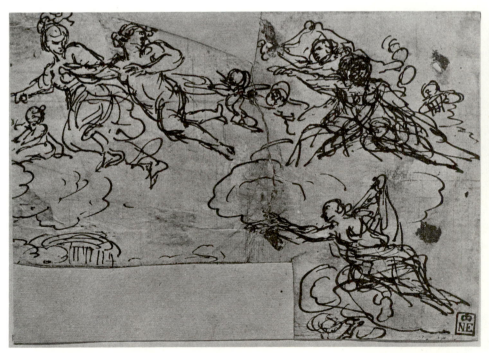

31. Study for Venus, Sala di Venere ceiling. Museum of Fine Arts, Budapest

30. Composition study for the Sala di Venere ceiling. Museum of Fine Arts, Budapest

32. Study for Venus, Sala di Venere ceiling. Uffizi, Florence

33. Studies for Venus, Sala di Venere ceiling. Uffizi, Florence

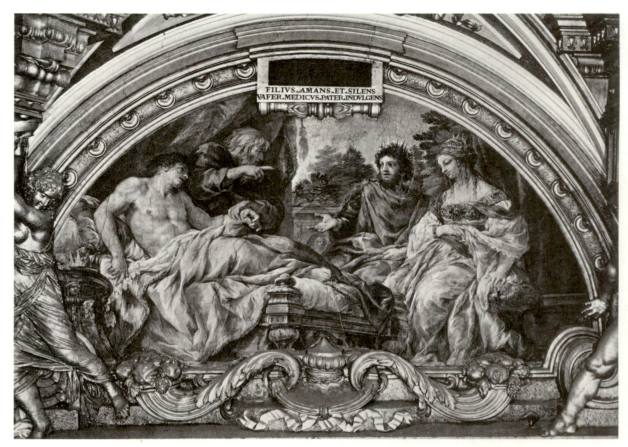

34. *Antiochus and Stratonice*, Sala di Venere

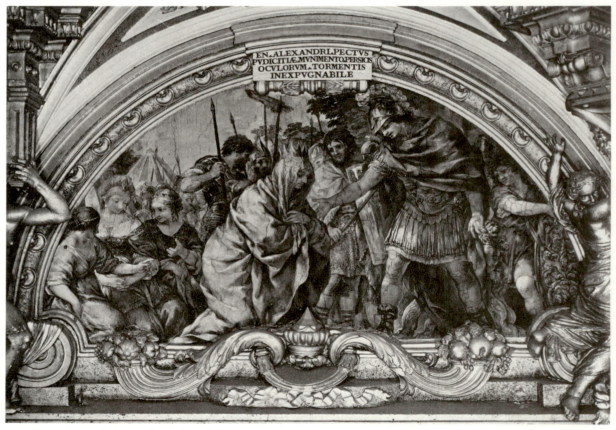

35. *Alexander and Sisigambis*, Sala di Venere

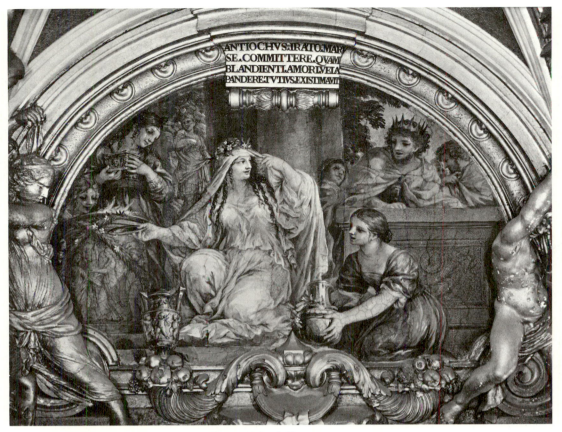

36. *Antiochus III and the Priestess of Diana*, Sala di Venere

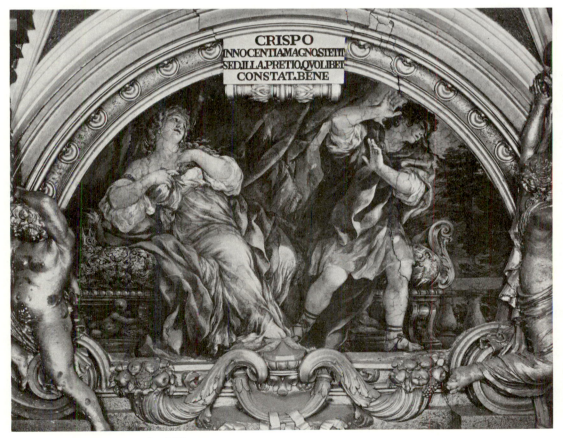

37. *Crispus and Fausta*, Sala di Venere

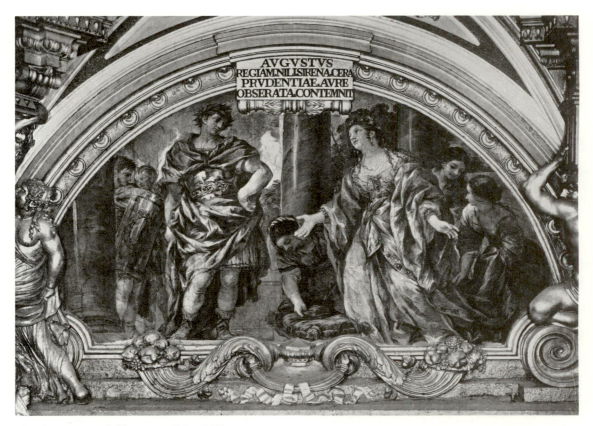

38. *Augustus and Cleopatra*, Sala di Venere

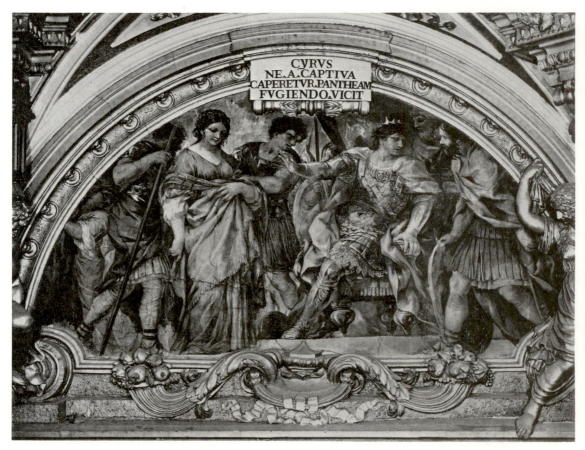

39. *Cyrus and Panthea*, Sala di Venere

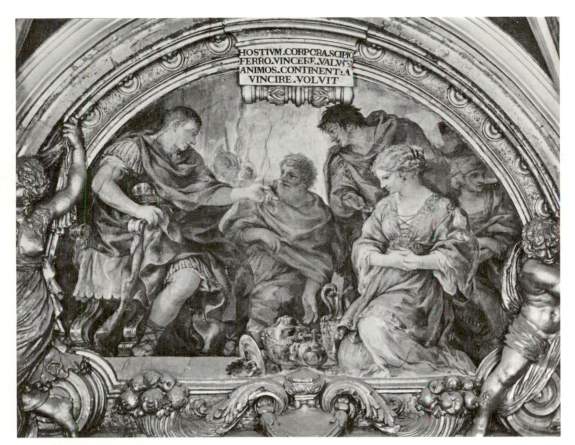

40. *Continence of Scipio*, Sala di Venere

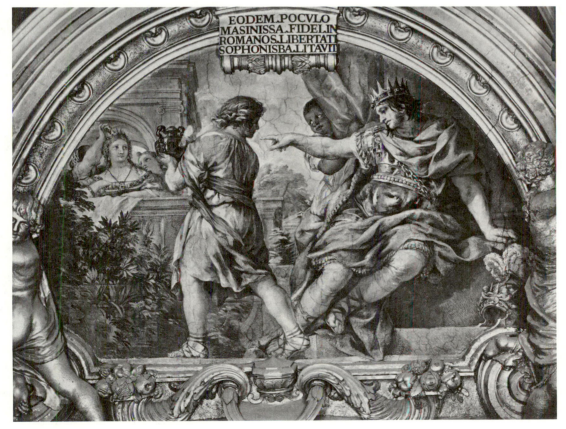

41. *Masinissa and Sophonisba*, Sala di Venere

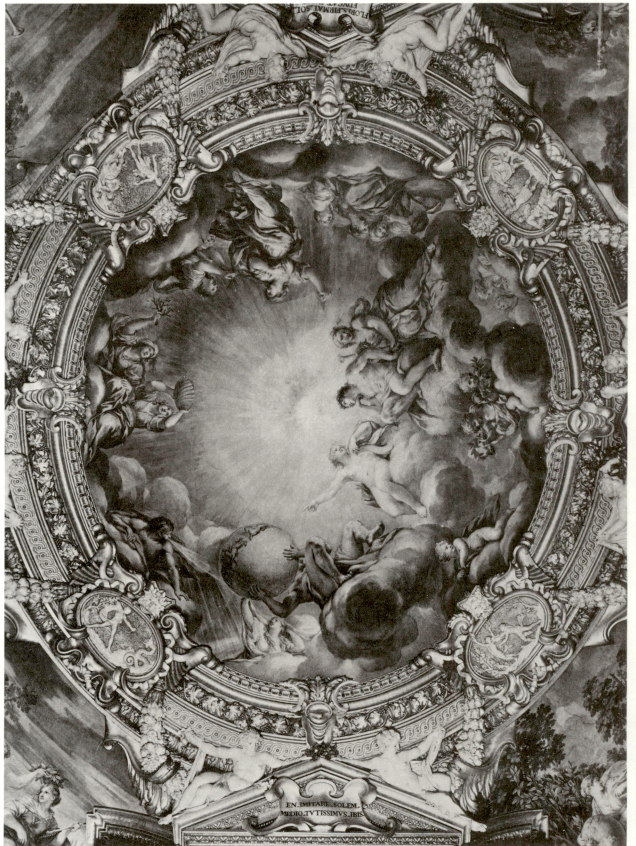

EN.IMITARE.SOLEM.
MEDIO.TVTISSIMVS.IBIS

42. Sala di Apollo, ceiling

43. Lunette with Scene from the Life of Alexander the Great, Sala di Apollo

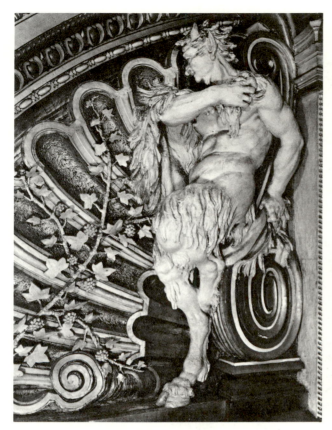

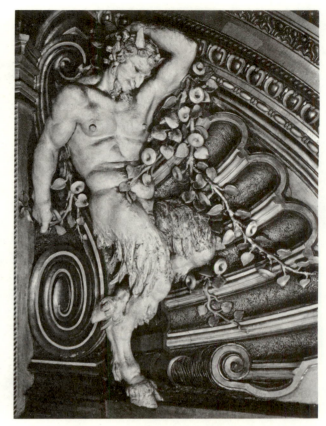

44. Satyr, *Augustus* lunette (left), Sala di Apollo

45. Satyr, *Augustus* lunette (right), Sala di Apollo

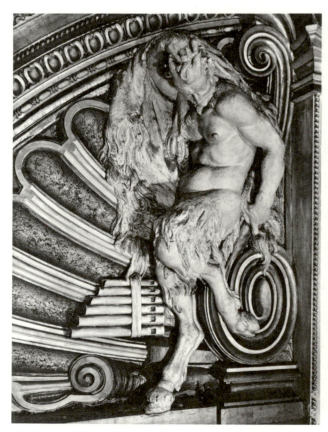

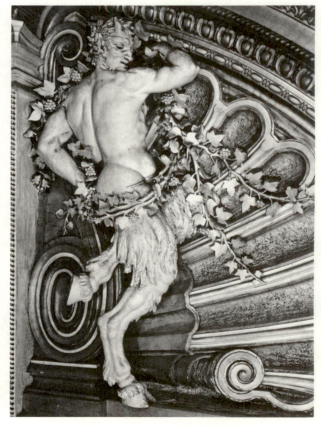

46. Satyr, *Alexander* lunette (left), Sala di Apollo

47. Satyr, *Alexander* lunette (right), Sala di Apollo

48. Satyr, *Justinian* lunette (left), Sala di Apollo

49. Satyr, *Justinian* lunette (right), Sala di Apollo

50. Satyr, *Julius Caesar* lunette (left), Sala di Apollo

51. Satyr, *Julius Caesar* lunette (right), Sala di Apollo

53. *Apollo and Daphne*, Sala di Apollo

55. *Apollo and Hyacinthus*, Sala di Apollo

52. *Apollo and Python*, Sala di Apollo

54. *Apollo and Marsyas*, Sala di Apollo

56. Pediment, *Augustus* lunette, Sala di Apollo

58. Pediment, *Justinian* lunette, Sala di Apollo

57. Pediment, *Alexander* lunette, Sala di Apollo

59. Pediment, *Julius Caesar* lunette, Sala di Apollo

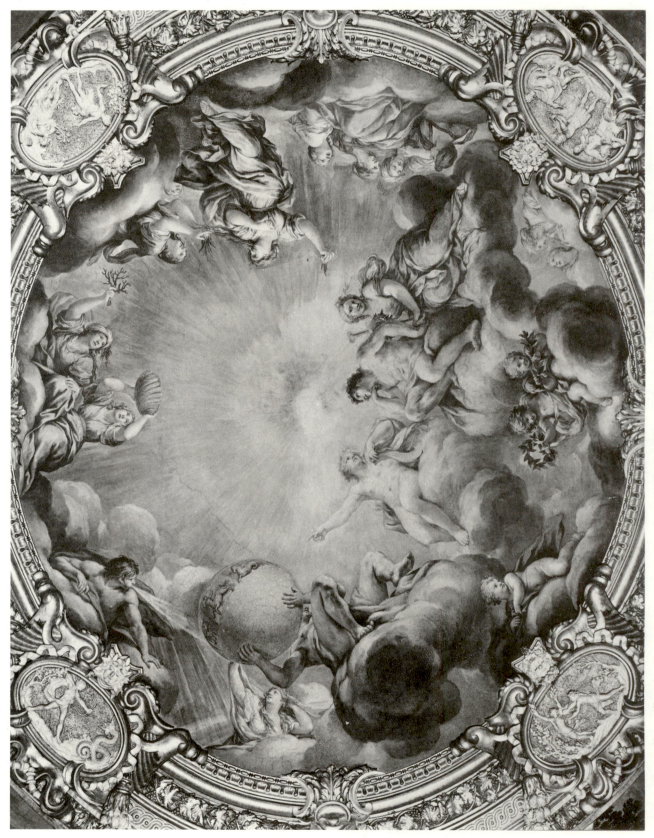

60. Sala di Apollo, ceiling fresco

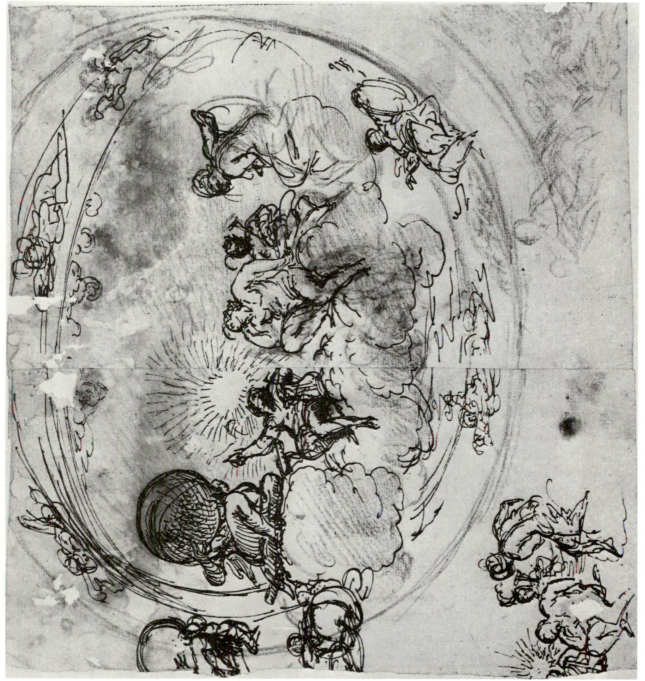

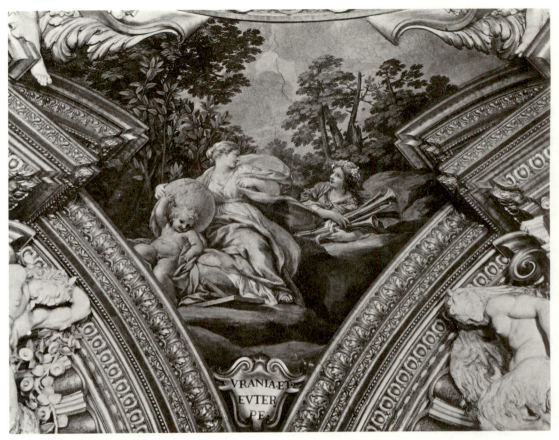

62. *Urania and Euterpe*, Sala di Apollo

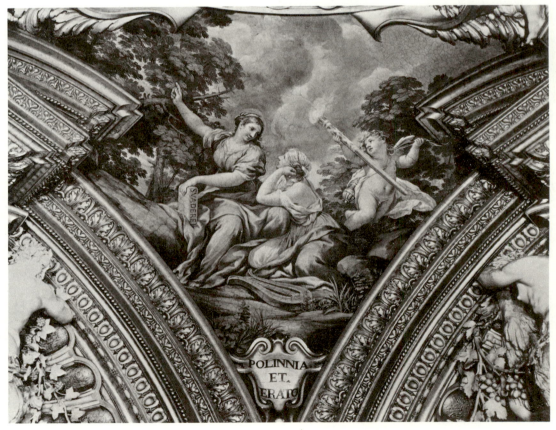

63. *Polyhymnia and Erato*, Sala di Apollo

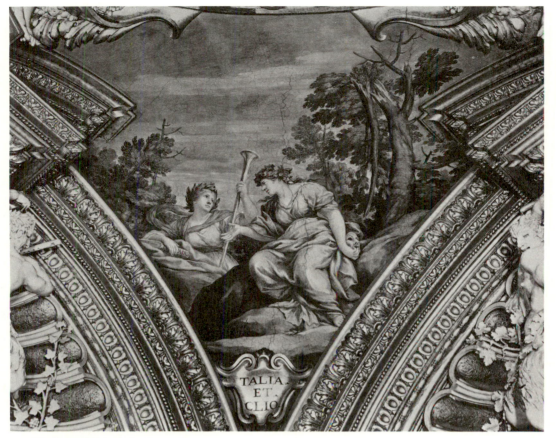

64. *Thalia and Clio*, Sala di Apollo

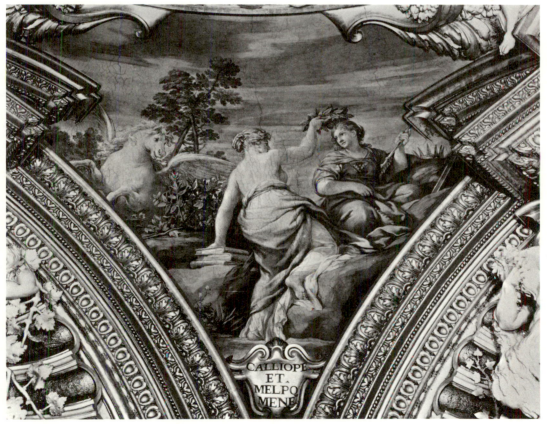

65. *Calliope and Melpomene*, Sala di Apollo

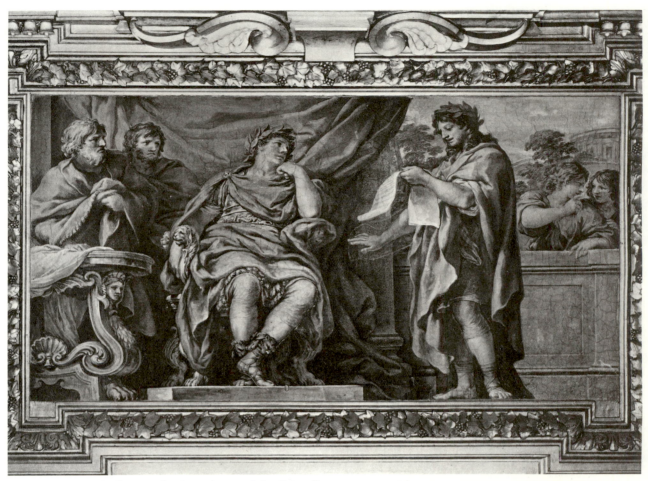

66. *Scene from the Life of Augustus Caesar*, Sala di Apollo

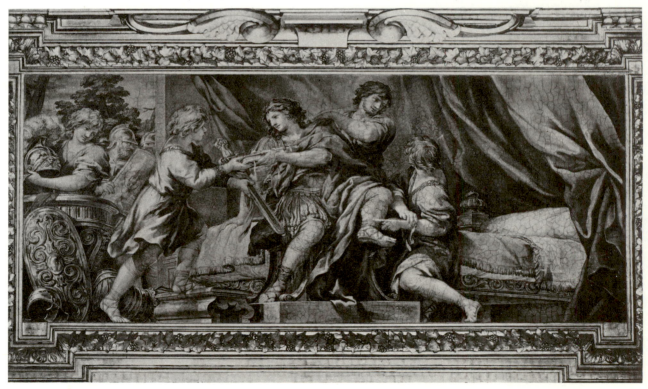

67. *Scene from the Life of Alexander the Great*, Sala di Apollo

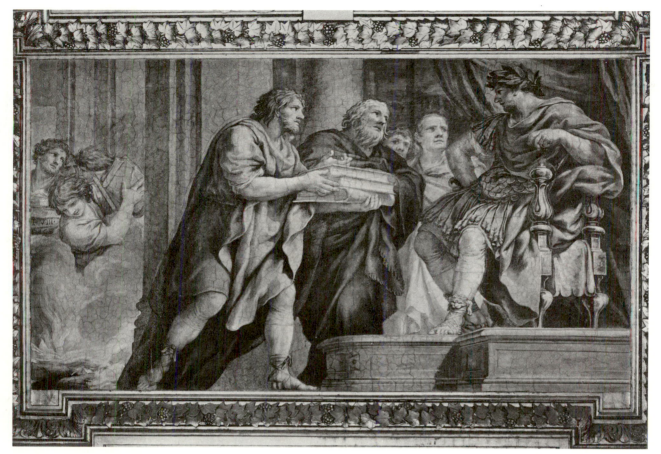

68. *Scene from the Life of Justinian*, Sala di Apollo

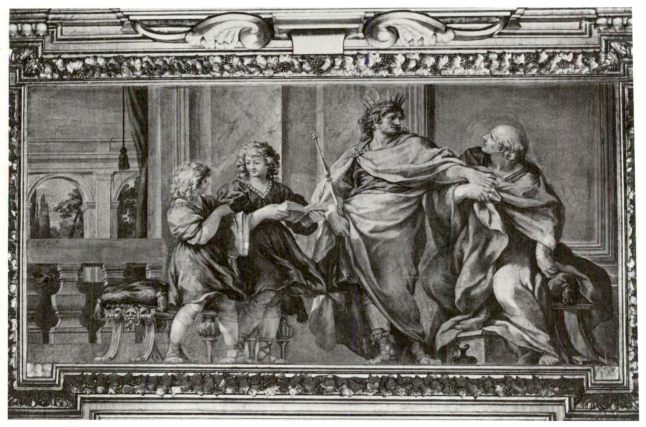

69. *Scene from the Life of Julius Caesar*, Sala di Apollo

70. Study for stucco decorations, Sala di Apollo. Uffizi, Florence

71. Study for the *Justinian* lunette, Sala di Apollo. Uffizi, Florence

72. Study for Hercules, Sala di Apollo ceiling. Gabinetto Nazionale delle Stampe, Rome

73. Study for hovering figures, Sala di Apollo ceiling. Uffizi, Florence

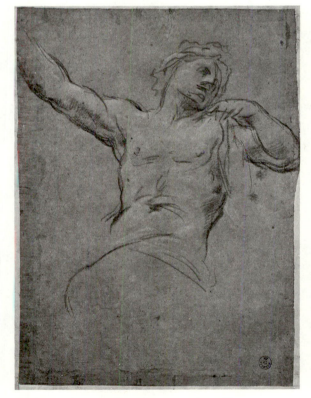

74. Study for Apollo, Sala di Apollo ceiling.
Uffizi, Florence

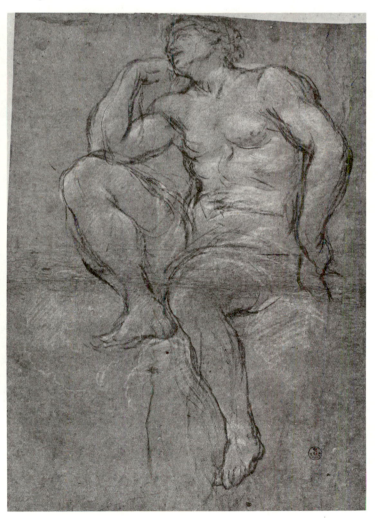

75. Study for the prince, Sala di Apollo ceiling.
Uffizi, Florence

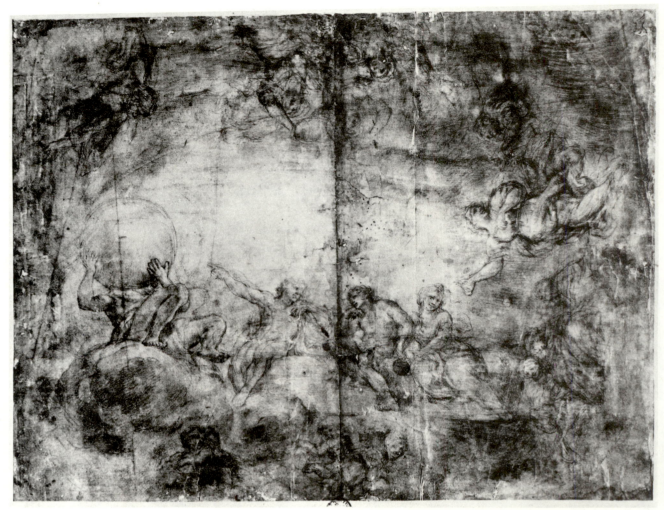

76. Ciro Ferri, composition study for the Sala di Apollo ceiling. Kunstmuseum der Stadt, Düsseldorf

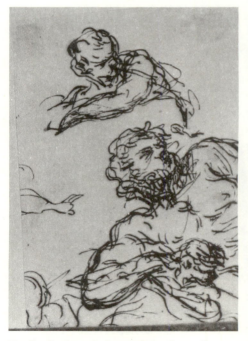

77. Study for wind god, Sala di Apollo ceiling. Private collection, Rome [?]

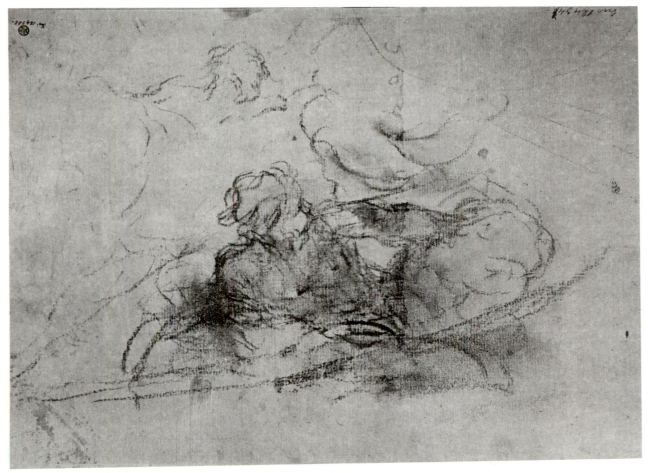

78. Ciro Ferri, study for wind god, Sala di Apollo ceiling. Gabinetto Nazionale delle Stampe, Rome

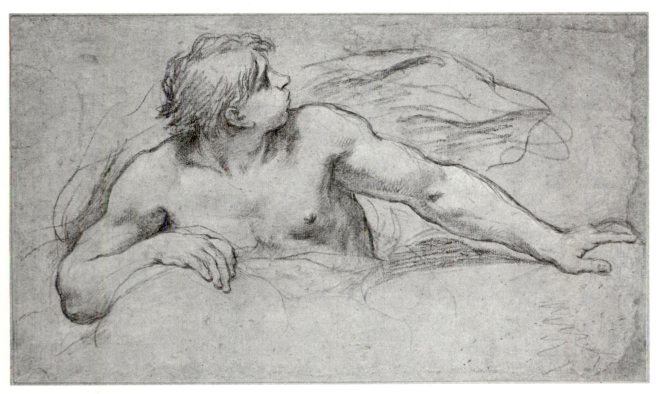

79. Study for wind god, Sala di Apollo ceiling. Metropolitan Museum of Art, New York

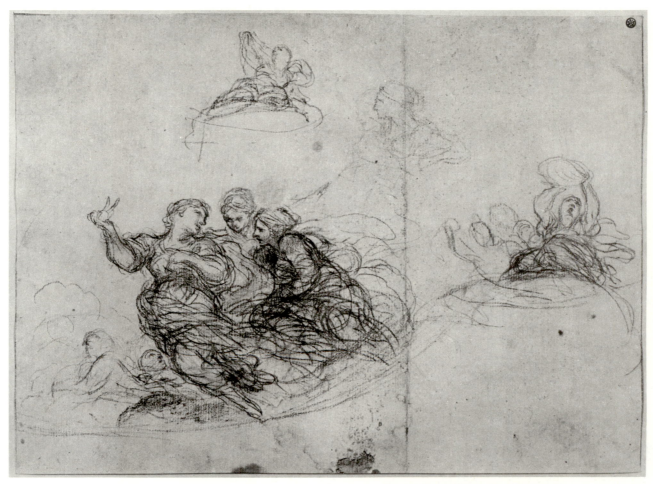

80. Ciro Ferri, figure studies for the Sala di Apollo ceiling. Gabinetto Nazionale delle Stampe, Rome

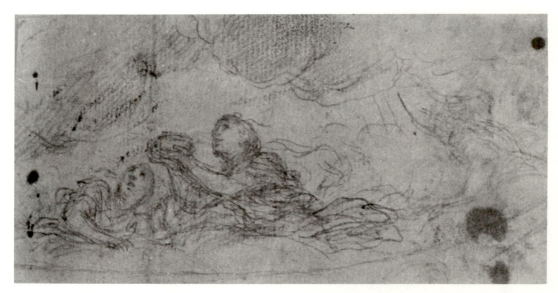

81. Ciro Ferri, figure studies for the Sala di Apollo ceiling. Private collection, Rome [?]

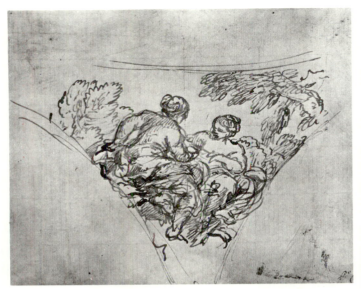

82. Study for pendentive, Sala di Apollo.
Keith Andrews Collection, Edinburgh

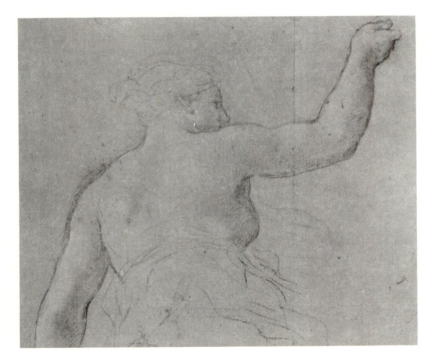

83. Study for Calliope, Sala di Apollo.
Private collection, Rome [?]

84. Study for the *Augustus* lunette,
Sala di Apollo. Cooper-Hewitt Museum
of Decorative Arts and Design, New York

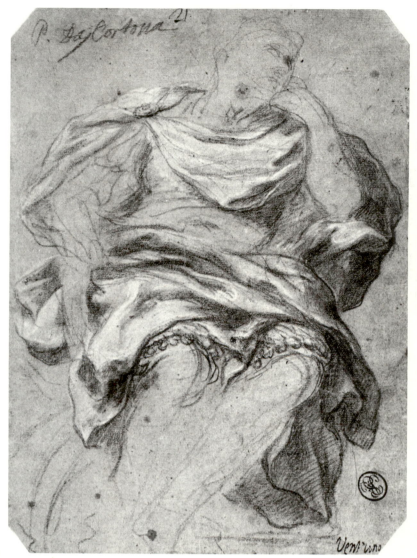

85. Study for Augustus, *Augustus* lunette, Sala di Apollo. Louvre, Paris

86. Ciro Ferri, composition study for the *Justinian* lunette, Sala di Apollo. Private collection, Rome [?]

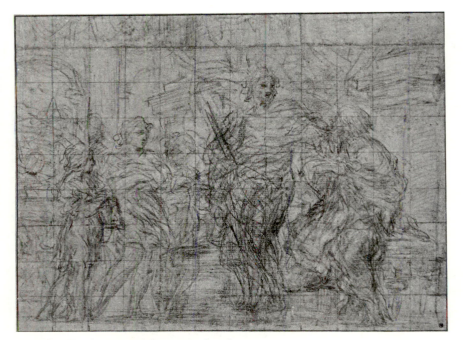

87. Ciro Ferri, composition study for the
Julius Caesar lunette, Sala di Apollo. Hessisches
Landesmuseum, Darmstadt

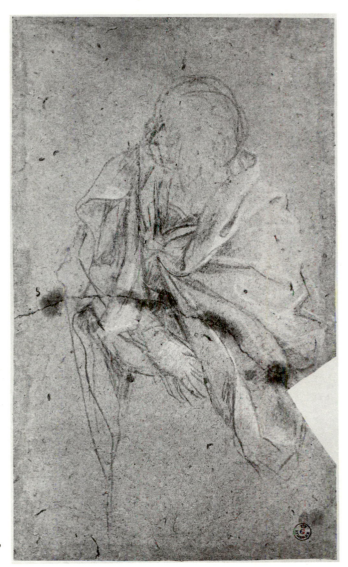

88. Figure study for the *Julius Caesar* lunette,
Sala di Apollo. Uffizi, Florence

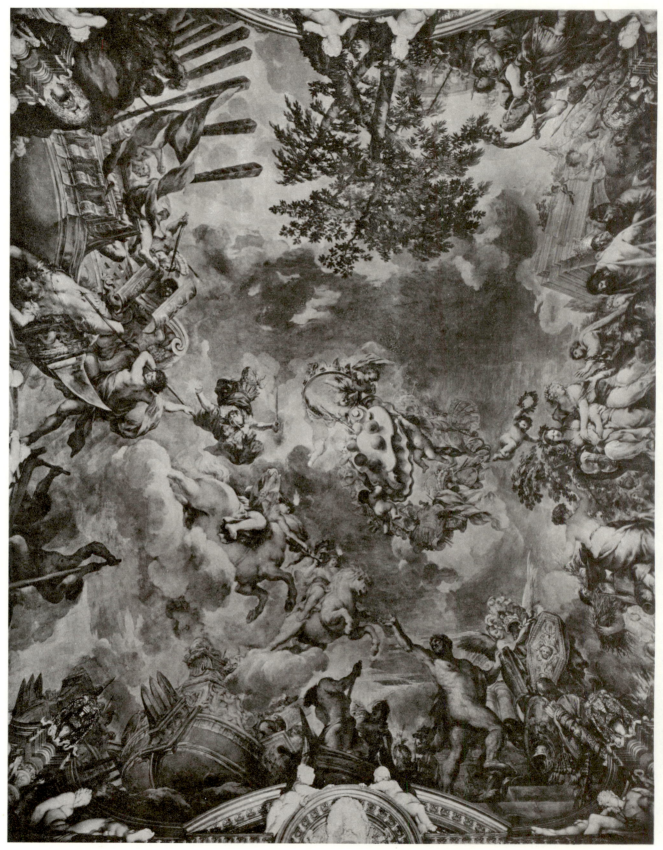

89. Sala di Marte, ceiling fresco

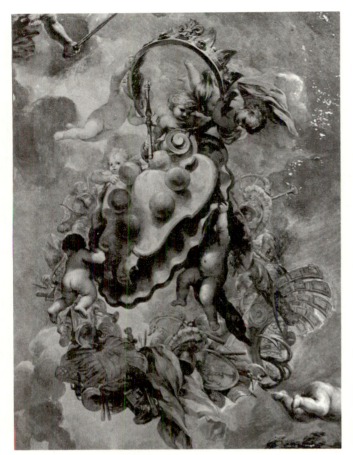

90. *Stemma Mediceo*, detail of the Sala di Marte ceiling

91. Composition study for section of the Sala di Marte ceiling. British Museum, London

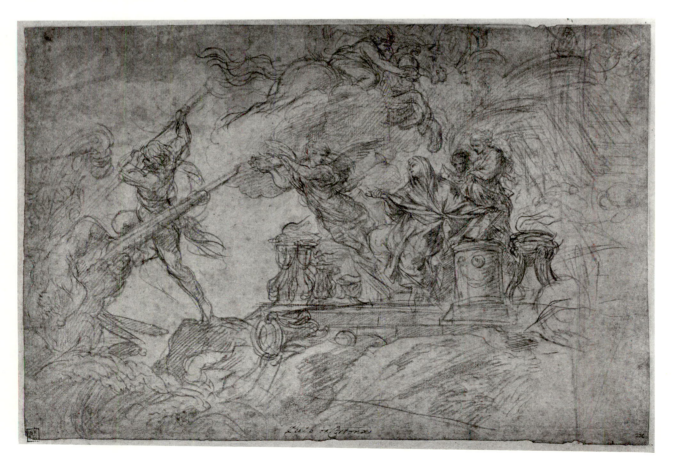

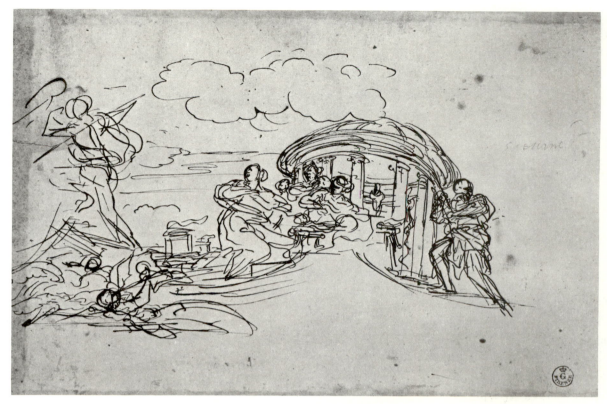

92. Composition study for section of the Sala di Marte ceiling. Uffizi, Florence

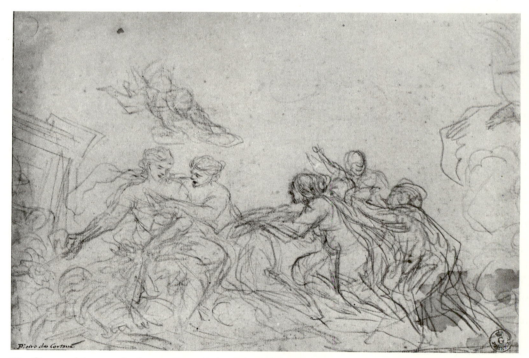

93. Composition study for section of the Sala di Marte ceiling. Uffizi, Florence

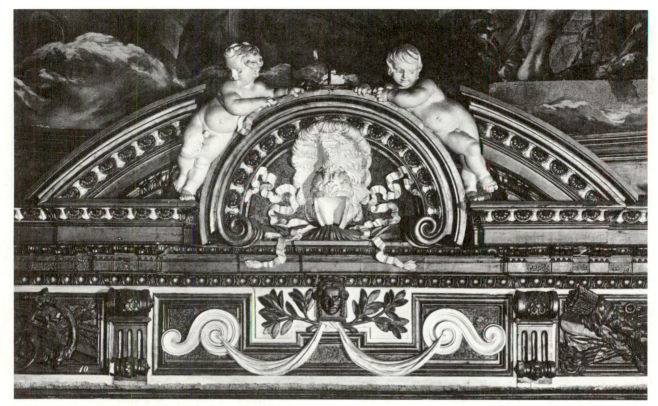

94. Detail of stucco decorations, Sala di Marte

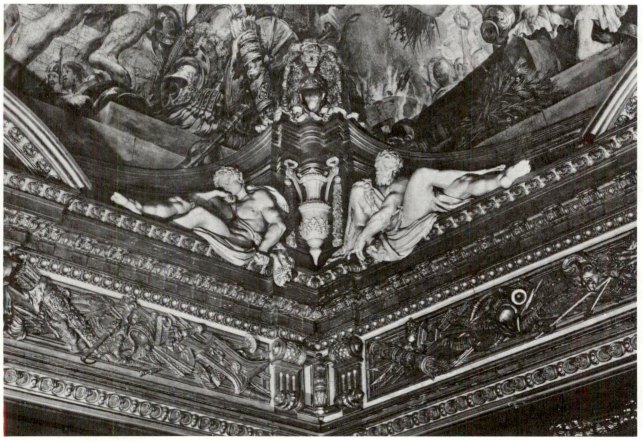

95. Detail of stucco decorations, Sala di Marte

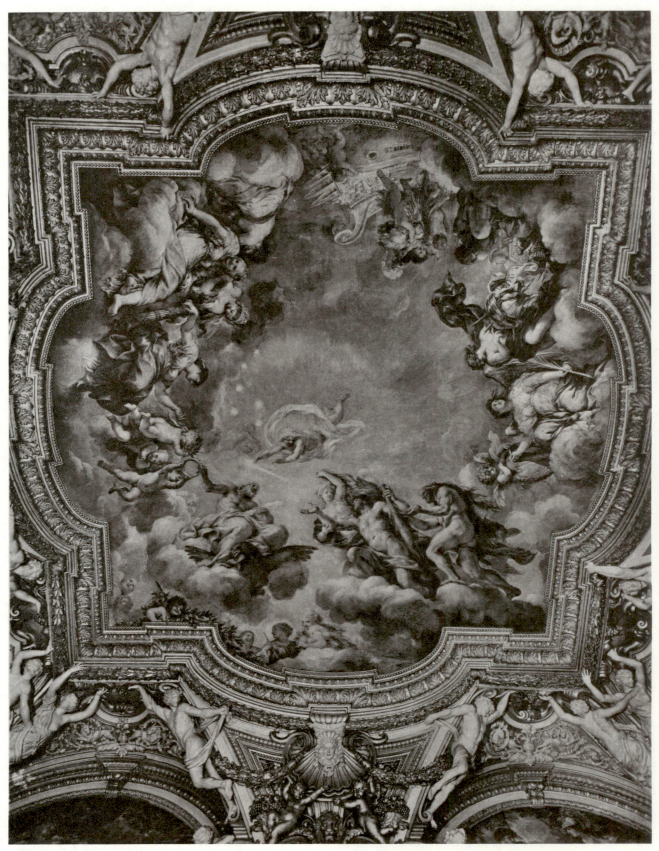

96. Sala di Giove, ceiling

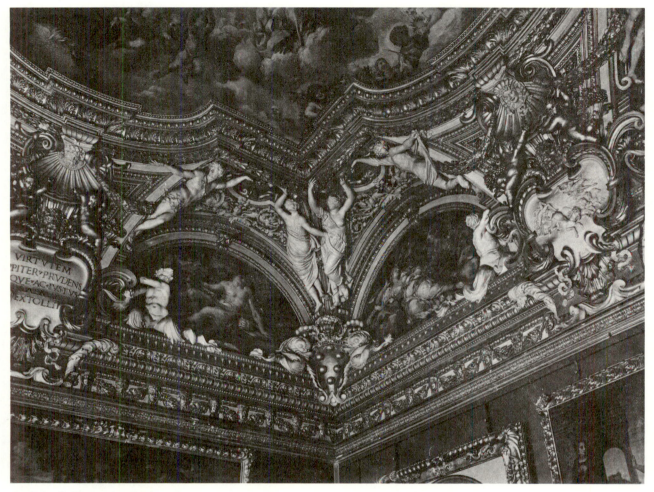

97. Sala di Giove, detail of vault

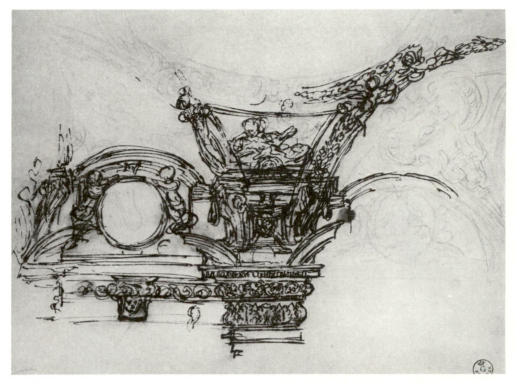

98. Study for stucco decorations, Sala di Giove. Uffizi, Florence

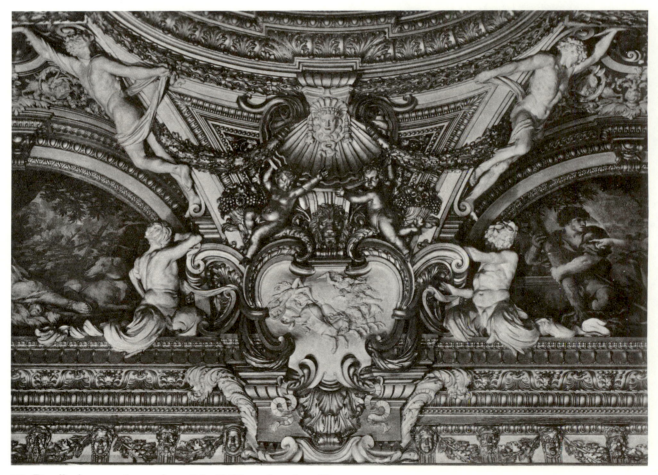

99. Detail of stucco decorations, Sala di Giove (south wall)

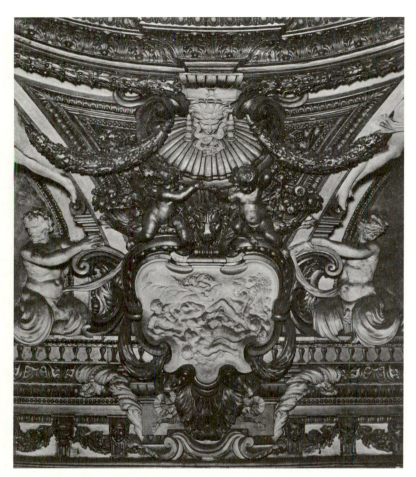

100. Detail of stucco decorations, Sala di Giove (north wall)

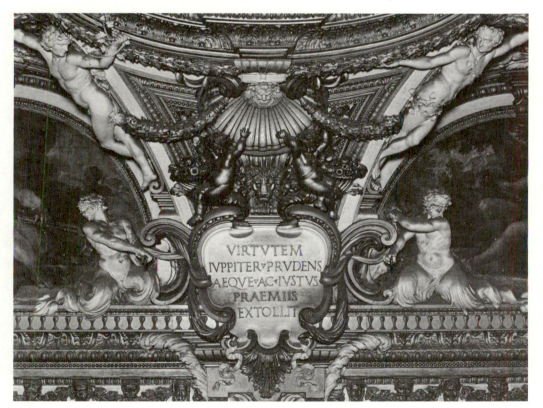

101. Detail of stucco decorations, Sala di Giove (east wall): Tritons holding hooks

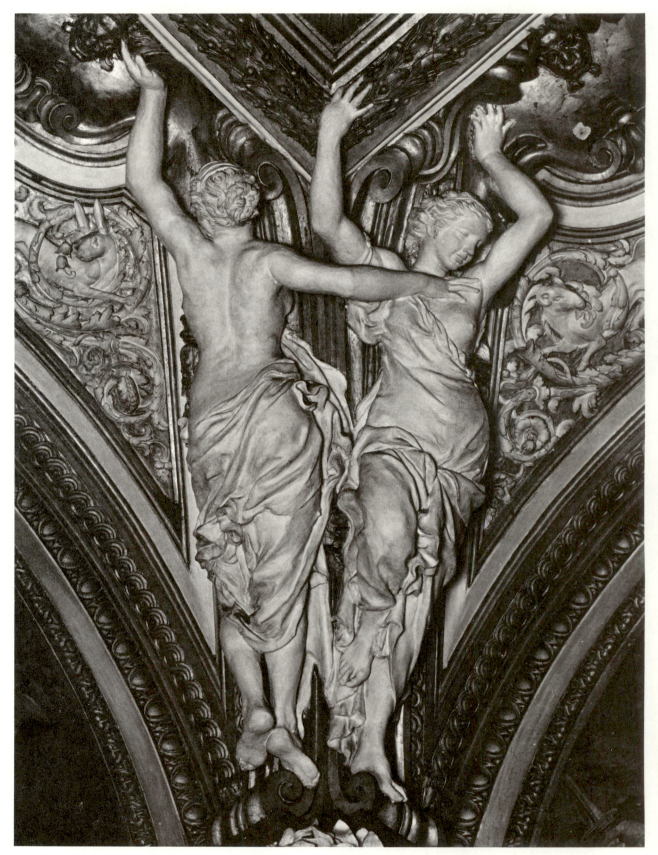

102. Pair of female spandrel figures (between *Minerva and Cecrops* and *Fury and Discord* lunettes), Sala di Giove

103. Detail of Fig. 102: head of a spandrel figure

104. Pair of female spandrel figures (between *Mercury* and *Castor and Pollux* lunettes), Sala di Giove

105. Pair of female spandrel figures (between *Bellerophon and Pegasus* and *Vulcan* lunettes), Sala di Giove

106. Pair of female spandrel figures (between *Apollo* and *Diana* lunettes), Sala di Giove

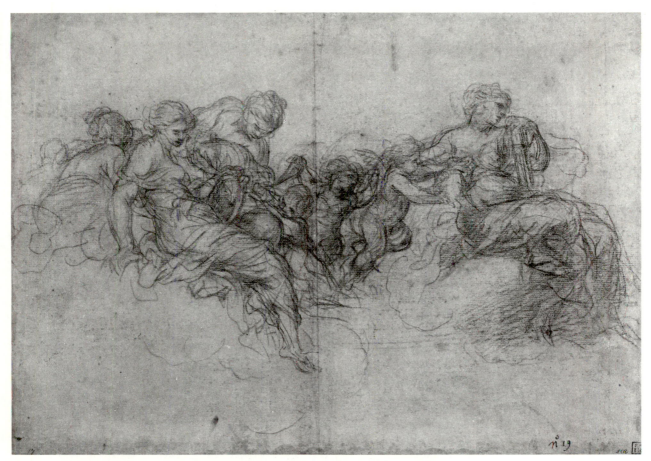

107. Study for figures in the Sala di Giove ceiling. National Museum, Stockholm

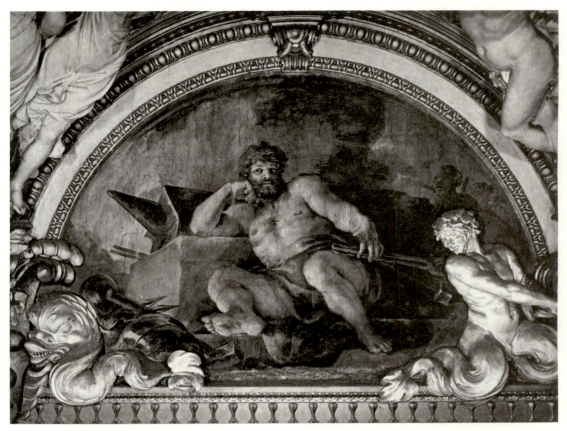

108. *Vulcan* lunette, Sala di Giove

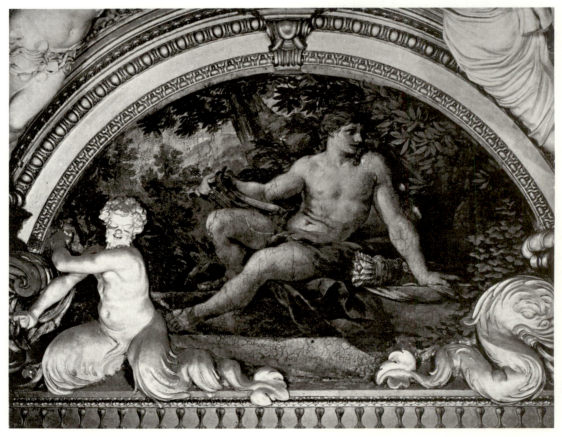

109. *Apollo* lunette, Sala di Giove

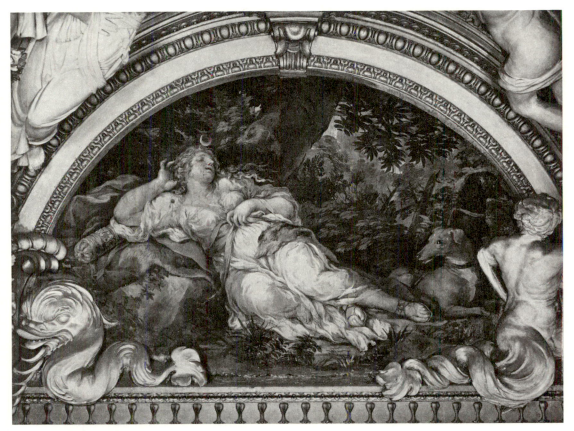

110. *Diana* lunette, Sala di Giove

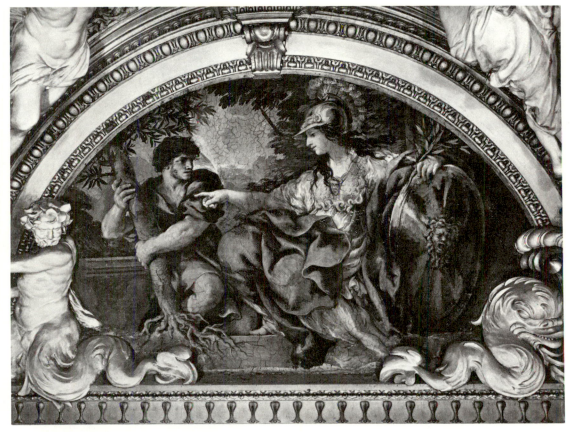

111. *Minerva and Cecrops* lunette, Sala di Giove

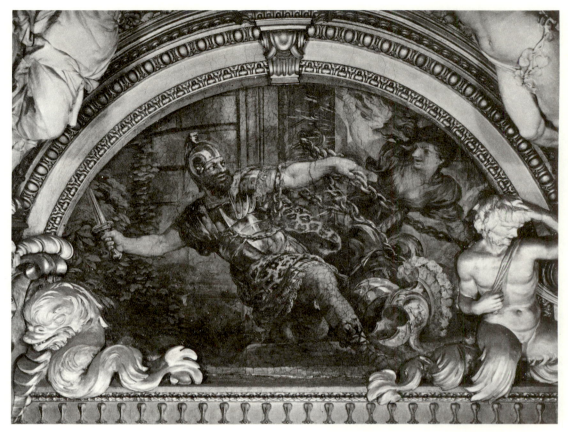

112. *Fury and Discord* lunette, Sala di Giove

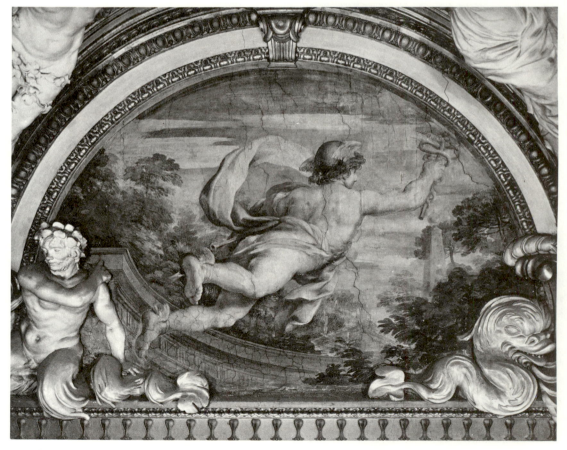

113. *Mercury* lunette, Sala di Giove

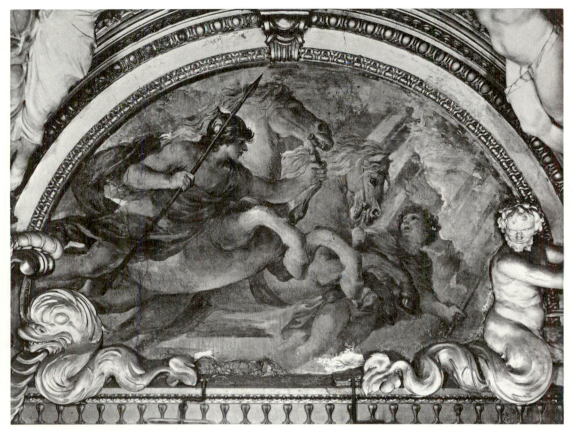

114. *Castor and Pollux* lunette, Sala di Giove

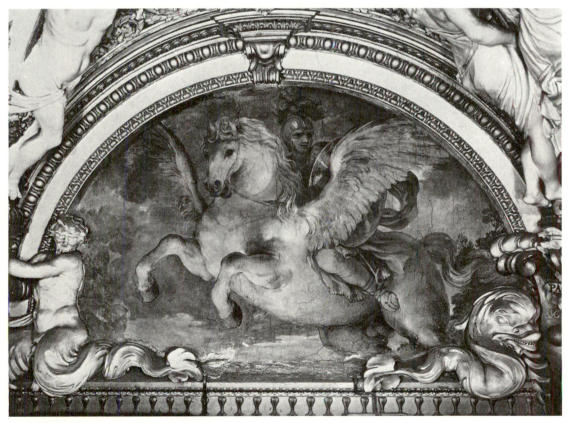

115. *Bellerophon and Pegasus* lunette, Sala di Giove

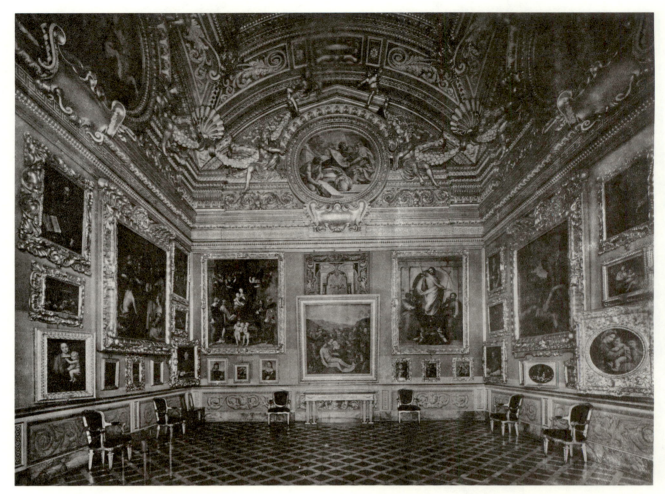

116. Sala di Saturno, general view

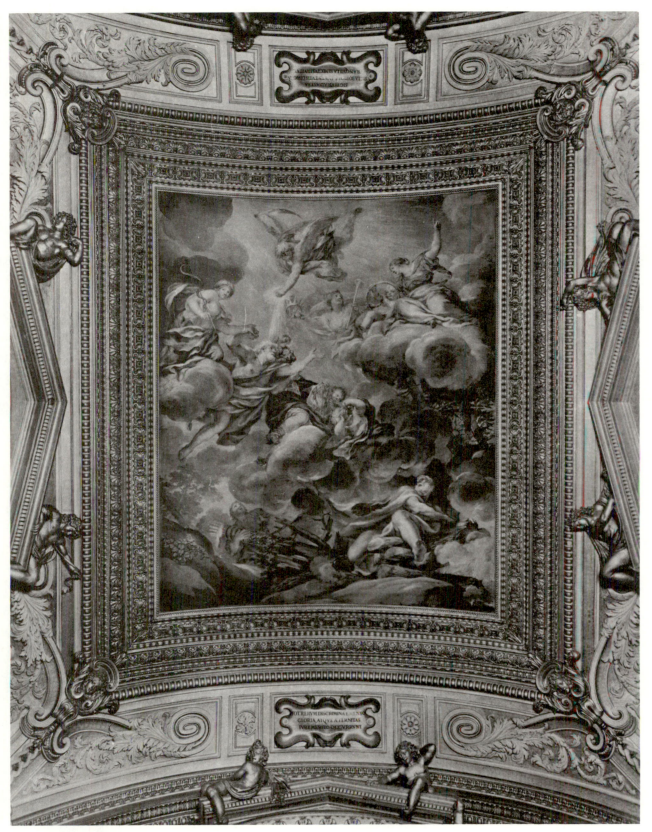

117. Sala di Saturno, ceiling

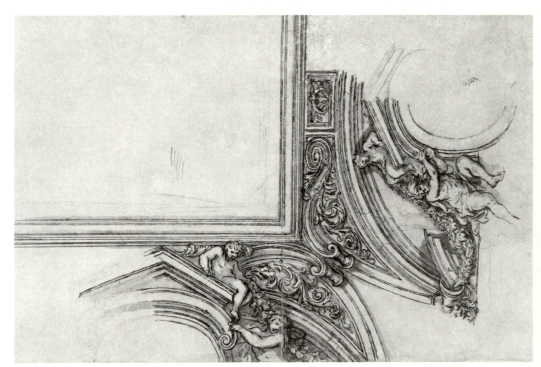

120. Study for stucco decorations, Sala di Saturno.
Kunstbibliothek, Berlin

119. Study for stucco decorations, Sala di Saturno.
Royal Library, Windsor

118. Study for stucco decorations, Sala di Saturno. Kunsthalle,
Hamburg

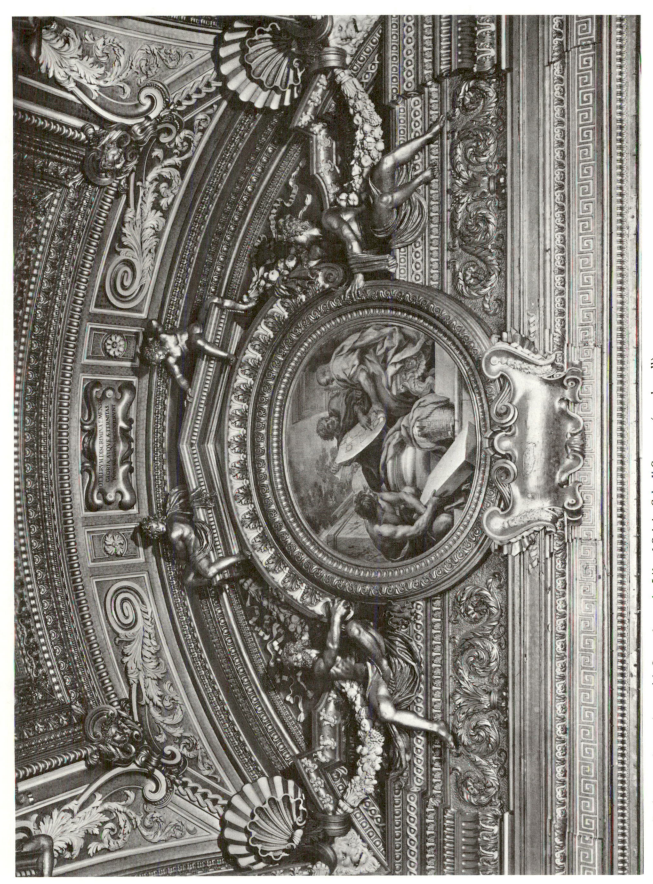

121. Detail of stucco decorations with *Scene from the Life of Scipio*, Sala di Saturno (south wall)

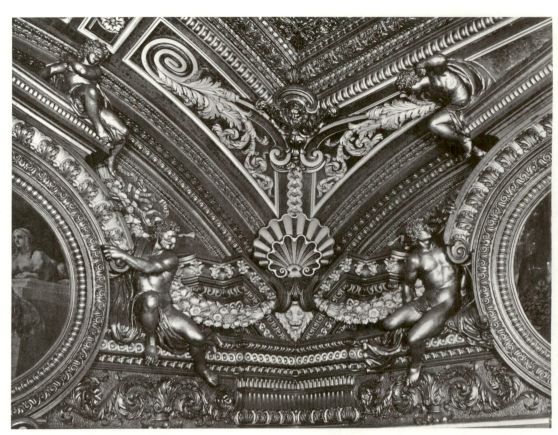

122. Detail of stucco decorations, Sala di Saturno (northeast corner)

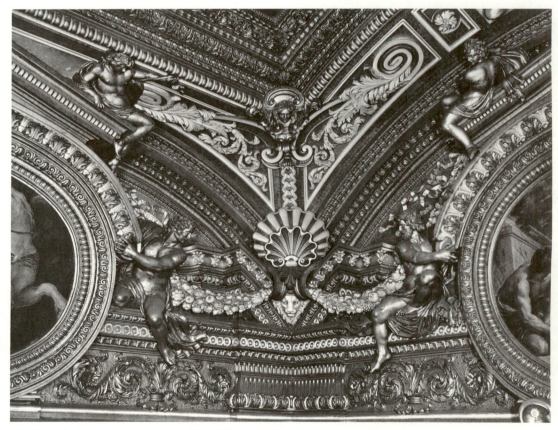

123. Detail of stucco decorations, Sala di Saturno (southeast corner)

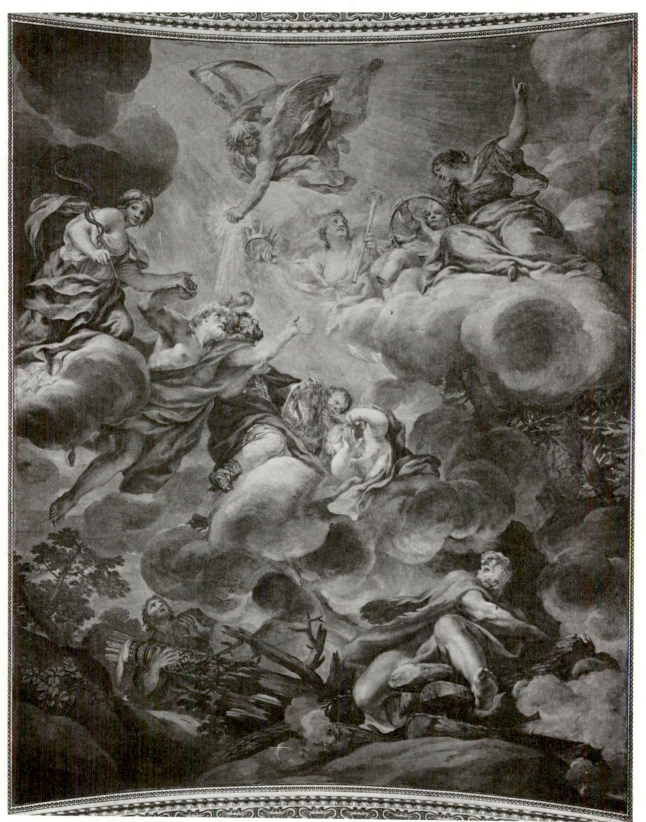

124. Ciro Ferri, ceiling fresco of the Sala di Saturno

125. Ciro Ferri, composition study for the Sala di Saturno ceiling. Private collection, Rome [?]

126. (Below) Ciro Ferri, composition study for the Sala di Saturno ceiling. Gabinetto Nazionale delle Stampe, Rome

127. (Top right) Ciro Ferri, composition study for the Sala di Saturno ceiling. Gabinetto Nazionale delle Stampe, Rome

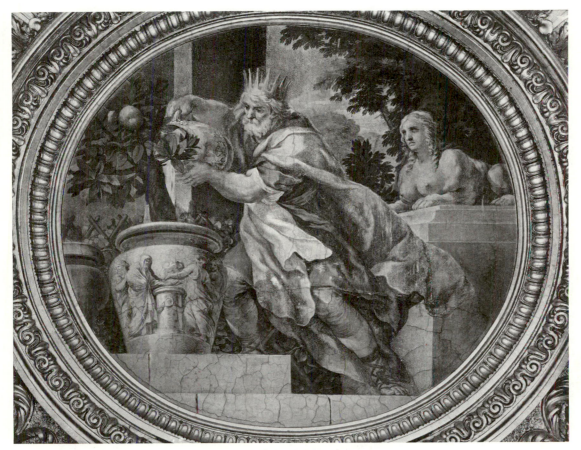

128. Ciro Ferri, *Scene from the Life of Cyrus*, Sala di Saturno

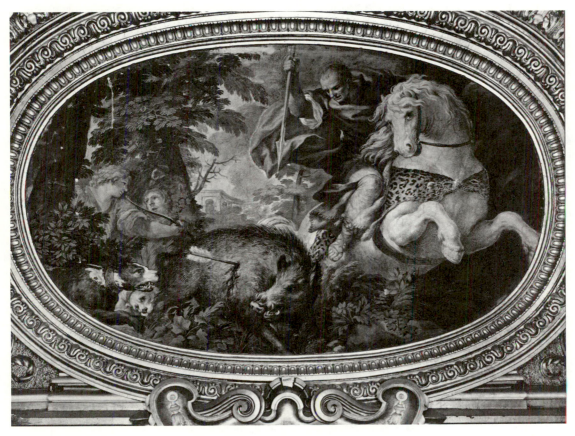

129. Ciro Ferri, *Scene from the Life of Sulla*, Sala di Saturno

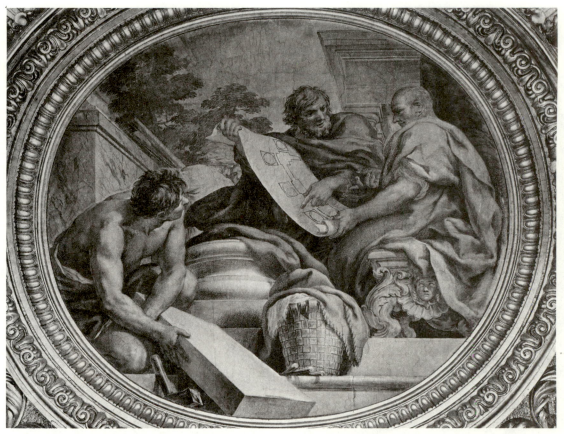

130. Ciro Ferri, *Scene from the Life of Scipio*, Sala di Saturno

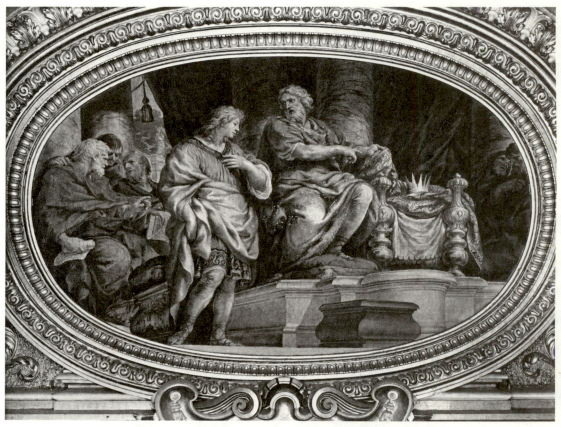

131. Ciro Ferri, *Scene from the Life of Lycurgus*, Sala di Saturno

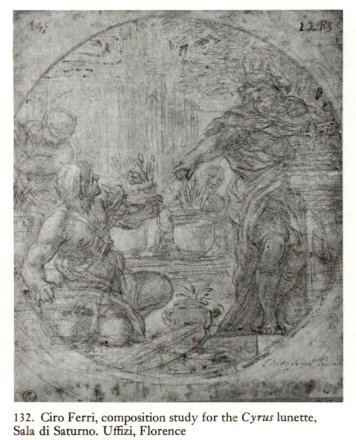

134. Ciro Ferri, study for a throne aedicule. Staatliche Museen, Berlin

132. Ciro Ferri, composition study for the *Cyrus* lunette, Sala di Saturno. Uffizi, Florence

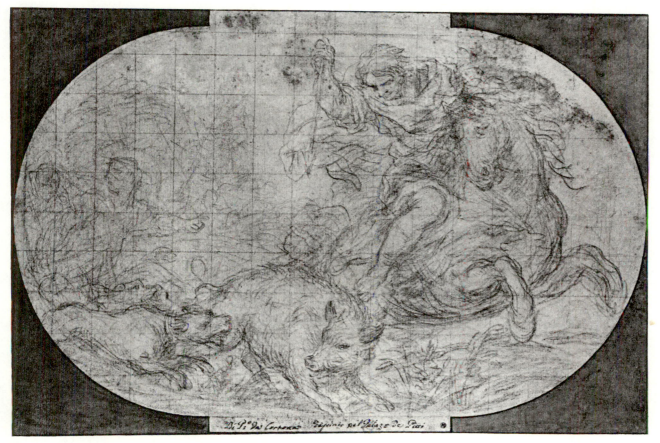

133. Ciro Ferri, composition study for the *Sulla* lunette, Sala di Saturno. Hessisches Landesmuseum, Darmstadt

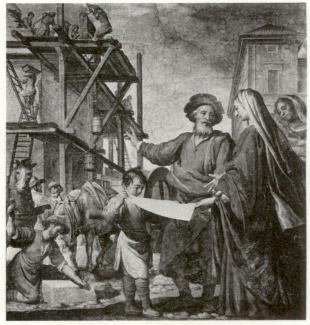

135. Pietro da Cortona, *St. Bibiana Refuses to Worship an Idol*. S. Bibiana, Rome

136. Agostino Ciampelli, *Building the Church of S. Bibiana*. S. Bibiana, Rome

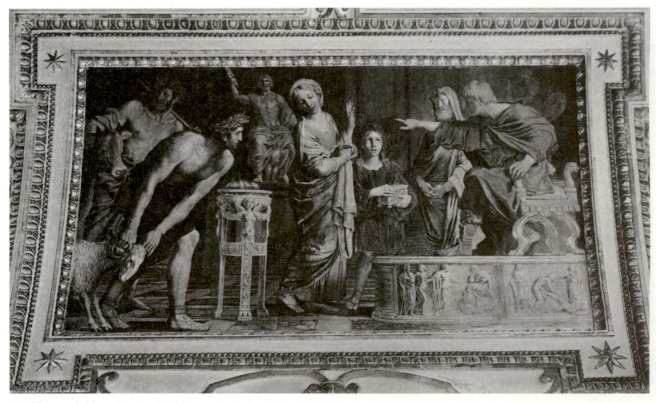

137. Domenichino, *St. Cecilia before the Judge*. S. Luigi dei Francesi, Rome

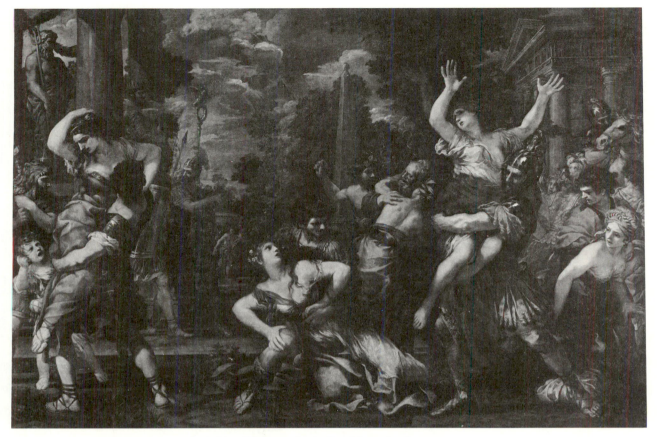

138. Pietro da Cortona, *Rape of the Sabine Women*. Capitoline Museum, Rome

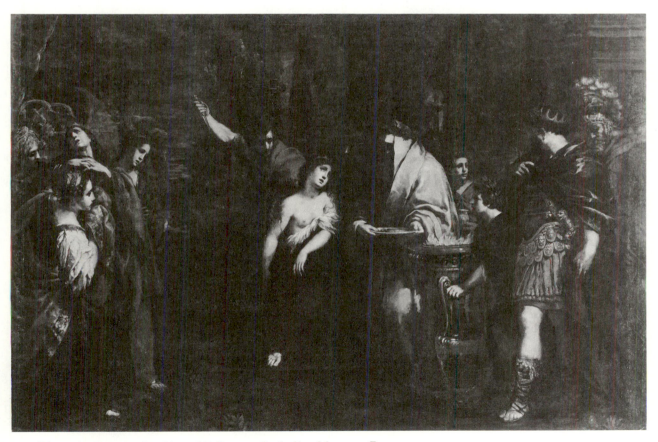

139. Pietro da Cortona, *Sacrifice of Polyxena*. Capitoline Museum, Rome

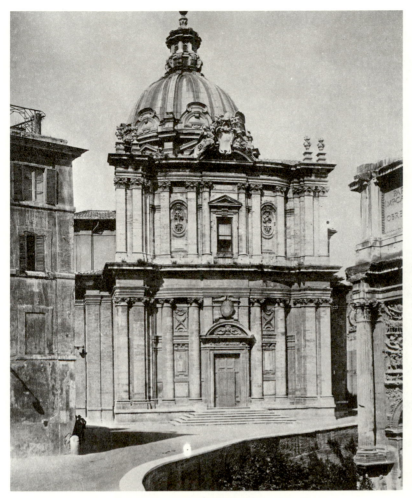

140. Pietro da Cortona, church of SS. Luca e Martina, Rome

141. Pietro da Cortona, ceiling decorations (engraving by Gherardo Audran), Villa del Pigneto (now destroyed), Rome

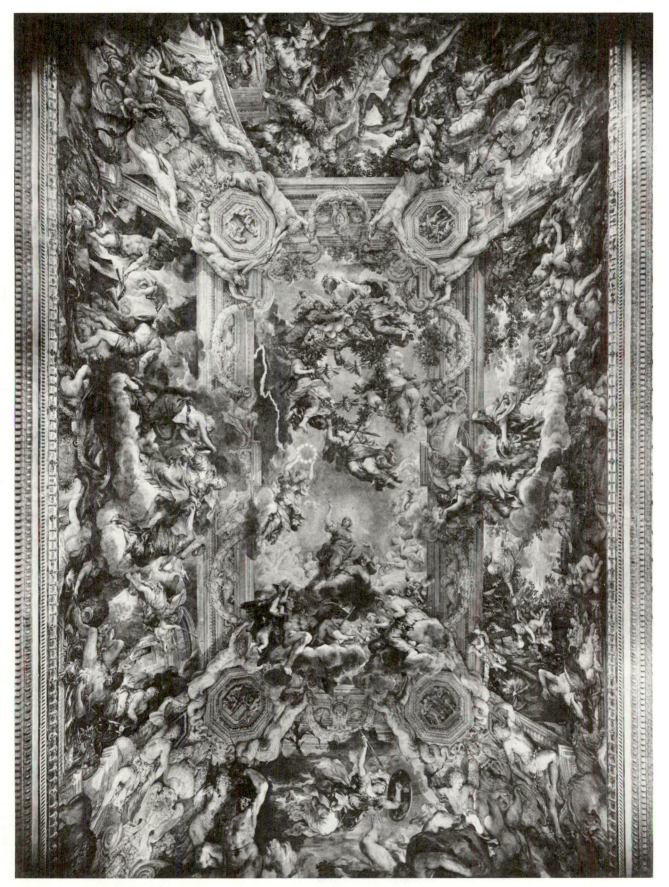

142. Pietro da Cortona, ceiling of the Salone, Palazzo Barberini, Rome

143. Pietro da Cortona, ceiling of the Salone (detail), Palazzo Barberini, Rome

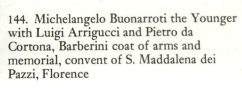

144. Michelangelo Buonarroti the Younger with Luigi Arrigucci and Pietro da Cortona, Barberini coat of arms and memorial, convent of S. Maddalena dei Pazzi, Florence

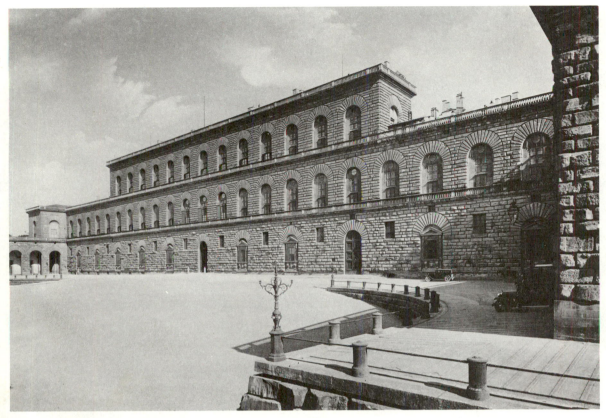

145. Piazza Pitti and the main facade of the Pitti Palace, Florence

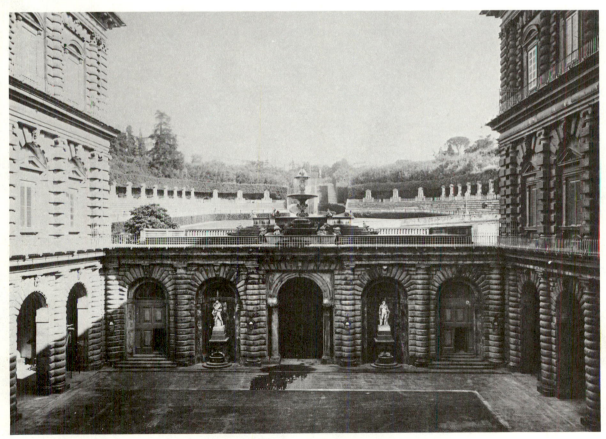

146. General view of the Cortile Grande and adjacent amphitheatre, showing entrance to the grotto, *Fontana del Carciofo* (terrace), and statue of *Dovizia* (terminus of *allée*), Pitti Palace, Florence

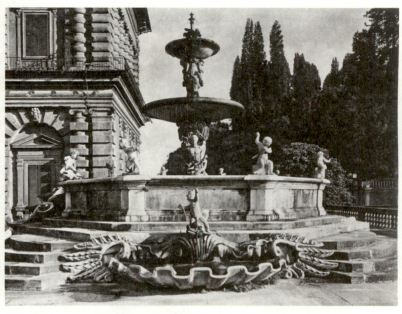

147. Giovanni Bologna, Pietro Tacca and Bartolommeo Salvini, *Dovizia*. Boboli Gardens, Florence

148. Francesco Susini, *Fontana del Carciofo*. Pitti Palace, Florence

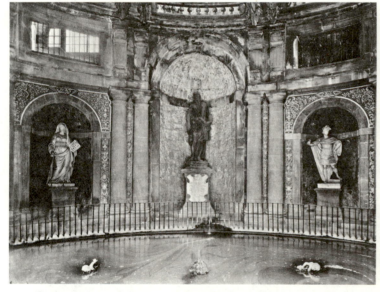

149. General view of the grotto, Cortile Grande, Pitti Palace, Florence. Left to right: Antonio Novelli, *Legislation*; Raffaeli Curradi and Cosimo Salvestrini, *Moses*; and Domenico, Pieratti, *Authority*

150. Wall fountain in the grotto, Cortile Grande, Pitti Palace, Florence

151. Giovanni da San Giovanni and others, general view of the Salone Terreno, Pitti Palace, Florence

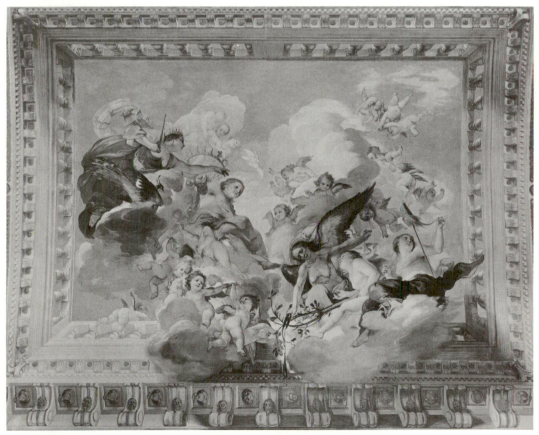

152. Giovanni da San Giovanni, central section of the vault, Salone Terreno, Pitti Palace, Florence

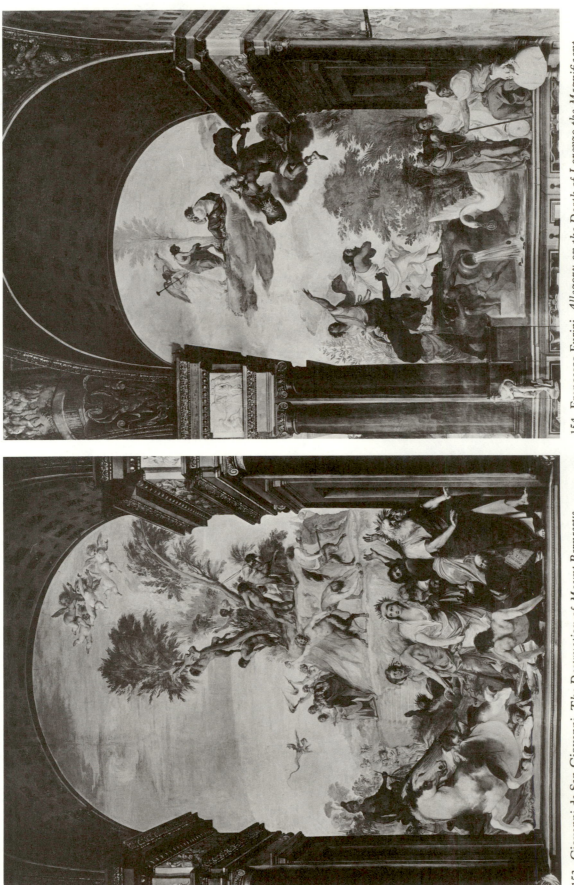

153. Giovanni da San Giovanni, *The Destruction of Mount Parnassus*, Salone Terreno (south wall), Pitti Palace, Florence

154. Francesco Furini, *Allegory on the Death of Lorenzo the Magnificent*, Salone Terreno (east wall), Pitti Palace, Florence

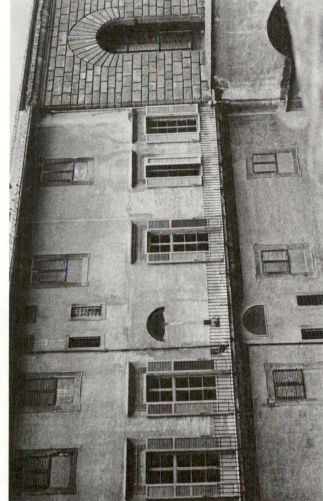

155. Detail of the Sala della Stufa, window and adjacent niche, Pitti Palace, Florence

156. Remigio Cantagallina, sketch of the Pitti Palace. Private collection, Arezzo

157. Garden facade of the east wing (showing nineteenth-century stairway at far right), Pitti Palace, Florence

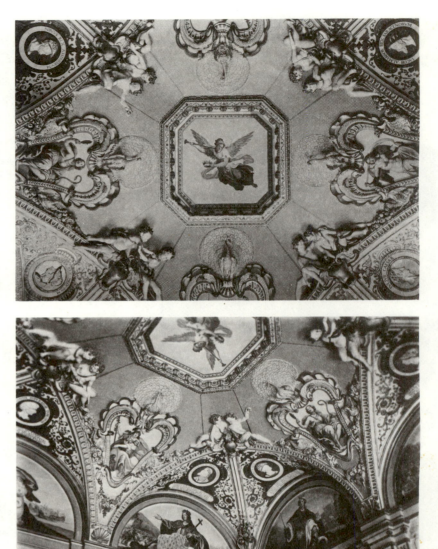

158. Matteo Rosselli and Antonio Novelli, central section of vault, Sala della Stufa, Pitti Palace, Florence

159. Matteo Rosselli and Antonio Novelli, detail of the vault, Sala della Stufa, Pitti Palace, Florence

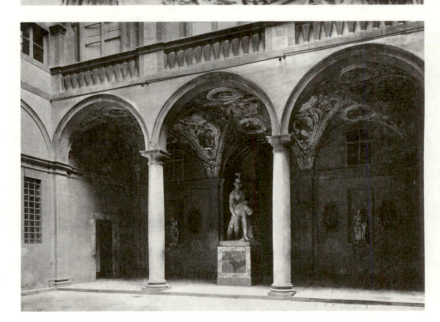

160. General view of the cortiletto showing loggia with decorations by Bernardo Poccetti, Pitti Palace, Florence

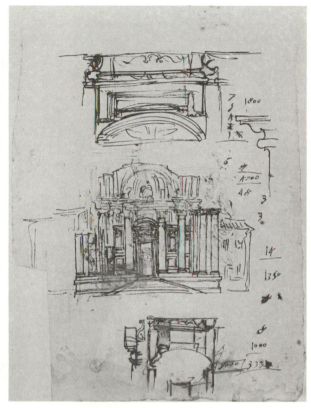

161. Detail of pilaster decorations, Sala della Stufa, Pitti Palace, Florence

162. Pietro da Cortona, sketch of SS. Luca e Martina under construction. Uffizi, Florence

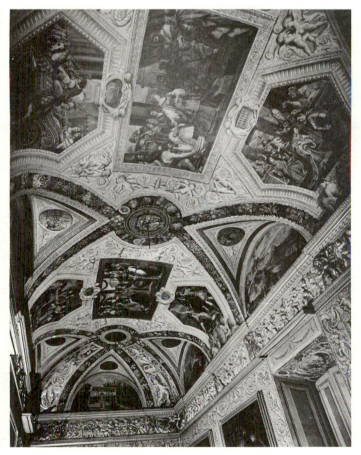

163. Pietro Paolo Bonzi and Pietro da Cortona, view of the gallery vault, Palazzo Mattei, Rome

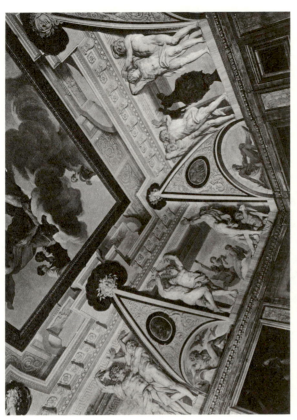

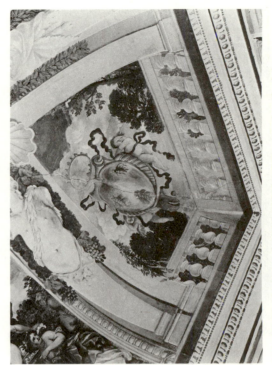

165. Giovanni Lanfranco, *The Gods of Olympus and Personifications of River Gods* (repainted), detail of ceiling fresco, Villa Borghese, Rome

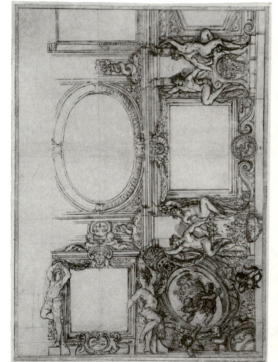

164. Pietro da Cortona, preparatory study for gallery at Villa Sacchetti (now Chigi), Castelfusano. Royal Institute of British Architects, London

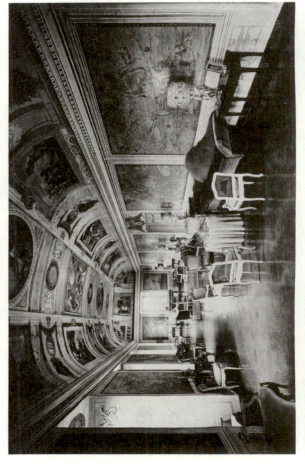

167. Pietro da Cortona and assistants, corner detail of the gallery vault with the Barberini coat of arms, Villa Sacchetti (now Chigi), Castelfusano

166. Pietro da Cortona and assistants, gallery, Villa Sacchetti (now Chigi), Castelfusano

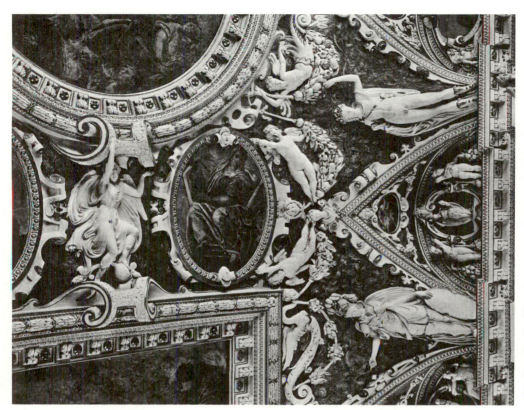

169. Detail of ceiling decorations in the Sala della Quattro Porte, Doge's Palace, Venice

170. Giulio Mazzoni, detail of stucco decorations in the Sala degli Stucchi, Palazzo Spada, Rome

168. Jacopo Strada, drawing of Giulio Romano's ceiling in the Sala di Troia, Ducal Palace, Mantua. Kunstmuseum der Stadt, Düsseldorf

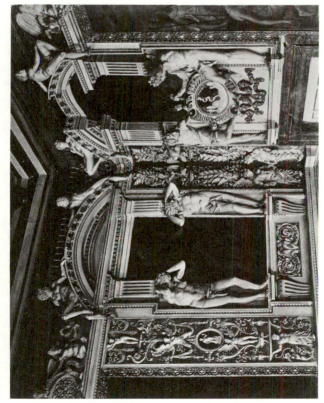

171. Pietro da Cortona, detail of stucco decorations in the vault, S. Lorenzo in Damaso, Rome

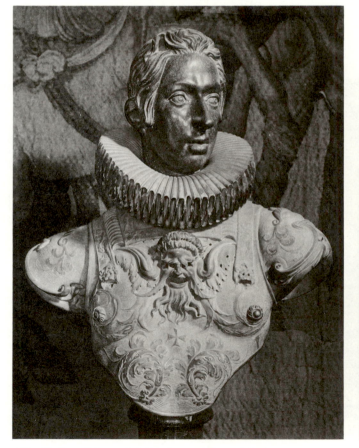

172. Cosimo Salvestrini (?), bust of Grand Duke Ferdinand II. Uffizi, Florence

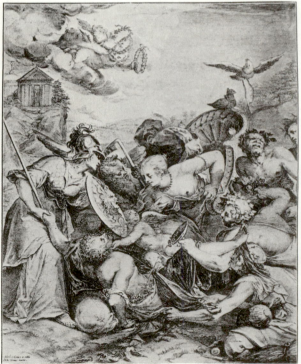

173. Otto Van Veen, *Youth between Virtue and Vice* (engraving by Pierre Perret)

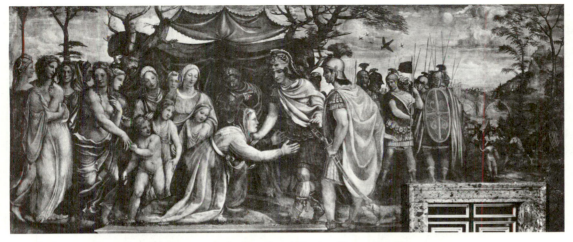

174. Sodoma, *Alexander the Great and the Family of Darius*. Farnesina, Rome

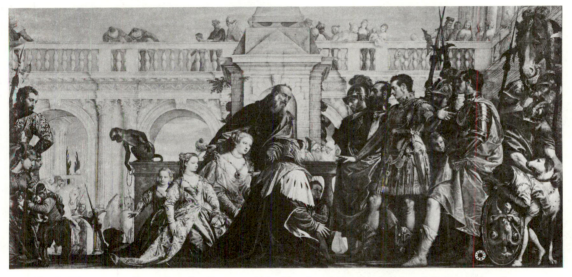

175. Paolo Veronese, *Alexander the Great and the Family of Darius*. National Gallery, London

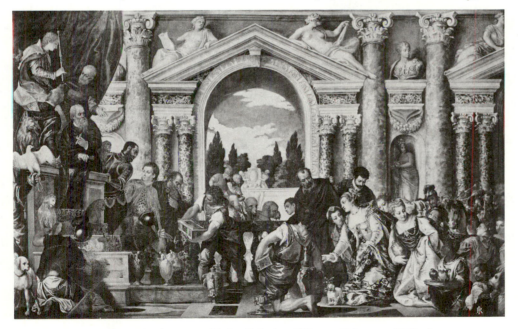

176. Paolo Veronese, *The Queen of Sheba Offering Gifts to Solomon*. Galleria Sabauda, Turin

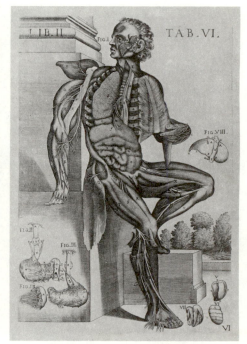

177. Annibale Garracci, detail of stucco decorations in the Farnese Gallery, Farnese Palace, Rome

178. Engraving after Pietro da Cortona from *Tabulae Anatomicae*

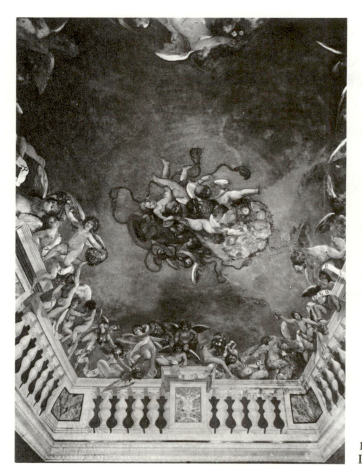

179. Unattributed, ceiling fresco, Casino Ludovisi, Rome

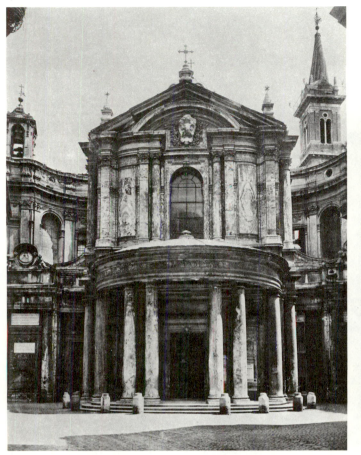

180. Pietro da Cortona, facade of S. Maria della Pace, Rome

181. Triton, formerly Villa del Pigneto, Rome (present location unknown)

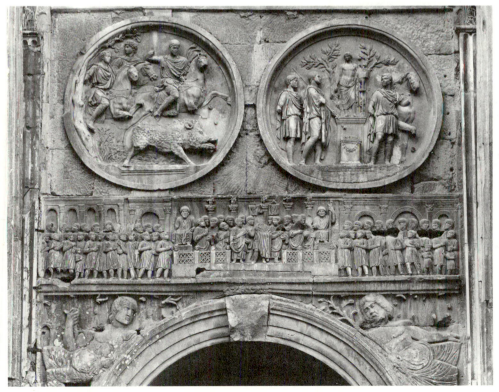

182. Hadrianic tondo relief, Arch of Constantine, Rome

183. Ciro Ferri, allegorical stemma of the Casa Medici (engraving by F. Spierre)

184. Pietro da Cortona, vault fresco before restoration, mezzanine ceiling, Pitti Palace, Florence

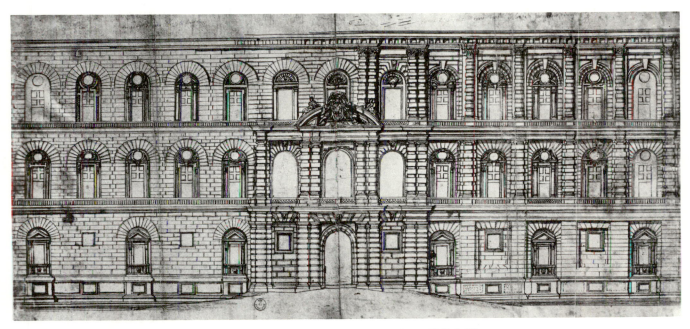

185. Pietro da Cortona, study for renovation of the facade of the Pitti Palace. Uffizi, Florence

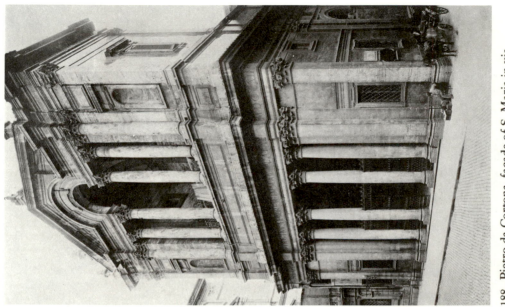

188. Pietro da Cortona, facade of S. Maria in via Lata, Rome

189. Stefano della Bella, *spettacoli* for the wedding of Ferdinand II and Vittoria della Rovere. Uffizi, Florence

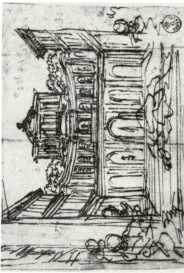

187. Pietro da Cortona, study for an architectural project at the Pitti Palace. Uffizi, Florence

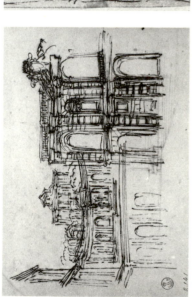

186. Pietro da Cortona, study for an architectural project at the Pitti Palace. Uffizi, Florence

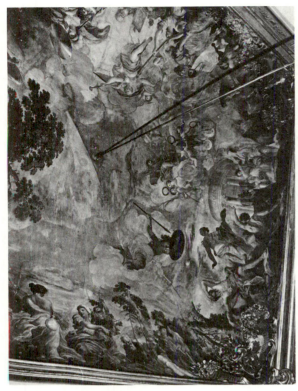

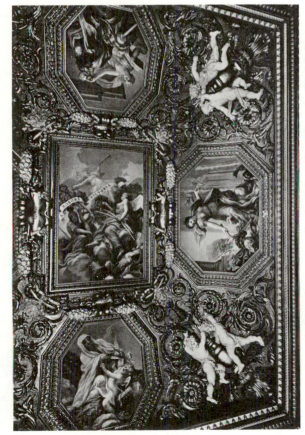

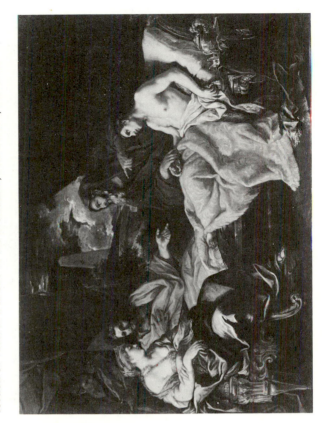

191. Anton Domenico Gabbiani, *Triumph of the Casa Medici*, section of vault in a salone of the Meridiana, Pitti Palace, Florence

190. Volterrano, ceiling decorations in the Sala delle Allegorie, Pitti Palace, Florence

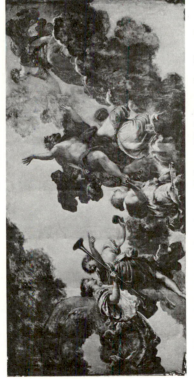

192. Pietro Liberi (?), *Apotheosis*, Palazzo Fini (later the Grand Hotel and now provincial government offices), Venice

193. Unattributed, *Antiochus and Stratonice*. Art Gallery of Ontario, Toronto

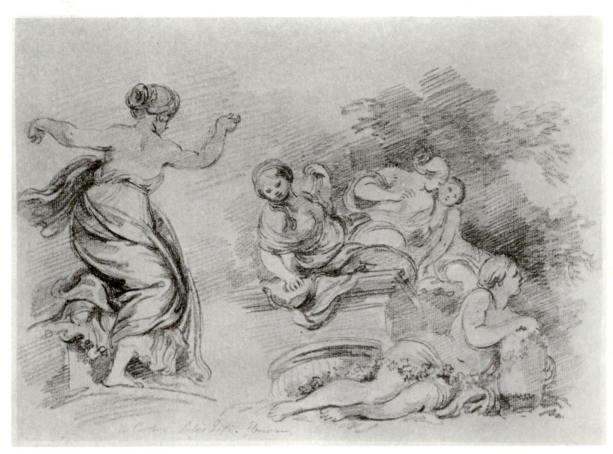

194. J.-H. Fragonard, sketches from the ceiling frescoes of the Sala di Marte and Sala di Venere. Location unknown

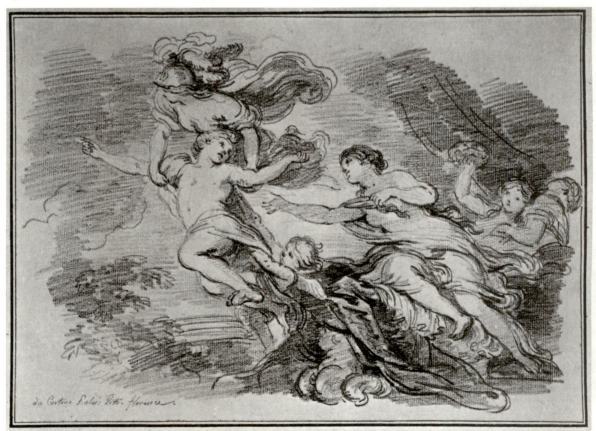

195. J.-H. Fragonard, sketch from the ceiling fresco of the Sala di Venere. British Museum, London

196-202. Pietro da Cortona, figure studies for the
Sala di Marte ceiling. Private collections, Paris

196. An oarsman

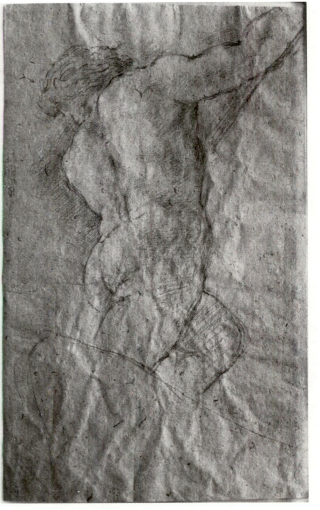

198. An oarsman

197. An oarsman

199. A female allegory

200. Hercules

201. Hercules

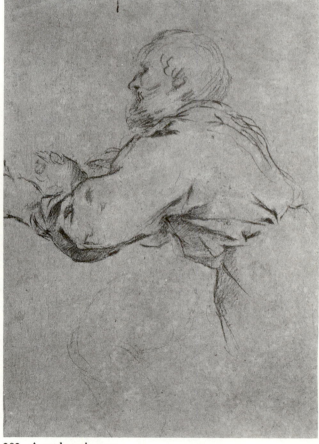

202. A male prisoner